FROM ENERGY TO INFORMATION

WRITING SCIENCE

EDITORS Timothy Lenoir and Hans Ulrich Gumbrecht

FROM ENERGY TO INFORMATION

REPRESENTATION IN SCIENCE AND TECHNOLOGY,
ART, AND LITERATURE

EDITED BY

Bruce Clarke and

Linda Dalrymple Henderson

STANFORD UNIVERSITY PRESS
STANFORD, CALIFORNIA

Stanford University Press
Stanford, California

Printed on acid-free, archival-quality paper

Printed and bound in Great Britain by
Marston Book Services Ltd, Oxfordshire

Library of Congress Cataloging-in-Publication Data

From energy to information : representation in science
and technology, art, and literature / edited by Bruce Clarke
and Linda Dalrymple Henderson.
 p. cm. — (Writing Science)
 Includes bibliographical references and index
 ISBN 0-8047-4176-X (alk. paper) — ISBN 0-8047-4210-3 (pbk. :
alk. paper)
 1. Technology—History. 2. Science—History. I. Clarke, Bruce.
II. Henderson, Linda Dalrymple. III. Series.
T15 .F78 2002
509—dc21 2002070594

Original Printing 2002

Typeset by G & S Typesetters, Inc. in 10/13 Sabon

CONTENTS

ILLUSTRATIONS

Christoph Asendorf is professor of art and art theory on the cultural studies faculty at the Europa-Universität Viadrina in Frankfurt/Oder, Germany. He is the author of *Ströme und Strahlen: Das langsame Verschwinden der Materie um 1900* (Berlin, 1989), *Batteries of Life: On the History of Things and Their Perception in Modernity* (California, 1993), and *Super Constellation: Flugzeug und Raumrevolution—Die Wirking der Luftfahrt auf Kunst und Kultur der Moderne* (Springer-Verlag, 1997).

Ian F. A. Bell is professor of American literature at the University of Keele in Staffordshire, England. His books include *Critic as Scientist: The Modernist Poetics of Ezra Pound* (Methuen, 1981), *Henry James and the Past: Readings into Time* (Macmillan, 1991), and *Washington Square: Styles of Money* (Twayne, 1993).

Robert Brain is assistant professor of the history of science at Harvard University. His book, *Being Analog: Graphic Recording Instruments and Scientific Modernism*, is forthcoming from Stanford University Press.

Bruce Clarke is professor of English at Texas Tech University. He has published *Allegories of Writing: The Subject of Metamorphosis* (SUNY, 1995), *Dora Marsden and Early Modernism: Gender, Individualism, Science* (Michigan, 1996), and *Energy Forms: Allegory and Science in the Era of Classical Thermodynamics* (Michigan, 2001).

Charlotte Douglas is professor and chair of the Department of Russian and Slavic Studies at New York University. She specializes in the history of Russian art, contemporary Russia, twentieth-century intellectual history, and the Russian avant-garde. Her *Kazimir Malevich* was published by Abrams in 1994.

N. Katherine Hayles is professor of English at the University of California, Los Angeles. Her most recent publication is *How We Became Posthuman: Virtual Bodies in Cybernetics, Literature, and Informatics* (Chicago, 1999), a study of the impact of information technologies on contemporary literature and literary theory, set in the context of the evolving history of cybernetics.

Linda Dalrymple Henderson is David Bruton, Jr. Centennial Professor in Art History in the Department of Art and Art History at the University of Texas at Austin. She is the author of *The Fourth Dimension and Non-Euclidean Geometry in Modern Art* (Princeton, 1983; new ed., MIT Press, forthcoming) and *Duchamp in Context: Science and Technology in the Large Glass and Related Early Works* (Princeton, 1998).

Bruce J. Hunt is associate professor of history at the University of Texas at Austin. His publications include *The Maxwellians* (Cornell, 1991), "The Ohm is Where the Art is: British Telegraph Engineers and the Development of Electrical Standards" in *Osiris* (1994), and "Doing Science in a Global Empire: Cable Telegraphy and Victorian Physics," in *Victorian Science in Context* (Chicago, 1997).

Douglas Kahn is director of the Center for Technocultural Studies at the University of California, Davis. He is the co-editor of *Wireless Imagination: Sound, Radio, and the Avant-Garde* (MIT, 1992), and the author of *Noise, Water, Meat: A History of Sound in the Arts* (MIT, 1999).

Timothy Lenoir is professor of history and chair of the Program in History and Philosophy of Science at Stanford University. He is the author of *Instituting Science: The Cultural Production of Scientific Disciplines* (Stanford, 1997) and the editor of *Inscribing Science: Scientific Texts and the Materiality of Communication* (Stanford, 1998).

W. J. T. Mitchell is the Gaylord Donnelley Distinguished Service Professor of English and Art History at the University of Chicago. He has been the editor of *Critical Inquiry* since 1978. His books include *Blake's Composite Art* (1976), *Iconology* (1987), and *Picture Theory* (1994). He has recently published *The Last Dinosaur Book: The Life and Times of a Cultural Icon* (Chicago, 1998).

Marcos Novak lives in Venice, California, and works on virtual architectures. He is currently investigating the convergence of technologically augmented physical architecture with the architecture of cyberspace. His instal-

lation "Invisible Architectures" appeared in the Greek Pavilion at the 2000 Venice Biennial.

Sha Xin Wei received his Ph.D. in mathematics from Stanford University in 2000. He is assistant professor in the School of Literature, Communication, and Culture at the Georgia Institute of Technology, with interests in critical studies of science and technology, differential geometry, and hybrid media.

Edward A. Shanken received his doctorate in art history from Duke University, where he is currently executive director of ISIS: Information Science + Information Studies. He is editor of *Is There Love in the Telematic Embrace? Visionary Theories of Art, Technology, and Consciousness* (California, 2002).

Richard Shiff is the Effie Marie Cain Regents Chair in Art and director of the Center for the Study of Modernism in the Department of Art and Art History at the University of Texas at Austin. He is the co-editor of *Critical Terms for Art History* (Chicago, 1996) and the author of *Cézanne and the End of Impressionism* (Chicago, 1984).

David Tomas is a professor at the École des arts visuels et médiatiques, Université du Québec à Montréal. The author of *Transcultural Space and Transcultural Beings* and a VRML Internet book, *The Encoded Eye, the Archive, and its Engine House*, he is completing another Internet book on deviant approaches to media history.

M. Norton Wise is professor of history at UCLA where he pursues the cultural history of physics in the nineteenth and twentieth centuries. He has co-authored *Energy and Empire* (with Crosbie Smith, Cambridge, 1989), edited *The Values of Precision* (Princeton, 1995), and is completing a book on bourgeois Berlin and laboratory science in the 1840s.

ACKNOWLEDGMENTS

This collection of essays originated in an April 1997 interdisciplinary symposium, "From Energy to Information: Representation in Science, Art, and Literature," organized at the University of Texas at Austin by the editors, with the assistance of Richard Shiff, Director of the Center for the Study of Modernism in the Department of Art and Art History. We are grateful for the financial and administrative support for that venture, which was provided by the Office of the Dean of the College of Fine Arts (former Dean John Whitmore and Dean David Deming), the Center for the Study of Modernism and the Effie Marie Cain Regents Chair in Art, the Department of Art and Art History (Chair Kenneth Hale, publicist David Willard, and designer Gloria Lee), and several departments across the University of Texas at Austin. Anne Collins Goodyear, Research Assistant in the Center for the Study for Modernism, worked with us tirelessly and with good cheer at every stage of the organization process, and was central to the symposium's success. An excellent group of art-history graduate-student volunteers assured its smooth running.

We are especially grateful to our friend and colleague Ilya Prigogine, whose plenary address on "Nature as Construction" was one of the highlights of the symposium. Several other conference speakers—Charles Altieri, Kristine Stiles, Gregory Ulmer, and Wayne Andersen—made vital contributions to the high level of discourse during those stimulating three days in Austin.

In the movement from symposium to book, we had invaluable help from colleagues who read and critiqued essays as they developed, including especially the contributions of Bruce Hunt, Richard Shiff, Norton Wise, Katherine Hayles, and Timothy Lenoir to the introductory materials. The symposium and this volume would never have occurred if the editors had not crossed paths at the 1993 meeting of the Society for Literature and Science (SLS). We thank the SLS for the rich interdisciplinary exchange it fosters and urge our readers to explore the society and its journal, *Configurations: A Journal of Literature, Science, and Technology*.

A Special Research Grant from the Office of the Vice President for Research at the University of Texas at Austin funded Heather Mathews's collaborative translation of the essay by Christoph Asendorf. A University of Texas College of Fine Arts Summer Research Grant and the David Bruton, Jr. Centennial Professorship in Art History assisted with costs related to illustrations. At Texas Tech University, our thanks go to the College of Arts and Sciences and the Center for the Interaction of the Arts and Sciences for editing and production support.

Portions of chapter 2 in this volume were adapted from chapters 3 and 5 in *Energy Forms: Allegory and Science in the Era of Classical Thermodynamics* by Bruce Clarke (Ann Arbor: The University of Michigan Press, ©2001) and are reprinted by permission of the publisher. Chapter 8 is adapted from the author's book *Noise, Water, Meat: Sound, Voice, and Aurality in the Arts* (Cambridge, Mass.: MIT Press, 1999) and appears by permission of the publisher. Material used in chapter 12 was revised from an essay in Roy Ascott, *Is there Love in the Telematic Embrace? Visionary Writings on Art, Technology and Consciousness,* edited by Edward A. Shanken (Berkeley: University of California Press, ©2003 The Regents of the University of California) and is reprinted by permission of the publisher. Chapter 16 is excerpted from *The Last Dinosaur Book: The Life and Times of a Cultural Icon* (Chicago: University of Chicago Press, ©1998 The University of Chicago) by permission of the publisher.

At Stanford University Press, Nathan McBrien provided expert guidance through the process of manuscript evaluation; Sumathi Raghavan, Helen Tartar, Anna Friedlander, and Stacey Lynn carefully brought the manuscript through production. Stanford's outside readers offered helpful feedback that has improved the completed volume, for which we are also very grateful.

We owe the greatest debt to our spouses and families, Donna Clarke and George, Andrew, and Elizabeth Henderson, who survived both the preparations for the symposium and the long process of its transformation into this volume.

FROM ENERGY TO INFORMATION

Introduction

BRUCE CLARKE AND LINDA DALRYMPLE HENDERSON

This collection of essays offers an innovative examination of the interactions of science and technology, art, and literature in the nineteenth and twentieth centuries. Our approach to interdisciplinarity is both broader and more tightly focused than past experiments in exploring the relationships of science and technology to art and literature.[1] In this volume, scholars in the history of science, art, literature, architecture, computer science, and media studies focus on five historical themes in the transition from energy to information: thermodynamics, electromagnetism, inscription, information theory, and virtuality. In the first five parts of the book, essays on the history of science and technology lead into articles treating concurrent creative and discursive productions. In the sixth and final part, an art historian and a literature scholar provide commentaries on related scientific and cultural representations that span the historical periods under consideration in the volume as a whole.

This book is unprecedented in its grouping of scholars from different humanities disciplines around specific moments in the history of science and technology. This arrangement makes it possible to discern broad connections among the modes of representation invented or adapted by each discipline in response to newly developed scientific concepts and models. Relating developments in literature and the plastic arts to significant phases in the transition from the era of energy to the information age allows unexpected resonances to emerge among materials not previously brought into juxtaposition. In particular, the essays collected here demonstrate the centrality of the theme of energy in modernist discourse. From this vantage the volume develops the scientific and technological side of the historical and cultural shift from modernity to postmodernity in terms of the conceptual crossover from energy to information.[2]

In our estimation, a primary step toward productive conversations between the humanities and the sciences is material as well as critical knowledge of the histories of science and technology germane to artistic and literary works. In the case of the historical sequence from the nineteenth-century sciences of energy to the twentieth-century sciences of information, experimental and theoretical developments have fed into technological innovations, which in turn have been commodified and distributed as cultural practices

throughout modern society. With regard to thermodynamics, the development of the steam engine produced both the technological reorganization of manufacturing and transportation and, at the beginning of the nineteenth century, a new research emphasis on the mechanics of heat. At mid-century, the development of thermodynamics was consolidated in the modern energy concept. The mathematics of probabilities adopted in the statistical methods of both social and physical sciences carried thermodynamics toward a logic of order and randomness that later unfolded throughout the twentieth century in the forms of quantum mechanics, cybernetics, information theory, and the subsequent and ongoing expansion of computer sciences and communication technologies.

By the later nineteenth century, electromagnetism had joined thermodynamics in radically challenging prevailing conceptions of physical reality. A succession of highly publicized discoveries and inventions in the 1890s, including X-rays and wireless telegraphy, focused attention on radiant energy in the form of electromagnetic waves vibrating at various frequencies in the luminiferous ether, the hypothetical medium credited with the transmission of such waves. The discovery of radioactivity and the identification of the electron subsequently kept the thermodynamic and electromagnetic themes of energy in the forefront of the public's imagination well into the twentieth century. The unlocking of nuclear energy at mid-twentieth century coincided with crucial advances in information technology. With the development of electronic information systems, the heavy technologies of the earlier industrial period and their accompanying images of monumental energies gradually shifted toward the lighter structures of high technologies and the increasingly transparent media of the computer screen and network interface. The mastery of heat engines and electrical dynamos leads irreversibly to the microscopic sculpture of circuits in silicon.

It is widely acknowledged that ours is an age marked by the pulse of information, but there is less recognition that the late nineteenth and early twentieth centuries were seen in their time as an era defined by the science and technology of energy. In fact, this theme is pervasive in the writings and manifestos of avant-garde poets and artists of the period. In 1863, one of the first chroniclers of modernism, Charles Baudelaire, adopted the scientific metaphor of electrical energy to describe the ideal relationship of the modern painter to the urban world around him. According to Baudelaire's essay "The Painter of Modern Life," the "lover of modern life" must "enter the crowd as though it were an immense reservoir of electrical energy."[3] In the early years of the twentieth century, French poet Jules Romains, founder of unanimism, joined Baudelaire's vision of urban energy to his hero Whitman's

adulation of the energy of the cosmos, describing himself as a "condenser of universal energies" in his 1908 "La Vie unanime."[4] In 1913 Ezra Pound would declare energy itself to be central to the new aesthetic of modernism, its force an image of imagism: "We might come to believe that the thing that matters in art is a sort of energy, something more or less like electricity or radioactivity, a force transfusing, welding, and unifying. . . . You may make what image you like."[5] The world of poets, artists, architects, and musicians was filled not just with the new scientific energies of thermodynamics, electromagnetism, and radioactivity, but also with new forces for creative expression and technological foundations for the reproduction and dissemination of that expression.

The prevalence of the term *energy* in early twentieth-century discourse suggests that the sense of intensification associated with these new energies was a basic impetus for artistic and literary modernisms. Although pessimistic themes of "heat death" darkened the initial cultural response to thermodynamics, early modernists saw radioactive materials as seemingly limitless sources of energy, and the new era of power generation offered a bracing sense of possibility for a future with abundant energy for new kinds of social and creative life.[6] For example, in marked contrast to the lassitude of art nouveau or the vagaries of symbolism, to be a poet or artist in the early twentieth century seemed to many to require modes of art forceful enough to rival the new scientific energies and technologies. Thus, it is not surprising to find energy at the center of the Italian futurists' aesthetic of dynamism. F. T. Marinetti's "Manifesto of Futurism" of 1909 declares, "We intend to sing the love of danger, the habit of energy and fearlessness." Or, as futurist painter Umberto Boccioni explained in his 1914 treatise, "Don't forget that life resides in the unity of energy, that we are centers who receive and transmit, so that we are indissolubly connected to everything."[7]

Guillaume Apollinaire presents a more specific aesthetic conception of energy in his 1913 *Les Peintres Cubistes*, arguing that "of all the plastic products of an epoch, works of art have the most energy," and "the energy of art imposes itself upon men, and becomes for them the plastic standard of the period."[8] In London, the vorticist retort to Italian futurism was articulated through hymns to the new orders of energy as enthusiastic as those of the Italians. In the first number of Wyndham Lewis's short-lived journal *Blast*, Ezra Pound declares: "The vortex is the point of maximum energy. It represents, in mechanics, the greatest efficiency." He is seconded by Henri Gaudier-Brzeska: "Sculptural energy is the mountain. . . . VORTEX IS ENERGY!"[9]

Modernist energies readily took on overtones of sex and gender as well. In D. H. Lawrence's *Women in Love* (1920), characters are distinguished ac-

cording to thermodynamic valences of hot desire, warm creation, and cold aggression.[10] The central couple experience, in an electromagnetic register, "a rich new circuit, a new current of passional electric energy, between the two of them, released from the darkest poles of the body and established in perfect circuit." [11]

The theme of energy would continue to be prominent in the writings of major modern artists and theorists such as František Kupka, Marcel Duchamp, Max Weber, Kazimir Malevich, and Paul Klee.[12] Energy would also be codified in art criticism in two particularly influential works of the 1930s and 1940s: John Dewey's *Art as Experience* of 1934 and Alexander Dorner's *The Way Beyond 'Art'* of 1947, dedicated to Dewey. *Art as Experience* centers on energy, specifically thermodynamics, to explain the means by which aesthetic works are created and perceived, while Dorner's text proclaims a new scientific reality that transcends the space-time world of Einstein and is constituted of "supra-spatial energies." [13]

With the explosion of the atomic bomb in 1945, a renewed postwar interest in Einstein and relativity theory, and the model of Dorner's book as well as a number of other articles linking art and science during the 1940s, the concept of energy continued to inform contemporary art writing. In "The Artist and the Atom," a 1951 *Magazine of Art* article, Peter Blanc compared Jackson Pollock drip paintings to the traces of subatomic particle collisions recorded in cloud-chamber photographs and declared, "Today nothing is left of matter. . . . All that is left is energy and the void." [14]

By the 1960s, however, like the atomic bomb tests that had once more coupled the demonstration of vast energies to ideas of destruction and extinction, the monumental and cosmic faces of energy would be driven underground. A distinct shift toward *information* as the prime stimulus for art and other forms of creative expression had begun in earnest. As several authors in this volume discuss in detail, the post–World War II decades brought to fruition a long period of anticipatory connections between energy and information. Many artists and writers, such as Roy Ascott and Philip K. Dick, would begin to explore the cybernetic linkage of energy and information in organisms and machines. In the 1960s, although novelist Thomas Pynchon briefly resuscitated Maxwell's Demon in *The Crying of Lot 49*, sculptor and earthwork artist Robert Smithson was unusual in his preoccupation with thermodynamics and entropy. Yet the list of Smithson's library makes clear that he was also well aware of the developing field of cybernetics and information theory, and his art theory evolved accordingly.[15]

Increasingly, however, the energy that would concern artists and others creating within the developing information age was simply the power required to drive the machines whose product was now information itself. Vi-

sual and literary representations of energy and entropy were to be super-seded by a range of data-scapes, by artistic installations and computerized video screens that wired energy technology directly into the display of images and texts.

Of primary concern in this volume are the modes of representation at work in the histories of modern science and technology, literature, and art. In this section, we consider some issues of representation, followed by a brief over-view of the ways that these issues touch on the disciplines addressed by the individual essays in this anthology. Later in the volume, to introduce each of its six main parts, we provide materials central to the specific interdisciplin-ary themes—thermodynamics, electromagnetism, inscriptions, information, virtuality, and materiality—that connect the history of science and technol-ogy to concurrent developments in literature and art. Here we look succes-sively across the three disciplines at the core of the volume—the history of science and technology, literary studies, and art history—to discover impor-tant insights into modern notions of representation.

Because *representation* is such a protean and contested concept, it will be helpful to sketch certain of its meanings and to stipulate the senses of the term that most apply to the following essays. In the history of artistic and lit-erary criticism, representation has denoted an outer mimesis, the making of an imitation or translation providing a more or less accurate rendering of that original object in another medium. The deliberate production of this new material reproduction yields a visual or verbal artifact bearing the im-age or description of another object, some preexisting entity in the world. This classical and neoclassical tradition of practical and external representa-tion is then decisively internalized in the idealist philosophy of Kant and his followers. Here the object and its representation exist for the sake and in the mind of a subject. The seat of representation lies in a consciousness and its ideas concerning natural and aesthetic objects.[16]

Although idealist philosophy would prove important for artists and writ-ers in the later nineteenth and early twentieth centuries, the general use of the term *representation* in discussing art and literature may be distinguished from the complex philosophical questions raised by mental representations.[17] Instead, many discussions of representation in art and literature consistently maintain a clear association with both pictorial and verbal figuration and, generally, with literal or metaphorical references to the phenomena of the visible world. This widely held view was codified recently in a long entry on

representation in the multivolume *Dictionary of Art*, which reflects the "fundamental intuition . . . that what can be represented coincides with what can be seen." [18]

In the visual arts of the early twentieth century, however, traditional concepts of representation that focused on resemblance to objects in the visual world met a frontal challenge with the rise of total abstraction in painting in the years before and during World War I. Over time, in art historical discourse the term *abstraction* came to oppose that of representation, an opposition encoded in the word *nonrepresentational*. [19] Given the formalist orientation of much early writing on modern art, there was little interest in what these colors and forms may have signified. [20] Once we realize that by the early twentieth century the visual and conceptual stimuli for artists and writers had expanded to include X-ray images of realms previously inaccessible to the human eye, or highly suggestive verbal evocations of the impalpable ether, we also see that the traditional conceptions of representation in both art and literature need to be enlarged. Artists in the early 1900s, including pioneers of total abstraction like Malevich, also turned their attention to a variety of other kinds of visual sources. Among these were scientific texts filled with diagrams and other sorts of illustrations. Fascinated by invisible forces and the notion of energy itself, these artists engaged in representational activities that were more like those of scientists attempting creatively to visualize or model natural phenomena.

One of the benefits of looking beyond the history of art and literature to that of science and technology is to discover there a broader usage of the term *representation*, one that offers a useful example for rethinking the limits of the term in these fields. In the history of science, representations emerge from scientific efforts to create visual analogues to phenomena that may or may not be available to normal channels of perception. Among historians of science, this broader, originally non-aesthetic conception of representation includes a wide range of activities. Here the concept is derived from the modeling of recondite natural processes in creative and often largely abstract ways, often having nothing to do with traditional modes of mimesis. Thus, in their introduction to *Representation in Scientific Practice*, Michael Lynch and Steve Woolgar include among the "varieties of representational devices used in science . . . graphs, diagrams, equations, models, photographs, instrumental inscriptions, written reports, computer programs, laboratory conversations, and hybrid forms of these." [21] Bruno Latour has also written extensively about such scientific representations, using the term *inscription* both for images invented by the hand of the scientist and for the automatic inscriptions recorded by registering apparatus in the laboratory. For Latour

such inscriptions are "immutable mobiles," transportable, stable, and combinable evidentiary artifacts central to the promulgating of scientific work and the making of converts to new theories.[22]

This volume considers pictorial and verbal images that convey information as representations, whether the data to be represented is *energic*—as manifested in thermodynamics or associated with the invisible realms revealed by the X-ray or suggested by talk of a luminiferous ether—or *informatic*—as manifested by digital codings or other orders of signification. The sciences readily recognize visualization and imaging technologies as central to scientific representation, which serves us well in rethinking artistic representation as a process of making visible or inventing new combinations of forms or symbols to express a new concept.[23] In fact, the avant-garde of twentieth-century artistic practices did not simply make a sudden leap from representation to total abstraction. It did not abandon representation, but instead forced a breakdown and reconstruction of its operations by attending to the scientific and technological expansion of its applications. In other words, a number of early twentieth-century styles, including cubism and futurism and much modern "abstraction," can be thought of as an artistic remodeling or remediation of scientific representation, in which the visualizing of phenomena beyond the range of normal vision—the transformative forms of energy, the medium of the ether, atomic and molecular particles—yield a variety of new pictorial forms. Historical conceptions of representation in art and literature clearly need to be extended to include this wider field of vision and visualization.[24]

The enlarging of the conception of representation in art and literature we advocate here must also be considered as a part of the more general rethinking of the implications of representation as a cultural activity. This broader reevaluation of representation has been stimulated by the work of historians and philosophers of science exploring the relation of constructed representation to scientific realism (e.g., Ian Hacking's *Representing and Intervening* of 1983) and by the writings of theorists such as Roland Barthes and Michel Foucault on the political implications of representation in science and culture.[25]

One of the authors in this volume, W. J. T. Mitchell, draws on Barthes and Foucault to suggest elsewhere that a renovated concept of representation could issue from a counter-idealist or "de-reified" approach that returns the concept to "something roughly commensurate with the totality of cultural activity. . . . Representation [would be] understood, then, as relationship, as process, as the relay mechanism in exchanges of power, value, and publicity."[26] In his paper for this volume, Mitchell puts this methodol-

ogy into action, showing in sharp critical strokes how the career of the dinosaur offers a cultural representation or dialectical image in which the discourse of science is pervasively bound up with sociological, political, and aesthetic motives.

Many of the other contributors to this volume are also engaged in rethinking the concept of representation, recognizing it as an aspect of cultural production and as a specific artistic and literary activity that has often been stimulated by new practices of representing in science and technology. They are also concerned with the discursive networks and technological media through which scientists, artists, and their interpreters and critics have communicated the products of their practices to each other. *From Energy to Information* pursues this renovation of representation precisely by setting up a range of interdisciplinary commerce to demonstrate how the "relay" effects of inscriptions circulating among science, technology, art, literature, and historical discourse define a significant amount of the cultural movement into modernism as well as into modes of postmodernism.

REPRESENTATION IN SCIENCE

In this volume, the essays contributed by historians of science focus on a series of representational devices with profound impacts on the arts and literature as well as on wider social practices. In "Time Discovered and Time Gendered in Victorian Science and Culture," Norton Wise investigates the cultural repercussions of the extension of sociologist Adolphe Quetelet's *normal curve*—a device for graphing the statistical dynamics of human populations—to the physics of gases and the biology of species. Quetelet's seminal social-scientific construction of statistical representations for otherwise imageless temporal sequences was relayed directly to and incorporated in the later emergence of statistical methods in thermodynamics and evolutionary theory.

In "Lines of Force, Swirls of Ether," Bruce J. Hunt traces the problematics of another scientific representation, the hypothetical ether medium. Attempts to model the ether exercised and ultimately modified representational practices throughout the physical sciences: "The ether began to evaporate as physicists ceased to think there had to be anything behind or beneath their electromagnetic fields and equations. What had begun as efforts to represent aspects of an underlying reality had come to be accepted as constituting the reality itself." As the practical successes of mathematical models of electromagnetic and gravitational fields displaced efforts to visualize the ether through mechanical models, it became increasingly apparent that scientific

and philosophical distinctions between the world and its representations were anything but clear and distinct.

The essays by Robert Brain and Douglas Kahn take up different aspects of the rise of graphic methods in modern science for the production of visual or auditory inscriptions of vibratory phenomena, in relation to various genres of artistic expression. Whether focused on electromagnetic waves or acoustic undulations, these developments created an early mode of correspondence between the registration of energies and transmission of signals. Just as light is a manifestation of radiant energy *and* a primary vehicle of perceptual information, in both the aerial conveyance of sound vibrations and the ethereal transmission of radio waves there is a convergence of energy and information, propagation through a medium and communication among observers. The inscribed line or curve—the graph as an informatic phenomenon derived from the dynamics of matter and energy—appeared to offer a kind of scientific lingua franca. In Brain's words, "the analogy of physical forces furnished the ontological solid ground that enabled the graph to become a universal currency of science, as well as an emblem of energy itself."

The scientific techniques of graphic inscription discussed by Wise, Brain, and Kahn show new ways of representing actual physical phenomena. In contrast, the heuristic models of physicists and the design practices of engineers and architects call forth representations that arrive before rather than after the thing represented comes into existence, if it does so at all. In "On the Imagination's Horizon Line: Uchronic Histories, Protocybernetic Contact, and Charles Babbage's Calculating Engines," David Tomas treats the temporality of such projective representations under the term *uchronia*. The profuse mechanical drawings for Charles Babbage's Difference Engine exhibit an "excess of representation" occasioned by the development and testing of prototypes. In this and countless other cases, the technological design and eventual production of mechanical instruments and inscription devices cycles back into the practices of the natural and medical sciences, further refining techniques for the representation of bodies and objects.

In "Authorship and Surgery: The Shifting Ontology of the Virtual Surgeon," Timothy Lenoir and Sha Xin Wei negotiate the design history and current implementation of digital imaging devices in the surgical theater, where representational regimes are immediately organized by the internal pathologies of bodies and the curative goals of surgical interventions. At the same time, these "new inscription technologies for writing and for re-writing the body . . . constitute the instrumentarium of a new epistemic regime," in which the subjects and objects of representation, both surgeon and patient, are transformed by the very media that place them into altered and augmented assemblages of bodies and machines.

REPRESENTATION IN LITERATURE

To connect the realms of literature and the visual arts to the history of science in the modern period is also to encounter a perennial or nonmodern mode of figural representation common to all three. By combining visual and verbal processes of metaphorical representation with narrative schemes that unfold those metaphors into spatial and temporal configurations, the discourse of *allegory* is a useful point of convergence for otherwise disparate disciplinary media.[27] For instance, pictorial and narrative representations of scientific concepts typically have borrowed from the traditional store of allegorical devices—anthropomorphism, prosopopoeia, daemonic agency, metamorphosis, miraculous modes of observation, transportation, or travel in space and time, and so forth. The allegorical cosmos is constructed through an articulation of narrative levels or realms of being mediated by narrators or characters who shift among them, finding the passages from one to another moralized landscape, temporal era, or physical incorporation. Representation in science often operates through comparable articulations and mediations between the seen and unseen, the microlevel and macrolevel, the human and the alien, the present state and its past determinations or future consequences.

In this volume, Bruce Clarke's "Dark Star Crashes: Classical Thermodynamics and the Allegory of Cosmic Catastrophe" traces the allegorical representation of early thermodynamic doctrines in the scientistic images of 1890s catastrophe narratives. In Camille Flammarion's *La Fin du Monde* in particular, the futuristic narrative is accompanied by allegorical engravings that drag the speculative future back to baroque doomsday visions. Allegorical structures in Flammarion's text attempt to remediate the clash in equilibrium thermodynamics between energy conservation and entropic dissipation in a way that confirms positive science's preeminence over religion in the area of cosmological pronouncements.

Ian F. A. Bell's "The Real and the Ethereal: Modernist Energies in Eliot and Pound" examines a more subtle example of literary scientism—the infusion of scientific modeling practices into the symbolic innovations of modernist poetics. T. S. Eliot and Ezra Pound developed methods of oblique suggestiveness that are partially inspired by scientific techniques for the visualization of imponderable substances and systems. Bell compares the seminal indirectness of Eliot's poetic strategies to the critical efforts of Pound to modernize poetic technique by reference to the dynamism of physical energies, to the quasi-mystical effects of wave motions in the cosmic ether, and to the physicists' own repertoire of heuristic representations, as seen in the work of James Clerk Maxwell, Ernst Mach, and Henri Poincaré.

Katherine Hayles's "Escape and Constraint: Three Fictions Dream of Moving from Energy to Information" traces changing representations of information technologies from the telegraphic era of Henry James to the postmodern intimations of virtual telepresence in Philip K. Dick and James Tiptree, Jr. Each is an allegory of cybernetic hybridity. The seductive materiality of information technologies generates "posthuman" desires to be translated from organic to informatic bodies.[28] But each attempt to envision the space of information as an ecstatic escape from the limitations of physical bodies leads also to "an arena in which the dynamics of domination and control can be played out in new ways." In sum, in this sampling, literary representations of energy and information range from the sensational emblematics of religio-scientific popularizations and the strenuous obliquities of modernist prosody to the ontological paradoxes of twentieth-century technoscientific narratives.

REPRESENTATION IN ART

Although the first of the art essays in this volume, Charlotte Douglas's "Energetic Abstraction: Ostwald, Bogdanov, and Russian Post-Revolutionary Art," is grounded in thermodynamics, the paintings it addresses date from the late 1910s and 1920s and are thus closer to the modes of representation considered in part 3. A more immediate reflection of the initial impact of thermodynamics on the imaginations of artists can be found in the illustrations for Flammarion's *La Fin du Monde* discussed by Bruce Clarke. Drawn by a variety of contemporary illustrators, including Albert Robida, these plates respond to Flammarion's text with graphic images of "heat death," allegorical suggestions of ideal worlds, or, as in Robida's case, futuristic imaginings appropriate to science fiction. Only rarely do the plates achieve any kind of representational innovation in response to new scientific ideas.

Flammarion's text was published just before Röntgen's 1895 discovery of the X-ray transformed the public's perception of the visual world, undercutting the status of visible light as an arbiter of truth. In addition to the invisible realms revealed by X-rays, artists were challenged to represent space as filled with ether and matter as actually dematerializing into the ether, as suggested by the discovery of radioactivity. Linda Dalrymple Henderson's "Vibratory Modernism: Boccioni, Kupka, and the Ether of Space" explores the commitment by artists such as the Italian Futurist Umberto Boccioni to represent these invisible, vibrating forms of energy, both by dematerializing the objects in his paintings and by attempting to make the ether itself palpable. While working in Paris from 1910 to 1912, František Kupka, the Czech pio-

neer of abstraction, also used transparency to evoke the invisible. By the latter part of 1912, however, he had replaced that more suggestive mode with bold, flat areas of patterned color by which he hoped to communicate his thoughts on the model of wireless telegraphy and vibratory thought transfer. The desire to visualize and paint invisible phenomena also characterized much of French cubist painting in the pre-World War I period.

A distinct change in approaches to representation occurred during and after World War I. No longer did artists seek to create a window onto the world of invisible forces and energies around them. Instead, many of them adopted a more diagrammatic approach, which made their paintings look as if they were registering those forces directly on the canvas's surface, or as if they were inventing simplified signs and Latourian inscriptions as a new, post-expressionist language of form. This shift in representational techniques toward harder edges, diagrammatic symbols or imagery drawn from scientific texts—and a rejection of the spatial illusionism of styles like cubism and futurism—is readily apparent in much wartime or postwar art. The shift can be seen in the mature works of former cubists like Marcel Duchamp and Francis Picabia, the Russian suprematist Kazimir Malevich, De Stijl painter Piet Mondrian, and Bauhaus artists Paul Klee and László Moholy-Nagy, among others (see the introduction to part 3 of this volume).

This is the artistic context for Charlotte Douglas's examination of the art of Malevich and his followers after 1918–1919, and their encounter with new models of thermodynamics in the energetics of Ostwald and Bogdanov. By that time, Malevich had already inaugurated a mode of abstract painting using an alphabet of pure geometric forms floating in an infinite white space he associated with the popular notion of a fourth spatial dimension, an idea that had concerned cubists and futurists as well. But Malevich rejected such earlier attempts to suggest complex spaces in favor of an infinite white space, free of gravity and specific orientation, which was based, to some degree, on the mystic philosopher P. D. Ouspensky's descriptions of his overwhelming first experience of "cosmic consciousness."[29]

Malevich's attempts to render four-dimensional experience would serve as an important inspiration some seventy-five years later for cyberspace architect Marcos Novak, whose experiments in virtual reality can be seen as a latter-day realization of certain of Malevich's goals. Yet, by the 1920s, Malevich and his followers had come to focus much more specifically on the theme of energy as their representational goal. Douglas's essay documents their various attempts to render "energy itself," often in the form of "graphs and painted diagrams."

The model of the diagram was also vital to the early work of British artist Roy Ascott, the focus of Edward Shanken's essay, "Cybernetics and Art: Cul-

tural Convergence in the 1960s." With the emergence of cybernetics and information theory in the 1950s, artists like Ascott, who were already interested in incorporating temporal experience in art, reconceived the work of art as an interactive "cybernetic system comprised of a network of feedback loops." The material representation that remained in Ascott's work took the form of symbols, diagrams, and texts that could be manipulated by the viewer as well as the actual charting of information flow in representations such as *Diagram*. Ascott was to become increasingly interested in joining cybernetic interaction to the developing field of telecommunications and, as Shanken notes, as early as 1968 he had already foreseen the prospect of interactive multimedia in cyberspace.

In a 1998 essay Ascott states that "all our instincts today are toward the construction of new realities."[30] For two decades Marcos Novak, who has worked with Ascott at his Wales Centre for Advanced Inquiry in the Interactive Arts, has been pursuing process-oriented representation as the visualization of new realities. Novak uses information in the form of computer algorithms to generate an interactive, multidimensional cyberspace filled with free-floating "liquid" architectures and, more recently, *transarchitectures*—a complex, orientation-free space of which modern painters like Malevich could only dream. In the new work he discusses in "Eversion: Brushing against Avatars, Aliens, and Angels," Novak focuses on the theme of *eversion*, his term for the pouring of virtuality into the everyday world to create a *newspace* by means of representations intended for senses other than vision.

Based on the technologies of sensors and effectors, Novak has conceived of *sensels*, which render "sense-shapes" or invisible "regions of activated, hypersensitive space" that detect and respond to the touch of a spectator's hand. Novak's recent installation at the 2000 Venice Biennale, "Invisible Architectures," included five small and two large invisible sensel sculptures on the light bar and floor of the gallery. Above the light bar hung four sculptural projections of a hypersolid, which was itself generated by the mathematical manipulation of a curved, three-dimensional form in four-space. These complicated organic simulations of a four-dimensional entity update technologically the fleeting glimpses of a higher reality Boccioni intuited in his 1913 *Unique Forms of Continuity in Space*. Concerned with many of the same themes as artists at the beginning of the twentieth century—invisible phenomena, synaesthesia, a fourth spatial dimension, the need to augment one's perceptual capabilities—Novak pushes the concept of representation to a new level of visionary presentation via digital information.

The final essay on art in this volume, Richard Shiff's "Puppet and Test Pattern: Mechanicity and Materiality in Modern Pictorial Representation," spans the transition from energy to information by examining the painting

of Georges Seurat in the 1880s and that of Jasper Johns in the 1950s. Shiff focuses on a central aspect of modern painting not addressed in earlier essays—the physicality and tactility of paint on a surface. Unlike Duchamp, who greatly admired Seurat's "scientific spirit" and who was in turn a model for Johns, these two painters never abandoned paint in favor of alternative, more technological materials.[31] Instead, the medium for Seurat's mechanicity was the material dot of oil paint, applied systematically on the model of the "graphic method" discussed by Robert Brain in this volume. For Shiff, Seurat's dots are highly tactile inscriptions, in which the materiality of the paint and the support medium are the subject of representation.

Yet, given the raster-like quality of Seurat's and Johns's paintings, Shiff finds the closest analogue to their technique in electronic media such as television screens and computer display monitors, evanescent counterparts to their painterly craft. Instead of the invisible realities pursued by the cubists and futurists, it is visible light and material substances that occupy Seurat and Johns as painters. Although here we are far from the imperceptible energies, such as X-rays and electrons or "cathode rays," that preoccupied early twentieth-century artists, the cathode rays illuminating our television and computer displays in the information age link the two eras. Shiff's essay similarly points up the conceptual parallels between the digital worlds fashioned by an artist–architect like Novak and the painterly touch of the digits on the hand of Seurat or Johns.

We believe that this volume's broader conception of representation extends its utility, making the term as useful for scientific, technological, artistic, and literary projects as it has been in the past for discussing the relations between natural objects and human subjects. Technological developments such as engines, motors, and mechanisms for observation, inscription, and communication both initiate and cycle back into the artistic and scientific representations of energy and information. Individuals are embedded in material and energetic fields of media; human and mechanical agents of representation assemble more or less stable and effective images out of the energy and information to which they have access. At this level, the differences among the practices of scientists, artists, writers, and engineers may be seen not as fundamental disciplinary barriers but as a matter of local variations due to divergent representational goals.

In promoting the academic linkage of literature and science, William Paulson has called for an "interdisciplinary cognition," a constant renegotiating of disciplinary boundaries, a readiness to reorganize one's powers of intellectual reception.[32] In assembling this volume we have been motivated

by similar commitments. The goals of this volume are pragmatic and concern the rigor of scholarly practices in interdisciplinary studies. *From Energy to Information* energizes and informs the metahistorical emphases of criticism and theory with precise documentary foundations. To further that end, we have provided "From Thermodynamics to Virtuality," a chronological primer on important developments in science and technology during the movement from energy to information regimes. We hope it will assist any reader who desires a succinct review of the historical sequences and conceptual details addressed by the essays that follow.

These essays are neither scientist nor technophobic. They privilege no single voice, stance, or discipline. Rather, they bring many different discursive dialects and systems of representation to bear on the historical fields constituted by the technoscientific unfolding of energy and information. The critical complementarities of these essays generate new fields of knowledge as they track the inscription of the real within the imaginary and symbolic structures of artwork and discourse.

From Thermodynamics to Virtuality

One can trace the movement from energy to information regimes by following the sequence of events that has channeled thermodynamics and electromagnetics into computation and media technology, the merger of life and information sciences, and the virtualization of matter and energy. Energy and information, two prime concepts in the history of science and technology, are also crucial discursive operators in the fields of aesthetics and critical theory.[1] The coupling between energy and information has overcome the prior divisiveness of modern thought by wiring physics into communications and replotting the interrelations between natural objects and cultural subjects. Science and technology are no longer ontologically disjoined from the discursive disciplines of the humanities and social sciences. The conceptual merger of energy and information has opened a new interdisciplinary space for a complex reintegration of natural and cultural multiplicities.

THE CULTURES OF ENERGY

Energy has perennially signified the power to affect observers. The classical sense of energy as a signifier of perceptual effects or psychological impressions inflects the connotative value of energy as a physical term. Obsolete as well as active extrascientific meanings of energy can reveal much about the term's cultural provenance over the last two centuries.[2] The prescientific concept of energy had not yet been abstracted from its social and psychological import as a measure of the intensity of an event's reception. Classical energy is "impressive" and "efficacious": it creates something *for* and *within* its recipient, but on the basis of powers exercised at its *source*. This expression-impression model of aesthetic energy is strikingly conveyed in its long-standing rhetorical and poetic usages.

The *Oxford English Dictionary's* (*OED*) first definition of the concept of energy is "with reference to speech or writing: force or vigour of expression," which is "originally derived from an imperfect understanding of Aristotle's use of ἐνέργεια (*Rhet.* iii. xi. §2) for the species of metaphor which calls up a mental picture of something 'acting' or moving." Here it is precisely literary efficacy that is in question, a power distributed between au-

thors and readers of creating and receiving mental effects. The semantic history of the term implicates it in a texture of aesthetic meanings: energy informs both the expression and the reception of effective tropes and figures. Its force binds poetic and visual images to the broader arena of material and physical powers and products. In its classical provenance, the aesthetic senses of *energeia* are not strongly divided from the physical sense of *dynamis*, the force or dynamism possessed by material objects. Its premodern usages do not distinguish between the natural and the spiritual senses of the term, because the prescientific concept of energy did not bear a primary reference to physical operations. Rather, it was indifferently divided between physical and cultural effects.

FORCE AND MECHANICAL ENERGY

Newton's laws of motion took shape two centuries prior to the consolidation of the modern energy concept. Mechanics is now defined as the branch of physics that deals with the energies of bodies in motion, but Newton's principles were elaborated in terms of the concept of *force*, the product of mass times acceleration. Thermal properties were not yet factored into classical dynamical systems, for which motion is the sole parameter of change and process, and momentum or *vis viva* is the conserved quality.[3] The physical concept of energy was gradually detached from these mechanical precursors—force and *vis viva*, or "living force."[4]

British physician and physicist Thomas Young is credited with the first use (in 1805) of the term *energy* in its modern sense, to "denote what is now called actual, kinetic, or motive energy, i.e., the power of doing work possessed by a moving body by virtue of its motion" (*OED*). In modern mechanics the physical sense of energy emerges as the *power of doing work*, the capacity to move material masses by transferring energy from one form to another.[5] In this new frame of conservation throughout conversion, the classical mechanical concepts of force and momentum could be extended to include *potential* forms, that is, "energy of position, . . . the power of doing work possessed by a body in virtue of the stresses which result from its position relatively to other bodies" (*OED*). No gross motions need be in evidence for potential energy to be present. A stone at rest but elevated above the earth possesses a quantity of potential energy by virtue of its position within a gravitational field. Upon falling that potential energy will be converted into an equal sum of kinetic energy calculated as one half its mass times the square of its velocity. This reconceptualization of mechanical force in terms of the conversion of kinetic and potential energies prepared scientists for understanding the more complex interchanges of energic potential-

ity and actuality exhibited by electromagnetic fields and chemical and atomic structures.

Newton's physics of forces described vectors, quantities determined by the specific trajectories of material bodies in spatial motion. With the emergence of thermodynamics in the mid-nineteenth century, physical attention was enlarged from vectorial forces to scalar energies, quantities described by their magnitude irrespective of their motions. In thermodynamics, the perceptible trajectories of singular bodies—planets and projectiles—give way to the quantifiable intensities of molecular populations, and the motions defined by classical mechanics become relative to the averaged behaviors of thermodynamic ensembles.

THE LAWS OF THERMODYNAMICS

The emergence of energy as a physical concept forced a transition from the orderly world of classical mechanics to the chaotic phenomena marshaled by the laws of thermodynamics. In the first half of the nineteenth century, the movement of heat was accounted for by the theory of *caloric*, a hypothetical fluid presumed to carry heat and to be conserved throughout its cycles. By mid-century caloric had been largely discarded and heat reconceived under the broader principle that *energy* was both conserved and interconvertible among thermal, mechanical, and other forms. This conceptual development led to the first law of thermodynamics: Within a closed system the sum of energy is conserved throughout its transformations; the sum of energy in the universe is constant.[6] The first law marks the continuity between classical dynamics and classical thermodynamics. It extends to the energy concept a conservation principle previously accorded other substances and processes: the conservation of matter recognized by chemistry, the conservation of *vis viva* in classical dynamics.

In contrast, the second law of thermodynamics is discontinuous with classical dynamics. This law introduced an irreversible parameter into the time-reversible mathematics of mechanical forces in the Newtonian scheme. The physics of heat engines forced this fateful confrontation with the temporality of real systems. It became necessary to measure the actual losses of usable energy involved in their operations, specifically, the amount of heat unrecoverable for conversion into work within the cycle of a steam engine's operation. This increment of inefficiency, the inexorable falling away from perfectly reversible performance, led to the initial formulation of the second law as the *dissipation* of mechanical energy. Whereas work may be completely converted into heat, in the process of converting heat into work some fraction always remains as heat. This practical observation on the necessary

functioning of heat engines was submitted to a dramatic global extension in William Thomson's seminal paper of 1852, "On a Universal Tendency in Nature to the Dissipation of Mechanical Energy."[7]

Thomson (Lord Kelvin) began by noting that, as only God can augment or diminish the sum of universal energy, the "absolute waste of mechanical energy" in a real heat engine must be conserved in some fashion. But the first law's hoarding is subsumed by the second law's theft. The fraction of thermal energy that eludes conversion into work is not annihilated, but it is left in a form from which it cannot be returned to potential energy or further seized by any human agency or instrumentality. Thomson drew out of these thermodynamic considerations a litany of cosmological consequences whose chilling tones would reverberate for the next century:

1. There is at present in the material world a universal tendency to the dissipation of mechanical energy.

2. Any *restoration* of mechanical energy, without more than an equivalent of dissipation, is impossible in inanimate material processes, and is probably never effected by means of organized matter, either endowed with vegetable life or subjected to the will of an animated creature.

3. Within a finite period of time past, the earth must have been, and within a finite period of time to come the earth must again be, unfit for the habitation of man as at present constituted, unless operations have been, or are to be performed, which are impossible under the laws to which the known operations going on at present in the material world are subject.[8]

Conceptual purchase on this irreversibly wasting aspect of worldly dynamical systems was physically if not culturally stabilized in 1865 when Rudolf Clausius coined the neologism *entropy* or "transformation-content" by analogy with the Greek root of the term energy or "work-content" (*en* in + *ergon* work). Thermodynamic entropy provides a measure of the energy unavailable for work within a closed physical system. Clausius then reformulated the second law to match the cosmic extension of the first law and of the principle of mechanical dissipation: the entropy of the universe tends to a maximum.

The formulation of entropy complicated the physical idea of energy in an unpredicted and unpredictable way. The scientific concept of energy was preceded by the notion of mechanical force, but nothing in classical mechanics anticipated the concept of entropy.[9] Energy had no sooner been delivered to the world of science as a primary physical concept on a par with matter than it was shadowed by its evil twin entropy, the demonic underside of energy's divine potency. As these florid metaphors may indicate, the twinned physical concepts of energy and entropy immediately began to generate both con-

ceptual and analogical surpluses. Although these twins may look alike, as was Clausius's intention, they have very different natures.

Although energy is multivalent, its sign (except under extreme conditions such as a "squeezed state") is mathematically stable.[10] Thermodynamic entropy is unitary but with an unstable sign: "Whether entropy be called positive or negative is a mere convention."[11] And this is the case not just mathematically but also with regard to the discursive career of the entropy concept. Throughout much of the modern period, however, the notion of entropy has been broadly accorded a negative valence. It has been played out as a proof of the inevitable degradation of energies, of the exhaustion of material and vital resources, as a synonym for melancholy reflections on the devolution of biological and human achievements, on the arrival of a world "unfit for the habitation of man as at present constituted," and ultimately, on the "heat death" of the universe itself. It is difficult to overestimate the extent to which the second law and its avatar entropy have been extended and culturally elaborated, used and abused in the form of deterministic scenarios of local and universal waste.[12]

WAVE THEORY: ETHER AND FIELD

During the nineteenth century, the attention of physics shifted from material bodies and mechanical forces to the imponderable phenomena of heat and radiation. The laws of thermodynamics were unfolded at the same time as the modern understanding of light and electromagnetism. In the first half of the century, Thomas Young and Augustin-Jean Fresnel revived Christiaan Huyghens's late-seventeenth-century wave theory of light, suppressed until then by the authority of Newton's corpuscular model of optical phenomena. Nevertheless, the resuscitated undulatory theory of light still functioned within a late-classical milieu that demanded mechanical explanations—visualizable models of material contact—for all phenomena, including radiant and electromagnetic energies. Although he was far from regarding it as an established fact, Newton himself had speculated at times about the existence of a gravitational ether—an imponderable physical medium that would account for the spatial transmission of gravitational forces. On the same mechanical model, the refashioned theory of a *luminiferous* ether was elaborated to serve as a material and vibratory medium for the propagation of light.

The theory of the ether ran alongside the rise of the energy concept as the stationary but undulating spatial foundation upon which the mobile contents of radiant energies were propped. Developed into a comprehensive explanatory cornerstone of late-classical physics, the luminiferous ether enjoyed a

tremendous vogue both within scientific circles and broadly across the popular consciousness. An important agent in the popularization of the ether concept was physicist John Tyndall, the director of London's Royal Institution from the 1850s to the 1880s. In the following passage from the sixth edition (1880) of *Heat: A Mode of Motion*, Tyndall sets the theory of the ether into a comprehensive atomo-mechanical frame of optical explanation:

> According to the theory now universally received, light consists of a vibratory motion of the atoms and molecules of the luminous body; but how is this motion transmitted to our organs of sight? Sound has the air as its medium, and a close examination of the phenomena of light has led philosophers to the conclusion, that space is occupied by a substance almost infinitely elastic, through which the pulses of light make their way. Here your conceptions must be perfectly clear. It is just as easy to picture a vibrating atom as to picture a vibrating cannon-ball; and there is no more difficulty in conceiving of this *ether*, as it is called, which fills space, than in imagining all space filled with jelly. The atoms of luminous bodies vibrate, and you must figure their vibrations, as communicated to the ether, being propagated through it in pulses or waves; these waves enter the pupil of the eye, cross the ball, and impinge upon the retina, at the back of the eye. The motion thus communicated to the retina, is transmitted thence along the optic nerve to the brain, and there announces itself to consciousness, as light.[13]

In the mid-nineteenth century, there were still several ethers at large in theoretical physics, the luminiferous version just described and various other hypothetical media posited to bear the operations of electricity and magnetism. In the 1850s and 1860s, James Clerk Maxwell recast Michael Faraday's early field conceptions into an ether theory of electromagnetism in which "lines of force" are conducted through some form of rotatory and elastic medium. In order to interrelate the phenomena of electricity and magnetism, and then of electromagnetism and light, Maxwell developed a series of ether hypotheses, the most important being the vortex-and-idle-wheel model elaborated in his essay, "On Physical Lines of Force" (1860–61).

Maxwell's mechanical models of energy propagation were remarkable not just for their ingenuity but also for their heuristic power.[14] Most famously, Maxwell used the mathematical relations of this ether model to specify the identity of electromagnetic and optical radiation.[15] Maxwell would go on to formulate mathematically a dynamical theory of the electromagnetic field independent of the details of any particular ether model. Bruce Hunt's essay reminds us, however, that Maxwell and his successors would continue to tinker earnestly with mechanical ether-models for several more decades.[16] And as Linda Henderson's work has shown, the general public continued to embrace the notion of the ether well into the twentieth century.

The eventual confirmation of inferences Maxwell drew from the heuristic manipulation of his ether fictions marks an important threshold in the development of contemporary science and in its convergence with symbolic processes at large in literary and artistic production. In the early study of energies, physical science was explicitly and significantly enhanced by investigating figurative representations of hypothetical entities—virtual artifacts rather than real or palpable objects. Like Sadi Carnot's ideal heat engine, Maxwell's diagram of the impalpable and elusive ether was the model of a fiction invented to reify a factual process—a heuristic construction or work of intellectual scaffolding representing something complex and invisible. Almost a century later, mathematical physicist John von Neumann would affirm: "The sciences do not try to explain, they hardly even try to interpret, they mainly make models." [17] Maxwell's science grasped what we now take to be a methodological truism: Scientific models are conceptual instruments that constitute as well as simulate the world.[18]

STATISTICAL MECHANICS AND MAXWELL'S DEMON

The phenomena of heat enforce a macroscopic focus on whole populations whose constituents are too minute to be observed or dealt with one by one. The kinetic theory of gases explains macroscopic properties—pressure, volume, density, and temperature—on the basis of the mechanical energies distributed within a population of perfectly elastic, constantly moving and colliding molecular particles. Statistical mechanics combined with the kinetic theory of gases to model thermal behaviors by treating the mathematical probabilities of the various distributions of kinetic energies among the freely mobile molecules in a sealed vessel of gas. The Demon came about as a thought-experiment using a form of statistical mechanics to contradict the seeming inexorability of the entropy law, the determined tendency of environmentally closed systems to dissipate thermal energies through the complete leveling off of kinetic differentials among the constituents of the system.[19]

"To pick a hole" in the seeming inexorability of the entropy law, Maxwell imagined an active agent and thus an *animated* mechanism, a thermodynamic engine supplemented and inhabited by a microscopic observer-operator, which sentient entity Maxwell nevertheless thought replaceable with an automatic mechanism.[20] An 1870 letter to J. W. Strutt (later Lord Rayleigh) set forth the operation and physical significance of the heuristic being soon to be immortalized by Lord Kelvin as Maxwell's Demon:

> If there is any truth in the dynamical theory of gases the different molecules in a gas at uniform temperature are moving with very different velocities. Put

such a gas into a vessel with two compartments and make a small hole in the wall about the right size to let one molecule through. Provide a lid or stopper for this hole and appoint a doorkeeper, very intelligent and exceedingly quick, with microscopic eyes, but still an essentially finite being.

Whenever he sees a molecule of great velocity coming against the door from A into B he is to let it through, but if the molecule happens to be going slow, he is to keep the door shut. He is also to let slow molecules pass from B to A but not fast ones. . . .

In this way, the temperature of B may be raised and that of A lowered without any expenditure of work, but only by the intelligent action of a mere guiding agent (like a pointsman on a railway with perfectly acting switches who should send the express along one line and the goods along another).

I do not see why even intelligence might not be dispensed with and the thing made self-acting.

Moral. The 2nd law of thermodynamics has the same degree of truth as the statement that if you throw a tumblerful of water into the sea you cannot get the same tumblerful of water out again.[21]

In theory, in performing its duties on the inside, the sorting Demon is neither adding energy to nor subtracting it from the system. There is to be no breach of the hermetic enclosure. The second law is to be abrogated strictly by internally arranging for the system to be *reshuffled* back into a state of higher thermal difference. The Demon's benevolent mechanical guidance reverses the irreversible drift of dissipation; it could as easily part the waters and reassemble the contents of the tumbler from the jumble of the sea. The Demon's effect is virtually to make systems go backwards in time to a point of lower entropy, lesser randomness. In the bipartite vessel of gas, the total amount of energy will be the same, as mandated by the first law, but the point is that it will be restored to a *usable form.* For instance, by replacing the partition between compartments with a piston, work could be extracted from the fall of heat from B to A. Ideally, such a Demon could operate the system as a perpetual motion machine, creating infinite amounts of mechanical work from a fixed quantity of energy.

But no Demons were literally forthcoming to restore the dissipated energies of industrial cultures firing up ever more grandiose heat-based technologies of physical power. Within this framework, however, an important advance was made when the Austrian physicist Ludwig Boltzmann developed some of Maxwell's heuristic suggestions into a statistical analysis of thermal entropy. Boltzmann followed Maxwell in treating energic relations of order and disorder with the mathematics of probability. His innovation was to define the entropy (S) of a physical system in terms of its possible energic complexions (P)—that is, the number of different possible ways to distribute its particles. Ordered complexions are relatively rare. There are many more

hat yield a random distribution in which thermal differences
minimum. It is more likely to find a system in a state of rela-
t. d disorder is likely to increase over time toward a maximum
st um in which the evolution of the system slows to a mini-
mu probabilistic restatement of the second law: in a closed sys-
ten olecular disorder is most likely to increase. In its simplest
forn quantification of the entropy law is:

$$S = k \log P.$$

As the i ible complexions P of a system increases, so does the
likelihoc rather than ordered distribution, and so (logarith-
mically) y S.

Transl terms, the Demon uses the microscopic information
it gathers the probable randomization of thermal energies
among the ich reveal themselves at the macroscopic level as an
increase in emon extracts a less probable state of differentia-
tion out of a e state of chaos. And "to think of entropy as a sta-
tistical meast allows its extension to systems that have nothing
to do with he s."[22] Boltzmann's statistical analysis of entropy joined
with Maxwell's Demon to move thermodynamic concepts beyond energic
applications and into the information age.

INFORMATION AND ENTROPY

Explicit attention to Boltzmann's statistical analysis of thermodynamics is
writ large in the founding documents of information theory and cybernetics.
In 1948, John von Neumann noted concerning the mathematical logic of au-
tomata that "thermodynamics, primarily in the form it was received from
Boltzmann . . . is that part of theoretical physics which comes nearest in some
of its aspects to manipulating and measuring information."[23] Two years
later, Norbert Wiener commented that the conceptual alignment of infor-
mation with the probabilities associated with a set of related patterns "was
already familiar in the branch of physics known as statistical mechanics, and
which was associated with the famous second law of thermodynamics."[24] At
the beginning of his general introduction to *The Mathematical Theory of
Communication* (1949), the first great formalization of modern information
theory, Warren Weaver outlined the set of thinkers most responsible for con-
necting energy to information, thermodynamics to cybernetics: Boltzmann,
von Neumann, Wiener, and Claude Shannon. He stated, "Dr. Shannon's

work roots back, as von Neumann has pointed out, to Boltzmann's observation, in some of his work on statistical physics (1894), that entropy is related to 'missing information.'"[25]

In order to exploit the link with statistical mechanics, Shannon defined information mathematically on the basis of the probabilistic distribution of a finite ensemble of message elements. This set of possible messages posits an informatic ensemble analogous to a thermodynamic ensemble having a set of possible complexions with various degrees of probability. Within this framework, information is quantified as a measure of the unpredictability of a message, specifically as an inverse function (the negative logarithm) of the probability of a particular message being chosen from a set of finite options. For Shannon, "information is a measure of one's freedom of choice when one selects a message."[26] For instance, making a selection from a binary set of choices (yes/no, on/off) yields one bit of information—some but not a great deal—because the options available at the information source are relatively constrained. The larger the ensemble of choices, however, the less probable any particular choice. In this decidedly "liberal" approach to calculating the value of information, the more choices offered a sender by a set of possible messages, the more information the message chosen will contain. Shannon's mathematical formalization of information (H) on the basis of such "probabilities of choice" yielded an "entropy-like expression," an equation strikingly analogous to Boltzmann's logarithmic formula for thermodynamic entropy:

$$H = -\Sigma p_i \log p_i$$

In linking physics directly to communications theory, the mathematical analogy between thermodynamic and information entropy has reconnected the natural sciences to the arts, humanities, and social sciences. Michel Serres celebrates that marriage in these terms: "Henceforth, the theoretical reconciliation between information theory and thermodynamics favors and advocates the practical reconciliation between those funds of knowledge which exploited signs and those which exploited energy displacements."[27] But this connection has also "been much debated, largely because Shannon's definition of information as a quantity directly related to disorder and multiple possibility is counterintuitive, going against an everyday notion of information as something singular and determinate."[28] For instance, information can also be measured on the other side of the communications circuit as a function of the *receiver's knowledge*, by the degree to which the receiver's uncertainty is diminished by the arrival of a message. Uncertainty in this sense is the state of a receiver with regard to the content of a message yet to arrive. If a recipient's uncertainty is great, the message that resolves it will

have a correspondingly high information value. As Shannon was developing his particular version of information theory, Norbert Wiener and many others were operating on the equally reasonable assumption that the quantity of information is greater as the probability of *receiving* the order or pattern that conveys it grows less. In this case, information is conceived as the *opposite* of thermodynamic entropy and so merits an opposite mathematical sign. Léon Brillouin would coin the term *negentropy* on this basis as a synonym for information.

Following the mathematical analogy of his formula for information to Boltzmann's formula for thermodynamic entropy, however, Shannon chose to name his information-measure the *entropy* of the message, and thereby to give entropy the same sign as information. Katherine Hayles has shown that the crucial distinction between Shannon's approach and those of Wiener and Brillouin is that the latter are still looking at informatic ensembles as thermodynamicists, for whom the statistical probability of disordered states makes the entropy of the ensemble analogous to a measure of the energic degradation of the system. The thermodynamic approach to entropy—a statistical measure of a macrostate in ignorance of the individual microstates—concentrates on uncertainty at the *destination*, that is, on the observer's ignorance of the particular microscopic "choices" a system makes as it evolves in time. Shannon's informatic redefinition of entropy—as the function of a choice among a set of probabilities that *resolves* the ignorance of a receiver—locates uncertainty at the information *source*. In other words, Shannon analyzes an informatic ensemble from a communication-engineering perspective, in which case the relative "disorder" of an ensemble, the greater entropy of a randomized set of probabilities, provides the agent of a message with a greater number of selection opportunities.[29] Shannon's "message entropy" is thus, relative to thermodynamic dissipation, a counter-entropic phenomenon.

One could say that Shannon's "information source" reenacts Maxwell's Demon. In the movement from energy to information, the concept of entropy initiated an ongoing shift away from the vision of a simple or homogeneous universe reducible to a reversible and predictable calculus, toward a cognition of complexity that offers to reunify nature and the human mind in terms of a shared order of multiplicity and irreversible time, random processes and unpredictable influxes of creative reorganizations. A sender of information creates order and so reverses the sign of entropy by assessing the largest possible array of informatic options, then choosing what fits the communicational situation. Systems that lack options are relatively predictable, low in information. Extreme order is as destructive of information as extreme chaos. Through this seemingly counterintuitive restatement of information as entropy, as a function of disorder or "surprise" rather than order and predictability, Shannon helped to open the door for a cascade of con-

ceptual developments leading to the contemporary sciences of general systems and theories of self-organization, autopoiesis, chaos, complexity, and their discursive analogues in the current critical focus on the contingent materialities of signs and communication.

The far-from-equilibrium thermodynamics developed by Ilya Prigogine and his coworkers is also linked to the statistical mechanics descending from Maxwell and Boltzmann. Here, thermal dissipation is studied as a potentially creative process that can drive the temporal organization of open dynamical systems: "Once we have dissipative structures, we can speak of self-organization. Even if we know the initial values and boundary constraints, there are still many states available to the system among which it 'chooses' as a result of fluctuations. Such conclusions are of interest beyond the realms of physics and chemistry. Indeed, bifurcations can be considered the source of diversification and innovation."[30] Classical dynamics allowed time to arbitrarily reverse its direction. For Prigogine, the infinite amount of information necessary for such temporal reversal is irrecoverable from dissipative or energy-consuming systems. What dissipative systems *can* do is bootstrap their physical entropy into form, self-organize on the basis of their own noise. Non-universal but nonetheless pervasive, "irreversibility is the mechanism that brings order out of chaos."[31]

CYBERNETIC COUPLINGS

The new relations forged at mid-twentieth century between information and entropy highlighted not only the potential positivities of randomness and disorder, but also the crucial difference between environmental isolation and openness. Even given the assumption of a universal tendency toward maximal entropy, organisms maintain their local organizations through *operational* closure structurally coupled to environmental perturbation by energy and data sources, and modern electronic systems process energy through informatic feedback. The classical emphasis on the equilibrium of sealed systems now begins to shift to the non-equilibrium operation of open and multiply coupled biological and technological ensembles.[32]

Boltzmann's work enabled Maxwell's Demon scenario to be reconceived according to the different kinds of information that can be extracted from the different levels of a system. The Demon anticipates the further development of information theory by positing an interactive observer that views the thermodynamic "channel." In hindsight, we now appreciate the Demon as a statistical operator whose tracking of the velocities and trajectories of individual molecules performs an information-gathering and data-processing function. Maxwell's intuition that the Demon could be replaced by a mechanism was

correct: in terms of contemporary computer architecture, the Demon is tantamount to a logic gate, a digital switch operating a binary aperture, and the Demon's sorting function can be realized as a string of algorithmic code that mechanizes a sequence of sensory and computational tasks.[33] Maxwell's Demon joins Charles Babbage's Difference Engine as one of the earliest intimations of the eventual development of artificial or machine intelligences that simulate and extend human perceptive, mnemonic, and calculative capacities.[34]

Norbert Wiener channeled his interest in information theory toward his effort to construct a science of *cybernetics*, which he defined as the "study of messages, and in particular of the effective messages of control."[35] Although the militaristic origins and imperial intellectual ambitions of cybernetics have invited a variety of skeptical reactions, Wiener's immediate aim was to advance early computer technology by investigating the informatic circuits that allow one to draw functional analogies between organisms and machines. Biological nervous systems and modern electronic devices both feed information from certain parts of their structures back into a processing network, and these internal messages enable both the organism and the machine to track and regulate their respective performances.[36]

John von Neumann also used analogies with biological and nervous processes and organs as a means to guide the design of computers and other electronic devices. In these early heuristic moves for the splicing of the biological and the technological, Wiener and von Neumann worked on conceptual and technological foundations laid in the previous century by the scientific and aesthetic development of inscription technologies. In his "General and Logical Theory of Automata," von Neumann traced structural parallels between living organisms and computational machines and other "artificial automata." He compared the differences between analogue and digital computers to the distinction between humoral and neural processes, and seized the human central nervous system as a model for the construction of digital processors. In particular, von Neumann proposed an analogy between the function of the organic neuron and the electronic vacuum tube.

The transmission of signals through communication channels, nerves or phone lines, is analogous to the temporal behavior of closed thermodynamic systems: In both cases, disorder tends to increase over time. In informatics this increment of systemic evolution is called *noise*. In the informatic situation, "the statistical nature of *messages* is entirely determined by the character of the source. But the statistical character of the *signal* as actually transmitted by a channel, and hence the entropy in the channel, is determined both by what one attempts to feed into the channel and by the capabilities of the channel to handle different signal situations."[37] The amount of "en-

tropy in the channel," as opposed to the entropy of a message before it is sent, is determined by the degree of noise that impinges on the signal—"anything that arrives as part of a message, but that was not part of the message when sent out."[38] No real-world channel can be made entirely free of some level of random fluctuation that introduces noise into the received message, and this circumstance introduces another level of uncertainty into the communication process. By the same token, the process of electronic computation is analogous to the transmission of a message. Here, the emergence of *error* represents the noise of computational transmission. In computation as well as communication, the margin of error as well as the increment of noise is counteracted by the injection of *redundancy* into coding protocols. With some sacrifice of efficiency, redundant coding provides a repetition of crucial calculative steps or message elements and so ensures a reliable if not impeccable level of accuracy at the end of the process.

At this point we reach a significant threshold in the development of contemporary technoscience out of these foundational mid twentieth-century documents. It is now broadly accepted that, just as the sign of entropy was reversed by information theory, so, too, the sign of noise has been reversed by the subsequent and pervasive extensions of informatic concepts, especially in physics and biology.[39] Yet at the moment of its informatic inception, much as thermodynamic entropy had been a century before, the concept of noise was treated only as a regrettable impediment to perfect efficiency. At the same time that Shannon and Weaver appropriated entropy into their informatic vernacular as a positive quantity, noise emerged in the old role of thermodynamic entropy as an uneradicable friction of communication. As entropy had begun as a measure of the loss of "usable energy," noise was immediately stipulated as a negative or destructive interference, the cause of a loss of "useful information."

But just as entropy is not properly conceived merely as energy's antithesis, by the very terms of Shannon's mathematicization of information, noise is not simply "anti-information." In a situation as pregnant with futurity as the unfolding of entropy, the productive ambiguity of noise emerged from the consideration that it, too, *is* information. Noise is precisely *unexpected* information, an uncanny increment that rolls the dice of randomness within every communicative and calculative transmission. In this volume, Doug Kahn discusses the modernist discovery, within the otherwise "pure" tones of an earlier musical acoustics, of noise: timbre is a musical noise that does not physically corrupt, but rather, informatically enhances the sound it inhabits. Similarly, much of the most exciting critical work of the past five decades has derived from the informatic integration of the disciplines of knowledge made possible by reversing the sign of noise.

VIRTUALITY

The mathematicization of information in communication theory established it as a scientific entity on a par with the physical concepts of matter and energy. The advent of information as a fundamental category also accompanied the relativization of matter and energy, which no longer possess the absolute existence implied by traditional laws of conservation. Both *can* be created and destroyed, but only (as quantified by Einstein's famous equation $e = mc^2$) by expending or producing the other. Thus a higher form of conservation law still determines, with relativistic adjustments, our understanding of the limits of material and energic phenomena; moreover, they are interconvertible only under what to us are extreme conditions. In contrast, information is inherently hyperbolic at all scales; more precisely, it has no proper scale.[40] As with entropy, conservation laws do not apply. Information can be endlessly replicated, multiplied, reproduced, piled up, and disseminated; conversely, it can be grievously deteriorated or utterly annihilated, expunged, defaced, or erased without any trace of compensatory vestige or remainder.

Although any medium and its messages can be lost, as long as traditional media are preserved, the scripts they bear are relatively hard to erase. "Carving is the prototypical kind of inscription," Marcos Novak writes, "though every other kind of writing partakes in this modification of one substance by another."[41] As a result, and in constant struggle against the entropic drift toward informatic as well as thermal disorganization, geologists, biologists, archaeologists, and historians have been able to salvage and interpret traces of the planetary, evolutionary, and cultural past. In contrast, information preserved in the form of electromagnetic coding, although equally material, breeds endless copies indistinguishable from any "original," yet if deleted and overwritten, leaves no scratch on any surface. For some, this ephemeralization of abiding fixation forebodes a disappearance and derealization of human efforts and accomplishments. Novak has no time for such obituaries: physical disembodiment "is the loss of inscription," but virtual "dis/embodiment" is "the agile shedding of one inscription in favor of another. . . . Digital writing celebrates the loss of inscription by removing the trace from acts of erasure."[42] What the virtual loses in place and permanence, it gains in velocity and transformativity.

The implosion of the mode of information within our technoscientific culture has produced a collective effort to bring forth the metaphysics of a new cosmos somewhere off to the side of the old universe of matter and energy. The nonplace of cyberspace underscores again that the mode of information and the modes of matter and energy are not immediately commensurate. In-

formation both forms and takes form from the interplay of the real and the possible, but in its own realm it plays out in the reversible dynamics of virtualization and actualization.[43] For example, consider as an instance of informatic virtuality the ontology of a hypertext located on the World Wide Web: "Deterritorialized, fully present in all its existing versions, copies, and projections, deprived of inertia, ubiquitous inhabitant of cyberspace, hypertext helps produce events of textual actualization, navigation, and reading. Only such events can be said to be truly situated. And although it requires a real physical substrate for its subsistence and actualization, the imponderable hypertext has no place."[44] For our "selves" as well, to enter the realm of cyberspace is to be informatically transformed into a hypertext and dispersed into digital patterns.

Informatic virtuality puts into question the traditional categories of conservation, identity, substance, and situated presence, by referring any ontological differences, especially those between the organic and the mechanical, to the common currency of information—significant traces and unpredictable swerves within immense but finite signifying ensembles. Techno-sublimity and techno-angst play over this border where, as Novak argues in his essay in this volume, fixed phases break down and previously incommensurable realms are set into fluid intercommunication. Donna Haraway's discourse on the cyborg makes clear that such boundary breakdowns can assist as well as subvert hegemonic practices. Haraway grasps both the potential eros of these monstrous syntheses and the political aggression that could be activated by the virtual transparency of informatics: "Communications sciences and modern biologies are constructed by a common move—*the translation of the world into a problem of coding*, a search for a common language in which all resistance to instrumental control disappears and all heterogeneity can be submitted to disassembly, reassembly, investment, and exchange."[45]

This instrumental dream of a "common language" that eliminates the resistant noise of materiality altogether has recently been treated in a way that underscores how the opening onto the virtual has also, not so paradoxically, reinforced the persistence of the Real, that residue of bodies "which escapes the net, the point of excess that breaks through symbolic forms of reality."[46] In "Lingua ex Machina: Computer-Mediated Communication and the Tower of Babel," David J. Gunkel surveys the long-standing quest to fashion a universal language capable of transcending the static of translation among the multiplicity of natural languages.[47] With the advent of modern computers, it was hoped that research in machine translation (MT) would succeed in automating translation through an intermediate language or *interlingua* that might ultimately serve as a new lingua franca obviating the need for translation altogether. Gunkel's critique of this effort persuasively shows

that, "ironically, universal MT is possible only if it is ultimately superfluous, and necessary only if it is fundamentally impossible."[48]

The virtual analog of MT research is the fantasy enacted by William Gibson's cyberpunk classic *Neuromancer* and pursued ever since by virtual reality (VR) technology. In the dream of "postsymbolic communication" through an immediate neural interface between the mind and the computer that eliminates the drag of translation from the velocity of thought, the virtual agent ascends to the disembodied state of Thomas Aquinas's angels, who converse from spirit to spirit without need of any material medium. The desire to see virtuality as a leap beyond organic contingency draws in its train a corollary wish to dispense with the encumbrances of language. However, "far from escaping the limitations of symbolic description, Virtual Reality is necessarily produced in and by the manipulation of descriptive signs," that is, the very coding protocols that enable computers to generate virtual worlds. "The apparent flight of VR away from the symbolic is ironically produced and substantiated in and by that from which it flees."[49]

Gunkel demonstrates how many of these computer-mediated quests for transcendent modes of universal communicative immediacy are based on a particular mythology, a culturally-specific reading of the Tower of Babel (Genesis 11:1–9) that posits an original (linguistic) unity from which humanity fell away and which we thus ought to be able to recover. If, however, there was never any such primal unity, if the origins and ontology of language were and remain irreducibly multiple, then we can never transcend the materialities of translation. The most considered responses to the techno-culture of the virtual have also come to similar conclusions about the "materiality of informatics" altogether, and about the reckoning our real and virtual manufacturing cultures need to make with the living forms of individual and ecological embodiment.[50]

The transit from energy to information brings us back to the body, in particular the human body at the complex threshold of a rupture with and re-doubling upon its material conditions. "The virtualization of the body is . . . not a form of disembodiment but a re-creation, a reincarnation, a multiplication, vectorization, and heterogenesis of the human. However, the boundary between heterogenesis and alienation, actualization and commodity reification, virtualization and amputation, is never clearly defined."[51] By clarifying the developments in science and technology and the literary and artistic productions that have spurred and responded to the cultural changes enacted by the historical movement from energy to information regimes, the essays in this volume can assist the thoughtful demarcation of this crucial but permeable boundary between subject and object, agency and commodity, form and medium, at the threshold of the virtual community.

THE CULTURES OF THERMODYNAMICS

INTRODUCTION

Some of the representations that circulate between the arts and sciences may be viewed as ideological constructions, images that encode the status and conflict of economic and political forces.[1] The sciences themselves have been important sources of ideological representations in which the wishful projections of subjects are presented or taken as immutable natural objects. In order to augment and extend their quotient of social authority, various hegemonic or oppositional interests put scientific ideologies and other forms of positivist scientism into cultural action.[2] The more historical distance one has—the more that scientific or social discourses have moved beyond their own prior formulations—the more easily discerned these superseded scientisms are. Perhaps for that reason, the essays most centrally concerned with science as a source of ideological representations occur at the beginning of this volume.

The essays in part 1 examine some ways that the natural-scientific discourses of energy have circulated through the human sciences and the arts.[3] The concept of physical energy has been complicated from the start by the pairing of energy and entropy in the laws of thermodynamics. Like energy, the concept of entropy had major repercussions across the social and cultural landscape of the nineteenth and twentieth centuries. In "Time Discovered and Time Gendered in Victorian Science and Culture," Norton Wise examines the analogy Victorian thermodynamics forged between the entropic time of energic dissipation in nature and the wasted time and wasteful disorganization of industrial populations. The mainstream of eighteenth-century thought had seen nature in terms of a perpetual equilibrium maintained by repetitive cycles of production. In contrast, nineteenth-century thinkers developed a linear view of temporality in which nature was seen in transit from a past moment of cosmic origin to an eventual future of ultimate decline, while moving through a potentially progressive present. This conceptual transition led to a devaluation of cyclical and repetitive time. Progressive linear time,

the time of creative individuals at the forefront of technoscientific and economic innovation, was coded as masculine, whereas cyclical time, the passive and repetitive time of social crowds and industrial laborers, was coded as feminine. Wise addresses this gendered construction of temporal and statistical concepts in relation to the social effects of industrial organization and the scientific emergence of energy laws. For many, the only reprieve from devolutionary disorder in nature and society was seen to lie in "the directing power of masculine reason and will." The pairing of energy and entropy was often incorporated into the gender binaries of modern culture to justify biases against persons and practices deemed wasteful, chaotic, or superfluous.

Early thermodynamics provided authorized terms for secular cosmologies open to a spectrum of speculations concerning the trend of the universe and the means by which human societies could assist or resist those vectors of development or devolution. In this period, certain artists and writers, philosophers and politicians began to refer their aesthetic visions and social prescriptions to the unfolding manifold of energic phenomena and the supposedly iron-clad dynamics of energy laws. Certain thermodynamic discourses focused speculative attention on the catastrophic collision of cosmic masses—asteroids, comets, planets, and stars—in order to moralize mundane matters such as militarism, capitalism, and sociopolitical conflicts. Bruce Clarke's "Dark Star Crashes: Classical Thermodynamics and the Allegory of Cosmic Catastrophe" studies the construction of allegories of energy in two fictional texts of the 1890s in which comets threaten the earth.

In H. G. Wells's short story "The Star" and Camille Flammarion's didactic novel *La Fin du Monde* the social authority of thermodynamics is registered parabolically through fables of the future. In these early science fictions, social conditions and scientific doctrines are represented through economic, political, and cosmological speculations about the future cataclysms promised by thermodynamic predictions. Both texts are indebted to the thermodynamic discourse of the 1860s, in particular, to British geophysicist John Tyndall's treatment of the conservation of energy as an antidote to the heat-death scenarios already attached to the second law. Various scientific partisans exploited the imbalance in the classical laws of thermodynamics—the slippage between the first law's guarantee of conservation and the second law's prediction of dissipation—to form competing allegories in which the fate of the cosmos is made to represent and repair present inequities in the circulation and distribution of commodities. Flammarion and Wells retailed forms of cultural paranoia induced by the initial articulation of the entropy law in order to counter those fears with recuperative visions of the future of natural and human energies. In both cases, the second law's promise of cosmic dissipation is answered by a providential reading of the first law's guar-

antee of eternal resources. In the culture of thermodynamics, energy laws are protean texts adaptable to divergent ideological needs.

Much modern expression aims to seize and shape the forms and conditions of physical energies, from the intimation of entropy in fin-de-siècle decadence to the celebrations of dynamism in futurism and vorticism, from the stark efficiencies of imagism to the superabundance of stream-of-consciousness narration, from the spatial refraction of cubism to the transcendent abstraction of suprematism. As Charlotte Douglas documents in "Energetic Abstraction: Ostwald, Bogdanov, and Russian Post-Revolutionary Art," the cultural authority of thermodynamics as a master discourse applicable to all facets of nature and culture was undiminished in the early decades of the twentieth century. In the years immediately following the Russian Revolution, writings extending energy concepts to political and aesthetic doctrines inspired a wide range of artistic productions. Following upon Kazimir Malevich's development of suprematism's geometric form language in 1915, artists around him, as well as those of the projectionist group, focused specifically on finding abstract means to represent energy itself. Energy is a leitmotif in the writings of these artists, and their paintings employ color in particular as a vehicle for the intensity of energy phenomena from electromagnetism to luminescent gases and cosmic flux. These painterly experiments of the 1920s resulted in reduced, simplified canvases presenting visual analogues to thermodynamical systems. In Russia at that time, the dynamism of physical energies was celebrated as the spirit of modern creative transformation and the vital force of social progress.

Time Discovered and Time Gendered
in Victorian Science and Culture

M. NORTON WISE

Man may work from sun to sun; woman's work is never done.

LINEAR AND CYCLICAL TIME

My subject is the structure of time as regularly represented in Victorian culture. It may be captured in the simple image of a line and a circle. The line symbolizes the linear time of historical progression, the circle the repetitive cycles of birth and death, the planetary orbits, machines of every kind (except power-producing engines), and of course clocks, the timeless keepers of time. As often as the images of linear and circular time were presented during the Victorian era, they were, just as often, gendered: masculine for history, feminine for repetition. My essay offers nothing new on gender theory. Instead, it sketches an account of how the stereotype of time came to be supported by Victorian science, by evolutionary theory and thermodynamics and their statistical interpretation.

A point of entry, from very late in the story, is Gustave Le Bon's *The Crowd* (1895), which relied heavily on British sources and is perhaps the most widely read book ever written on mass psychology. Filled with fear and loathing at what seemed to be increasingly threatening mass movements—riots, strikes, electoral politics, parliamentary government, and the role of the popular press—Le Bon provided a sweeping analysis and indictment of crowds of all kinds. His little book hits all of the points I want to touch. He sets the crowd within an evolutionary account of the growth and ultimate decay of "races" (peoples or nations). In this account, the formation of a race depends on a small number of leading figures whose fundamental ideas initially shape society. Its decay sets in when the ideas have been lowered to the level of mediocrity, to become sentiments, the unreasoned, unconscious possession of the masses. "By the mere fact that he forms part of an organized crowd, a man descends several rungs in the ladder of civilisation." [1]

One key feature of le Bon's presentation of this descent is the primitive, feminine character of the crowd. "It will be remarked that among the spe-

cial characteristics of crowds there are several—such as impulsiveness, irritability, incapacity to reason, the absence of judgment and of the critical spirit, the exaggeration of the sentiments, and others besides—which are almost always observed in beings belonging to inferior forms of evolution—in women, savages, and children, for instance." The great numbers of these lower evolutionary forms stand in sharp contrast to the few truly masculine intellects whose "fundamental ideas" exercise the selective pressure that organizes and elevates the whole. "It cannot be gainsaid that civilisation has been the work of a small minority of superior intelligences, constituting the culminating point of a pyramid, whose stages, widening in proportion to the decrease of mental power, represent the masses of a nation."[2]

Le Bon's masses carry standard labels of feminine temporality: imitation and repetition. But they are not therefore female. They include the pathetic male products of a French lycée education. Subjected in these "factories of degeneration" to endless mimetic repetition, "their mental vigour has declined, their fertile capacity for growth has dried up, the fully-developed man appears, and he is often a used-up man. Settled down, married, resigned to turning in a circle, and indefinitely in the same circle, he shuts himself up in his confined function." Thus the linear time of conscious will gives way to the circular time of unconscious repetition. The schoolrooms of France have become nurseries for the socialism and anarchism of the masses.[3]

Le Bon characterizes their degraded state as "a mere swarm of isolated individuals," like "grain[s] of sand amid other grains of sand, which the wind stirs up at will." Everyone is reduced to the same level of the "normal." The heterogeneity from which all progressive action would spring is swamped by homogeneity. Structured order is replaced by random disorder, and all that remains are "those mediocre qualities which are the birthright of every average individual." As a consequence, "the philosophy of history," of linear historical time, is reduced to "the philosophy of number." The fully feminized crowd is a statistical object.[4]

It may be apparent from these excerpts that le Bon based his gender stereotypes for time and the crowd on current views of the evolution of species and the degradation of energy. The origins of such scientistic representations in Victorian culture had a rather clear beginning.

TIME DISCOVERED

Looking back to the late eighteenth century and Enlightenment France, we find that nature itself was not temporal for many of those who counted themselves the arbiters of reason in science, especially those who addressed

mathematical reason and precision measurement—Étienne de Condillac, Antoine-Laurent Lavoisier, the Marquis de Laplace, Charles-Augustin de Coulomb, Comte Lagrange, and the Marquis de Condorcet. Some would dispute this point for Condorcet, and clear exceptions are not difficult to name—Comte de Buffon, J. B. Robinet—but while recognizing the great diversity of Enlightenment culture, it is fairly accurate to say that for the dominating figures of the Academy of Sciences neither external nature nor human nature changed over time. Progress in the state of knowledge and society could certainly be attained, but such progress only realized nature, without changing it. "Revolution," for example, whether scientific or political, continued to refer in part to a return to a natural state of things, prior to the rule of unnatural authority in the form of despots, dogmas, and privilege.[5] Often this return to the natural state was represented as a return of childlike innocence, in which the truths of nature were to be implanted uncorrupted on the tabula rasa of the child's receptive mind. Such Lockean allegories of science, transmitted through the works of Condillac, along with much of the rest of John Locke's sensationalist philosophy, became a standard of Enlightenment. The chemist Lavoisier, for example, presented the new methodology of the chemical revolution, which had led to his articulation of the oxygen theory, as a return to childlike methods of learning, thus to natural methods.[6]

To recover the natural state typically meant to discover the state of equilibrium, the balanced state, around which contingent individual events would be found continually to oscillate in the repetitive cycles of nature, from planetary revolutions to agricultural harvests. An icon for this ideal is a popular revolutionary image of "Republican France," or "Marianne" (figure 1.1). Marianne's pendant is a mason's level, with an oscillating pendulum to locate the level or balanced state. Its three sides sometimes stood for liberty, equality, and fraternity, but in general the level represented equality. The new republic would restore the natural equality of the people and the attendant equilibrium of human society, with natural laws protecting the natural rights of all. Not eternal change, then, but the timeless ideal of balanced oscillation often constituted the goal of rational enlightenment. The oscillations revealed an underlying state of order in the midst of apparent chaos.[7]

The nineteenth century changed all that. Throughout Europe, *Nature* was becoming essentially temporal, or progressive—whether as upward or downward progression, progress or decay. This striking change of belief is sometimes called the "discovery of time," the linear time that became synonymous with history.[8] The full-scale movement is too often pushed back into its roots in the eighteenth century, where later writers sometimes located their heritage, but two examples will help to capture the mainstream of Victorian science in the 1830s.

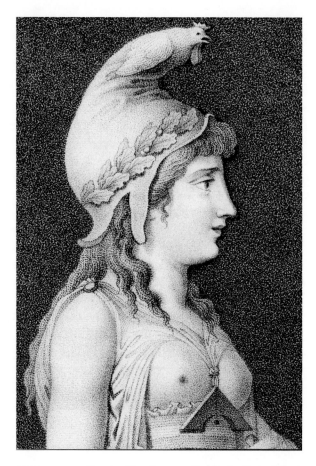

FIGURE 1.1. Darcis, "*La France républicaine*," or "*Marianne.*" Engraving. Musée Carnavalet, Paris (Inv. Hist. GCXXIII).

Consider the solar system. In his *Exposition du système du monde* of 1796 Pierre-Simon Laplace popularized a mathematical proof (given at length in his *Mécanique céleste*) that the solar system would remain stable forever, with the planets executing periodic oscillations about the mean motions of their ever-repeating cyclical orbits. In Britain, this proof was widely celebrated by the leading lights of physical science, as in the following political metaphor from the liberal Whig professor of natural philosophy in Edinburgh, John Playfair: "all the inequalities in our system are periodical . . . our system is thus secured against natural decay; order and regularity preserved in the midst of so many disturbing causes; and anarchy and misrule eternally proscribed." [9]

By the 1830s misrule had returned. Astronomers had determined that

Enke's comet was losing motion, which seemed to imply that a resisting medium or *ether* occupied interplanetary space and would eventually stop the motions of the planets as well, by which time they would have collapsed into the sun. The conservative Cambridge mathematician and reverend William Whewell, already an opponent of the deist view that natural laws alone governed the world, made the new findings a centerpiece of his *Bridgewater Treatise* on physics and astronomy in relation to natural theology. "To maintain either the past or future eternity of the world," he announced, "does not appear consistent with physical principles, as it certainly does not fall in with the convictions of the religious man, in whatever way obtained. We conceive that this state of things has had a beginning; we conceive that it will have an end." In this and a series of related writings, Whewell attacked equilibrium theories on all fronts, from geology and the tides to political economy, and proclaimed a "universal law of decay" for all of nature. He joined a rapidly escalating chorus of voices who were finding progression along a line of time everywhere they looked.[10]

Not everyone, however, found decay to be the ultimate calamity that Whewell foresaw. A few natural-law liberals quickly found that they could build an argument for the evolutionary progress of humanity upon the degradation of nature. The radical professor and popularizer of astronomy at Glasgow University, J. P. Nichol, developed a nebular hypothesis to account for the evolution of the solar system, extending a Laplacian speculation on the formation of the steady-state solar system into a grand theory of the birth and death of worlds. Nichol concluded his 1837 *Architecture of the Heavens* with his characteristic euphoria: "Nay, what though *all* should pass?. . . . That gorgeous material framework, wherewith the Eternal hath adorned and varied the abysses of space, is only an instrument by which the myriads of spirits borne upon its orbs, may be told of their origin, and educated for more exalted being." Nichol had already joined John Stuart Mill in building a new "science of progress" based on the view that every existing state of things, whether the arrangements of the planets or of society, was to be understood as one term in a series, a temporal series in which no stage ever recurred.[11]

A second example of the move to temporality is offered by the little book that launched evolutionary ideas into the public consciousness like no other. Written by the Edinburgh publisher Robert Chambers, the *Vestiges of Creation* appeared anonymously in 1844, the same year in which Darwin wrote an unpublished sketch of his own evolutionary theory. In this domain of natural history, the balancing acts of the Enlightenment had culminated in the work of the great French naturalist Georges Cuvier, whose *Researches on Fossil Bones* of 1812 and *Animal Kingdom* of 1817 seemed to do for the fix-

ity of species what Laplace had done for the timeless cycles of the solar system. Each species, Cuvier argued, had been fitted precisely for its function in nature and though it constantly varied in the course of its reproductive generations to maintain this adaptation to the conditions of existence, it varied only "within rather narrow limits" (the common phrase of balancers).[12] In this effort he exploited a mass of newly available fossil evidence—and even a collection of mummified animals brought back from Napoleon's expedition to Egypt—to convince his readers that although there had been extinctions, and although new species had appeared from time to time, there had been no evolution of species, as his colleague Jean-Baptiste Lamarck at the Natural History Museum in Paris was arguing and as Erasmus Darwin was claiming in England. There, Charles Lyell forcefully held the fort of geological equilibrium, with extinctions and saltations, in his *Principles of Geology* of 1831–1833. But it was almost as though the arguments of Cuvier and Lyell worked against them, for in retrospect, extinctions and creations in a story of ancient fossils already introduced temporality into nature and provided a short step to evolutionary reinterpretation. The opportunities became fully public in the fight that erupted in Paris from 1825 to 1830 between Cuvier and Etienne Geoffroy Saint-Hilaire. In addition, the popular press filled the minds of their readers with fanciful images of dinosaurs and other primitive animals from "deep time."[13]

The *Vestiges of Creation* drew on this popular background as well as on a great body of recent work in geology and natural history. Some people immediately attributed it to Nichol because of its heavy reliance on his account of the evolution of the solar system, but others were suggested as well, and the speculations only added to its enormous audience (over 23,000 copies in Britain by 1860). As Jim Secord aptly puts it, the book presented "a vision of nature appropriate to the industrial age and the middle classes," a highly readable synthesis of astronomical, geological, and organic evolution. Supported, contested, and denounced by turns, it nevertheless carried the message into every nook and cranny of Victorian culture that nature itself had become historical, time had become progressive. Interestingly, the messenger himself exhibits the transformation. In 1822 he had argued for a politically and cosmologically self-balancing world.[14]

THE REVALUATION (DEVALUATION) OF REPETITION

But what now of the repetitive cycles that had formerly maintained the balance of nature? Not surprisingly, they underwent a severe devaluation. That devaluation can be seen most easily in political economy. Returning briefly

to the late eighteenth century and to the physiocratic economics prominent in France, we find the view that the wealth of a nation consists in its agricultural production, the measure of the sustainable size of its population. Accordingly, physiocrats divided the economy into two sectors, a productive agricultural class and a sterile manufacturing and trading class. While the "sterile" manufacturers merely transformed their "barren" expenditures into goods of equal value, the farmers (landlords) were engaged in "reproduction." That is, through seeding the soil, their productive expenditure, once optimized, "gave birth" to twice its value in produce during every annual cycle. Because only half of this doubled reproduction was required for the following agricultural cycle, the other half was available to support the apparatus of the state. Thus, under physiocratic doctrine, all value in the economy was ascribed to ever-repeated cycles of reproduction. Its repetitive character, even though described in feminine metaphors, clearly did not devalue agricultural reproduction. Or, to put the point differently, repetition and reproduction did not yet serve as a touchstone for devaluing an activity as feminine (unless sterile).[15]

That situation began to change in the classical political economy of Adam Smith, Thomas Malthus, and David Ricardo, where the distinction between productive and sterile sectors was transformed into a (much-debated) distinction between productive and unproductive labor. Productive labor now became all work done that produced a commodity for sale, any commodity, whether grown or manufactured. Unproductive labor, on the other hand, became work that did not produce a product for sale, such as the work of servants and, implicitly, child rearing and housekeeping. This distinction is surely one of the most elementary and pervasive of the formal elements that went into the construction of the famous two spheres of middle-class Victorian life, the male and the female.[16] With respect to time, however, the early classical economists still envisaged a balanced economy in which there were no essentially transformative forces in action. Whatever expansions the economy might experience as a result of extended agriculture or transportation would always run up against the infamous stationary state, where supply and demand reached equilibrium at the "natural price." And that stationary state was closely linked to the Malthusian equilibrium of population maintained by the opposing forces of sex and starvation. The theory implied that workers' wages could never for long exceed the cost of subsistence.

Only after about 1830 did British political economy become essentially temporal, and then rather rapidly. This transformation occurred across the political spectrum, from the conservative William Whewell, to the populist evangelical Thomas Chalmers, to the radicals Charles Babbage and John Stuart Mill. They saw both material and moral sources of transformation. In the

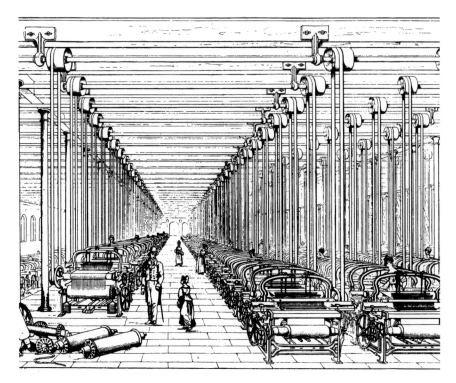

FIGURE 1.2. "Power Loom Factory of Thomas Robinson Esq[R], Stockport." Source: Andrew Ure, *The Philosophy of Manufactures, or, An Exposition of the Scientific, Moral and Commercial Economy of the Factory System of Great Britain* (1835; London, 1967), foldout, facing p. 1.

material dimension, technological innovation now seemed to all to be transforming society, with no end in sight. They pointed to many kinds of machinery, but the textile mill crowded with power looms, all driven by a single massive steam engine, provided the image of the future (figure 1.2).[17] Railroads and steamships carrying goods and people to all corners of the earth completed the picture of unlimited economic expansion.

In the moral dimension, however, these progressive forces were fast producing the condition of massive, urban, unskilled labor that was called the "social problem," marked by poverty, disease, and crime. The correlate of material progress and personal well-being for some seemed for the moment at least to be the material and moral decay of the working classes under the Malthusian law of subsistence wages. To improve their condition, conservatives emphasized the moral leadership of church and state, evangelicals pointed to religious conversion, and liberals and radicals looked to secular education. Nevertheless, the face of the factory town displayed misery on a

massive scale. This misery was quickly documented in the 1830s and 1840s in what Ted Porter describes as "the rise of statistical thinking" and what Ian Hacking has called an "avalanche of numbers."[18] The masses became a statistical object and the social problem became a problem for statistical analysis. (The middle-class analysts, it should be noted, did statistics largely on the lower classes, rather than on themselves.)

Three things now need knitting together: productive labor, time, and statistics. Happily, Charles Dickens did that long ago in the satirical novel *Hard Times* (1854), and his images are apt. If, as previously noted, the distinction of productive from unproductive labor provides an obvious referent for distinguishing linear from cyclical time, a more profound distinction emerges from the productive category itself. Though the image of industrial production may have become progressive for the nation and for the middle classes, and especially for owners and managers of factories, it had become largely repetitive for those who "minded" the machines that now did the work that replaced human labor. Here is Dickens on Coketown:

> It had . . . vast piles of buildings full of windows where there was a rattling and a trembling all day long and where the piston of the steam-engine worked monotonously up and down. . . . It contained several large streets all very like one another and many small streets still more like one another, inhabited by people equally like one another, who all went in and out at the same hours, with the same sound upon the same pavements, to do the same work, and to whom every day was the same as yesterday and to-morrow, and every year the counterpart of the last and the next. . . . Time went on in Coketown like its own machinery.[19]

The factory time of the workers was eternal repetition, as E. P. Thompson has described it in his classic "Time, Work-Discipline, and Industrial Capitalism."[20] What Thompson does not say is that with factory time as repetition, both workers and their time were feminized. Look closely at the preceding drawing of the Stockport power loom factory (figure 1.2). It is striking that the rows of machine minders are all women, while the only man—dignified, with cane and top hat—is the overseer. More generally, Dickens portrays the factory as feminizing all workers, both male and female, by turning them into cogs in the mechanism, or ciphers, ready either to follow orders or alternatively to follow the seductive charms of Slackbridge the labor organizer in a herd-like fashion, without individual wills or the power to reflect or resist: all, that is, except the tragic hero Stephen Blackpool, who must sacrifice his life for his independence.

Dickens's sympathy for the kindly feminine qualities of these downtrodden people did not prevent him from recognizing their barbarous side, nor from portraying it as equally feminine. This point can be illustrated by look-

FIGURE 1.3. "The Sea Rises." Source: Dickens, *A Tale of Two Cities*, vol. 20 of *The Writings of Charles Dickens* (Boston, 1894), facing p. 220.

ing a bit sideways, to Dickens's *Tale of Two Cities* and to one of its famous etchings (figure 1.3), which turns what had so often been portrayed during the French revolution as a heroic rising of the people into effeminate savagery. "The men were terrible . . . but the women were a sight to chill the boldest. . . . They ran out with streaming hair, urging one another, and themselves, to madness with the wildest cries and actions. . . . Give us the blood of Foulon, Give us the head of Foulon, Give us the heart of Foulon."[21] And who could forget the sinister Madame Lafarge knitting, knitting, knitting.

Returning to Coketown, from the perspective of the managing class that Dickens satirizes, the ever-threatening but machine-like workers are an undifferentiated mass, a mass to be known by statistics, or "stutterings," collected in tabular statements of average behaviors by government commissions appointed to the task. When Louisa Gradgrind, the daughter of the town's gentrified keeper of utilitarian virtue, visits Stephen's dwelling, it is "the first time in her life she was face to face with anything like individuality in connexion with them. She knew of their existence by hundreds and by thousands. . . . She knew them in crowds passing to and from their nests, like ants or beetles."[22]

The hundreds and thousands recall the image of a statistical distribution over the crowd that often stood behind the objectified, depersonalized averages that Dickens ridicules. It is the normal curve—the error law or curve of errors in the nineteenth century—as popularized for social statistics by Adolphe Quetelet in the 1830s and 1840s (figure 1.4). Even though the curve itself did not often appear, its shape was visible in tabular reports of statistical data, as in Edwin Chadwick's widely read *Report on the Sanitary Condition of the Labouring Population of Great Britain* (figure 1.5).[23] In its symmetric distribution about a central peak, the curve embodied the representation of a people by mean values, or Quetelet's "mean man," with its uniform rates of birth, death, crime, insanity, and suicide. This national "budget" seems to be Dickens' image when he describes Louisa's perception of the hands in the mills:

> Something to be worked so much and paid so much, and there ended; something to be infallibly settled by laws of supply and demand; . . . something that increased at such a rate of percentage, and yielded such another percentage of crime, and such another percentage of pauperism; something wholesale, of which vast fortunes were made; something that occasionally rose like a sea, and did some harm and waste (chiefly to itself), and fell again; . . . But, she had scarcely thought more of separating them into units, than of separating the sea itself into its component drops.

Louisa had learned this averaging statistical vision of knowledge from her father, for whom time itself was marked out by the "deadly statistical re-

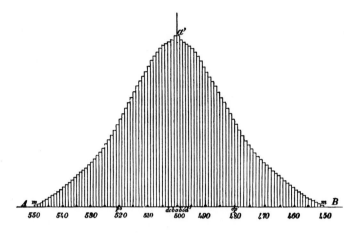

FIGURE 1.4. The normal curve. Source: M. A. Quetelet, *Letters Addressed to H. R. H. The Grand Duke of Saxe Coburg and Gotha, on the Theory of Probabilities, as Applied to the Moral and Political Sciences* (1846), trans. O. G. Downes (London, 1849), p. 68.

Ages	Manchester Union		White-chapel Union		Bethnal Green		Strand Union		Oakham & Uppingham Unions		Alston with Garrigill		Bath Union		Total	
	No. of Hus-bands who Died	No. of Or-phan Chil-dren	No. of Hus-bands who Died	No. of Or-phan Chil-dren	No. of Hus-bands who Died	No. of Or-phan Chil-dren	No. of Hus-bands who Died	No. of Or-phan Chil-dren	No. of Hus-bands who Died	No. of Or-phan Chil-dren	No. of Hus-bands who Died	No. of Or-phan Chil-dren	No. of Hus-bands who Died	No. of Or-phan Chil-dren	No. of Hus-bands who Died	No. of Or-phan Chil-dren
20—25	11	20	7	12	2	3	1	4	—	—	1	2	—	—	22	41
25—30	56	126	17	40	9	19	11	19	12	25	5	12	9	28	119	269
30—35	108	317	31	85	25	89	23	70	8	36	4	16	13	52	212	665
35—40	108	333	42	114	40	137	20	69	19	71	6	24	12	52	247	800
40—45	126	361	63	201	40	153	35	81	24	68	12	58	18	84	318	1006
45—50	112	302	61	178	44	105	23	58	19	50	18	84	9	37	286	814
50—55	100	183	78	137	45	107	24	34	30	60	9	30	4	15	290	566
55—60	97	138	51	37	45	54	20	17	24	36	14	11	1	6	252	299
60—65	147	148	87	46	53	35	25	17	26	15	13	4	1	4	352	269
65—70	96	60	48	18	52	17	15	13	26	13	1	—	—	—	238	121
70—75	87	55	54	8	57	7	13	—	32	10	4	—	—	—	247	80
75—80	60	22	25	4	24	8	5	2	22	4	1	—	—	—	137	40
80—85	35	4	17	2	7	—	5	—	11	6	1	—	—	—	76	12
85—90	5	—	7	3	2	—	—	—	—	—	—	—	—	—	14	3
90—95	1	—	2	—	—	—	—	—	1	—	—	—	—	—	4	—
95—100	—	—	—	—	—	—	—	—	—	—	—	—	—	—	—	—
100—105	1	—	—	—	—	—	—	—	—	—	—	—	—	—	1	—
Totals	1150	2069	590	885	445	734	220	384	254	394	89	241	67	278	2815	4985
No. receiving Relief previous to husband's death	199	—	80	—	—	—	37	—	11	—	27	—	—	—	—	—
Total Deaths below 60 years of age . . . 1746																

FIGURE 1.5. Tables of mortality in various districts. Source: Edwin Chadwick, *Report to Her Majesty's Principal Secretary of State for the Home Department, from the Poor Law Commissioners, on an Inquiry into the Sanitary Condition of the Labouring Population of Great Britain*, intro. M. W. Flinn (1842; Edinburgh, 1965), p. 257.

corder" in his observatory, which "knocked every second on the head as it was born, and buried it with his accustomed regularity."[24] If Gradgrind in his own rhythms thus epitomizes Coketown's factory time, he nevertheless controls that time and reaps the rewards of its imposition.

Coketown, in short, is home both to the productive progressive time of the masculine managers of the political economy *and* to the repetitive feminized time of the statistical masses, who in all their anonymous fluidity threaten to wash over the entire system if not severely controlled. The forces of order and disorder coexist. Progressive production of economic value, furthermore, of *work* converted into commodities for sale, rides on the back of a continuous *wasting* of the sources of work, whether humans or engines. Here we come very close to the context within which the principles of both thermodynamics and evolution were elaborated in Britain.

TIME AND STATISTICS IN THERMODYNAMICS

Previous papers have shown how the two laws of thermodynamics, energy conservation and energy dissipation, emerged from a Dickensian setting, focusing on the resources that William Thomson drew from the industrial city of Glasgow.[25] Glasgow was Thomson's Coketown, full of mills, foundries, engine builders, and shipyards, as well as the poverty and disease that constituted the social problem. He maintained constant contact with the engine-fired heart of the city through his engineering brother James and through the Philosophical Society of Glasgow, where the Whig managers of the city and its industry produced the kinds of "ologies," tabular statements, and statistics on which Gradgrind relied.

The society's *Proceedings* display its values. Consider the "History and Description of the Kelp Manufacture" by Charles F. O. Glassford, Esq., a subject "intimately associated with our social and commercial progress as a people," for in 1848 it supplied valuable iodine and potash salts for nine chemical manufacturers in and around Glasgow. Glassford concerned himself also with improvement of the poverty-stricken Highlanders of the Scottish islands, the crofters who gathered the kelp from the sea and dried and burned it, avoiding any procedure that "wastes and dissipates the kelp salts." But in their miserable condition they had little incentive to improve either their methods or themselves. Instead, a considerable population sat "idle for months" during the winter. They required both knowledge and a profit-sharing economy.

> The kelper would, in this way, profitably occupy time, which is usually spent and squandered in the most trifling manner, he would increase his own and the

comforts of his wife and family, and would at least be helping to move the fulcrum, which would elevate him as a man and as a reasonable and thinking being. . . . By this means he would become a more responsible individual, ascertain his own weight and individuality, and would, with a little assistance, be permanently raised in his own estimation, and in that of those around him. . . . When he finds his labour productive to himself, and not merely to his landlord, he would shake off his apathy and become a man, action would be substituted for inaction, and new and better fields for industry and enterprise would be opened up.

The masculine image for improvement and productive labour is elevation, being lifted or raised, having weight. In this condition, time brings progress; otherwise, time brings only waste, as the crofter "hang[s] about listless and idle in the vain endeavour of passing the day in ease and comfort."[26]

Although they shared Glassford's moral imperative, the problems of work and waste for the Thomson brothers were focused on steam engines. During the 1840s, the engine acted as a mediator for the Thomsons between their engineering concerns with political economy on the one hand and their concerns with natural philosophy (physics) on the other. The work done by the engine served as a common referent and measure for labor value in political economy and for energy in physics. They asked a key question: Does the production of work in an engine always involve waste? In 1851, they ultimately answered, yes: Whenever work is produced by the directed action of an engine, an unavoidable degradation or dissipation of energy is also produced in the passage of heat from high to low temperature.

Put in Glasgow terms, the steamships of the British Empire could continue to operate until all the energy available in the earth and sun had been converted into heat at the temperature of the ocean, that is, until the motions of the molecules constituting heat had been diffused and dissipated to their lowest-temperature equilibrium distribution. Thomson published his cosmological generalization of the principle in 1852, "On a Universal Tendency in Nature to the Dissipation of Mechanical Energy." The principle had, in part, arisen from and continued to reflect the easy analogy between the degraded state of energy in the ocean and the degraded state of the laboring poor, as represented statistically for real cities like Glasgow and London as well as the imaginary Coketown. As Chadwick analyzed the effect of miserable conditions in producing unruly crowds and mobs, consisting primarily of "mere boys": "They substitute, for a population that accumulates and preserves instruction and is steadily progressive, a population that is young, inexperienced, ignorant, credulous, irritable, passionate, and dangerous, having a perpetual tendency to moral as well as physical deterioration." The

substitution marked a deterioration of potential labor value and a consequent threat to the wealth of the nation.[27]

Analogous substitutions concerned Thomson: for a reservoir full of water available to drive a mill, an unconstrained rush of a river into the ocean; for concentrated heat available to power a steam engine, heat diffused away by conduction. His mathematical physics in the 1840s depended crucially on these latter systems, which he took up from Joseph Fourier's *Analytical Theory of Heat* (1824) and from Emile Clapeyron's 1834 account of Sadi Carnot's *Motive Power of Fire* (1824). Fourier had shown, among many other results, that heat concentrated at a point and diffusing in one dimension, always distributed itself according to an exponential law, which he connected with the error curve through work on probabilities that he had done for the statistical bureau in the early 1820s. He concluded his work as he had begun, with a hymn to mathematical unity in all of nature, here linking the diffusion of heat with the motion of light, with mean values and the probability of errors from numerous observations, with questions of insurance, and with various applications of probability theory.[28]

Although Thomson did not immediately develop it, the conceptual analogy between dissipated powers in nature and the degraded state of the crowd, as represented by the normal curve, seems to have been almost ready-made for interpreting thermodynamics, especially when the theory identified heat with molecular motion. In 1859, James Clerk Maxwell first obtained the normal distribution for molecular velocities in a gas directly through the gas-crowd analogy after having become familiar with Quetelet's normal curve for social statistics. His sources included his professor of natural philosophy at Edinburgh, J. D. Forbes, a close acquaintance of Quetelet, and John Herschel, whose 1850 review of Quetelet's popular account contained the proof of the distribution law that Maxwell adopted. Maxwell was also familiar with Thomas Henry Buckle's infamous attempt in the *History of Civilization in England* (1857–61) to use Quetelet's claims as the basis for obtaining statistical laws of history, which he later cited repeatedly. The very variety of these sources suggests the prominence of the normal curve as a description of variation in mass phenomena. Maxwell adopted it for his velocity distribution to express the undifferentiated nature of the molecules in a gas and their randomization, which was simultaneously their disorder and degradation, now submitted to a perfectly predictable mathematical relation. Ludwig Boltzmann soon showed that the relation followed uniquely from maximizing disorder (as entropy) according to the second law of thermodynamics. Even more than Maxwell, he was fond of citing Quetelet on the statistical properties of masses of people.[29]

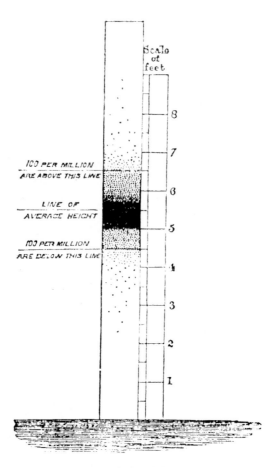

FIGURE 1.6. Normal distribution. Source: Francis
Galton, *Hereditary Genius: An Inquiry into its Laws
and Consequences* (London, 1869), p. 28.

In the work and waste scenario of thermodynamics, as in that of political
economy and the social problem, two different senses of time are involved:
the progressive time of directed work and the dissipative time of random mo-
tion in a statistical mass. It is a mistake to imagine the second law as having
to do only with dissipation. In the interpretation of its founders in Britain, it
was just as much about the conditions for the progress of civilization and the
moral duty of man to maximize the utility of the productive forces available
in nature. Left to themselves, these forces would necessarily dissipate, to no
purpose. The sun would exhaust its fuel, all waters would run down to the
ocean, and the winds would die. The historical progress of civilization, with
more urgency now than ever, depended on directing this decline into pro-

ductive work, just as women, children, and immature males depended on the directing power of masculine reason and will for their improvement.

EVOLUTION

In a form similar to work and waste, Darwin's theory of evolution involved two principles: a principle of fecundity, in which masses of individually varying members of a species are continuously reproduced, and a principle of selection, which in effect directs the mass to ever more perfect states of adaptation. Because selection does all of the progressive work, while reproduction just spreads out and maintains the mass of variation, it would come to seem "natural"—to many male interpreters at least—that selection should be gendered masculine and reproduction feminine.

This result, however, acquired its statistical form only gradually, especially in Darwin's own work, where it appears clearly only after he became familiar with the 1865 writings of his cousin Francis Galton, which reinterpreted individual variation in terms of Quetelet's normal curve and its various representations (figure 1.6).[30] That Darwin did not give individual variation a statistical representation seems surprising on several counts: his reliance on Malthus for his principles of fecundity and selection, his dependence on the standard images of political economy for his basic conceptual structure, and the fact that his entire theory rests on the notion of variation of individual traits over a population. The conundrum may have a resolution that is of interest here. Quetelet's normal curve, with its graphic depiction of a mean value, was deeply embedded in the balancing acts of Enlightenment science, aimed at isolating natural states, true values, and inherent stability, while eliminating temporality in nature. Its purpose was not to emphasize variation, but to show that variation always averaged out to reveal an underlying law-like regularity. Even Robert Chambers understood the significance of the curve in this way: "The human being, a mystery considered as an individual, becomes a simple natural phenomenon when taken in the mass."[31] Darwin's perspective was the opposite. He wanted to emphasize not natural uniformity but natural variation as the basis for temporal change, for the gradual appearance under selection of new varieties and new species. Thus his rhetorical constructions, though they typically include variation as difference of degree in a continuously variable trait like beak length, concentrate on variation as difference of kind between varieties.

A good place to see this is in *The Variation of Animals and Plants under Domestication* (1868), in the juxtaposition, for example, of individual variation within breeds of pigeons with variation between breeds. Although

Darwin gives numerous measurements to establish the variation within a breed, he reports them only to suggest how the differences between breeds have arisen by selection from a varying progenitor.[32] At this point he knew Buckle's *History of Civilization* and was familiar with Galton's transformation of the significance of the normal curve. Galton now used it not to eliminate variation about the mean but to show what had to be done to improve the human race by selecting its more valuable specimens from the high end of the distribution and limiting the reproduction of those at the low end. Darwin would soon incorporate this eugenic perspective in *The Descent of Man and Selection in Relation to Sex* (1871).[33]

In this new text, Darwin also produced his most infamous statements about sex and gender in human evolution, relying on a much-expanded version of sexual selection. We tend today to identify sexual selection with females choosing males for their beauty or on other aesthetic grounds, complementing the physical battles between males to possess females, as in Darwin's long chapters on the function of the remarkably beautiful plumage of many male birds. But Darwin cautions against extending the sense of beauty in the lower animals to the complex ideas of civilized man. "A more just comparison would be between the taste for the beautiful in animals, and that in the lowest savages, who admire and deck themselves with any brilliant, glittering, or curious object." Although some vestiges of the animal sense of beauty remain in savages, sexual selection for them operates as it does for all higher animals, primarily by combat between males. "With mammals the male appears to win the female much more through the law of battle than through the display of his charms."[34]

Without going into any detail here, sexual selection provided an asymmetric mechanism of inheritance (based on Darwin's strange notion of pangenesis), such that continually striving and competing males evolved more rapidly than more passive females, at least in those characteristics favorable for battle. This process of sexual selection coupled with natural selection to produce higher reasoning powers and a higher degree of individuality, which mature males passed on to their male offspring, while females remained at the lower evolutionary level of emotion, sentiment, imitation, and sameness, somewhat closer to savages.

> It is generally admitted that with woman the powers of intuition, of rapid perception, and perhaps of imitation, are more strongly marked than in man; but some, at least, of these faculties are characteristic of the lower races, and therefore of a past and lower state of civilization. . . . We may also infer, from the law of the deviation from averages [normal curve], so well illustrated by Mr. Galton, in his work on 'Hereditary Genius,' that if men are capable of a decided pre-eminence over women in many subjects, the average of mental power in man must be above that of woman.[35]

Similar views had been promoted twenty years earlier by the more socially engaged theorist of evolution, Herbert Spencer, who, like Darwin after him, considered division of labor in the political economy to be the analogue of physiological divergence and speciation in biology and the mechanism of individuation in human evolution. Spencer, too, held that women were on a lower evolutionary level. He correlated savagery with hero worship, thus lack of individuality, and found his correlation born out among women.[36]

CONCLUSION

If we now look at the normal curve with the Victorian gaze that spread through the social and natural sciences between about 1840 and 1870, we should be able to shift our attention rapidly, from a *crowd* to a *gas* to a *species*, and to recognize that for each of these statistical objects the curve came to represent a primitive, dissipated, or randomized state of an undirected mass. In sketching their interrelation, I have attempted to show how these interpretations came to support some tenaciously gendered stereotypes of linear and cyclical time, of historical progression and mechanical repetition, of order and disorder. More particularly, I have suggested that the two laws of thermodynamics (energy and entropy) and the two principles of evolution (variation and selection) lent great authority to the representation of progress and decay as masculine and feminine. This ideological association, however, did not compromise the empirical validity of the laws in other respects. On the contrary, their very validity helped to project the gender stereotypes into external nature, both physical and biological. By the end of the nineteenth century, when Gustave Le Bon wrote *The Crowd*, he could draw support from across a wide spectrum of social statistics, psychology, historiography, and the arts, as well as from the natural sciences and such specialized offshoots as eugenics.

This depressing narrative has its limits, however. It first captured the imagination of middle-class scientific and scientistic interpreters only in the nineteenth century, being quite incompatible with the most prominent sciences of the late Enlightenment, in which repetition supplied the epitome of natural order. Has it also had an end? Perhaps. The so-called sciences of complexity, developed over the last thirty years, seem to be revaluing repetition. In these areas, repetition has become the generative source from which order and structure "emerge," in the literal meaning of emergent properties. "Order out of chaos" is the popular phrase, but chaos theory is only one of a very wide range of subjects in which explanations of order proceed from bottom-up accounts of nonlinear interactions between elements of many-body systems. Repeated over and over again, the interactions produce the

forms of organization that appear in the natural world. Leaves, hearts, and brains, not to mention epidemics, demographic distributions, and cities, all seem to exhibit such emergent properties.

Under these conditions, the old gender stereotypes, so far as they have depended on support from the sciences, can hardly survive. A bolder conclusion would be that, just as in the nineteenth century, the sciences themselves have also changed in part through their participation in the social transformations that have changed gender stereotypes including those having to do with repetition. Though surely correct if construed broadly, that thesis will require a great many particular studies for its adequate articulation.[37]

Dark Star Crashes: Classical Thermodynamics and the Allegory of Cosmic Catastrophe

BRUCE CLARKE

COSMOS AND COMMODITY

Allegories fluctuate between obsolescence and the critique of obsolescence. Allegorical structures are typically in transit to obsolescence: They produce even as they resist the obsolescing of the materials they preserve. Thus the profoundly allegorical tenor of Baroque and other emblems of ruin or superannuation—*memento mori* such as the broken remains of an archaic statue or a defunct commodity like a 386 desktop computer. There is always something anachronistic about allegory. Its generic bric-a-brac results from the overlapping and clash of distinct temporal phases or cultural eras. Counter to symbolist techniques, which seek to collapse time in instantaneous fusions of multiple meanings, allegory operates by means of temporal montage.[1] The spatial stratification or segmentation of allegorical levels often represents an archaeology of distinct historical periods. Allegorical temporality is discontinuous time. In allegory, some temporal dissonance, some historical clash of past and present, present and future, generates a layered text often intended to neutralize or harmonize that dissonance, to recuperate an obsolescence. In the modern technoscientific period, for which the present is already obsolete, the allegorical anachronisms of science fiction typically establish a significant dissonance between images of the present and the future.

Walter Benjamin's critical readings of modern society perform an allegorical decoding of the mythic image of time. Benjamin credits allegory with restoring irreversible time to cultural forms, aligning nature with history rather than myth. In *The Dialectics of Seeing*, Susan Buck-Morss reconstructs Benjamin's Arcades project as a critical system that pivots on the conceptual relations between social myth and critical allegory: "It was the Baroque poets who demonstrated to Benjamin that the 'failed material' of his own historical era could be 'elevated to the position of allegory.' What made this so valuable for a dialectical presentation of modernity was that allegory and myth were 'antithetical.' Indeed, allegory was the 'antidote' to myth."[2]

In the 1850s, both the laws of thermodynamics and the theory of evolu-

tion introduced irreversible time into the scientific description of physical and biological systems. The dissipative transformations of energy and the progressive metamorphoses of species now marked the performance of the world-system over time and marked it as a system *in time*. As Norton Wise notes in "Time Discovered and Time Gendered," thermodynamics displaces temporal systems from repetitive and cyclical to linear and progressive. Today we view the arrival of irreversible time within thermodynamics as bringing physics closer to the actual workings of open and far-from-equilibrium systems, thus as an advance over the generalized temporal reversibility that functioned within the regime of Newtonian dynamics. But at first, the linearity of thermodynamic time came forward precisely as *mythic* rather than historical time.[3] An apocalyptic concept of heat death—the ur-form of "energy crisis"—arose as a deterministic outcome of the mechanics of energy laws. Hypothetical thermodynamic causality was troped as a universal and seemingly imminent mythic fate. An engraving in Camille Flammarion's *La Fin du Monde* depicts the stark human meaning of heat death (figure 2.1).

Victorian thermodynamic prophecies of a universe evacuated of vitality by mechanical dissipation were founded on proverbial western concepts of temporal linearity, fruition, and summation followed by apocalyptic cessation.[4] Ilya Prigogine and Isabelle Stengers have commented on this mythic aspect of thermodynamic time in the nineteenth century: "The specific form in which time was introduced in physics, as a tendency toward homogeneity and death, reminds us more of ancient mythological and religious archetypes than of the progressive complexification and diversification described by biology and the social sciences."[5] Irreversible time emerged in science simultaneously in the *historical* form of random evolutionary transitions and the *mythic* or phantasmagoric form of certain, imminent heat death. For Benjamin, however, the burden and the benefit of irreversible time determine a new cultural ethic—it makes human history into a matter of fabrication rather than fate. Benjamin's practice depends on seeing nature not as mythic predetermination but as a temporal and technological construction, something we make as it makes us.[6]

To critique pernicious interweavings of social mythology and scientific ideology, Benjamin developed a "modern form of emblematics," which Buck-Morss graphs upon two conceptual axes.[7] At the intersection of these thematic coordinates stands the *commodity* in the form of a dialectical image.[8] Benjamin surveyed the modern cultural field through the scope of the commodity to reveal the material subtexts of mystified meta-narratives such as *progress*, *social evolution*, and *the new*. The dialectical images of modern commodities circulate through three interlocking discursive dimensions—myth, nature, and history—divided between axes of consciousness (waking

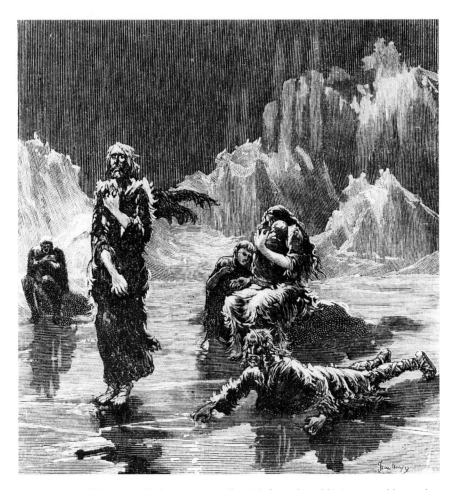

FIGURE 2.1. "The miserable human race will perish from the cold" (La misérable race humaine périra par le froid). Source: Camille Flammarion, *La Fin du Monde* (Paris, 1894), p. 121.

and dream) and reality (nature in time) and sorted into the "axial fields" of natural history, mythic history, mythic nature, and historical nature. Each field possesses what we can call an *emblem* and a *mode*. Natural history's emblem is the fossil, its mode the trace; mythic history's emblem is the fetish, its mode the phantasmagoria;[9] mythic nature's emblem is the wish image, its mode the symbol; and historical nature's emblem is the ruin, its mode allegory per se. Plotted on these axes, Benjamin's Arcades project explores the cultural dreamwork of the modern ideological dialectic between the cosmos and the commodity.

Here, I use Benjamin's map of the phantasmagoric commodity to read some of the interplay between science and myth in the early cultural elabo-

ration of the laws of thermodynamics. Dialectical images populate influential nineteenth-century discourses that circulated with the authority of science while troping nature precisely as a commodity. Phantasmagoric descriptions are clearly visible in the early discourses of physical energy. For instance, British physicist Balfour Stewart wrote in *The Conservation of Energy*, "energy may be like the Eastern magicians, of whom we read that they had the power for changing themselves into a variety of forms, but were nevertheless very careful not to disappear altogether. . . . It is necessary to penetrate the various disguises that our magician assumes before we can pretend to explain the principles that actuate him in his transformations." [10] Stewart retails this trope of metamorphic agency to expound the first law of thermodynamics, which asserts that the sum of energy in a physical transaction is *conserved* throughout its transformations. Whether potential, kinetic, chemical, atomic, mechanical, radiant, or thermal—the qualities of energy alter without loss of absolute quantity. In 1874 Stewart coauthored with another eminent Victorian scientist, mathematical physicist P. G. Tait, *The Unseen Universe or Physical Speculations on a Future State*, which contains further mythic analogues of energy's metamorphoses. "We see that whereas (to our present knowledge, at least) matter is always the same, though it may be masked in various combinations, energy is constantly changing the form in which it presents itself. The one is like the eternal, unchangeable Fate or *Necessitas* of the ancients; the other is Proteus himself in the variety and rapidity of its transformations." [11] The law of energy conservation comes forth in Stewart and Tait as classical patriarchal ideology. Virile energy is reified in opposition to dull feminine matter as an occulted, potent, and conserved presence that manifests itself in metamorphic guises—from vital sun to luminiferous ether to chemical effect to electromagnetic dynamism to thermal flows to dead pools of entropy—without loss of substance or essence. Especially in its bourgeois cultural applications, the discourse of thermodynamics produced allegories of *capital* that exemplify Marx's famous analysis of the metamorphosis of commodities. We note that anything metamorphic—energy, life, the soul—can function as an analogue of the commodity. Through the "theological niceties" of the commodity, metaphors of money in circulation mime the energies of the natural world as well as powers of the supernatural world. [12]

Within the axial fields of Benjamin's dialectical coordinates, the cultural allegories instigated by the natural sciences fluctuate among various mythic and historical positions. The discourse of evolution developed into an allegory of industrial society, as the fossil or trace of natural history is transferred to the obsolescence of used goods and outmoded ideas. Commodity fetishism marks the phantasmagorias that unite scientific ideas to social demands

and translate material into mythic history. Wish images circulate as symbols of a mythic nature transfused in modernity by the awesome new divinities of the heat engine and the electrical dynamo. And the emblematical ruin of historical nature returned in the iconography of entropy, heat death, and crashing comets. In our culture, the discursive products of science inevitably enter into the allegorical dialects of commodification. The fantastic moralizations of energic or entropic catastrophe show that scientistic prophecies of disaster are always local rhetorical manipulations. One advocates the doom that most advances one's ongoing situation.

PHANTASMAGORIC SPECULATIONS

The laws of thermodynamics prime the socioeconomic figures that pervade French astronomer and author Camille Flammarion's *La Fin du Monde* of 1894.[13] Anticipating by a century 1998's comet-catastrophe spectacles *Deep Impact* and *Armageddon*, Flammarion's fictionalized popularization of Victorian cosmology imagined that in the semi-advanced world of the twenty-fifth century, a monster comet is discovered on a collision course with Earth. A scientific colloquium is convened in Paris to debate possible effects, which didactic device allows Flammarion to offer a seminar on later nineteenth-century theories of geological and cosmological evolution, especially as these sciences envisioned possible modes of physical catastrophe bringing life on earth to an end. Once the comet passes without irreparable damage, humanity evolves toward an "apogee" of cultural and spiritual development, a sensuous utopia cut short only by the inexorable processes of geological and solar entropy.

Flammarion's vivid but obsolete prophecies underscore the ironies that develop from the modern scientific revision of time-narratives. *La Fin du Monde* strove to synthesize scientific positivism and bourgeois spiritualism, only to fracture that synthesis by trying to hold the apocalyptic determinations of classical thermodynamic revelations within a parallel positivist discourse of utopian social prophecy. Both the apocalypse and the utopia are now defunct. Nevertheless, the specter of a cosmic collision between the earth and a killer comet provided vivid emblematic cover for a number of urgent sociopolitical contents. In this section I trace the ways that this fin-de-siècle apocalypse provides a phantasmagoric cosmic mediation for a series of worldly phenomena—war, revolution, and political economy.

To begin with, *La Fin du Monde* is fairly explicit about the martial connotations of the impending threat. At first Flammarion's comet appears like "an army of flaming meteors." But it is sufficiently gaseous that "the main

body of the celestial army" passes by without causing a total devastation. Moreover, despite some momentary damage, the comet's ultimate effect is beneficial, reinvigorating: "this cataclysm did not bring about the end of the world. The losses were made good by an apparent increase in human vitality, such as had been observed formerly after destructive wars; the earth continued to revolve in the light of the sun, and humanity to advance toward a still higher destiny." [14] Flammarion's similes underscore *La Fin du Monde*'s ideological drive, despite its manifest critique of standing armies, to justify capitalist economies of war by positing the dialectical necessity of militarism as a negative moment leading to a future evolutionary transcendence of war altogether. The losses of combat and the expenditures demanded by war economies are recuperated and rationalized through a wishful reading of dynamical regimes in which sudden bouts of destruction yield a creative restructuring at a higher level of development.

Fables of impending destruction by colliding planets can also mask the direct collision and fiery clash of political regimes in a social revolution. Flammarion develops the world of the twenty-fifth century as the progressive aftermath of a series of revolutionary transformations, beginning with "the great social revolution of the international anarchists who, in 1950, had blown up the greater portion of [Paris] as from the vent of a crater." Flammarion's own political attitude is discernible as a fairly positivist, scientized form of libertarian liberalism. To abolish the military and purge the state bureaucracy once and for all, Flammarion tells us, "a radical revolution was necessary. From that time on, Europe had advanced as by magic in a marvelous progress—social, scientific, artistic, and industrial. Taxation, diminished by nine-tenths, served only for the maintenance of internal order, the security of life and property, the support of schools, and the encouragement of new researches. But individual initiative was far more effective than the old-time official centralization." [15] The passage of the comet is the last in a series of revolutionary preparations and the final catalyst for humanity's higher-evolutionary development.

At the beginning of the narrative, however, Flammarion also treats the emergence of the comet in its aspect as news, that is, as a doomsday media item hyped by the popular press, and as a modern telecommunicated disaster, reported more or less in real time. The charge of the extraordinary colloquium at the Parisian Institute is to separate vulgar misunderstanding and media misinformation from a properly scientific grasp of the situation. Like *Wall Street Week* pundits predicting the coming year's movement of the Dow Jones average, the Parisian experts engage in studied debate about the impending comet's effects. The first speaker reassures the audience that the world will not be utterly destroyed by the comet, and illustrates his confi-

dence with the following declaration: "I confess that if the Bourse was not closed, and if I had never had the misfortune to be interested in speculation, I should not hesitate today to purchase securities which have fallen so low." [16] But he is abruptly interrupted in a tendentious fashion: "This sentence was not finished before a noted American Israelite—a prince of finance—editor of *The Twenty-fifth Century*, occupying a seat on one of the upper steps of the amphitheater, forced his way, one hardly knows how, through the rows of benches, and rolled like a ball to the corridor leading to an exit, through which he disappeared." [17] Figure 2.2 subtly depicts this "prince of finance" as a Prince of Darkness. As he rolls out of the domed meeting hall, the tails of his frock coat spread out to suggest the wings of a fallen angel embarking on a devilish scheme. Dashing down like a diabolical fireball, this Luciferian manipulator personifies the evil comet looming overhead. He wings away to Chicago by airship to place his new acquisition of scientific intelligence into timely motion. Capitalizing on the information that the comet crash will not be globally fatal, he causes the stock markets to be reopened and buys up shares whose price has crashed in mistaken anticipation of the cosmic catastrophe.

Flammarion's text provides a skewed but acute analysis of media manipulation, the ways that the public traffic in scientific assertions can impinge on a market economy. "As in other days," Flammarion informs us, "the monasteries had accepted bequests made in view of the end of the world, so our indefatigable speculator had thought best to remain at his telephone, which he had caused to be taken down for the nonce into a vast subterranean gallery, hermetically sealed" with "special wires uniting . . . the principal cities of the world." From this occulted command-center the devilish market-and-media manipulator makes a further fortune off the comet affair. At first, responding to an unverified local report, headlines in *The Twenty-fifth Century* declare, "*Death of the Pope and all the bishops! Fall of the Comet at Rome!*" When it turns out that the Vatican has been unharmed, the wily editor provokes further circulation by cynically converting the correction of misinformation into an act of divine intervention: "*Great Miracle at Rome!*" [18]

In the bourgeois economic allegory at stake in these passages, the crucial connections are those among energy, capital, and catastrophe. The ominous comet looms over this story like the threat of a stock-market collapse over a mismanaged or overheated economy. Indeed, capital investment is that to which (financial) catastrophe can occur—and in the form precisely of a *crash*, the collision of high prices falling back to earth, as ruined speculators jump to their deaths out of high windows. And just as certain thermodynamic moralists bank on the "impending heat death of the universe"—that is, on some train of reasoning based on the *imminent* possibility of some uni-

FIGURE 2.2. "He rolled down like a ball" (Se précipita comme une boule). Source: Camille Flammarion, *La Fin du Monde* (Paris, 1894), p. 54.

versal entropic catastrophe—one can capitalize *on* a stock-market crash, especially on the mediated perception that such a crash is "impending." And yet, the market generally "revives" after a crash, as in these cosmic collision scenarios, the momentary devastation clears the ground for a utopian future.

Within *La Fin du Monde* the stock-market affair is a bit of social satire leavening the heaviness of the narrative's other apocalyptic themes. Flammarion demonizes the Jewish tycoon with a scenario of cynical exploitation. "Speculation" is explicitly presented as the corrupt capitalistic device of playing on manufactured perceptions, especially on expectations of the future. In the comet's aftermath, with the dissolution of the military in the onset of a more perfect society, Flammarion explains how "men perceived that the military system meant the maintenance of an army of parasites and idlers, yielding a passive obedience to the orders of diplomats, who were simply *speculating* on human credulity." [19] Through the Jewish tycoon and the international diplomat, Flammarion defines and demonizes a culture of destructive speculation, developed to paranoid length by details such as the subterranean stronghold in telecommunication with minions located in military-industrial capitals. But this satire actually bites the author back by revealing—through the projection of his demonic double, the "American Israelite"—the structure of his own rhetorical manipulations.

The ideological alarm associating Jewish financiers with market capitalism and media corruption, however, centers on the term *speculation* in a way that also frames Flammarion within his own stereotypes. For the entire scenario of financial speculation emerges in tandem with the comet's impending and actual collision with the earth, which is itself produced by an act of *fictive* speculation, the very "futuristic vision" that holds this narrative in the grip of thermodynamic images of catastrophe coined earlier in the nineteenth century. In the phantasmagorias of thermodynamic apocalypse that emerged in the 1850s and 1860s, entropy came forward as the uncontrollable aspect of physical systems, historically concurrent with other modern anxieties over the control of capital, material resources, ethnic minorities, and subject populations. The initial notion of thermodynamic entropy was charged at its inception by the cultural stresses of imperialism and industrial capitalism, and then elaborated by later narratives providing a paranoid view of present social relations extrapolated into a speculative future.

For various ideological purposes Flammarion articulated some of the forms of mythic history and cultural paranoia induced by the initial discourse of thermodynamics—the notion that somehow the *cosmos* (as opposed to the economy operated by a particular political regime) is out to get us, perhaps by dooming us to a slow death of entropic fatigue, or else by hurling at us out of nowhere a fiery comet of vast destruction. In these equivocations

on the act of *speculation*, financial, scientific, and fictional predictions typically produce an allegory of the present, a transformation that puts the present under threat of demonic control by the future. The paradigmatic science fiction of a speculative future necessarily re-presents the chaos of the present in the mode of allegory—as a totalized system—and this textual conversion of the present is then registered within the text of the future as a paranoia of control. In *La Fin du Monde*, allegory and commodification converge to promote and subvert Flammarion's own brand of prophetic positivism, to enhance and collapse his own speculative holdings of intellectual paper, through phantasmagoric spins on the laws of thermodynamics.

DARK STAR CRASHES

Certain allegories of thermodynamics operated on the first as well as the second law to moralize the conservation as well as the entropic dissipation of energy. To revise T. S. Eliot's modernist expression of entropic melancholy in "The Hollow Men," in some thermodynamic fables the world ends not with a whimper but with a bang. These more robust visions of destruction and ruin arose spontaneously from the imagery of competing energies and the contemplation of colliding masses. As Gregory Bateson has noted, "from the time of Newton to the late nineteenth century, the dominant preoccupation of science was with those chains of cause and effect which could be referred to forces and impacts." [20] In tandem with heat death and other notions of energic fatigue, a separate register of thermodynamic catastrophe developed from speculations about the cataclysmic collision of cosmic bodies—asteroids, comets, planets, and stars. What happens when the kinetic energy resident within a physical system is suddenly dissipated in a chaos of disorderly fragments? In particular, what happens when massive bodies in extremely rapid motion hurtle into each other? If despite this sudden leap into higher entropic states, the sum of their energies of motion is conserved, where does that power go when the explosion is over? And what might these physical considerations have to do with modern hopes and fears over individual and cultural progress or survival? For some scientistic speculators, the first law of thermodynamics held out the promise of violent transformation rather than utter annihilation and thus salvaged creative hope out of entropic despair.

In *La Fin du Monde* and again in H. G. Wells's "The Star," another tale in which a comet threatens to collide with the earth, it is implied that episodes of vast destruction can release more energies than they consume, repairing cosmic fatigue with new resources of power. [21] In "The Star," a com-

pact parable published in the Christmas 1897 number of the *Graphic*, the star that rises upon the world is not a herald of peace but a threat of destruction.[22] The monster comet collides with Neptune, "and the heat of the concussion . . . incontinently turned two solid globes into one vast mass of incandescence." Then the augmented projectile takes dead aim at Earth. Its malignant heat raises flood tides and typhoons that devastate the Pacific hemisphere, but a direct hit is averted when the moon interposes itself, takes the brunt of the impact and deflects the star, which then dashes on "the last stage of its headlong journey downward into the sun. . . . And as the storms subsided men perceived that everywhere the days were hotter than of yore, and the sun larger, and the moon, shrunk to a third of its former size, took now fourscore days between its new and new. But of the new brotherhood that grew presently among men, of the saving of laws and books and machines . . . this story does not tell."[23]

Wells's coy short story recapitulates in miniature the shape and detail of *La Fin du Monde*, the second part of which details a "new brotherhood" in a post-cometary futurity that carries the story of human progress forward to a final demise ten million years in the future.[24] At first, however, *La Fin du Monde* opens upon a state of global lassitude induced by the rogue comet that has emerged from deep space on a collision path with the earth. "For more than a month the business of the world had been suspended" as if under the paralysis of a death sentence: "The courts themselves had no cases; one does not murder when one expects the end of the world."[25] When the comet is just days away from impact, as the speakers at the Parisian colloquium debate the possible effects of the comet's solid and gaseous elements, the first law of thermodynamics is repeatedly invoked in the particular form of the mechanical conversion of the energy of motion into heat. The president of the Astronomical Society reviews the basic science involved:

> "The audience before me is too well informed not to know the mechanical equivalent of heat. Every body whose motion is arrested produces a quantity of heat expressed in caloric units by mv^2 divided by 8338, in which m is the mass of the body in kilograms and v its velocity in meters per second. For example, a body weighing 8338 kilograms, moving with a velocity of one meter per second, would produce, if suddenly stopped, exactly one heat unit; that is to say, the quantity of heat necessary to raise one kilogram of water one degree in temperature."[26]

A moving body is typically brought to a sudden stop by colliding with an equal body moving with an opposite velocity.[27] This detail of Victorian physics also inflects "The Star" at two points. The first is Wells's own didactic device, early in the story, for placing physical concepts before the reader: "The schoolboy . . . puzzled it out for himself—with the great white star,

shining broad and bright through the frost flowers of his window. 'Centrif-
ugal, centripetal,' he said, with his chin on his fist. 'Stop a planet in its flight,
rob it of its centrifugal force, what then? Centripetal has it, and down it falls
into the sun!'" Here the idea of the sudden arrest of planetary motion is con-
ceived in its inertial rather than thermodynamic aspect. The latter consider-
ation returns at the end of the story, at its second point of intersection with
the first law of thermodynamics, which is applied now to a defunct phase of
solar physics, the meteoric theory of solar energy. In the aftermath of the
star's near-collision with the earth, "the days were hotter than of yore" be-
cause the comet and the greater portion of the moon, having crashed into the
sun, are conceived to have augmented not just its mass but also its energy,
by the conversion of their mechanical energy upon collision into heat.[28]

For these formulations of the first law in relation to solar energy, both
Wells and Flammarion may have been indebted to the popular physical ex-
positions of John Tyndall, professor of natural philosophy at the Royal In-
stitution from the 1850s to the 1880s and an avid popularizer of leading
scientific research.[29] For instance, in the lead essay of his 1865 collection
Fragments of Science, "The Constitution of Nature," Tyndall stated: "Acted
on by [gravity], the earth, were it stopped in its orbit to-morrow, would rush
towards, and finally combine with, the sun. Heat would also be developed
by this collision . . . equal [to] that produced by the combustion of more than
5,000 worlds of solid coal, all this heat being generated at the instant of col-
lision." [30] In the solar physics of Tyndall's time, decades prior to the under-
standing of nuclear energy, the sun's steady rather than diminishing produc-
tion of light and heat was accounted for in several ways. According to the
meteoric theory, the solar system supplied the sun a constant infusion of rap-
idly moving interplanetary matter. This meteoric source of fuel augmented
an allied theory of solar condensation, in which the sun maintained its en-
ergy at an even level through the constant shrinkage of its radius. During the
debate at the Parisian Institute, it is eventually pointed out that, catastrophic
comets aside, in all probability the world will end when the sun burns out:

> "The probable cause of the heat of the sun is the condensation of the nebula in
> which this central body of our system had its origin. . . . The temperature of
> this great day-star does not seem to have fallen any; for its condensation is still
> going on, and it may make good the loss by radiation. Nevertheless . . . the time
> will come when the circulation, which now supplies the photosphere, and
> makes the central mass a reservoir of radiant energy, will be obstructed and
> will slacken. . . . The brilliant photosphere will be replaced by a dark opaque
> crust which will prevent all luminous radiation. . . . The earth, a dark ball, a
> frozen tomb, will continue to revolve about the black sun, traveling through
> an endless night and hurrying away with all the solar system into the abyss of

space. *It is to the extinction of the sun that the earth will owe its death, twenty, perhaps forty million years hence.*"[31]

But Flammarion holds this momentary reversion to entropic rationales in check by placing it in relation to a long list of more or less plausible dooms-day scenarios, with the effect of diminishing their overall shock value. And in the immediate event, the comet deals the earth a severe but not irrepara-ble global blow: "the number of the dead was one-fortieth of the population of Europe." So *La Fin du Monde* anticipates "The Star"'s simple structure of an averted cosmic threat that produces a spiritual transformation of humanity. The latter part of Flammarion's lengthy didactic fable narrates our higher evolutionary destiny, the perfect mastery of material conditions. "Progress is the supreme law," the narrator declares, looking back upon a distant future when humanity "had risen . . . to the position of a sovereign who ruled the world by mind, and who had made it a paradise of happiness, of pure contemplation, of knowledge and of pleasure." The future shape of human biological and social evolution produces a dated catalog of unre-markable marvels: the "weather could be predicted . . . electricity had taken the place of steam." These technological developments are overshadowed by biological mutations that over many millennia unfold new powers of percep-tion: "the electric sense . . . the psychic sense." For millions of years human-ity mounts evolution's rainbow to reach a hazy "apogee" of sentient devel-opment (figure 2.3).[32]

But now the world of the future is poised to fall back from its zenith. The time has come of inexorable physical decline brought on by the geological decrepitude of the earth. Many of the ecological disasters presented as physi-cal hypotheses in the great comet debate of the twentieth-fifth century are now seen to come true. The first characters in the novel granted proper names and the last two survivors of the expiring posthuman race, Omegar and Eva, are subjected to a humorously lugubrious apotheosis. One can sense the relief with which Flammarion disposed of this modicum of per-sonal interest in order to proceed to the actual finale of his opus, the true end of *La Fin du Monde*, in his "Épilogue: Après La Fin du Monde Terrestre—dissertation philosophique finale." On the frontispiece of this final chapter, Flammarion's illustrator has pictured the dark star of thermodynamic spec-ulation (figure 2.4).

Flammarion brought his readers this far in order to assure them that sci-ence guarantees a new beginning after the end of the world. In the end, gravi-tation and the first law's guarantee of the mechanical conversion of motion into heat outmaneuver the second law of thermodynamics. The headlong momentum of the comets that had threatened the earth partakes of the cos-mic dynamism necessary to make a new start. For even "a planetary corpse,

FIGURE 2.3. "The apogee" (L'apogée). Source: Camille Flammarion, *La Fin du Monde* (Paris, 1894), p. 299.

a dead and frozen world . . . still bears . . . within its bosom an unexpended energy—that of its motion of translation about the sun." The meteoric theory of solar energy is now reprised in terms of the energies latent in the fall of planets into the sun: "If the earth should fall into the sun, it would make good for ninety-five years the actual loss of solar energy. . . . The fall of all the planets into the sun would produce heat enough to maintain the present rate of expenditure for about 46,000 years."[33] In fact, Flammarion is transcribing a table of nearly identical information offered in the final pages of Tyndall's magnum opus on thermodynamics, *Heat: A Mode of Motion.*[34] A few pages before this table, Tyndall had made a strong statement of the meteoric theory's positing of gravity over entropy:

> Whatever be the ultimate fate of this theory, it is a great thing to be able to state the conditions which certainly would produce a sun,—to be able to discern in the force of gravity, acting upon dark matter, the source from which the starry heavens *may* have been derived. For whether the sun be produced, and his emission maintained, by the collision of cosmical masses—whether . . . the internal heat of the earth be the residue of that developed by the impact of cold dark asteroids, or not—there cannot be a doubt as to the competence of the cause assigned to produce the effects ascribed to it. Solar light and solar heat lie latent in the force that pulls an apple to the ground.[35]

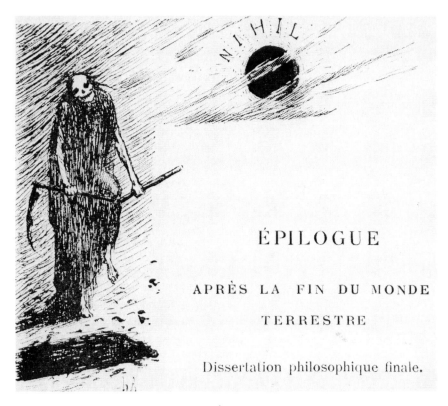

FIGURE 2.4. "After the end of the world" (Épilogue: Après La Fin du Monde Terrestre—dissertation philosophique finale). Source: Camille Flammarion, *La Fin du Monde* (Paris, 1894), p. 397.

Tyndall's profession of cosmic optimism provoked a powerful counterargument from some thermodynamic doomsayers who envisioned the end of the world as an utterly final event. In a passage of *The Unseen Universe*, Stewart and Tait replied directly to Tyndall's materialist declarations: "If the present physical laws remain long enough in operation, there will be (at immense intervals of time) mighty catastrophes due to the crashing together of defunct suns . . . growing in grandeur but diminishing in number till the exhaustion of energy is complete, and after that eternal rest, so far at least as visible motion is concerned." [36] This "eternal rest" awards the second law cosmological precedence over the first law, at least to the limits of the "seen" or material world, in order to credit the "unseen universe" of divine agency with the ultimate responsibility for bringing material worlds into being.

Tyndall, however, ranked the first law over the second, in order to maintain a secular materialist position in which matter itself, aided by gravity, is

endowed with the ability to regenerate energy sources.[37] He stated this position succinctly in his article "The Constitution of Nature." [38] Extrapolating from the mechanical theory of heat to the dynamism of cosmic origins, Tyndall again affirmed: "In the attraction of gravity, therefore, acting upon non-luminous matter, we have a source of heat more powerful than could be derived from any terrestrial combustion. And were the matter of the universe thrown in cold detached fragments into space, and there abandoned to the mutual gravitation of its own parts, the collision of the fragments would in the end produce the fires of the stars." [39]

Flammarion extended Tyndall's promise of a self-organizing universe into an oscillating eternity of creations and destructions, envisioning in more elaborate detail Tyndall's intimation of the originary force of dark star crashes:

> Long after the death of the earth, of the giant planets and the central luminary, while our old and darkened sun was still speeding through boundless space, with its dead worlds on which terrestrial and planetary life had once engaged in the futile struggle for daily existence, another extinct sun, issuing from the depths of infinity, collided obliquely with it and brought it to rest!
>
> Then in the vast night of space, from the shock of these two mighty bodies was suddenly kindled a stupendous conflagration, and an immense gaseous nebula was formed. . . . [It] began to turn upon itself. And in the zones of condensation of this primordial star-mist, new worlds were born, as heretofore the earth was. . . . And these universes passed away in their turn.[40]

CONCLUSION

A consistent thermodynamic idiom of catastrophic and cataclysmic rhetoric runs from John Tyndall's popular expositions of the early 1860s to Flammarion's compendium of cosmological endgames and H. G. Wells's scientific fables, and from there to broad dissemination in the cosmological imaginary of international modernism. For instance, the "Ithaca" chapter of James Joyce's *Ulysses* (1922) tells of "The appearance of a star (1st magnitude) of exceeding brilliancy dominating by night and day (a new luminous sun generated by the collision and amalgamation in incandescence of two nonluminous exsuns)." [41] And again, in Yevgeny Zamyatin's 1923 essay "On Literature, Revolution, Entropy, and Other Matters," creative thermodynamic catastrophe is updated for application to current sociopolitical upheavals: "Two dead, dark stars collide with an inaudible, deafening crash and light a new star: this is revolution." [42] Joyce's nova and Zamyatin's vision of revolution have their sources in a specific recuperative Victorian moralization of the first law of thermodynamics in direct response to the heat-death scenar-

ios elaborated on the basis of the second law. Spinning out of the cultural allegories constructed on these models of energy, the dark stars that rose over the discourse of classical thermodynamics heralded an explosive historical era driven in its economic and political transformations by phantasmagoric specters of the entropic fates awaiting the world and its inhabitants and by secular scientists' positive promises that new life can always be created out of violent collisions.

In these scientistic images of a cosmos variously doomed to imminent or ultimate energic ruin, the world is subjected to the accidental breakdown or inevitable obsolescence that typically befall the industrial commodity. In anticipation of contemporary responses to periodic energy crises, recuperative scenarios are then concocted by which the world is *recycled* and so salvaged out of its own junk heap. Flammarion counters his own entropic phantasmagorias by projecting an economic wish-image onto the physical universe. In the fullness of eternity, the commodified cosmos is granted the transcendental capacity to maintain itself in perpetually productive circulation. This ultimate guarantee retroactively underwrites the hopeful saga of posthuman evolution toward an apogee of happiness narrated earlier in the text. Walter Benjamin addressed his critique of modernity precisely to such scientistic myths of evolutionary progressivism. "The phantasmagoric understanding of modernity as a chain of events that leads with unbroken, historical continuity to the realization of social utopia, a 'heaven' of class harmony and material abundance" did not represent history's telos; rather, "this conceptual constellation blocked revolutionary consciousness like an astrological force."[43] For Benjamin, the truly malign or baleful influence wrought by the dark stars of classical thermodynamics was the discursive collision of these allegories of cosmic catastrophe with modern society. And yet, that dark astrology marked the beginning of the conceptual transition of thermodynamic ideas from the cycles of mythic history to the self-organizing possibilities of irreversible time.

Energetic Abstraction: Ostwald, Bogdanov, and Russian Post-Revolutionary Art

CHARLOTTE DOUGLAS

I sense energy—not the soul! —*Kazimir Malevich*

Everything reduces to a question of energy—life's future culture.
 —*Kliment Redko*

Thermodynamics and its extensions into energetics as it was presented in the works of Wilhelm Ostwald (1853–1932) and the systems thinking of Alexander Bogdanov (1873–1928) so permeated the art of the Russian avant-garde in the first years after the Revolution that it may be said to form a major underlying paradigm of Russian abstract painting between about 1918 and 1924. Ostwald's and Bogdanov's philosophies of science informed the post-Revolutionary art of the well-known Kazimir Malevich and his followers Ivan Kudriashev and Ivan Kliun; Petrograd's Mikhail Matiushin and his students Boris and Maria Ender; the writings of the historian and theorist Nikolai Punin; the Russian constructivists including Georgii and Vladimir Stenberg, Konstantin Medunetsky, Liubov Popova, and Alexandra Exter; and the constructivist theorists Nikolai Tarabukin and Boris Arvatov. A younger group of abstract painters, who called themselves "The Method" or "Projectionists," were the closest followers of Bogdanov, his most attentive students, and, in the end, the last representatives of abstract painting in Russia for a long time.

Despite the common conceptual link, however, these artists and theorists varied in their approach to making energetic ideas visible on canvas. They spoke of and attempted to represent energy itself, the energy of gases, of electromagnetic forces, and of the cosmic flux. The study of energetic systems, which was a major topic of discussion in Russia during much of the 1920s, led to paintings of graphs and painted diagrams of relationships, and to the presentation of organizational paradigms as works of art. The primary visual element these artists had in common was an avoidance of depicted objects, objects in this view of the world being merely transitory webs or nodules of energy. In major part, this artistic trend was the product of the immediate ideological demands on artists created by the October Revolution, which re-

quired an art based on materialism, science, and analysis, rather than an idealist or essentialist abstraction. The inclination to embrace the ideas of Ostwald and Bogdanov so wholeheartedly had its origins much earlier, however, in the socialist philosophies of the second half of the nineteenth century and their development in modernism early in the twentieth century.

WILHELM OSTWALD

Since the 1860s, the sciences in Russia had been associated with the social democratic movements, as society sought substitutes for the disintegrating verities of church and tsar.[1] No one could have been more suited to these social and philosophical needs than the chemist and energeticist, Wilhelm Ostwald (1853–1932), world-renowned for his founding of physical chemistry as a discipline, and especially for his pioneering work in electrochemistry, his position as cofounder and editor-in-chief of the prestigious journal *Zeitschrift für physikalische Chemie*, and as recipient of the 1909 Nobel Prize in chemistry.

Ostwald was born in Riga, Latvia, and taught at the Riga Polytechnic in the Department of Theoretical Chemistry before his appointment in 1887 to the Chair of Physical Chemistry in Leipzig, where out of nothing he built an internationally prestigious research center. Ostwald's parents were ethnic Germans; his father was a cooper who came to Riga before his birth, his mother was the daughter of a baker whose family came from Moscow. Despite his German descent, however, Ostwald was considered one of Russia's own during his lifetime. Both he and his wife—also a German from Riga—read and spoke Russian. His chemistry text was standard in Russian universities, but he was acclaimed for more than his textbooks. Between 1888 and 1913, Ostwald published some thirty individual titles in Russian; several extremely popular ones were published in a number of other languages as well.

Until around 1885 Ostwald subscribed to the mechanical, atomic, and molecular vision of the world. After that time, he gradually became convinced that those concepts were based on arbitrary hypotheses, and that the same experimental results could be explained entirely in terms of the laws of thermodynamics as they applied to energy and its transformations. By the mid-1890s, Ostwald saw energy as the only reality: "Everything that happens in the world," he maintained, "is nothing but a change in energy."[2] Through his organization, "The Bridge," until his death in 1932, Ostwald advanced a monistic, unitary science, which encompassed not only all of the subdivisions of chemistry and physics, but also biology, psychology, and sociology. Society, he maintained, was bound by an "energetic imperative" to waste as

little energy as possible, and to use its transformations for the benefit of human collectives. Advances in science and technology, he predicted, would lead inevitably to a new and evolved art.

Energy and the laws of conservation and entropy were first principles in Ostwald's elaborations of a *socioenergetics* and *cultural energetics*. In his social philosophy, energy became the basis for monetary exchange, and its economy the moral measure of any action. It also became the standard for a rational ethics and the basis of a universal religion. Undoubtedly because of its mass-energy equivalency, Ostwald admired and enthusiastically supported Einstein's work on special relativity, calling it the most far-reaching new concept since the discovery of the energy principle, and likening it to the work of Copernicus and Darwin.[3] He was the first to propose Einstein for the Nobel Prize, and he repeated his nomination twice more in the twelve years before the prize was actually awarded.[4] In the last thirty years of Ostwald's life he devoted himself to the elaboration of energetics, the methodology and organization of the sciences, metascience, art color theory, internationalism, and pacifism.[5]

ALEXANDER BOGDANOV AND TEKTOLOGY

Ostwald's monism, with its base in the ideas of Ernst Mach and Richard Avenarius, and especially his social energetics, were taken up and expanded upon by the Russian Marxist, Alexander Malinovsky—better known as Alexander Bogdanov. Although Bogdanov was a Marxist and a materialist, he adopted Ostwald's thermodynamic model of the world in which the laws of conservation of energy and entropy provided a common conceptual base for all physical and social processes. Bogdanov also shared Ostwald's interest in a rationalized organization of the sciences, and in the development of a metascience that would unite and subsume the discrete disciplines. Bogdanov, a psychiatrist well-grounded in physics and biology, was a student in the natural sciences department of Moscow University beginning in 1892, and received a medical degree with a specialty in psychology from Kharkov University in 1899. Undoubtedly his medical education first brought him into contact with the work of Ostwald.[6]

Bogdanov was a genuine Marxist, but unlike Lenin, not a believer in Marxism as an eternal and immutable doctrine. After his graduation, he was arrested repeatedly by the tsarist authorities and spent four years in exile in provincial towns, first in Kaluga and then in Vologda.[7] In 1903, when the Russian Social Democrats split into Bolsheviks and Mensheviks, Bogdanov took the part of the Bolsheviks, becoming second only to Lenin in the lead-

ership of the Bolshevik center. When the Bolsheviks split, he led the left faction against Lenin. He continued to be very active in political work until 1910, when he was forced out in continuing disputes with Lenin about Marxism, party discipline, and political tactics. From then on, even after the October Revolution, he refused to rejoin the Bolshevik party.[8]

In 1900, while in exile in Kaluga, Bogdanov met and became close, personally and philosophically, to Anatole Lunacharsky, the future Commissar of Enlightenment. When Bogdanov was moved to Vologda in 1901, Lunacharsky, who was also in exile, requested and received a similar transfer. In Vologda, Lunacharsky moved in with Bogdanov, and in September 1902 (OS) he married Bogdanov's sister, Anna A. Malinovskaia.[9]

Ostwald's all-encompassing energetics persuaded Bogdanov to see the world as a dynamic of interactive processes that operated on physical principles. Bogdanov's three-volume work *Tektologia* (Tektology), the first two volumes of which were published in 1913 and 1917, was a project proposal for developing a general systems science, through a search for structural similarities in the fundamental processes involved in every discipline.[10] A universal science of organization, tektology was built on formal concepts derived from mechanics and thermodynamics, made general enough to be applicable to any subject of investigation, practical or theoretical, regarded as a "system."

Bogdanov's term *organization* had several connotations. He characterized it generally as the "science of building," or architectonics. *Organization* more particularly referred to the structural and functional relationships within defined boundaries, that is, a system; or to the relationship of parts to the whole inside a system. Tektology analyzed static and dynamic relationships of constituent elements, using such conceptually abstract terms as equilibrium, resistance, organization and disorganization, regulation, conjunction, explosion, crisis, egression, and degression. It sought to establish basic laws and organizational mechanisms, and, like mathematics, to "reveal that invariable tendency which is hidden under the visible complexity."[11]

Bogdanov also understood Marxism in these terms, modeling it on a thermodynamic evolutionary paradigm in which there were gradual, even cyclical, transformations of society, rather than the dialectical processes postulated by orthodox Marxism. He analogized the Revolution to a chemical explosion in which the resulting new compounds are not final, but continue to undergo thermodynamic processes. (Needless to say, Lenin strongly disagreed.)[12] Bogdanov is credited not only for being an early originator of the discipline of systems theory, but also an early founder of cybernetics because of the positive and negative interdependencies (i.e., feedback loops) built into his theories.[13]

Tektology, a "general science of organization," was proposed as a universal method of analysis that could be applied effectively in all spheres of knowledge, including the physical and biological sciences, sociology, culture, and economics. Such a uniform approach to diverse material, in Bogdanov's view, would work against the isolation of disciplines and the energetically wasteful multiplication of methods that specialization produced. As a controlling metascience, tektology would inaugurate a cognitive restructuring, unleashing unprecedented creativity in the solution of old problems, and the conceptualizing of new ways to interrogate and view the world. When the sensational success of the eclipse observations in 1919 stimulated renewed interest in Einstein's theories, Bogdanov did not hesitate to cast general relativity in tektological terms.[14]

PROLETKULT: SCIENCE, ART, AND MARXISM

Bogdanov and Ostwald were widely published and quite well known before the Revolution. After that event, however, when artists were charged with the task of developing a new, rational, and demystified art, many looked to Bogdanov and Ostwald for a scientific approach that was explicitly congenial with Marxism.[15] For Bogdanov, culture, including science, was a fundamental organizing principle of society, and inevitably the product of the social system that produced it. Because he believed that a "general cultural hegemony" of the working class was crucial to the success of the political and economic revolutions, work on developing a proletarian culture was to him imperative to sustain the socialist revolution.

Bogdanov's conception of a new proletarian art was expansive, and based on cultural analysis, rather than on political or ideological content. In *Art and the Working Class* (published in 1918),[16] he contended that art is organized independently of any civil task assigned by the artist, and that the content of art is all of life, without thematic limits. Art does not merely *defend* the interests of a class, but rather is necessarily *structured* by its class origins, and it adopts that point of view at a fundamental level. The working class, according to Bogdanov, should not reject the art of the past, but understand it. The proletariat must genuinely possess past culture including an analytical awareness of its underlying assumptions. Bogdanov advocated, therefore, the reexamination of the arts and sciences to reveal its biases and unstated premises, as a step to the development of a new science and art. Ultimately, Bogdanov imagined a cognition that has been substantially liberated from emotional involvement, a more "objective" cognition that would serve in the construction of the new consciousness and hence a new art.

Bogdanov began his efforts to initiate a new proletarian culture before the Revolution, while he was in exile abroad. With Lunacharsky and Maxim Gorky—himself a great admirer of Ostwald—he ran schools for workers, first in 1909 in Capri and the following year in Bologna. Based on this experience, after the February Revolution and a week before the October Revolution in Petrograd, he led the establishment of the Proletarian Culture movement (Proletkult). For the next six years, Proletkult sponsored schools and workshops throughout the country. They taught workers to read, write, make art, and to think about science, principally from Bogdanov's organizational point of view. The students were primarily workers; the faculty often included the pre-Revolutionary literary and artistic avant-garde. Although at first nominally independent, the schools were soon financed from the budget of the Commissariat of Enlightenment (Narkompros), headed by Lunacharsky. Although each Proletkult center was quite autonomous and there was no "official" school program until 1921, when Lenin personally intervened, Bogdanov was actively engaged in the schools, suggesting curricula and explaining and publishing his ideas about the reexamination of science, art, and culture in Proletkult-sponsored books and periodicals. Even after Lenin's denunciations, the Proletkult workshops continued to explore Bogdanov's organizational-tektological approaches to artistic theory and cultural questions; in Moscow this section was led by the constructivist artist and theorist Nikolai Tarabukin.[17]

Immediately after the Revolution the avant-garde and the Proletkult organization had two points in common: Both sought the creation of a new art, and both demanded the separation of art from the state. In its rapid consolidation within the structure of Narkompros, the avant-garde functioned within an organization that also gave Proletkult dependable financial and political support, because it was headed by Bogdanov's old friend and brother-in-law. Together with the avant-garde's hands-on educational work in the Proletkult workshops, this inevitably led to considerable overlapping of interests. It is no wonder that many proletariat schools harbored avant-garde inclinations in art theory and practice.[18] Although neither Lunacharsky's nor Bogdanov's personal taste inclined to futurism or constructivism, both men restrained themselves from advocating any particular style or approach for the new art. And both were too sophisticated to be enamored of a naively superficial social or civil art.

In Petrograd, one of the most articulate expositions of Bogdanov's philosophy was advanced by the critic and theorist Nikolai Punin, who headed the Petrograd Visual Arts Section of Narkompros. His lectures, read to teachers in the summer of 1919, followed Bogdanov's ideas and terminology closely. Punin emphasized machine culture, systems thinking, organization,

efficiency, method, abstract images, and the work of art as a form of human cognition. Following Ostwald and Bogdanov, he predicted an art that was fundamentally altered by technology, and he pointed to sensation as the basis of spatial perception, locating the source of this idea in the energetic ideas of Ostwald and Mach. "The effect of the machine is seen not only in the change of [a person's] psychic complex," Punin told the teachers, "but also in . . . the artist's aspiration to regulate his own artistic, creative forces. The machine has shown him the possibility of working with precision and with the maximum economy of energy; energies must be expended in such a way that they are not dissipated in vain—this is one of the basic laws of contemporaneity which was formulated by Ernst Mach."[19]

In Petrograd, too, the artist Mikhail Matiushin and his students, Maria and Boris Ender, were well aware of Ostwald and his energetics. In her introduction to their 1932 book on color combinations, Maria Ender formulates her discussion as a discourse on Ostwald's color work, but even earlier, the Enders were evidently quite conversant with energetic concepts.[20] In December 1920, Boris Ender painted a semi-abstract rendition of the human body. It is untitled, but contains on its reverse an inscription that reveals its motif—universal energy and its transformations in the forms of life. A painting, he suggests, can depict a planar cross-section of dynamic vital energy:

> Electrical energy
> is not current
> but migrating energy
> a wire will give rise to a magnet
> the property
> of life
> is a more complex migrating
> energy
> which being more complex than a plane is impossible
> to reduce into a plane
> but it is possible to capture its tracks
> on a plane.[21]

His sister Maria describes the whole natural world as an inscription of energy.

> A tree is saturated with solar energy. The branches are arranged along the most intense solar energy, the roots, along the path of the most intense salts of the earth force. The forest reveals the saturation of space in three dimensions; it captures the forces of life. The frost picture on the window is force-currents caught on the plane.
>
> I want to catch direction. The body grows out of the meetings of various movements. There are no boundaries—the connection of things. Things are nodules of various energies.[22]

Malevich "discovered" suprematism in 1915 (figure 3.1). Like a research scientist, he always spoke of this event as a discovery rather than an invention, and he spent the rest of his life trying to explain its meaning. His radical visual conclusion in suprematism was, in fact, arrived at in the course of experimentation with mystical and symbolist ideas, a search for a way to convey in art a higher order of reality.[23] But having arrived at suprematism, Malevich recognized its radical historical character, and, in an attempt to explain the movement's deep significance for art, he repeatedly reinterpreted suprematism as a worldview.

Although there is some evidence that Malevich was aware of Ostwald's energetics shortly before the Revolution, his primary encounter with the ideas of Ostwald and Bogdanov can be dated approximately as late 1918 or early 1919, just at the time when many artists were attempting to understand what a Marxist art might be, what such an art might represent, and how it might be represented.[24] At a Proletkult lecture in 1920 Malevich told his audience, "The new suprematist conclusion leads to new systems, beyond the tangle of objects, to a purely energetic force of motion."[25] Ostwald's energetics offered a way for Malevich to continue his pre-Revolutionary pursuit of the invisible and immaterial, while reinterpreting it to the "reality" of the scientific concept of energy. Its new centrality for suprematism is readily apparent in Malevich's notes for a lecture on suprematism: "The development of primary energy. . . . The dynamism of the form of primary energy. The explosion. The accumulation of elements in a dense energy web as an expression of dynamism. . . . Color as a means of expressing a dynamic geometrism of form. . . . White as the ultimate expression of geometric energy."[26]

During this period, colors for Malevich were indicators of levels of energy, present in the world as motion and a universal force. Like Ostwald, Malevich also developed a socio-energetic interpretation of colors, which he believed were characteristic of particular social groups. So taken was Malevich with a thermodynamic worldview, that when he was asked to suggest a program for the new art school in Vitebsk in late 1919, he divided the faculty into three departments: statics, velocity, and dynamics. In the statics department, where students were to study two years, the subjects have a distinctly Bogdanovian ring: "Statics: Geometricism of form. The composition of contrasting forms. . . . Construction. System. History of the system. System theory."[27] And when he became director of the Museum of Artistic Culture in Petrograd in 1923, he set the study of painted "systems" (i.e., paintings) to be one of its primary aims.[28]

Like Malevich, Liubov Popova first mentions energy in late 1918 or early 1919. "Structure in painting = the sum of the energy of its parts," she wrote in a catalogue statement, but unlike Malevich, who sought to interpret al-

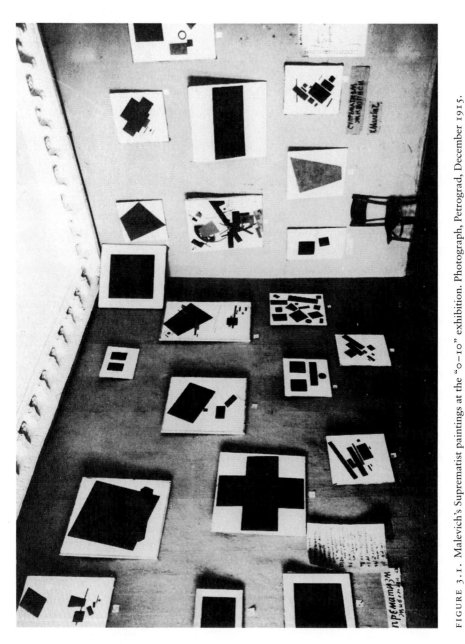

FIGURE 3.1. Malevich's Suprematist paintings at the "0–10" exhibition. Photograph, Petrograd, December 1915.

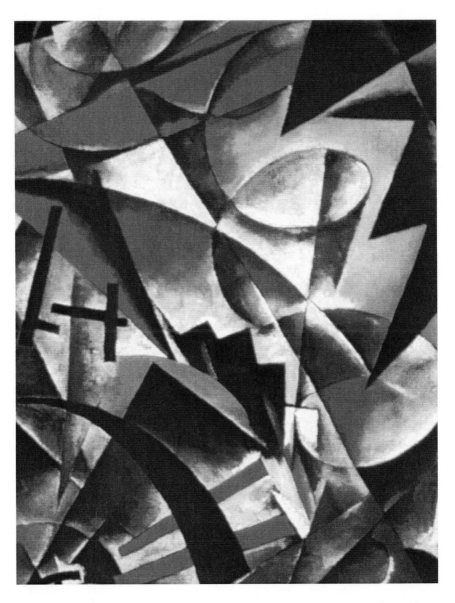

FIGURE 3.2. Liubov Popova, *Painterly Construction*, 1920. Oil on canvas, 62⅝ × 49¼ in. State Tretiakov Gallery, Moscow.

ready existing painting, Popova's interest in energy was directed at her on-going work.[29] The large painting called *Painterly Construction* (1920), over five feet high, is unlike any of Popova's previous work (figure 3.2).[30] This depiction of a deep space in violent motion, with spirals ascending along a diagonal the entire height of the canvas, and arrows and zigzags striking

downward among great rotating colored swaths, is clearly a painting about energy—Popova's image of the energetic world. "Color participates in energetics by its weight," she wrote, and "Energetics = direction of volumes + planes and lines or their traces + all colors." [31]

Bogdanov actively promulgated his ideas about tektology and art. Many artists were familiar with them from his publications and public lectures. He taught in the Social Science Department of Moscow University, lectured at the Russian Academy of Sciences and the Russian Academy of Artistic Sciences, and was the first president of the Soviet Academy of Social Sciences.[32] Directors and artists such as Vsevolod Meyerhold, Sergei Eisenstein, Liubov Popova, Nadezhda Udaltsova, Alexander Rodchenko, Vladimir Tatlin, and Solomon Nikritin all had direct connections with the Proletkult art and theater studios. The young abstract painters Valentin Iustitskii and Boris Rybchenkov headed the Proletkults of Saratov and Smolensk, respectively. Eisenstein promoted a close alliance between Proletkult and LEF (Left Front of the Arts), a Moscow constructivist group led by Osip Brik and Vladimir Mayakovsky. Theorists such as Nikolai Tarabukin and Boris Arvatov, who were instructors at the Moscow Proletkult, depended heavily on Bogdanov for their concepts of proletarian art, collective creativity, and the programmatic re-examination of the structural elements of earlier art.

THE CONSTRUCTIVISTS

These many connections with Proletkult bore the most fruit in the theory and creative work of constructivism. Organized in 1921 in the discussions held at Moscow's Institute of Artistic Culture (INKhUK), the constructivists were a group of artists and theorists including Liubov Popova, Varvara Stepanova, Alexandra Exter, Georgii and Vladimir Stenberg, Alexander Rodchenko, Konstantin Medunetsky, Aleksei Gan, and Nikolai Tarabukin, among others. They created an abstract and material visual idiom that rejected both illusion and subjective or spiritual references. Constructivist artists adopted a visual vocabulary they felt to be scientific or "objective," and expressed an interest in energy, efficiency, and abstract relationships, producing a body of work that was concrete, material, and exemplary of the metastructures of Bogdanov's tektology. "Constructivism is a new science," said the artist Georgii Stenberg: "Constructivism is the means of cultural development of the world, that teaches engineering to be economic, efficient, and social." [33] There is no more succinct expression of constructivism's underlying model than the slogan printed in the *Konstruktivisty* (Constructivists) exhibition catalogue by the Stenbergs and Medunetsky in January

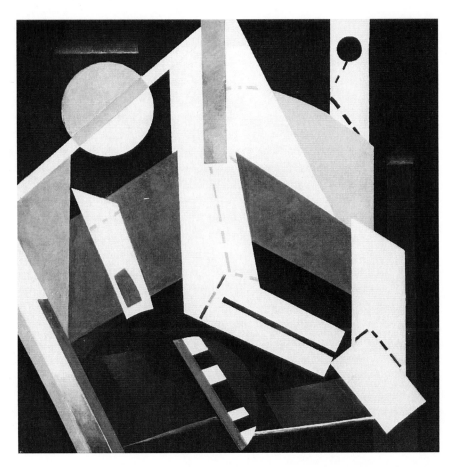

FIGURE 3.3. Alexandra Exter, *Construction*, 1922–23. Oil on canvas, 35¼ × 35¼ in. The Museum of Modern Art, New York, The Riklis Collection of McCrory Corporation (fractional gift), 1983.

1922: "Constructivism will lead humanity to master a maximum of cultural values with the minimum expenditure of energy." [34]

"Here in Russia," Popova wrote, "in connection with the sociopolitical moment in which we are living, the goal of the new synthesis has become *organization* as a principle for any creative activity, including artistic design." [35] Like Bogdanov, she envisioned a distinct and separate discipline that "specially researches the laws of organization of the elements—of different times or of the same time—and the systems of their organization." [36]

In time, Popova and Exter developed an unusual diagrammatic style, where straight and dotted lines seem to indicate a measured and organized motion or process within a rationalized system (figure 3.3). Other constructivists approached subjects related to energy in a different way. Vladimir

Stenberg suggested a kind of magnetic plasma, and Medunetsky depicted an archetypal scientific instrument. Alexander Rodchenko made a series of paintings exploring light as a creator of form.

Several other abstract artists addressed themselves to the issue of light and luminosity. Under the influence of the rocket engineer and philosopher Konstantin Tsiolkovsky, whom he knew personally, Ivan Kudriashev developed a cosmic abstraction that he called space painting. From the mid-1920s Kudriashev was interested particularly in the movement and flashes of luminescence in cosmic space. He represented dynamic forces, giving titles to the works that referred to paths of motion through deep space. Although not associated with thermodynamics directly, Kudriashev made explicit the understanding of abstraction shared by many Russian painters of the time: "Painting in the form that is defined in my work is ceasing to be an abstracted color-form construction, [rather it is] becoming a realistic expression of the contemporary perception of space. . . . Space, volume, density, and light—and materialistic reality—this is something substantially new that today is established by space painting."[37]

In a series of spectacular paintings in 1922, Ivan Kliun also took up the depiction of luminous atmospheric effects (figure 3.4). Kliment Redko, a projectionist, was similarly concerned with the representation of luminosity, conveyed by surface areas of glowing color. To these painters, the depiction of luminous effects endorsed recent scientific explanations of their origin and mechanisms, and emphasized the artists' own embrace of the materialistic worldview. "A painting," Redko wrote, "is an organizer of atmospheric phenomena," and "The northern lights are an indicator of a new scientific basis of luminosity in the energy of light."[38]

But Malevich, who at the time had serious disagreements with Kliun and others, and who always was acutely aware of the mutability of conceptions of the world, commented wryly:

> After many efforts they have managed to disclose and define the cause of the northern lights; in one scientific version it is said that the main cause of this phenomenon is nitrogen, which, present in the higher strata of the atmosphere forms into a crystal shape at low temperature, and refracting solar rays or electricity, gives forth a green light characteristic of the northern lights. . . . Consequently the past definition is refuted, i.e. that the cause of the northern lights is God who, let us say, lowers his beard which exudes light. . . . If the new science of nitrogen, radium and ether considers the cause of many phenomena, it will thereby discover a whole series of those powers which were called God dispersed through all phenomena. There are no grounds to think that, after this later discovery of nitrogen as the cause of the northern lights, a new culprit will not be found in the future. Neither God nor nitrogen, nor X will be respon-

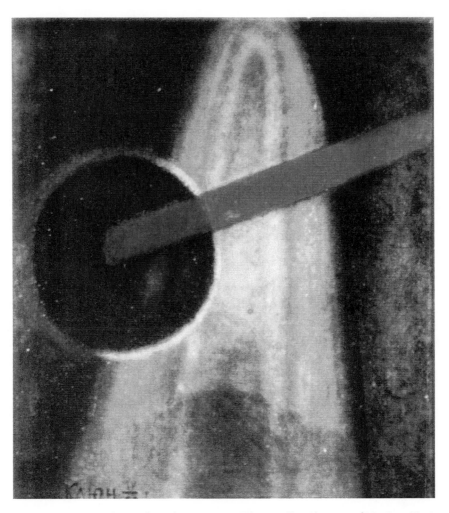

FIGURE 3.4. Ivan Kliun, *Spherical Space*, 1922. Oil on cardboard, 24 × 21⅝ in. State Tretiakov Gallery, Moscow. Gift of George Costakis.

sible. Nitrogen and God will be a misunderstanding on the part of religious science and . . . material science. . . . Today it is God, tomorrow nitrogen, the day after a new X, and all names and X's will form the sum total of misunderstandings.[39]

PROJECTIONISTS AND THE END OF ART

Seeking the path of social relevance with unswerving determination, the constructivists soon concluded that the end of art was at hand and, conse-

quently, the end of the function of artists. By late 1921, many in the group had come to believe that, as a product of the aristocracy and the bourgeoisie, the notion of painting and of art itself was anathema to the new class, and should be abandoned utterly. To them, such ideas made it dubious, even a "swindle," to continue training young people in art, to bring them up to be "stupid and useless in life." The very existence of the VKhUTEMAS art school (Higher State Art and Technical Studies), where several in the group were teaching, was called into question. Such conclusions were not arrived at without pain. In a discussion held at INKhUK in December 1921, Arvatov suggested that creative young people henceforth be sent to polytechnical schools. Georgii Stenberg, in despair, said artists were no longer good for anything, and "should be dealt with the way the Cheka dealt with counterrevolutionaries." Someone else suggested bitterly that, "we need to tell the proletarian masses who are standing on the threshold of culture, that art is just a pack of lies."[40]

The Moscow projectionists were the last great school of Russian abstract painters. Former students at VKhUTEMAS, they rebelled against the "end of art" movement led by their professors. They turned to Bogdanov's teachings, both their exhortation to analyze past art (for example, they measured and studied the composition of old masters) and the principles laid out in *Tektologia*. Their work explored ways to make artistic connections to thermodynamics and energetics, color as vibration and luminescence, and systems theory. Between about 1920 and 1924 they founded and ran a small research division of the Museum of Painterly Culture, which had been all but abandoned by the constructivists. "Everything reduces to the question of energy—life's future culture," wrote Kliment Redko, a member of the group, and he called his paintings "electro-organisms."[41] In notes for a declaration to accompany his entry in a 1922 Russian exhibition in Berlin, Redko alluded to thermodynamic concepts and relativity theory:

> ART TODAY is the worldview of radio substance, out of which arises potential— energy in the variety of its forms. The highest manifestation of matter is light. . . . Art "today" explains anew the concept of "abstract," just as there exists time in and of itself, and cognition leading to its perception. . . .
>
> Because the contemporary known unit of velocity of light has overtaken the entire previously known velocity, artists study the elements that form the new periodic states of electromatter, constructing their works according to the spatial mechanics of two reciprocal forces—compression and expansion, distancing and approach.[42]

Redko painted electrical and atmospheric phenomena and called his works luminism. Mikhail Plaksin and Alexander Tyshler, also members of the group, depicted coalescing structures of glowing gases; Tyshler called this

FIGURE 3.5. Alexander Tyshler, *Color-Form Construction in Red*, 1922. Oil on canvas, 39¾ × 25¾ in. State Tretiakov Gallery, Moscow.

series of works "Organized Coordinates of the Tension of Color" (figure 3.5). Other members of the group included Solomon Nikritin, Sergei Luchishkin, and Nikolai Triaskin.

In their art, the projectionists sought to embody Bogdanov's tektological theories in the most direct way. Solomon Nikritin, who had attended the Moscow Proletkult workshops, wrote in 1924: "All the intellectual work of the masses concentrated in one discipline—in the projectionist expression of organizational classification and methodology—is projectionism realized. The contemporary art of projectionism is tectonics—(the algebra of organizational science)."[43] Nikritin was a leading exponent of tektology in artistic theory. His fervent devotion to an evolutionary Marxism, combined with his knowledge of Bogdanov's theories, led to his belief that art was evolving toward an expression of the true nature of the universe:

> Projectionism is a doctrine postulating the evolutionary character of the "laws" of the world, a doctrine that teaches that "today" nature sets out on the path of evolving toward a concrete realization of universal organization. . . . I call projectionism the single and final doctrine in the sense that in its basic features it expresses the only objective way to a genuine realization of the energy of the world, and hence of the life of each separate human being.
>
> I call this doctrine the last one, in the sense that the interrelation described in it between a person and the world cannot fail to be seen objectively as the final form of interrelationship, given the magnitude of its grasp of the whole.[44]

The exploration of Bogdanov's ideas in art was not limited to Moscow and St. Petersburg. Many groups sponsored by Proletkult in provincial cities experimented with aligning their art with the abstractions of tektology. The work of Valentin Iustitskii, for example, who was the Director of the Proletkult workshop in Saratov, shows the same concerns. His paintings are generalized organizational flow charts that give visibility to paradigmatic processes and to Bogdanov's objectless systems (figure 3.6). By early 1924, the projectionists, too, were concentrating on an art reduced to statistics and general laws, demonstrated through diagrams, plans, and projects. Luchishkin's painting *Coordinates of the Relationship of Painted Masses. Abnormal*, for example, consists of a vertical red oval on a black ground, a work that appears strikingly advanced to us today.[45]

In Russia, a monistic universe based on Ostwald's energetics and elaborated in Bogdanov's search for a universal model of thermodynamic systems provided a real-world analogue for post-Revolutionary abstraction. The organizational order and high level of abstraction formulated in Bogdanov's *Tektologia* lent scientific authority to the artistic structures of constructivism and projectionism. Still, it should be noted that this common conceptual basis did not result in an identifiable style of abstraction. Its representation in

FIGURE 3.6. Valentin Iustitskii, *Painterly Easel Construction*, 1921. Oil on canvas, 29½ × 35 in. State Radishchev Museum, Saratov.

art varied from visual interpretations of invisible currents and fields of energy, to depictions of spatial, atmospheric, and gaseous phenomena, ending logically as painted organizational diagrams of processes, and painted graphs about art. But by 1925, after Lenin's various interventions in Proletkult, after Bogdanov had been repeatedly denounced and briefly imprisoned (in 1923), after the constructivists had abandoned painting completely, the projectionists moved to conventional figurative works, and the Russian avant-garde movement came abruptly to an end.

It was no accident that the development of an energetic metatheory of abstract relationships occurred at a time and in a society that aspired to epochal industrial revolution. Russian post-Revolutionary modernism was grounded in materialism and a social concern that looked forward to industrialization and machine culture, and which, in turn, facilitated a formal and abstract vision. Bogdanov repeatedly maintained that there was no such thing as absolute knowledge or eternal truths, and he chastised the "old science" for its

inclination in this direction, as he did Lenin for his rigid vision of Marxism, and his doctrinaire Bolshevism.[46] And yet, because they could be applied to concrete models in such diverse spheres of knowledge, Bogdanov did think that the physical laws of energy and the concepts derived from them would hold true, at least for the foreseeable future, and that they could be utilized and maximized for the benefit of humankind.

For artists and art theoreticians, the energetics that elaborated the laws of thermodynamics provided a vision and a methodology that formed the paradigm for the new art, and that promised change and advance. The avant-garde of the new era set out to make works of art that suggested the material and structure of the unified energetic world. At times they succumbed to the hope that such an art would prove universal and inevitable, emerging out of natural principles with the relentlessness of mathematical laws. As Punin expressed it in 1919, these artists were trying to "find those methods of work which would allow them to create artistic forms, independent of personal influence, objective, more or less stable, and more or less obligatory for all humanity."[47] For a few years, energetics seemed to make possible just such an "objective" art.

ETHER AND ELECTROMAGNETISM:

CAPTURING THE INVISIBLE

INTRODUCTION

Part 2 focuses on another major event in early energy discourse, the convergence of electricity and magnetism in electromagnetism and the rise of modern field theory out of the late-classical attempts to grasp the matrix of all visibility, the luminiferous ether. The ether hypothesis presented science with a paradoxical object—an entity demanded by the assumption of material continuity in the classical mechanistic program, and yet entirely absconded from all objective measures of empirical detection. A virtual object occupying a medial position halfway between nature and culture and circulating in various conceptual forms among several generations of investigators, the discourse of the ether called modern field theory into existence.

In "Lines of Force, Swirls of Ether," Bruce J. Hunt surveys the last decades of ether research in England at the end of the nineteenth century. The ether had pervaded the thinking of British physicists, yet it resisted their efforts to represent its workings in a full and consistent way. In Michael Faraday's systems of lines of force, and later in the sets of equations devised by James Clerk Maxwell and refined by Oliver Heaviside, the line between the field and its representations was crossed and in a sense erased. Set against the story of the failed attempts to devise a likeness of the ether, Hunt shows how the success of field theory raises important questions about the fundamental nature of representations in modern science.

The ether ultimately faded out of the descriptive and explanatory regimes of modern physics, only to take up a series of new locations in metaphysical speculation and aesthetic production. In the early twentieth century, the ether remained as a cultural artifact richly embedded with scientific associations. In Ian F. A. Bell's "The Real and the Ethereal: Modernist Energies in Eliot and Pound," the interpretive tact and figurative tactics of the ether researchers are precisely what the Anglo-American literary modernists appre-

ciated in turn-of-the-century discourses of science. By eliciting the poem's oblique evocation of the universal ether medium in the famous simile of an atmospheric evening "spread out against the sky / Like a patient etherized upon a table," Bell offers an original recuperation of Eliot's modernist icon J. Alfred Prufrock—a figure usually seen to convey a sense of indecision and anaesthetic paralysis before the overwhelming complexities of modern life. Marking Eliot's canny metonymy of sky and spirits of ether, Bell reads in these lines a subtler sense of Prufrock's "provisory" strategies. That is, Eliot's character exhibits a scientifically informed awareness that his attempts to seize the significance of events are interpretive hypotheses akin to those forwarded by physicists offering analogical descriptions rather than definitive explanations of imponderable phenomena.

The increasingly anti-mechanistic complexion of energy physics and field theories enabled the London modernists, as a defining mark of their own modernity, to integrate scientific rhetoric with poetic discourse. Linda Henderson's "Vibratory Modernism: Boccioni, Kupka, and the Ether of Space" demonstrates a similarly avid and productive reception of energy physics among modern artists. Altered conceptions of space and matter in the early years of the century were instrumental in the visionary refashionings of modernist art. Both the X-ray and wireless telegraphy appeared to give scientific validation to earlier occult images of universal space as filled with waves vibrating in an ether medium. At the same time, the discovery of the electron in 1897 and of radioactivity in 1898 evoked a dematerializing matter endlessly emitting particles into the surrounding ether, which served as a conceptual bridge in this newly fluid relation of space and matter.[1]

Donald Benson has pointed up the status of the ether as what we might call a factual fiction, and a similar term could be used to describe the attempts of early twentieth-century artists and poets to represent the spatial characteristics or energetic effects of the invisible ether.[2] Bell contends that in the face of invisible, ineffable realities, and paralleling trends in contemporary scientific discourses, modern poets created the "art-object as hypothesis, as something we speculate with and through, as an instrument not for confirmation but for alterability." The same might be said of the attempts of cubist and futurist artists, such as Umberto Boccioni, to give visual form to dematerializing matter and space as a wave-filled ethereal medium. Boccioni's works, along with Kupka's invention of thought patterns meant to be projected from mind to mind, on the model of wireless telegraphy, were all self-conscious fictions, imaginative attempts to "capture the invisible." If painters in this era cited contemporary science to give their art a scientistic air of "fact," they were also supported, thanks to the X-ray, by the newly current image of the artist as a visionary seer with heightened perceptual capabilities.

For the broad public through World War I at least, the ether grounded the new, invisible realities of radiant energies and their suggestion of continuity between space and matter—a view supported as well by Henri Bergson's philosophy of flux. William Everdell's recent argument that discontinuity is a basic characteristic of modernism overlooks this key aspect of early twentieth-century thought in favor of a description more accurate for modernism's later configuration.[3] Only with the popularization of quantum theory (as well as Jean Perrin's work on Brownian Motion, which established empirically the existence of the atom), would a view of reality as discontinuous replace the dominant belief of ethereal continuity. Boccioni's *Unique Forms of Continuity in Space* is a vivid testament to continuity as embodied in the fiction of the ether, which, although displaced for scientists by Einstein's special theory of relativity after 1905, continued to play a key role in popular conceptions of reality for several decades.[4] The spatiotemporal and atomic discontinuities of post-classical physics have tended to obscure the cultural continuity of the ether as a discursive matrix of empirical and mythopoetic explanation.

Lines of Force, Swirls of Ether

BRUCE J. HUNT

In March 1914, the Irish physicist John Joly wrote to tell Joseph Larmor, the Lucasian professor of mathematics at Cambridge, that Trinity College Dublin was finally preparing to strike a medal in honor of their mutual friend, George Francis FitzGerald, who had died thirteen years before at the age of forty-nine. The FitzGerald medal was (and is) awarded each year, along with a scholarship, to an outstanding physics student at Trinity. FitzGerald's likeness was to appear on the front; but what, Joly asked, should be put on the back? "His work was largely in the Aether," Joly mused to Larmor, "but this medium—however useful—does not lend itself to pictorial treatment." There seemed to be no way to put a picture of the ether itself on the medal, and FitzGerald's "model of the Aether," Joly said, "would—I suppose—hardly do?" [1] Perhaps, he asked, they might instead use an equation from one of FitzGerald's papers on electromagnetic theory? In the end, the back of the medal was left blank. The ether had once again eluded "pictorial treatment."

By the time Joly wrote his letter, the ether was on the verge of being banished from science and from nature, but only after a long and distinguished run. [2] It rose to particular prominence toward the end of the nineteenth century, when enthusiastic physicists hoped the ether would provide the key to "a theory of everything," and that by laying bare its hidden mechanical substructure they would be able to explain and literally link together everything in the universe. In what follows, I take a brief look at this ethereal medium and at some of the attempts that were made, despite all obstacles, to treat it pictorially. I also touch on physicists' efforts to represent the electromagnetic field, a close relative to the ether and the eventual successor to most of its functions. Finally, I use my examination of the ether and the field to raise some broader questions about the status and function of representation in science.

Ideas about an ethereal medium filling all space can be traced back to ancient times, but they took on a more mechanical form in the seventeenth century, when René Descartes made such an ether the foundation of his new view of the physical world. The planets, he said, were carried around the sun by enormous ethereal vortices, and light itself was a pressure or "tendency

to motion" in this space-filling ether. According to Descartes, magnetic forces arose from the flow of tiny screw-shaped particles through the same subtle medium.

In the eighteenth century, in the face of the Newtonian emphasis on forces acting across empty space, ethereal theories faded somewhat, but they made a comeback early in the nineteenth century with the advent of the wave theory of light, particularly through the work of the French physicist Augustin-Jean Fresnel. If, as abundant experimental evidence indicated, light indeed consisted of waves, then these waves had to be *in* something. So the ether was resurrected and generally pictured as a very thin elastic solid or "jelly" stretching across interstellar space. But while elastic-solid theories were able to explain much about the behavior of light, they raised some serious puzzles. In particular, how could such a jelly be both rigid enough to transmit the rapid vibrations of light and fluid enough for ordinary matter (indeed, whole planets) to move through it seemingly without resistance? This sort of puzzle— the need for it to do two or more seemingly contradictory things at once— would always bedevil theories of the ether.

Such problems were in some ways eased, and in others exacerbated, when physicists began to look to the ether to account not only for the phenomena of light, but for those of electricity and magnetism as well. Beginning in the 1830s, the English experimenter and electrical theorist Michael Faraday had begun to treat electric and magnetic forces as the products not of direct actions at a distance, but of the pushing and tugging of "lines of force" stretching across space—the sort of curved lines revealed when one sprinkled iron filings around a bar magnet. Faraday generally contented himself with observing and recording these lines of force directly (he gave elaborate instructions on how to "fix" a pattern of filings on a page and so produce a permanent record) rather than trying to reduce them to mathematical laws, but others soon did so, and produced beautiful sets of curves depicting results calculated from theory (figure 4.1).

Faraday also shied away from attempting to ground his lines of force in the actions of a mechanical ether, but other scientists who were attracted to his "field" approach, particularly the Scotsmen William Thomson (later Lord Kelvin) and James Clerk Maxwell, soon took this step. They came to look upon the space around magnets, charges, and currents not as empty, but as filled with activity and energy—and energy, they believed, could subsist only in the motion and strain of a material medium (figure 4.2). By the late 1850s and early 1860s Thomson and Maxwell had worked out theories that, at least tentatively, treated the electromagnetic field as the product of the structure and motions of an underlying mechanical ether. The most important of these theories was one Maxwell published in installments in 1861–62 under

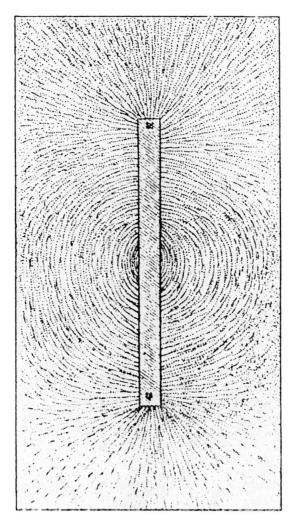

FIGURE 4.1. Faraday's lines of magnetic force. Source: Michael Faraday, *Experimental Researches in Electricity*, 3 vols. (London, 1839–55), vol. 3, plate IV, fig. 3. Michael Faraday's many experiments with currents and magnets led him to regard space not as empty and inert, but as filled with force and activity. He pictured currents, magnets, and charges as surrounded by lines of force, curving across space in patterns like those revealed when iron filings are sprinkled around a bar magnet, as shown here. This conception eventually led to his theory of the electromagnetic field.

FIGURE 4.2. Maxwell's lines of magnetic force. Source: James Clerk Maxwell, *Treatise on Electricity and Magnetism*, 2 vols. (Oxford, 1873), vol. 2, fig. xvii. This particular depiction, one of many, shows the lines of magnetic force in a uniform field disturbed by an electric current in a wire running perpendicular to the plane of the paper.

the title "On Physical Lines of Force."[3] Here he laid out his influential "vortex and idle wheel" model of the ether, in which the spinning of tiny vortices in the ether represented a magnetic field, and the motion of even smaller "idle wheel" particles represented an electric current (figure 4.3).

The status of Maxwell's vortex model has long been a matter of controversy among historians and philosophers of physics, some maintaining that it was nothing more than a fanciful heuristic device, never meant to be taken

FIGURE 4.3. Maxwell's vortex ether model. Source: James Clerk Maxwell, "On Physical Lines of Force," *Philosophical Magazine* (1862), plate 1. In this illustration, Maxwell pictures the ether as filled with tiny elastic vortex cells separated by layers of even smaller particles, the latter acting as "idle wheels" to transfer rotational motion from one vortex to the next. The spinning of the vortices (shown by the curved arrows in the diagram) corresponded to a magnetic field, and the translational motion of the idle-wheel particles corresponded to an electric current (from A to B in the diagram). Elastic strain in the vortex cells corresponded to an electric field, and Maxwell showed that any change in this strain would shift the position of the idle wheel particles and so produce what amounted to a transitory electric current—the "displacement current" that soon became the keystone of his theory. Maxwell also found that his vortex ether would propagate waves at a speed just equal to that of light, thus pointing toward his revolutionary conclusion that light itself was electromagnetic waves.

seriously, others arguing that Maxwell regarded at least some parts of his model as realistic representations of the electromagnetic ether. The best evidence points toward the latter conclusion. Maxwell seems to have thought that a magnetic field really does contain spinning vortices of some kind, though he did not think they were really linked together by anything as contrived as his hypothetical idle wheel particles.[4] Maxwell believed that his model had captured some aspects of the real structure of the ether, but not quite the whole thing. In any case, his model led him to two important

FIGURE 4.4. FitzGerald's wheel-and-band ether model (unstrained). Source: diagram by the author. FitzGerald's 1885 model pictured the electromagnetic ether as an array of wheels set on vertical axles and connected to their neighbors by rubber bands running around their rims. The spinning of the wheels represented a magnetic field, while the stretching or loosening of the bands that resulted from unequal rotation of the wheels represented an electric field. The model is shown here in its unstrained state, with the wheels either stationary or all spinning at the same rate. The bands are thus neither stretched nor loosened, and the model represents a region in which there is no electric field and the magnetic field is either zero or constant.

theoretical results: (1) the expectation that changing electric fields will give rise to "displacement currents," even in space devoid of ordinary matter, and (2) the striking hypothesis that light itself consists of waves in the electromagnetic ether.

Maxwell died in 1879 at the age of forty-eight, before many of his ideas had gained wide acceptance, and his work was carried on, refined, and extended by a group of younger physicists.[5] These "Maxwellians," most of them British, soon began to devise ether models of their own. One of the best was the "wheel-and-band" model FitzGerald devised in January 1885, the one Joly would mention years later when discussing what to put on the FitzGerald medal. Most Victorian ether models, including Maxwell's, existed only on paper, but FitzGerald built an actual working version of his—"rather pretty," he later said, "on a mahogany board with bright brass wheels."[6] The wheels, set on vertical axles and arranged in a grid, were connected together by rubber bands running around their rims. Sadly, the whole array was apparently

FIGURE 4.5. FitzGerald's wheel-and-band ether model (strained). Source: diagram by the author. FitzGerald's wheel and band model could be used to depict a wide range of electrical phenomena. Removing the bands from a region made it correspond to a perfect conductor, and turning the wheels adjoining such a region corresponded to applying an electromotive force, as with a battery. Here such a force, shown by the arrow, has been applied along a channel connecting two conducting plates, thus giving them the opposite charges shown. Neighboring wheels are turned by the differing amounts, and the connecting bands are thus tightened on one side (shown by the narrow lines) and loosened on the other (shown by the hatched lines). Because the strained bands will try to turn the wheels back to their original positions, the charges on the plates will persist only as long as the electromotive force is kept up.

tossed out in the 1970s during a housecleaning at the Trinity College Dublin Physics Department.

FitzGerald devised his model to help illustrate J. H. Poynting's 1884 discovery that, on Maxwell's theory, energy flows through the field along paths perpendicular to the lines of both electric and magnetic force. Poynting's theorem had several striking consequences. Perhaps the most surprising was that the energy conveyed by an electric current does not flow along within the conducting wire, as everyone had always assumed, but instead travels through the seemingly empty space outside it—that is, through the ether. The wire thus acted not as a pipeline for electrical energy, but merely as a sort of guiding thread. In FitzGerald's model, the spinning of the wheels represented the strength of the magnetic field and the strain of the rubber bands that of the electric field (figures 4.4 and 4.5). By tracing how energy sloshed

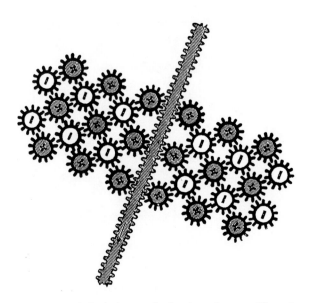

FIGURE 4.6. Lodge's cogwheel ether. Source: Oliver J. Lodge, *Modern Views of Electricity* (London, 1889), p. 187. This cogwheel model depicts the ether as an array of tiny wheels geared directly together. When an electric current, shown here as a straight rack, is started up, it first has to set in motion all of the magnetic vortices geared to it. Moreover, any change in the current has to work against the momentum of the whirling machinery in the surrounding ether. Lodge's model provided a vivid mechanical analogue to the electromagnetic phenomenon of self-induction.

back and forth between the spinning of the wheels and the stretching of the bands, FitzGerald was able to use his model to depict a wide range of electrical and magnetic phenomena in a vivid and generally consistent way.

FitzGerald's friend and fellow Maxwellian, the Liverpool physicist Oliver J. Lodge, was also an ardent deviser of mechanical models. In his popular and influential book, *Modern Views of Electricity* (1889), Lodge laid out a number of hydraulic and mechanical analogues of electric circuits, in which the flow of water or the strain in a cord represented an electric current or charge.[7] He also described in great detail the workings of his own model of the ether, which he had devised in the mid-1880s. Like Maxwell and FitzGerald, Lodge treated a magnetic field as an array of spinning ethereal vortices, but instead of linking their motions together with idle wheels or rubber bands, he pictured them as geared directly to one another like tiny cogs (figure 4.6). Lodge's model was remarkably vivid, and once a reader had grasped its workings, he or she could almost feel the machinery in the

surrounding ether being cranked into motion when an electric current was started up.

Although this intensely mechanical style of physics had a substantial following in the late nineteenth century, it did not appeal to everyone. The robust industrial character of Lodge's cogwheel ether irritated a number of critics. On encountering Lodge's *Modern Views*, the French physicist and philosopher Pierre Duhem wrote:

> Here is a book intended to expound the modern theories of electricity and to expound a new theory. In it there are nothing but strings which move around pulleys, which roll around drums, which go through pearl beads, which carry weights; and tubes which pump water while others swell and contract; toothed wheels which are geared to one another and engage hooks. We thought we were entering the tranquil and neatly ordered abode of reason, but we find ourselves in a factory.[8]

The industrial flavor of Lodge's model clearly reflected the late Victorian setting in which it was produced; in some sense, Lodge really did take his readers into a factory. But while Lodge, like FitzGerald, clearly enjoyed the mechanical engineering aspects of devising such models, neither man imagined for a moment that the ether really consisted of brass wheels connected by rubber bands, or of tiny cogwheels spinning in space. FitzGerald gave particularly careful thought to this issue and drew an important distinction between what he called *analogies* and *likenesses*: his wheel-and-band model (figure 4.7), and Lodge's cogwheels, were meant as *analogies* to the ether, not *likenesses* of it; such models reflected a similitude of relations, not of things themselves. "I do not in the least intend to convey the impression," FitzGerald wrote in one of his first published accounts of his model, "that the actual structure of the ether is a bit like what I have described"; if the ether could somehow be examined under great magnification, he said, we would certainly not spy an array of tiny brass wheels and rubber bands.[9] The spinning of the wheels was related to the strain in the rubber bands in the same way that the strength of the magnetic field was related to that of the electric field, but magnetic fields were not otherwise at all *like* grids of spinning brass wheels.

Analogous models such as FitzGerald's and Lodge's were very useful for teaching purposes, and could also be used as research tools. FitzGerald in particular often analyzed electromagnetic problems by seeing how they worked out on his wheel model, an approach that led him to some important theoretical insights concerning the propagation of potentials. But the Maxwellians also sought to devise genuine *likenesses* of the ether intended to reflect its actual structure and motions. The most important of these proposed likenesses of the ether was the vortex sponge theory that FitzGerald devised early

FIGURE 4.7. FitzGerald's sketch of his wheel-and-band model. Source: Notebook 10376, p.15, G. F. FitzGerald Collection, Trinity College Library, Dublin. FitzGerald often sketched arrays of wheels and bands in his research notebooks, especially in the late 1880s, and used them to analyze the propagation of forces and potentials. Translating back and forth between the field equations and his model allowed him to clarify important points, particularly concerning the vector potential. FitzGerald made the sketch shown here during a controversy over the supposed instantaneous propagation of Maxwell's potentials, something FitzGerald regarded as impossible, since there could be no instantaneous propagation of anything in his wheel model.

in 1885, at almost exactly the same time that he was inventing his wheel-and-band model.[10] FitzGerald pictured the ether as a perfect liquid in energetic and very fine-grained turbulent motion, forming a tangle of spinning vortex filaments. This vortical motion could store substantial amounts of energy, and its rotational momentum gave the fluid medium a degree of kinetic elasticity and cohesion that would, FitzGerald thought, enable it to transmit waves and exert stresses much like—perhaps exactly like—those in the electromagnetic field. FitzGerald felt sure that, with the vortex sponge, he was on the right track; he said later that he had a "feeling in [his] bones" that the properties of the ether would be found to result from the random motions of an underlying perfect liquid, just as the kinetic theory of gases had shown that the properties of gases arose from the random motions of their constituent molecules.[11]

Indeed, FitzGerald became convinced that *everything*, including matter itself, could ultimately be resolved into motion, and that, as he declared in

FIGURE 4.8. Lodge's electric and magnetic whirls. Source: Oliver J. Lodge, *Modern Views of Electricity* (London, 1889), p. 171. This illustration shows (A) a line of magnetic force surrounded by a hypothetical electrical whirl in the ether, and (B) a segment of electric current encircled by one of its lines of magnetic force, which is in turn surrounded by an electrical whirl, "each magnetic line of force round a current being an electric vortex ring." In this way, Lodge both illustrated the relationship between electric and magnetic lines of force as postulated in Maxwell's field theory, and suggested how these lines of force might ultimately result from vortex motions in the ether.

1890, "ether, matter, gold, air, wood, brains are but different motions." [12] His confidence in the vortex sponge never wavered, and even after FitzGerald's death, Lodge and many others continued to have faith that it constituted at least the first glimmerings of a true likeness of the ether. Indeed, from the 1880s until his own death in 1940, Lodge declared repeatedly that the ether would almost certainly be found to be a perfect liquid "squirming internally with the velocity of light" and that detectable electric and magnetic fields resulted from partial alignments of this squirming motion (figure 4.8). [13]

However strong the feeling in FitzGerald's bones, neither he nor anyone else ever managed to surmount the formidable mathematical obstacles facing any attempt to show that a vortex sponge could really account for electric, magnetic, and other phenomena. When the governing equations were examined more closely, the tangle of vortices was found to be unstable, its mo-

tions dissipating themselves into more and more finely grained turbulence. In the end, the vortex sponge seemed to serve mainly as a mechanism for soaking up the time and energies of FitzGerald and other late Victorian mathematical physicists.

But while efforts to devise a consistent mechanical likeness of the ether seemed to be swirling into a dead end, work on the electromagnetic field and its mathematical representation was advancing rapidly. Physicists might not be able with assurance to say much about the structure and motions of the ether that supposedly underlay electric and magnetic forces, but they could say a lot about how those forces were related to each other and to the changing distribution of energy within the field. However hard it might be to devise a full and realistic model of the ether itself, a knowledge of the lines of force and of the equations that described their shape, motion, and associated energies could be extremely useful in itself.

Oliver Heaviside, another of the British Maxwellians and one with a particularly practical bent, observed to FitzGerald in 1893 that in tackling many electromagnetic problems he found it "easier to follow the behaviour of tubes of displacement and induction [i.e., lines of electric and magnetic force] than the corresponding quantities in a model." [14] Or as Heaviside put it more forcefully to the German physicist Heinrich Hertz, "My experience of so-called 'models' is that they are harder to understand than the equations of motion!" [15] Rather than constructing mechanical models, Heaviside preferred to devise electromagnetic equations—though equations of a particular kind. In some of his writings, Maxwell had made use of *quaternions,* mathematical quantities (first devised by the Irish mathematician William Rowan Hamilton in 1843) that can be used to specify both magnitude and direction in space. By using quaternions and their associated differential operations, Maxwell was able to represent the relationships between electric and magnetic quantities in a compact, vivid, and spatially concrete way (figure 4.9).

Heaviside refined and simplified Maxwell's quaternion methods into a vector algebra tailored to fit electromagnetic requirements. His versions of the "div" and "curl" operators provided a visualizable mathematical machinery that enabled him to clarify greatly the relationship between electric and magnetic forces. Guided by his analysis of how energy flows through the field, in 1885 Heaviside used his new mathematical tools to recast the long list of electrical and magnetic relations Maxwell had given in his *Treatise* into a compact set of four vector equations—the set known ever since as *Maxwell's equations.* In free space, away from any charges or currents, these equations take on a particularly simple and symmetrical form:

$$\text{div } \epsilon E = 0 \qquad \text{curl } H = \epsilon \, \partial E / \partial t$$
$$\text{div } \mu H = 0 \qquad -\text{curl } E = \mu \, \partial H / \partial t$$

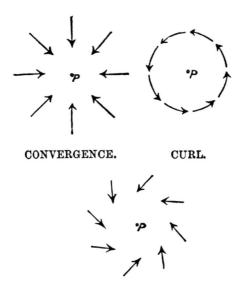

CONVERGENCE. CURL.

CONVERGENCE AND CURL.

FIGURE 4.9. Maxwell's illustrations of the quaternionic operations "convergence," representing the concentration of a field quantity around a point, and "curl," representing its rotation. Source: James Clerk Maxwell, "On the Mathematical Classification of Physical Quantities," *Proceedings of the London Mathematical Society* (1871), 232. A single quaternion could express both the magnitude of a physical quantity, such as a force or velocity, and its direction in space, and so provided a far more compact and physically meaningful way to represent the complex spatial relationships of field theory than did the separate Cartesian coordinates traditionally used. (When Oliver Heaviside and others later simplified quaternions to produce modern vector notation, a change in sign conventions converted Maxwell's "convergence" into the now more familiar "divergence.")

Here E and H stand for the electric and magnetic intensities, respectively, while ϵ and μ are associated field constants.

Heaviside's new set of Maxwell's equations provided a direct and apparently complete mathematical representation of the electromagnetic field. Their structure reflected another observation of Duhem's: British physicists (unlike their French and German counterparts) used equations not just as a series of syllogisms to lead from one ascertainable fact to another, but as a

model meant to depict each step of a physical process, including parts that might be hidden from us.[16] In Heaviside's equations, one could almost see the lines of force diverging from an electric charge or curling around a loop of current, or the tubes of energy bending through space before converging on a wire. In the form Heaviside had given them, Maxwell's equations constituted a sort of symbolic model of the electromagnetic field—a model in which carefully constructed mathematical quantities and operations served to mimic the workings of nature.

Although this trend toward the purely mathematical modeling of the electromagnetic field proved very useful, particularly in the development of wireless telegraphy and other new technologies, not everyone was happy with it. With Heaviside's vector formulation of Maxwell's electromagnetic theory very much in mind, William Thomson (Lord Kelvin) complained in 1896 that it was "mere nihilism, having no part or lot in Natural Philosophy, to be contented with two formulas for energy, electromagnetic and electrostatic, and to be happy with a vector and delighted with a page of symmetrical formulas."[17] He did not object so much to the equations themselves, he said, as to the fact that some people seemed to be *satisfied* with them, and willing to give up the search for a deeper physical reality. A few years later Kelvin went further, denouncing what he called "a most rude recrudescence of neo-pantheism, neo-Berkeleyanism, neo-vitalism, and neo-nihilism, which had grown up in the last ten years of the nineteenth century, and grown up in a manner singularly inconsistent with the bright and clear teaching of realities and faith in realities with which the century commenced, and with which the century had in the main been conducted."[18] The underlying physical realities were atoms and the ether, Kelvin said, and no neo-nihilist was going to convince him otherwise.

Science perhaps never slid as far into neo-pantheism and neo-nihilism as Kelvin feared, and many physicists (and others) retained their confidence in the ether well into the 1920s and 1930s. Indeed, as late as 1933, when Oliver Lodge came to publish what he rather grandly called *My Philosophy*, he gave it a revealing subtitle: *Representing My Views on the Many Functions of the Ether of Space*.[19] Nonetheless, younger physicists' attitudes toward the ether were definitely beginning to shift in the first decades of the twentieth century, in a way that centered on what Kelvin had called the "teaching of realities" and, in his striking phrase, "*faith* in realities" (my italics). What were the realities, and what were their proper representations? Which was more real, the ether or the field? The vortex sponge or a set of vector equations?

Reflecting years later on his own experience as a young physicist at the time, Albert Einstein remarked that "One got used to operating with these

fields as independent substances without finding it necessary to give oneself an account of their mechanical nature." [20] One could visualize the fields and follow their workings mathematically without worrying about their supposed mechanical substratum. The ether began to evaporate as physicists ceased to think there had to be anything behind or beneath their electromagnetic fields and equations. As so often happens, what had begun as an attempt to represent aspects of an underlying reality had gradually come to be accepted as constituting the reality itself.

The Real and the Ethereal: Modernist Energies in Eliot and Pound

IAN F. A. BELL

To begin with one of the most famous beginnings in modernist literature—
T. S. Eliot's "The Love Song of J. Alfred Prufrock":

> Let us go then, you and I,
> When the evening is spread out against the sky
> Like a patient etherized upon a table. . . .

It is a shocking beginning in various ways. An initial proposal of a gentle,
companionable journey is arrested sharply by the discordance of its simile's
qualifying description, "Like a patient etherized upon a table." The com-
mentaries, generally, have tended to sanitize this discordance either by in-
voking literary history (taking us back to French symbolism, to Laforgue's
delight in anti-poetic vocabulary and alarming combinations of images) or
by accounting for the simile in terms of Prufrock's psychology (where the im-
age projects the speaker's self-protecting desire for anaesthesia rather than
reflecting the landscape). Such accommodations not only diminish the shock
but obviate the double function of its strategy. The first is to alert us to the
extent that the simile deliberately refuses its principal function, which is to
create a picture. The discordance between the terms of the simile neither al-
lows us a fresh visualization of the evening sky nor permits its awkwardness
a quasi-cubist or quasi-symbolist questioning. Second, it offers a warning
about the machinery of literary style: The patient is "etherized," not "anaes-
thetized," upon the table—an instance of striking lexical incest where ether
as a medium of space replicates the sky it is designed to qualify. The poem
insists upon the self-consciousness of this strategy by placing the fulcrum of
the simile, "Like," at the very beginning of the simile's second half (a mere
five lines later, we find, for comparison, a more conventional use of the trope
in "Streets that follow like a tedious argument / Of insidious intent"), where
the line is broken to place the centrality of the fulcrum with mathematical pre-
cision and where we are given a Donne-like gritty visual sinuousness. This
self-consciousness thrusts the technique of the simile upon us; foreground-
ing analogical mechanics as the mechanics of analogy and emphasizing the

work of literary procedure. As we shall see, such foregrounding, in company with its artisanal emphasis, belong to shifts in the ways in which scientific discourse begins to advertise itself toward the end of the nineteenth century.

There is a good argument for claiming that Eliot's poem inaugurates the modernism of Anglo-American letters. And it matters that the shock tactics of its beginning problematically incorporate the ether, a term that draws its resonance from the liberationist discourse of scientific thought at the century's turn. If the poem's ether displays language's feeding upon itself as a form of closure, it does so on behalf of a self-interrogation and critique as a form of openness. The poem's other beginning is the epigraph it takes from Dante's *Inferno*, where Guido de Montefeltro is asked by Dante to tell his story. Guido assumes that because Dante is in Hell, the story will not be repeated in the world of the living, and so he feels able to offer narrative disclosure. To tell a story that cannot be repeated is to tell a secret, to maintain a remove from the real, the actual, the visible—in short, to sustain the invisible and the ineffable. It is this complex of disclosure and secrecy, of openness and closure, which orchestrates the poem's subject—Prufrock's efforts to seek shape through telling his own story, or, rather, the struggle and the process of those efforts as he attempts and discards varying styles, types, allusions, and forms as means of allowing his figure to emerge out of and against a concrete world whose office is to "fix you in a formulated phrase." In other words, the subject of the poem is hypothesis itself. That Prufrock finally fails in the world of the living (the world of determinist biology and its classifications, which "fix" by means of a pre-established vocabulary) is itself a gesture toward the sciences of the ineffable—the new languages for questioning the solid materiality of three-dimensional Euclidean geometry and Newtonian mechanics through the more dispersive notions of the fourth dimension and relativity, the languages of the ether, electromagnetism, X-rays, and wireless telegraphy. These are explorations into those forms of the "real" that may be but conjectured and suggested rather than affirmed, "formulated," within the fictions of decisive measurement and tangible objects.

So the beginning of Eliot's poem at the beginning of Anglo-American modernist poetry provides a striking figure for some of the negotiations between aesthetic and scientific practices during the new era. Each is orchestrated by a nexus of equations between silence and speech, the living and the dead, the immaterial and the material, openness and closure, in order to reclaim the ether from the ethereal within a new language for modernity.

At its most comprehensive, this new language was that of energy, of lines of force. If Eliot's poem registers one kind of beginning for literary modernism,

then Pound's essay of 1913, "The Serious Artist," marks another. He had defined the "Art of Poetry" already as a combining of "essentials to thought," which he described in turn as "these dynamic particles, *si licet*, this radium."[1] Now he claimed that "the thing that matters in art is a sort of energy, something more or less like electricity or radioactivity."[2] Pound's most comprehensive statement on poetry as energy occurs in a later essay on the medieval poet Guido Cavalcanti, where the new language for the ineffable, for liberating the material from materialism, is given especially vibrant color: "We appear to have lost the radiant world where one thought cuts through another with clean edge, a world of moving energies . . . magnetisms that take form, that are seen, or that border the visible . . . these realities perceptible to the sense, interacting."[3] By making the medieval modern through the discourses of energy, Pound established the ground of his entire poetic practice.

Indispensable support was given, again in 1913, by his receipt of the manuscripts of the sinologist Ernest Fenollosa—material that he published in 1920 as *The Chinese Written Character as a Medium for Poetry*. It was this material that enabled Pound to advance the argument that "poetry agrees with science and not with logic." What underpinned this argument was a version of the turn-of-the-century shift from Newtonian physics and Euclidean geometry to field-theory physics, electrodynamics, and claims for a fourth spatial dimension. Pound valued Chinese script for its resistance to what he called the "tyranny" of logic: "According to this European logic thought is a kind of brickyard. It is baked into little hard units or concepts. These are piled in rows according to size and then labeled with words for future use." Set against such mechanicalism is the Chinese system, where meaning is found not so much in objects themselves but in the lines of relation or of force between them: "A true noun, an isolated thing, does not exist in nature. Things are only the terminal points, or rather the meeting points of actions. . . . Neither can a pure verb, an abstract motion, be possible in nature. The eye sees noun and verb as one: things in motion, motion in things." Here, poetry and science pursue the same trajectory: "Valid scientific thought consists in following as closely as may be the actual and entangled lines of force as they pulse through things."[4]

This shared pursuit was made possible by the theorizations of the constitution of matter within field physics, where materiality was conceived by Lord Kelvin, building upon Helmholtzian hydrokinetic and electrokinetic investigations, as "neither a solid atom, nor a mass of atoms, but a whirl in a fluid ether."[5] Although the "whirl" (reworking Helmholtz's "vortex ring") is the focus of attention, we should note that this source of action and creativity within the ineffable is grounded in the particular medium of the ether— the medium through which electromagnetic exchange could take place. In a newly material sense, it is Lord Kelvin's notion of the "ether undisturbed by

ponderable matter"[6] that underwrites Fenollosa's proposition that "relations are more real and more important than the things which they relate."[7] While the post-Einsteinian world of the 1920s was shown the insecure tenure of the ether as a meaningful scientific term, there is no doubt that for the 1910s, the period of high modernism in poetry, there existed a powerful alliance between artists, poets, occultists, theosophists, and scientists testifying to the potency of the ether as the freshly and authoritatively sanctioned source of the ineffable.[8]

As Linda Henderson notes in the following essay, Madame Blavatsky's *Isis Unveiled* (arguably the single most comprehensive and influential dialogue of science and occultism for the modernist moment) proposed that the "ether, or astral light" could contain "daguerreotype impressions of all our actions"—constituting, in effect, a "great picture-gallery."[9] To inhabit an etherized state is then to inhabit an ideal site for a character such as Prufrock, who is concerned, above all, with hypothesizing the means of visualizing his story. But the ethereal lesson here extends further—it facilitates a particular literalization of itself at the level of technique. Pound frequently used scientific discourse, especially that of electromagnetism, and thoroughly in tune with the occult resonance of modernism, to decipher ancient myths and mystical dogma. In an important essay of 1912, "Psychology and Troubadours," he offered to consider the body as "pure mechanism" in order to explicate the "psychic experience" accumulated in the Greek myths surviving in the mediaeval poetry of Provence. To this end, he argued for two forms of consciousness, the *phantastikon* and the *germinal*, both of which were conceived as forms of force, as tensile energy, and which he explained by electromagnetic analogy: "1st, the common electric machine, the glass disc and rotary brushes; 2nd, the wireless telegraph receiver. In the first we generate a current, or if you like, split up a static condition of things and produce a tension. . . . In the telegraph we have a charged surface . . . attracting to it, or registering movement in the invisible aether." Pound's analogy feeds ultimately into a complex account of sexual gnosis, but what I want to stress here is the rhetorical strategy of the analogy. It is offered as "an assistance to thought," as the "handiest" illustration.[10] In common with the simile with which "Prufrock" begins, the analogy is deliberately foregrounded as an analogy, as a technique of expression. As such, it both illuminates and limits its figurative capacity. The rightness of its metamorphic vision coexists with a skepticism about its own procedure. The ether is allowed then to be newly material and fictional simultaneously, and it is this simultaneity that legislates its most powerful effect for those modernist literary handlings of the ineffable that derive specific impetus from the models of science.

What I am suggesting is that we understand the modernist art-object as hypothesis, as something we speculate with and through, as an instrument

not for confirmation but for alterability. As such, its picture-making facilities, its potential for offering possibilities for shape and form, are, to a large degree, informed by discernible shifts in the epistemological turnings of turn-of-the-century scientific discourses. Specifically, the vocabularies of the ether and electromagnetism coincide with new shadings for the technique of analogy and for the status of science's claims to "truth." The ether in "Prufrock" and in "Psychology and Troubadours" is presented by analogical devices that proclaim their factitiousness and their provisoriness: it is through these features that it signals its less well-recognized, but perhaps most telling, scientific tenor.

Analogy depends upon relation, and when Pound's Fenollosa claims that "Relations are more real and more important than the things they relate," it is a claim that finds verification not through the Aristotelian notion of metaphor, "the use of material images to suggest immaterial relations," but through a proposal for "identity of structure." [11] Such identity displays how poetry agrees with science, not with logic, and it picks up on the new objectivity advanced during the 1880s and 1890s by the German physicist Ernst Mach.[12] For Mach in 1882, "The aim of research is the discovering of the equations which subsist between the elements of phenomena." These "equations" were understood more accurately as "functions" in a gesture against mechanistic physics: "Instead of equations between the primitive variables, physics gives us, as much the easiest course, equations between *functions* of these variables," functions that displayed the "interdependence" of the world.[13] Mach distrusted what he saw as the subjective and metaphysical procedures of Newtonian physics and its faith in the materiality of objects. For him these were merely fictions, conceptual constructs inappropriate to a world of the ether and moving energies. In common with contemporary biology, he was drawn to principles of correspondence and comparison as guides to scientific method, and this is where the mathematical notion of functions emerged as not only more faithful to this changing world but also more objective than the methods of materialist science. After two decades of thought, he summarized in 1897:

> The connections of nature are seldom so simple, that in any given case we can point to one cause and one effect. I therefore long ago [1872] proposed to replace the conception of cause by the mathematical conception of function,— that is to say, by the conception of the dependence of phenomena on one another, or, more accurately, the dependence of the characteristics of phenomena on one another.[14]

This conception of function is Mach's version of the method of analogy, which he advanced in objective counter to the subjective fixities of traditional

physics. We see here how the method of science approximates to the technique of poetry: "That relationship between systems of ideas in which the dissimilarity of every two homologous concepts as well as the agreement in logical relations of every two pairs of concepts, is clearly brought to light, is called an *analogy*." [15] As the Machist Henri Poincaré put it in 1908:

> We may perceive mathematical analogies between phenomena which have physically no relation either apparent or real, so that the laws of one of these phenomena aid us to divine those of the other. . . . The aim of mathematical physics is not only to facilitate for the physicist the numerical calculation of certain constants or the integration of certain differential equations. It is besides, it is above all, to reveal to him the hidden harmony of things in making him see them in a new way. [16]

The announcement of Pound's Fenollosa—that "the primitive metaphors do not spring from arbitrary *subjective* processes. They are possible only because they follow objective lines of relation in nature herself"—lays claim to a similar reality of analogy, its being objective and ineffable simultaneously. [17] And what is especially striking about this new objectivity is that it retains human agency as part of its meaning. It recognizes and recasts the objective–subjective complex of scientific knowledge through precisely the "interdependence" that is the ambition of the Machist method and well summarized by Martin Kayman *via* Poincaré: "We construct the world in thought, but that construction is determined by the necessary relations experienced and conceptualized in our sensational experience of the world, translated, through a language of conceptual convention, into law." [18]

The retention of subjectivity within the relational objectivity of analogy propounded by Mach and Poincaré returns us to the factitiousness of the form at the level of technique, as we saw in "Prufrock" and "Psychology and Troubadours." The poem in particular foregrounds its technical deployment of analogy (in the shape of the simile) as a partial figure, a testing of possibilities for expression. This highly self-conscious critique of its own procedures is itself thoroughly in tune with changes in the status and design of scientific discourse in the age of the ether and electromagnetism—changes that shifted the grammar of science from the totalizing aims of explanation to the flexible forays of description. One of the major effects of the rise of non-Euclidean geometry during the 1870s and 1880s, as Linda Henderson has shown, was its contribution to the decline of faith in the absoluteness of scientific truth in favor of relativist epistemologies. [19] Such unsettlings belonged also to the anti-positivist project of Mach and Poincaré, responding to a world revealed increasingly as ineffable.

Although Mach provided the main voice, in England it was one of his dis-

ciples, Karl Pearson, who brought him to a wide audience in 1892: "Step by step men of science are coming to recognize that mechanism is not at the bottom of phenomena, but is only the conceptual shorthand by aid of which they can briefly describe and resume phenomena. . . . All science is description and not explanation." So, the law of gravity, for example, is not so much "the discovery by Newton of a rule guiding the motion of the planets" as it is the "invention of a method of briefly describing the sequences of sense-impressions, which we term planetary motion."[20] To move from "discovery" to "invention" is to move to confessing the partiality of method and to denying the authoritarian imposition of "explanation." In parallel with the strategy of Prufrock's simile, it engages with the function of the provisory and the exploratory against the totalizing falsehood of completeness and representation. And it is in this sense that scientific discourses become creative, finding their most donative tone not only in Einsteinian relativity but also in Planck's work on quantum theory from 1900 onward.

In his Gifford Lectures of 1927, Sir Arthur Eddington, one of the great popularizers of science, summarized the potential for creativity in quantum theory's release from the "scheme of deterministic law" by the kinds of *questioning* it enabled:

> Considering an atom alone in the world in State 3, the classical theory would have asked, and hoped to answer, the question, What will it do next? The quantum theory substitutes the question, Which will it do next? Because it admits only two lower states for the atom to go to. Further, it makes no attempt to find a definite answer, but contents itself with calculating the respective odds on the jumps to State 1 and State 2. The quantum physicist does not fill the atom with gadgets for directing its future behaviour, as the classical physicist would have done; he fills it with gadgets determining the odds on its future behaviour. He studies the art of the bookmaker not of the trainer.[21]

The liberation offered by the new physics and by non-Euclidean geometry involved an important lesson about the partiality of scientific grammar, about the need to recognize the provisory occasion of that grammar, which offered a safeguard against what Eddington saw as the potential deceit of its shadowy relation to its subject: "It is difficult to school ourselves to treat the world as purely symbolic. We are always relapsing and mixing with the symbols incongruous conceptions taken from the world of consciousness. Untaught by long experience we stretch a hand to grasp the shadow, instead of accepting its shadowy nature. Indeed, unless we confine ourselves altogether to mathematical symbolism it is hard to avoid dressing our symbols in deceitful clothing." Modernism translated poet, physicist, and geometer into bookmakers. The shared tool of their technique, the analogy or simile that marks the risk and the meaning of their exploration, is both objective *and*

factitious, both real and alert to its partiality and shadowy deceit. It is precisely as a result of this combination that analogy can maintain the adventure of calculating the odds, sustaining its authority as description within the uncertainties of hypothesis. The art and science of the bookmaker in the age of the ether, non-Euclidean geometry, and electromagnetism is thereby enabled to be freshly creative because the announced factitiousness of the bookmaker's procedures reveals above all difference—its distance from shared languages and from the object or situation to which it refers.

The thrust of Mach's notion of analogy was to foreground its self-consciousness as an instrument, as a means of critical inquiry by virtue of this distance, this confessed removal into another lexical register. And for Pound, a large part of the scientific significance of the Chinese ideogram was determined by a similar self-consciousness. Although the phonetic word was neutral, having little or nothing to "exhibit the embryonic stages of its growth" and thus not bearing "its metaphor on its face," the etymology of the ideogram was "constantly visible."[22] Distance, difference, and self-consciousness within the matrix I have been describing make for creativity because they open up spaces for change and alterability. As Mach had claimed for his view of analogy, it depended upon a yoking together of conceptual dissimilarity and relational agreement, laying the ground for revised notions of difference that could be both objectively and speculatively exploratory.[23]

To be creative, then, is to explore, to question; and it is not accidental that the poem miming Prufrock's journey is constructed largely through the interrogative mode. To question is to raise the possibility of moving from one state to another. It is always a liminal activity where the self is poised for change at the edge or boundary of things and in this sense also it is appropriate that Prufrock's condition is "etherized." Linda Henderson and Bruce Clarke have drawn upon two highly influential texts on the developing science of the ineffable during the 1870s and 1880s—Balfour Stewart and Peter Guthire Tait's *The Unseen Universe* and Charles Howard Hinton's *A New Era of Thought*—to show that the ether was often understood as the medium and boundary between the third and fourth dimensions of space.[24] Liminally, boundaries propose not only ends but beginnings—a threshold, an interstitial arena where change may take place but where a final shape may be anticipated only by further questioning. The situation of the etherized self approximates perhaps to the Kantian "purposiveness without purpose," or, following Hinton, to the supposition "that we are not in, but on the aether, only not on it in any known direction, but that the new direction is that which comes in." Clarke quotes this supposition (and it is worth noting its subjunctive form, its appropriately hypothetical tenor) to claim it instructively as an example of how late-Victorian theories of hyperspace "would

preserve even while suspending the laws of physics." Such entanglements match the trope of analogy itself in conditioning the form of hypothesis that most closely ties modernist art and science in their joint negotiations of the ineffable.

To claim parallels and interactions between scientific analogy and modernist simile is, in part, to claim more generally the rhetoric of science as a sign of modernity. It belongs to the effort to restructure the embattled positions of the arts in the early years of the twentieth century—their struggles with the competing hermeneutics of the newly emerging epistemologies in psychology and anthropology, with the increasing professionalization of knowledge in all its forms, and with the patterns of industrial capitalism. It also belongs to a sustaining of responsive and responsible notions of a role within the public arena: the urge, in Pound's most potent phrase, to "Make It New." The resonance of this sign is to be sought within the contradictory relationship between the intolerance of an ambition for order and design and that particularly American predilection for discourses of construction, with their stress on building and on efficiency. While the former proposes an essentially confining system, the latter predicates the openness of a world recognized as man-made and thus subject always to further remaking.

But to leave the claim here at the level of ideas is to disguise what is arguably the most significant factor of science's sign within modernist aesthetics—its pragmatic function in the labor of composition itself. James Clerk Maxwell famously produced a "real" model of the ether on behalf of his theory on the unification of electromagnetic and luminiferous activity—a model based upon analogy where, rather flatly, "By a physical analogy I mean that partial similarity between the laws of one science and those of another which makes each of them illustrate the other."[25] The flatness of the statement might suggest that the emphasis here is simply on a notion of correspondence; but while such congruence is certainly a prime element, it should not conceal the thrust of the provisory language Maxwell uses—the similarity is "partial" and its function is to "illustrate." This provisoriness bespeaks a modesty of endeavor that is one of modernism's least recognized features.

In a very direct way, Maxwell's notion of model is strikingly prescient of the modernist commitment to picturing and prioritizing the relational over the phenomenal. Margaret Morrison has offered a description of Maxwell's analogical method with which Pound's Fenollosa would find absolute agreement: "the emphasis was on mathematical rather than physical similarity, a resemblance between mathematical relations rather than phenomena of things related. . . . The advantage of the method of analogy over a purely analytical formalism was the visual representation provided by the lines,

surfaces and tubes." [26] This was precisely how Fenollosa resisted the "brick-yard" of logic, how he encouraged poetry to agree with science by providing "a vivid short-hand picture of the operations of nature," one that registered the "lines of force," the "transference of power," between phenomena.[27] And both Maxwell and Fenollosa understand the necessary modesty of this operation. Fenollosa's picture may be vivid, but it is also "short-hand," and Maxwell's model has no ambitions beyond its immediate facilitating figurability.

What is also being shared here is a conjunction between the modesty of provisoriness and the labor necessary to both experiment and composition. A recent discussion of Maxwell by Bruce Clarke takes advantage of Maxwell's own youthful poetry to suggest that we may replace terms such as "model" and "analogy" with the more immediately expressive term "allegory." [28] Clarke's substitution implicates the labor of the provisory: "Maxwell's experimental allegories are pursued non-dogmatically, not to inculcate a doctrine but to construct a testable hypothesis." This goes beyond what might otherwise be merely another metaphor (in its weaker sense) for creativity, to locate the pragmatics of dealing with a world being revealed as simultaneously material and ineffable. Describing the ether as a "factual fiction," [29] Clarke argues that "Maxwell was convinced of its existence in some form, but skeptical about any particular description of it, including his own. To nineteenth-century physics generally, it appeared to be a necessary fiction—the material medium needed for the propagation of lightwaves, as sound was propagated by waves of air—but it entirely eluded any stable determination of its qualities." So, comparably to the exercise of the literary allegorist, Maxwell understood that "any given analogical vehicle was dispensable, in that many others could be devised to convey the same meanings." It is in this special sense that the "fiction" of the ether is productive: an artisanal means of getting about which refuses any privileging of itself against other, alternative, fictions save by its capacity for efficiency and figurability at any given, inevitably transitional, moment.

It is the factitiousness, the willingness for self-critique, and the provisoriness, the sense of being dispensable, that structures the *work* of analogy, allegory, and simile. As usable tools for exploration, they invite the heuristic endeavor of scientific and aesthetic hermeneutics—and it is with the modesty of their occasion that they mark such a distinctive track within modernism. Prufrock's etherized world recognizes its own fragility between unfixed positions. This intersticiality or hiatus is characteristic of Eliot's early poetry: in the language of *The Hollow Men*, it is a world of the "Shadow" that falls between identifiable places, "Shape without form, shade without colour, / Paralyzed force, gesture without motion," of the "whisper" that substitutes

for the plenitude of speech, of "deliberate disguises" that stand in for expressive personality. These "disguises" are not the tropes through which Prufrock seeks understanding (they are the forced performances demanded by the very codes that Prufrock wants to resist), but they indicate the risk of his endeavor, a risk acknowledged by the work of the tropes themselves. Prufrock, by contrast, is alert to the liminal possibilities of the ether and its negotiations of the "real" and the "unreal," the phenomenal and the ineffable; and he recognizes the value of "factual fictions," the difficult business of pursuing the heuristic project of finding form.

Prufrock's ether incorporates not only the hiatus of modernity but also its partial nature: streets are "half-deserted," retreats are "muttering," the cheap hotels are for "one-night" only, women merely "come" and then "go." All is transitional and fragmented, as later, when the human body is perceivable only as voices, eyes, and arms. Things cannot be fully known but merely speculated. Prufrock is overwhelmingly self-conscious about all this. Like Pound's poetic alter-ego Hugh Selwyn Mauberley toward the end of the decade of high modernism (and that decade's other poetic creation of scientific figure),[30] he needs to be seen not as the largely passive aesthete overwhelmed by circumstance that is urged by so many of the commentaries, but as an active agent attuned to the "factual fictions" necessary for exploring and constructing possibilities for meaning. The shift from the simile of the poem's first stanza to the unusually extended (in contemporary terms) metaphor of the fog and the cat in the second (where the metaphor is tested and found wanting as a source of consolation and completeness) prepares the reader not only for self-consciousness and factitiousness in the register of linguistic experiment, but for the realization that the world of tropes is, as Henry James would phrase it, both the limit and the extent of its occasion. And this is the modesty of the work Prufrock undertakes: his tropes make no claim to register anything other than their own literariness, their own "factual fictions" where they become potentially real by virtue only of their own style, their literary *endeavor*. Here is writing as action, anticipating the pragmatism of Pound's later dictum that "ideas are true only as they go into action." And writing as action within modernism crucially incorporates precisely that modesty exemplified by scientific analogy—a distrust of final interpretation or anything beyond factual approximation, and a willingness to accept the provisory and transitional.[31]

It is then, finally, this modesty of constructive work that characterizes one of science's fundamental lessons for modernist aesthetics; and it is a lesson on behalf of which Prufrock's ether is exemplary. The ether stimulates the trope that is the first of a series whereby Prufrock attempts to turn his world to factual meaning while understanding that such putative facticity is pos-

sible only through the work of fiction. His reliance effectively is upon the trope of a trope, a turning again that recognizes not only the experienced actuality of the world's partial nature but turns it to potential advantage by the modesty of his instrument. Prufrock's efforts to comprehend the partiality and provisoriness of his own practice is on behalf of a world that itself can be only partial and provisory. His ether both etherizes and etherealizes simultaneously.

Vibratory Modernism: Boccioni, Kupka, and the Ether of Space

LINDA DALRYMPLE HENDERSON

Although painted in the same year, 1912, Umberto Boccioni's *Matter* (figure 6.1) and František Kupka's *Amorpha, Fugue in Two Colors* (figure 6.2) would rarely ever be juxtaposed in an art history lecture. Their differences far outweigh any similarities or seeming connections between them. Although Boccioni's subject can be discerned as the relatively volumetric, material form of his mother, seated on a balcony, any sense of ponderable matter and gravity has disappeared from Kupka's remarkably flat, two-dimensional image. The broad planes of pure color in Kupka's painting present a stark contrast to the gradations of light and shade and the flurry of individual brushstrokes animating Boccioni's complex surface. Yet, these two paintings stand as exemplars of what might be called *vibratory modernism*—and, at base, they are united by the shared, if differing, responses of their creators to the ether, an entity largely forgotten during the later course of the twentieth century.

The term *ether* has recently reentered popular discourse in the context of computers and the "Ethernet." But, as Bruce Hunt's essay in this volume establishes, at the turn of the twentieth century the concept was well known as the imponderable medium thought to fill all space and to serve as the vehicle for the transmission of vibrating electromagnetic waves. Although Einstein's special theory of relativity of 1905 challenged the mechanical underpinnings of the ether hypothesis, that theory gained acceptance among scientists only gradually and was not widely popularized until 1919. Thus, the ether continued to loom large in the popular imagination through the 1910s and into the 1920s, even after most scientists had dispensed with it as a fictional construction.[1] For the lay audience the ether was virtually synonymous with space, and it thus offered a new conception of the space that had been the subject of painters for centuries. During the 1890s, conventional ideas of matter, the artist's other primary focus, were also changing rapidly due to the discovery of the X-ray in 1895 and the subsequent identification of the electron and various radioactive emissions.[2] Early twentieth-century artists were thus confronted by radically new conceptions of both space and matter, and the ether played a central role in this new paradigm of physical reality.

The artistic response to the ether generally took two distinct forms, and

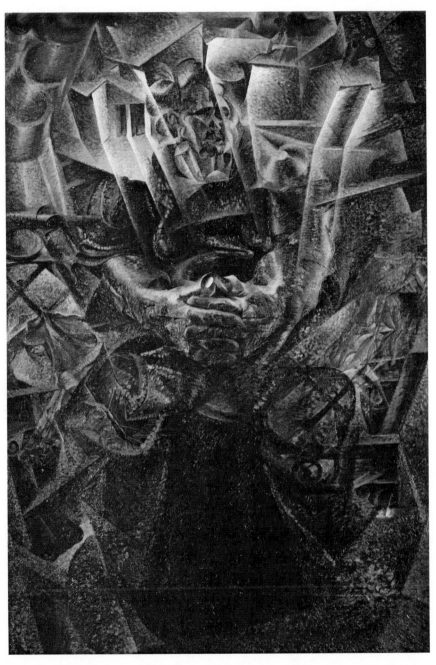

FIGURE 6.1. Umberto Boccioni, *Matter*, 1912. Oil on canvas, 88⅝ × 59 in. Private collection. (Photo: Luca Carra, Milan).

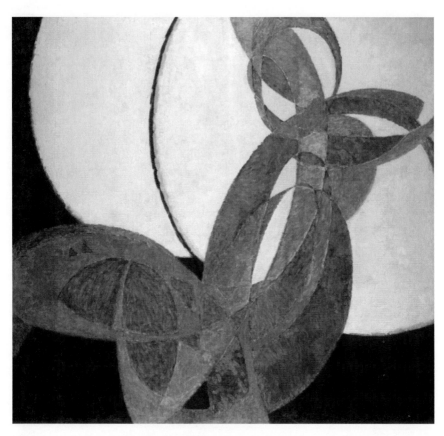

FIGURE 6.2. František Kupka, *Amorpha, Fugue in Two Colors*, 1912. Oil on canvas, 83⅜ × 86⅝ in. National Gallery, Prague. © 2001 Artists Rights Society (ARS), New York / ADAGP, Paris.

the paintings of Boccioni and Kupka are emblematic of that contrast. Some artists, such as the Italian futurist Boccioni, sought to give physical form to the ether as a space-filling medium. "What needs to be painted," Boccioni declared in a lecture of 1911, "is not the visible but what has heretofore been held to be invisible, that is, what the clairvoyant painter sees."[3] For Boccioni, one of those things to be revealed was the vibrating etherial medium itself.

Other artists—as well as poets—found in the ether and the Hertzian waves of wireless telegraphy an effective model for a new kind of artistic communication and, as a result, a stimulus to reconceive the very nature of painting (and the painted canvas surface) as well as poetry. This was the case for Kupka, the Czech pioneer of abstraction working in Paris. By late 1912 he had come to think of his paintings as vehicles for a telepathic, vibratory transfer of thought, a view shared by the Russian-born German Expression-

ist Wassily Kandinsky. Marcel Duchamp would ground his *Large Glass* project of 1915–1923 in yet other applications of the theme of electromagnetic wave vibrations.[4]

Prominent poets such as F. T. Marinetti, Guillaume Apollinaire, and Ezra Pound responded to the notion of wave-born vibratory communication as a new model for their literary craft. Marinetti declared the futurists to be the inventors of "wireless imagination," and Apollinaire's 1914 poem "Lettre-Océan" celebrated the Eiffel Tower's new *télégraphie sans fils* (TSF) station with words radiating like waves from the verbal signs of the tower at the page's center.[5] Pound described poets as "on the watch for new emotions, new vibrations . . . sensible to faculties as yet ill understood" and urged them to write "in new wavelengths."[6] Responding to Italian futurism and the French cubist presence in Barcelona during World War I, the Spanish avant-garde likewise embraced the vibratory model of wireless transmission. The sole issue of the periodical *Arc-Voltaic* (figure 6.3), published in February 1918, bore a cover design by Joan Miró complementing the "Vibrationism of ideas" and "Poems in Hertzian waves" explored within by the painter Rafael Barradas and the poet Joan Salvat Papasseit, respectively.[7]

Although the concept of a mysterious world-filling substance can be traced back to Aristotle, Newton had posited an aether he described as "exceedingly more rare and subtile than Air, and exceedingly more elastick and active."[8] The characteristics of the ether as theorized by Maxwell and the physicists who followed him seemed curiously contradictory. The ether must have both the rigidity of an elastic solid (necessary for the transmission of vibrating waves) and the rarefaction that would allow it to "pass through even the densest matter, as easily as water through a sieve."[9]

From the mid-nineteenth century onward, the ether was also discussed as the possible source of matter itself. Lord Kelvin in the 1860s proposed that atoms might well be whirling vortex rings in the ether. Sir Oliver Lodge and others in the 1890s advocated an "electric theory of matter" grounded in the electron and its interaction with the ether.[10] As Lord Balfour declared of the ether in his 1904 address before the British Association for the Advancement of Science, "It seems possible now that it may be the stuff out of which [the] universe is wholly built."[11] Conversely, with the discovery of radioactivity, scientific popularizers like Gustave Le Bon argued that matter was also in the process of decaying back into the ether—suggesting an image of space as a fluid realm of continuous cohesion and diffusion.[12]

Much like the highly popular notion of a suprasensible fourth dimension of space, with which it was sometimes associated in this period, the ether could be all things to all people.[13] For example, the theosophist Rudolf Steiner quoted extensively from Lord Balfour's 1904 address in his periodi-

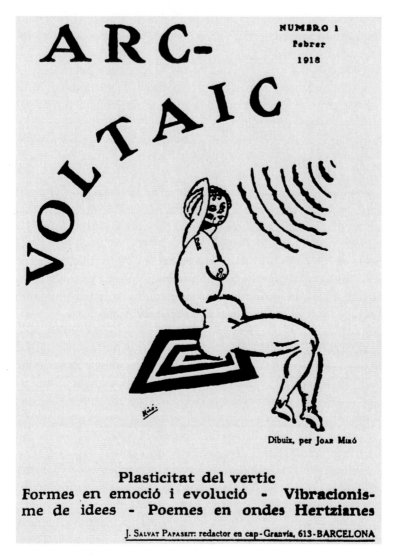

FIGURE 6.3. Cover, *Arc-Voltaic*, no. 1 (February 1918).

cal *Lucifer-Gnosis* in 1908, a magazine well known to Kandinsky.[14] Steiner compared Balfour's text to the writings of theosophy's founder Madame Helena Petrovna Blavatsky, whose 1877 *Isis Unveiled* connected the ancient "aether" as "world-soul" and "astral light" to the modern ether treated in the writings of scientists such as Balfour Stewart and Peter Guthrie Tait.[15]

In their 1875 book *The Unseen Universe*, Stewart and Tait had proposed that the ether might serve as a bridge to an imperceptible universe into which the energy dissipated through entropy might be flowing. "In fine," they as-

sert, "what we generally called Ether, may be not a mere medium, but a medium *plus* the invisible order of things, so that when the motions of the visible universe are transferred into Ether, part of them are conveyed as by a *bridge* into the invisible universe, and are there made use of and stored up." [16] In Stewart and Tait's hypothesis of the ether as a vehicle for cosmic energy storage Blavatsky found support for her argument that the "ether, or astral light" might also be storing visual imprints or "daguerreotype impressions of all our actions." Such a "great picture-gallery" containing "the images of events . . . imbedded in that all-permeating, universal, and ever-retaining medium," she argued, would explain the faculty of clairvoyant "psychometric power" or the transference of thoughts and images. [17]

Although Blavatsky herself was never particularly interested in the concept of a fourth dimension, Stewart and Tait, in the revised edition of *The Unseen Universe* (1876), made one of the first published connections between the ether and the fourth dimension. Like so many of the subsequent authors who embraced the fourth dimension as the spatial location of an invisible world, Stewart and Tait used the analogy of the relation of lower dimensions to one another: "Just as points are the termination of lines, lines the boundaries of surfaces, and surfaces the boundaries of portions of space of three dimensions:—so we may suppose our (essentially three-dimensional) matter to be merely the skin or boundary of an Unseen whose matter has *four* dimensions." [18] Similarly, the Englishman Charles Howard Hinton, one of the major popularizers of four-dimensional hyperspace and its implications, would propose in his *A New Era of Thought* of 1888 that the ether was perhaps the boundary or surface of contact between the worlds of three-dimensional and four-dimensional existence. [19] For occultists, in particular, both hypothetical constructs—the ether and a fourth dimension of space—could add a scientific or mathematical patina to discussions of the unknown and the invisible.

Distinctions between science and occultism were often not so sharply drawn in the late 1800s and early 1900s as they would be in subsequent eras. Artists like Boccioni, Kupka, and Kandinsky derived support for their theories from both scientific and occult sources, and etherial vibrations—from X-rays to Hertzian waves—were an area where the two readily came together. The French occultist Albert de Rochas, for example, drew on Lodge's writings on electromagnetism to support his case for the projection of bodily emanations as well as thoughts (figure 6.4). [20]

Among scientists, the widely published Lodge and his colleague Sir William Crookes, along with the French astronomer Camille Flammarion, were deeply interested in the implications of ether vibrations for psychic phenomena such as telepathy. In his 1897 presidential address before the Society for

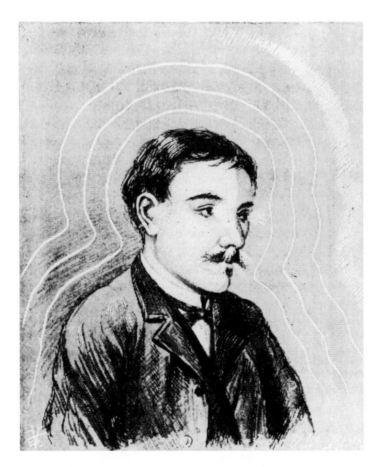

FIGURE 6.4. Emanations surrounding a hypnotized subject. Source: Albert de Rochas, *L'Extériorisation de la sensibilité* (1895; Paris, 1909), p. 57.

Psychical Research Crookes had set forth a "table of vibrations," frequently reproduced in this period, pointing up the vast ranges of vibrating waves in the ether that are invisible to the human eye, which perceives only the narrow band of visible light.[21] For occultists the vibration model also suggested that sensitive individuals might expand their receptivity to include larger ranges of vibrations: "If we had other cords to our lyre, ten, one hundred, or a thousand, the harmony of nature would be transmitted to us more complete than it is now, by making these cords all feel the influence of vibrations," Flammarion argued in his 1900 book *L'Inconnu*.[22] Or, as Crookes had asserted in his 1898 presidential address before the British Association, "ether vibrations have powers and attributes equal to any demand—even to the transmission of thought."[23]

In the 1910 "Technical Manifesto of Futurist Painting," Boccioni had declared, "Who can still believe in the opacity of bodies, since our sharpened and multiplied sensitiveness has already penetrated the obscure manifestations of mediumistic phenomena? Why should we forget in our creations the doubled power of our sight, capable of giving results analogous to the X-rays?"[24] As this statement and his earlier reference to painting the invisible suggest, Boccioni considered the futurist painter to be clairvoyant—with access to the invisible akin to the penetrating action of X-rays or the vision of a spiritualist medium. Both science and occultism, along with an exposure to French cubist painting in fall 1911, nourished his developing futurist art and theory. Two works, his 1912 painting *Matter* (figure 6.1) and his 1913 sculpture *Unique Forms of Continuity in Space* (figure 6.5), serve particularly well to demonstrate Boccioni's commitment to representing the invisible ether. Although he was far less concerned than Kupka with telepathy on the model of wireless telegraphy, Boccioni was deeply interested in the projection of states of mind by means of vibrations and referred on several occasions to Hertzian waves. Indeed, his writings and art make clear the results of his positive response to the question he had asked himself in his diary in 1907: "How, when, and where can I study all that chemistry and physics?"[25]

Like many others at the turn of the century, Boccioni believed firmly in the evolution of consciousness, and he argued that the futurists were "primitives of a new, completely transformed sensibility," possessed of a "psychic force that empowers the senses to perceive what has never been perceived before."[26] He attributed this development to the "altered conditions of existence" produced by contemporary science "with steam, electricity, motor fuels, Hertzian waves and all the researches of chemistry and biology."[27] Scientific discoveries like X-rays and radioactivity paralleled the "mediumistic phenomena" that so impressed Boccioni, including the "perception of the luminous emanations of our bodies . . . which have already been found to appear on the photographic plate."[28] Armed with his futurist "ultrasensitivity," Boccioni set forth to embody a new conception of matter—dematerializing and materializing simultaneously—in his remarkable painting *Matter*.[29]

The painting of X-ray transparency that Boccioni had learned from his encounter with cubism in 1911 plays a role in the dematerialization of his mother's form in *Matter*, just as it had done in his 1911 triptych, *States of Mind* (Museum of Modern Art, New York). In the painting *States of Mind: The Farewells* of that series, for example, transparent views of railroad passenger cars and embracing couples overlay the central image of a locomotive. Yet in *Matter*, there is an unprecedented interpenetration between object and environment, created by the painting's "compenetration . . . of planes that

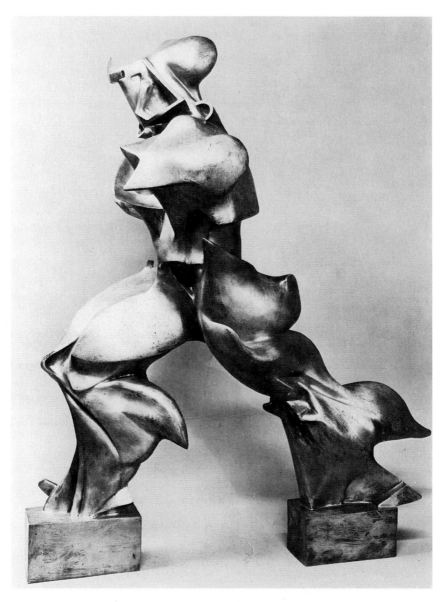

FIGURE 6.5. Umberto Boccioni, *Unique Forms of Continuity in Space*, 1913. Bronze, 43⅞ in. high. The Museum of Modern Art, New York. Acquired through the Lillie P. Bliss Bequest. © 2000, The Museum of Modern Art, New York.

are colorful, vibrant, efflorescent, atomic," as the critic Roberto Longhi described it in 1913.[30] On the model of radioactivity and occult theories about bodily emanations, Boccioni paints vibrating atoms of matter that dematerialize into energy.[31] Just as Crookes's popular tool, the spinthariscope, allowed a viewer to observe the emissions of a speck of radium striking a fluorescent screen, in *Matter* Boccioni's divisionist brushstrokes evoke the realm of atomic matter in the process of transformation. Bergson's conception of reality as constant flux was certainly one source for Boccioni, who quoted Bergson's statement that "any division of matter into autonomous bodies with absolutely defined contours is an artificial division."[32] However, scientific and occult discussions of the ether as interpenetrating (or even composing) all matter now made it possible to think of matter and ether-filled space simply as degrees on a continuum. As Boccioni asserted in his 1911 Circolo Artistico lecture, "solid bodies are only atmosphere condensed."[33]

In *Matter*, at the same time that atomic matter dematerializes into the surrounding ether, Boccioni materializes the previously immaterial and invisible ether-like "atmosphere," creating "a new kind of material body existing between one object and another."[34] In his writings Boccioni specifically cites "the electric theory of matter, according to which matter is only energy, condensed electricity and existing only as force," and his painting testifies to the widespread belief that the ether was somehow at the root of matter.[35] If Boccioni makes the texture of the ether material and palpable, he also represents the ether by signs of its vibratory waves, including visible light, which was at times cited as the only manifestation of the ether perceptible to the human eye.

Of course, with his futurist "ultrasensitivity" Boccioni adds other ranges of vibrations and thus charges his painting with shafts of electromagnetic light, such as the eerie X-ray-like rays or ultraviolet rays that descend upon and through the sitter from the top of the painting. These rays articulating the painting's surface can also be read as futurist "force-lines" (a concept derived from Faraday and Maxwell) and, given the widespread view that electric and magnetic forces resulted from strains in the ether, as further signs of the ether itself.[36] Describing the "atmosphere" (i.e., the ether) in futurist paintings as "the sensible conductor of dynamic forces," Boccioni argued in 1913, "It should be clear . . . why an infinity of lines and currents emanate from our objects, making them live in an environment which has been created by their vibrations."[37]

Boccioni's ideas on materializing the invisible ether were supported by contemporary scientific theory, but he also drew from occult literature on the exteriorization of thought and mediumist materializations. Boccioni had asserted in his 1911 lecture, "And so, if solid bodies give rise to states of

mind by means of vibrations of forms, then we will draw those vibrations."[38] And in his 1914 summa *Pittura scultura futuriste* he would declare, "For us the biological mystery of mediumist materialization is a *certainty*, a *light* in the intuition of physical transcendentalism and plastic states of mind."[39] Rather than the telepathic model of communication that was to interest artists such as Kupka or Kandinsky, it was the physical manifestation of thought or will that Boccioni sought to represent in futurist painting. Thus, the etherial vibrations condensing into forms around his mother in *Matter* are presumably manifestations of her state of mind, including Bergsonian memory images, such as the horse at the left and the walking man at the right. As such, these memory imprints in the ether might be thought of as the latter-day counterparts to Blavatsky's "daguerreotype impressions" in a cosmic, etherial image bank.[40]

Boccioni's determination to make the ether itself palpable as substance and as ultimate sign of continuity is clearest in his 1913 sculpture, *Unique Forms of Continuity in Space*. This sculpture brings together in the issue of continuity the artist's commitment to the ether and his personal interpretation of the fourth dimension of space. Although Bergsonist philosophy underlies Boccioni's basic belief in continuity, the theme of continuity was also central to Victorian physics as practiced by figures such as Lodge. In his 1909 book *The Ether of Space*, Lodge quoted Maxwell's assertion that "the vast interplanetary and interstellar regions" of the universe are so "full of this wonderful medium . . . that no human power can remove it from the smallest portion of space, or produce the slightest flaw in its infinite continuity."[41] Elsewhere, I have interpreted Boccioni's sculpture in relation to his motion-oriented futurist response to cubism's fourth dimension.[42] But when Boccioni's commitment to the ether is clarified, it would seem that the continuity suggested by the fourth dimension's spatial properties *and* by the ether underlie the materialization of the invisible in this work.

Boccioni's 1914 *Pittura scultura futuriste* boldly claims the fourth dimension for futurism, recasting it in dynamic terms:

> With the unique form which gives continuity in space we create a form which is the sum of the potential unfolding of the three known dimensions. Therefore we cannot make a *measured and finite* fourth dimension, but rather a continuous projection of forces and forms intuited in their infinite unfolding. In fact, the unique dynamic form which we proclaim is nothing other than the suggestion of a form in motion which appears for only a moment to be lost in the infinite succession of its variety.[43]

Boccioni may well have thought of that "unique dynamic form" as a four-dimensional entity passing through three-dimensional space, registering a succession of different appearances. This would be the four-to-three-

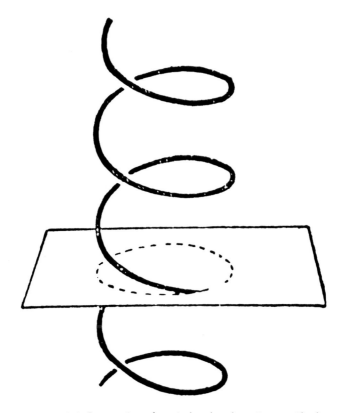

FIGURE 6.6. Intersection of a spiral and a plane. Source: Charles Howard Hinton, *The Fourth Dimension* (London, 1904), p. 27.

dimensional analogue of Hinton's model of the passage of a three-dimensional spiral through a two-dimensional film, which would register in the film as the "relative motion" of a point tracing a circle (figure 6.6). In reality that "point" would be a succession of points on the spiral, defined as the spiral moved vertically in its "absolute motion."[44]

Yet Boccioni's primary goal in his sculpture seems to have been to embody the physicality of the registering medium—in this case the ether as three-dimensional counterpart to a two-dimensional registering film. As he writes elsewhere in his 1914 book,

> We want to model the atmosphere, to denote the forces of objects, their recip-rocal influences, the unique form of continuity in space. This materialization of the etherial fluid, the imponderable; this transposition into the concrete of what one could call the new biological infinity and which illumines the fever of intuition, is it perhaps just a literary idea? All the human researches of our epoch, don't they without a doubt aspire to this imponderable which is in us, around us and for us?[45]

If on one level Boccioni tied the "infinite unfolding" of forces and forms in *Unique Forms of Continuity* to a fourth dimension of space, in the end the work also stands as perhaps his most successful materialization of the ether—with its particular effect of "ether drag"—which definitively destroys the closed boundaries of the sculpture. Like paintings such as *Matter*, Boccioni's sculpture testifies to his commitment to inventing the new languages of form and space he believed were necessitated by modern science.

Turning to Kupka, a Czech painter living in Paris in the midst of the salon cubist circle, we find an artist equally interested in invisible reality. "Great art makes of the invisible and intangible, purely and simply experienced, a visible and tangible reality," Kupka had written in his manuscript treatise of 1912–1913, "La Création dans les arts plastiques." [46] Like Boccioni, Kupka was deeply engaged with science and occultism and the rich interconnections between them. A former spiritualist medium, Kupka attended lectures on physics, biology, and physiology at the Sorbonne, and the physics of electromagnetism—adopted and popularized by occultists as well—was a key stimulus for him.[47] His pursuit of the invisible in the years before World War I, in fact, can be thought of as a trajectory from an early exploration of X-ray-like clairvoyance to his ultimate adoption of telepathy based on wireless telegraphy as a model for artistic communication. Thus, Kupka initially conceived of his paintings as revelations of the invisible akin to an X-ray plate, and works such as the 1911 *Planes by Colors* (figure 6.7) actually give the appearance of an X-ray plate held up to the light. Here Kupka's translucent figure also exhibits the characteristic contrasting nose of an X-ray photograph, produced because X-rays penetrate the cartilage of the nose, but not the surrounding bone structure of the head (figure 6.8). Kupka also adopted the metaphor of the X-ray plate for the mind of the artist, describing it as "an ultrasensitive film, capable of sensing even the unknown worlds of which the rhythms would seem incomprehensible to us." [48]

By 1912, however, Kupka had begun to move away from his transparent renderings of recognizable forms with their X-ray associations. In his subsequent works surfaces are transformed into opaque patterns of color, and a concomitant change is apparent in his theoretical stance. Kupka's treatise chapter entitled "Émission et réalisation" raises the possibility of a future art form that could communicate directly between the mind of the artist and the viewer:

> Observing the progress accomplished in diverse domains we may suppose and foresee the possibility of other means—new—of transmission: transmission more direct by magnetic waves like those of the hypnotizer. On this point the future holds surprises; we must wait to see appear *X ... graphes* or *X ... graphies*, of which the arrangement will expose events that are invisible, subtle,

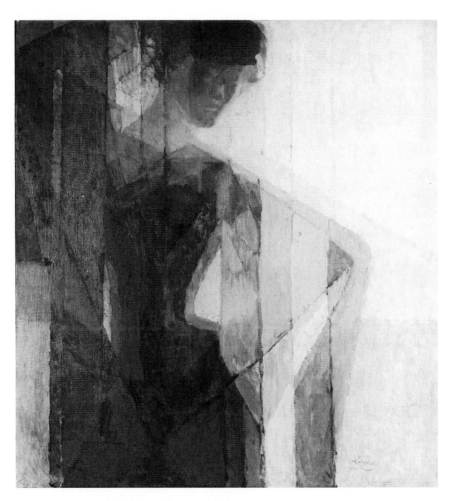

FIGURE 6.7. František Kupka, *Planes by Colors*, 1911–12. Oil on canvas, 43⅜ × 39⅜ in. Musée National d'Art Moderne, Centre Georges Pompidou, Paris. © 2001 Artists Rights Society (ARS), NY / ADAGP, Paris.

still poorly elucidated, as much of the exterior world as of the psyche of the artist. By these means, increasingly perfected, the artist will perhaps be able to make the viewer see the "film" of his rich subjective domain, without being obliged, as today, to work laboriously when he realizes a painting or sculpture.[49]

Kupka's use of terms such as *emission, transmission*, and *waves* is not limited to this passage, but characterizes much of the completed treatise. Indeed, by this time Kupka had shifted away from his earlier conception of the artist as a clairvoyant revealer of higher realities to the idea of the artist as an emitter of telepathic waves, on the model of wireless telegraphy. That

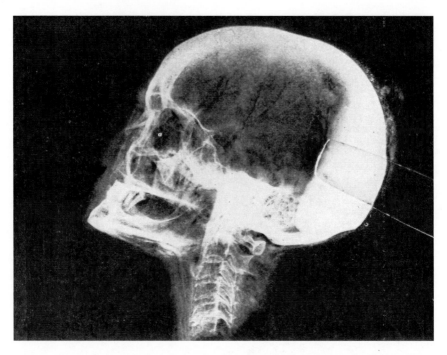

FIGURE 6.8. X-ray of a skull. Source: G. H. Niewenglowski, *Techniques et applications des rayons X* (Paris, 1898), plate 3.

technology involved the generation of a spark discharge in an oscillating primary circuit, which would create a resonant alternating current and resultant spark in a secondary circuit at some distance. As in the case of Kupka's interest in X-rays, however, both scientific and occult sources supported his theories on the possibility of communication by means of vibrations in the ether.

The process of exteriorizing thought had been central to the theories of French occultists such as Albert de Rochas and Hippolyte Baraduc, whose writings are filled with references to emission, vibration, electricity, and ether or ether-like substances. Baraduc drew on occult theories such as Baron Von Reichenbach's Odic force as well as scientific conceptions of a vibrating ether in his exploration of the interaction of the human soul and its surrounding environment. His 1896 text *L'Ame humaine: ses mouvements, ses lumières et l'iconographie de l'invisible fluidique* documents his use of a photosensitive plate, at times aided by an electric current, to record the different stages of that interaction, including the "luminous vibrations of the soul" he termed *psychicones* (figure 6.9).[50] For Baraduc, these psychicones recorded the thought or state of mind of the subject, and Annie Besant and C. W.

PSYCHICONE
formé au centre d'un
nimbe odique.

(Avec électricité, sans appareil,
avec la main.)

FIGURE 6.9. "Psychicone." Source: Hippolyte Baraduc, *L'Ame humaine: ses mouvements, ses lumières et l'iconographie de l'invisible fluidique* (Paris, 1896), plate 19.

Leadbeater in their 1901 book *Thought-Forms* cited Baraduc as the "scientific" counterpart to their own work.[51]

Colonel Albert de Rochas, the primary French advocate of traditional magnetism and Reichenbach's Od, took particular care to bolster his assertions by citing contemporary developments in the physics of electromagnetism. He actually added fifteen such appendices to his 1895 text *L'Extériorisation de la sensibilité*. In addition to the writings of Oliver Lodge, Rochas included a remarkable 1892 lecture entitled "Cerebral Radiation" by the American engineer Edwin Houston.[52] Based on the wave vibrations in the ether documented by Hertz, Houston posited a theory of "thought waves" that could travel through the ether and evoke resonant "molecular vibrations" in a "receiving brain." Foretelling Baraduc, Houston suggested that these thought waves could perhaps be registered on a "suitably sensitized plate."[53] And, like Kupka later, he hypothesized that at some future time such graphic records of thought waves might be able to stimulate the appropriate molecular vibrations in the brain of a viewer and give rise to the thought originally projected. As Besant and Leadbeater would do in *Thought-Forms*,

Houston emphasized that what was transmitted was not a recognizable form, but rather "the undulatory movements of the ether created by cerebral operations."[54] Such ideas were subsequently reiterated in sources such as Henry Fotherby's article "L'Éther, véhicule de la conscience subliminale," published in the *Annales des Sciences Psychiques* in July 1906.[55]

Telepathy and the theory of wireless telegraphy (before it had come into wide commercial use) thus provided a rationale for a direct, abstract mode of communication, free of the identifiable images that remained in Kupka's X-ray related paintings. Although Houston's ideas were available in the numerous editions of Rochas's book, Crookes also stimulated interest in telepathic communication by means of his highly publicized presidential addresses before the Society for Psychical Research and the British Association in 1897 and 1898. Crookes's lectures, both published in the *Revue Scientifique* and available in occult sources as well, could make an even stronger case for telepathy after the discovery of X-rays and the emergence of early wireless telegraphy practice. Thus, Crookes's model for "brain waves" was the X-ray, whose extremely short wavelength allowed it to penetrate solid matter.[56]

Although Crookes considered Hertzian waves, with their wavelength in the range of a meter or much longer, to be far too low in frequency to penetrate the brain, he nevertheless connected the brain's functioning to the technology of wireless telegraphy. Having compared the structure of the human brain (i.e., the narrow gap between nerve cells) to a wireless telegraphy wave detector, Crookes also posited the possible existence of "masses of nerve coherers in the brain," which would receive ether vibrations and produce "molecular movements in the brain."[57] Like Crookes and Houston, Kupka often spoke of the brain in terms of its "molecular state."[58] He augmented the telegraphic overtones of the brain's activity through his use of electrical terminology, discussing artistic creativity, for example, in terms of flashing sparks that equally evoke a wireless telegraphy installation.[59] Kupka's woodcut *Fantaisie physiologique*, included in the 1923 Czech publication of his treatise (figure 6.10), gives vivid expression to this new conception of artistic creation as the reception and emission of waves.

A firm believer in the evolution of consciousness, Kupka anticipated the possibility of a future era of completely dematerialized, purely telepathic artistic communication. Recognizing the limitations in the receptivity of his contemporary audience, however, he concluded, "For now, the work of art conceived and traditionally executed" in oil on canvas is still necessary.[60] That the visible spectrum also consisted of electromagnetic waves allowed Kupka to maintain his electromagnetic theory of art, basing it for the present on visible light and color. Although the telepathic element of that theory

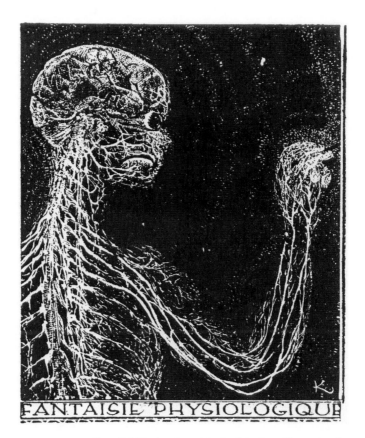

FIGURE 6.10. František Kupka, *Fantaisie physiologique*. Illustration for *Tvoření v umění výtvarném* [Creation in the Plastic Arts] (Prague, 1923), p. 163.

implied transcending the recognized organs of sense, his artistic theory and practice as set forth in 1912 and 1913 ultimately relied upon the production of waves of colored light by the canvas and their perception by the sensitive eye. Thus, for Kupka, paintings such as *Amorpha, Fugue in Two Colors* of 1912 were exteriorizations or emissions of the "vision of the artist," flat, self-sufficient objects that would in turn "emit," by reflection, electromagnetic waves of colored light.[61] These waves of visible light stand as the counterpart to Edwin Houston's thought waves, the abstract patterns captured on a sensitive plate that might then generate molecular vibrations of thought in the mind of a viewer.

Kupka's conception of his paintings as generators of vibrations calls to mind the somewhat better-known goal of Wassily Kandinsky to create works of art that would produce a *Klang* or sympathetic vibration in the soul of a viewer.[62] Having lived on the outskirts of Paris during 1906–1907, the

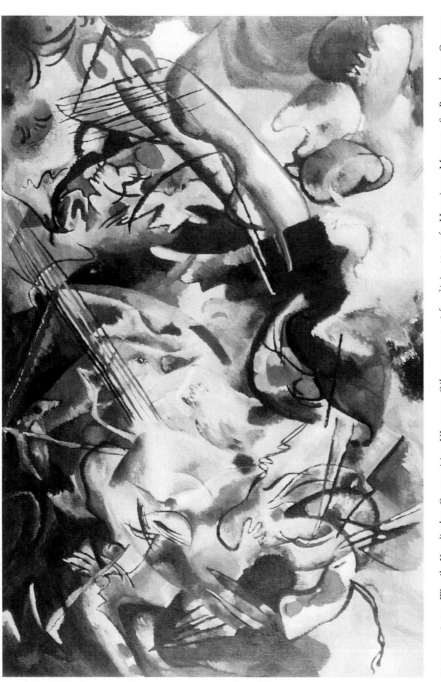

FIGURE 6.11. Wassily Kandinsky, *Composition VI*, 1913. Oil on canvas, 6 ft. 4¾ in. × 10 ft. Hermitage Museum, St. Petersburg. © 2001 Artists Rights Society (ARS), NY / ADAGP, Paris.

Russian-born Munich resident read many of the same sources as Kupka: not only the theosophists Blavatsky, Steiner, Besant, and Leadbeater, but also occult scientists and scientific occultists such as Crookes, Flammarion, Baraduc, and Rochas. The literature on Kandinsky has tended to focus largely on Besant's and Leadbeater's *Thought-Forms*, but their work was obviously just one manifestation of a much larger fascination in this era with the transfer of thought by means of ether vibrations.[63]

Drawing particularly on the theories of Steiner, Kandinsky saw the artist as a visionary prophet whose paintings—freed of the materiality of objects—could help usher in the new "epoch of the Great Spiritual" he envisioned for society. As noted earlier, Steiner quoted extensively from Lord Balfour's address before the British Association, which had suggested that the ether might be the basic "stuff out of which [the] universe is built,"[64] and such views supported Kandinsky's anti-materialist stance. Indeed, his 1911 treatise *On the Spiritual in Art* refers specifically the "electron theory—i.e., the theory of moving electricity, which is supposed completely to replace matter," the same "electric theory of matter" upon which Boccioni had seized.[65] In his quest for a pure form of artistic communication, Kandinsky initially used a technique of hidden, apocalyptic imagery, meant to sensitize and spiritualize a viewer. Gradually, however, that iconography was further and further obscured to produce anarchic, chaotic images of pure color and form meant to unsettle the complacent viewer and prepare him or her for a new level of spiritual consciousness (figure 6.11).[66]

Kandinsky was a firm believer in the musical, synaesthetic possibilities of color turning into "sound," and his paintings give visual and, hence, aural form to the necessary dissonance that he and his composer friend Arnold Schoenberg believed would become "the consonance of tomorrow."[67] Although the sympathetic resonance of strings or a tuning fork served Kandinsky as an inanimate model in the realm of sound for his painting's desired *Klang* in a viewer's soul, it was the human-to-human communication based on the etherial telegraphy–telepathy analogy that provided the essential support for his theory.[68] In the light of the new conception of dematerialized matter and ether-filled space, as well as the prevalent model of vibratory thought transfer, Kandinsky's purest compositions of 1913, like the paintings of Kupka and Boccioni, gain a new cogency and can be recognized likewise as examples of vibratory modernism.

If these artists' interest in a vibrating etherial medium led to variations in painted pictorial space and form, Marcel Duchamp was prompted to make even more radical formal inventions by his interest in etherial vibrations and the model of wireless telegraphy. Duchamp had matured as an artist in close proximity to Kupka, and, sharing his deep engagement with science, had pro-

duced paintings in 1911–12 that paralleled Kupka's concern with X-rays.[69] Like Kupka, Duchamp's interest ultimately turned to Hertzian waves, but instead of painting exteriorizations of thought, the younger artist gave up painting completely to function more like an engineer in creating his masterwork of 1915–23, *The Bride Stripped Bare by Her Bachelors, Even* or *The Large Glass* (figure 6.12). For the *Large Glass* project, Duchamp worked on two panes of glass over nine feet tall, using a variety of unorthodox materials including lead wire (with which he "drew" the forms in a precise, impersonal style), lead foil, mirror silver, and dust as well as conventional oil paint and varnish. Seeking to avoid self-expressive painting and drawing, he adopted laboratory-like techniques that approximate in places the creation of electrical and even telegraphy equipment.[70] The "Oculist Witnesses" at the right side of the lower panel, for example, were the result of Duchamp's scraping away mirror silver applied to the glass, much the way wireless telegraphy pioneers produced a wave-detecting spark gap by inscribing lines in a silver film on glass.[71]

Determined to "put painting once again at the service of the mind," Duchamp had begun in 1912 to make hundreds of notes for the work, which he described as "a sketch . . . for a *reality which would be possible by slightly distending* the laws of physics and chemistry."[72] He ranged through a variety of fields of science and technology to create the humorous "Playful Physics" of the *Large Glass*, but electromagnetism and, specifically, wireless communication are central to his "painting of frequency," as he called the work.[73] According to Duchamp's notes, in this scientific allegory of sexual quest the biomechanical Bride (the skeletal form at the left of the upper panel) triggers the mechanical sexual activities of the three-dimensional, gravity-bound Bachelor Apparatus below by means of her "commands."

Given Duchamp's references in his notes to the Bride's "sparks" and "splendid vibrations," her possession of an "emanating ball," and her "electrical control of the stripping" (to be carried out by the Bachelors), it is clear that his model for communication in the *Large Glass* was the Hertzian waves of wireless telegraphy.[74] Beyond the wireless telegraphy antennae atop the Eiffel Tower, the first contemporary experiments in "radio control," carried out in Paris by Edouard Branly in 1905–6, may have been another stimulus.[75] Seeking to differentiate the Bride further from the Bachelors, Duchamp had speculated extensively on how to make her four-dimensional. In view of the association of the ether with the fourth dimension in this period, the Bride does seem to exist in an etherial, wave-filled "paraspace" possessing the qualities of immeasurability and freedom from gravity popularly associated with the fourth dimension.[76]

While Duchamp's brother, Raymond Duchamp-Villon, wrote of the need

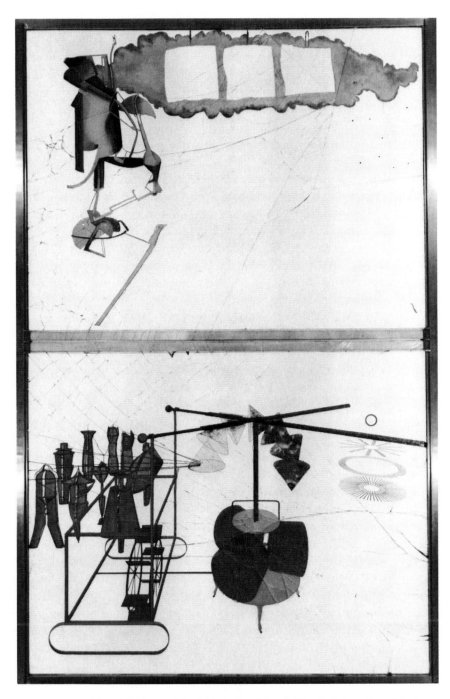

FIGURE 6.12. Marcel Duchamp, *The Bride Stripped Bare by Her Bachelors, Even* (*The Large Glass*), 1915–23. Oil, varnish, lead wire, lead foil, mirror silvering, dust, and aluminum foil on glass panels, mounted within a wood and steel frame, 109¼ × 69¼ in. The Philadelphia Museum of Art, Bequest of Katherine S. Dreier. © 2001 Artists Rights Society (ARS), NY / ADAGP, Paris.

for art "to reveal the vibration of thought itself and thereby to provoke states of consciousness hitherto unexpected or unknown,"[77] Duchamp certainly shared none of Kupka's or his brother's goals of mystical consciousness-raising. Yet he, too, may have incorporated an aspect of telepathic thought transfer on the model of Baraduc. Defining the cloudlike "Milky Way" to the right of the Bride as her "cinematic blossoming" or imagined orgasm, Duchamp had hoped to imprint the image photographically on the glass surface.[78] Since he had explored the theme of bodily emanations or "exteriorizations" like those of Baraduc and Rochas in paintings of 1910–1911, he may well have thought of this image, "the sum total of the Bride's splendid vibrations," as an ironic, sexual thought projection akin to Baraduc's photographic records of the soul's "luminous vibrations."[79]

The kind of automatic, objective recording provided by photography represented an ideal for Duchamp, and the theme of indexical registering instruments is prevalent within the operations of the narrative of the *Large Glass* as well as in certain of his techniques for its production. Just as the fabrication of the Oculist Witnesses paralleled that of a Hertzian wave detector, the entire *Glass* has been compared to a giant photographic plate or X-ray plate, poised to capture visible and invisible light.[80] "Wiring" instead of drawing his forms, Duchamp had indeed *built* his "painting of frequency" as a kind of apparatus far removed from the traditional medium of painting. His frequency apparatus would undergo an unexpected vibratory permutation after he ceased work on it in 1923. As the *Glass* was shipped back to Connecticut in the back of a flatbed truck after a 1926 exhibition, the glass panes shattered, producing the symmetrical cracking Duchamp said made the work "a hundred times better."[81]

Instead of painting or sculpting the ether as Boccioni attempted to do, Duchamp—like Kupka and Kandinsky—reconceived the work of art as an object meant to interact with its environment and viewers. Drawing upon the reigning model of etherial, wave-filled space, Kupka and Kandinsky focused on a highly personal vibratory communication meant to be projected to the mind or soul of a sensitive observer. Duchamp, by contrast, built an apparatus modeled on an impersonal wave-detector or other registering instrument whose narrative presents in equally detached terms a sexual encounter-at-a-distance bridged only by the Bride's projected vibratory commands.

More attuned to the expressive goals of Boccioni, Kupka, and Kandinsky than to the cool, engineer-like precision of Duchamp, a statement by Edward Carpenter in his 1905 *The Art of Creation* nevertheless effectively sums up a view of nature with which they were all acquainted:

Nature is a great vehicle, an innumerable network and channel of intelligence and emotion. . . . The messages of light and sound and electricity and attrac-

tion penetrate everywhere; and as modern science shows us that the air, the sea, and the solid frame of the earth itself may be the vehicle of waves which without wire or definite channel may yet convey our thoughts safely to one another through intervening leagues of distance, so surely we must believe that the countless vibrations ever going on around, and ever radiating from and impinging upon every known object, are messengers too of endless meaning and feeling.[82]

For Carpenter and many others in the early years of the century, wireless telegraphy confirmed the probable existence of a cosmic "Internet" through which thoughts might travel from one individual to another. Although today he is also a mostly-forgotten relic of the early modern period, Carpenter, like the ether, was widely known in this period, and his writings would have contributed further to the popularization of the prevalent vibratory conception of nature.

As we have seen, a number of major artists and writers of early modernism were united in their mutual concern with the new paradigm of reality represented by ether-filled space, matter born from and dematerializing into the ether, and the new possibilities of communicating (and seeing) offered by the model of vibrating waves in the ether. For artists, the ether was perhaps the most tantalizing element of the physics of electromagnetism at a time when physics still seemed visualizable—before the advent of the increasingly mathematical approaches of relativity theory and quantum mechanics. Such a new conception of reality had demanded new form-languages to express it. In all its manifestations, the ether served as a potent stimulus for creative invention by artists and writers alike.

TRACES AND INSCRIPTIONS:

DIAGRAMMING FORCES

INTRODUCTION

Part 3 occupies a conceptual space midway between energy and information. The impetus for this section comes from the visual arts and the distinct change in the look of painting that occurred by the later 1910s and 1920s. Rather than trying to give visual form to invisible phenomena, such as vibrating waves, material particles, and lines of force, as in Boccioni's *Matter*, by the wartime and postwar period many artists had begun to represent energy and related phenomena in a diagrammatic language drawn from the realms of science and technology. Artists such as Kazimir Malevich, Paul Klee, Piet Mondrian, Marcel Duchamp, Francis Picabia, and László Moholy-Nagy all engaged the issue of the scientific diagram and the notion of painting as a form of *inscription,* in Bruno Latour's sense of the word.[1] Although Duchamp was particularly interested in automatic indexical registering and such apparatus forms a major theme within the current section, most of these artists had a more generalized interest in the diagram or scientific illustration as a new mode of representation appropriate to the post-expressionist cultural climate. Indeed, their painting itself became a kind of deliberate inscribing, as many of them (including Duchamp) adopted the scientist or engineer as the proper model for the artist.[2]

Robert Brain's "Representation on the Line: Graphic Recording Instruments and Scientific Modernism" examines the emergence of the automatically registered lines of the graphic method as a mode of scientific representation thought to inscribe "the language of the phenomena themselves."[3] The automatically graphed line often provided a direct registration of energy processes. Central to Brain's discussion are the French engineers Jules-Victor Poncelet and Arthur Morin, who developed a variety of performance-measuring instruments as the basis of a "science of the work of forces."

French physiologist Etienne-Jules Marey saw the graphic method as a universal means of scientific communication. His laboratory's work in acoustical registration played an important role in Ferdinand de Saussure's development of structural linguistics, based on the phonographic recording of elementary linguistic signs. Marey's interest in the graphed line as an energy inscription also had an impact on later nineteenth-century art through the experiments of psycho-physicist Charles Henry. In particular, neo-impressionist artist Georges Seurat was attracted to Henry's use of the graphic method to produce a "scientific aesthetic" based on predetermined psychological effects of lines. Brain shows how the graphic method led to the analog precursors of cybernetic digitality.

In "Concerning the Line: Music, Noise, and Phonography," musicologist Douglas Kahn focuses on the implications of the automatically recorded line for the development of avant-garde music. A nodal point between his essay and Brain's is a work of literature, Alfred Jarry's *Gestes et opinions du docteur Faustroll, Pataphysicien,* in a chapter of which Jarry cites the British mathematician Arthur Cayley's claim that "a single curve drawn on a blackboard two and a half meters long can detail . . . all the sounds of all the instruments and all the voices of a hundred singers and two hundred musicians, together with the phrases . . . which the ear is unable to hear." While Brain examines the implications of this claim for science and engineering, Kahn applies it to music and technology, now reconceived both as visible sound and as recordable by phonography. A primary theme in his discussion is automatic registration—from the late eighteenth-century Chladni figures that registered sound patterns on the surface of plates to Dayton Clarence Miller's analysis of sound that would be generated by preexistent curves, such as a profile of a face. This was the root of John Cage's musical composition of "a portrait of Beethoven repeated fifty times per second"—the reference to Beethoven serving as an ironic allusion to Cage's quest to free music from self-expression. Kahn also discusses a related sort of "found" inscription treated in a short essay by German poet Rainer Maria Rilke, "Primal Sound" of 1919.[4]

Returning to the realm of art as inscription in the post–World War I period, Marcel Duchamp, Cage's friend later in life, shared his interest in an impersonal, precise mode of art making that emphasized the mind of the artist. According to Duchamp, a painting should be "the diagram of an idea,"[5] and he celebrated the depersonalized line and images produced by registering instruments, including the photographic camera. In his 1919 essay, "Natural and Abstract Reality," the Dutch De Stijl artist Piet Mondrian advocated "abstract representation" for its universality (versus naturalism's specificity) and cited the model of the diagram: "The diagrammatic representation of things . . . gives us a more general notion of things."[6] Francis

Picabia based many of his paintings directly on scientific illustrations, and Lázló Moholy-Nagy chose to diagram forces directly in works such as his *Dynamic Constructive Energy System (Design for a Light Machine for Total Theater)* of 1922.[7]

As Christoph Asendorf chronicles in his essay, "Bodies in Force Fields: Design Between the Wars," scientific diagrams were likewise essential to the practice of Moholy's fellow Bauhaus artist Paul Klee. Deeply interested in science, Klee believed that art should "make visible," and he sought to give schematic form to a conception of nature as process and fluid interpenetration.[8] Adopting the lines and arrows of scientific diagrams, Klee developed a language of signs to convey the play of forces and energies in nature. Asendorf draws parallels with the development of fluid, interpenetrating spaces in architecture at the Bauhaus and then goes on to examine the sociopolitical implications of the new conception of society as a "space in which energies cross" and the attendant restraints that emerge in a worldview such as that of Ernst Jünger. He concludes by considering Alexander Dorner's celebration of Herbert Bayer's graphic design as the true fulfillment of modernism's engagement with the theme of energy. Diagrams in painting become the prototypes for the field of graphic design as a whole.

In the context of inscriptions and diagrams, the work of Malevich and his followers can now be recognized as part of the larger aesthetic shift from the prewar to the postwar period. If Malevich's first suprematist works of 1915 give visual form to the experience of floating free of gravity in an infinite, white, four-dimensional space, his reduced geometric elements have the quality of diagrammatic signs, and indeed, Malevich was interested in diagrams of troop movements as well as other types of scientific diagrams.[9] At GINKhuK (State Institute of Artistic Culture, Leningrad) in the early 1920s Malevich made didactic diagrams as he created the *Analytical Charts*, setting forth his theory of the "additional element" driving the evolution of artistic styles. These diagrams were based on the model of infection by the sickle-shaped tuberculosis bacillus.[10] If medical metaphors were adopted to describe the creative process at GINKhuK, the representation of energy also remained a central issue, as Douglas's essay establishes.

Although certain artists such as Ivan Kliun, Kliment Redko, and Alexander Tyshler sought to capture the actual appearance of high-energy phenomena in a reduced, simplified language, others signified those effects more schematically. Automatic registrations of energy could serve as models. Maria Ender, for example, celebrated the indexical "frost picture on the window" as "force-currents caught on the plane."[11] Reflecting the centrality of the energetics of Ostwald and Bogdanov, Malevich and his colleagues shared the view that "things are nodules of various energies,"[12] and in the 1920s they were at the forefront of inscribing those energies.

In the wake of the development of cubist collage and the birth of abstraction, the painted canvas surface largely had been reconceived as a surface of inscription rather than a window onto visible or invisible worlds. And in the climate of the postwar period, those inscriptions were not gestural strokes of self-expression, but rather depersonalized lines associated with automatic recording apparatus and scientific diagrams, the "language of the phenomena themselves." Thus, in the 1920s, the line—inscribed on the new surface—often bore a double meaning: The information that was to be encoded in the image itself as well as a declaration of the artist's interest in a scientifically oriented persona.[13] Rather than the cubist or futurist fictions that had imagined the look of invisible realities, the new diagrammatic language had the look of fact and suggested the possibility of a universal language of communication, such as that utilized in inscriptions within the scientific community itself. If artists like Duchamp produced humorous variations on this theme, as in the *Large Glass*, that dream of communication would ultimately give birth to the modern field of graphic design. The theme of energy and its depiction highlights this important transitional phase in the history of modernism in art and music.

Representation on the Line: Graphic Recording Instruments and Scientific Modernism

ROBERT M. BRAIN

This essay delineates the movement from energy to information through the optic of the graphic method. It proposes elements of an alternative genealogy of the computer and the information age, and seeks to call attention to the work of those who have begun to make it conceivable.[1] Sometimes drawing from unfamiliar sources, the essay traces lines of descent different from the standard accounts of either intellectual history or the history of engineering or business organization. It points to a different set of instruments and a different intellectual tradition, specifically that which came to be known in the early twentieth century as analog representation and calculation.

In his *Exploits & Opinions of Doctor Faustroll, Pataphysician*, the fin-de-siècle French neoscience fabulist Alfred Jarry told of the puzzlement of M. René-Isidore Panmuphle, bailiff in charge of the prosecution of Faustroll for obscure irregularities, when in the course of his investigation he discovered a manuscript containing a single line, thought by the accused to represent a small fragment of the beautiful and the true of all art and all science, "which is to say the All."[2] Panmuphle recalled a proposition of the English mathematician, cited by William Thomson, Lord Kelvin, the great Scottish scientist with whom Faustroll claimed to have communicated telepathically.[3] "Cayley," remembered Panmuphle, asserted that "a single curve drawn in chalk on a blackboard two and a half meters long can detail all the atmospheres of a season, all the cases of an epidemic, all the haggling of the hosiers of every town, the phrases and pitches of all the sounds of all the instruments and of all the voices of a hundred singers and two hundred musicians, together with the phases, according to the position of each listener or participant, which the ear is unable to seize." The late Faustroll, it seemed to the astonished Panmuphle, grasped the All in the form of an overweening Curve, "recorded . . . in the two dimensions of a black surface."[4]

Jarry dedicated his playful parody to his friend, the art critic Felix Fénéon, who had skillfully defended such ideas as they guided the painting techniques of his friends Georges Seurat and Paul Signac. But his satire also targeted a more serious scientific imaginary, one in which leading scientists promoted

the graphic method of representing automatically recorded curves as "the language of the phenomena themselves," or the "universal language of science." In the statements of their most ardent promoters, such as the French physiologist Etienne-Jules Marey or the engineer Ernest Cheysson, graphic recording devices appeared not merely as an effective laboratory method, they became the primary technique of universal communication, "perfectly suited to the age of steam and electricity." [5] Although perhaps the best-known avatar of the graphic method, Marey was only one voice among many. Writing from Berlin in 1879, the American psychologist G. Stanley Hall described to readers of *The Nation* back home a revolution in scientific communication nearly completed. In Europe, Hall wrote, "the graphic method is fast becoming the international language of science." In Germany, he added, "it has revolutionized certain sciences by its unique logical method, and in one or two cases at least has converted the lecture room into a sort of theater where graphic charts are the scenery, changed daily with the theme, and where the lecturer is mainly occupied in describing his curves and instruments and signaling assistants, who darken the room, explode gases, throw electric lights or sunbeams, simple or colored, upon mirrors or lenses, or strike up harmonic overtones, as the case may be." [6]

Such choreography dominated the scientific education of an entire generation of Europeans. Many of them articulated it further, both as a scientific method and as a cultural imaginary. The introduction of the graphic method into nineteenth century effectively parceled out the world into distinct disciplinary fields, each with its own disciplinary analysts or experts who learned, memorized, and carried with them their own "mental library of curves," the mastery of which defined their specific competence in their field. [7] Specialists delivered their harvest of graphic representations not only to the marts of disciplinary exchange—journals, conferences, texts—but also to the broader public domain, what Marey called the *oeuvre commun*, of science. [8] In these accounts, the graphic method served to implement a fantasy in which automatic recording instruments would generate a vast heterotopic space of inscription that would push out speech altogether and replace it with mechanized forms of thinking and communication. [9] Graphic data from laboratories, factories, machines, hospitals, weather tell-tales, and demographic surveys would pour into this space generating the "landscape of curves" (*Kurvenlandschaft*), which Jürgen Link has described as a fixture of modern life. [10]

For Marey and other proponents of the graphic method, the principal enemy of scientific communication had a name: language. "Born before science," Marey wrote, "and not being made for it, language is frequently improper to express exact measures and well defined relations." A scientific age

had rendered language obsolete, Marey argued. Hence, "it is not doubtful that the graphic form of expression will not soon substitute itself for all others, each time it acts to define a movement or a change of state, in a word a phenomenon of any sort." In place of verbal or written discussion, Marey imagined scientific and technical communication as a mute exchange in which the inflections of mechanically registered curves compelled assent or dissent in a similarly automatic fashion. "Let us keep for other needs the insinuations of eloquence and the flowers of language," Marey asserted; "let us trace the curves of phenomena which we want to know and compare with one another; let us proceed in the manner of geometers among whom demonstrations are not discussed." [11]

Marey envisioned a more or less centralized system of communication in which the exchange of these curves would produce smooth disciplinary exchange of experimental results across institutional, international, and, ultimately, disciplinary boundaries. He invoked the example of meteorology, which had long been organized for international collaboration.

> Of this order are the graphics of meteorology, thanks to which the state of the atmosphere is expressed at the same moment throughout the whole extent of the civilized world. Each country sends its contingent of elements to construct the table of the whole: rainy or calm weather, barometric pressure, temperature, direction of the wind, etc., and it points on the map to the information furnished by each observatory. The dispatches arrive from all over, documents accumulate, pile up. Fear not that a confusion will be produced; far from that, the more complex are the elements, the more the ensemble appears simple. [12]

For Marey, the condition for the possibility of the graphic method as a simple, clear, and universal medium of scientific exchange derived not just from its logical clarity, but rather from its capacity to inscribe, and thereby represent, mechanical work, or energy. Over and over again, Marey explained how the graphic recording served as an experimental cornerstone of much of the science that comprised the emerging thermodynamic worldview. [13] Unlike the calculus, which could only furnish a measure of work or energy in ideal cases where one knew the mass to be moved and the nature of the movement imparted to it, the self-registered curve furnished this measure directly, as it unfolded over the course of its movement. Indeed, Marey noted, the first person to use the graphic method in this way was none other than James Watt, inventor of the steam engine, whose technique had been perfected by a generation of mechanical engineers as a measure of the motive power of engines. Nearly a century later it remained "necessary to continue to extend this mode of the inscription of work and to introduce it everywhere where mechanical forces are in play . . . only the graphic method represents work

with the form under which it was produced." The inscription of work made sense because of a presumed analogy that obtained between all physical forces. "The analogy in question above which relates all physical forces to one another traces the plan after which one may proceed to the inscription of heat and electricity." The analogy of physical forces enabled the graph to become a universal language of science, as well as an emblem of energy itself.[14]

For many scientists, especially practitioners of the new disciplines of psychophysics, experimental psychology, or linguistics, the practical employment of the graphic method as a universal currency of exchange provoked an inquiry into a new conception of the subject, as a transducer of graphic signals. Ferdinand de Saussure famously rendered the subject as an effect of the language system, which in the first instance meant a receiver, transducer, and sender of vibratory acoustic signals. Gabriel Tarde amplified this perspective, arguing that "our senses give us, each according to its own special viewpoint, the statistics of the exterior universe. Their proper perceptions are, so to speak, their particular graphic tables. Each sensation, color, tone, taste, and so on is none other than a number, a collection of innumerable measures of vibration repeated as a whole by a single figure."[15] At the other end of Europe, Ernst Mach's work in psychophysics brought him to the similar conclusion that the epistemological subject dissolves irretrievably into the mechanical elements—sounds, colors, temperatures, pressures, spaces, times, and sensations of movement—that are experienced as sensation. Mach unsentimentally concluded that *"Das Ich ist unrettbar"* (the I is unsalvageable).[16]

If the notion of the irretrievable subject became a source of anguished concern for some, others exulted in the proposition that it might be replaceable—*unrettbar, aber doch ersetzbar*—by a new type of universal machine. In an 1879 article, Hall had already reported that scientists, impressed by the capacity of the graphic method to reduce all knowledge to motion in time and space, had come to foresee "the actualization of a universal self-mending, self-governing, self-reproducing, self-knowing machine."[17] For several decades, this foresight remained but a fantastical gleam in a few scientist's eyes, and fodder for spoofs such as Jarry's. But after 1918 this European imaginary took firm root on North American soil, where it embarked on an accelerated trajectory through servomechanisms and automated machinery toward its realization in a series of large-scale differential analyzers and analog computers of 1930s and 1940s. On the heels of these feats of technical engineering grew a new scientific movement—*cybernetics*—which sought to unify a variety of scientific disciplines through a more rigorous and mathematically sophisticated treatment of the graphic curve using new innovations in harmonic analysis. In the hands of researchers such as Norbert

Wiener, Arturo Rosenblueth, and John von Neumann, the focus shifted from the referent to the signifier, from the energy represented by the curve to the graphic wave itself as *message*. "The unifying idea of these diverse disciplines," Wiener wrote, "is the MESSAGE, and not any special apparatus acting on messages."[18] What had begun in the nineteeth century as an attempt to create a universalized model of energy science was transformed into a universal science of communication and control. The defining feature of the coming "age of communication and control," wrote Wiener, that which sets it off from "the age of steam engines" or "power engineering," was that in it "the main interest is not the economy of energy, but the accurate reproduction of signal."[19]

THE ONTOLOGY OF THE GRAPHIC IMAGE

Around 1800 a new species of scientific instrument appeared in the cabinets of natural philosophers, betokened by a new semantic marker. Apart from established suffixes for experimental apparatus ("-scope", and "-meter", for example), the "-graph" designated instruments that, as the Greek etymology suggests, could "write" or "draw."[20] The "-graphs" facilitated mechanical forms of writing or image making, generally with little or no intervention of the human hand and, in many cases, the capacity to produce multiple copies from an original.[21] These mechanical instruments for drawing, tracing, and inscribing entered the armamentarium of natural philosophy at the moment when the measuring apparatus acquired a new role, use, and representation among experimentalists.[22] Where eighteenth-century natural philosophers had relied on stringent rules of social organization, bodily regulation, and literary reportage to control experimental evidence, the turbulence of the revolutionary epoch made them look toward transferring the burden of credible testimony to the scientific instrument or machine. Rigorous attention was devoted to making the instrument a foolproof relay of natural processes, which were then communicated to the disembodied mind of the experimenter.[23] In some versions, the resulting inscriptions functioned as images of nature's ciphers, revealed to the philosophical adept.[24]

The new configuration of experimental inscription drew heavily upon the methods of manufacture, above all the indispensable techniques of copying, or mechanical reproduction. Copying, of course, had formed the basis for artisanal and industrial processes since the dawn of human history. Casting, molding, stamping, punching, die-casting, turning, and printing from surface or cavities all comprised a family of traditional procedures that became the focus for an explosion of industrial innovation. Many of the great ad-

vantages of steam-driven manufacture derived from the clever mechanization of these kinds of processes. Their principle "pervades a very large portion of all manufactures," wrote Charles Babbage in *Economy of Machinery and Manufactures*, "and is one upon which the cheapness of the articles produced seems greatly to depend."[25] The principle was simple: Great pains could be lavished upon the original, from which a potentially unlimited series could be reproduced, thus making possible unprecedented new economies.

The newfound and systematic attention to copying processes renewed an interest in their philosophical implications. In the industrial age manufacturers spoke of copying in two registers, one practical, the other theological. In the first instance, proper copying technique preserved metric relations within the object through the transmission, a virtue for standardizing machine components, but also vouchsafing verisimilitude between original and copy. For many British industrialists, the notion of copying underpinned the theological rationale for a manufacturing society. Traditionally, the arts of copying had often been enshrouded with an aura of magic or theological mystery.[26] The logic of the negative—wax to seal, cast to form, stone to print—carried with it the enigma of parentage, of the transmission of physical and, usually, optical resemblance to another object, upon which the imprint remained stored as memory.[27] Copying therefore referred not simply to a merely material process, but to a meeting of sensible surfaces, a matrix where internal properties and external regimes coincided. Hence, whether in its secular or theological formulations, copying or mechanical inscription signified an ontological relay, or in Andre Bazin's characterization of the photographic image, a "transference of reality from the thing to its reproduction."[28] This kind of rhetoric, in both its secular and theological versions, pervaded early accounts of photography and continued through the nineteenth century.[29]

Hence the power of the graphic recording instrument as a means of allowing nature's manufactory to produce its own images unimpeded by complicated steps of intervention. Although there had been a few examples of automatic recording instruments, the one that gripped the imagination of scientists and engineers came from the workshop of James Watt. Looking to find a foolproof means of measuring the duty, or work performed, of his steam engines, James Watt tried several techniques before settling upon the ingenious technique developed by his assistant John Southern of mechanically tracing the movements of the piston inside the cylinder of the engine. The Watt indicator diagram, as the instrument became known, consisted of a cylinder in communication with the motor, which contained a piston balanced between the steam pressure and a spring coil (figure 7.1). Affixed to the piston rod was a pencil and registering apparatus made from a piece of

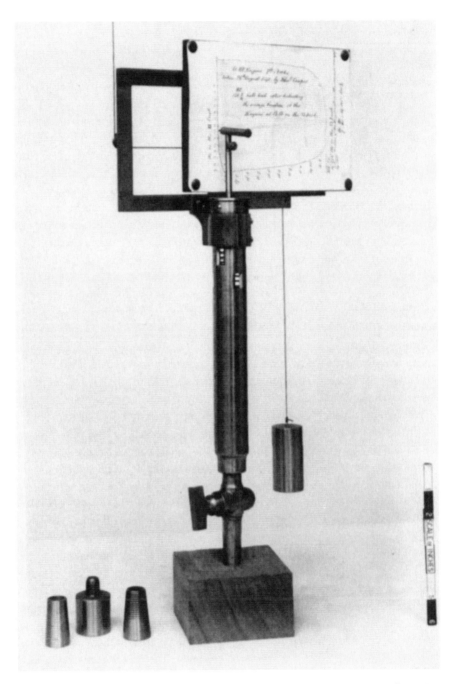

FIGURE 7.1. James Watt indicator diagram. Source: Science & Society Picture Library, Science Museum, London.

paper attached to a small board, whose displacements were proportional to the volumes created by the piston.[30] The loop-shaped line traced out by the stylus was set against two coordinates that plotted a graph showing the relation between the pressure in the cylinder and displacement of the piston.

The Watt apparatus thus became one of the first devices to rely upon a graphic copying process to record on one surface the memory of the actions of another. The engineers used the curve in two distinct ways. The most important was to determine, at any instant of time and under any given circumstances, the actual power of the engine, gauged as a work-integral. By measuring the area under the curve geometrically, the engineer obtained a figure directly proportional to the work developed by the engine when the indication was taken. Provided the engine ran continuously at a constant speed and that the number of revolutions and the length of stroke were known, a remarkably precise determination of *"laboring force,"* later called "work" and eventually, "energy," could be achieved.

The second use of the indicator diagram enabled engineers to examine the shape of the curve to determine any perturbations or disturbances, any pathological deviations, in the normal functioning of the engine. It allowed the engineer to discover, for example, whether there were any defects in those parts of the machinery by which the steam is admitted to the piston. By inspecting the trace for irregularities, it could be determined, for example, whether the slides were properly set or whether the steam-ports were large enough, a defect that might even suggest that a different arrangement of the working parts of the machinery would be advisable. This was the *observational* function of the device, its capacity to render visible remote regions within the machine or occurrences too fleeting for unaided inspection.

When the indicator diagram became public in the 1820s, after decades of remaining a closely guarded industrial secret, several French engineers seized upon it fervently as the solution to several recalcitrant problems. For Restoration engineers trained at the Ecole Polytechnique, the prevailing problems were defined within the framework of the system of practical mechanics and descriptive geometry of Gaspard Monge. Throughout the revolutionary epoch, Monge promoted descriptive geometry as a universal language of industry, linking artisans and engineering elites, articulating the boundary area between theory and practice, and enabling the mechanization of operations performed within specific trades.[31] For engineers increasingly concerned with representing dynamical phenomena, Monge's descriptive geometry offered helpful techniques, but ultimately fell short of the precision required for the new steam-powered industrial systems.[32]

Throughout the 1820s, French engineers struggled with, in the words of one of the most influential treatises on power engineering, "the necessity to

establish a type of *mechanical currency* (*monnaie mécanique*), if one can speak thus, with which one can establish the quantity of work employed in executing all sorts of manufacture."[33] The term "mechanical currency" simultaneously invoked the physical and economic resonances of the notion of work, or labor-value, positing a kind of universal equivalent that might serve as a medium of exchange between "the businessman and the capitalist" and the engineers in gauging the power of engines.[34] Jean-Victor Poncelet, Professor at the United Artillery Engineering School in Metz, reckoned this measure in terms of the vertical elevation of a heavy body: "This definition and this measure of mechanical work conforms with the way in which, in the arts, all works are paid in relation to the vertical elevation of loads."[35] Contemplating Watt's method of graphic registration, Poncelet recognized that it provided the solution to the desideratum of a practical measure of work. Like the definition in terms of falling bodies, the graphic method measured work as the product of effort and the distance through which it is exerted: force x distance instead of force x time. This set the measure apart from existing measures taken with balance instruments, like the spring dynamometer, which measured only the quantity of motion or effect of the work done. This was easily achieved by plotting the curve of movement against a coordinate grid in which the spaces traversed would serve as the abscissa, the flow of time the ordinate. The instrument, then, would involve combining the continuous uniform movement of a stylus or plate with the object whose motion one wished to measure.

Poncelet, together with his Metz colleague and fellow *polytechnicien*, Arthur Morin, immediately began building all sorts of self-recording dynamometers for use in a variety of industrial and experimental situations. Much of the universalizing ambition of descriptive geometry now became materialized in the instruments, whose domain of potential application would prove as broad as mechanics itself. Dynamometers for steam engines improved upon the Watt indicator diagram; others measured the work expended with contrivances drawn by animals or locomotives on roads of different constructions; some were used for ballistics experiments, to measure air resistance or the trajectory and penetration of projectiles, or the recoil of cannons; some measured the relative elasticity of materials of various kinds.[36] These problems of practical physics formed the constellation of problems that would find their theoretical expression in the new sciences of energy.[37]

Poncelet and Morin proselytized far and wide for the new instruments. Demonstration devices displaying graphic recording of the law of falling bodies placed in French lycées would inculcate the principle of mechanical work as a "self-evident axiom" for every schoolboy. At the same time, they campaigned (unsuccessfully) to have the graphical measure of mechanical

work adopted as a legislative measure. Noting just how much confusion reigned among legislators deliberating on the values of roads, bridges, canals, and railways, or among agriculturalists considering investments in equipment, Morin suggested that the new measure of work, "founded on well-established experimental bases," might clarify calculations of the utility of public works projects and to enable industrialists to trade in the currency of labor value.[38] The engineer observed that although the measure of horsepower found widespread service as a conventional unit of measure, it "has no legal value, and it would be great to desire that a legislative measure that could give that character, since it is *the currency of industrial work [la monnaie du travail industriel]*."[39]

Self-recording instruments thus entailed a new method of mechanical surveillance. Scientists frequently formalized the new invigilation in regimes of training, setting down rules and protocols to ensure the rigor and purity of the observation. Many such protocols formed part of a broader strategy to replace, wherever possible, human agency with machine-like figures, or better, machines themselves. Morin routinely appended to his descriptions of apparatus a *mémoire* that linked his method to Watt's indicator diagram, and outlined a broader philosophy of automatic registration and its application to all types of inanimate and animate motors. Protocols stipulated the conditions required to make the instrument properly *self*-recording, that is, capable of measuring the continuous physical quantities within the apparatus itself, without mechanical or human interference. The sensibility of the instrument, for example, had to be proportional to the efforts being measured, at every point in its temporal course, and had to remain unaltered by usage. These conditions ensured that the operations performed within the apparatus could safely be regarded as analogous or homeomorphic to the phenomenon being recorded.[40]

Self-recording instruments, Morin emphasized, must furnish indications "in a manner independent of the attention, of the will or of the prejudices of the observer."[41] Here the engineer invoked the relentless nineteenth-century drive to police the individual will and its propensity to error with mechanical protocols. Lorraine Daston and Peter Galison label this impulse *mechanical objectivity,* and argue compellingly that it represents not merely an epistemological guarantee, but a broader moral vision.[42] Mechanical objectivity, they contend, pitted the virtues of the machine against the vices of human nature, and bestowed moral authority upon those who understood the difference. With the image of the machine older, deeper Christian ascetic ideals of self-discipline and restraint became transformed into modern, secular values, which prepared the scientist to receive Nature's inscriptions. "Nature speaks to those who know how to interrogate her," read the mantra that

adorned Morin's treatises on his instruments. Nature's voice spoke best through the machine in the primordial, preverbal idiom of images.

THE INSTRUMENTS OF SCIENTIFIC MODERNISM

Like the Renaissance invention of linear perspective, which unleashed decades of efforts by artisan-engineers to bring ever-new artifacts within the new representational conventions, the Poncelet-Morin instruments gave rise to similar attempts to render diverse phenomena through the graphic method. Over the next several decades, enterprising disciplinary practitioners adapted the graphic method to the needs of a surprising range of scientific and practical disciplines. In almost every instance the importation of the graphic method brought with it the core representational, epistemological, and moral values assigned it by Poncelet and Morin: the concept of work or energy, mechanical observation, and universal communication. But the exchange worked in the other direction as well. Each new disciplinary application added to or augmented the growing complex around the graphic method, until by the turn of the century it had accreted a set of distinctive elements: a practical mathematics, a technological complex, an observation language, an embodied subject, a representational art, and a moral and political imaginary. This section briefly examines several cases of application, in order to make manifest some of the ways this occurred.

The Poncelet-Morin instruments attracted immediate attention around Europe in many quarters of scientific and engineering research and inspired numerous attempts to improve them or adapt them to a variety of purposes. One of the most important adaptations of the instruments came at the hands of several young German physiologists, who quickly devised modifications of the instruments suitable for registering physiological functions such as muscular action, circulation, and respiration. Carl Ludwig produced the most important of these devices, the kymograph, by adding a self-registering component to a hemodynamometer (blood pressure recorder) used by a French engineer-physician to measure arterial pulse. Hermann Helmholtz, a young medical doctor with interests in physics and physiology, similarly modified devices that had been used to measure muscular effort to measure the "energy" of the muscle (work done) along the ordinate, which unfolded in the "time-spaces" (*Zeiträume*) represented along the abscissa.[43] With the new instruments, Helmholtz succeeded in articulating "a close connection between both the fundamental questions of engineering and the fundamental questions of physiology with the conservation of force."[44] In the words of his close colleague Emil Du Bois-Reymond, this meant that for physio-

logical experimentation the "proper form of physiological representation should be a curve: the dependence of the effect on each condition presents itself in the form of a curve, whose exact law remains, to be sure, unknown, but whose general character one will be able in most cases to trace."[45]

It was just these sorts of analogies between a variety of phenomena considered as graphic waveforms that captured the imagination of Etienne-Jules Marey.[46] The French physiologist, who spoke of himself as an engineer *manqué*, made a career of developing and promoting the graphic method not only in his own field, but across the full range of scientific disciplines. Marey advanced a post-lapsarian image of nineteenth-century science, with scientific disciplines having fallen deeper into a mutually incomprehensible Tower of Babel-like isolation.[47] In part, this was a problem of the science's international character and the preference of scientists to write in their own languages. But it also resulted from the division of labor, the manifest gains of which became lost when "the scientist specializes . . . and the horizons of each retract." The answer lay in the new Adamic language of the graphic method, which offered not only clarity, but represented all results as energy relations, the "language of the phenomena themselves."[48]

Marey endeavored to realize the grand universalist vision of graphic inscription through very mundane and particular means. Innumerable graphic registration devices sprung from his trusty hands, including not only the famous instruments of chronophotography and cinematography, but also key components of self-recording apparatus, such as the Marey tambour, a diaphragm that enabled the capture and amplification of even the most delicate of movements. Marey imagined these components as mechanical analogs of human sentience, models of the ways in which functional activity cut channels deep into the organism. In many instances, the instruments effectively turned the body inside out, producing a freestanding, functional double of human functions. Marey's physiological recording devices duplicated the body's own arterial structure in the tube used to transmit the pulse signal (figures 7.2 and 7.3). Similarly, the receptive components of the apparatus, first the Marey tambour (the skin), then the elastic tubes (here acting as nerves), and the smoked drum or paper (memory), could all be said to stand in for different components of the sensory functions of an observer. Self-recording instruments, Marey contended, functioned not as prosthetic devices, not as amplifications of existing senses in the way of a microscope, telescope, or stethoscope, but "like new senses," possessing "their own domain," standing over against the human observer, and constituting "their own field of investigation."[49] This was the domain of energy, of forces; uniquely adapted to this realm, graphic registration instruments captured the phenomena "from within" and "under the form in which they are produced."[50]

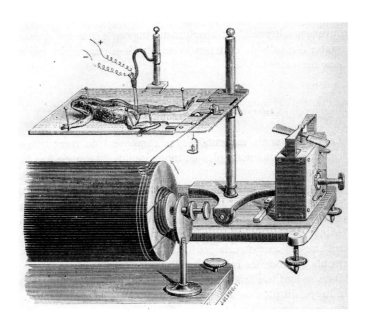

FIGURE 7.2. Myograph. Source: E. J. Marey, *La méthode graphique en sciences expérimentales* (Paris, 1878), p. 194.

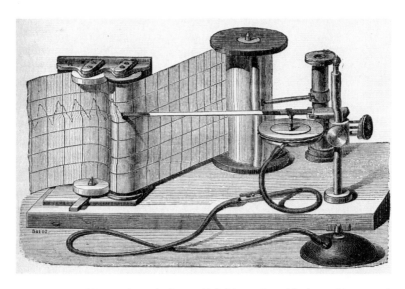

FIGURE 7.3. Marey polygraph. Source: E. J. Marey, *La méthode graphique en sciences expérimentales* (Paris, 1878), p. 457.

Human subjects fell out of the picture, except as provisional operators of the machine, a technical necessity unlikely to last. Marey eschewed epistemological reflection on these matters, but Joel Snyder has persuasively argued that the absence of the human subject underwrote a notion of objectivity implicit in many of Marey's statements. The task of sorting out the philosophical implications of this fell to others, such as Ernst Mach, who had also written the most thoroughgoing account of the physics of the sphygmograph.[51]

Regardless of his precise philosophical position, Marey followed the French engineers in championing the instruments of graphic recording as an impartial, public measure suitable to the rising culture of technoscientific expertise characteristic of the early French Third Republic. Marey touted his Paris laboratory as a place where disciplinary practitioners of all kinds could come and acquire training in the methods of graphic recording, an endeavor that would advance both the cause of specialization and a broader interdisciplinary culture of expertise. His numerous collaborations helped establish the graphic method across a broad spectrum of scientific research programs, both in France and abroad.

One of the most fruitful collaborations to emerge from Marey's laboratory brought the physiologist together with several key figures in the new discipline of scientific linguistics. In 1874, Marey began collaborative work on the graphic recording of vocalization with his College de France colleague, the professor of linguistics Michel Bréal and another member of the Paris Societé de linguistique, the expert on deaf-mutism Charles Rosapelly (figure 7.4). In its technical aspects this work paralleled the similar work of Edison, which resulted in the invention of the phonograph in 1877. But Marey and Bréal had scientific rather than commercial aims, specifically to give new laboratory foundations to the science of linguistics, and to thereby overturn the dominance of German philology.[52]

Their graphic studies of vocalization played an indispensable role in the formation of modern linguistics, especially the system developed by Bréal's protegé Ferdinand de Saussure.[53] They rendered fleeting and unseen phenomena of speech as a materialized and visible object. The *image vocale*, in Bréal's terminology, or the *image acoustique*, as Saussure called it, served to codify the concept of the elementary linguistic signal, or phoneme, the key notion for the constitution of the modern science of linguistics.[54] Saussure remained unequivocal in his treatment of the acoustic image as a graphic representation. "The linguistic signal," he asserted, "being acoustic in nature, has a temporal aspect, and hence certain temporal characteristics: (a) it occupies a certain temporal space, and (b) this space is measured in just one dimension: it is a line."[55] The material signifier or acoustic image (Saussure

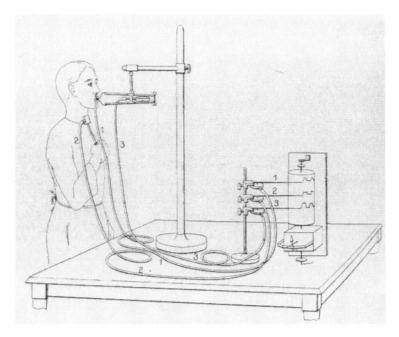

FIGURE 7.4. Marey-Rosapelly vocal polygraph. Source: Charles Rosapelly, "Inscription des Mouvements Phonétiques," *Travaux du Laboratoire de M. Marey* (Paris, 1875).

habitually spoke of these as one) became transformed into a circuit model of communication in which words or verbal messages are exchanged, put across, got over, sent, passed on, received, and taken in.

Saussure credited his break with a referential, correspondence picture of language to the graphic inscription of speech. "The first linguists," he explained, "who knew nothing of the physiology of articulated sound constantly fell into pitfalls. For them, letting go of the letter meant losing their footing. For us, it means taking a step toward the truth." [56] The graphic phonetic studies assessed precise metrological values to speech. These enabled him to formulate his famous break with a correspondence theory of language and its replacement with a conception of a living language as a vast array of relative and contrasting acoustic images, distinguished from one another by measurable degrees of difference. The acoustic image enabled Saussure to define a fundamental unit of linguistic analysis: the phoneme, defined as phonetically similar but slightly different sounds (pin, spin, tip). The ear and brain—armed with a stock of phonic imprints—analyzed acoustically the sound images which self-registering instruments placed before the eyes. Ultimately, Saussure was less interested in the psychophysics of speech than in the

effects of these processes for linguistic understanding. Nevertheless, the material conditions of speech conditioned every aspect of the language system.

The collaboration between Marey and the linguists stimulated a welter of investigations by French scientists into the graphic curves produced by sensory and psychophysical functions. One of the most remarkable research programs came from the eccentric polymath Charles Henry, a historian of mathematics, Sanskritist, and experimental psychologist with close personal ties to members of the artistic avant-garde. Around 1885 Henry began publishing the elements of a new "scientific aesthetic," a reformulation of the aesthetic ideas of Humbert de Superville, Hoene de Wronski, and Charles Blanc as problems amenable to laboratory investigation using the methods and instruments of Marey, Helmholtz, Wilhelm Wundt, Gustav Theodor Fechner, and others. Henry sought to generalize Fechner's discovery that the ratio of .618 . . . , known since ancient times as the "golden section," indeed produced a harmonious effect on observers, though for psychophysical rather than metaphysical reasons. Henry hypothesized that there should be a range of other aesthetic effects that could be determined with the techniques of psycho-physiology, using principles derived from Helmholtz and Wundt, such as the law of least effort, the principles of the orientation of the eye, and the method of expression, which used graphic registration to record feelings of pleasure and pain, or excitement and inhibition. Henry argued that a working knowledge of these principles, coupled with a series of measuring instruments of his design, would aid artists in problems of composition and give them greater control over the aesthetic effects their works produced on the beholder.[57]

Henry rooted his psychophysical technique in the graphic method of representing energy relationships through movements. "By the graphic method," he wrote, "all phenomena are translatable by the changes of direction automatically registered . . . this is the course to be followed if one wants to know the aesthetic of things and it is probable that the results will go beyond the scope of aesthetics . . . with the use of more and more delicate apparatus and more precise media of observation."[58] Because with the graphic method all sensory phenomena were in principle reducible to line, as sonorous waveforms, the lengths of luminous undulations, and so on, the artist or artisan, poet or musician—"all workers of the line," Henry wrote—could compose works based on constants and contrasts with known psychological effects. To facilitate these measures, Henry designed instruments, the Rapporteur ésthetique and the Cercle Chromatique—an aesthetic protractor printed on a translucent fabric and precision color wheel, respectively—to gauge the angles of virtually any sort of curve or the metric relations of any two shades of color. He also compiled catalogs of linear measures and their correspond-

ing values for inducing sensations of pleasure or pain, or excitement or inhibition.[59]

Among the artists who engaged Henry's scientific aesthetic, the most famous was Georges Seurat. The young painter attended Henry's lectures, studied his writings (along with the works of Helmholtz, Chevreul, Rood, and other scientists), and as his notebooks confirm, composed some of his late paintings with Henry's techniques of linear directions, angular motions, and their corresponding chromatic schemes in mind.[60] In his catalog for the exhibition *Georges Seurat, 1859–1891*, Robert Herbert questions the emphasis of earlier authors (including himself) on Henry's primacy for Seurat, since many of the same ideas could be found in earlier sources such as Charles Blanc and Humbert de Superville.[61] In my view, such discussions (and the earlier literature itself) place too much emphasis on ideas and treat science as if it were primarily an intellectual activity. By contrast, as I argue in this essay, science is often about materials and instruments first and ideas second. Like Seurat, Henry may have taken ideas from earlier thinkers about such things as directional lines, but his real contribution was the notion that theses were forms of "energy," and, hence, measurable with his instruments. Unlike the earlier aestheticians, Henry offered Seurat the imprimatur of science for such activities. But Seurat's late notebooks and correspondence also suggest that although he was privately exploring the Henry scientific aesthetic more thoroughly than ever, he remained publicly guarded and somewhat touchy about it. Seurat reacted with particular annoyance to charges that this mechanized method diminished the role of his own talent and education in the painting's execution. Seurat seems to have most feared the kind of reaction imagined by Thadée Natanson to his work, in which a visitor to an exhibition of Seurat's paintings overhears the query, "the paintings are done by machine?," to which the exhibition attendant replies, "No, Monsieur, by hand." [62]

Seurat apparently came to see the utopian promise of universal mechanization as increasingly problematic, as a reading of his last paintings—in both their technique and social narrative content—demonstrate.[63] On the one hand, Seurat's construction of his penultimate painting, "The High-Kick" [*Chahut*] resembles a Marey high-speed photograph of the dancer as a laboring or sportive body, a motif that underscores the sense of a mechanized perception of a fleeting instant, a metabolic exchange between energy and image (figure 7.5). On the one hand, the dancer's relation to the pig-headed bourgeois in the foreground raises questions about whether her quasi-mechanical performance engenders freedom or enslavement. In the formal reliance on the machine-like algorithms and in its content, Seurat raised the stakes on the anarchist principle of freedom from the will through the mech-

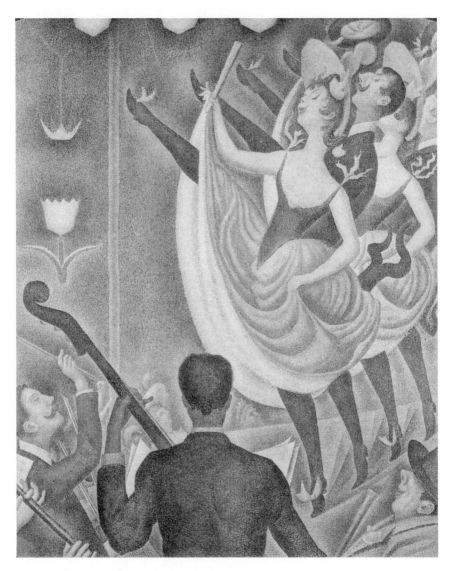

FIGURE 7.5. Georges Seurat, *Chahut* [High-Kick], c.1889–90. Oil on canvas, 66⅞ × 54¾. Source: Collection Kröller-Müller Museum, Otterlo, The Netherlands.

anization of labor, making the painting an examination of the conditions of its own possibility.[64]

These instances illustrate the extent to which a relatively unassuming class of artifacts underwrote the culture of science around 1900. There was no exaggeration or grandiosity in the inaugural lecture of a German professor that year, when he suggested that "in principle it would not be difficult to take stock of our entire knowledge by using the self-recording machines

and other automatic devices." There were, in fact, an increasing number of attempts to do just that, by building large-scale analog computing apparatus on the basis of automatic recording instruments. The emblematic machine of this type had been built by Lord Kelvin (William Thomson), the very person with whom Jarry's Faustroll communicated telepathically.

The real Thomson, long handy with indicator diagrams and dynamometers, sought to construct an apparatus that would not only record continuous natural phenomena, but would automatically perform the calculations necessary to integrate the resulting graphic waveform. Thomson's immediate problem derived from the problems of measuring tidal fluctuations, a problem to which a special committee of the British Association for the Advancement of Science had been formed. The physicist concerned himself with the harmonic motions in a line—different amplitudes, phases, and periods—described by Fourier analysis, which he regarded as "an indispensable instrument in the treatment of nearly every recondite question in modern physics."[65] The French physicist J. B. J. Fourier had shown in his *Théorie analytique de la chaleur* (1807) that any periodic vibration or motion, no matter how complicated, can be built up by the superposition of an appropriate number of simple harmonic curves. Fourier's analysis thus allowed all sorts of complex waveforms to be resolved into simpler curves based on the sines and cosines of trigonometry. Such curves were easily visualized and so, reasoned Thomson, with self-recording instruments, mechanizable, too. To this end, Thomson built an instrument for gauging, analyzing, and predicting the very archetype of waveform motion: the tides.[66] This device, the so-called tidal analyzer (figure 7.6), predicted not simply "the times and heights of high water, but the depths of water at any and every instant, showing them by a continuous curve, for a year, or for any number of years in advance."[67]

James Thomson, the physicist's brother, made the machine possible with an ingenious invention, the so-called disk-globe-and-cylinder integrator.[68] This device effectively mechanized the operation of the planimeter, making it possible to automatically evaluate the integrals required for harmonic analysis. "The object of this machine," William Thomson wrote, "is to substitute brass for brain in the great mechanical labour of calculating the elementary constituents of the whole tidal rise and fall."[69] With the "brass for brain" analogy, Thomson implicitly compared his machine to Charles Babbage's difference engine, the great failed attempt to mechanize the labor of computation.[70] Thomson's "analogue" computer succeeded, however; and he built several others following the tidal analyzer, with potential applications to a broad range of harmonic phenomena.[71] James Clerk Maxwell, after praising the labor-saving capacities of the Thomson analyzer, marveled over the range of problems to which the machine might be addressed.

FIGURE 7.6. William Thomson, tide predictor. Source: Science & Society Picture Library, Science Museum, London.

It would not be devoid of interest, had we opportunity for it, to trace the analogy between these mathematical and mechanical methods of harmonic analysis and the dynamical processes which go on when a compound ray of light is analyzed into its simple vibrations by a prism, when a particular overtone is selected from a complex tune by a resonator, and when the enormously complicated sound-wave of an orchestra, or even the discordant clamours of a crowd, are interpreted into intelligible music or language by the attentive listener, armed with the harp of three thousand strings, the resonance of which, as it hangs in the gateway of his ear, discriminates the multifold components of the waves of the aerial ocean.[72]

Maxwell's remarks signaled the enormous promise of analog computing. A welter of similar devices followed in the wake of the Thomson apparatus, including Albert Michelson's remarkable harmonic analyzer, and a monumental tidal analyzer built by the U.S. Coast and Geodetic Survey, dubbed "the giant brain," built on the eve of the First World War.[73] These would serve as the prototype for a range of servomechanisms and differential analyzers—hence, most computers—until the Second World War, including those upon which the work of the cybernetics movement was launched.[74]

CODA: FROM ENERGY TO INFORMATION

Through these kinds of analog computing machines, the complex of graphic recording instruments reached its apotheosis on the eve of the Second World War. During the 1920s and 1930s servomechanisms and automatic integrating apparatuses based on graphic recorders proliferated, culminating in some of the key technological innovations of the war, when, in Peter Galison's words, "servomechanical theory would become the measure of man." [75] For the most part, the history of cybernetics has been seen through the lens of the revolution that occurred just after World War II in electronic digital computers and information theory. This historiography, although often illuminating, treats cybernetics as a beginning rather than an endpoint of history, and the conditions of the passage from energy to information thereby remain enclosed in the proverbial cybernetic black-box. An alternative analysis of the transition, by contrast, would require detailed attention to the pre-war collaborations from which the war efforts derived, which, to simplify only slightly, centered on developing the graphic method complex, especially the instrumental technologies of analog computers such as Vannevar Bush's differential analyzer and a host of theoretical concerns centering on the harmonic analysis of wave-form phenomena.

The differential analyzer—both the existing versions and the projected ones—established the discursive medium for the proto-cybernetic investigations, determining the field of possibilities and limitations in what could be thought, visualized, enunciated, and represented (figure 7.7). Bush's project grew out of attempts of the research laboratory of MIT's electrical engineering department to develop methods for handling the refractory equations generated by telephone lines and long-distance power networks. As Larry Owens has shown, he came to the problem using the familiar graphic methods of early twentieth-century engineering, having even built a graphic recording instrument for his master's thesis. [76] Bush put several graduate students onto the problem of building devices modeled on Thomson's disc-globe-and-cylinder integrators as a means of coming to grips with the complex equations. A series of devices, called product integraphs, followed, meeting all expectations, and inspiring a more ambitious device using electrical as well as mechanical components. [77] That machine is the differential analyzer, a long table-like frame arrayed with interconnectible shafts, a series of six disc integrators and drawing boards. It was ingeniously contrived to convert the rotations of shafts one into another in several different ways. The change of variables in an equation were linked to the rotation of shafts, which enabled the calculator to add, subtract, multiply, divide, and integrate. Through these mechanisms the differential analyzer functioned as mechanical model of the

FIGURE 7.7. Vannevar Bush and the differential analyzer. Source: National Museum of the History of Technology, Smithsonian Institution, Washington, D.C.

differential equation, kinetically acting it out through an elegant and dynamical arrangement of parts.[78]

Meanwhile, several of Bush's students and colleagues explored the engineering applications of the new machine, developing an entirely new genre of servomechanisms, which used an amplified graphic signal to continuous, "closed-cycle" control, directing other machinery in accordance with the changes of line. Until this time servos were usually some sort of gyroscopic instrument, because it remained extremely difficult to deliver an appreciable quantity of force or power and give usefully accurate indications. H. L. Hazen, one of Bush's key associates, devised a method to do that, using an electrical method to accomplish the task of the Thomson integrator, producing a machine which, in the words of a popular account, "follows a line like a hound following a trail."[79] Not only would the new servomechanisms yield a welter of industrial and technological applications, from factory automation to steering ships and controlling guns, they would begin a new theoreti-

cal reflection on the nature of servomechanisms that would stand at the center of cybernetics under the rubric of feedback.[80] Although the task of the new devices remained the recording, transmission, and direction of energy, they enabled a new degree of freedom to consider the nature of the signal in some abstraction from the constraints of the material support. The technological crossover from energy to information was accomplished in an analog format.

The full instantiation of the possibilities of digital computers did not come about immediately, of course; in many respects they are still in the making. Only with parallel processing in the 1980s has digitality begun to vanquish the linear problematics that graphical and analog machines materialized. Yet, as the last vestiges of the graphical–analog configuration vanish in the accelerating crush of discontinuous bits of information, the utopian dreams encoded within graphical recording ironically rouse a wistful nostalgia, a redemptive yearning for the universal meanings that Faustroll found in the convexities and concavities of a continuous line.

Concerning the Line: Music, Noise, and Phonography

DOUGLAS KAHN

Within the history of Western art music, the determination of extramusicality rested not in a hard and fast materiality but in the power of musical practice and discourse to negotiate which sonorous materials would be incorporated from a world of sounds, including the sounds of its own making, and how.[1] In the latter half of the nineteenth century, this task was aided by acoustics, itself still closely associated with that science known as music. At the same time, acoustics was separating itself from music by using new techniques of *visible sound* derived from graphic techniques and automatic recording instruments. Although they were to become increasingly alienated, acoustics and Western art music were both in the business of determining what was music and what was noise. Sometimes they agreed and sometimes they did not, but they were always complementary. Two *lines* played an important role in this determination—the graphic line, whether it be visible or figurative, inscribed by hand, mind, machine, or nature; and the conceptual dividing line between noise and music, that is, between sound and musical sound.

The line between sound and musical sound ran straight through avant-garde music, supplying a heraldic moment of transgression and its artistic raw material, a border that had to be crossed to bring back unexploited resources, restock the coffers of musical materiality, and rejuvenate Western art music. In order to make extramusical material musical, the sounds of the world were processed in numerous ways. First, the sounds of the world were to be categorized, explicitly or implicitly, into referential *sounds* and nonreferential *noises*, such that a noise could be incorporated into the nonreferential operations of music. For the avant-garde, there was an operative exchange between the distinctions of sound versus musical sound from the perspective of music, and the distinctions of sound versus noises within the sphere of extramusicality, whereby the *sound* of the former was recuperated through the *noises* of the latter. A remainder of sound was usually dismissed as *imitative* during this time. Second, these privileged *noises* of the sphere of extramusicality would align themselves with already existing musical attributes and elements, such as dissonance, timbre, and percussion. Third, these

noisy correspondences within music were emphasized as themselves bearing traces of the world of true extramusicality; this was the basis of *resident noises*. Fourth, sounds were technologically selected or manipulated to render them suitable as musical material, as in phonographic practices such as *musique concrète*. And finally, sounds were processed through the operations of aurality, a feature of John Cage's dictum to *hear sounds in themselves*. The underlying presumption was that the nature of music was sonic, therefore the importation of worldly sounds into music meant diminishing or eradicating sounds that were too significant, too referential. Most importantly, this process displaced significance to music itself, such that the most common way to make noise significant was to make it music, but by doing so the significance of sounds were rendered insignificant.

This modernist resolve against the mimetic ran up against the changed conditions of aurality in the latter half of the nineteenth century, represented most importantly by phonography, the mimesis machine, which incorporated all classes of sounds. By *phonography*, I mean the phonograph as the technological device for recording and reproducing sound (including phonautographic and visible sound practices, technologies predating and paralleling the specific inventions of Charles Cros and Thomas Alva Edison, as well as the later developments of optical sound film and other technologies). But I also mean phonography as an emblem for a dramatic shift at that time in ideas regarding sound, aurality, and reality. Phonography was associated with a number of crucial developments: It foregrounded the parameters of *a sound* and *all sound*, presented the possibility of incorporating all sound into cultural forms, shifted cultural practices away from a privileging of utterance toward a greater inclusion of audition, placed the selfsame voice of presence into the contaminated realm of writing, and linked textuality and literacy with sound through inscriptive practices.

The promise of phonography, before and after the actuality of the phonograph, added another player to older discourses and practices based upon musical technologies. When it pointed more toward the production and not the reproduction of music, phonography necessarily invoked the world of *all sound*. The pressure of worldly sound brought to bear upon musical practice was exacerbated in the 1920s with the marked development of auditive technologies and institutions, improvements in microphony, the phonograph, and the development of sound film, as practiced within music, radio and cinema. Dramatically new approaches to sound began to materialize.

In order to move through the entanglements of Western art music, noise and phonography, in this essay I concentrate on the inscriptive practices involved through the concentrated figure of the *line*. The line can draw the boundary between musical sound and noise by being the threshold at which

too much of the world is detected. In this way the line is a sonic buffer, a silencing device. The line can also inhere in the world of all sound written in the jagged line at the end of a phonographic needle, transmuted from its attenuated state to make the world thicker with sound in its repetition. Or the line can do both, remaining within music or demarcating music from the world while suffused with its own plenitude.

FOLLOWING THE COSMOS TO THE LETTER

Historically, lines of sound have been called upon to be much more than what they initially appear to be. The best early example is the single string of the Pythagorean monochord, which vibrated in accord with the cosmos ever since the Pythagorean narrator at the end of Plato's *Republic* joined music to the motion of the celestial spheres. Pythagorean ideas of the universe and music, mediated through mathematics (if at times only simple proportionality or the unconscious musical math of Leibniz), have had a remarkable longevity through the ages. Central among these ideas was that the cosmos assumes harmonious proportions, tonalities, and as we shall see, periodic frequencies. It did not matter that in the lore of Pythagoras his own music was never without words and sounded strange to the tastes of the day, or that his insight into the mathematical basis of music was sparked by the percussive sounds of a blacksmith's hammers. By the nineteenth century, Pythagoreanism in music came to mean instrumental music with a high regard for consonance and little regard for percussion; gone was the lore of the resonance of the single string. The legacy of neo-Pythagoreanism within modernism, however, has been fairly peculiar, both as it pertains to notions of the breadth of *all-sound* and to the capability of a line to represent many attributes of the world, including a range of sounds.[2]

Beginning in the late eighteenth century and pervading the nineteenth century, three new inscriptive practices as applied to sound—graphical techniques in general, visible sound techniques, and automatic recording instruments as represented by the phonautograph and phonography—contributed to a loosening up of the reliance of acoustics upon music. A plethora of lines made sound tangible and textual by making the invisible visible and holding the time of sound still. There had been older means of the visualization of sound, but these were fundamentally transformed.

The concentric rings on the surface of water, which since antiquity had provided a visual analog in time for advancing spheres of sound within the air,[3] gave way in 1785 to the inscriptive stasis and intricacy of Chladni's sound figures of sand on the surface of plates (figure 8.1), and subsequently

FIGURE 8.1. Chladni plate with vibration pattern in sand. Source: A. Privat-Deschanel, *Traité élémentaire de physique* (Paris, 1869), p. 793.

to other instrumental means for tracking and trapping time. Technologically, the string of the Pythagorean monochord, which through its production of a mathematics had vibrationally, spatially, and harmonically structured the cosmos, gave way to the inscription of the wavering line of automatic recording technologies. Of early importance was Édouard-Léon Scott's phonautograph, which inscribed sound wave impressions on lamp-black, but, unlike the later phonograph, could not replay these inscriptions. Phonautography brought sound once and for all down from its literally astronomical and inaudible heights in the music of the spheres, to physically etch actually audible events onto surfaces, on the surface of the earth.

Scott's phonautograph may have notched the scope of sounds down from the cosmos to the earth, but he still wanted the entire earth at the end of a stylus. For Scott, phonautographic inscriptions were to be the stenographic, if not hieroglyphic, means to "force nature to constitute herself a general written language of all sounds."[4] Noise abatement among inscriptive practices actually persisted from earlier traditions. Whether a stone was thrown into the water by Vitruvius in the last century B.C. or by Helmholtz in the nineteenth century, it was, in effect, an act of percussion graphically muted by surface tension and rendered in regular wave patterns. The earliest auto-

matic recording instruments (and this included the general class of instruments not applied to sound, e.g., the James Watts indicator diagram) and other early visual sound technologies valued mellifluence and repetition through time over sounds of short duration, let alone the momentary noise of percussion. Sounds were sustained through the continuity of bowing, vocalization, or the rotary motion of instrumental cranks registered upon rotating recording surfaces. By these very actions, musical tones and vowels were privileged. All of this was in place prior to the advent of Edison's phonograph in 1877. Phonography revived these ideas and codified them in the practice of actual audibility. Instead of the delimited range of elite utterances informing neo-Pythagoreanism, the comprehensive range of sounds heard by the workaday rumblings of the speaking machine (it was, after all, also a listening machine) gave credence to claims of *all-sound*. Because every sound fell amid this plenitude, noises and their provocations within culture were subject to more elaborate negotiations.

When the modernist arts engaged these inscriptive techniques, the fecund and discriminating capabilities of the single string were carried over to invest the single line of inscription with unlimited signs of life, and with the function to demarcate boundaries among the arts. The line, in other words, should not immediately be understood as enacting reduction upon a richer reality, because from the perspective of the line itself, there was so much it could contain. Whether parodic or deeply serious, the perceived ability to encode incredibly complex phenomena simply overrode the reduction of phenomenal complexity. The intensification of inscription was nowhere as pronounced as in instances involving a simple line, as opposed to the accumulation of simple lines arrayed in an alphabetic system that could be grouped, read, and written, or an array of lines topographically extended into a space.

Alfred Jarry was particularly interested in such a line to assist him with the Rabelaisian density of his *Exploits and Opinions of Doctor Faustroll, Pataphysician* (posthumously published in 1911). Toward the end of the story, the itinerant Faustroll drowns after his sieve boat fails: The water "swirled hissing around their feet, with a noise opposite to the deglutition of an emptying bathtub."[5] In the next chapter, entitled "Concerning the Line," his soggy corpse becomes but a simple "letter from God" open to a profound reading by the Marine Bishop who "remembered that, following the proposition of the learned Professor Cayley, a single curve drawn in chalk on a blackboard two and a half meters long can detail all the atmospheres of a season, all the cases of an epidemic, all the haggling of the hosiers of every town, the phrases and pitches of all the sounds of all the instruments and of all the voices of a hundred singers and two hundred musicians, together with the phases, according to the position of each listener or participant, which

the ear is unable to seize." If so much could be unraveled from one line, what could one expect then from "the wallpaper of Faustroll's body . . . unrolled by the saliva and teeth of the water," like a musical score? Nothing less than "all art and all science were written in the curves of the limbs of ultrasexagenarian ephebe, and their progression to an infinite degree was prophesied therein." [6]

Jarry's passage was generated in part through a parody of Sir William Thomson (Lord Kelvin). His *Popular Lectures and Addresses* contain an 1883 address entitled "The Six Gateways of Knowledge." [7] The gateways of knowledge are the senses, the sixth one being the result of breaking the sense of touch into the sense of heat and the sense of force. The gateways do not fully discriminate among perceptual functions; for instance, sound does not just enter the gateway of hearing, it can also be perceived through the sense of force. To this end, Thomson gives the example of how "the greatest master of sound"—Beethoven—"used to stand with a stick pressed against the piano and touching his teeth" (271). In fact, Thomson makes the argument that "all the senses are related to force," and in particular, "the sense of sound . . . is merely a sense of very rapid changes of air-pressure (which is force) on the drum of the ear" (297). In a graphic rendering of sound, time is the independent variable and air pressure is the function; indeed, only the slowness in the variation of barometric pressure prevents it from being heard. Ostensibly, within the progress of Thomson's text, this would be a demonstration where all other complications are eliminated such that a range of complications in air pressure could alone be observed (282–83), but it becomes instead an adulation of "the potency of mathematics" (284) to represent complex phenomena with the simplicity of a line. In the process, the air pressure complications that might give rise to a representation of noise are never entertained; noise is here deferred or forever postponed, lost to a fascination with mathematics. This was no oversight, because Thomson repeats the requisite formulation for so many treatises on music and acoustics: musical sounds are periodic, noises are aperiodic, and although they meet at certain junctures for cultural reasons, they are fundamentally distinct by dint of physics (278–79). As he says in another context, following Lord Palmerston, "Dirt is matter in its wrong place" (460).

Enter into Thomson's text Professor Cayley, the mathematician who demonstrated in a lecture the ability of a simple curve to represent the price of cotton over time, or to graph mortality over the course of a plague (drawing on the legacy of William Playfair and his *Commercial and Political Atlas* of 1785, the same year Chladni announced his sound figures). For Thomson, this was applicable to musical sound, where a "single curve, drawn in the manner of the curve of prices of cotton, describes all that the ear can possibly

hear," whether it might be the "single note of the most delicate sound of a flute" or "the crash of an orchestra" (282). The latter most excited him: A complicated sound might be "less distinctly periodic," but the "superposition of the different effects is really a marvel of marvels" (282–283) in the way that the linear subsumption of complexity can result in such simplicity. Such complexity is compounded by what the composer writes, the subtleties of interpretation given by each instrumentalist in an orchestra of one hundred instruments, along with two hundred voices of a chorus singing along with the orchestra. Of course, it becomes tautological that the subsumed complexity of music will produce a simple line and not the fractured line of noise, that is, "not music." Consequently, the *power of mathematics*, the simplicity of graphical representation, and acoustical discourse within the framework of science at that time enforced cultural practice. Noise was eliminated and music bolstered within the given confines of musical sound.

RESIDENT NOISES

Like Lord Kelvin, Hermann Helmholtz had adherents among the arts, especially composers who had read his monumental study *On the Sensations of Tone*, or one of its popularizations. Two elements in the book were particularly influential: the delineation between noise and music and his use of specialized instruments and devices, especially sirens. Avant-garde composers reacted against the former with the idea of what I call here *resident noises*, while the same composers were interested in a more positive manner in the musical possibilities for the siren's generation of glissandi. Whether they agreed or disagreed really did not matter in the end, however, because the discursive and sonic use of noise and glissandi came to function similarly in relation to the sounds of the world and worldliness in general. The inscriptive characteristics of noise pertained to representations of waveforms, whereas those of the glissando were evident to the naked eye and ear, with the figure of the glissando easy to grasp in concept. Neither inscription needed elaboration into alphabetic form for purposes of articulation. Remembering that a deviation from periodicity and regularity or a breach of purity were all that was needed for noise to exist, its existence was tracked to every corner of music. The glissando was instead simplicity writ large, the revenge of regular waveform amplified to gigantic proportions.

Helmholtz was required to rid his study of noise from the outset: "Noises and musical tones may certainly intermingle in very various degrees, and pass insensibly into one another, but their extremes are widely separated." He directed his readers away from the noise and noisy figures of "the splashing of water . . . the splashing or seething of a waterfall or of the waves of

the sea" and directed their imagination instead to a stone dropped into calm water.[8]

The Italian futurist composer Luigi Russolo, who inaugurated avant-gardism in music with his *Art of Noises* manifesto (1913 and in a 1916 book of the same name), took exception to the cultural claims of acoustics: "Acoustical science, which is indubitably the least advanced of the physical sciences, is particularly applied to the study of pure sounds, and until now has completely neglected the study of noises. This is perhaps because it was thought that sounds must be sharply divided from noises—an absurd division . . . which has no reason to exist at all."[9] Russolo singled out Helmholtz in rejecting the neat division between sound and noise:

> *Sound* is [usually] defined as the result of a succession of regular and periodic vibrations. *Noise*, instead, is caused by motions that are irregular, as much in time as in intensity. "A musical sensation," says Helmholtz, "appears to the ear as a perfectly stable, uniform and invariable sound." But the quality of continuity that sound has with respect to noise, which seems instead fragmentary and irregular, is not an element sufficient to make a sharp distinction between sound and noise.[10]

Because all that is needed to establish *continuity* in the ear is something vibrating at sixteen times per second, as Russolo noted, then an aperiodic waveform repeating at sixteen times per second will constitute a noise that makes a sound. In this determination, he necessarily relied upon inscriptive practices of representing sounds lasting only one-sixteenth of a second, because it would be impossible to distinguish with the naked ear whether or not such a sound was faithfully being repeated. In terms of the quality of the vibrations themselves, Russolo pointed out that what are commonly understood as musical sounds are, in fact, acoustical irregularities that produce an instrument's timbral signature. In keeping with the graphic attributes of water, he demonstrated these properties by asking his readers to imagine waves emanating on the surface of water from a rowboat as it is launched, if the boat is shaken a little. It was upon this basis that he valorized "the great variety in the timbres of noises in comparison to the more limited ones of sounds." Noises were preferable, in other words, because musical sounds were merely limited, not pure. "Thus, the *real* and *fundamental* difference between sound and noise can be reduced to this alone: *Noise is generally much richer in harmonics than sound.*"[11]

Russolo formulated his argument not just in formal, acoustic terms, but also in terms of replacing notions of purity with a richness of noise meant to correspond to the richness of life, especially modern life and its emblematic moments within militarism. Russolo argued that music had become anachronistic because its self-referentiality had afforded no link with the world

and its sounds and remained self-occupied, while everything that happened in life all around it had energetically advanced into the modern world. His stated goal was to open music up to the plenitude of *all sounds*, the subtle and delicate noises of nature and rural settings, the brutal noises of the modern factory, city and war while avoiding *imitation*.

For Russolo, *noise* constituted a confusion that simultaneously disrupted both musical and imitative sound, and therefore was particularly suitable for music. Worldly noise could be directly imitative or not specifically associated with an object or action. The worldly noise in which Russolo was interested eschewed easy meaning because it could easily be incorporated into music. Because it confounded imitation in its natural habitat, it was seen as wilder, belonging more to the world; after all, program music already trafficked in imitation. Although noise was wilder still within the frame of Western art music, music was nevertheless quite capable of absorbing this already semantically destabilized material: "the ear must hear these noises mastered, servile, completely controlled, conquered and constrained to become elements of art." [12] Musicalization of noise meant domestication.

Once controlled noise had the advantage of coming from life and recalling it, it could exceed music while remaining within music. The connection with the world was primarily elaborated through four avenues:

1. an expansion of timbral effects to a point of rejection within existing conventions of Western art music, signaling a breach from the outside;

2. the surrounding discourse of manifestoes, declamations and texts rife with extramusical rationale and images of the world;

3. a shift from purity to plenitude; and

4. the introduction of the *intonarumori*, the instruments specifically designed to play Russolo's music.

In many ways, these instruments repeated organologically the process by which noises were introduced semiologically. Functionally, however, the actual sound of Russolo's noise was incorporated through the category of timbre, something that already resided within music. What Russolo did within the sphere of artistic materiality was to construct an elaborate argument for the expanded use of timbre within music. In the end, he did not argue for a fundamentally different notion of auditive materiality, which would have guaranteed a degree of autonomy for his *art of noises*, but was instead satisfied with his efforts at what he called a "great renewal of music." [13]

Thus, Russolo's *noise* basically presented timbre as a *resident noise* that invoked the world without incorporating it. Musical sound and noise thus could not be separated in Helmholtzian style, because noise was deeply imbedded in musical materiality. [14] Whereas resident noises may have once been limited to wolf tones or the spare wayward sound, entire classes of

extramusical sounds were now identified in the midst of music and ready to serve as a material resource fulfilling the emancipatory rhetoric of avant-garde music. Music could thus become an auditive world unto itself, replete with its own demarcations of musical and extramusical sounds, and it was not necessary to go outside music for the rejuvenation that noise could bring, only release the repressed within music itself.

The impulse animating ideas of resident noise was also responsible for the prominence of the glissando within modernism. Like Professor Cayley's graphic line within which so much of the world was intensified, the glissando was the simplest of lines, one that commanded a presence by always falling short of becoming a melodic line. Like melody, however, it was firmly ensconced within music. Within modernism it became a way to allude to worldliness without transgressing the line between sound and musical sound either in terms of extramusicality or resident noises. At the same time, the investment of worldliness within a line mimicked the phonographic ciphering of sound. The glissando was not a line of noise that disrupted purity and periodicity along a tiny jagged graphic representation, invisible to the eye. It was as large as life and could envelope listeners in its smooth contours.

The glissando was a line of plenitude within music, a lifeline that would come to signify the infinity of nature and freedom. The worldliness of glissandi flowed graphically and sonically out of nature and rounded out the angularity of urban environments. Modernist glissandi are also closely associated with sirens, the precise clinical instruments adopted by Helmholtz for acoustical research or the heralds of the new day of industrialism, urbanism, and militarism. In 1922 the Russian Sergei Yutkevich of FEKS (Factory of the Eccentric Actor) announced, "The electric siren of Contemporaneity bursts with a mighty roar into the perfumed boudoirs of artistic aestheticism!" [15] Sirens cried out in public in an already abstracted sound, scanning the auditive range in order not to leave anyone out and, in the process, created a unique signature people failed to notice at their own peril. It seemed to be the perfect modernist anthem.

If the task of the avant-garde composer was to invoke the world yet remain aloof from any direct ties with it, then the glissando was well suited to the purpose, as it could travel outdoors in the form of sirens and yet always faithfully return, for glissandi had the advantage of being undeniably musical from the start. Glissandi alluded to worldliness by being set in contrast to the segmentation of both temperament and instrumental design. The silenced sounds between notes, between microtones, were seen as markers of a lack of freedom, of restricted movement within a comprehensive and infinitely fine universe, and the gradient of all possible pitches was considered to be typical of the wealth of lived experience outside music.

Glissandi were also attractive to composers because they were very mod-

ern; they could formally outdo dissonance, touching upon an infinite gradation of the pitches they traversed while at the same time evoking a grand lyricism, a gestural sweep stringing together the more disparate and wayward elements of a composition. Noise was an atomistic element that signaled an abundance apart from itself, whereas the glissando contained nothing less than infinity while attracting elements in its vicinity. Noise invoked the world, whereas the world dwelt within the glissando. A modernist glissando was not so much a trace of the world as a tracing with it.

For Edgar Varèse, the glissando was part of a tactic, along with the strewn and skewed pitches of percussion, that other resident noise, to saturate and blanket temperament.[16] Combined, they underscored a flanking maneuver over and against the nature of the piano keyboard, a percussion instrument given over to temperament, and the constitution of the symphony orchestra. In Varèse's tactic, percussion and glissandi compensated for the weakness of the other. The specific points along the infinite gradation reduced to a simple, passing tone of the glissando were reinvigorated by the complexity of individual percussive sounds, with their abbreviated packages of noisy timbre, from a variety of different instruments. Correspondingly, what was lost in the restricted pitch mobility of the percussion was gained in the diapasonic movement of microtonality along the glissando. Indeed, for all the attention subsequently paid to the role of percussion within the development of his musical strategies, Varèse himself maintained a special emphasis on the role of glissandi.[17]

For a number of other composers including Russolo, Henry Cowell, and Percy Grainger, the glissando was a line that circumscribed the world by recording its diapason while filtering out sounds not already belonging to music. It was a sweeping generalization made from within music. As such, it resembled the primary strategy within avant-garde music, which consisted of the incorporation of hitherto extra-musical noise into the province of music by disallowing or reducing the associative aspects of sound. Both appealed to the expanse of the world, but because the glissando was already within music, it was not as risky an enterprise. Just as the curvilinear Doppler effect united the physical world of sound with that of light, the glissando undulating through space and warping in time was a delineation of all that was outside and, in this way, was a line of sanitized noise.

BEETHOVEN AT FIFTY TIMES PER SECOND

Edison, who was partially deaf, often clamped his teeth down upon the horn of his phonograph, but not because he was frustrated with the workings of his new device. Lord Kelvin would have recognized this odd behavior imme-

diately as a modern instance of Beethoven with a stick in his mouth, as another gateway for hearing rerouted through bone conduction. The ensemble of a skull fused to a horn, flanked by Edison and his phonograph, was not the only gateway possible for the simple reason that, unlike the Beethoven's piano, Edison's phonograph could speak *and* write. Developed within a technological environment informed by the telephone, telegraph, phonautograph, and speech synthesis, the phonograph was born through intersecting imperatives to fuse speech and writing.

One of Edison's earliest musings about the possibility of phonography concerned the idea for a device that could take the unique phonautographic shape of every vocal sound and automatically transcribe it into the appropriate letter. Edison's idea that this realm of inscription might find its own voice was given a boost when he read an article entitled "Graphic Phonetics," a report on the research, commissioned by the French Linguistic Society, by Professor Étienne Marey, Dr. Rosapelly, and M. Havet on mechanically recording graphic representations of vocal vibrations and speech organ movements.[18] Edison's first phonograph inscribed its surface with what he perceived as dots and dashes similar to Morse code, thereby demonstrating an interregnum between the lived temporality of the voice and the inscription of mechanical code. This was both a step forward and a step back from the chirographic script registered on Leon-Scott's phonautograph or other mechanisms of visible sound.

Less than a year after the invention of the phonograph, this imagined legibility led to enough speculation about phonographic alphabets that Alfred Mayer felt compelled to warn against phonographic writing. It was futile, he said, "to hope to be able to *read* the impressions and traces of phonographs, for these traces will vary, not alone with the quality of the voices, but also with the differently-related times of starting of the harmonics of these voices, and with the different relative intensities of these harmonics."[19] A word was already too different from its sound to be unambiguously transcribed, let alone reinscribed and heard. But there was another problem: The simple inscription could be infused with more than what might be immediately apparent. How could one tell how much was recorded in an inscription when all sounds were condensed into the fluctuations of a single stylus, "the superposition of different effects" that Lord Kelvin had mentioned? And how could multiple, superimposed recordings be untangled? For example, one early phonograph demonstration consisted of a mixture of several separate recordings superimposed in the same groove, including one "track" by a coronet player. "The phonograph was equal to any attempts to take unfair advantage of it, and it repeated its songs, and whistles, and speeches, with the cornet music heard so clearly over all."[20]

Alfred Mayer's warnings did not reach or rupture the enthusiasm of

László Moholy-Nagy, who during the early 1920s argued for extending the phonograph from simply a machine for reproducing sound to one for producing sound. The way this task could be carried out involved "precise examination of the kinds of grooves (as regards length, width, depth, etc.) brought about by the different sounds; examination of the man-made grooves; and finally mechanical-technical experiments for perfecting the groove-manuscript score. (Or perhaps the mechanical reduction of large groove-script records.)"[21] He went on to develop these ideas in a 1923 article, "New Form in Music: Potentialities of the Phonograph." In an article a decade later, "New Film Experiments," he was able to point to drawn sound on film as confirmation of his earlier ideas. He even imagined that "the creation of the ideal synthetic tenor is within reach."[22] He made his own film, now lost, entitled *The Sound of ABC* where letters, lines and profiles were drawn onto the optical sound track, prompting him to ask one person, "I wonder how your nose will sound?"[23]

The possibility of phonographic playback of any inscription literally caught the corner of Rainer Maria Rilke's eye when he saw the coronal suture, the jagged lines atop the skull inhabiting every good poet's den. Skulls, of course, had been mapped with the scalp still on, but phrenological reading was a poor cousin for a writing that could cut to the bone. What if this line could be decoded, now that the machine for sonorizing lines had been invented? This was the basic question he asked in his essay "Primal Sound" (1919): "What would happen? A sound would necessarily result, a series of sounds, music. . . . Feelings—which? Incredulity, timidity, fear, awe—which of all the feelings here possible prevents me from suggesting a name for the primal sound which would then make its appearance in the world?"[24] He was reluctant to say what sound would be produced, but he showed less reserve about entertaining the possibilities of a truly ubiquitous recording by tracing the needle of phonographic sonorization along the delineation of the entire visible world. "What variety of lines then, occurring anywhere, could one not put under the needle and try out? Is there any contour that one could not, in a sense, complete in this way and then experience it, as it makes itself felt, thus transformed, in another field of sense?" He had noticed the same confluence of senses in Arabic poetry, but to an unnamed woman it was nothing more than "the presence of mind and grace of love."[25]

Rilke was thus compelled to diagram the technical motives in the perceptual spatiality or nonspatiality of lovers and poets. The decoding of the entire visible world would unlock so many of its mysteries that the phonograph would become the technology of choice to investigating the conflict between love and poetry. In this way it surpassed other technologies of perceptual extension, such as the telescope and microscope, because their experiences remained remote (can you smell Mars, walk through its canals, trace the con-

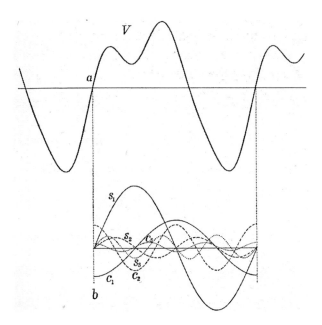

FIGURE 8.2. Curve of a violin tone and its sine and cosine components. Source: Dayton Clarence Miller, *The Science of Musical Sounds* (New York, 1916), p. 101.

tours of plankton?), whereas one could become immersed in the sonorized secrets of all lines.

Despite such enthusiasm there was another characteristic pertaining to the line, which intensified its complexity, made it more capable of writing the world, and at the same time frustrated its transparency and legibility. Baron J. B. J. Fourier showed in 1822 that any periodic waveform can be analyzed through its sinusoidal components. This meant that there was a deeper running harmonic complexity within sound waves that was not rendered within their graphic inscription (figure 8.2). Despite the intensification of the line of the wave, however, the component parts ultimately obeyed the mandates of periodicity and thus Fourier's analysis was predisposed for use in schemes of noise abatement and valorization of given musical conventions.

This was, indeed, the case in an unusual demonstration by the American acoustician Dayton Clarence Miller in his influential book *The Science of Musical Sounds*, first published in 1916 and widely available to mid-century. Contrary to other acousticians in the mold of Helmholtz, and in agreement with composer-practitioners of resident noise, Miller rejected the simple equation of musical tone with periodicity and noise with aperiodicity, pointing out instead that there were plenty of instances of musical sound that were aperiodic and periodic sounds that were perceived as noise. For Miller, noise was better defined as "a sound of too short duration or too complex in struc-

FIG. 94. Reproduction of a portrait profile by harmonic analysis and synthesis.

FIGURE 8.3. Reproduction of a portrait profile by harmonic analysis and synthesis. Source: Miller, *Science of Musical Sounds*, p. 119.

ture to be analyzed or understood by the ear." Complexity was gauged by a person's apperceptive capabilities or predisposition. The complicated construction of Wagner's "Tannhäuser Overture" could be heard as noise by some, music by others. That an individual's confusion can produce noise meant there was nothing intrinsically noisy about physical structure. That qualification given, Miller then abandoned the study of noises in the book "until we understand the simpler and more interesting musical tones. *Tones* are sound having such continuity and definiteness that their characteristics may be appreciated by the ear, thus rendering them useful for musical purposes." Thus, noise was introduced only to be eliminated through characteristics belonging to acoustical study itself, which prescribed an evolution from the simple to the complex, instead of their coexistence. What noise remained was brought into line by a machine, woman, and beauty.[26]

To demonstrate harmonic analysis and synthesis, Miller drew a line profile from a photograph of a woman and analyzed it mechanically to thirty terms, "but the coefficients of the terms above the eighteenth were negligibly small." The equation was then set into a synthesizer and a second curve drawn by machine, reproducing the profile drawn from the photograph (figure 8.3).

FIGURE 8.4. Wave form obtained by repeating a portrait profile. Source: Miller, *Science of Musical Sounds*, p. 120.

It was at this juncture that desire and aesthetics are plied into this machine inscription: "If mentality, beauty, and other characteristics can be considered as represented in a profile portrait, then it may be said that they are also expressed in the equation of the profile." If the simple curves compounded within this profile were expressed as simple tones, then the resulting sound wave could be repeated periodically to produce a sound (figure 8.4). For Miller, this demonstrated that the "sense beauty of form may be likened to beauty of tone color, that is, to the beauty of certain harmonious blending of sounds."[27]

Although this technique never went very far in practical application, its appeal was obvious. It could slip in and out of semiotic registers while keeping one foot in the indexical; some sound would always be reproduced in accord with the representation. Directly inscribing sound promised a notational form circumventing the vagaries and economies of instrumental interpretation, a newfound technical control, technical control at subperceptual levels where control could go unobserved, and a fusion of the arts. In arts specifically, direct sound inscription would mean a connection between the visual arts and music, if not the more extensive connections possible once voices and sounds could be synthesized.

Miller's demonstration found its way to a 1937 article by John Cage, entitled "The Future of Music: Credo." More than a decade before Cage's dictum of *letting sounds be themselves* came into being, he was interested instead in *capturing and controlling sounds*. He was also interested in the control possible through new means of synthesizing music by inscribing figures on the optical sound track of film: "It is now possible for composers to make music directly, without the assistance of intermediary performers. Any design repeated often enough on a sound track is audible. Two hundred and eighty circles [sic] per second on a sound track will produce one sound, whereas a portrait of Beethoven repeated fifty times per second on a sound track will have not only a different pitch but a different sound quality."[28] Cage apparently thought that this technique was viable because twelve years later he was still celebrating "adventurous workers in the field of synthetic music," for whom "twenty-four or n frames per second is the 'canvas' upon which this music is written."[29]

Nevertheless, Cage's choice of a profile of Beethoven, the masthead of the

symphonic repertoire, was obviously parodic. Here the singular genius humbly assumes a position within avant-garde musical materiality as one pitch and tone-color among an infinity of others. Cage maintained Beethoven as his chief antagonist for many years to come, especially as he campaigned against the harmonic music of the Germans and against self-expression within art.[30] Cage's Beethoven writ small at fifty times per second was, in this way, not a demarcation from noise but a declaration from a music founded upon noise to demarcate itself from musical convention.

"I, THE ACCELERATED LINE"

Let us end our specific concerns with the line with a qualification: Attempts at the intensification of the inscription betrays a certain violence when they are seen as a compensatory maneuver for the reduction of phenomenality, and this would be apart from the normative restraint involved in describing certain artistic bounds. This is nowhere more evident than where the object of inscription and process of investing inscription return from other bodies to one's own. Cage's *50 Beethovens per second* is just one instance of inscribed bodies within a modernism rife with bodies stretching without pain to accommodate the suturing of montage or wireless disembodiment and telematic displacement. But Henri Michaux's description of an overdose of mescaline, in his book *Miserable Miracle* (1956), is most vivid in describing what it would be to enter the corporeal warp of inscription, and in the process gives a glimpse into the violence involved in a reduction of phenomenality. At one point, lines and furrows raced through his body, then oscillated into outlines of faces "stretched and contorted like the heads of aviators subjected to too much pressure that kneads their cheeks and foreheads like rubber."[31] But then he "WENT DOWN" to a place where he became what he beheld: "at this incessant, inhuman speed, I was beset, pierced by the electric mole boring its way through the essence of the most personal part of myself. . . . Caught, not by anything human, but in a frenzied mechanical agitator, a kneader-crusher-crumbler, treated like metal in a steel mill, like water in a turbine, like wind in a blower, like a root in an automatic fiber-shredder." Mentally sound people live their lives as spheres, but he experienced the absolute helplessness of being "nothing but a line. . . . I, the accelerated line." Michaux experienced his transplantation into the place where inscription meets signal, where the line becomes electrical, as the ultimate horror. Here it becomes apparent that it is easier to reconnoiter a reduction of phenomenality when the phenomenon lies outside oneself.

Bodies in Force Fields: Design Between the Wars

CHRISTOPH ASENDORF

The representation of energies is one of the main themes of modernism in the arts during the 1920s and 1930s. In the styles of Jugendstil and Art Nouveau, interest had focused less on solid form itself than on the process of its production. According to Georg Simmel in his 1902 essay on Rodin, the significance of the immaculate body of classicism had been replaced by the psychophysical reactions a sculpture produced in the viewer. For Henry van de Velde, lines pulsed with a "life force," and Alfred Gotthold Meyer observed the conversion of power and mass in iron architecture.[1] Whereas Jugendstil saw in all things an *élan vital* at work, soon thereafter the futurists identified the "vibrations" of the modern world, and Delaunay celebrated "*simultané*," the permeation of the external world with the power of color.

The primary difference between these earlier theorizations and those that arose in the arts between the wars seems to me to lie in the latter's higher degree of abstraction. Although the pulsing lines of Jugendstil were often only applied and thus remained at the level of description and although the futurists used a speeding car to embody aerodynamic motion, subsequent artists sought to express the *processes* underlying such actions. One can also describe this change as an inversion: the view of objects from outside was replaced by an analysis of their functions. The artist dealt henceforth with *interactions between forces and effects*. Thus, in addition to the disciplines in which an understanding of social interaction was emerging, creative methods were being developed in the arts and architecture that attempted to represent the play of forces, their transmission, or the process of their exchange.

PROCESS-ORIENTED THOUGHT

One of the outstanding laboratories in which a modern iconography of energy was developed was the Bauhaus. There, according to Henri Lefebvre, one was no longer concerned with the object in its environment, but rather with something different: "mastering global space by bringing forms, functions and structures together in accordance with a unitary conception"—

that is, with the free play of relations.[2] Lefebvre's hypothesis cannot be verified, because no comprehensive theory of the dynamics of spatial relations was formulated in the Bauhaus. But individual complexes of works do exist that implicitly deal with such a theory. This is evident in the case of Paul Klee, whose peculiar mode of seeing is revealed by the way he describes an everyday process: "A sleeping person, the circulation of his blood, the measured breathing of the lungs, the delicate functioning of the kidneys, in his head a world of dreams with links to the powers of destiny. A constellation of functions united at rest."[3] Had Klee wanted to visualize this process, he would have had to take into account a number of different factors: the body from outside, its inner spaces and rhythms, as well as the space of the imagination. Here we approach a flowing concept of space that integrates very different levels of reality and experience.

Indeed, in his work Klee developed a concept of space involving a fluid transition between objects, from figure to background, and from micro- to macrocosm. To this end, he made use of a variety of techniques. Volume and space are bound by patterns of lines and grids interwoven with figures.[4] The object and its environment are no longer strictly separated, but instead interact with one another. For example, the grid picture *Blühendes* (Blossoming) of 1934 does not depict a plant or tree, but instead the process of blossoming itself, signaled by graduated tones radiating outward into space (figure 9.1).[5] In this work, the continuum of color-differentiated patches in the grid pattern replaces the figure and its ground. Klee's pen-and-ink drawing *Anfänge von Sacralbauten* (Origins of Sacred Structures) (private collection, Italy) of 1926 shows a horizontal system of lines in which verticals are inserted to suggest the as-yet unconnected beginnings of the buildings. It is precisely this intermediate state that appears to interest Klee—the point where open space still floods an area that is later to be framed and encapsulated. Nothing is predetermined, and possibilities remain open. This mode of thinking links Klee to the most advanced ideas of his time, from the open spaces of the "New Architecture" to Robert Musil's *The Man Without Qualities*, with its chapter titled "If there is a sense of reality, then there must also be a sense of possibility."[6]

In this context we should consider a further process: Klee's use of loose, overlapping and translucent areas of color, which emphasizes the phenomenon of permeability. *Vermittlung* (Mediation) of 1935 (figure 9.2) demonstrates permeability through an image of communication between two people. Here we see contoured figures, and perceive—without being able precisely to differentiate—something resembling areas of transmission that seem to transpose these figures onto one another. The painter does not actually portray people, but instead visualizes conversation as an abstract in-

FIGURE 9.1. Paul Klee, *Blühendes* (Blossoming) (1934). Oil on canvas, 3 1⅞ × 3 1½ in. Kunst-museum, Wintherthur. © VG Bild-Kunst, Bonn 2000.

terchange. The watercolor *Atmosphärische Gruppe in Bewegung* (Atmospheric Group in Motion) of 1929, with its interplay of different elements, demonstrates this principle as well.[7]

The pictorial space in Klee's works is often fluid and ambiguous. He is concerned not with fixed conditions but with motion, the depiction of transition. His paintings, diaries, and theoretical writing revolve around phenomena of movement in all conceivable variations.[8] For Klee, movement is inherently regular, and therefore an artist should be able to record its flow. He thus works at times with diagrammatically simplified means, developing a language of signs to represent changes in directions or dynamics. Klee used arrow-shaped icons to navigate through his works, introducing this symbol into his art just as it was becoming common on traffic signs.[9] In his pictures,

FIGURE 9.2. Paul Klee, *Vermittlung* (Mediation) (1935). Oil on canvas, 47¼ × 43⁵⁄₁₆ in. Kunstsammlung Nordrhein-Westfalen, Düsseldorf. © VG Bild-Kunst, Bonn 2000.

different arrows may denote quite different forces according to their color and shape, but each force they indicate is necessary to the final result. In *Mögliches auf See* (Possibilities at Sea) of 1932 (figure 9.3), for example, Klee illustrates the course of a ship as it relates to gravity, buoyancy, and wind speed. The artist uses a similar pictorial language but a more symbolic focus in the 1926 *Um den Fisch* (Around the Fish) in which he places complex life cycles in a greater, cosmic context.[10]

Klee also employed images of nature to characterize the preconditions for and intentions of his artistic work. He differentiated between the experience

FIGURE 9.3. Paul Klee, *Möglisches auf See* (Possibilities at Sea) (1932). Oil and sand on canvas, 38¼ × 37⅝ in. Norton Simon Museum, Pasadena. © VG Bild-Kunst, Bonn 2000.

of a sailor in antiquity—who used his boat as part of his daily routine—and that of a modern person walking across the deck of a steamer. The latter must be prepared for the following: "(1) his own movement, (2) the movement of the ship, which could be in the opposite direction, (3) the direction and speed of the current, (4) the rotation of the earth, (5) its orbit, (6) the orbits of the moon and the stars around it. The outcome: a constellation of movements in space with the individual on the steamer at its center."[11] Klee was concerned with inventing a variable system, a pictorial sign system, which—alternating between visualization and abstraction, between micro- and macrocosm—was appropriate to a force field charged with energy.

In the late work *Vorhaben* (Intention) of 1938 (figure 9.4), Klee formulated this notion in a particularly impressive way. The light and dark sections

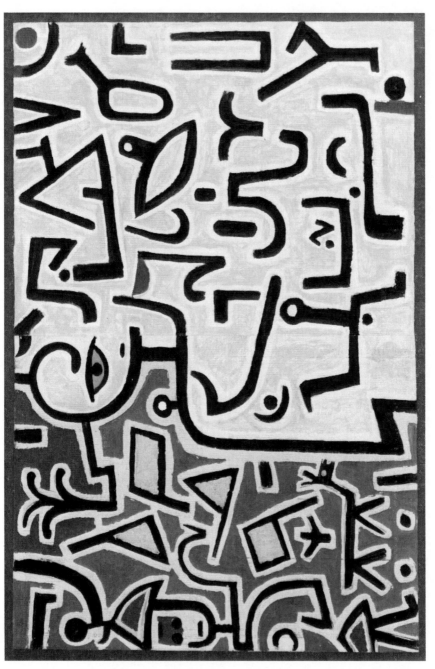

FIGURE 9.4. Paul Klee, *Vorhaben* (Intention) (1938). Colored paste on newspaper on burlap, 29½ × 44 in. Kunstmuseum, Berne, Paul Klee Stiftung. © VG Bild-Kunst, Bonn 2000.

of the picture are divided by the outline of a human figure. More precisely, they are divided by half of the figure: the two parts of the picture are thus readable as interior and exterior spaces. The "interior" contains largely abstract ciphers, while on the "exterior," these ciphers are altered slightly and are portrayed as the abbreviated forms of people, animals, or plants. The theme of *Vorhaben* is thus a process of transformation. The partially open human outline, along which the transformation takes place, fulfills two functions: maintaining both the separation and the penetrability of the two spheres. In the language of biology, this would be a membrane, and one would speak of permeability, osmosis, and potentials for action. Klee transferred these functions to highly differentiated intellectual-spiritual processes, much as he had already experimented with other models of the transfer of energy and information in his work.[12]

With his "membrane" depicting something neither visible nor even visualizable, Klee also touched upon a problem of fundamental importance to the psychological theory of his times. A central theme of Gestalt psychology, to which Klee's work has been related, is the problem of the penetrability and impenetrability of the boundaries of the self, which it considers in relation to the environment.[13] Formulating his field theory in the mid-1930s, Kurt Lewin described the personality as an organization of systems of interaction. Lewin examined the contrast between solidity and permeability, or fluid balance, theorizing that situational variations may influence personal boundaries.[14]

The theme of membranes and the processes of exchange or penetration addressed by Klee played an additional role in the Bauhaus circle—a role with more concrete relevance to the tasks of design. "Der Raum als Membran" (Space as Membrane) is the title of an essay published by Bauhaus student Siegfried Ebeling in 1926 (figure 9.5).[15] In his essay, Ebeling approached architecture from an unusual standpoint, starting from biology and the construction of a cell. Modern biology views the organism as a system; the behavior of an isolated part of that system changes depending on the context in which it is studied. Ebeling considered the problem of life to be one of organization. The cell, as a basic structural element of life, does not exist in a stable state but in a form of "fluid balance." Substances are continually absorbed, transformed, and released again. The processes of metabolism take place via membranes—the surfaces between the outside world and the inner world of a cell or an organism. Ebeling hoped to solve architectonic problems from this same perspective: he viewed a house as "a relatively rigid, multi-cellular, hollow space." As a membrane, the space of the house should harmoniously balance the energies of the earth and the atmosphere with those of the person living in it. In this way it becomes clear why

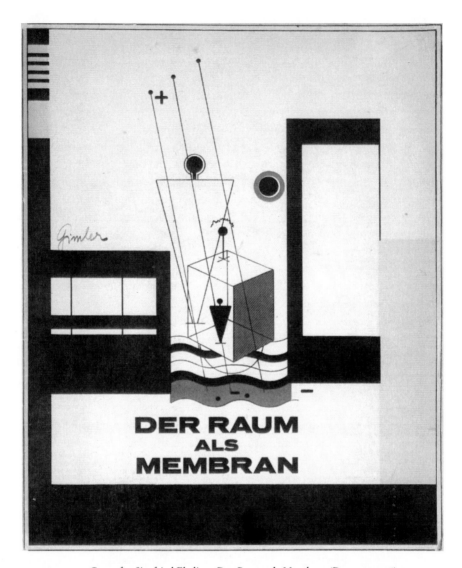

DER RAUM
ALS
MEMBRAN

FIGURE 9.5. Cover for Siegfried Ebeling, *Der Raum als Membran* (Dessau, 1926).

Ebeling defined space as "negative"; he saw it as being, so to speak, without qualities, free of anything that might impede the flow of energies.[16]

The "New Architecture," which concentrated on the field of construction, had a general tendency to neglect questions of household technology. Ebeling, on the other hand, made domestic technology his starting point: heating, ventilation, lighting, even the radiation from sun lamps. He demanded that these systems be developed in such a way that their interactions transformed a space from an "unimportant enclosing mass" into a mem-

brane. Here we find the origins of an ecological architecture, one that seeks to balance the inhabitants and their environment, but which also places a large measure of trust in technology. Ebeling's main concern, however, was not functional optimization, but the effect of building materials, colors, or proportions within the overall context. The house is therefore understood as "the medium of passage for a continual flow of . . . energies," [17] a concept that recalls Klee's *Vorhaben.*

Among the readers of this essay was Ludwig Mies van der Rohe. As Fritz Neumeyer has shown, [18] Mies found confirmation in Ebeling's work for a number of principle concerns at a time when his own architecture was undergoing definite changes. Naturally, in Mies's work there can be no question of "biological building." But with the dissolution of the strict floor plan, which he had practiced since the design of his famous Brick Country House of 1923, Mies produced free-flowing interiors. Certainly, the glass exterior walls could be referred to as membranes. The principle of continuity can also be discerned in Mies's verticals: according to Sigfried Giedion, the steel supports throughout the block of apartments on the Weissenhof Estate convey a sense of the "stream of energies which flow throughout the entire house." [19] Later, Mies's intentions to make his buildings "into neutral space," to "bring together nature and houses in a superior union," [20] also suggest Ebeling's concept of "negative space."

The most prominent example of such a concept of architecture is surely the Barcelona Pavilion of 1928–1929. On a podium that raises the building, removing it a little from its surroundings, the theme of enclosing and simultaneously opening up space is realized in an extremely skillful way. Almost like an exploded-view drawing (if only on one plane), the surfaces enclosing space slip away from each other. An X-ray view from above would demonstrate clearly that, with the exception of the enclosing side walls, the edges of the individual surfaces do not directly touch anywhere. The surface of the floor, the freestanding walls of the interior, and the roofs are arranged in a free rhythm with respect to each other. Inside, a most ambiguous picture is also presented. Besides areas of marble, several kinds of mirrors and frosted glass function as walls, filtering the space zones behind them to varying extents. A rich play of reflection and overlapping develops between the polished marble, the chrome supports, the glass, and the water in the outside pools, while the viewer's every movement means that the sky and the background fall onto the surfaces differently. This is a space open and flowing in all directions, a virtuoso oscillation between figuration and dissolution.

The theme of transfers or the process of interaction between separate spheres concerned Klee, Ebeling, and Mies, each in his own field. In the last of the Bauhaus books, published under the title *Von Material zu Architektur*

FIGURE 9.6. László Moholy-Nagy, *Von Material zu Architektur* (Berlin, 1929), plate 209.

in 1929, László Moholy-Nagy transferred these same aesthetic considerations to the whole of modern civilization. For Moholy, space becomes conceivable in all dimensions, and thus all boundaries become permeable. In the last chapter of the book, he demonstrates this idea using a suggestive series of photos ranging across all aspects of contemporary life—great sporting events, traffic, industry, and modern architecture (figure 9.6). All are given as evidence to support Moholy's thesis that the modern mode of perception no longer recognizes any separation at all, but instead must be understood as the continual, mutual penetration of objects and events. As Moholy con-

cludes, in this world of new spatial experiences, "constant fluctuation" has taken the place of static relations.[21]

TOTAL MOBILIZATION

In his 1932 text, "Der Arbeiter" (The Worker), Ernst Jünger also describes society as a space in which energies cross. But here persons find themselves in precisely determined, functional contexts, as demonstrated, for example, by modes of communication: "The power, traffic, and news reporting services appear as a field within whose system of coordinates the individual may be established as a specific point—one 'takes a bearing on him,' for example, by setting the dial of an automatic telegraph." [22] Evidence of this kind leads Jünger to his central theme: He analyses modern civilization entirely on the basis of his notion of *total mobilization*. He thus transfers a formerly military term to society as a whole, and, it must be noted, without any critical intention.

"Total Mobilization" was originally the title of an essay by Jünger contained in the collection of works *Krieg und Krieger* (War and Warriors) in 1930. The most recent war technology in particular had demonstrated this theme with crass clarity:

> We have already left the era of the shot that is aimed. The squadron leader who gives the orders for a bombing attack from a great altitude in the dead of night is no longer able to differentiate between combatants and non-combatants, and the deadly cloud of gas spreads out over every living thing like a fog. But the possibility of such threats does not presuppose partial, nor general, but total mobilization, even extending to the child in the cradle.[23]

In this text, Jünger still uses his term *total mobilization* to refer to the form of war appropriate to the technological age. In "Der Arbeiter," however, this perspective shifts. To follow Jünger's theorization, mobilization as a permanent state will alter our living spaces. The cultural landscape shaped by industrialization, for example, is only a transitory landscape, a workshop in which all forms are constantly being remodeled. It remains provisional, disordered, characterized by the chaos of an anthill and a confusion of architectures. The reason for this is industry's embryonic state. But Jünger sees this stage succeeded by the emergence of a "firmness of line," a sensibility "for the icy geometry of light. . . . The landscape will become more constructive and dangerous, colder and more blazing." [24]

According to Jünger, the "total work character" of World War I was only the testing ground for a new reality in which the image of man also changes decisively. The constant demand is then to "treat the body as a mere instru-

Ringsiedlung bei Leipzig

Luftaufnahme der Autostraße Köln—Bonn mit den neuartigen Zu- und Abfahrtswegen

**STELLT EINEN VERSUCH ZUR NEUEN
UND KONSTRUKTIVEN FORMUNG DES LEBENS DAR**

Industrielandschaft alten Stiles DER ARBEITSPLAN...

FIGURE 9.7. Illustration from *Die veränderte Welt*, ed. Edmund Schultz with an introduction by Ernst Jünger (Breslau, 1933), pp. 126–27.

ment." This interlocking between man and machine has an effect on physiognomy. Jünger remarks on an increasing lack of individuality as a feature typical of the times, a "mask-like rigidity of the face," its metallic quality expressing its adjustment to high speed, pressure, heat, and the like. In a world in which technology is gaining a comprehensive "total" character, people no longer play a special role as compared to objects; they are cynically considered from the standpoint of "mere maneuverability." Here Jünger introduces the concept of "organic construction," meaning the "narrow and unprotesting fusion of man and his tools." A central attribute of the image of society in Jünger's work is this idea of a homogeneity, which makes the individual into an atom. As such, he is the object of the mobilization that fuses man and technology into one single active body.[25]

The book *Die veränderte Welt* (The Altered World) appeared as "an illustrated primer of our times" in 1933. Edited by Edmund Schultz and with an introduction by Jünger, it has been called with some justification a "visual commentary" on "Der Arbeiter," which had been published a year before.[26] An image of the broadcasting tower in Königswusterhausen appears at one point in the volume, essentially invalidating the ideal of free, unregulated communication that is always present in classical modernity: "At the same time as there has been an increase in means to dominate space, a new awareness of space has been awakened in man. The growing range of transport and news broadcasting and the ability to exercise power over a much wider area have, as phenomena, also extended political spheres. It is no wonder, therefore, that new beginnings of imperial politics may be observed in different places around the world."[27] This is not a matter of free interaction, but of a space under uniform control.

Whereas Moholy-Nagy had always described his intended urban space as transparent, fluctuating and open to changing configurations, the authors of *Die veränderte Welt* had a different vision. For example, under a photograph of the control center of a power plant—a place from which the flow of energy is directed—they place the picture of a large public rally, commenting that "progress has also been made in the technology of mass movements." A distant view of cities and landscapes is provided, often from above, in a bird's-eye view (figure 9.7). All differentiation and detail disappear as the image is reduced to a few powerful figures, on the model of a circular metropolis that appears to be the fulfillment of Ledoux's vision—or a highway landscape obviously intended to represent an attempt at what is called the "new and constructive formation of life." The circulation currents in this new world are channeled and centrally guided. In this vision of a cold and regimented modern age at the close of the Weimar Republic, the dynamics of mobilization lead to a world of totalized technical efficiency.[28]

HARMONIOUS INTERACTION

In many respects, the works of Herbert Bayer, with his visualizations of energetically interwoven worlds, present a counter scheme. Bayer's design for the title page of the Bauhaus magazine during his period in Dessau had already demonstrated this: elemental bodies, light and shade, and lettering and images overlap and penetrate one another. A dynamic co-existence has taken the place of rigid arrangement. On the title page of his catalog for the 1935 exhibition "The Wonder of Life," Bayer superimposed Polyclitus' Doryphoros, colorized and overlaid with a circulatory system, over the X-ray of an egg. The world of the ancients and that of modern science interact and are shown as elements of one culture. On a double page of the same catalogue, the network of the German highway system is compared to the human nerve system and muscles, and Hitler appears as the heart of this "organism" (figure 9.8). This demonstrates a worrisome uncertainty, a brief political heresy on Bayer's part, which was only conclusively resolved by his emigration in 1938.

Under the political and technological conditions in the United States, Bayer's energetic vision of the world became more differentiated. He developed his own visual code to represent modern reality, a code that enabled him to express his interest in the continuity of movement and form. "Electronics—a New Science for a New World" was the title of an information brochure Bayer designed for the General Electric Company in 1942 (figure 9.9). The history, employment, and future applications of electrical devices were presented in a series of extremely well-designed double pages. As might be expected, one motif appears more often than others: the paths of electrons, which, as in models by Rutherford and Bohr, circle an atomic nucleus. But Bayer effectively explores the full potential of this motif. Paths of electrons circle people like planets. Bayer depicts electrons in both the micro- and macrocosm; they become the ultimate, all-encompassing energetic cipher.

Bayer's paintings from this period bear titles such as *Interstellar Austausch* (Interstellar Exchange) of 1941 or *Himmlische Räume* (Celestial Spaces) of 1942 (figure 9.10).[29] The arrows that had indicated ambiguous potentials in the work of Paul Klee now precisely indicate the direction of rotation of heavenly bodies, formations of energy, or the constant interpenetration of meteorological phenomena in the earth's atmosphere—energetic images that function universally. In 1943 Bayer received an important commission from the Museum of Modern Art to design the exhibition "Airways to Peace." The general theme was the transformation of the world as a result of the airplane. One of the central objects was a large, hollow globe that could be entered by visitors, who would see the surface of the planet painted on its in-

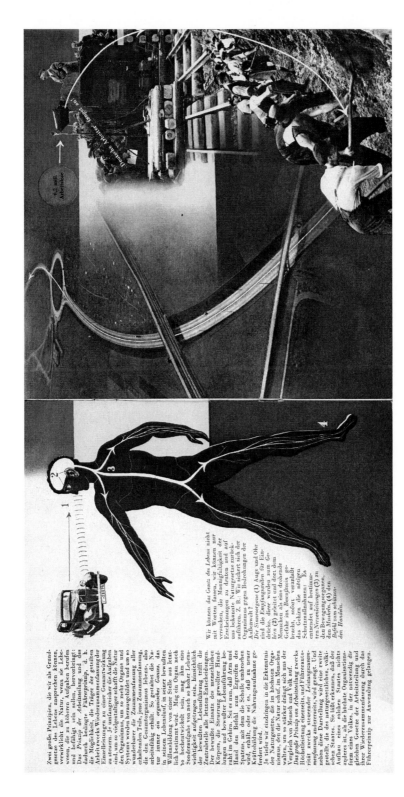

FIGURE 9.8. Herbert Bayer, Double-page illustration from *The Wonder of Life* (1935). © VG Bild-Kunst, Bonn 2000.

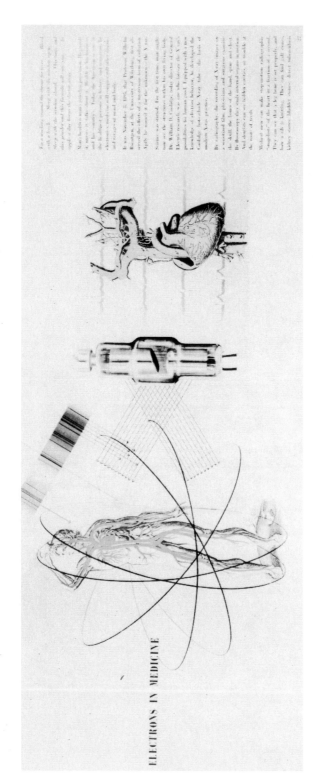

FIGURE 9.9. Herbert Bayer, "Electrons in Medicine," from *Electronics* (brochure for General Electric Company), 1942. © VG Bild-Kunst, Bonn 2000.

FIGURE 9.10. Herbert Bayer, *Himmlische Räume* (Celestial Spaces) 1942–45. Oil on canvas, 25 × 30 in. Denver Art Museum, Gift of Joella Bayer. © VG Bild-Kunst, Bonn 2000.

terior rather than on its exterior. This inversion expanded the visitors' perspective, making it possible to survey larger areas with one look at the concave surface. The understanding of concepts by means of visual aids was similarly expanded by a ramp from which visitors could look down at aerial photographs. The staging of this exhibition, its space-integrating form, and—in the middle of the war—its optimistic representation of a geography of global relations are indicative of the attraction aviation technology held for Bayer. He viewed it as an effective catalyst for the emergence of a civilization characterized by the notion of universal interaction.

Bayer's work is the main topic of Alexander Dorner's *The Way Beyond 'Art'*, published in 1947. A museum director and emigrant like Bayer, Dorner reflects upon the influence of modern civilization on the tasks facing design. Dorner's starting point is a sociobiological concept of an integration of man, nature, industry, and society based on the ideas of John Dewey, who wrote the foreword and to whom the book is dedicated. For Dorner, the designer's starting point must be a dynamic one: the "organic revelations of life

and the harmonious interactions between beings and their environment" become the focus of his work.[30] In Dorner's view of the world as a sociobiological continuum, there is neither static state nor separation, but only processes and transformations. Dorner argues with vague analogies much as Sigfried Giedion had done in his slightly earlier work, *Space, Time, and Architecture*. He believed that development presses onwards toward "integration on a dynamic basis," and that there is no significant difference between the theory of relativity, atomic energy, and works of art insofar as they are all tied to a "superspatial" world of waves and interactions.[31] Dorner considered Bayer's work notable because he was able to find a visual language for this superspatial reality, developing understandable symbols, bringing about their interactions, and relating them to everyday experience.[32]

Dorner's perspective has not been left unchallenged. Especially provocative was his thesis that the development of art ended with modern techniques of design and visual communication. Dorner had clearly expressed this view, not only in the title, but also in the first sentence of his book: "The intention of this study would be more precisely expressed if its title were 'The decay of the visual form of communication known as "art" and the beginning of a new type of pictorial understanding.'"[33] And, of course, for Dorner the first representative of this new type of image-maker was Herbert Bayer. Although the subsequent development of pictorial language during the rest of the century has not borne out Dorner's predictions of Bayer's centrality, Bayer was certainly one of the most inventive iconographers of energy. This is particularly true with regard to contemporary large-scale technology.

Bayer clearly perceived this technology's connection to the civilization surrounding it. The artists of the Bauhaus used painting and architecture to reflect process-oriented thought, but Bayer was interested in applying that approach to the whole of civilization. In that respect he concurred with Jünger. Jünger, however, countered every openness with rigid control, while Bayer aimed toward an expanding interaction of global proportions.

REPRESENTING INFORMATION

INTRODUCTION

The arrival of the mathematical theory of communication had repercussions far beyond the improved efficiency of telephone lines. Prior cultural formations could now be reconceptualized and often quantified in terms of information functions. Charles Babbage's premature dream of mechanized calculation was an early tremor of the development that would unfold heat-engine technology into electronic communication and conduct statistical mechanics into information theory and cybernetics.[1] Part 4 links the diagrammatic emphases of part 3 to this historical threshold when the discourse of energy passed explicitly into the theory of information, leading to new revolutions in the form and possibility of scientific and aesthetic representations, specifically through the mediation of calculating engines and electronic media. The essays in this section examine the anthropological sites, dystopian images, and utopian spaces of cybernetic ideas—the use of communication and control systems, feedback loops, and informatic simulations to model the structural coupling of organisms and machines.

In "On the Imagination's Horizon Line: Uchronic Histories, Protocybernetic Contact, and Charles Babbage's Calculating Engines," David Tomas examines the prehistory of contemporary information technologies in the visionary engineering designs for Babbage's steam-driven computing machines. Along with the railway system and the photographic camera, Babbage's designs crossed a "threshold of representation" with transformative effects on the body's sensory capacities. Tomas's particular project is to meditate on the *temporal* disjunctions constellated by our current reception of Babbage's work. In the 1840s his calculating engines were too advanced to be constructed; only in 1991 was one of them finally assembled. In the intervening years his meticulous and voluminous mechanical drawings held the calculating engine in a kind of virtual space and time. Tomas develops the concept of *uchronia* for the present actualization or rearticulation of the unrealized potentialities of the past, and probes the problematics of the virtual temporal-

ities suspended between the protocybernetic era of Babbage's original drawings and the digital present.[2]

For writers and artists, the human–computer coupling of cybernetics suggested new realms of freedom and domination. Just as the discourses of energy had bifurcated into dreams of power and vistas of individual and social progress on the one hand and nightmares of human devolution and cosmic exhaustion on the other, so has the discourse of information prompted divergent narratives of ambiguous transformation. Katherine Hayles's "Escape and Constraint: Three Fictions Dream of Moving from Energy to Information" explores the literary intimation that with the shift from energic to informatic regimes, it might be possible to escape the conservation laws foregrounded in thermodynamics, as well as their social and economic correlates of limited social mobility and finitude of economic resources. The desire that information provide a realm of excess and superabundance has been extrapolated by a number of writers into stories about telematic transcendences that inevitably fall back into the restricted world of material and energic constraints. In Henry James's short story "In the Cage," a telegraphy girl struggles to escape her social and physical circumstances, but is unable to transcend into a new social world with the mobility and alterability of the information that passes through her station. In Philip K. Dick's "The Three Stigmata of Palmer Eldritch" and James Tiptree, Jr.'s "The Girl Who Was Plugged In," disquieting fantasies of exiting the organic body into alternate realms of informatic hallucination and simulation are followed by devastating realizations of the futility of virtual escapism. Each story is suspicious about the idea that one can leave energy and matter behind, but each enacts that suspicion for different reasons, corresponding to various phases of communication technology and their associated social concerns. At the same time, each of these texts presents female characters constrained as much by derogatory gender assignments as by the laws of physics. Female subjects consistently figure the permeability of all subjects to the informatics of corporate domination.

Edward A. Shanken's exploration of artistic responses to communication technology in "Cybernetics and Art: Cultural Convergence in the 1960s" surveys the reception of cybernetics in the theory and practice of the art, sculpture, and music, with a focus on the wider cultural frames of British artist Roy Ascott's interest in cybernetics. Ascott and many of his contemporaries extracted from Norbert Wiener and other sources a cluster of cybernetic themes—contingency, probability, feedback, systematic interactivity, the operational unity of organisms and machines—which they enthusiastically carried into the making and teaching of interactive artworks. Contingency was a prominent theme in the concert music of the 1950s, most famously in

John Cage's 4′33″. Audio feedback infiltrated the experimental music of the 1950s and 1960s and visual feedback was utilized by electronic installations such as Les Levine's 1969 *Contact: A Cybernetic Sculpture*. Cybernetic ideas informed numerous experiments in coupled representations, making the random factors of the audience an active component in the total system of the artwork, and in creating syntheses of technological, visual, and textual materials. We can now see in the art Shanken discusses precursors of contemporary simulation technologies of the sort discussed in part 5, as well as precursors of current forms of narrative and plastic art and entertainment from hypertexts to video games.[3] In the mode of information, previously discrete media commence to merge within the medium of digital codings.

On the Imagination's Horizon Line:
Uchronic Histories, Protocybernetic Contact,
and Charles Babbage's Calculating Engines

DAVID TOMAS

Between the 1820s and 1840s, a number of unprecedented thresholds of vision were created by new machines and engineering structures that were linked to the steam engine and steam power. Steam locomotion produced the railway system, a massive engineering works that served as a powerful new imaging system. Railways radically changed the human organism's relationship to its natural environment.[1]

But through its global reach and powers of transportation and communication, another new imaging system would come to rival the railway system. That system was photography, with its lengthy chemical processes, ponderous yet portable apparatuses, and surprisingly compact and mobile products: the unique daguerreotype and the negative–positive photogenic drawing process.[2] In contrast to the railway system, photography would change the human organism's relationship to time, memory, and history.

Beyond these more obvious candidates, the calculating engines of Charles Babbage also qualify as a singular and esoteric category of new imaging system. Although these machines were never manufactured, and indeed were to achieve only a fragmentary existence in Babbage's lifetime, they occupy a unique position in the history of western representation. As a number of historians have pointed out, in addition to its particular importance in the history of computing devices, Babbage's work on his calculating engines marked a watershed in nineteenth-century machine tool design and machine-shop practices, engineering design, and the art of mechanical drawing.[3]

In measuring Babbage's contribution to the history of machines, his drawings of the calculating engines are significant not only because of the nature and complexity of Babbage's project, and not only because, as he argued, mechanical drawing is fundamentally different in its objectives and representational logic from artistic drawing, but also because of the role that they played in Babbage's work as the principal, indeed, the only means of its realization.[4] They provide the only access to the unusual representational and

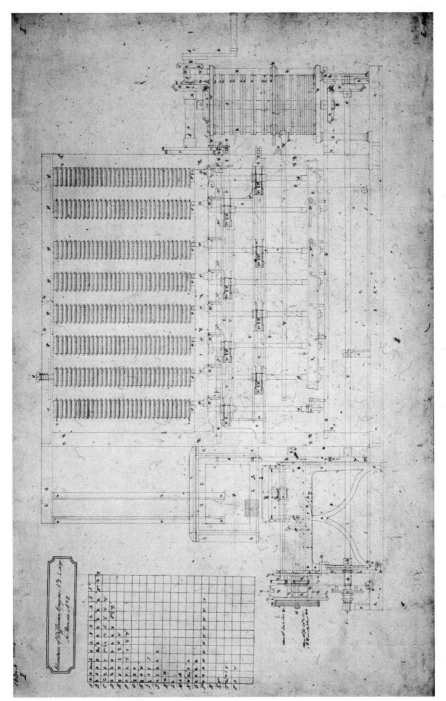

FIGURE 10.1. Charles Babbage, Elevation of Difference Engine No. 2. Ink on paper, 24 × 37¾ in. Source: Science & Society Picture Library, Science Museum, London.

epistemological spaces exposed as a consequence of the project's incompleteness (figure 10.1).

I

The drawings and notes that Babbage produced in connection with the different calculating engines number in the thousands. In 1991, Allan Bromley noted that the "sheer bulk of the material is daunting even before its complexity is revealed on a cursory examination."[5] These words are to be found in the introduction to a substantial cross-referenced list of all the material pertaining to Babbage's calculating engines in the London Science Museum Library. One system of classification and representation therefore serves as a cursory chart of a domain of knowledge whose frontier is marked by some drawings, models, prototypes, and a full-sized version of Difference Engine No. 2, which are on display in a museum setting. But beyond the display's attempt to encapsulate and celebrate the history and intellectual contributions of Babbage's project in a clear and economic manner, what is most significant about the array of objects, drawings, and didactic panels is that the artifacts seem to escape the embrace of the captions and information that surround them. Instead they point elsewhere, not just to a distant world and body of knowledge—to an archaic culture of machines and to the unusual subculture that engendered them—but to a *culture* of archaic machines and the unusual subcultures that they suggest.

The dual experience of an otherness rooted in both a lost past and an accessible but fragmentary past that has grown new roots in the present is rendered more special by the fact that this distant world and these new roots are matrices from which important elements of our own world have evolved, if only indirectly. They are also the matrices from which a parallel world could evolve should an incomplete past provide a new basis *in the present* for a different trajectory of the future. In this case, a miscellany of fragments would function as the governors for a future whose primary reference would be not to the present but rather to a kind of virtual past. These matrices represent a "distant" set of possibilities of which our own world is one.

A word that identifies works that deal with eccentric or virtual histories and the possibilities they embody is *uchronia*, based on the nineteenth-century French word *uchronie*: a philosophical term that refers to the historical reconstruction of fictive events on the basis of given historical referents.[6] More generally, the word evokes an imaginary deployment in time, perhaps like the arrangement of drawings and prototypes on display and archived in London, and the fragmentary array of representational and epistemological spaces that are associated with them.

Uchronic histories also point to peculiar kinds of interdisciplinary spaces that might exist between history and other disciplines such as art, science, and literature. There, parallel and fictive types of knowledge might take shape in tendentious tension. They suggest worlds that are governed by speculative and unstable types of knowledge that can set one's imagination in motion. There it can oscillate between the known and the unknown, the possible and the impossible, as it is stretched to the limits of its comprehension. As a consequence, these spaces raise questions about dominant forms of knowledge, their ultimate uses, and their various natures and attributes. For example, what are the relationships between the disciplinary compartmentalizations of knowledge and their social and epistemological functions? How do specific patterns of compartmentalization influence our ways of modeling the world and our behavior, and how do they determine future patterns, models, and forms of knowledge? What are the mechanisms that ensure that dominant forms of institutionalized knowledge continue to influence the development of future forms? The ultimate value of uchronic histories lies in their own peculiarities and attributes, and in the fact that they represent different, eccentric, often marginal and unstable configurations of knowledge that embody different histories and anthropologies of human activity.

2

Babbage pitted his mind against the proliferation of mathematical errors produced by the manual computing of mathematical tables. He proposed to engage with the origins of these errors on their own terms of reproduction, namely in terms of the principle and procedures of copying. The elegant and highly sophisticated economy of the ensuing engagement was represented on paper, more paper, and yet more paper—like the endless mathematical tables that the calculating engines were designed, paradoxically, to fix in the vise of perfection, but which they never did.

Bromley's inventory of the Babbage archive in the Science Museum reveals about five hundred engineering drawings, one thousand sheets of mechanical notations, and a series of notebooks totaling between six and seven thousand pages. Compared with the surviving artifacts, this inventory represents a staggering excess of representation, a veritable sediment of human traces whose density and complexity exceed the grasp of the imagination, just as the day-to-day, minute-by-minute, second-by-second experience of the genesis of the drawings is now beyond its reach.

A lengthy discussion by Dionysius Lardner, one of Babbage's contemporaries, sets the stage for an appreciation of the quality, quantity, and pecu-

liar status of the drawings produced for the calculating engines. The interest of this passage lies in the way that it links mechanical drawing to an economy of invention that highlights both a graphic system's predictive powers, its expediency, and its necessary generation of an *excess of representation* as a prerequisite to obtaining an acceptable economy in the design of hypothetical mechanisms. It also opens the way for an appreciation of the drawings as the products of Babbage's intellectual engagement with the seminal idea that it was possible to construct an automatic machine to compute and print error-free mathematical tables, that one could replace the mental labor of mathematicians and manual computers by mechanisms that reproduced pertinent aspects of the computational workings of the human mind:

> As might be expected in a mechanical undertaking of such complexity and novelty, many practical difficulties have since its commencement been encountered and surmounted. It might have been foreseen, that many expedients would be adopted and carried into effect, which farther experiments would render it necessary to reject; and thus a large source of additional expense could scarcely fail to be produced. To a certain extent this has taken place; but owing to the admirable system of mechanical drawings, which in every instance Mr. Babbage has caused to be made, and owing to his own profound acquaintance with the practical working of the most complicated mechanism, he has been able to predict in every case what the result of any contrivance would be, as perfectly from the drawing, as if it had been reduced to the form of a working model. The drawings, consequently, form a most extensive and essential part of the enterprise. They are executed with extraordinary ability and precision, and may be considered as perhaps the best specimens of mechanical drawings which have ever been executed. It has been on these, and on these only, that the work of invention has been bestowed. In these, all those progressive modifications suggested by consideration and study have been made; and it was not until the inventor was fully satisfied with the result of any contrivance, that he had it reduced to a working form. The whole of the loss which has been incurred by the necessarily progressive course of invention, has been the expense of rejected drawings. Nothing can perhaps more forcibly illustrate the extent of labour and thought which has been incurred in the production of this machinery, than the contemplation of the working drawings which have been executed previously to its construction: these drawings cover above a thousand square feet of surface, and many of them are of the most elaborate and complicated description.[7]

As Lardner points out, it is the accumulation of (rejected and antiquated) drawings that becomes an independent measure of the project's powers of intellectual consumption. Beyond this, his observations allude to the fact that the drawings embody an autonomous process of intellectual engagement with an idea, and that these drawings were this idea's extended culture.

Confronted with their virtual state (and notwithstanding the recent construction of Babbage's Difference Engine No. 2, which retains the status of a working display in the Science Museum), a number of historians have pieced together the social or technical history of the calculating engines.[8] But one can also begin from the sketches, engineering drawings, models, and fragments and move in an altogether different direction, guided by a completely different set of goals and questions. How are we to account for a dense sediment of paper and its culture, mute testimony to a passion, indeed, an obsession to articulate an idea through all its possible forms while gradually narrowing it down to a working mechanism? Or how are we to grasp this idea's articulation through space and time by way of media (pencil and pen) that bind the eye and hand in a particular intimate way? And when it is a question of models of the mind, what relationship is there between the means of articulating an idea and the model? Beyond Babbage's contributions to the history of machines, computing devices, and mechanical drawings, his project can frame a new understanding of a mechanical drawing's anthropological status as a protocybernetic threshold of representation. In the context of an incomplete project of this magnitude, because of its peculiar logic and existence outside of its own and our own spaces and times, how might it contribute to a uchronic reconfiguration of the historical and anthropological imaginations?

3

An early and unfortunately undated pair of talbotypes (figures 10.2 and 10.3) and a related suite of wax paper negatives of an engineering model of a locomotive attributed to William Henry Fox Talbot raises questions about the relationship between a representation, its material basis, and the senses that can also be raised in the case of Babbage's mechanical drawings.[9] In a number of these unusual images, the locomotive seems to be struggling like an alien protoplasmic life-form to take its shape and its place *in* our world. Given the fact that these photographs were developed at the time when a new threshold in the history of perception was being crossed, a threshold when each photograph functioned like a petri dish for a new vision of the world, how are we to grasp their significance?

Like Turner's 1844 painting of the Great Western Railway, *Rain, Steam, and Speed* (figure 10.4), these tiny photographic sites dissolve the representational system underlying the dazzlingly haptic displays of painterly virtuosity associated with this old representational medium. But in contrast to Turner's stochastically based railway painting, each of the little photographs and negatives mark a radically different, yet closely related perceptual thresh-

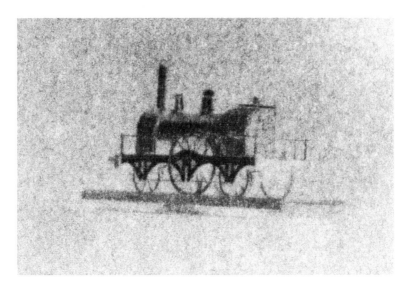

FIGURE 10.2. William Henry Fox Talbot, Talbotype of a model locomotive engine, c.1845. Wax paper negative, 3⁵⁄₁₆ × 3¹⁄₁₆ in. National Museum of Photography, Film, and Television, Bradford. Source: Science & Society Picture Library, Science Museum, London.

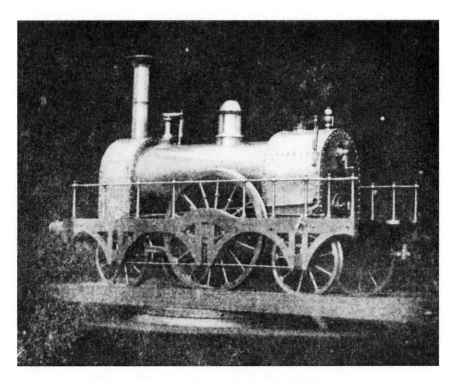

FIGURE 10.3. William Henry Fox Talbot, Talbotype of a model locomotive engine, c.1845. Positive salt print, 3⁵⁄₁₆ × 4¹⁷⁄₃₂ in. National Museum of Photography, Film, and Television, Bradford. Source: Science & Society Picture Library, Science Museum, London.

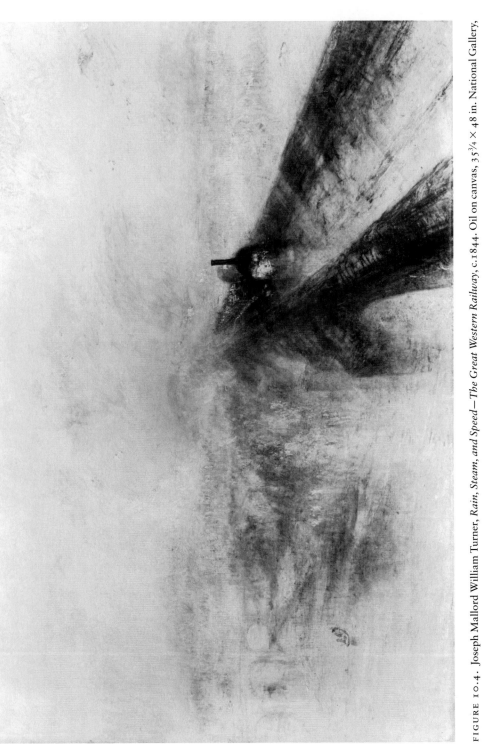

FIGURE 10.4. Joseph Mallord William Turner, *Rain, Steam, and Speed—The Great Western Railway*, c.1844. Oil on canvas, 35¾ × 48 in. National Gallery, London. © National Gallery, London.

old, one whose individual peculiarity is amplified by its kinship with similar images.

If the daguerreotype's beautiful mirrored surface evokes a Holbeinesque world of perfect representation and sumptuous surfaces, then the model locomotive's emergent form brings to mind the first photographs produced by Joseph Nicéphore Niépce, the one of ordinary rooftops (c. 1826), the other of a table-top (c. 1824). In these revolutionary images, ordinary things are the armature allowing a new medium of representation to take a physical form, while that new medium seems to act like a new type of amniotic environment for vision. With these images, as in the case of Talbot's early experimental photographs, the chemical process itself seems to be the subject of representation, and the images are there to allow for its existence. Inasmuch as vision begins to immerse itself in a chemically based protoplasmic medium, the tiny locomotives point beyond Turner's mattery stochastic surfaces to the world of experimental science, to chemistry, an ascending discipline that would dominate a second mid-nineteenth-century stage of the Industrial Revolution. It also points to the fact that the human eye would begin to operate in a number of radically different, yet curiously related sensory environments in the contexts of photography and the railway system.

When set beside *Rain, Steam, and Speed*, this group of salt prints and wax negatives becomes a strange, alien doppelgänger. The silent space that unfolds between Turner's painting and the talbotypes and wax paper negatives, images that were in all probability also exposed in the mid-1840s, is a memorial to the body's sensory transformation. What the painting and the photographic images highlight are the relationships between the senses and nineteenth-century systems of representation and transportation. And the space that is the measure of their difference is a silent witness to the fact that the body's sensory universe would be forever changed as a consequence of these systems. If Talbot's photographic images cannot claim to represent an obvious and therefore celebrated point of rupture and transformation in the history of the senses, they can nevertheless be treated as a special, if obscure, threshold and passageway in that history and in the history of western representation. I would like to suggest that what I have said in connection with these photographs and Turner's painting can also be said in relation to Babbage's mechanical drawings and system of mechanical notation, although in terms of a different register of surfaces and inscriptive traces.

Holbein's *The Ambassadors* can provide the basic measure of all modern media thresholds because of the virtuosity of the painter's handling of his medium, the transparency of its subject's rendition, the scientific, technological and political dimensions of its subject, and its unique presentation of conflicting (dominant and deviant) perspective systems. When measured against

The Ambassadors's crystalline environment, each of the examples I have discussed represents a new perceptual threshold that emerges from a medium as from a special protoplasmic environment: mattery in the case of Turner's painting, thinly gelatinous in the case of Niépce's image of rooftops, waxy in the case of the talbotypes. The historical and cultural significance of these works is related to the way each threshold maps singular transformations in the history of perception, and the way that each threshold is configured as an interface between particular media, scientific and technical instrumentation, technologies or manufacturing processes, and physical and chemical processes. Finally, the significance of each of these works is linked to the way that the sense of sight is rendered palpable by the threshold's structural organization in relation to a given medium's perceptual qualities and material density.

Although the drawings of the calculating engines are of a completely different order of reality than these other pictorial representations, when set beside such contrasting thresholds it is precisely their difference and distance from them that helps one to see what those delicate patterns of lines, numbers, and letters might represent.[10] Their peculiarity resides in their highly systemic, collective, and abstract nature. Neither single images, however complex, nor an easy- or difficult-to-digest series of images, these mechanical drawings map the space and time of the objects they collectively describe in ways that are very different if not altogether beyond the capabilities of these other types of representations. Babbage's drawings belong to a different category of image, one that is not considered to be an end in itself but rather, as Lardner noted in the case of the products of the calculating engines, a means to an end.[11] This is why, in the case of Difference Engine No. 2, a set of such drawings could be used as the foundations to construct the machine they described. But the way they operate as interconnected representations that have to be read and decoded in the context of a culture of machine tools is also intimately related to the way they function as the products of very different subcultures, those broadly connected to engineering. On the whole, these subcultures tend to be less sensitive to the aesthetic dimensions of a drawing and to its particular economy of eye and hand. As a consequence, they are also less sensitive to the fact that these dimensions might also be important sites of speculative activity and systemic thought: parallel and yet different from those that in the case of an artist are in the active service of an idea. But the moment one isolates the drawings from their operating contexts, their aesthetic dimensions, however thin, are rendered more palpable, and the operations of the eye, the hand, and the mind are projected, like peculiar doppelgängers, outside of their historical time and space. Perhaps this is one of the reasons why these drawings are such strange artifacts today

when they reappear in distant contexts such as the Science Museum Library. Namely, they now embody a different model and aesthetics of the mind from the one they might originally have promoted.

4

What do we see when we look at a scientific or technical representation, if as Bruno Latour suggests, it represents the "*fine edge* and *the final stage* of a whole process of mobilization"? What do we see if that representation is all that remains of a "*cascade* of ever simplified inscriptions" and their setting, "a giant optical device that creates a new laboratory, a new type of vision, and a new phenomenon to look at"?[12] What do we see if the whole process of mobilization has fallen away and disappeared and what remains are a few words, some images, and an instrument or two? How are we to make cultural sense of these artifacts and representations in their terms *today*, especially if, as in the case of Babbage's calculating engines, they were so unfamiliar in their own day? In other words, how are we to sense their effects of defamiliarization on a contemporary mind and allow what we sense to destabilize our own historical consciousnesses? It is one thing to lose oneself in a complex pictorial representation like *The Ambassadors* or *Rain, Steam and Speed: The Great Western Railway*, but it is of another order of experience to lose oneself in a set of mechanical drawings such as those that were produced for Babbage's calculating engines.

It seems to me that we can think of each category of representation as the embodiment of the possibility of two generic types of impossible histories. The first type is impossible in the sense of Henry Adams, when he noted that he had experienced four impossibilities in his lifetime: the ocean steamship, the railway, the electric telegraph, and the daguerreotype.[13] Holbein's and Turner's paintings and the talbotypes would fit into this category. The second is also impossible, but in the sense of the analytical engine's infinite capacities.[14] Perhaps this is also a sense of the impossible that Adams was suggesting with his list of new media of transportation and communication inasmuch as they, too, embodied the promise of an infinite capacity to represent. Both these impossibilities are of interest because of the way that they cantilever the human imagination over the frontier of a particular historical limit or propel it through a new threshold of human perception.

There is a third impossibility that Adams and his generation did not experience because it existed only in fragmentary forms and thus in a liminal state. That impossibility is represented by Babbage's lifetime project. If its overall shape could be experienced at all, then it could only be experienced

as a kind of virtual uchronic entity ensconced in graphic form. Its impossibility was grounded not only in the infinite that the analytical engine embodied in finite form, but also in the evaporating possibility of constructing the engines themselves and the residues that were left behind as testimonies to the projects excessive ambitions.

But there is also a fourth type of impossibility that clothes our imaginations when they roam the space between "promise and performance" in a libertarian spirit.[15] In "Drawing Things Together," Latour has noted some of its characteristics when he describes the power of perspective drawing in the following terms: "Fiction—even the wildest or the most sacred—and things of nature—even the lowliest—have a meeting ground, *a common place*, because they all benefit from the same 'optical consistency'."[16] Perspective and similar systems have been devised to bridge the gap between "promise and performance" in the service of the normalization of representation. A system of perspective can thus be used as a perfect illustration of Latour's argument: "Innovations in graphism are crucial but only insofar as they allow new two-way relations to be established with objects (from nature or from fiction) and only insofar as they allow inscriptions either to become more mobile or to stay immutable through all their displacements."[17]

The Ambassadors is a perfect illustration of this argument—but also of its limits. For this painting also embodies the (anamorphic) proposition that a common spatial frame of reference, even a graphic one, can be a very slippery foundation for the normalization of perception and the imagination, especially if this frame is the arena for the conflicting operations of more than one system of representation. Moreover, Babbage's abortive work on his calculating engines demonstrates that all systems of representation are open to turbulence or disorganization if they have served as the medium or channel for the imagination's voyage into the unknown and that voyage has, for one reason or another, been prematurely terminated. In such cases, the voyage's fragmentary and incomplete archive is particularly vulnerable to the transgressive activities of marauding imaginations that are not necessarily operating under the same disciplinary constraints as a machinist, engineer, or historian of technology.

From the perspective of an early twenty-first century eye, there might be other ways of apprehending and experiencing the ambiguity and cognitive instability that is inherent in decontextualized or fragmentary representations and artifacts. For example, is it not possible to treat artifacts and representations as peculiar kinds of representatives and, at the same time, treat one's encounters with such representatives in *intercultural* terms? Such an approach would lead to a different kind of anthropology of contact spaces, one that would be keyed into uchronic histories and fictional encounters with rep-

resentations and artifacts that not only exist but are treated as *intelligent agents* from other times and spaces.[18] After all, drawings, photographs, paintings, and prototypical artifacts are, as we have seen, much more than historical artifacts, simple machine proxies, or mute images. As the calculating engines demonstrate, they can embody working models of the mind's mental processes. Finally, in this connection, could one not also raise the possibility of an erotic sensuality of contact or a sensuality associated with the grain or materiality of communication—one rendered palpable through the contact between different media—and this contact's principle role as interface?

In *The Pencil: A History of Design and Circumstance*, Henry Petroski argues: "The point of a pencil is its raison d'être; all else is infrastructure." He goes on, however, to caution that the pencil could not be effectively articulated without an infrastructure, which he defines as "an underlying prerequisite for the effective functioning, dissemination, and acceptance of inventions—once their novelty wears off."[19] Petroski and other historians of engineering drawing suggest that the pencil and related marking instruments coupled to other tools for the visualization of graphic information (such as printing, linear perspective, and projective systems of geometry) lay at the foundations of the research and development of modern engineering artifacts.

For example, in *Engineering and the Mind's Eye*, Eugene Ferguson has argued that "many features and qualities of the objects that a technologist thinks about cannot be reduced to unambiguous verbal descriptions; therefore, they are dealt with in the mind by a visual, nonverbal process." The visual, nonverbal process of learning and understanding that Ferguson identifies is "converted" into sketches, drawings, plans, and specifications that serve as collective tools of visualization, and he has emphasized that the "information that the drawings convey is overwhelmingly visual: not verbal, except for notes that specify materials or other details; not numerical, except for dimensions of parts and assemblies." But he has also cautioned: "Although the drawings appear to be exact and unequivocal, their precision conceals many informal choices, inarticulate judgments, acts of intuition, and assumptions about the way the world works."[20] These concealed influences can also shape an artifact's physical form as well as its infrastructure. Innovations in graphism thus do not provide a guarantee that such choices, judgments, traces of intuition, and assumptions will be excluded from the domain of the visible—in fact, they provide additional means for their manifestation.

Although different categories of sketches—thinking, prescriptive, or talking—are used to capture fleeting ideas, present new ideas, or actively explore alternative ideas, let us not forget that their modes of inscription are also complex technical artifacts.[21] The common pencil is not only at the roots of many technical inventions, but it can also serve, as Petroski has demonstrated,

as an admirable metaphor for engineering design and practice. Hence, the point of a pencil's or pencil-like instrument's contact with an inscriptive surface is also an interface between a powerful metaphor and an emergent idea.

During the course of his history, Petroski notes that the field of engineering drawing is similar to that of engineering artifacts inasmuch as both are subject to relentless destruction. On the one hand, "ideas that are improved upon are displaced in much the same way the old files on computer disks are written over with the new, and the artifacts that are improved upon are often discarded or cannibalized for a new, improved product." [22] On the other hand, if the point of a pencil is its raison d'être, then this raison d'être is coupled to the pencil's eventual destruction in the service of an idea. Historians and sociologists are now turning their attention to the inscriptive foundations of complex technical artifacts and processes of scientific visualization, but there has been little attempt to investigate the fine edge of an inscriptive tool's infrastructure, namely its "culture" of contact as articulated by the human senses in conjunction with the flow and translation of information from one medium to another. For it is at this more or less precise site that novelty is constantly reconstituted in the contact of and friction between different media. Here the principle of the copy is tenuously articulated into existence as an image or trace that is measured against the imagination, the impossible, and perhaps even the infinite. This site is also the place where a marauding imagination can articulate a libertarian reading along or against the preexisting traces of an idea but to the beat of a strange, ethereal tango of the senses.

Is it possible to conceive of the meeting of an inscriptive device and inscriptive surface in terms that would do justice to the astonishing intellectual and sensory richness of this contact? Are we able to resurrect the rich representational atmosphere and potent sensory presence of an emergent idea? How are we to situate ourselves in relation both to this process of emergence and to our own history, which might have been destabilized, however slightly, by contact with the process? Can we picture the emergence and flow of information in and among different categories of sketch and drawing conceived as an aesthetic and intellectual field of possibilities? How, in short, are we to "touch" the other that is an "idea" in the process of its rematerialization from the point of view of its particular manifestation as "mind"? In other words, what would it be like, in this state of consciousness, to retrace, to copy the informal, inarticulate, intuitive, emergent, inscriptive trajectory of Babbage's project, or any other similar kind of project—in the present and in terms of a future that is both ours and someone else's?

Moreover, if we choose to explore the archive of drawings, models, and prototypes that are the remains of Babbage's project, given the fact that there was no real end to this project, its prototypical artifacts, or its systems of

representation, how are we to take account of our passage through this liminal zone of human activity? One could choose to explore the individual or collective spatial and representational characteristics of this fragmentary array with a view to rendering it comprehensible from the point of view of the history of technology, computing devices, or its relationship to an emerging manufacturing culture. Or one could treat the archive or its elements as a point of departure for the investigation of new types of future possibilities (including aesthetic possibilities).

What impact would such choices have on the conventional idea of a new kind of technological artifact? Or what impact would they have on the facts that the evolution of technological forms creates privileged sites for new kinds of previously unexperienced sensory activity and that these sites are often located *within* the boundaries of a particular object? Where, for example, would any given technological artifact *begin* and where would it *end*: at its material boundaries or at the limits of its history as an idea? And how would this "idea" be defined through time and over space? Finally, what about all the antiquated machines and scientific instruments that litter the museums, auction rooms, and shelves of antiquarian shops that specialize in these types of cultural artifacts? These artifacts embody a whole range of different possibilities: novel forms of time travel and of potential zones of intercultural contact and transcultural experiences. I mention intercultural contact and transcultural experiences because, for the most part, they are no longer used and they often belong to forgotten bodies of knowledge; thus they remain well outside of most people's realms of experience. But if used today in new situations or even in terms that mirror their former uses, they would create strange folds in time and history, like the Science Museum's Difference Engine No. 2 (figure 10.5).

Francis Spufford has drawn attention to the eccentric position of the Difference Engine No. 2 that was built in 1991 from Babbage's plans: The person who designed it never saw it, and his contemporaries never experienced it. Spufford points out that its paradoxical status can be likened to a "fictitious antique" or to a "relic of a nonexistent history."[23] This is true, however, only if we ignore the mechanical drawings and concentrate instead on the object, and, moreover, on the (re)constructed object whose status and impact on the contemporary imagination Spufford summarized in exemplary fashion:

> The Engine is in effect a collaboration between times. Its functional, successful existence here and now vindicates Babbage's design, but the *design* alone. The Science Museum did not mean to test the Engine's feasibility then, only its feasibility now. They abolished, rather than re-creating, contemporary constraints. They acted on their own power to complete what had been uncompleted, to realize what had been unrealized. The object in the gallery therefore says nothing decisive about whether Babbage could have succeeded. . . . When

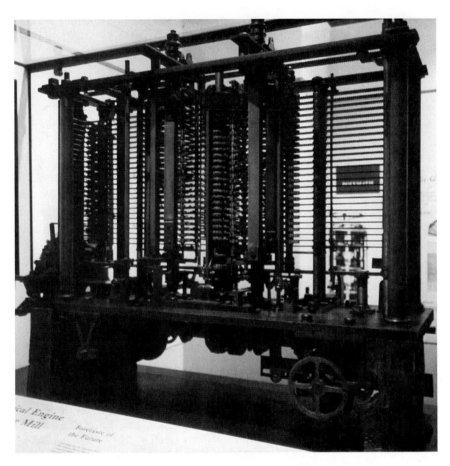

FIGURE 10.5. Difference Engine No. 2, Science Museum, London. Photograph: David Tomas.

we look at it, this synthetic thing made from now's response to then, we are dealing with a relationship to the past, with our own ability to imagine and retrieve, and with the fluctuating process by which at different times different parts of history seem to come to prominence as we recognize unfinished business there. . . . We nominate some times as livelier than others because, like the living present, they seem to contain unexhausted possibilities, of which our sense that at a certain point things could have gone otherwise gives a perverse sort of index.[24]

Later in his essay Spufford argues that "words, which summon worlds, are [the] proper medium" of thought directed to imaginary worlds.[25] But the drawings and machine fragments suggest that other media are also useful for such thought. They suggest that it is precisely to the design drawings that we should look not only for the uniqueness of Babbage's vision but for its strangeness as well.

When we talk about "engines for new worlds of experience," or the fact that new technologies of the caliber of virtual reality create new sites for the fusion of body and mind, we tend to fall into the same fallacy as historians who treat the evolution of various imaging systems such as photography or systems of transportation and communication such as railways as autonomous systems.[26] We cannot treat such systems in these compartmentalized and essentialist ways. Comments like those of Henry Adams or the careers of William Henry Fox Talbot, Isambard Kingdom Brunel, and Charles Babbage, among others, suggest that there are other ways of conceiving of a culture and history of technical objects. They point, for example, to an intersystemic or network-based approach to a culture of imaging systems and the culture of information that they articulated. We should look, in addition, to the interface *between* media and to the sites of their peculiar or odd thresholds for data concerning alternative histories.

In 1822, at the beginning of his long engagement with the possibilities of automatic calculation by means of machinery, Babbage summarized his initial contact with its idea in the following words:

> The idea appeared to possess that species of novelty which gives so much pleasure and makes so strong an impression on the mind, when, for the first time we express in words some principle of, or precept to, which we have long tacitly assented. When we have clothed it with language we appear to have given permanent existence to that which was transient, and we admire what is frequently only a step in the process of generalization as the creation of our own intellect.[27]

Earlier I suggested that uchronic histories could point to a peculiar type of interdisciplinary space that might exist between history and other disciplines such as art and science where parallel and fictive types of knowledge might take shape in tendentious tension. I noted that they suggest a world governed by speculative and unstable types of knowledge that can set one's imagination in motion, in oscillation, between the known and the unknown, the possible and the impossible. Babbage's words, written at the beginning of his long project to build his calculating engines, seem to register a context—a triangulation between idea, novelty, and pleasure—through which the powerful and novel possibilities of calculating on the basis of steam power could be intuitively measured in an ad hoc and preliminary manner.[28] One wonders if this measure continued to operate throughout Babbage's career and whether its primary focal point was the tip of his or his draftsman's pencil or pen?

The notes, sketches, drawings, prototypes, and new types of machine tools that stage Babbage's project for a present-day imagination can also be treated as the miscellaneous elements of an unstable interdisciplinary environment. They are the traces of information and agency that could only exist under

such tenuous conditions; and they represent this environment's insubstantial geography. They are the products and representatives of new forms of communication, such as Babbage's system of mechanical notation, that were developed to incubate the emerging forms of the various calculating engines and that could also incubate all types of machines or machine-like systems. They also plot an ever-expanding horizon line in the field of the human imagination. As Babbage noted in connection with the analytical engine: "The Calculating Engine is a Locomotive that lays down its own railway." [29] This is an impossible image that straddles the limits of the possible, inasmuch as steam power had originally provided Babbage with the idea of computing mathematical tables automatically. [30] Finally, these objects, traces, and representations provide a particularly complex set of views on the idea of progress and its relationship to the workings of the imagination—one that is fragmented, dissipated, remarkably incomplete, strangely virtual, and enigmatically speculative.

Perhaps, therefore, Babbage's words are as fitting an epitaph as any to a project of this magnitude and to the fact that it was never completed. The words are all the more poignant given the fact that the project's key artifacts are, nevertheless, preserved in a state of suspended animation in a different medium from the metal that was to serve as the vehicle for their ultimate and final forms.

Such is also the case with the Science Museum's Difference Engine No. 2, which, although complete, lacks its printing mechanism and can thus never fulfill the mandate of its design. To place Babbage's words in the position of an epitaph for an incomplete series of machines that they entitled in the first place is to suspend the calculating engines between word and image, in an indeterminate embryonic space between the poles of the possible and the impossible, the knowable and the unknowable, in a space that traces the uchronic scenario of a "first" protocybernetic contact.

Escape and Constraint: Three Fictions Dream of Moving from Energy to Information

N. KATHERINE HAYLES

"Information wants to be free." More than a hacker's slogan, this cry echoes across the twentieth century and through a variety of communication technologies, from the telegraph to the computer. At stake is the hope that information will constitute a new regime, an economy of exchange not bound by the laws of conservation formulated for energy in the nineteenth century. The second law of thermodynamics dictates that in a closed system, the amount of energy available for useful work decreases with every exchange. Information, by contrast, is not subject to the same constraints. If I have a disk and make a copy for you, we both have the information. Like the fabled magic pot, information promises to proliferate endlessly without cost. At the end of the twentieth century, as information technologies move toward nano-components, optical storage media, and photonic switches, this promise sings its siren call louder than ever. Charles Ostman, senior fellow at Global Futures, a consulting firm that anticipates near-future technological development, predicted recently that once nanotechnology is developed, all shortages will disappear. The "coveting of stuff, territory, physical things will no longer be an issue because there won't be any reason for it—you can make what you need. Wars, conquests, enslavement of peoples, malevolent dictatorships—all the stuff driven by predation—will be obsolete." [1]

Assumptions that may not be immediately apparent link the conservation laws of thermodynamics with the formation of the liberal subject. If one simply makes whatever one desires, virtually without cost, private property would cease to be meaningful, and with it an idea of selfhood based on the notion that in the first instance one owns oneself, a proposition that C. B. Macpherson has called possessive individualism and that he identifies as foundational to liberal philosophy. [2] If these constraints fall away, surely others can follow. Operating in the economy of information, one can dream that social position and economic class will cease to matter, that one could even loosen the constraints of living in a single body located at a single position in space and time.

One kind of response to these speculations is articulated by Robert

Markley in his critique of the information superhighway.[3] Rightly criticizing the rhetoric of free information, Markley points to the ecological and social costs involved in developing a global information network. But important issues remain obscured if the emphasis falls solely on recuperating the regime of information and returning it to the constraints governing matter and energy. To understand fully the dynamics at work, it is necessary to look at the joints, often uneasily fabricated, where the regime of information is articulated with the world of matter and energy and the constraints they imply.

On one side, the dream of freely flowing information strains to escape scarcity, restricted physical space, class, gender, embodiment, time, and mortality. On the other, the claims of corporate profit, stratified social structures, physical confinement, female dependence on powerful males, and marked and failing bodies reassert their inevitability. Running across these straining joints are certain common lines of force. Because technologies of communication make the dream possible, one powerful issue is how to articulate the body together with prostheses of communication. Another is how subjectivities change as they are reconfigured for a regime of information, and change again as they are pulled back into the constraints of energy and matter. Processes of signification are also involved, for the nature and dynamics of signifiers change as they move from the flat, durable inscriptions of print into the coded chains characteristic of electric and electronic communication technologies. As I have noted elsewhere, in the regime of information, struggles for possession yield to issues of access, narrators characterized as speaking or writing voices shift to decoders and encoders, and flat signifiers are transformed into accordion structures whose expansions and contractions across multiple levels are regulated by coding rules.[4] This change from flat to accordion structures bestows remarkable transformative powers on the signifiers and opens the possibility of interventions into the coding-decoding chains. Because these interventions frequently require humans to interact with communication technologies, the changed nature of signification ties back into the prostheses uniting humans and machines. Signification, technology, and subjectivity co-evolve together.

Three fictions, stretching across the span of the twentieth century, will be used to interrogate these complex dynamics. Of course these writings cannot begin to represent all of the complex social, economic, and technological changes involved, but they raise issues that may suggest directions for further research.

Henry James's "In the Cage," written in 1898, explores intimations of an information regime through telegraphy.[5] As the woman in the telegraph cage sends out messages and uses her active imagination to reconstruct dangerous sexual liaisons from the sparse codes, she also contemplates her own future

marriage to Mudge the grocer, a transaction firmly rooted in the constraints of scarcity. Vacillating between the dream of information and the restrictions of matter and energy, the telegraphist attempts to code her interactions in ways that would inscript into them the regime of information. The struggle here is not so much to perform a subjectivity appropriate to information as to re-interpret actions performed under the regime of energy so that their significance escapes that regime.

In Philip K. Dick's *The Three Stigmata of Palmer Eldritch*, written two-thirds of a century later, the issue is not reinscription but transubstantiation, a dream of translation into a regime of information that fundamentally changes the nature of subjectivity.[6] A corporate battle between the purveyors of two drugs, one of which preserves traditional subjectivity and the other of which radically alters the experience of subjectivity, sets the stage for moving beyond information considered as a separate space to information as simulation. Once posited as simulation, information develops the power to infect reality, making *it* appear to be a simulation.

The last text is James Tiptree, Jr.'s "The Girl Who Was Plugged In," a fiction whose title resonates with James's girl in the cage.[7] Written in 1973, the story postdates Dick's fiction enough to envision the regime of information not as competing with reality but as interpenetrating and indeed indistinguishable from it. In this respect Tiptree's fiction seems to hearken back to James's story, but with the crucial difference that here subjectivity is split between two bodies. One body exists in a real-life dream in which scarcity drops away; the other body participates in that dream but at the same time endures extreme physical constraints.

The trajectory formed by these three fictions displays a clear pattern. First, the regime of information is figured as an escape, but the more powerfully it exerts its presence as a viable place in which to live, the more it appears not as an escape at all but rather as an arena in which the dynamics of domination and control can be played out in new ways. What changes is finally not the economy of scarcity, but the subjects within and through whose bodies the informational codes are transmitted.

CODE AS REINSCRIPTION: "IN THE CAGE"

"In the Cage" is structured through a series of oppositions that dramatize the contrast between the constraints of ordinary life and the freedom of an information regime. Confined in the small space of the telegraph cage, the girl feels that her nervous system, and especially her imagination, extends outward through the telegraph network, until there "were times when all the

wires in the country seemed to start from the little hole-and-corner where she plied for a livelihood."[8] The messages she is given by her customers operate according to a similar dual logic. In one guise they are words to be counted, commodities that make money for the company.[9] But decoded by her imagination, they become tokens of the secret lives of the aristocrats who make use of her services, whom she imagines occupy a regime in which calculation is transformed to passion, constraint into glorious freedom.

The different economy in which her imagination operates, compared to the economy of her mundane life, is illustrated through the diverse effects her imaginings have on the future compared to those of her betrothed, Mr. Mudge the grocer. In the informational economy, imagining the future makes it blossom with possibility. The girl eagerly anticipates the visits of the dashing Captain Everard, whom she intuits is having an adulterous liaison with Lady Bradeen, variously encoded in the telegrams as "Mary," "Cissy," or "Miss Dolman." In this regime, the more the girl imagines, the more there is. In contrast are the anticipations of Mudge, who seems to wear the future out by fingering it over and over in his calculations, as though his imaginative life operated according to laws of conservation that subtract anticipated pleasures from lived pleasures in a strict balancing of quantities.[10]

Operating in an economy of scarcity privileges possession, and possession takes place within a dialectic of presence and absence: one has money or loses it, one possesses an object or gives it away. Information is not a presence or an absence and so does not operate within that dialectic. Rather, information emerges from a dialectic of pattern and randomness, signal and noise. With information, it is not a question of possession but access. The contrast is played out in the different strategies adopted by the girl and Mrs. Jordan, a clergyman's widow. Mrs. Jordan hopes to regain her former status by arranging flowers for the wealthy, a service that allows her to enter their homes. According to her account, this physical proximity gives her chances much superior to those the girl enjoys. She urges the girl to join her in her enterprise, intimating that this is the way for the girl to find a wealthy husband. Trapped in her cage, the girl has no physical entry into spaces of wealth and privilege, but she does have access to the messages they send. As she hesitates between joining Mrs. Jordan and continuing to send messages, the girl is forced to confront what, exactly, the information regime can do in helping her.

The matter comes to a head in a meeting the girl allows to happen outside the cage between herself and Captain Everard. At stake for the girl in this encounter is the regime into which her actions will be inscribed. If they take place in the realm of scarcity, her initiatives can only be read as the advances of a shopgirl to a gentleman, which, if they proceed to a sexual en-

counter, the girl realizes would not even be considered significant enough to count as infidelity on his part toward his lover, Lady Bradeen.[11] After this encounter, the Captain appears to offer the girl money, as if offering to buy sex or silence. Norrman argues that the girl's ultimate goal in meeting with Everard is to get him to marry her. This may indeed form part of her intention, but as the meeting progresses, it becomes clear to her that an equally likely—in actuality, far more likely—possibility is that she would become his mistress. Desperate to avoid this interpretation of their relationship, the girl struggles to define the realm in which their interactions take place as something beyond and above the regime of scarcity, to establish an economy in which she can be extravagantly generous toward the Captain rather than the other way around and in which the relation between them will be "not a bit horrid or vulgar" (193).

Significantly, this realm turns out to be the regime of information. The girl has an opportunity to exercise her generosity by recalling for the Captain a telegram Lady Bradeen sent to him that was intercepted. Emphasizing the informational nature of the exchange is the fact that the telegram, intended to be transcribed into Morse code, is itself written in code, a series of numbers correlated with events in the physical world through undisclosed encryption rules. The girl had already intervened in the coding chains when she corrected Lady Bradeen's code for the place name that corresponded with the pseudonym "Miss Dolman."[12] Whether this "correction" was a mistake that led to the telegram's interception we do not know.[13] However this may be, the arbitrary nature of the code is underscored when the Captain announces that "It's all right if it's wrong," possibly because the number code passed secret information to him that the mistake exonerated him from knowing (223).

These events, left mysterious by the narrator, have the effect of emphasizing the arbitrariness of codes. This arbitrariness is of a different nature than that pointed out by Saussure when he asserted the relation between the signifier and signified is arbitrary. Saussure meant to deny that a "natural" relationship exists between a word and a thing. It is an oft-told story how theorists, following Saussure, further separated signifier from signified until the signified seemed to recede from view. By contrast, in codes the signified does not disappear. Rather, at every level of code the relation between signifier and signified is precisely specified by rules governing the transformations of encoding and decoding. Nevertheless, mistakes happen, and a symbol in the object code may be incorrectly correlated with the matching symbol in the target code. These mistakes do not testify to an inevitable undecidability in the relation between signifier and signified, mark and concept, such as a deconstructionist reading would display. Rather, coding error points instead to the inevitability of noise in the system, a shift that is bound up with conceptual-

izing the signifier not as a flat mark but as a series of transformations be-tween different levels of code.

In brief, the shift signals a change of emphasis from the limitations on lan-guage to produce meaning to the limitations on code to transmit messages accurately. Whereas the arbitrariness of language implies the inability of lan-guage to ground itself in originary meaning, the arbitrariness of code leads to multiple sites for intervention in the coding chains and thus to a focus on the fragility of messages as they are encoded, sent through communication channels, and decoded through a series of articulations between humans and machines. Deconstruction focuses on economies of supplementarity, coding theory on techniques of supplementation that graft organic components to-gether with communication prostheses. Deconstruction implies a shift from the authority of a speaking subject to the instabilities of a writing subject, whereas coding theory implies a transformation from the writing subject to a post-human collective of encoders and decoders.

Significantly, in James's story the girl is only infrequently depicted as working the sounder; her efforts tend not toward a seamless integration with the machine but rather move in the opposite direction of transforming words from commodities into intuitions. Before the telegrams are translated into code, the girl operates selectively on some of them to encrypt them into com-binations other than those the company intends. "Most of the elements swam straight away, lost themselves in the bottomless common, and by so doing kept the page clear. On the clearness, therefore, what she did retain stood sharply out; she nipped and caught it, turned it and interwove it" (156). The girl's selective attention is here represented as a coding operation, a physical rearrangement of marks on the page that erases some of the "ele-ments" and makes others into signifiers resonant with meaning. She will later enact this metaphoric action physically when she takes the telegram from Lady Bradeen, erases one of the words, and puts another in its place. Jennifer Wicke points out the importance of the girl's interventions into the coding sequences: "This putative action mystifies the process of the sending out of the telegrams, but also alters it, produces it back so that the nameless intermediary of the process of communication reorchestrates that informa-tion, as James calls it, that ceaselessly traverses the cage." [14]

Viewing language as a code rather than a loose network of floating signi-fiers entails different reading techniques. At issue is the difference between a language that cannot unambiguously say what it means, and a message that cannot be encoded and decoded without undergoing transformations as in-terventions break the coding rules and thereby produce noise in the system. Thus what is available for readerly inspection is not so much the ambiguity of meaning—we never find out to what the numbers in the telegram refer—

but rather the places in the text where interventions in the coding chain occur, as when the girl alters the telegram. A characteristic of code, as distinct from natural language, is the leverage power that comes about through the multiple coding correlations, as when a single keystroke changes the entire appearance of a text on computer screen. This characteristic enters the story through a plot that makes the fate of Captain Everard and Lady Bradeen hang upon a change in the coded telegram. That the climax depends upon a mistake in the coding sequence, not simply on ambiguities in language, indicates that the form of the story, like the yearnings of the protagonist, locates itself within the regime of information.

Yet matters are not quite so simple. At the close of the nineteenth century, the regime of information had not penetrated far enough into the social infrastructure to maintain itself as a separate space. Although the story's climax validates the power of information when the girl displays her power by dangling the message the Captain so desperately needs to recover, this proves to be a momentary—if satisfying—triumph rather than the establishment of a regime of information as a place where one might live. The end reasserts the power of the economy of scarcity, albeit with some reservations. It arrives when Mrs. Jordan shares with the girl the news she is to be married. The encounter escalates into a contest for preeminence based on who knows the most information about the scandalous affair between Lady Bradeen and Captain Everard. Mrs. Jordan knows, as the girl does not, information having to do with presence and absence. She tells the girl that Lord Bradeen discovered Lady Bradeen had taken an object—"It's even said she stole it!"—and given it to Captain Everard (240). But the girl knows the object to which Mrs. Jordan refers in her formulation, "something was lost—something was found," was a telegram, or more precisely the message the telegram contained (240). Since her office has destroyed the physical copy of the telegram, it is only through a memory made eidetic by the excitement of her imaginative decodings that she remembers the number sequence and can reproduce it for the Captain. What is produced, then, is not a presence or an absence but a pattern where the crucial issue is whether a mistake has been made in the code.

Mrs. Jordan believes it is only because Lady Bradeen is able to rescue the Captain by "stealing" the object that he agrees to marry her, while the girl has the bittersweet knowledge that it was she, not Lady Bradeen, who produced the message that saved the Captain and Lady Bradeen. This information she simultaneously gave away to the Captain and kept for herself, an exchange possible only within the regime of information. This doubleness is soon to end, however, for the realm of information cannot sustain its powers, cannot offer a real space in which to live. Her exciting double life, one

strand of which was spun in an informational realm replete with mystery and the promise of infinite expansion, is about to collapse into a single life-line whose unwinding in the regime of scarcity is all too easily foreseen. As the girl and Mrs. Jordan exchange confidences, the girl holds back the infor-mation that it was she who saved the Captain. But this very hoarding indi-cates she has fallen back into a regime of scarcity, for if she gives this news to Mrs. Jordan, she will lose the sense of superiority she savors by know-ing something those around her do not. She has become an inhabitant of Mudge's world, where her secrets, like his anticipations, are worn out if they are fingered too often. Resigned to the inevitability of her return to the re-gime of scarcity, she resolves to postpone her marriage no longer and in fact to hasten it. Nor does this reassertion of scarcity claim her as its only victim. Mrs. Jordan will enter into marriage with a butler because, as she admits in an incautious burst of emotion, "it has led to my not starving!"(236). And the Captain will enter into a marriage in which his authority in the house-hold is much diminished, because it is Lady Bradeen who has the fortune while he has mostly debts.

In opening the informational realm to view, exploring its dynamics and possibilities, and finally allowing it to be folded again into a regime based on conservation, James writes what might be called the prequel to the story of information in the twentieth century. As the century progresses, fictions show the regime of information penetrating further into the constitution of subjects and the construction of reality. The girl may feel a doubleness in her life, but she never doubts such fundamental facts as where her body is lo-cated or what, in an ordinary sense, her identity is. As the regime of infor-mation expands in force and scope, and as technologies of communication penetrate deeper into the infrastructure of society, these anchors in everyday physical reality begin to drift and finally come unmoored, although as we shall see, this does not mean that the laws of conservation cease to operate.

CODE AS TRANSUBSTANTIATION:
THE THREE STIGMATA OF PALMER ELDRITCH

Published in 1965, *The Three Stigmata of Palmer Eldritch* reflects the emerg-ing awareness in the United States of hallucinogenic drugs. Dick gives this awareness his own twist in making the drug a communication technology. Can-D is ingested by colonists on Mars to relieve the unbearable bleakness of their lives on an inhospitable alien planet, housed in dismal underground dwellings appropriately called hovels. Under the influence of Can-D, the col-onists collectively project their consciousness into miniature dolls, Perky Pat

and Walt, modeled on Barbie and Ken. While inhabiting the dolls, each person knows the thoughts of others sharing the same doll, highlighting the drug's function as a communication technology. The drug is further linked to communication technologies by satellite broadcasts that push the drug and use encrypted messages to tell the colonists when the next drop will take place.

In sharp contrast to the regime of scarcity that the colonists inhabit in mundane reality, the drug creates a space of promise and infinite expansion characteristic of the realm of information. In the Perky Pat world, the women are all buxom and beautiful, the men all drive fast sports cars, and every day is Saturday. Moreover, these common goods are achieved without sacrificing individual identity. Although the women all enter Perky Pat and the men enter Walt (no transgendering for Dick), each person retains her or his sense of self and individual agency. The dolls' imagined actions in the carefully realistic miniature sets, "minned" to precisely resemble Earth artifacts, result from the desires of all the people occupying the doll. If two of the women want Pat to go swimming and the third doesn't, Pat will go swimming, and Walt will follow her into the water only if the majority of men occupying him agree he should. Thus the drug, despite its hallucinogenic properties, preserves intact fundamental aspects of the liberal subject, including agency and a sense of individual identity based on possession, for it is primarily through the display and consumption of commodities that the Perky Pat world is made to seem real.

Reinforcing these attributes of the liberal subject are older notions about a central core of identity comprising an essential self that inhabits the body but is not identical with it. To perform this identity in the Can-D world, the colonists draw on the medieval distinction between the "accidents" of a corruptible body and the "essence" of the immortal soul. When Fran goes into Pat's body, she ventures to her companion, Walt/Sam, " 'I used to be Fran,' " but now she believes " 'I could have been anyone before. Fran or Helen or Mary, and it wouldn't matter now. Right?' " (48). Sam, intent on having virtual sex with Fran, disagrees. " 'It's important that you're Fran,' " he asserts. " 'In essence' " (49). The suggestible Fran/Pat picks up on his distinction, calling the doll's breasts "accidents" and acknowledging they are " 'Not mine. Mine are smaller, I remember' "(48). The exchange illustrates that the experience reinforces an essential sense of self, notwithstanding the translation process and the "accidentals" it appears to change. It also suggests why some colonists regard tripping on Can-D as a religious experience. They debate whether, when translated, they enter an incorruptible realm in which the "essential" soul manifests itself in a world that never decays, a world that amounts to a commodified version of heaven (158).

The narrative viewpoint recreates the accidental/essential distinction on a descriptive level by marking a clear boundary between the illusory world of Perky Pat and the reality of the colonists' everyday lives. Although the colonists are experiencing themselves as the glamorous Pat and Walt, the narrator describes them as an objective eye would see them, sprawled in the hovel with drool dripping from their mouths from the chewed-up Can-D. When the drug wears off, the colonists also see the scene the narrator describes and are plunged back into the reality they never in actuality escaped. As in James's story, the realm of information promises an escape it cannot deliver. This firm basis in a realm of conservation is reinforced by the capitalistic market that links Perky Pat dolls with Can-D. As the colonists scramble to get together enough truffle skins to purchase the legal layouts and the illegal drug (in Dick's satirically rendered economy, truffle skins circulate as currency because they are the one object that cannot be successfully simulated), it is clear that liberal subjectivity, capitalism, an essential self, and narrative realism are all part of the same cultural configuration—a configuration based in laws of conservation and a corresponding systemic creation of a regime of scarcity.[15]

Whereas for James the collapse of a space of information provides the story's resolution, in Dick the folding of the information realm back into a regime of scarcity functions as prologue rather than conclusion. Can-D has a rival, Chew-Z. Palmer Eldritch, a "mad capitalist" as Darko Suvin has called him (instead of a mad scientist), has returned from a decade-long trip out of the solar system with a new drug that promises to remedy the deficiencies of Can-D and, more importantly, to hand over the ultimate prize of religion. "God promises eternal life," the Chew-Z slogan boasts, "We can deliver it" (160). The promise is based on one of Chew-Z's two major differences from Can-D. While Can-D preserves conventional time, Chew-Z creates a subjective perception of time that is much longer than the actual time elapsed. Someone under the influence of Chew-Z might experience hours, days, even months of time passing, while in the real world, only a few seconds have gone by. As users soon learn to their dismay, however, time by itself means little; if it passes in a nightmare world, long duration is not a blessing but a curse. Whereas actions in the Can-D world happen as a net result of all the users' agencies, in the Chew-Z world one person alone determines the rules by which the world operates—Palmer Eldritch. Moreover, the stakes are alarmingly raised, for if one dies in the Chew-Z world, one is dead in the real world as well.

Leo Bulero, the corporate mogul who markets the interdependent products Perky Pat and Can-D, pales in comparison with Palmer Eldritch, who ruthlessly intends to use Chew-Z to take over Earth as well as Mars. Dick's

work from this period often sets up a contrast between two types of capitalism. The more beneficent kind folds family relationships into the corporation, and the bonds between employer and employee include claims of loyalty and friendship. The profit motive is not lacking, but it is tempered by other considerations. In some deep way the stability of the subject is bound up in Dick's work with this kind of capitalism, as if he intuited that the liberal subject, capitalism, and the family are as inextricably entwined as Perky Pat and Can-D.[16]

By contrast, the more rapacious kind of capitalism represented by Palmer Eldritch has left behind any consideration of the subject as someone capable of loyalty or betrayal. Palmer Eldritch does not intend merely to make a profit. Rather, his goal is to infect everyone in the solar system with himself, as if he were eating them from the inside and displacing their subjectivities with his own. Leo, who has been captured by Eldritch and given Chew-Z involuntarily, thinks, "It's Palmer Eldritch who's everywhere, growing and growing like a mad weed" (196). Just as Palmer Eldritch seems to eat people from the inside, so Chew-Z seems to have the power to eat reality from the inside. The narrative viewpoint that revealed the Can-D world as illusory appears powerless to constitute this difference with Chew-Z. Moreover, discussions about the Can-D world used conventions that assumed surfaces were "accidental" and interiors "essential." Extending this convention to the Chew-Z world leads to a disconcerting insinuation, for now reality is the exterior husk and the simulation is the underlying essence that keeps breaking through. Posing as an information realm that can satisfy the deepest desires of humans trapped in a regime of scarcity, the Chew-Z world reveals itself not as a refuge but as a rapacious dynamic that preys on the autonomy of the liberal subject and indeed on the autonomy of the world itself.

This is the nightmare vision that, once articulated, the narrative tries to draw back from by a series of strategies, none of which is entirely successful. The narrative reacts as if the vision is too horrific to bear, but any attempt to mitigate it pales alongside the strength of the horror. Consider the following sequence of events. Hoping to exploit Barney's feelings of loyalty, Leo gives him a brain-rotting drug that Barney is to take and blame its effects on Chew-Z. As part of this plot Barney, now living on Mars, is supposed to communicate with a satellite broadcaster using the code book the broadcaster has given him. When he opens the book he finds it blank, presumably because by that time he is an inhabitant of the Chew-Z world—or rather, he has been inhabited by it—and Palmer Eldritch has intervened in his perceptions so that he cannot read the code. Here is an instance, then, where intervention in the chain of coded signifiers appears to cause a decisive turn of plot, much as it did in James's story.

The difference between Dick's epistemological assumptions and James's can be measured by what happens next. Under the influence of the drug, Barney time-travels into the future and learns that his failure to help Leo out was not crucial after all, for as more people take the drug, they realize it is a con and banish it. Instead of following through on a chain of events in which the issue is loyalty or betrayal, the plot twists to throw the emphasis elsewhere. The person who reveals this information to Barney is his future self, who helpfully reassures him that the experiences of the present-day Barney are hallucinations that will wear off in time. The issue here, then, is whether the narrative can regain ontological stability. The future Barney reinforces this stab at stability by making reality depend on a congruence of subjectivity and time. He argues that he is real because he is in his own time, whereas the present-day Barney is a phantasm because he has traveled out of his time.

After offering this reassuring parsing of events, however, Barney's future self begins to display the stigmata of Palmer Eldritch, throwing doubt on which Barney is real—if indeed either is. Moreover, his assurances to Barney that the Chew-Z world will wear off in time are scarcely trustworthy, because they are offered by the perpetrator of the world himself. His cover blown, Palmer Eldritch tells Barney that the best way he can spend the sub-jective eons before the drug wears off is as an inanimate object. When Barney tries to project his consciousness into a wall plaque, Eldritch intervenes to switch bodies with him. First the code book is the site of intervention, then the body. The first intervention destroys the cipher that allows different levels of signifiers to be correlated, the second breaks the indecipherable complexities that unite mind and body. Unmoored from its basis in embod-ied physicality, the "self" becomes increasingly destabilized, subverting the narrative's attempts to regain ontological security.

It is the switch of bodies, not the decision to take or not take the drug, that provides the climax. The body switch threatens to be fatal, for Eldritch at that moment in "real" time is on a defenseless space cargo ship about to be shot to smithereens by Leo Bulero's heavily armed gun ship. Its authen-ticity guaranteed by the finality of death, this would appear to be the real world. Again, the narrative reaches toward the stability of a secure ontology, albeit in a different time and place than before. Just before the fatal shot is fired, however, the effects of the drug wear off and Barney is translated back into his own body in a Martian hovel. Present again in his own time and space, Barney is confident this is reality, although he later realizes that the switch back into his "real" body is not complete, for he retains some trace of Palmer Eldritch within himself, just as he has left some trace of himself in Eldritch. It appears that subjectivity cannot be transmitted from one body to another without change, for noise in the channel creates an irreversible al-

teration of identity. Thus even when reality is apparently restored, it differs in some degree from what it was before the interventions happened.

In this space-opera mixture of the fantastic with the melodramatic, remarkable are not so much the dizzying turns of plot as the dizzying reversals of which world is authentic and which fake, which subject is a simulacrum and which a real person. The net result of the narrative's veering now toward ontological security, now toward destabilization, is to break down the distinctions that enabled the fake and the real to be constituted as separate categories. To an indeterminate extent, the fake and the real have been infused into one another.

Also subverted is the status of the body as a guarantor of identity, a physical presence inhabited by an essential self within. The status of Palmer Eldritch's body has been peculiar from the beginning. Several characters grow suspicious that an alien has eaten Eldritch from the inside during his long interstellar journey and taken over his body. Eldritch's three stigmata are not so much artificial aids to a natural body, then, as they are signifiers that the entire body is a prosthesis manipulated by the alien. The body itself has become a prosthesis of communication, for Palmer's body and its surrogates are brought into play primarily when the alien/Palmer wishes to communicate with someone. The implicit threat to the liberal subject posed by a realm of information in which possessive individualism no longer functions as a foundation for subjectivity is here realized through the science fiction trope of the alien. The irony, of course, is that this subversion has been achieved without realizing information's dream of endless plenitude. The liberal subject may be eaten from the inside, but capitalism continues more rapaciously than ever. Indeed, Kim Stanley Robinson has suggested that the alien who takes over Palmer Eldritch's body can be taken as "representing the spirit of capitalism, just as his product Chew-Z could be thought of as the ultimate consumer item."[17]

After the narrative's wild veering between ontological stability and destabilization, a resolution can scarcely be achieved by coming down on one side or the other, for the oscillation suggests that the opposite outcome is equally likely, in which case the resolution would have no more authority than a roulette wheel that stops on red rather than black. Instead, the text offers different strategies for dealing with a world that cannot be unambiguously categorized as either real or fake. During the instant Barney was translated into the alien's body, he briefly shared Palmer's consciousness. Barney senses that the alien is immensely old, so old that Barney decides he must be what humans have called God. Authorized by this ultimate signifier, the alien appears to be definitively named, thus stabilizing the regression into ontological uncertainty.

However, Anne Hawthorne, a character ambiguously represented both as a pilgrim to Mars bent on converting colonists to her religion and a spy for Leo Bulero, disagrees with Barney's assessment. " 'The key word happens to be *is*,' " she asserts. " 'Don't tell us, Barney, that whatever entered Palmer Eldritch *is* God, because you don't know that much about Him; no one can. But that living entity from intersystem space may, like us, be shaped in His image. A way He selected of showing Himself to us. If the map is not the territory, *the pot is not the potter*. So don't talk ontology, Barney; don't say *is*' " (232). Here the oscillation does not disappear but rather is made irrelevant to living one's life. Ontological security is sacrificed, but Anne implies it is possible to live a perfectly satisfactory life without this security. A key element in Anne's calm acceptance of the alien/Palmer Eldritch is the modesty of her expectations. The crucial gap between "is" and "appears," ontology and experience, inheres in the signifier called Palmer Eldritch but is not confined to that body, as the replication of the stigmata within other bodies indicates. In a deep sense, the stigmata are not manifestations of God but rather of a reality whose ontology cannot be unequivocally stabilized. Even though Anne also takes on the stigmata from time to time, she is not bothered by her inability to bridge the gap between experience and ultimate reality, because her faith paradoxically allows her to give up ontology.

Leo Bulero practices a different strategy, based on continuing contestation and the exercise of personal power. The grander the claim, the more ambitious the project, the more likely it is that the stigmata will reappear. In contrast to Anne's acceptance is Leo's conviction that he can triumph over Palmer Eldritch. Leo believes his thinking is more elevated than the ordinary person's because he has been taking E-therapy radiation treatments from Dr. Denkmal's evolution clinic. With his supposedly more evolved brain, he hatches the plan to become a Protector of Earth, gathering other humans evolved through E-therapy into a group that will become a watchdog society protecting Earth against the likes of Palmer Eldritch. Although he sports the stigmata, he convinces himself that inside is a core of authenticity. Echoing the colonists' distinction between accidents and essence, Leo intends to draw on this core to save himself and the Earth. But even if we accept Leo's claim that his project will be successful, at best he can only win the battle, for the war to maintain his human identity has already been lost.

More successful is the modest plan Barney decides upon. During the brief moment Barney shared Eldritch's mind, he realized that the alien intended to spend his days taking over Barney's life on Mars. Barney reasons that if life on Mars is good enough for the alien, it can be good enough for him, and he resolves to enjoy it despite its privations. Compared to the fatal attractions and illusory promises of the realm of information, the regime of scarcity ends up looking not so bad after all. It is significant that Barney intends to share

this life with Anne Hawthorne, the pilgrim who is content to admit she can never grasp ultimate reality.

These modest accommodations notwithstanding, *The Three Stigmata of Palmer Eldritch* represents a more profound subversion of conventional reality than did James's "In the Cage." More is at stake than revealing the emptiness of information's promise as a realm of effortless plenitude. If Can-D points to the sweetness of this illusion, Chew-Z points to the scarier possibility that, instead of a person consuming the drug, the drug will consume the person. With Chew-Z simulation acquires an ominous agency of its own, including the power to re-enter reality and eat it from the inside. Nevertheless, for Dick there still remains a distinction between simulation and reality. Hideous as the stigmata are, they nevertheless bring a degree of epistemological stability if not ontological security to the narrative, for they function as markers that indicate, more or less reliably, the realm within which the characters are operating. If the stigmata are absent, the character is in conventional reality; if present, the character is operating in the Chew-Z world, where Palmer Eldritch makes the rules and infects all subjectivities with his alien identity. The stigmata thus have the effect of marking the space of simulation and constituting it as a distinguishable phenomenon. The next step is a fiction in which these markers are lost and there is no distinction whatever between simulation and reality.

Tiptree's "The Girl Who Plugged In" takes this step, for here there are no stigmata. There is, however, a price for this merging of simulation and reality—a price exacted by establishing a binary division between a stigmatized and a privileged body. Although agency is recuperated, it is no longer the will of the possessive individual, but an agency completely dependent on accordion signifiers operating through communication technologies that present multiple sites for intervention. The self has become a message to be encoded and decoded, but the self the receiver decodes is never exactly the same self the sender encoded. Distributed between a privileged body and a stigmatized body which are connected by a noisy channel in which many interventions are possible, the liberal subject is not so much lost as reconstituted as a dream of the machine. The focus thus shifts from how the self expresses its agency to questions about who controls the machine. Whatever the status of information, the machine is definitely not free.

CODE AS (RE)INCARNATION: "THE GIRL WHO WAS PLUGGED IN"

In the near-future world of Tiptree's story, advertising has been banned. The communication conglomerate GTX has responded by airing shows following the beautiful people around the world, with strategic product placement

much as depicted in *The Truman Show*. Beautiful people often tend to be unreliable from a commercial viewpoint (just as Truman Burbank proved unreliable), so GTX has a new idea. They decide to build a beautiful person from scratch, a genetically engineered body without a functioning brain, to be operated remotely by a cybernetically modified human who will control the body as a *waldo*. For the operator they use P. Burke, a wretched, deformed woman off the streets who hitherto has looked up to the beautiful people as to gods. Immured in an underground cavern at the heart of a high-tech research center, P. Burke undergoes numerous operations that extend her nervous and sensory system into wires. After months of practice, P. Burke learns to inhabit the beautiful fifteen-year-old girl-body as if it were her own, a body that GTX advertising whizzes name Delphi. P. Burke still needs to tend to her own body as well, so while Delphi "sleeps" (i.e., returns to a vegetative state when her operator has withdrawn), P. Burke falls back into her own loathsome flesh and carries out the routines that enable her to continue living: eating, exercising, excreting.

Like Dick's novel and James's story, Tiptree's fiction constructs a sharp contrast between an informational realm and a "real" world of severe constraints that operates according to the laws of conservation. On the one hand, Delphi lives in a world of seemingly endless possibility, expansive in its glittering displays of wealth and privilege. On the other hand, P. Burke lives a severely controlled, Spartan existence in an underground cavern where her every move is closely monitored. Yet there are important differences between Dick's novel and Tiptree's fiction, illustrated by the comparison with Perky Pat. Both the Perky Pat layouts and Delphi's glamorous life exist to market commodities. Whereas the dolls are inanimate and move only in the drug-enhanced imaginations of the participants, Delphi appears to those around her as a normal person, complete with small talk and conspicuous consumption. Recall that the colonists maintained their sense of individual identities while their minds were projected into the doll. On some level they knew the difference between their "real" bodies and the doll's physique. For P. Burke, the projection into Delphi's body is so complete that she perceives it as her own. During the time of projection she experiences her identity as Delphi, all the more strongly because Delphi is everything she might have wished to be and so painfully was not. With Perky Pat, the narrative viewpoint constituted a sharp distinction between the stigmatized locale and the privileged world, but now the bodies themselves fall into these categories: P. Burke's deformed flesh versus Delphi's heavenly features. In Dick's novel, the binary division between the colonists' lives in the hovel and their expansive existences in the Perky Pat world was used to mark one as real, the other as illusory. Even when the Chew-Z world threatened to dis-

place the autonomy of the real world, there was still an implicit conceptual division between reality and illusion, the world as it is in itself and the world as it was created by Palmer Eldritch's mind.

By contrast, in Tiptree's story both spaces are real. Indeed, in some respects Delphi lives a more "real" life than P. Burke in her secret niche within the research complex, for Delphi moves in a socially constructed space that, filmed by the media and beamed out to communication networks throughout the world, represents the epitome of the autonomy, freedom, and agency of the liberal subject. The irony lies not in the illusory nature of this world but rather in the appearance of freedom and luxury in Delphi's life, in contrast to the constant surveillance she is under and the discipline to which both she and P. Burke are subject, for GTX is dedicated to "freeing the world from garble"(46). The issue, then, is not which world is real, for both Delphi's high-flying life and P. Burke's Spartan physical existence are located in real time and space. Rather, the focus is on the connections that make the two bodies into an integrated cybersystem, the kinds of discipline, surveillance, and punishment to which the bodies are subject, and the distribution of agency between these two different sites in the cybersystem.

The join between bodies is not altogether seamless. There is a gap of a few microseconds between the time that P. Burke thinks the command and Delphi's body enacts it, a temporal reflection of the physical space that separates them. Delphi's body also does not work in exactly the same way as other human bodies. Although Delphi sees and hears as well as normal humans, to conserve bandwidth the engineers left her with little sense of touch, almost no smell, and only enough kinesthesia for the body to work correctly. It is no accident that the senses she needs for broadband communication with the TV networks are left intact, while the intimate senses most deeply bound up with pleasure are diminished, making sex for her mostly a cerebral experience. Moreover, the diurnal pattern of waking and sleeping does not, in her case, signify that her body is refreshing itself. Rather, it reflects and enacts the distribution of agency, consciousness, and subjectivity between the two bodies according to a strict law of conservation that dictates P. Burke's body must "sleep" while the consciousness is inhabiting Delphi, and Delphi's body must "sleep" while the consciousness is back in P. Burke's body.

Intervening in both the media-constructed public world of Delphi and the secret research-dominated existence of P. Burke is the corporate structure and politics of GTX. It is the conglomerate that controls the communication channels through which subjectivity-as-message flows and decides how the distribution of subjectivity will be parsed as they regulate the "sleep" cycles and construct the differing sensory systems of P. Burke and Delphi. Thus the time gap does more than signify that agency is distributed; it also indicates

that multiple sites are available for intervention by the corporation into the subjectivity-as-message as it flows through the channels.[18] GTX no longer finds it necessary to discipline the bodies directly, for Delphi/P. Burke can be controlled even more effectively by intervening in the messages that flow between the bodies.[19]

Discipline becomes necessary when Delphi attracts the attention of Paul Isham, son of a top-ranking executive at GTX. In a script familiar from the 1960s, Paul uses the power and access bestowed on him by his family connections to make satirical TV shows critical of capitalism. As infatuated with Paul as he is with her, Delphi willingly accompanies him on romantic excursions, tolerated by GTX in a precise calculation that balances the leeway she is allowed against the strength of her ratings. Finally a "ferret-face" twerp at GTX, plotting for advancement, convinces his superiors that he should be allowed to discipline P. Burke/Delphi, which he does by twisting the dials that control the messages flowing between the bodies. The result is excruciating pain for both bodies. Paul, present when the discipline is administered, comes to the erroneous conclusion that his beloved Delphi has had an implant placed in her brain. Furious at this interference with his desires and defilement of his love object, he plots to "free" Delphi from her imprisonment.

He can do so, he thinks, through a wire mesh cage he has constructed that will cut off the signals sent to Delphi's brain. As if in ironic reversal of James's story, he plots to rescue Delphi from the realm of information by placing her in the cage. He hires a pilot to fly a small plane and whisks Delphi away from her keepers, in a wild dash for freedom that is undercut because GTX can track the plane's precise location through its computers. When Paul tries to place the cage over his "bird" (as he thinks of Delphi), she resists, knowing that if she is put in the cage she will cease to be the person Paul loves, and in fact will cease to be a person at all. Alarmed that his intervention does not free Delphi, Paul directs the plane toward the research center, determined to force the researchers to remove the supposed implant. His mistake is thinking that Delphi is an autonomous subject whose free will has temporarily been interfered with. In reality, Delphi's subjectivity cannot be separated from the integrated cybersystem that also includes P. Burke.

The climax comes when Paul bursts into the research center and demands to have Delphi "freed." P. Burke, inhabiting Delphi's body, knows that Paul is coming, and as he enters the inner sanctum to which her cubicle is attached, she bursts through the doors, croaking his name in a scarcely intelligible voice. Overwrought, Paul fails to recognize her as a part of the cybersystem that includes Delphi, seeing her as an independent and remarkably hideous creature scarcely recognizable as human with all the surgical inter-

ventions practiced upon her body. His response is to shoot her, whereupon Delphi also collapses, since there is now no one to operate her body.

But not completely. After Delphi/P. Burke had fallen in love with Paul, anomalies had begun occurring that should have been technically impossible. Delphi stirred in her "sleep" and one or twice murmured Paul's name, as if the waldo was somehow breaking into consciousness by itself. Meanwhile P. Burke, knowing a crisis was coming, has been fighting with all her might to leave her own flesh and force herself into Delphi's body.[20] The narrative intimates that in some measure one or both of these attempts may have partially succeeded, for after P. Burke dies, Delphi still retains enough consciousness to say plaintively "I'm Delphi," asserting the right to become the autonomous subject she can never be (78). The implication is that some measure of the possessive individual can survive, if only momentarily. If the corporation can intervene in the channels to discipline the bodies, perhaps the bodies can also intervene to send messages the corporation has not authorized. Such an intervention, however transitory, is by no means trivial, for GTX's "nightmares are about hemorrhages of information, channels screwed up, plans misimplemented, garble creeping in" (46).

As the narrative moves toward resolution, the ferret-faced twerp rescues his career by discovering the next big technical development in the corporation research labs, the ability to time-travel. Delphi is the site of the oracle, the voice that can reveal the future. Throughout, the narrator has been calling her story a tale of the future.[21] As if anticipating Ostman's utopic vision, her ironic tone mocks the reader for thinking that soon communication technologies will enable us to inhabit a realm of information that will bestow endless plenitude on those fortunate enough to enter it. Instead, the future itself has become a commodity, one of many sites available for sale through the miracle of communication technology. Like subjectivity, time can now be sent through the wires and so is subject to distribution according to corporate needs. The implication is that subjectivity and even time may be transformed, but capitalism continues intact.

Any claim to possessive individualism based on ownership of the self has thus been coopted by a union between corporate capitalism and communication technologies so potent that it operates in the intimate territory of nerve and muscle as well as in the global networks. What is changed is not historical power differences but rather the distribution of subjectivities in coordination with communication technologies. Information goes from being an imagined realm of plenitude in James's story, to a marked realm that interpenetrates reality in Dick's novel, to reality in Tiptree's fiction. As Timothy Lenoir has suggested, Baudrillard's prediction of a hyperreality that will dis-

place reality has proven too conservative to keep up with the transformative power of information technologies. Tiptree's story suggests that we will not call what emerges hyperreality; we will simply call it reality. Despite the differences in historical contexts and authorial voices that give these fictions distinctive visions, they concur in puncturing the dream of an informational realm that can escape the constraints of scarcity. Finally, it is not scarcity and market relations that are transformed, but the subjects who are constrained and defined by how they participate in them.

Cybernetics and Art: Cultural Convergence in the 1960s

EDWARD A. SHANKEN

In 1956, Hungarian-born artist Nicolas Schöffer created his first cybernetic sculpture *CYSP I* (figure 12.1), the title of which combined the first two letters of *cybernetic* and *spatio-dynamique*.[1] In 1958, scientist Abraham Moles published *Théorie de l'Information et Perception Esthétique*, which outlined "the aesthetic conditions for channeling media."[2] Curator Jasia Reichardt's exhibition *Cybernetic Serendipity* popularized the idea of joining cybernetics with art, opening at the Institute of Contemporary Art (ICA) in London in 1968, and traveling to Washington, D.C., and San Francisco between 1969–1970.

Not surprisingly, much artistic research on cybernetics had transpired between Schöffer's initial experiments of the mid-1950s and Reichardt's landmark exhibition over a decade later. Art historian Jack Burnham noted that these inquiries into the aesthetic implications of cybernetics took place primarily in Europe, whereas the United States lagged behind by "five or ten years."[3] Of the cultural attitudes and ideals that cybernetics embodied at that time in Britain, art historian David Mellor has written, "A dream of technical control and of instant information conveyed at unthought-of velocities haunted Sixties culture. The wired, electronic outlines of a cybernetic society became apparent to the visual imagination—an immediate future . . . drastically modernized by the impact of computer science. It was a technologically utopian structure of feeling, positivistic, and 'scientistic.'"[4]

The evidence of such sentiments could be observed in British painting of the 1960s, especially by a group of artists associated with Roy Ascott and the Ealing College of Art, such as Bernard Cohen, R. B. Kitaj, and Steve Willats.[5] Similarly, art historian Diane Kirkpatrick has suggested that Eduardo Paolozzi's collage techniques of the early 1950s "embodied the spirit of various total systems," which may possibly have been "partially stimulated by the cross-disciplinary investigations connected with the new field of cybernetics."[6] Cybernetics offered these and other European artists a scientific model for constructing a system of visual signs and relationships, which they attempted to achieve by utilizing diagrammatic and interactive elements to create works that functioned as information systems.

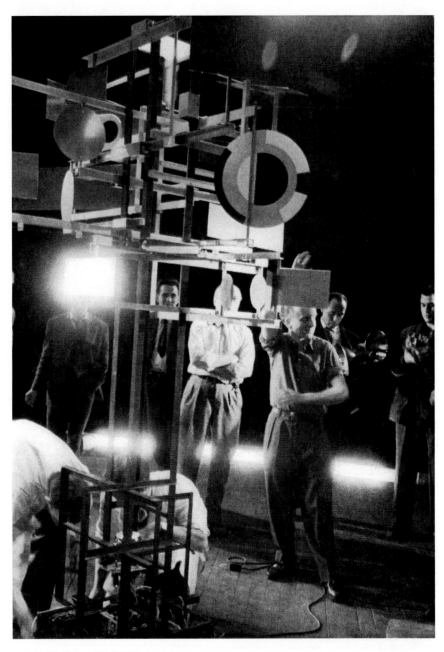

FIGURE 12.1. Nicholas Schöffer, *CYSP I*, 1956. Electronic, interactive sculpture. Shown on the stage of the Sarah Bernhardt Theater, Paris, where it performed with the Maurice Bejart ballet group, to a concrete music composition by Pierre Henry in 1956.

This essay begins with a general overview on the origin and meaning of cybernetics, and then proceeds to examine the convergence of cybernetics with aesthetics, paying particular attention to connections between the scientific paradigm and several distinct tendencies in post-World War II experimental art that emerged independently of it. These complementarities are crucial in explaining not only why it was even possible for art to accommodate cybernetics, but why artists utilized cybernetics in particular ways. The discussion focuses on the artistic practice, art pedagogy, and theoretical writings of British artist Roy Ascott. In 1968, Ascott rightly described himself as "the artist responsible for first introducing cybernetic theory into art education [in Britain] and for having disseminated the concept of a cybernetic vision in art through various art and scientific journals."[7]

True to his "cybernetic vision," Ascott conceived of these various aspects of his praxis as interrelated components of a larger system comprising his total behavior as an artist. The conceptual continuities that run through his work as an artist, teacher, and theorist offer unique insights into the impact of cybernetics, not only on Ascott's *oeuvre*, but on art in general. The intersection of cybernetics and art provides access, moreover, into a richly textured convergence of cultural ideas and beliefs in the 1960s.

THE ORIGIN AND MEANING OF CYBERNETICS

The term *cybernetics* was originally coined by French mathematician and physicist André Marie Ampère (1775–1836) in reference to political science. In the 1940s, American mathematician Norbert Wiener, generally acknowledged as the founder of the science of cybernetics, recoined the term from the Greek word *kubernetes* or *steersman*—the same root of the English word *governor*. According to Wiener, cybernetics developed a scientific method using probability theory to regulate the transmission and feedback of information as a means of controlling and automating the behavior of mechanical and biological systems. Cybernetics also drew parallels between the ways that machines, such as computers, and the human brain process and communicate information. W. Ross Ashby's *Design for a Brain* (1952) and F. H. George's *The Brain as Computer* (1961) were important works in this regard and suggest the early alliance between cybernetics, information theory, and artificial intelligence.[8]

Emerging concurrently with the development of cybernetics, the closely related field of information theory was also concerned with the behavior of communication systems, and in particular, the accuracy with which source information can be encoded, transmitted, received, and decoded.[9] In gen-

eral, the theory pertained to messages occurring in standard communications media, such as radio, telephone, or television, and the signals involved in computers, servomechanisms, and other data-processing devices. The theory could also be applied to the signals appearing in the neural networks of humans and other animals. With regard to cybernetics, information theory offered models for explaining certain aspects of how messages flow through feedback loops.[10] A feedback loop enabled individual components of a system to dynamically communicate information back and forth. Wiener envisioned cybernetics as offering a method for regulating the flow of information though feedback loops between various interrelated components in order to predict and control the behavior of the whole system. Cybernetics could facilitate automation by enabling a system to become self-regulating and therefore maintain a state of operational equilibrium. In Europe and North America, the concept of *feedback* became a pervasive trope of the 1960s, entering into popular parlance as a common term for verbal exchange of ideas ("I want your feedback"), and, as will be discussed, becoming incorporated into pop music and experimental art via the feedback of musical instruments and video cameras.

To summarize, cybernetics brings together several related propositions:

1. phenomena are fundamentally contingent;

2. the behavior of a system can be determined probabilistically;

3. with regard to the transfer of information, animals and machines function in quite similar ways, so a unified theory of this process can be articulated; and

4. by regulating the transfer of information, the behavior of humans and machines can be automated and controlled.

Cybernetics makes a fundamental shift away from the attempt to analyze the behavior of either machines or humans as independent and absolute phenomena. The focus of inquiry becomes the dynamic and contingent processes by which the transfer of information among machines and humans alters behavior at the systems level.

ART, CYBERNETICS, AND THE
AESTHETICS OF INTERACTIVE SYSTEMS

By Ascott's own account, he discovered the writings of Wiener, George, and Ashby in 1961, just before taking a position his mentor Victor Pasmore had secured for him as Head of Foundation Studies at Ealing College of Art. The work of these and other authors writing about cybernetics and related fields

captivated his imagination, catalyzing what Ascott described as an Archimedean " 'Eureka experience'—a visionary flash of insight in which I saw something whole, complete, and entire." [11] Ascott's insight was a sweeping yet subtle vision of the potential artistic applications of the cybernetic principles of information, feedback, and systems.

With regard to the relationship he perceived between cybernetics and art, Ascott noted in retrospect that the "recognition that art was located in an *interactive system* rather than residing in a material object . . . provid[ed] a discipline as central to an *art of interactivity* as anatomy and perspective had been to the renaissance vision." [12] In the 1960s, he did not use the term *interactivity* (a term that in the 1990s became jargon for multimedia computing). But Ascott frequently used the words *interact, interaction, participate,* and *participatory* to express the idea of multiple levels of interrelations among artist, artwork, and audience as constituents of a cybernetic system. This interactive quality underlying Ascott's early vision of cybernetic art was founded on the concepts of process, behavior, and system. As he wrote in his 1967 manifesto "Behaviourables and Futuribles," "When art is a form of behaviour, software predominates over hardware in the creative sphere. Process replaces product in importance, just as system supersedes structure." [13]

Moving away from the notion of art as constituted in autonomous objects, Ascott redefined art as a cybernetic system comprised of a network of feedback loops. He conceived of art as but one member in a family of interconnected feedback loops in the cultural sphere, and he thought of culture as itself just one set of processes in a larger network of social relations. In this way, Ascott integrated cybernetics and aesthetics to theorize the relationship between art and society in terms of the interactive flow of information and behavior through a network of interconnected processes and systems. But Ascott's concern with enabling viewers to participate in the process of composing a picture predates his awareness of cybernetics. For example, in 1960 he created his first *Change Painting,* six Plexiglas (*perspex* is the British term) panels, each containing an abstract shape rendered in a painterly gesture. Each shape, according to the artist, was like a seed intended to capture the potential of myriad possibilities of a much larger idea distilled to its essence. These "ultimate shapes," as he has called them, were set in various layers of a grooved frame that permitted each panel to slide horizontally along its length. The variable formal structure of a *Change Painting* (figure 12.2) made possible a multiplicity of compositional states.

It was Ascott's intention that viewers could more actively participate in the creative process by determining the state of the artwork according to their subjective aesthetic sensibilities at a particular moment. Thus, both the work itself and one's experience of it unfolded over the duration of interact-

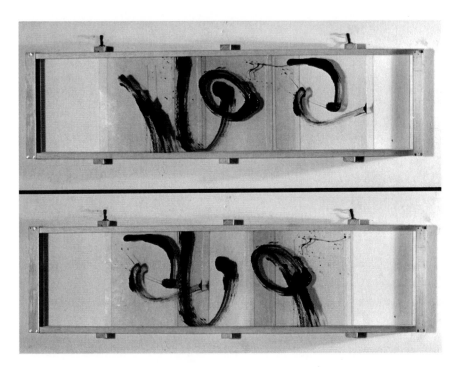

FIGURE 12.2. Roy Ascott, *Change Painting*, 1960. Wood, plexiglas, and oil, 66 × 21 in. Two different states.

ing with it. Each work depended on an exchange of information between the artist, the viewer, and the object. The ongoing, cumulative result of these interactions represented the potential of the work's infinite number of compositional possibilities. Although the principles of contingency, feedback, and control could be used to explain Ascott's *Change Painting*, the artist was not yet familiar with these concepts within the context of cybernetics. Nonetheless Ascott's theoretical and artistic concerns resulted in the expression of related ideas in visual form, indicating how scientific ideas and artistic ideas are complementary, and can arise independently from many common sources of human knowledge and social exigency.

Because it predates his awareness of cybernetics, Ascott's initial research into the durational aspects of art and his pursuit of audience participation and interactivity must be understood in other contexts. A number of mid-century contemporary artists in Britain participated in the exploration of art's temporal dimension. Mellor has observed that "the timetable of the performed painting/action became a key document [for artists] and the notion of the art work as notated event in time underlay John Latham's first theorizing of the 'event-structure'" around 1954.[14] Art historian Kristine Stiles has

traced one of the roots of this tendency to the performative aspects of *art informel* painting first demonstrated to a large audience by Georges Mathieu in Paris in 1954, and later in London at the ICA in 1956.[15]

Certainly Stiles is correct that the genealogy from gestural abstraction to happenings to the performative elements of interactive art offers important insight into the growing concern in the 1960s with the temporal dimension of the plastic arts. By Ascott's own estimation, the work of the New York school, and Jackson Pollock's web-like compositions in particular, greatly influenced his own thinking about art. While the abstract expressionist ethos of unbridled expression of the unconscious was too romantic for Ascott's temperament, Pollock's physical, corporeal involvement in and around his paintings established an important model for experimenting with the process by which art comes into being. In addition, the interconnecting skeins of Pollock's dripped and poured paint came to suggest, for the younger artist, ways in which art functions metaphorically within connective networks of meaning.[16] Pollock's decision to take the canvas off the easel and paint it on the ground altered the physical working relationship between artist and artwork from a vertical plane to a horizontal one, in which the artist looked down on the canvas from a bird's eye view. In so doing, this method of working contributed to the reconceptualization of painting from a "window on the world" to a cosmological map of physical and metaphysical forces.

In this regard, Ascott was drawn to the conceptual orientation of Marcel Duchamp's diagrammatic works. For example, *3 Standard Stoppages* (1913–1914) also mapped a horizontal relationship between artist and artwork. Moreover, it exemplified the method of chance operations that Ascott would employ in subsequent works. Duchamp's *Network of Stoppages* (1914), which can be interpreted as artistic analog to the decision-trees of systems theory, offered a model for the interconnected semantic networks of form and text that Ascott presented in his solo exhibition at the Molton Gallery in London in 1963. Similarly, the *Large Glass* (figure 6.12) was interpreted by Jack Burnham as Duchamp's visual map of the structural foundations of western art history and the internal semiological functioning of art objects through a diagrammatic and transparent form.[17] Though widely disputed, Burnham's cabalistic interpretation of the *Large Glass* is particularly relevant with respect to Ascott's work. For Ascott also drew on mystical sources and used cartographic imagery and transparent media to examine the semiological function of art. Further, the transparency of the *Large Glass*—always including the viewer's changing point of view and context—has been interpreted by Ascott as a precursor to the interactive interfaces of digital computer networks, including his own telematic art projects such as *La Plissure du Texte* (1982) and *Aspects of Gaia* (1989).[18]

Also predating Ascott's awareness of cybernetics, D'Arcy Wentworth Thompson's theories of biomorphology and Henri Bergson's vitalist philosophy deeply impacted the artist's concern with the temporal aspects of art as a durational process of organic unfolding. For example, the "seeds" or "ultimate shapes" with which Ascott sought to capture the essence of potentiality in *Change Painting* may be related to Thompson's ideas of organic development and Bergson's concept of *élan vital*, the vital impetus the philosopher theorized as the animating factor essential to life.[19] Similarly, the durational and mutable aspects of these works were indebted to Bergson's concept of *durée*, which theorized a form of consciousness that conjoined past, present, and future, dissolving the diachronic appearance of sequential time, and providing instead a unified experience of the synchronic relatedness of continuous change. In this light, Ascott's interactive visual constructions of the early 1960s can be interpreted as models in which potential forms could creatively evolve, revealing the multiple stages of their nature (as in the growth of a biological organism), over the duration of their changing compositional states. Ascott conceived of the infinite combination of these compositional transformations as comprising an aesthetic unity, a metaconsciousness or Bergsonian *durée*, including all possible combinations of temporality and consciousness.

ART AND CYBERNETICS: CONVERGENCES AND COMPLEMENTARITIES

Although rooted in a combination of earlier aesthetic, biological, and philosophical models, Ascott's *Change Painting*, which varied as the result of the systematic feedback of information between viewer and artwork, can be seen as a visual analog to the cybernetic theories that the artist would later adopt. Yet one would be hard-pressed to identify a tenable link between cybernetics on one hand, and Pollock, Duchamp, Thompson, and Bergson on the other. Because artists notoriously draw on an enormously wide range of sources, mapping cybernetics onto the history of art is an imprecise science at best. Many twentieth-century artists experimented with process, kinetics, interactivity, audience-participation, duration, and environment, and their work can be explained without recourse to cybernetics. Instead, they relied primarily on aesthetic tendencies that became increasingly central to artistic practice in the post-World War II period.

Nevertheless, a historical approach offers much insight into the aesthetic context in which cybernetics gained currency among artists like Ascott, who were experimenting with the ideas of duration and interaction in the 1960s.

While cybernetics offered a flexible theory that was adaptable to a wide range of applications in the sciences, social sciences, and humanities, it might be argued that in the absence of a complementary aesthetic context, there would have been no common ground for the accommodation of cybernetics to artistic concerns. It is safe to say that the particular ways artists utilized that scientific theory depended, in part, on extant correspondences between aesthetics and cybernetics. The following discussion identifies some of the art historical sources for the convergences and complementarities between aesthetics and cybernetics at mid-century.

If the impressionists began an exploration of the durational and perceptual limits of art, the cubists, reinforced by Bergson's theory of *durée*, developed a formal language dissolving perspectival conventions and utilizing found objects that represented wrinkles in time and space.[20] Early twentieth-century experiments with putting visual form into actual motion included Duchamp's *Bicycle Wheel* (1913) and Naum Gabo's *Kinetic Construction* (1920). Gabo's motorized work in particular, which produced a virtual volume only when activated, made motion an intrinsic quality of an art object's form, further emphasizing the inextricability of time from perception. By the 1950s, experimentation with duration and motion by artists such as Schöffer, Jean Tinguely, Len Lye, and Takis gave rise to the broad, international movement known as kinetic art. Schöffer's *CYSP I*, for example, was programmed to respond electronically to its environment. The motion of viewers and performers triggered its own behavior over time. In this work, Schöffer drew on aesthetic ideas that had been percolating for three-quarters of a century and intentionally merged them with the relatively new field of cybernetics.

The spirit of interactivity and audience engagement gave birth in the 1960s to *nouvelle tendence* collectives working with diverse media to explore various aspects of Kinetic Art and audience participation, including groups such as Groupe Recherche d'Art Visuel (GRAV) in Paris and ZERO in Germany. French artist Jacques Gabriel exhibited the paintings *Cybernétique I* and *Cybernétique II* in "Catastrophe," a group show and happening organized by artist Jean Jacques Lebel and gallerist Raymond Cordier in Paris in 1962. Gabriel's text published on the poster publicizing the event stated, "L'Art et le Cybernétique, c'est la même chose" (Art and cybernetics are the same thing). As another example, artist Wen-Yeng Tsai's *Cybernetic Sculpture* (1969) was comprised of stainless-steel rods that vibrated in response to patterns of light generated by a stroboscope and to the sound of participants clapping their hands.

Beginning in the early 1950s, Western concert music also employed the compositional tactic of engaging the audience more directly in a work, an aesthetic strategy that, through cross-fertilization, played a major role in the

development of participatory art internationally. Again, while not directly related to cybernetics, these musical experiments can be interpreted loosely as an independent manifestation of the aesthetic concern with the regulation of a system through the feedback of information amongst its elements. The most prominent example of this tendency premiered in 1952, American composer John Cage's 4'33". Written for piano but having no notes, this piece invoked the ambient sounds of the environment (including the listener's own breathing, a neighbor's cough, the crumpling of a candy wrapper) as integral to its content and form. As has been well documented, Cage's lectures at the New School influenced numerous visual artists, notably Allan Kaprow, the founder of happenings, and Yoko Ono and George Brecht, whose "event scores" of the late 1950s anticipated Fluxus performance.[21]

Also related to developments in experimental music, the visual effects of electronic feedback became a focus of artistic research in the late 1960s when video equipment first reached the consumer market. Following the pioneering work of composers like Cage, Lejaren Hiller, Karlheinz Stockhausen, and Iannis Xenakis in the 1950s, by the mid-1960s, audio feedback and the use of tape loops, sound synthesis, and computer-generated composition had became widespread in experimental music. Perhaps most emblematically, the feedback of Jimi Hendrix's screaming electric guitar at Woodstock (1969) appropriated the National Anthem as a counterculture battlecry. The use of electronic feedback in visual art includes Les Levine's interactive video installations such as *Iris* (1968) and *Contact: A Cybernetic Sculpture* (figure 12.3), in which video cameras captured various images of viewers that were fed back, often with time-delays or other transformations, onto a bank of monitors.

A similar approach was taken in *Wipe Cycle* (1969) by Frank Gillette and Ira Schneider. As Levine noted, *Iris* "turns the viewer into information. . . . *Contact* is a system that synthesizes man with his technology . . . the people are the software." Schneider amplified this view of interactive video installation, stating that, "The most important function . . . was to integrate the audience into the information," and Gillette added that it "rearranged one's experience of information reception."[22] Woody and Steina Vasulka also experimented with a wide variety of feedback techniques, using all manner and combination of audio and video signals to generate electronic feedback in their respective or corresponding media. "We look at video feedback as electronic art material. . . . It's the clay, it's the air, it's the energy, it's the stone. . . . It's the raw material that you . . . build an image with."[23] In these ways, twentieth-century experimental art tended to focus on temporality, to put art into motion, to utilize the concept of feedback, and to invoke interaction with the viewer. In general, such work emphasized the artistic process as opposed to the product and accentuated the environment or context (es-

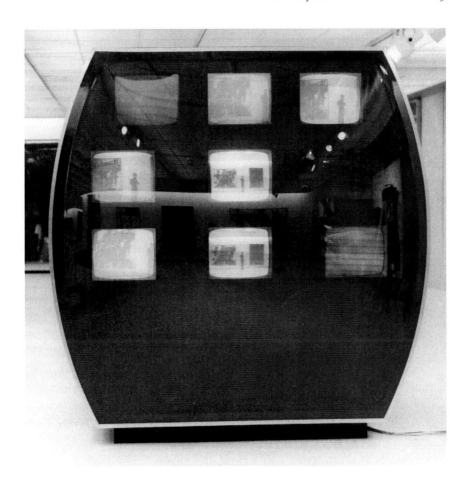

FIGURE 12.3. Les Levine, *Contact: A Cybernetic Sculpture*, 1969. Interactive video installation. Photo © Les Levine.

pecially the social context) as opposed to conventional content. These tendencies helped to form the aesthetic context in which cybernetics converged with art.

EARLY ALLIANCES AND FURTHER COMPLEMENTARITIES

Ascott's 1963 solo exhibition, *Diagram Boxes & Analogue Structures*, at the Molton Gallery in London, offers an early example of combining cybernetics and art. By this time, Ascott had assimilated cybernetics as a primary theoretical foundation for merging Bergsonian ideas with constructivism and kinetic art, while at the same time employing the use of diagrams and text as a formal element, developing an original way to apply artistic and scientific

theories to generate visual form. Like Schöffer's "spatiodynamic" sculptures of the early 1950s (which were also based on constructivist principles), Ascott's work added a durational, kinetic element, further extending this lineage in a temporal dimension.[24]

Ascott's statement in the exhibition catalog exemplifies how cybernetics was part of a complex amalgam of aesthetic, philosophical, and scientific ideas that led to his creation of interactive, changeable works of art: "Cybernetics has provided me with a starting point from which observations of the world can be made. There are other points of departure: the need to find patterns of connections in events and sets of objects; the need to make ideas solid . . . but interfusable; an awareness of change as fundamental to our experience of reality; the intention to make movement a subtle but essential part of an artifact."[25] In this passage, the artist explicitly states that cybernetics provided a conceptual framework for interpreting phenomena artistically. Akin to Bergson's concept of durée, he recognizes "change" as fundamental, suggests the modular, concrete aesthetic of constructivism, and shares concerns in common with earlier and synchronous developments in contemporary art internationally, which sought to vitalize art through movement, enactment, and performative elements.

Ascott extended this search for "patterns of connections" to draw parallels between the forms of art and the forms of science, for example, the "ultimate shapes" in his *Change Painting* and the analog wave patterns that represent and carry information in communications systems. He developed a taxonomy of "analog forms," which, like waveforms, were meant to symbolize and convey universal qualities, potentials, intentions, and strategies. In works like *Video Roget* (1962), a moveable calibrator at the center of the piece enabled the relationships among the analog forms (and categories of meaning) to be varied by the user. On the page preceding the reproduction of *Video Roget* in the exhibition catalog, the artist provided a related diagram on tracing paper, entitled *Thesaurus* (1963). The reader could interact with the *Thesaurus* by superimposing it on the image of *Video Roget* to reveal suggested meanings of the individual analog forms and the possible feedback loops among them (figure 12.4).

Ascott extended the parallel he drew between the forms of art and science to include nonwestern systems of knowledge as well. The phrase "to programme a programming programme" appears on a 1963 sketch for the 1964 construction *For Kamynin, Lyubimskii and Shura-Bura*, dedicated to the Russian computer scientists. Yet despite the scientific jargon, in this work and others from the 1960s and 1970s, Ascott visually suggested equivalences between *I Ching* hexagrams, binary notation of digital computers, scatterplots of quantum probability, wave frequencies, and biomorphic shapes (figure 12.5).

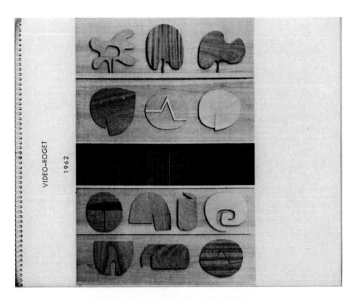

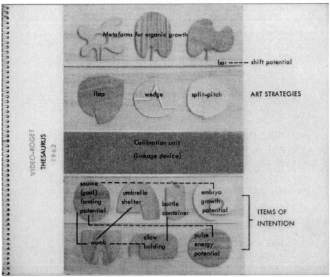

FIGURE 12.4. Roy Ascott, *Video Roget* and *Thesaurus*, 1963. Illustration of *Video Roget* (1962) and tracing paper overlay. Source: Roy Ascott, *Diagram Boxes and Analog Structures* (exhibition catalog, Molton Gallery, London, 1963).

FIGURE 12.5. Roy Ascott, untitled drawing, 1962. $7^{7}/_{8} \times 9$ in. approx. Note *I Ching* hexagrams in upper register, followed by binary notation, scatter-plots, and wave-forms. A "calibrator" in the middle suggests the ability to juxtapose or combine various permutations of these systems of information representation.

Two years later Korean-born artist Nam June Paik drew a striking parallel between Buddhism and cybernetics:

> Cybernated art is very important, but art for cybernated life is more important, and the latter need not be cybernated. . . .

> Cybernetics, the science of pure relations, or relationship itself, has its origin in karma . . .

> The Buddhists also say

Karma is samsara

Relationship is metempsychosis[26]

In a similarly nonhierarchical way, Ascott's theoretical-artistic propositions about the future combined recent advances in science and technology with ancient systems of knowledge. Like an appropriate response to a *koan*, an apparent paradox that cannot be resolved by logical formula, Ascott's amalgamation of science, art, and mysticism never sought an unequivocal resolution of these seemingly irreconcilable systems of knowledge. Rather, having intuited the paradoxical nature of knowledge, he attempted to better understand the underlying systems by which meaning is constructed.

CYBERNETIC SYSTEMS, SEMANTIC SYSTEMS, AND THEIR DISCONTENTS

In works like *Video Roget (Thesaurus)*, Ascott equated visual forms (through which meaning is formally derived) with semantic systems (through which meaning is derived via taxonomic relationships) by drawing both into the principle of contingency that Wiener attributed to the operations of cybernetics. In a two-page diagram (drawn like an electric circuit) in his 1963 exhibition catalog, Ascott wrote, "This Thesaurus is a statement of my intention to use any assembly of diagrammatic and iconographic forms within a given construct as seems necessary." By explicitly stating his intention to use text in his "constructs"—*to use text in and as art*—Ascott strategically expanded the range of what counted as art to include diagrammatic, iconographic, and textual forms as inter-related parts of a cybernetic art system. The universe of potential meanings of such works was to be derived taxonomically and discursively through multi-layered processes in which the flow of information between artists and the objects they make, the semantic systems which govern the reception of works of art, and the actual responses of viewers were all mutually contingent.

Ascott's concern with the semantic complexities of visual representation and the relationship between art and text in the mid 1960s presaged the conceptual art practice of American Joseph Kosuth and the British collective Art & Language in the late 1960s. Indeed, their work shared Ascott's interest in the taxonomic relations through which semantic meaning is—or fails to be—generated. Art & Language attempted to subvert the logic of art objects through the use of textual interventions, in order to interrogate what British art historian Charles Harrison has referred to as the modernist "beholder discourse."[27] To that end, Mel Ramsden's *Elements of an Incomplete Map*

(1968), for example, incorporated four annotated volumes of *Roget's Thesaurus*. Like Ascott's *Video Roget (Thesaurus)* (1963), Ramsden's work suggested equivalences between the way in which language signifies meaning in an interconnected rhetorical system like a thesaurus, and the way in which form signifies meaning in an interconnected visual system. Ascott's cybernetic art employed the further strategy of creating an interactive situation that undermined conventional subject-object relationships between art and audience, thereby raising similar questions about spectatorship.

But whereas Ascott genuinely believed in cybernetics as a "practical and intellectual tool" for the creation of art, the members of Art & Language were much more skeptical, and applied scientific principles to art in a tongue-in-cheek manner, suggesting a parallel between the dogma of cybernetics and the dogma of modernist aesthetics. For example, in *Key to 22 Predicates: The French Army* (1967), Terry Atkinson and Michael Baldwin offered a key to abbreviations for the French Army (FAA), the Collection of Men and Machines (CMM), and the Group of Regiments (GR). Using logic reminiscent of Lewis Carroll, the artists then described a variety of relationships amongst these elements as part of a system (of gibberish): "The FA is regarded as the same CMM as the GR and the GR is the same CMM as (e.g.) 'a new order' FA (e.g. morphologically a member of another class of objects): by transitivity the FA is the same CMM as the 'new shape/order one.' " [28]

This ironic description—through a looking glass, so to speak—mocked the manner of cybernetic explanations with pseudo-scientific acronyms. It reduced to absurdity the systematization of relationships between individuals, groups, and institutions that Ascott employed in defining his theory of a cybernetic art matrix in the 1966–1967 essay, "Behaviorist Art and the Cybernetic Vision." Similarly, in Harold Hurrell's artwork, *The Cybernetic Art Work that Nobody Broke* (figure 12.6), a spurious computer program for interactively generating color refused to allow the user to interact beyond the rigid banality of imaginary binary input demanded by the black and white text that was the work's only physical manifestation. If the user put in a number other than 0 or 1, the program proffered the message: "YOU HAVE NOTHING, OBEY INSTRUCTIONS!" If the user put in a non-number, *The Cybernetic Art Work That Nobody Broke* told him or her that there was an "ERROR AT STEP 3.2." [30]

Harrison has interpreted these experiments as "flailing about—products of the search for practical and intellectual tools which had not already been compromised and rendered euphemistic in Modernist use." [31] But they may be interpreted equally as ironic critiques of artists' failures to address the incommensurability of science and art, and as parodies of the rigid confines within which claims for interactive participation might transpire. Such in-

THE CYBERNETIC ART WORK THAT NOBODY BROKE

```
TYPE ALL PARTS
1.1 TYPE "YOU HAVE RED"
1.2 TYPE "YOU HAVE GREEN"
1.3 TYPE "YOU HAVE BLUE"
1.4 TYPE "YOU HAVE YELLOW"
1.5 TYPE "YOU HAVE NOTHING, OBEY INSTRUCTIONS!"

3.05 PRINT#
3.06 TYPE # FOR PP=1:1:3
3.1  PRINT "TYPE EITHER 1 OR 0 IN BOTH A AND B."
3.2  DEMAND A
3.3  DEMAND B
3.4  DO STEP 1.1 IF A=0 AND B=0
3.5  DO STEP 1.2 IF A=0 AND B=1
3.6  DO STEP 1.3 IF A=1 AND B=0
3.7  DO STEP 1.4 IF A=1 AND B=1
3.8  DO STEP 1.5 IF A>1 OR A<0 OR B>1 OR B<0
3.9  DO STEP 3.05

DO PART 3
TYPE EITHER 1 OR 0 IN BOTH A AND B.          A=1
          B=1
YOU HAVE YELLOW

TYPE EITHER 1 OR 0 IN BOTH A AND B.          A=8
          B=3
YOU HAVE NOTHING, OBEY INSTRUCTIONS!

TYPE EITHER 1 OR 0 IN BOTH A AND B.          A=1
          B=0
YOU HAVE BLUE

TYPE EITHER 1 OR 0 IN BOTH A AND B.          A=1
          B=1
YOU HAVE YELLOW

TYPE EITHER 1 OR 0 IN BOTH A AND B.          A=0
          B=0
YOU HAVE RED

TYPE EITHER 1 OR 0 IN BOTH A AND B.          A=R
ERROR AT STEP      3.2
          R                IS UNDEFINED.
```

FIGURE 12.6. Harold Hurrell, *The Cybernetic Artwork that Nobody Broke*, 1969. Text for lithographic print. Source: Charles Harrison, *Essays on Art & Language* (London, 1991).

sights offered a valuable critical perspective on Ascott's cybernetic art theory and practice (and that of other similar-minded artists). At the same time, the resistance of Art & Language to the purposeful conjunction of art and technology can be interpreted as a reactionary manifestation of the collective's rejection of media-based art.

CYBERNETICS AND ART PEDAGOGY

Ascott's theories of art and cybernetics also directly informed his creation of a method for teaching art based on the same principles—a cybernetic pedagogy. In 1964, he described the continuum between his work in the studio and his work in the classroom, which he felt complemented each other: "In trying to clarify the relationship between art, science and behaviour, I have found myself able to become involved in a teaching situation without compromising my work. The two activities, creative and pedagogic, interact, each feeding back to the other. Both, I believe, are enriched." [32] It is no coincidence that he used the language of cybernetics to suggest how his art practice and pedagogy interacted, "each *feeding back* to the other," as part of a mutually reinforcing system. As artist and critic Eddie Wolfram wrote in 1968, "I do not know of any other artist/teacher who projects such a high incident of integration between his teaching ideas and the art-hardware that he makes." [33]

In the classroom, cybernetics offered a clear model for reconceptualizing art and education and their roles in a larger social system, by suggesting the organization of art education curricula in terms of a behavioral system of feedback and control. The course of study Ascott implemented at Ealing beginning in 1961 focused on these cybernetic principles. Students collaborated as elements of a system that regulated their artistic behavior as an integrated whole. For example, as Ascott explained, forming groups of six, each student would be "set the task of acquiring and acting out . . . a totally new personality, which is to be narrowly limited and largely the converse of what is considered to be their normal 'selves.'" [34] A student's preconceptions about his or her personality, strengths and weaknesses as an artist, and about the nature of art itself, were not only thrown into question, but were actively transcended through the forced adoption of different behavioral characteristics and a rethinking of art-making and art as process and system. His or her individual behaviors had to be integrated into a coherent group process, and each member would be "of necessity interdependent and highly conscious of each other's capabilities and limitations" in order to accomplish together the "set goal of producing . . . an *ordered entity*." [35] In this way, stu-

dents learned about the principles of cybernetics by applying them to art. Their own behavioral interactions became part of a cybernetic art system in which the controlled exchange of information organized the overall structure.

British composer Brian Eno, who was a student of Ascott's at Ipswich from 1964 to 1966, offered a first-hand account of his teacher's pedagogical methods, and their impact on him:

> One procedure employed by Ascott and his staff was the "mindmap." In this project each student had to invent a game that would test and evaluate the responses of the people who played it. All the students then played all of the games, and the results for each student were compiled in the form of a chart—or mindmap. The mindmap showed how a student tended to behave in the company of other students and how he reacted to novel situations. In the next project each student produced another mindmap for himself that was the exact opposite of the original. For the remainder of the term he had to behave according to this alternative vision of himself.[36]

Eno further noted: "For everybody concerned this . . . extraordinary experience . . . was instrumental in modifying and expanding the range of interaction each student was capable of."[37]

Moreover, in Ascott's Groundcourse, students were introduced to other experimental artists and intellectuals in a variety of disciplines. One powerful example of the influence of this guest lecture program was the impact on the young British musician Peter Townshend of artist and holocaust survivor Gustav Metzger's presentation on destruction in art. Townshend, who would later form the rock band The Who, has credited Metzger's theory with giving him the idea to destroy musical instruments onstage at Who concert performances—a performative gesture that visually symbolized the anger and rebellion of a generation.[38] Stiles has theorized this transference of ideas from Metzger to Townshend as an example of the process by which the most advanced conceptual developments in experimental visual art are transmitted in insidious ways to become incorporated into popular culture.[39] Such a theory of the operations of art in culture offers a model for understanding how Ascott's cybernetic conception of art entered into the popular imagination.

"BEHAVIOURIST ART AND THE CYBERNETIC VISION"

As with the relationship between his artistic and pedagogical practices, so Ascott has identified substantial systematic feedback (in the cybernetic sense of the term) between his work writing aesthetic theory and his work as an artist and teacher.[40] Ascott's essay "Behaviourist Art and the Cybernetic Vision" exemplifies his theories on, and larger social ambitions for, the appli-

cation of cybernetics to art.[41] As his theoretical point of departure, Ascott joined the principles of cybernetics with emerging theories of telecommunications networks. In opposition to conventional discourses on the subject-object relationship between viewer and artwork, Ascott declared the objectives of art to be the *processes* of artistic creation and reception.

Indeed, process became an increasingly central area of artistic inquiry in the late 1960s and 1970s, laying the conceptual groundwork for the popular use of interactive electronic media that would follow. As Stiles has noted:

> In their writings and works, many artists became increasingly aware of how process connects the superficially independent aspects and objects of life to an interdependent, interconnected network of organic systems, cultural institutions, and human practices. However awkwardly these artists' works anticipated the end of a century that witnessed the advent of massive electronic communication systems like the Internet, their research was vital in visualizing process as a means to align art with the future.[42]

For his part, Ascott theorized the close relationship between the current aesthetic concern with process and the possibilities that cybernetics, computers, and telecommunications held for the future of art and culture.

Ascott's goal in "Behaviourist Art and the Cybernetic Vision" was ambitious: the theorization of a cybernetic system for educating society. In this text, he proposed a new paradigm of art which "differs radically from [the determinism of] any previous era" and would be distinguished by its emphasis on ambiguity, mutability, feedback, and especially behavior.[43] These visionary prospects were incorporated into what he called the Cybernetic Art Matrix (CAM), an elaborate, integrated system for enhancing his cybernetic vision throughout culture. When Ascott devised CAM in 1966, he thought of it as an interrelated system of feedback loops designed to serve professional artists and the general public. It established a model in which the flow of information and services, as well as the behavior of individuals, groups, and society, was self-regulating throughout the whole. CAM was intended to provide a variety of functions, such as facilitating interdisciplinary collaboration between geographically remote artists and scientists, providing a pragmatic art education curriculum for the young, and enriching the lives of "the new leisured class" by enhancing creative behavior and providing amenities and modes of aesthetic play. Ascott used symbolic formulas and numerous acronyms to identify particular niches within CAM, and to explain methodically how the various layers were connected within the system.

Ascott envisioned technology as playing a vital role in implementing his cybernetic vision, as a means to enhance human creativity on the individual level and to enable collaborative interaction among participants from diverse

fields and geographic locations. For example, the artist conceived of the computer as "a tool for the mind, an instrument for the magnification of thought, potentially an intelligence amplifier. . . . The interaction of artifact and computer in the context of the behavioral structure, is equally foreseeable. . . . The computer may be linked to an artwork and the artwork may in some sense be a computer."[44] In this description, largely informed by H. Ross Ashby's 1956 article, "Design for an Intelligence Amplifier," Ascott's conception of the computer was not simply as a tool for generating images, but rather as an integral component in an interactive, behavioral system.[45]

Ascott's artistic concern with the behavioral implications of cybernetics gradually moved away from the localized environments of his *Change Painting* and other kinetic constructions, and expanded into the possibilities of geographically remote interaction. Inspired in part by the global village prophesied by Canadian media theorist Marshall McLuhan, Ascott envisioned the emergence of art created interactively with computers and through interdisciplinary collaborations via telecommunication networks: "instant person to person contact would support specialized creative work. . . . An artist could be brought right into the working studio of other artists . . . however far apart in the world . . . they may separately be located. By means of holography or a visual telex, instant transmission of facsimiles of their artwork could be effected . . . Distinguished minds in all fields of art and science could be contacted and linked."[46]

What Ascott theorized in 1966 can be described in contemporary language as interactive multimedia in cyberspace. These ideas have become cornerstones of the communications, electronics, and entertainment industries' development and marketing of online services, computer games, and a vast array of software and peripherals in the 1990s and 2000s. Here is another example in which conceptual ideas theorized in the spaces of experimental art later became popularized and commercialized in other modes of cultural production.

THE CYBERNETIC SIXTIES: A LEGACY

Cybernetics had a decisive impact on art. That impact was mediated by the aesthetic context that coincided with the emergence of cybernetic theory in the late 1940s, and by the complementarities between cybernetics and central tendencies of twentieth-century experimental art. Given the emphasis of post-World War II art on the concepts of process, system, environment, and audience participation, cybernetics was able to gain artistic currency as a theoretical model for articulating the systematic relationships and processes

among feedback loops including the artist, artwork, audience, and environment. In the absence of that common ground, it is possible that cybernetics might not have been accommodated to art, or that it would have been accommodated in a very different way.

Roy Ascott's *Change Painting* exemplifies how ideas derived from aesthetics, biology, and philosophy could result in the creation of a visual analog to cybernetics, even though the artist was not yet aware of that scientific theory. More generally, this example shows how various fields and disciplines can independently produce homologous forms in response to a more or less common set of cultural exigencies. Ascott's work as an artist, teacher, and theorist also indicates how the flexibility of cybernetics allowed that theory to be applied to a wide range of social contexts. However, this programmatic quality in the application of cybernetics gives reason for pause: Given that related ideas had already been incorporated into mid-century aesthetics, artists had a wealth of ideas from which to derive and develop formal strategies, pedagogical methods, and theoretical exegeses. In other words, the accomplishments that were made in visual art under the banner of cybernetics might very well have been achieved in the absence of that scientific model. Cybernetics, however, possessed the authority of science, and for better or worse, Ascott brought that seal of approval to bear on his work. Ironically, while Ascott's CAM theory adopted a rigid cybernetic language and organizational schema, his creative imagination was far from limited to the domain of scientifically provable facts and formulas. Instead, he incorporated a wide array of ideas from diverse systems of knowledge, with the result that cybernetics was transformed in his hands from science into art.

Cybernetics also offers a model for explaining how ideas that emerged in the domain of experimental art eventually spread into culture in general. Ascott conceived of this transference in terms of multiple series of interconnected feedback loops, such that information related to the behavior of each element is shared and exchanged with the others, regulating the state of the system as a whole. Such is the case with Ascott's own theorization in 1966 of interdisciplinary collaborations over computer networks, a concept that became the central focus of his theory and practice in 1980, and subsequently has been popularized through web-based multimedia at the turn of the century.

Ascott drew on cybernetics to theorize a model of how art could transform culture. He was particularly insistent that cybernetics was no simple prescription for a local remedy to the crisis of modern art, but represented the potential for reordering social values and reformulating what constituted knowledge and being. In 1968 he wrote: "The art of our time tends towards the development of a *cybernetic vision*, in which feedback, dialogue and in-

volvement in some creative interplay at deep levels of experience are paramount. . . . The cybernetic spirit, more than the method or the applied science, creates a continuum of experience and knowledge which radically reshapes our philosophy, influences our behaviour and extends our thought." [47] Here, Ascott staked a passionate and ambitious claim for the significance of art as a cybernetic system. Ultimately he believed that cybernetic art could play an important role in altering human consciousness, and thereby transform the way people think and behave on a social scale. Indeed, cybernetics has become so enmeshed into the fabric of the industrialized West that it is difficult to imagine conceiving of phenomena in terms not mediated by the principles of feedback and systems.

VOXELS AND SENSELS:

BODIES IN VIRTUAL SPACE

INTRODUCTION

The participatory vision fostered by Ascott and other like-minded artists celebrated the humanism of Norbert Wiener's initial desire to use cybernetics to foster "the *human* use of human beings," and this communitarian emphasis continues in some contemporary approaches to the Internet. At the same time, the drift of informatics has been to dissolve human uniqueness into hybrid assemblages of machines and organisms, and to supplement or supersede personal agency with increasingly autonomous communication systems. In many fields of contemporary critical and discursive practice, methodological focus has shifted from the individual as unique agent to the distributed collectivity of informatic infrastructures that couple human action to machinic and computational prostheses. Digital technologies in the virtual era both problematize the individual and deterritorialize the world.

Those with access to the right networks can extend their identities to the edges of the World Wide Web and multiply their virtual representatives at will. The technological ability to sample and rewrite informatic scripts that is foregrounded in digital media also has profound material and cultural consequences in the here and now, seen most clearly in molecular biology's manipulation and hybridizing of life forms at the level of genetic codes. The essays in part 5 document the increasingly inextricable interlinking of the physical and the virtual. Virtual reality just makes it more obvious that we have always lived our symbolic and practical lives within self-ordered spaces, precarious cosmoi of our own construction. The advent of non-Euclidean and n-dimensional geometries preceded and prepared for the scientific and philosophical transformations of space and time in the modern and postmodern eras, and many things dreamed of earlier this century by artists and engineers are being realized in cyberspace today.[1]

As Timothy Lenoir and Sha Xin Wei show in "Authorship and Surgery:

The Shifting Ontology of the Virtual Surgeon," the latest inscription technologies are transforming not only the cultural institutions of reading and writing, but also the practical techniques of industrial and medical interventions. The integration of virtual imaging and robotic technologies with surgical knowledge and techniques in the operating room has displaced the surgeon proper from his or her traditional position as the *author* of the surgery. Applying Michel Foucault's critique of the author-function in modern discursive institutions to an unlikely fusion of medical and engineering expertise, Lenoir and Sha trace a comparable diffusion of signature in the application of virtual imaging technologies.

In the contemporary surgical theater, two-dimensional arrays of pixels on television monitors are being superseded by three-dimensional virtual spaces rendered in voxels (volume pixel elements). Through interaction with such three-dimensional proxies of the interior of the patient's body, the surgeon can rehearse and perfect the procedure before his computational robotic prosthesis translates it into an actual operation. Architect Marcos Novak moves further along this path by anticipating a technology of *sensels*—his term for the elements of a sensed field of virtual structures projected into ordinary space—as a way to fuse the real and the virtual. Both the voxel and the sensel represent bits of scanned or projected information formed into composite multidimensional images through the digital patterning of electrical energies.

Novak has coined a number of related terms to talk about the possibilities of designing connections among real and virtual spaces.[2] He began with "liquid architectures," where the physical body enters cyberspace through its representation by an "avatar" or digital body and mingles with virtual constructions. "Transarchitectures" followed with an investigation of "eversion," Novak's term for the pouring of liquid virtuality out into the receptacle of everyday space. In his current design phase, "invisible architectures" of "sensels" electronically create an interactivated space, where each point reports what it senses and can thus be granted "meta-material" attributes. For Novak, the immersion of the senses into the "liquid" of virtual reality and the "eversion" of the virtual into the sensory world at hand represent the poles of a new continuum of space.

In "Eversion: Brushing against Avatars, Aliens, and Angels," Novak addresses this exteriorizing of virtual entities. He traces back to the seminal physical work of Michael Faraday and to James Clerk Maxwell's famous Demon the ideas that real space is not empty but is instead suffused with energy fields, and that human beings might be supplemented with virtual agents able to inhabit the micro- and macrospaces of those fields. Against that nineteenth-century backdrop of thought-experimental energy physics,

the current development of informatic entities transmitted and embodied through networks of energy and data fields is in no way an alien or deviant quest, but a culmination of modern technoscientific research. Thus Novak envisions the complementing of cyberspatial avatars with the eversion of digital objects and agents. Their presence among us renders our space–time continuum a "new-space" where four-dimensional constructions are projected into three-dimensional simulations, a space traversed by virtual as well as real bodies.

Authorship and Surgery: The Shifting Ontology of the Virtual Surgeon

TIMOTHY LENOIR AND SHA XIN WEI

The advent of computer-mediated writing has spawned a nostalgic industry on the culture of the book and lamentations about the demise of the institutions of print culture.[1] But the changes occurring in the institutions of writing and authorship may represent even more profound shifts. As computer-mediated communication permeates our daily lives in our banks, our stores, our classrooms, and even our bedrooms, the specter of loss of human agency and autonomy—perhaps even a reconfiguration of "the human" itself—invariably surfaces. Computer scientists Hans Moravec, Ray Kurzweil, and Bill Joy are among the most recent to trumpet the emerging potential for new artificial intelligence and networking technologies to blur the boundaries between human and machine on the frontier where the soul and silicon chips unite.[2] But even before computer-mediated communication became a common experience, indeed even before the advent of personal computers, André Leroi-Gourhan speculated in his *Le Geste et la parole: Dessins de l'auteur* (1964) that by externalizing thought in matter, most palpably in the form of electronic media, writing itself—perhaps the tool that set mankind on its peculiar evolutionary trajectory—harbors the end of the human: not an apocalyptic end but the extinction of one species and its replacement by something else. It seems paradoxical that augmenting and accelerating the very tools—writing technologies—that have distinguished humanity could somehow induce a mutation and break with our past. According to Friedrich Kittler's analysis of the effect of computer-mediated writing on literature, that mutational event may be further along than we realize. Arguing that in computer-mediated writing man-made writing passes through microscopically written inscriptions, which, in contrast to all previous writing tools, are able to read and write by themselves, Kittler has suggested that the last historical act of writing may well have been the moment when, in the early 1970s, Intel engineers laid out a dozen square meters of blueprint paper in order to design the hardware architecture of their first integrated microprocessor.[3]

Changes are indeed taking place in our modes of writing and reading, but

it would be premature to proclaim the death of writing. Rather, in this paper we explore the opposite claim: At no time has writing been more central to our material existence. Media inscribe our situation. We are immersed in new inscription technologies for writing and for rewriting the body, a growing repertoire of computer-based media for creating, distributing, and interacting with digitized versions of the world. In our daily activities, we witness a fusion of digital and physical reality. This fusion is not, as Baudrillard predicted, the replacement of the real by the hyperreal—the obliteration of a referent and its replacement by a model without origin or reality—but a new configuration of ubiquitous computing in which wearable computers, independent computational agent-artifacts, and material objects are all part of the landscape. To paraphrase Case in Gibson's *Neuromancer*, "data is being made flesh."[4] These new media reshape the channels of our experience, transforming our conception of the "real" and redefining what it means to perform an experiment, to formulate a "theory," to be an "author," and, some would maintain, to be a "self."[5]

Recent developments in surgery provide a site to explore these themes. Ordinarily we do not think of surgeons as authors and writers. Alongside fighter pilots and extreme athletes they are typically depicted as persons of action, autonomous agents in the most vital sense who bring vast fields of knowledge, decision-making ability, and practical technical skill to bear in a life-and-death instant. But surgery provides a dramatic example of a field newly saturated with writing technologies that are transforming the categories of subjectivity, agency, and reality. Examining computer-mediated surgery through the lens of authorship may provide a useful allegory for other domains where new computer-mediated technologies of writing are reshaping agency and subjectivity. For just as the "author" considered as a singular nodal point of intention guaranteeing the unity of a literary work is being disbursed into distributed networks, so, too, are individual surgeons being replaced by software-mediated, machine-human collectivities. And just as the experience of the text is being displaced from the fictive world generated in the reader's imagination to an interactive performance externalized in a virtual world (or headset), so, too, is the surgical intervention planned in advance in the imagination of the surgeon. Once the creative act of practical genius, surgical plans are being displaced by the construction of a multidimensional simulation that includes not only the surgeon as one of its feedback loops, but also a host of other agents, among them codes that indicate allowable procedures in the pricing structure of the patient's health maintenance organization. In the near future, surgeons will no longer boldly enact modestly preplanned scripts, modifying those scripts in actual practice to adjust for the vicissitudes of the real case (such as anatomical structures

displaced from their canonical appearance in a medical atlas or pathological phenomena peculiar to the individual patient). Increasingly, surgeons must use extensive three-dimensional authoring tools to generate a simulation that becomes a software surgical interface. This interface guides the surgeon— now a collective—in performing the procedure. As we explain in more detail later, *authorship* and *surgery* are becoming indistinguishably fused, but in the process the "surgeon-author" as independent agent is disappearing.

As an example of the transformation of surgery through new writing technologies, consider Dr. Ian Hunter's performance of a surgical procedure on the eye (figure 13.1).[6] He does so in the newly emerging discourse network powered by Silicon Graphics Reality Engines, which simultaneously communicates, via the Scaleable Coherent Interface on Fiber Channel at 8 gigabits per second, with potentially hundreds of other agents and with virtual reference tools, including a library of distributed virtual objects and the databanks of the National Institute of Health's Digital Human. Although he appears singly here rather than in the more typical scene of a crowded operating theater with assistants and technicians, Dr. Hunter is assisted by a team of surgeons in an operating room with which he is virtually present. They see him as he performs the delicate surgery with them. Dr. Hunter's participation in the surgical intervention is obviously mediated by a vast technological infrastructure, and that network includes not only texts and practices of anatomy, physiology, and pathology including some traditional practices from earlier generations, but new fields such as biophysics, computer graphics and animation, biorobotics, mechanical engineering, and biomedical engineering. In contrast to a printed article in the *Journal of the American Medical Association* that previously would have crowned a successful medical achievement, Dr. Ian Hunter's work exists in a vastly co-authored interactive 3D VRML simulation of the surgical intervention that will have few paper traces. In fact, its paper traces are only intended for people such as grant officers, congressional aides, unregenerate text-bound physicians who don't currently have the technical capacity to "read" the simulation. (Lawyers, especially, will scour the printout of the code for purposes of defense litigation.) And though the institutional affiliations on the "publication" may include familiar addresses such as "Department of Surgery," there are others in this new discourse network—places such as the JHU-ISS Center for Information-Enhanced Medicine, the Mayo Clinic Biomedical Imaging Resource, Industrial Light and Magic, and IP (Internet protocol) addresses— that name completely new "sites" at machines physically located in such diverse places as the MIT Media Lab and the NASA-Ames Research Center.

Our analysis hinges on the relationships between networks and subjects. The "conditions of possibility" outlined by Michel Foucault in his discus-

FIGURE 13.1. Ian Hunter's microsurgical robot. Source: I. W. Hunter, T. D. Doukoglou, et al., "A Teleoperated Microsurgical Robot and Associated Virtual Environment for Eye Surgery," *Presence: Teleoperators and Virtual Environments* 2:4 (1994), cover image.

sions of discourse networks and authorship provide our entry-point. As Foucault noted, the author-function is characteristic of the mode of existence, circulation, and functioning of certain discourses within a society.[7] As a result, certain types of discourses are endowed with an author-function, and others are not. Not every discourse, whether written or spoken, may be accorded the status of being the product of an author. *Author* is a position that defines a subject in a discourse network rather than a quality inherent in an individual named, for instance, "Shakespeare." The same is true of *surgeon*.

As Foucault argued in *Birth of the Clinic*,[8] *surgeon* is a position within a discursive formation, constituted by the configuration of various statement types. Moreover, this configuration of statements is inseparable from the coordination of behaviors and the organization of the senses, the literal disciplining of bodies into the agents we call *surgeon*. As every surgeon discovers in medical school, learning how to talk the talk is inseparable from learning how to walk the walk. In this sense agency is a product of the disciplining regime of discursive formations.

Our analysis draws upon two distinct features of the author-function: namely, authorship as a set of social institutions and conventions, and authorship as embedded within a specific material media-technological formation. For various reasons, the combined effect of these features in the pe-

riods Foucault studied was to locate the author in the agency of a single person. Foucault's analysis focused on the institutional aspects of authorship. He observed that texts, books, and discourses began to have authors to the extent that authors became subject to punishment. Discourse can be subversive, and in order to control the potentially transgressive acts of discourse, texts were attributed to individuals as responsible agents. Further, Foucault pointed to the appropriability of discourses, the establishment of the system of literary ownership of texts with rules concerning author's rights, rights of reproduction, and so forth.

In *The Archaeology of Knowledge*, Foucault wrote that the material existence of the signs composing a statement is crucial to its intelligibility: "The coordinates and the material status of the statement are part of its intrinsic characteristics. That is an obvious fact." [9] Certainly Foucault did not overlook the issue of materiality. But as an archaeologist he was drawn to archives holding texts inscribed exclusively on paper or on canvas with ink or paint, and even within this domain he did not consider whether the medium of typed inscription versus that of, for example, handwriting played a role in constituting the author-function. Furthermore, even admitting Foucault's paper-fetishism, he tended to dismiss the materiality of communication as insignificant in comparison with considerations of the institutions of the letter. [10]

Foucault's focus was on the conditions that determine the status of a statement, and he located status determination in social institutions: "The statement cannot be identified with a fragment of matter; but its identity varies with a complex set of material institutions. . . . The rule of materiality that statements necessarily obey is therefore of the order of the institution rather than of the spatiotemporal localization; it defines possibilities of reinscription and transcription (but also thresholds and limits), rather than limited and perishable individualities." [11] From this perspective, media may be important but only insofar as they are components of institutional structures, or are perhaps themselves considered from a certain perspective as institutions.

To go beyond Foucault's analysis it is useful to consider Marshall McLuhan's media thesis: The medium is the message. Instead of focusing on the content of media—the ideas, images, or sounds they convey—or on the institutional framework of media, McLuhan enjoins us to consider the transformative power of the media themselves. The medium is the message, McLuhan writes, "because it is the medium that shapes and controls the scale and form of human association and action." [12] Media are what configure our relations with one another and with ourselves. In McLuhan's view, media are extensions of the senses, and by amplifying any single medium, the ratio among the senses is changed. As extensions of the senses, media, according to the thesis of the materialities of communication, configure our social awareness, our experience of the world, and even our experience of ourselves. [13]

Felix Guattari has given a useful formulation of the conditions of subject formation that is sensitive to a Foucaultian consideration of discursive structures and institutions as well as to the materiality of technological media emphasized by authors such as McLuhan, Derrida, Chartier, and Kittler.[14] Of particular importance for our thesis is what Guattari calls the machinic dimensions of subjectivation.[15] Consistent with Guattari's formulation, we might regard media technology, the machines of sign production and distribution, the material substrate of the semiotic productions of the mass media, informatics, telematics, and robotics, as inseparable from the formation of subjectivity, and not just with respect to memory and information-processing, but with respect to sensibility (in much the same way McLuhan suggested).

Guattari distinguishes among three components leading to subjectivity, which we find useful for examining the ways in which computer-mediated communication potentially alters the subject, our sense of the world, and agency:

> Recognition of these machinic dimensions of subjectivation leads us to insist, in our attempt at redefinition, on the heterogeneity of the components leading to the production of subjectivity. Thus one finds in it: (1) signifying semiological components, which appear in the family, education, the environment, religion, art, sport . . . , (2) elements constructed by the media industry, the cinema, etc., [and] (3) a-signifying semiological dimensions that trigger informational sign machines, and that function in parallel or independently of the fact that they produce and convey significations and denotations, and thus escape from strictly linguistic axiomatics.[16]

This definition implies a heterogeneous set of components that mutually constitute subjectivity. Linguistic, behavioral, and institutional considerations making up what Foucault would have considered discursive formations are part of this picture. But by attributing equal importance to the "a-signifying semiological dimensions of informational sign machines," Guattari emphasizes the constitutive power of media and information technology. Reminiscent of an approach suggested by Madeleine Akrich and Bruno Latour,[17] Guattari's suggestion incorporates certain nonhuman actors, namely the machines of sign production and symbol manipulation on all levels—visual, auditory, and tactile—and the material characteristics of communication channels through which they are mobilized. If, as we believe, the position of the subject is not given by a biological or psychological a priori, but constituted through Foucaultian discursive formations and the material configuration of the senses through technological media, then the technologies of virtual reality at work in contemporary medicine are not only transforming the practices but the very "subject" of the surgeon.

The contribution of the material configuration of media in constituting the author-function is particularly salient for our case, the virtual surgeon. For more than anything else, through the absorption of computer-mediated writing technologies affecting many other disciplines, the reconfiguration of this material-media component of surgery is shifting—and along with it the subject, surgeon. Indeed, it is hard to judge whether the traditional term *surgeon* is appropriate any longer. The "surgeon" Dr. Hunter is constituted by a web of data streams coursing through high speed routers governing the flow of data packets, a vast array of massive parallel processors, complex systems of stacked algorithms, the material institutions and standards sustaining them, and not least, the graphical user interface that is Dr. Hunter's portal to this world.

In what follows, we explore conditions bringing about such a shift from the unified heroic surgeon/agent, the stereotypical embodiment of scientific expertise, technical skill, and nerves of steel, to the dispersed, robotically enhanced image of Hunter. We are registering this shift not only in the subject-position *surgeon* but also in objective surgical bodies themselves. We move from the massively resistant material body, the object of surgery on the table of our hero-surgeon, to the simulated, virtually present body of Dr. Hunter's telesurgical robotic system, a large multimodal data set solidified through floating point calculations. Concomitant with the shift in the ontology of surgical domain, we also note crucial changes in the surgeon's subjective bodily experience through the application of virtual reality to surgical intervention.

THE MINIMALLY INVASIVE SURGERY REVOLUTION

The practical developments in surgery that interest us date back to the 1970s when the first widely successful endoscopic devices appeared. First among these were arthroscopes for orthopedic surgery, available in most large hospitals by 1975, but at that point more a gimmick than a mainstream procedure. Safe surgical procedures with such scopes were limited because the surgeon had to operate while holding the scope in one hand and a single instrument in the other.

What changed the image of endoscopy in the mind of the surgical community and turned arthroscopy, cholecystectomy—removal of the gallbladder with instruments inserted through the abdominal wall—and numerous other microsurgical approaches into common operative procedures? The introduction of the small, medical video camera that is attachable to the eyepiece of the arthroscope or laparoscope. French surgeons were the first to develop small, sterilizable high-resolution video cameras that allowed all

members of the team to view the surgical field by looking at a video scene together, rather than forcing the surgeon to peer down the scope alone.[18] With the further addition of halogen high-intensity light sources with fiber-optic connections, surgeons were able to obtain bright, magnified images viewable by all members of the surgical team on a video monitor, allowing cooperative teamwork and opening possibilities for surgical procedures of increasing complexity, including suturing and surgical reconstruction done only with videoendoscopic vision. The first laparoscopic cholecystectomy was performed by French surgeons in 1989.

Surgeons in France and the United States built upon this technology by developing new, specialized instruments for tissue handling, cutting, and hemostasis. Due to the benefits of small scars, less pain, and rapid recovery, endoscopic procedures were rapidly adopted after the late 1980s and became a standard method for nearly every area of surgery in the 1990s. Patient demand has had much to do with the rapid evolution of the technology. Equally important have been the efforts of health care organizations to control costs. In a period of deep concern about rapidly rising healthcare costs, any procedure that improved surgical outcomes and reduced hospital stays interested medical instrument makers. Encouraged by the success of the new videoendoscopic devices, medical instrument companies in the early 1990s foresaw a new field of minimally invasive diagnostic and surgical tools. Surgery was about to enter a technology-intense era that offered immense opportunities to companies teaming surgeons and engineers to apply the latest developments in robotics, imaging, and sensing to the field of minimally invasive surgery. While pathbreaking developments had occurred, the instruments available for such surgeries allowed only a limited number of the complex functions demanded by the surgeon. Surgeons needed better visualization, finer manipulators, and new types of remote sensors, and they needed these tools integrated into a complete system.

TELEPRESENCE SURGERY

A new vision emerged, heavily nurtured by funds from the Advanced Research Projects Agency (ARPA), the NIH, and NASA, and developed through contracts made by these agencies to laboratories such as Stanford Research Institute (SRI), the Johns Hopkins Institute for Information Enhanced Medicine, the University of North Carolina Computer Science Department, the University of Washington Human Interface Technology Laboratory, the Mayo Clinic, and the MIT Artificial Intelligence Laboratory. The vision promoted by Dr. Richard Satava, who spearheaded the ARPA program, was to

develop "telepresence" workstations allowing surgeons to perform telerobot-ically complex surgical procedures that demand great dexterity. These work-stations would recreate and magnify all of the motor, visual, and sensory sensations of the surgeon as if he were actually inside the patient. The aim of the programs sponsored by these agencies was to enable surgeons to perform surgeries, such as certain complex brain surgeries or heart operations not even possible in the early 1990s, improve the speed and surety of existing procedures, and reduce the number of people in the surgical team. Central to this program was telepresence–telerobotics, which allows a virtually pre-sent operator the complex sensory feedback and motor control he would have if he were actually at the work site, carrying out the operation with his own hands. The goal of telepresence was to project full motor and sensory capabilities—visual, tactile, force, auditory—into even microscopic envi-ronments to perform operations that demand fine dexterity and hand-eye coordination.

Philip Green led a team at SRI that assembled the first working model of a telepresence surgery system in 1991. With funding from the NIH, Green went on to design and build a demonstration system. The proposal con-tained the diagram shown in figure 13.2, which illustrates the concept of workstation, viewing arrangement, and manipulation configuration used in the surgical telepresence systems today. In 1992, SRI obtained funding for a second-generation telepresence system for emergency surgeries in battlefield situations. For this second-generation system the SRI team developed the precise servo-mechanics, force-feedback, 3-D visualization and surgical in-struments needed to build a computer-driven system that could accurately reproduce a surgeon's hand motions with remote surgical instruments hav-ing five degrees of freedom and extremely sensitive tactile response.

In late 1995, SRI licensed this technology to Intuitive Surgical, Inc., of Mountain View, California. Intuitive Surgical furthered the work begun at SRI by improving on the precise control of the surgical instruments. Intuitive added the EndoWrist™, patented by company cofounder Frederic Moll, which contributed two additional degrees of freedom to the SRI device—in-ner pitch and inner yaw (inner pitch is the motion a wrist performs to knock on a door; inner yaw is the side-to-side movement used in wiping a table). These enhancements allowed the system to better mimic a surgeon's actions, enabling the robot to reach around, beyond, and behind delicate body struc-tures. Through licenses of IBM patents, Intuitive also improved the 3-D video imaging, navigation, and registration of the video image to the spatial frame in which the robot operates.

A further crucial improvement to the system was brought from the MIT Artificial Intelligence Laboratory by Kenneth Salisbury, who imported ideas

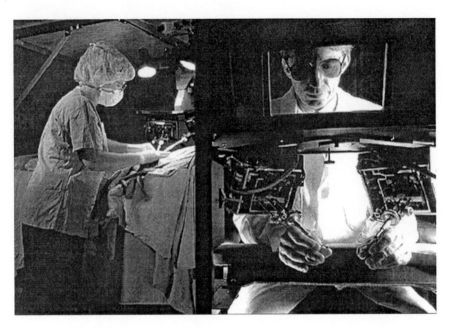

FIGURE 13.2. Philip Green, Stanford Research Institute, surgical manipulators with computer generated force feedback. Source: Philip Green, "Microsurgical Manipulators with Computer Generated Force Feedback." Source: *Time*, 148:14 (Fall 1996), 13.

from the force-reflecting haptic feedback system he and Thomas Massie invented as the basis of their PHANToM™ system, a device permitting touch interactions between human users and remote virtual and physical environments. The PHANToM™ is a desktop device that provides a force-reflecting interface between a human user and a computer. Users connect to the mechanism by simply inserting their index finger into a thimble. The PHANToM™ tracks the motion of the user's fingertip and can actively exert an external force on the finger, creating compelling illusions of interaction with solid physical objects. With a stylus substituted for the thimble, users can feel the stylus tip touch virtual surfaces. The haptic interface allows the system to go beyond previous instruments for minimally invasive surgery (MIS). These earlier instruments precluded a sense of touch or feeling for the surgeon; the PHANToM™ haptic interface, by contrast, gives an additional element of immersion. When the arm encounters resistance inside the patient, that resistance is transmitted back to the console, where the surgeon can feel it. When the thimble hits a position corresponding to the surface of a virtual object in the computer, three motors generate forces on the thimble that imitate the feel of the object. The PHANToM™ can duplicate all sorts of textures, including coarse, slippery, spongy, or even sticky surfaces. It also reproduces friction. And if two PHANToM™s are put together a user can "grab" a vir-

tual object with thumb and forefinger. Given advanced haptic and visual feedback, the system greatly facilitates dissecting, cutting, suturing, and other surgical procedures, even those on very small structures, by giving the doctor inches to move in order to cut millimeters. Furthermore, it can be programmed to compensate for error and natural hand tremors that would otherwise negatively affect MIS technique.

The surgical manipulator made its first public debut in actual surgery in May 1998. From May through December of that year Professor Alain Carpentier and Dr. Didier Loulmet of the Broussais Hospital in Paris performed six open-heart surgeries using the Intuitive™ system. In June 1998 the same team performed the world's first closed-chest video-endoscopic coronary bypass surgery completely through small (1-cm) ports in the chest wall. Since that time more than 250 heart surgeries and 150 completely video-endoscopic surgeries have been performed with the system, which was approved for sale throughout the European Community in January 1999.

COMPUTER MODELING AND PREDICTIVE MEDICINE

A development of equal importance to the contribution of computers in the MIS revolution has been the application of computer modeling, simulation, and virtual reality to surgery. The development of various modes of digital imaging in the 1970s, such as computerized tomography (CT), which is especially useful for bone; magnetic resonance imaging (MRI), which is useful for soft tissue, ultrasound, and later positron-emission tomography (PET) scanning have made it possible to do precise quantitative modeling and preoperative planning of many types of surgery. Because these modalities, particularly CT and MRI, produce two-dimensional "slices" through the patient, the natural next step (taken by Gabor Herman and his associates in 1977)[19] was to stack these slices in a computer program to produce a three-dimensional visualization. Three-dimensional modeling first developed in craniofacial surgery, a field focused on bone, whose digital imaging method of choice, CT scanning, was highly evolved. Another reason for this development was that in contrast to many areas of surgery where a series of two-dimensional slices—the outline of a tumor for example—give the surgeon all the needed information, a craniofacial surgeon must focus on the skull in its three-dimensional entirety.

Jeffrey Marsh and Michael Vannier at Washington University in St. Louis pioneered the application of three-dimensional computer imaging to craniofacial surgery in 1983.[20] Prior to their work, surgical procedures were planned with tracings made on paper from two-dimensional radiographs.

Frontal and lateral radiographs were taken and the silhouette lines of bony skull edges were traced onto paper. Cutouts were then made of the desired bone fragments, and the clinician moved these cutouts in the paper simulation until the overall structure approximated normal. Measurements were taken and compared to an ideal, and another cycle of cut-and-try was carried out. These hand-done optimization procedures were repeated to produce a surgical plan that promised to yield the most normal-looking face for the patient.

Between 1983 and 1986 Marsh, Vannier, and their colleagues computerized each step of this two-dimensional optimization cycle.[21] The three-dimensional visualizations overcame some of the deficiencies in the older two-dimensional process. Two-dimensional planning, for instance, is of little use in attempting to consider the result of rotations. Cutouts planned in one view are no longer correct when rotated to another view. Volume rendering of two-dimensional slices in the computer overcame this problem. Moreover, comparison of the three-dimensional preoperative and postoperative visualization often suggested an improved surgical design in retrospect. A frequent problem in craniofacial surgery is the necessity of having to perform further surgeries to get the final optimal result. For instance, placement of bone grafts in gaps leads to varying degrees of resorption. Similarly a section of the patient's facial bones may not grow after the operation, or attachment of soft tissues to bone fragments may constrain the fragment's movement. These and other problems suggested the value of a surgical simulator that would assemble a three-dimensional interactive model of the patient from imaging data, provide the surgeon with tools similar to engineering computer-aided design tools for manipulating objects, and allow him to compare "before" and "after" views to generate an optimal surgical plan. In 1986, Marsh and Vannier developed the first simulator by applying commercial computer-aided design (CAD) software to provide an automated optimization of bone fragment position to "best fit" normal form.[22] Since then, customized programs designed specifically for craniofacial surgery have made it possible to construct multiple preoperative surgical plans for correcting a particular problem, allowing the surgeon to make the optimal choice.

These early models have been further extended in an attempt to make them reflect not only the geometry but also the physical properties of bone and tissues, thus rendering them truly quantitative and predictive. R. M. Koch, M. H. Gross, and colleagues from the ETH Zurich, for example, have applied physics-based finite element modeling to facial reconstructive surgery (figure 13.3).[23] Going beyond a "best fit" geometrical modeling among facial bones, their approach is to construct triangular prism elements consisting of a facial layer and five layers of epidermis, dermis, subcutaneous

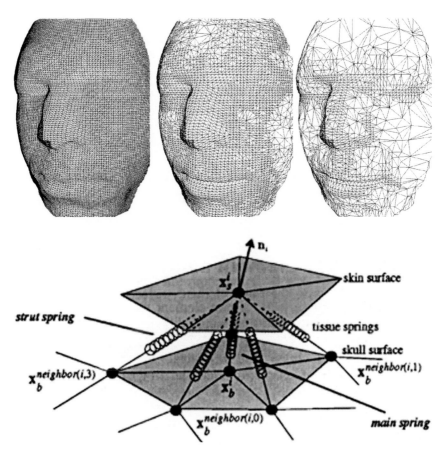

FIGURE 13.3. Craniofacial modeling with predictive tissue physics. Source: R. M. Koch, M. H. Gross, et al., "Simulating Facial Surgery Using Finite Element Models," *Siggraph 96* (1996), p. 423.

connective tissue, fascia, and muscles, each connected to one another by springs of various stiffness. The stiffness parameters for the soft tissues are assigned on the basis of segmentation of CT scan data. In this model each prism-volume element has its own physics. All interactive procedures such as bone and soft tissue repositioning are performed under the guidance of the modeling system, which feeds the processed geometry into the finite element model program. The resulting shape is generated from minimizing the global energy of the surface under the presence of external forces. The result is the ability to generate highly realistic three-dimensional images of the post-surgical shape. Computationally based surgery analogous to the craniofacial surgery previously described has been introduced in eye surgeries (discussed later), in prostate, orthopedic, lung and liver surgeries, and in repair of cerebral aneurysms.

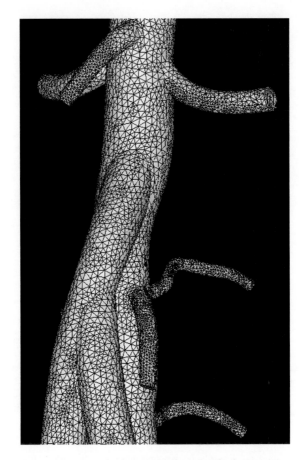

FIGURE 13.4. Charles A. Taylor, Stanford University, cardiovascular finite element modeling combining physiologic function and medical imaging data. Source: Charles A. Taylor, M. T. Draney, et al., "Predictive Medicine: Computational Techniques in Therapeutic Decision-Making," *Computer Aided Surgery* 4:5 (1999), 235.

Equally impressive applications of computational modeling have been introduced into cardiovascular surgery. In this field, simulation techniques have gone beyond modeling structure to simulating function, such as blood flow in the individual patient who needs, for example, a coronary bypass surgery. Charles A. Taylor and colleagues at the Stanford Medical Center have demonstrated a system that creates a patient-specific 3-D finite element model of the patient's vasculature and blood flow under a variety of conditions (fig. 13.4). A software simulation system using equations governing blood flow in arteries then provides a set of tools that allows the physician to predict the outcome of alternate treatment plans on vascular hemodynam-

ics. Modern medicine has prided itself on being science-based and grounded in experiment. But despite its many impressive successes, science-based medicine has never been *predictive*. The builders and advocates of these systems argue that they have crossed the Rubicon to predictive medicine.

MEDICAL AVATARS

Computational modeling has added an entirely new dimension to surgery. In finite element modeling the patient data derived from CT, MRI scans, and other physical measurements are the inputs for the model and visualization. For the first time the surgeon is able to plan and simulate a surgery based on a mathematical model that reflects the actual anatomy and physiology of the individual patient. The visualization of the patient data is then used to generate a surgical plan. The plan is the script the surgical team will perform including the path to be followed through the patient's body; the operations along the path to be performed on various structures, such as making incisions, clamping off arteries, and moving or manipulating around structures; and the repair or removal of the diseased tissues. Once the plan is constructed, a simulation of the surgery is created using the patient's data set. The surgical simulator is a VR system that combines the three-dimensional images of the patient data in an interface connected to a robot for manipulating the surgical tools. The robot incorporates extremely sensitive haptic feedback and is programmed to create the physical sensations of tissue resistance, cutting, and so on appropriate for the particular surgical procedure along the entire path of the operation. The visual data and the haptic program are coordinated with one another in the VR system. Moreover, the model need not stay outside the operating room. Several groups of researchers have used these models to develop "augmented reality" systems that produce a precise, scaleable registration of the model on the patient so that the model and the 3-D stereo camera images are fused. The structures rendered from preoperative MRI or CT data are registered on the patient's body and displayed simultaneously to the surgeon in near-to-real time. Intense efforts are underway to develop real-time volume rendering of CT, MRI, and ultrasound data as the visual component in image-guided surgery. Intraoperative position-sensing enhances the surgeon's ability to execute a surgical plan based on three-dimenstional CT and MRI by providing a precise determination of his tools' locations in the geography of the patient.[24] This procedure has been carried out successfully in removing brain tumors and in a number of prostatectomies in the Mayo Clinic's Virtual Reality Assisted Surgery Program (VRASP), which currently is headed by Richard Robb (figure 13.5).

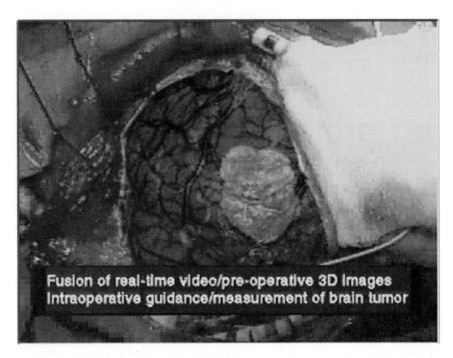

Fusion of real-time video/pre-operative 3D Images
Intraoperative guidance/measurement of brain tumor

FIGURE 13.5. Synthetic vision using the Virtual Reality Assistant Program at the Mayo Clinic: superposition of direct video with graphics rendered from brain tumor data. Source: Richard Robb, Mayo Clinic: <http://www.mayo.edu/bir/guide.html>.

TELEOPERATED MICROSURGICAL ROBOTS

One of the first systems to incorporate all these features in a surgical simulator was the microsurgical robot (MSR) developed for eye surgery by MIT robotics scientist Ian Hunter (see fig. 13.1 above). The MSR is particularly useful for illustrating our thesis that the ontology of the objects as well as the subject position of the surgeon are being transformed by new computer-mediated forms of communication and agency. At the same time, this work illustrates our point that the agency of the surgeon has never been so completely inscripted: the surgeon writes with a battery of three-dimensional authoring tools, and he must be constantly written into the operating scene.

The MSR system incorporated features described such as data acquisition by CT and MRI scanning, use of finite element modeling of the planned surgical procedure, and a force-reflecting haptic feedback system that enables the perception of tissue-cutting forces including those (scaleable between 3–100 times) that would normally be imperceptible if transmitted directly to the surgeon's hands. A distinctive feature of Hunter's MSR is its immersive virtual environment, which fuses video, touch, and sound into a virtual reality experience.

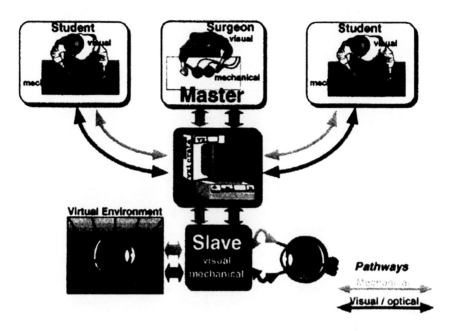

FIGURE 13.6. Ian Hunter's master-slave model. Source: Hunter, Doukoglou, et al., "A Tele-operated Microsurgical Robot," p. 271.

The MSR has three components: a microsurgical "master" and "slave," a virtual environment (VE), and an active mannequin (illustrated in the lower right-hand corner of figure 13.1). The master and slave subsystems (visual, auditory, and mechanical) communicate through a computer system that enhances and augments images, filters hand tremors, performs coordinate transformations, and runs safety checks. The surgeon wears a helmet (visual master) that controls the orientation of a stereo camera system (visual slave) that observes the surgery. Images from the stereo camera system are relayed back to the helmet (or to an adjacent screen) where the surgeon views them. In each hand the surgeon holds a pseudotool (a shaft shaped like a microsurgical scalpel) that projects from the left and right limbs of a force-reflecting interface (mechanical master). The master and slave components communicate via a fiber optical connection and can be located at different sites so long as signal degradation is avoided (figure 13.6).

The face for the virtual environment is created from the face of the patient with measurements made by a 3-D laser scanner and fitted by a parametric representation edited manually to add details not captured by the scan. These three-dimensional imaging systems are integrated into the slave unit itself, so that the patient about to be operated upon *and* the surgical model are mapped into the VE. Updates of the forces generated on the slave tool and the actual deformation of the tissue as it is cut are reflected back to the

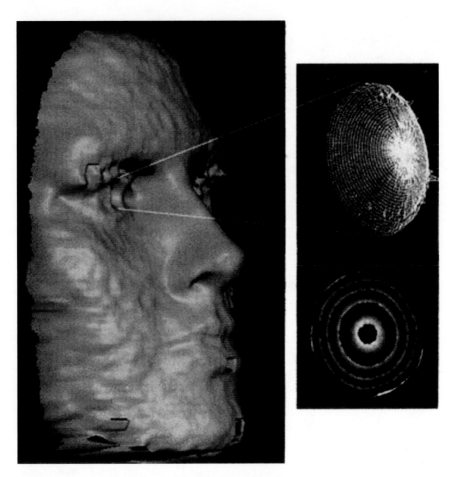

FIGURE 13.7. Ian Hunter finite element model of lens and cornea with realtime updating. Source: Ibid.

surgeon via the mechanical master. In this way virtual surgery is a realistic simulation, both seen and felt. In a final step for constructing the presurgical plan, a mannequin is produced from the computer model with polymers appropriately chosen to reflect the tensile properties of the tissue types making up the face or eye. The surgeon practicing on the surgical mannequin has the sense of cutting actual tissue.

One of the most innovative features of the MSR is its predictive capability. The geometric model of the eye is generated by a finite element model and incorporates physical properties of corneal and lens tissues that allow simulation of the change in the refracting power of the eye resulting from surgery. In this way, the effects of the surgical steps to be performed can be estimated in the planning stage and checked through comparative updates as the surgery proceeds (figure 13.7).

VISUALIZATION

Major differences separate the computer-mediated surgical systems we have described from previous modes of surgery and experiences of the surgeon. Consider first the differences introduced by visualization and volume rendering. The visualizations employed in the new computer-mediated procedures are based on completely different methods than those that previous generations of surgeons relied upon. All earlier imaging modalities—X-rays, CAT scans, even MRIs—constructed two-dimensional views of anatomical objects. Although such images are useful for diagnosing many problems, direct access to the three-dimensional structure is preferable for surgical purposes, and in many cases for diagnosis.

Obviously, when planning a surgery on such organs, the ability to visualize the structure in its actual anatomical setting is crucial. A variety of powerful computer graphics tools have been developed to solve these problems by converting raw two-dimensional CAT or MRI data to three-dimensional volume. Among these tools is an algorithm called Marching Cubes.[25] This technique renders the surfaces of objects as a fine mesh of intersecting triangles and can provide very precise images of single structures useful for diagnosing tumors and other disease states of that specific structure, but it is less useful for understanding the context of surrounding anatomical structures. The anatomical context, however, is crucial for designing and implementing a surgery. For example, in designing an arterial stent graft it is important to know whether the planned stent is anatomically possible given the anatomy of the particular patient.

A significant alternative method to the meshing-triangle iso-surface representations generated by Marching Cubes is a method for tracing volume along an arbitrary ray. This rendering method was first developed at Pixar Studios as the basis of the Renderman system used to produce the cinematic animation effects in *Toy Story* and *Jurassic Park*. Other large visualization packages, including special hardware, such as graphics boards and accelerators, have been created to generate volume-rendered images directly from the input of "raw" (CAT, MRI, and ultrasound) imaging data. Among these programs are Voxel-Man, VoxelView, ARTMA, and several others.

The products of these imaging modalities differ from their predecessors in important ways. Much less expensive predecessor systems for representing three-dimensional anatomy, such as stereoscopic viewers and wax models dating back to the eighteenth century, also allowed the surgeon to rotate the structure and examine it from many angles. But these previous systems were all generalized anatomies rather than patient-specific, living anatomies, generated in real time. Moreover, ray-tracing volumetric rendering methods produce physically accurate representations of the internal volumes and

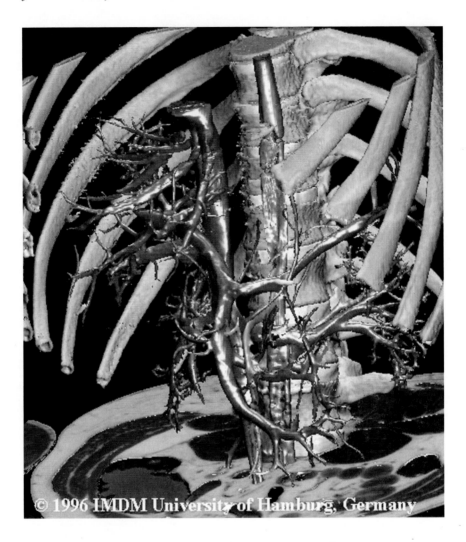

© 1996 IMDM University of Hamburg, Germany

not just the surfaces, as with meshed surface triangle methods like Marching Cubes.

In a volume-rendered data set the surgeon sees *while inside the body* what is obstructing the path, as well as what is behind or next to it, from all directions, allowing more certain navigation through these interior spaces. A structure can be zoomed in on, viewed from any angle, even (unreal) angles impossible to see in any other way. Furthermore if some organ, tissue, or fluid is obstructing the view of the object the surgeon wants to see, the obstruction can be filtered out. This means, of course, that the new surgical object in the virtual environment has an "unnatural" appearance from a pre-virtual surgery point of view—surfaces are unnaturally colored, passageways

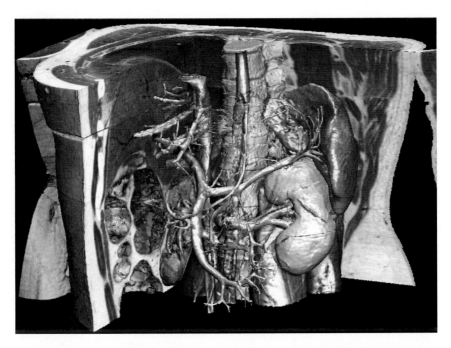

FIGURES 13.8a (facing page) and 13.8b. Voxel-Man volume rendering of internal organs. Source: Karl-Heinz Hoehne, "Voxel-Man 3D Navigator," in *Voxel-Man 3D Navigator—Inner Organs: Regional, Systemic and Radiological Anatomy* (New York: Springer Verlag, 2000).

such as the colon are "clean," and so on. But the objective is to isolate and manipulate the tissue in question.[26]

At this point we see some of the interesting ways in which workers in this new medium try to retain comfortable features of the medium being replaced. We see, for instance (figure 13.8) from Voxel-Man, elements, such as shading and texture, of pictorial realism in these images. In part, as Marching Cubes creators Lorensen and Cline note, this drive toward realism is due to the demands of physicians rather than radiologists. Physicians, Lorensen and Cline observed in their original discussion of the algorithm, lack the skills to interpolate three-dimensional images from two-dimensional radiological data.[27]

THE SURGICAL BODY AS HYPERTEXT NARRATIVE

Although standard tropes of pictorial realism serve to familiarize readers of medical imagery with new visualization techniques, spatialized hypertextual strategies are also introduced in order to annotate volume elements trans-

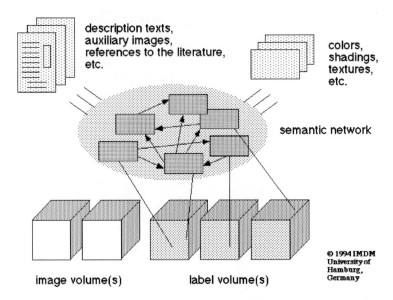

FIGURE 13.9. Voxel-Man intelligent volumes and semantic networks. Source: Andreas Pommert, Martin Reimer, Rainer Schubert, Thomas Schiemann, Ulf Tiede, and Karl-Heinz Hoehne, "Symbolic Modeling of Human Anatomy for Visualization and Simulation," in Richard A. Robb, ed., *Visualization in Biomedical Computing 1994* (Bellingham, Wash.: SPIE—The International Society for Optical Engineering, 1994), pp. 412–23.

forming them in the process to "intelligent volumes." Just as it would be mistaken to analogize new volume rendering methods with older methods of "imagining" the interior spaces of the body, it would also be a mistake to think of these intelligent hypertext volumes as the analog of earlier medical atlases. Text-bound atlases are limited in the ways they present anatomy by the particular emphasis—physiological, anatomical, or systemic—of the persons constructing the atlas. Multiple perspectives are difficult to combine. Ordinarily these are further limited in dimensionality, such as sagital, dorsal, and so on. The intelligent volumes of hypertext atlases are context-specific down to the level of volume elements (figure 13.9).

The Voxel-Man project is a particularly clear illustration of this hypertextualization of the surgical body. The key idea underlying the approach is to combine in one single framework a computer-generated spatial model to which a symbolic model of the human body is attached, a complete atlas with textual description of whatever detail necessary for every volume element in an anatomical structure. These constituents differ for the different domains of knowledge such as structural and functional anatomy. The same voxel (volume pixel element) may belong to different voxel sets with respect

to the particular domain. The membership is characterized by object labels that are stored in "attribute volumes" congruent to the image volume, including features like vulnerability or mechanical properties, which might be important for the surgical simulation. Patient-specific data for that particular region, such as the specific frames of MRI or CAT data used to construct the simulation, can also be included.

Such intelligent volumes are not only for teaching and review. Built into the patient-specific surgical plan, the hypertext atlas assumes the role of surgical companion in an "augmented reality" system. In Hunter's surgical manipulator, for example, various pieces of information—patient-specific data such as MRI records or particular annotations the surgical team made in preparing the plan—appear in the margins of the visual simulation indicating particular aspects of the procedure to be performed at the given stage of the surgery. The surgeon-team and the procedures it designs are thus inscribed in a vast hypertext narrative of spatialized scripts to be activated as the procedure unfolds. In this form of augmented reality, we encounter a narratology that would have delighted Julian Greimas and Paul Ricoeur: a non-chronological spatial distribution of actants generates both plots and characters in this medical narrative.[28]

DISCOURSE NETWORKS 2000: REGIMES OF THE COBOT

The microsurgical robots we have described are particularly designed to enable delicate and intricate surgeries, such as stereotactic neurosurgery and many brain surgeries, otherwise limited by the capabilities of the human hand and by the workspace available. In addition, the tracking capabilities of the system's teleoperator extensions allow a surgical tool to follow precisely a moving organ, such as a moving eye or beating heart. An imaging system mounted on the robot limb with the same axis of rotation as the eye, for example, is locked-on via servocontrol so that the surgeon sees a stabilized eye in the virtual environment and can proceed with the required surgery. Such extensions allow heart surgery without forcing the heart to stop.

Entangled economic, disciplinary, and political histories are bringing about, in the Foucaultian sense, the constitution of a new discursive formation. The shift in the subject positions *author* and *surgeon* can be mapped nicely along the dimensions of responsibility and subversion Foucault noted as central to establishing the author function.[29] As Elliot Freidson, Magali Larson, Charles Rosenberg, and Paul Starr have variously argued, the autonomy of the physician—the ability to act as a free, creative agent guided by the standards of a professional community—was predicated on a contract

with society in which the person authorized to practice surgery was held personally liable, both financially and criminally, for malpractice and professional misconduct.[30] This near-absolute autonomy of the physician reached its zenith in the early decades of the twentieth century following the Flexner Reforms. But as the practice of medicine has become more technology-intensive, moving into hospital-clinics with large infrastructures of technical support beyond the reach of physicians to own and manage themselves, the autonomy of the physician has been limited. Within the health maintenance organization (HMO) at the center of the modern health-care industry the physician is a large ticket item, but also just another employee. Along with this deterioration of the physician's autonomy has come a redistribution of responsibility for acts of malpractice. The health-care organization or hospital in which the procedure is performed and without whose support staff and technology the procedure could not have been performed has come to be named codefendant in malpractice cases.

In the surgical domain of VR-interfaces and real-time volume rendering, this distribution of responsibility goes several steps further: The responsible agents are a different cast of characters. For instance, up until now, the physician has depended on a radiologist to read the sequence of x-rays or an MRI. The radiologist produces a written report with a diagnosis for the physician, and the physician processes this written account together with the images supplied to produce an imaginary representation, the basis for intervention. In this system, mistakes in reading the imaging data are the responsibility of the radiologist. All sorts of conventions come into play in making a diagnosis, such as the orientation of the patient's body on the imaging system, the direction one reads the image, and so forth. In new real-time imaging systems, however, the radiologist is replaced by a software package that automatically segments the data, giving it structure. The radiologist is displaced by another set of agents: namely, the authors of the code. And as we well know, a traditional problem is the unprovability of software.[31] Can we tell who is responsible for a coding error? Not a simple matter. Similarly, in the telerobotics systems we have examined, the surgeon-function dissolves into the ever more computationally mediated technologies of apperception, diagnosis, decision, gesture, and speech. The once autonomous surgeon-agent is being displaced by a collection of software agents embedded in megabits of computer code. How is this possible?

Consider the surgeon planning an arterial stent-graft before the advent of real-time volume rendering. He used a medical atlas—or perhaps more recently a three-dimensional medical viewer—in combination with echocardiograms, CAT scans, and MRI images of his patient. At best the surgeon dealt with a stack of two-dimensional representations, slices separated by sev-

eral millimeters. These were mentally integrated in the surgeon's imagination and compared with the anatomy of the standard human. Through this complex process of internalization, reasoning and imagining, the surgeon "saw" structures he would see as he performed the actual surgery, a quasi-virtual surgical template in his imagination. No matter how you slice it, the position of the surgeon as an autonomous center of agency and responsibility was crucial to this system.

In the VR surgical theater we are describing, a much more concrete discursive setting appears, one of stainless steel clamps, CPU's and video monitors. This networked theater is shared by the imagining surgeon and imagining colleagues brought together by the technologies of telepresence. But the theater is filled also with hyperreal colleagues, constructed by programmers from a constellation of software companies. Software-generated models and data visualizations project back onto the patient's body and into the surgeon's computer-mediated vision. But there is one further step here beyond the "mental" agency of the subject in Foucault's discourse network. In our case, the imaginary functions carried out by Foucault's ethereal discursive subject are rendered literal. They are completely externalized in computational algorithms for data segmentation, volume rendering, and graphical presentation.

More than vision is at stake in computer-mediated surgery. Discourse networks, of whatever technical constitution, are as much social constructs forged from controversy and labor as they are material configurations. We have been pointing to the "interests" of physicians, health maintenance organizations, and ordinary patients in the construction of the desire for these technologies. Consider a recent development in the field: gesture macros and speech macros. Under the pressures of documenting medical procedures for reimbursement by HMOs, some physicians have sought ways to say more with less. Using speech-recognition systems, the physician needs to utter only certain phrases into a recognizer, from which the system constructs many pages of "written" documentation of the medical performance according to the templates of legal language.[32] These speech macros mediate, via computational logic, the surgeon's self-presentation, and they inscribe the surgeon into the legal and authorial structures of the new collective medical agent. Other layers of augmentation can be foreseen. Analogous to the insertion of material constraints, cost-factors, and building code regulations in current CAD-CAM design tools, surgical simulators could be augmented with the list of allowable procedures the patient's HMO authorizes, and within this list various treatment packages could be prescribed according to benefit plan. One could, for instance, implement a version of the Oregon Health Plan, which ranks 700 diagnoses and treatments in order of importance. Items be-

low line 587 are disallowed.[33] In the future, the appropriate constraints and efficiency measures could be preprogrammed into the surgical treatment planning simulator.

A glimpse of the next step in this dispersion of agency and its accompanying surveillance may be offered by the work of Michael Peshkin and Edward Colgate in the robotics laboratory at Northwestern University. Peshkin and Colgate are building a Force Reflective Endoscopic Grasper, a modification of surgical endoscopic telesurgical robots for use in automobile manufacturing. Peshkin and his colleagues are modifying these surgical systems to build *cobots*. Traditional robots supply the power and mobility and the human operator provides guidance. Cobots reverse this relationship. Cobots dispense with the powerful motors that drive conventional robots—and make robots dangerous. Instead, the primary function of the cobot is guidance of the human operator, its secondary function to offer support against gravity. According to Peshkin: "The human worker supplies all the force necessary to move the component, while taking advantage of the cobot's guidance to push it along quickly and easily without fear of collisions. The future may hold cobots of other shapes. . . . [T]he benefit of conventional robots is not their strength or autonomy, but rather the fact that they are directed by computers. . . . You can think of a cobot as a physical interface for a person to collaborate with a computer." [34]

Noting that computer-assisted surgery shares the features of necessary cooperation between human and machine found in automobile assembly, Peshkin and Colgate are also designing an arm-like cobot to be used in computer-assisted surgery. So we are only a few lab benches away from introducing cobotic agency into the severed mechanical stem of the surgeon's tool, thereby inserting a computationally mediated apparatus of discipline between the surgeon's hand and the patient's flesh.

Eversion: Brushing against Avatars, Aliens, and Angels

MARCOS NOVAK

> To make music is to express human intelligence by sonic means.
> —*Iannis Xenakis*

ALIENS I: TRANSMORPHOSIS

Entries for a future glossary: liquid architectures, transarchitectures, trans-music, extreme intermedia, disembodied dance, habitable cinema, naviga-ble music, nanomusic, nanotonality, eversion, transmodernities, the produc-tion of the alien.

In my work and writings I trace a sequence of developments in the poet-ics of new technologies that begins with architecture and spreads to culture at large. This sequence articulates what I perceive to be a growing cultural tendency toward algorithmic indirection, liquid variability, nonretinality, and, eventually, full virtuality (figure 14.1). The ascendancy of the liquid over the fixed is a phenomenon that is emblematic of an intellectual condi-tion in which previously irreconcilable, even inconceivable opposites coa-lesce into strange but ultimately tenable alloys. More alien fusion than mere Hegelian synthesis, this phenomenon is also thriving in popular culture. Elvis Presley moves backward, meets Abbot and Costello and becomes Elvis Costello, then moves forward, meets Adolf Hitler and becomes Elvis Hitler. Marilyn Monroe encounters Charles Manson and becomes amalgamated into Marilyn Manson, who in turn presents an identity construct that is at once familiar and alien, androgynous and unsexual, shock performer and polite, articulate talk-show guest. Meanwhile, global citizens are nomadic resident-aliens; teenagers, affiliated by alienation, morph into tribes of self-destruction, bringing terrorism to high school cafeterias; and transgenic doc-tors threaten to clone themselves with the help of their spouses. Telomerase research seeks to make us immortal (but may only make us more cancerous instead), nanotechnology promises not only to replicate but also to minia-turize us, and terraforming Mars is a concrete project whose outcome is surely the production of terrestrial Martians.

Easy opposition involves redundant bipolarity. Like two faces of a coin,

FIGURE 14.1. Marcos Novak, liquid architecture immersive environment. Computer-generated image.

polar opposites imply one another. A more interesting form of opposition consciously seeks what Peirce would call *thirdness*, or what Magritte would search for using Goethe's notion of *elective affinities*, forming a third position somewhere off the axis of an existing continuum. It is possible to go farther still: Whereas bipolar opposition relates two elements already on some common axis, or even the axis of a constructed thirdness, the form of opposition I have in mind does not find offsets along extant continua but posits continua where none previously existed, creating alloys that are between-above their constituting, previously unrelated elements. Although these alloys soon reveal themselves to be alien to their origins, they rapidly establish themselves as materials from which to launch additional transmorphings, which we are encountering with increasing frequency. In this climate, it is the familiar that is suspect.[1]

If the operations associated with the idea of the liquid suggest that parameterization leads to radical variability within a continuum implied by a thing and its opposite, or even its near opposite, the operations associated with the metamorphic *trans* suggest something more powerful: that a continuum can be established between any two things, even if those things would otherwise cancel each other out. It is useful to distinguish between bipolar

opposition, which admits to a continuous variation between two given poles—a field condition—and binary opposition, which only allows discrete, disjunctive selection between one pole or the other—a state condition. To give an example: In glass, solid and liquid are opposed in one sense, but belong to the same continuum. Presence and absence, on the other hand, are opposed in quite a different way, though they still share a common axis. There can be continuous variation between solid, liquid, vapor, and gas, but presence and absence seem inherently binary. What then, of liquid and absence? What would be between these poles? What above? And what of the more distant positions that are so easily imagined? The notion of transmorphosis anticipates that technology will soon allow combinations of precisely this kind. However, whereas the liquid simply suggests a becoming-continuous, transmorphosis suggests a becoming-alien.

Thus, while the notion of the liquid leads us to oppose the stability and permanence of architecture with a radical variability and to propose *liquid architectures*, the notion of *trans* leads us to oppose previously unrelated aspects of solidity/liquidity and presence/absence and to propose transarchitectures that are not present in any ordinary sense, architectures of partial, variable, and contingent presence, not only in cyberspace, but right here, in ordinary space. Already this statement seems perplexing. What could this mean? And yet, as we shall see, exactly this is the new potential for the arts of space.

ALIENS II: FROM IMMERSION TO EVERSION

Eversion is the obverse of immersion. Literally, it means "to turn inside-out," and differs from the more common *inversion*, which signifies "turning outside-in" or simply "turning over." Eversion also has mathematical and biological uses, and these provide other fruitful associations and resonances, but those are beyond the scope of the present text.

As captivating as the concept of immersion into virtuality has proven to be, it focuses on our entry into information spaces and has an unfortunate but strong connection with a narrow understanding of virtual reality. More importantly, immersion is not a complete conceptual apparatus: it lacks a complementary concept describing the outpouring of virtuality onto ordinary space. Because there is neither reason, desire, nor likelihood that we will abandon ordinary space soon, if ever, and every reason why we should augment it now, such a companion concept is necessary. Eversion is this complementary concept and signifies a turning inside-out of virtuality, a casting outward of the virtual into the space of everyday experience.

First, let me offer some context for this term. Eversion is one of a growing set of concepts I have proposed in describing the cultural and poetic circumstances brought about by the exponential growth of information technologies. There can be little question that we are tending toward a culture of ubiquitous virtuality. As modernity encounters the high slopes of exponential change, it undergoes a phase transition into a new stage I call *transmodernity*, or, better yet, *transmodernities*, placing emphasis on the inherent multiplicity and diversity that the proliferation of possibilities offers and requires.[2] The transition from modernity to transmodernities is not a sequential development, as postmodernity presumed itself to be, but a change of state of modernity when and where it encounters sufficiently great and accelerating change. Also, as I envision them, modernity and transmodernity exist in parallel. What is implied here is that modernity is capable of multiplicity and internal variability. If ordinary modernity is characterized by the production of the "new," which is, in any case, an ongoing cultural project, transmodernity is characterized by the production of the "alien," a much more focused concern, in its many forms, both literal and metaphoric, both popular and unsuspected. So far we have experienced this exponential change primarily through immersion into information technologies. As change accelerates, however, the technological becomes cultural and the immersive becomes everted. Hence, the transmodernity that has so far been brewing within information technologies has already begun to be cast onto the world at large by the very same forces that drive the economics and politics of technology. In other words, eversion makes the encounter with transmodernity as inevitable as television.

Second, the notion of eversion complexifies the already altered nature of our relationship to space. The word *space* is now just shorthand for *space-time*, and *space* is no longer innocent. Cyberspace already implies a space laden with intelligence. For the time being, the metaphor and technology of immersion keeps cyberspace apart from our conventionally embodied experience. Eversion, as I have described it, predicts that the phenomena we are familiar with in cyberspace will find, indeed are finding, their equivalent, everted forms in ordinary space. Thus, phenomenologically, the nature of space itself, this space, our space, is already undergoing significant changes into what I call *newspace*, the sum of local, remote, virtual, and interactivated space. Hence, we will encounter the transmodern-alien in a space already contaminated by the eversion of virtuality.

The effort to evert virtuality is already underway. The history of human-computer interfaces and displays, from alphanumeric to holographic and beyond, and the development of computer graphics as such, visual mathematics, and scientific visualization, give evidence to the need to import into ordinary space what we mine from the virtual. The emerging combination of

the wireless Internet with ubiquitous computing is further demonstration of the growing entanglement of these two domains. Hypersurface architecture, proposed by Stephen Perrella, the notion of *cybrids*, proposed by Peter Anders, and my concept of transarchitectures all share a concern for the theory and implementation of a lived-in and living virtuality.[3] While some insist on producing dead form even as they use the tools of computer animation, the transarchitects of eversion realize that the virtual is liquid, active and alive, more sensuality than shape, more behavior than appearance, more motion than model, more animate space than animate form.

MAXWELL'S DEMON, THEREMIN'S
ANTENNAE, AND FARADAY'S GARDEN

The archaeology of our relation to an altered sense of space goes back to at least Michael Faraday. In 1820, at almost exactly the same time Nikolay Lobachevsky was writing about non-Euclidean geometry and Victor Hugo was declaring that the book would kill the building, or that bits would triumph over atoms, as Nicholas Negroponte would articulate it in our time, Michael Faraday understood that space was not empty.

Michael Faraday developed the idea of the magnetic field run through by lines of force, demonstrating that space was not vacant, unstructured, or innocent. Faraday went further to recognize the connections between space, field, force, electricity, magnetism, and even light. Building on Faraday's work, James Clerk Maxwell reconciled electricity and magnetism through his field equations, and made it clear that light itself was simply a form of electromagnetic radiation. Maxwell's field equations were, in turn, central in Einstein's conjoining of space with time and mass with energy.

Maxwell also studied the behavior of gases, and, through the thought-experiment known as Maxwell's Demon became one of the originators of what would later come to be known as cybernetics. Maxwell's Demon was conceived as what we would now call an *intelligent agent*, located at the aperture between two chambers filled with gas, initially at the same temperature and pressure. The Demon would sense fast moving molecules and selectively allow them to pass from one chamber to the other, eventually overcoming entropy and creating a disequilibrium that could be used to provide power. Although it was later shown that this process would consume more energy than it produced, for a while it seemed that Maxwell's Demon could overcome entropy with information. The relation between energy and information has remained problematic ever since.[4]

In 1920, Lev Sergeyevich Termen, better known as Leon Theremin, created the first truly electronic musical instrument. The theremin produced

electromagnetic fields around two antennae. The fields acted as sensors: They detected the presence of a performer's body and modulated the frequency and amplitude of oscillators that produced sounds. Careful motion within the fields produced music. No direct contact was necessary. The theremin was the first expressive instrument to be played solely through presence, that is, through engaging a new conception of interaction with invisible form-in-space.

If we connect Iannis Xenakis's conceptions of music as being "inside-time," "outside-time," and "temporal," and allow ourselves to see music as extended form, we can look at a physical performance on a theremin and realize that not only can the interaction of human presence and sense-activated space create music, but also that the actions that perform music on a theremin have distinct three-dimensional shapes as "music-outside-time," linking spatialized music to temporalized, animated, liquid architectures. In fact, writing about metamusic—and, I would argue, transmusic and transarchitectures—Xenakis anticipated a visual music of quanta of light, localized in space, fired by photon-guns.[5] We will return to these later.

Of course, the electromagnetic theremin still operates in analog fashion. Present-day sensor technologies employ analog phenomena to detect a variety of conditions, and, via sampling and quantizing, make the collected sense-data available to digital computation, conjoining analog space to digital space, interaction to computation. A good example is an interactive artwork by Perry Hoberman, *Faraday's Garden*, consisting of a room full of electrical appliances, through which a viewer can walk as if through a garden.[6] Strewn among the sundry appliances are sensors that inform computers of human presence and activity. As one walks through the room, machines turn on and off in glorious cacophony. Old gramophones and fans, lamps and power tools, announce that space is not only not empty, but actually attentive and intelligent. Meanwhile, thousands of satellites and pieces of space debris orbit the Earth like a halo of alien flies. We see ourselves through their eyes.

ALIENS III: EXPONENTIAL GROWTH
AND THE PRODUCTION OF THE ALIEN

The word *alien* is derived from the Latin *alius*, which in turn comes from the Greek *allos*, from which the word *else* also derives. When in computer language we write a conditional statement, "if x then y else z," we are, in effect, writing "if x then y alien z," which expands into something of this form: if condition x is true, then make outcome y true; if condition x is not true, then produce the alien outcome z.

It has frequently been said that modernity is characterized by a fascina-
tion with change. It is also frequently noted that we live in a time of expo-
nential change. Moore's Law predicts that computational power will double
every eighteen months. It is further argued that, because improvements in
technology provide the means for further improvements in technology, there
is reason to believe that this rate will continue unabated and spread far be-
yond its own initial enabling technologies into all aspects of culture, follow-
ing what Kurzweil calls "the Law of Accelerating Returns."[7]

One implication of exponential change is that the ratio of technological
advancement to perceived cultural effect also changes exponentially. If we
consider the familiar graph of an exponentially rising curve as a diagram of
the growth of the cultural impact of technological change, placing the amount
of technological advancement on the horizontal axis and reading the amount
of cultural impact on the vertical axis, we can see that for most of history, it
would have taken a large amount of technological advancement to produce
a small amount of cultural impact, spawning predictable changes with little
or no surprise. As the slope of the curve changes, this balance shifts until we
reach a stage in which these terms are reversed and the opposite becomes
true: a small amount of technological advancement produces an increasingly
large amount of cultural impact. At the extreme, if exponential growth con-
tinues unabated, each infinitesimally small amount of technological change
will produce an infinitely large amount of cultural surprise.

While modernity as a cultural outlook has always been understood in
terms of its relation to change, what has now become apparent is that that
relation is not fixed, but changes character as we move along the curve of ex-
ponential growth. Up to a certain point, the impact of change remains pre-
dictable, but beyond a certain point, even the smallest increment of change
is amplified into a condition sufficiently removed from its origins to warrant
being called alien. The popular fascination with aliens is a symptom of this
transition into the posthuman, a vernacular awareness of the proliferation of
flavors and species of alienness and alienation.[8] Hence, we must ask what the
alien might be with respect to any particular cultural endeavor. In the case
of architecture as an art of space, we must ask this for each term: architec-
ture, art, and space.

SENSOR SURFACE

By definition, a sensor is a device intended to activate an inaccessible region
of reality in such a way as to make it available to our senses. This activation
has specific spatiotemporal extension, or, in other words, specific shape in

spacetime. Like Faraday's fields and their lines of force, analog sensor space has both overall contour and internal structure. Every sensor has an implicit focus, contour, surface, volume, or hyper-volume. Our ordinary impulse is to use sensors as transducers and components of control systems, and to concentrate our attention not on the spatial extension of the sensor-field but on the task at hand. Another view is possible, in which sensors interactivate space.

Analog sensors have a relatively fixed form, and their internal structure is determined by the particular physical principle that they employ. Infrared sensors, for example, can detect degrees of intensity of projected or reflected infrared light whose spatial extension is a series of concentric isosurfaces. If one works directly with the analog signals generated by such sensors, one is limited to the specific shapes implicit in their modes and principles of operation. Digital sensors are analog sensors whose output is not made available to us directly but is mediated by a layer of abstraction that helps generalize their spatial extension. For example, triangulation and other techniques of exploiting redundancy and overlap are used to infer specific location. An overlay of sampling and quantizing converts analog sense signals to digital data. Once this is accomplished, the shape of the sensed field becomes an abstract region of space with a coordinate system that is relatively independent of the original shape implicit in the underlying analog phenomena that are actually sensed. Not only is the overall form of the sensed field altered by this, but the internal structure also changes. Whereas previously the internal lines of force had to conform to the physical principles underlying the sensor's operation, and to the grain these principles imposed, now the internal shapes become totally programmable, like pixels on a screen.

I use the term *sensels* to describe the elements of a sensed field, by analogy to the more familiar *pixels* (picture elements), *voxels* (volume elements), and *texels* (texture elements).[9] Just as we can use an array of pixels to create any image we please within the confines of a screen, or a three-dimensional array of voxels to create any desirable form within the confines of an overall volume, so, too, can we create a precise sense-shape with an array or volume of appropriate sensels. Such a shape would be exact but invisible, a region of activated, hypersensitive space. In fact, all the techniques of computer graphics can be brought to bear upon the creation of sensed-form. Moreover, all the techniques of computer animation also apply, as do those of real-time simulation. Because sensels are not bound to exist on a screen, however, and because, as sensors, they are inherently intended to mediate between the invisible world and our own senses, they open up entirely new aspects of interface and expression (figure 14.2).

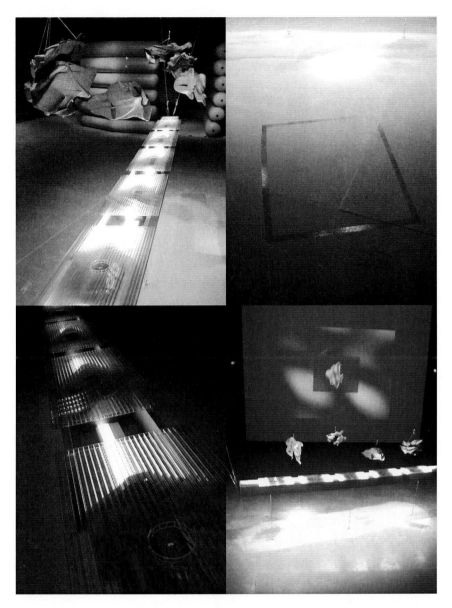

FIGURE 14.2. Marcos Novak, "Invisible Architectures" installation, Venice Biennale, 2000. The installation consists of a series of interrelated elements: (a) a core of algorithms generating (b) a series of virtual, liquid forms that are displayed on (c) a large video display, accompanied by (d) *transactive*, navigable, spatialized audio, controlled by (e) a series of five small and (f) two large invisible "sensel" sculptures, acting as (g) invisible interfaces to virtuality and placed in direct juxtaposition with (h) four suspended rapid-prototyped forms deriving from the projections of (i) a single four-dimensional form created by extruding one of the virtual forms into a fourth spatial dimension.

UPPER LEFT: General installation views, showing "light bar" with five small invisible sensel sculptures and four rapid-prototyped sculptures suspended above; UPPER RIGHT: one of two large invisible sensel sculptures defined on the gallery floor; LOWER LEFT: light bar; LOWER RIGHT: video display of virtual liquid forms.

FROM SENSELS TO SENSE-SELVES

Consider this: you reach into a sensor space. As your fingers cross into a se-lected region, sounds are triggered. Curious, you try to trace the extent of the region that causes the sounds. Soon you discover that it is a tall, elon-gated, shape, tapering at both ends. Exploring further you begin to realize that it is a sculpted form, an invisible rendition of Brancusi's "Bird in Flight." What has happened here?

What I am proposing is that a new form of sculpture has been born. This new form of sculpture reverses most of the ordinary expectations we might have about sculpture: Since there is nothing to see, voyeuristic visuality has been replaced with Duchampian nonretinality. The still prevalent prohibi-tion against touching the work has also been destabilized, since the object can only be known by touch: untouchability has been replaced with hyper-tactility. However, this sense of touch is problematized: There is nothing there to touch. Tactility becomes virtualized and synaesthetic.

Now let's follow this a step further. Instead of having the region of space be a simple shape, let's use a three-dimensional scan of someone's head and shoulders, a classical bust. Rather than render it in pixels, or voxels, let's ren-der it in sensels. Now, when we interact with the sensor region, we can ac-curately trace our fingers across the face of the sculptural portrait. Although we cannot see the face of the person, we can, ever so lightly, caress their fea-tures. Voyeurism is replaced by intimate touch.

Let's take a further step. We know that we can represent a model not only via computer graphics, but also through animation. The invisible portrait can be animated either passively, as a precomputed animation, or actively as an interactive real-time simulation. By animating sensels rather than pixels, we can create dynamic and coherent regions of space that can sense the world and our presence in it and that can take any definite form we wish to give them. Again, the now-animated sculpture is not visible. It is something we can only sense through a form of synaesthetisized touch.

One more step: Why stop at the head? Why not scan and animate an entire body? Several bodies? Now we reach a significant landmark: We have established avatars in our midst, invisible presences that perambulate near us acting as stand-ins or agents. One of the strangest predictions of the idea of eversion becomes true in the most direct of ways. We have moved from sensels to sense-selves. What are these invisible apparitions? What are the origins of our imagination of such entities? Spirits and ghosts, avatars and aliens, phantasms and specters, these are the naive conjurings of what we are now technologically able to release among us.

BRUSHING AGAINST ANGELS I

In Wim Wenders's film, *Wings of Desire*, angels walk among humans eaves-dropping, hearing their inner dialogues, their thoughts and fears and worries. Occasionally, the angels place an ethereal hand on a heavy shoulder to soothe a person. More often than not, they just observe. Now consider this: a gallery space with an installation that is entirely invisible, consisting of animated, autonomous sensor-presences. Walking into the gallery, you see nothing but space, empty space. But should you persist and remain in the gallery, perhaps you will brush against one of these presences, triggering synaesthetic clues of your encounter. Perhaps, alerted to this presence, you will reach out to touch the unseen visitor. The sensor-field of the invisible presence can be as detailed as we wish it to be: You can reach out and touch the face of an angel. Touching gently, and paying attention to carefully correlated synaesthetic clues such as sound, voice, light, or projections, you will be able to feel every feature and expression on the angel's face.

NANOSPACE

Physicist Richard Feynman's 1959 lecture, entitled "There's Plenty Of Room at the Bottom," predicted that design would proceed all the way down to the scale of atoms. In the intervening time, nanotechnology, the discipline that has emerged to study how such design capability is to be realized, has numerous concrete accomplishments in the creation of nanomachines.[10] These successes have, in turn, fueled additional speculations as to what is possible once the frontier of scale is crossed. Below nanoscale (billionth of a meter), there are pico (trillionth), femto (quadrillionth), even atto (quintillionth) scales, at each of which design and computation can be envisioned.[11]

One of the most provocative proposals to emerge from nanotechnology is J. Storrs Hall's *utility fog*. Hall invites us to consider a *foglet*, a nanomachine that is a cross between a supercomputer and a nano-robot or nanobot. As a computer, a foglet is a full supercomputer designed specifically for massively parallel processing and communications. As a robot, this foglet consists of a dodecahedral structure with six telescoping and gripping arms, arranged in such a way that it can grasp and hold other foglets under algorithmic control. Intelligent nanorobotic Velcro.

Now consider the scale at which Hall imagines this can be built: a foglet is about the same size as a human cell. We are ordinarily unaware of the enormity of the numbers of molecules, atoms, and particles that make up

ordinary matter, and so it will be useful to suspend disbelief until some of these numbers are considered. A cubic inch of space would contain 16 billion foglets. As fantastic as this may seem, it is conceivable because, with a reach of only 10 microns, the foglet would still consist of 5 trillion atoms, plenty of material for both its mechanical and computational requirements.

Utility fog is a collection of such foglets sufficient to fill a space, say a room. If the foglets are relaxed and distant from one another, they are invisible. If they are contracted, they take on aspects of solid matter. Under algorithmic control, they can vary smoothly between one state and the other, morphing from apparent nothingness to objecthood, or from one form and behavior to another. Hall builds on this informed speculation and performs some of the calculations necessary to make a persuasive argument that this is indeed possible in some not too distant future. Kurzweil estimates that it will take fifty to one hundred years to achieve this.

We do not have the technology to build utility fog at present, but we do not have to reach the limits of physical possibility to see what this implies. Even if we could only build sixteen, rather than sixteen billion such machines into a cubic inch, even if each foglet occupied an entire cubic inch by itself, the implications for our relation to space and architecture would be profound. At the scale that Hall envisions it, utility fog is an intelligent meta-material. It seems reasonable to assume that before we get to that level, we will build intelligent meta-components, elements of a generalized space-frame construction system that can sense its environment, adjust, and even reconfigure itself dynamically. Intelligent meta-components suggest that we can build liquid architectures in real space. Combined intelligent meta-materials and meta-components hint at the transarchitectures of alien transmodernities.

A ROMANCE OF MANY DIMENSIONS

The subtitle of Edwin A. Abbott's famous *Flatland* is "A Romance of Many Dimensions," the word "many" directing our attention to the more general problem of understanding a space of n dimensions by thinking analogically of spaces of $n+1$ or $n-1$ dimensions.[12] Information space, whether immersive or everted, is inherently multidimensional. Physical reality, as presented to us via superstring theory and its superset, membrane theory, is also inherently multidimensional. At one point string theory thought that there could be as many as twenty-six spatial dimensions, but at present, the number is believed to be merely ten. In nature as in artifice, there is much more to reality than meets the eye, so perhaps the eye needs to learn to see more than it normally does.

BRUSHING AGAINST ANGELS II

In my earlier discussion of the gallery in which regions of space were acti-vated in the forms of intelligent presences, I called the presences "angels." This was not motivated by any religious reason, but because of the likeness these presences show to the angels in Wenders's film and to the larger history of interaction with invisible presences. Although I understand these pres-ences to be everted avatars, it may be useful to give them a distinct name. So, angels, yes, but alien angels of a technologized spirituality.

I have long argued that it makes little sense to replicate the outside world in cyberspace. It makes even less sense to take a poor replica of the familiar from cyberspace and evert it onto the real. Just as it is more challenging to explore the ways in which the virtual exceeds the real in cyberspace, it is also more interesting to evert our cyberspace discoveries from virtuality onto ordinary space. In my work I have explored spatial ideas that are inherently nonvisual: n-dimensional geometries, curved transEuclidean spaces, ab-stract artificial life fitness landscapes. Musically, also, I am trying to under-stand what n-dimensional sound may be like, how it would propagate, what musical form and formation would be appropriate to it, and how its shad-ows would play in our spacetime. This parallel consideration of architecture and music is necessary: when space and time combine into spacetime, archi-tecture and music conjoin into archimusic. To make architecture is to ex-press human intelligence by spatial means; to make archimusic is to express human intelligence by spatiotemporal means. When spacetime is understood as n-dimensional, archimusic must be considered n-dimensionally as well.

Higher dimensional phenomena behave in ways we find difficult to com-prehend, and this strangeness carries through to the projections or sections by which we know higher space (figure 14.3). In three-dimensional space we can understand rotation about a point or about a line. In four-dimensional space objects can rotate about surfaces; in five, they can rotate about hypersur-faces. Since we have no direct equivalent, our understanding of these higher rotations is necessarily partial. Sound also is affected: An n-dimensional sound of uniform loudness and frequency, emanating from a single source in higher space can sound to us as a multiplicity of sounds of varying pitches, timbres, and intensities emanating from numerous moving sources in our space, simply on the basis of how it happens to drop into, intersect with, or project onto our space. Should the n-dimensional sound be part of n-dimensional music, the pattern becomes richer with every drop in dimension, until, in our three-dimensional world, even the simplest four-dimensional music sounds complex and intricate. Many such phenomena are waiting to be studied.

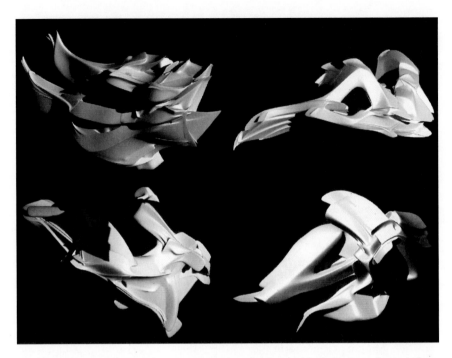

FIGURE 14.3. Marcos Novak, computer-generated orthographic projections of a single four-dimensional form, used to generate the four rapid-prototyped sculptures in the *Invisible Architectures* installation.

Transmodernity will surely take the new dimensions offered in cyberspace or discovered by physical space as raw materials for constructing new, multi-dimensional species of the alien, first in virtuality, and soon thereafter, via eversion, in real space augmented into newspace. Sensels will give interactivated form to this everted virtuality; parametric sound systems will localize the corresponding sound; photon-guns such as those Xenakis envisioned will provide a visual-musical correlate, if that is desirable or necessary; and developments of intelligent meta-components and meta-materials will allow the creation of *n*-dimensional liquid architectures in newspace.

To register the ramifications of all this, let us revisit the hypothetical gallery in which we first brushed against our alien angels. My initial observation was that eversion implied that sensels would interactivate regions of space, and that we would learn to detect the shape of those regions synaesthetically. Pressing forward now, we can see that the implication of components derived from nanotechnology is that the gallery itself becomes liquid and can change form dynamically. Pressing even further, the implication of materials derived from nanotechnology, such as Hall's utility fog, is that the distinction between space and boundary finally fades into a programmable

continuum. In effect, every location in space becomes a voxel of variable presence or absence, permeability or hardness, attribute x or attribute y. At this level, the gallery itself takes on the capacity of a three-dimensional screen, upon which anything can be projected.

If space itself becomes a screen upon which anything can be projected, not as a hologram but as a variation in density and material presence, then it becomes possible to project onto space the computation of the behavior of liquid n-dimensional architectures, inherently virtual designs now made palpable in familiar space. An archimusic of varying densities and qualities of space animates the space of the gallery, which is itself fluctuating, and we can touch the archimusic. Our alien angels need no longer be anthropomorphic, but can take on forms appropriate to their origins, and, strange though these forms may be, we can still touch them, too. And, finally, our gallery can move outdoors. Because eversion is about puncturing the barrier of computer screens as we know them and letting virtuality pour out and saturate newspace, there is no longer a need to remain confined to dark interiors. Eversion brings virtuality to sunlight.

REPRESENTATION FROM

PRE- TO POST-MODERNITY

INTRODUCTION

To recover the histories of science and technology is to be reminded repeatedly that their content and methods are constantly being renegotiated, that separate and successive phases and applications of particular sciences emerge, crest, are supplanted, overlap, and clash. There are no timeless essences in this field, only irreversible contingencies, coalescings of material and social forces, and swervings away from fixed expectations. *From Energy to Information* details how the unfolding of the sciences of energy into information technologies has created new lines in the cultural imaginary, how new forms of representation have arisen as new technological media recycle the contents of older ones.[1] New modes of data storage and manipulation now join the traditional practices of art and literature to digital media and virtual reality. When viewed in proper historical perspective, the very physical nature and irreversible dynamics of material and energetic systems are observed to organize the flow of creative bifurcations in technoscientific and cultural practices. Digital virtuality, too, ceases to be an anomaly or a threat and takes its particular place in the total scheme of operations.

In "Puppet and Test Pattern: Mechanicity and Materiality in Modern Pictorial Representation," Richard Shiff considers some aspects of this issue of representational complexity as it emerges in the history of art during the transition from energy to information regimes. In line with the essays by Robert Brain, David Tomas, and Timothy Lenoir and Sha Xin Wei and their concern with modes of graphic representation, Shiff examines the effects of representational materiality on the levels of significance that can be drawn from particular inscription practices. At one level, for instance, the materiality of artistic media can function precisely as noise, as the introduction of a quantity of noise into the signal of the image. At another, the noise of representational materiality can become the signal, and so converts the os-

tensible image into noise, and this figure-ground relation can be set up to os-cillate undecidably between the two. Comparing an 1886 work by Georges Seurat and a 1958 work by Jasper Johns with regard to these dynamics of the material properties of their respective support surfaces, Shiff considers the general question of artistic media by which photographic, electronic, and digital imagery can revert to the seemingly more physical mode of painting.

Shiff's essay places into an informatic context a range of phenomena re-lated to what W. J. T. Mitchell treats in *Picture Theory* in terms of Walter Benjamin's "dialectical image"—multistable imagery that creates split repre-sentations, that is, noisy visual or conceptual paradoxes in which more than one order of representation is collapsed into the same image.[2] In "Dinosaurs and Modernity," through a short excursion into cultural science studies de-rived from his *Last Dinosaur Book*, Mitchell approaches the dialectical and distinctly modern image of the dinosaur as it roams the historical and the-matic range of this volume.[3] Dissecting the layers of narration that sediment this exemplary quasi-object within the discursive foundations of our moder-nity, Mitchell observes how the dinosaur's multistable career, split between scientific concept and popular image, has negotiated the transition from the age of energy to the era of information.[4]

From its Victorian to its postmodern embodiments, constructions of the rise and extinction of the dinosaur reveal the close interactions and the mu-tual determinations of scientific explanations and popular usages. The iconic changes of the dinosaur—its commodification and circulation as an object of knowledge and fantasy, its implication in visions of modern catastrophe and postmodern obsolescence—trace the cultural repercussions of energy laws and information technologies through the eras of high and late capital-ism. In the multiple forms of the dinosaur image, prophecy and commerce, science and technology, art and literature all combine to frame a major para-dox of our modernity—the desire to place the archaic alongside the new in order to measure our "progress." With an eye on the continuities that bind the ostensible divisions in our theories of evolution and our experiences of historical change, Mitchell's analysis of the dinosaur image administers a bracing dose of critical skepticism about the revolutionary novelty of postmodernity. Information science and informatic technology do not ab-solve modern societies from political inequities, but rather, confront us with new opportunities to upset or correct the cultural balance of knowledge and power.

Puppet and Test Pattern: Mechanicity and Materiality in Modern Pictorial Representation

RICHARD SHIFF

> Only a god [can] prove a match for matter.
> —*Heinrich von Kleist, "On the Puppet Theater" (1810)*

ACCIDENTS OF THE MEDIUM, THE CONDITION

By the beginning of the nineteenth century a great many works of industry and art, as well as ideas about them, were recognizably "modern," at least from our perspective. At that moment of early modernity, Heinrich von Kleist composed a brief essay, "On the Gradual Fabrication of Thoughts While Speaking" (1805–1806). He addressed it—*his* thought—to a former military cohort, O. A. Rühle von Lilienstern. Accordingly, Kleist's German text employs the familiar *du*. An alien reader (you or I) notices reflexivity here. Nominally directed to its author's friend, the text immediately invokes the importance of soliciting such a friend—in fact, any acquaintance at all:

> Whenever you (*du*) seek to know something and cannot find it out by meditation, I would advise you, my dear and very clever friend, to talk it over with the next acquaintance (*Bekannte*) you encounter. [Do not] question him; no, tell him about it. . . . The idea will come to you in speaking. . . . [For] it is not *we* who "know"; it is rather a certain condition (*Zustand*), in which we happen to be, that "knows." [1]

Kleist's musing here foreshadows his more famous rumination "On the Puppet Theater" (1810). The latter advances a series of three anecdotes through the conceit of a conversation initiated by a chance encounter; the "you" is now a person depersonalized, a *Sie*. [2]

Kleist's "On the Gradual Fabrication of Thoughts While Speaking" poses this question: Why do we say what we say, and how do we know what we mean? Or rather, how do we know what *it* (what we say) has come to mean, at the very moment we say it? We find that the "full thought, to [our] astonishment, is completed [only] with the period." [3] Kleist's own logic is appropriately circular. Composing his argument, he must have been applying its

wisdom to himself. His writing amounts to a conversation with the preexisting textual material he invokes (Molière, Mirabeau, La Fontaine, figures who appear in no predictable order), as well as with his familiar addressee, his *Bekannte* ("you," *du*). Having moved from thought to thought for his reader of the early nineteenth century, Kleist concludes with a thesis that, to readers today, might seem commonplace but by no means banal. He argues that each person's encounter with the momentary play of a discursive medium—its possibilities and its limitations—determines what is thought, visualized, enunciated, represented. We come to know what we try so hard to say only as the medium that contains our expression assumes a shape proper to itself.

From the perspective of the late twentieth century, with Marx, Freud, Heidegger, and Lacan in view, it is difficult to decide whether Kleist's pronouncement—"it is not *we* who 'know' [but] a certain condition, in which we happen to be"—amounts to a radical subjectivity or a radical objectivity, a radical idealism or a radical materialism. Perhaps these terms have ceased to be adequate to the issues. Given Kleist's statement, we might infer that the articulation of profitable thought occurs within the microcosm of an individual's chance engagement with a discursive accomplice ("the next acquaintance you encounter"). But we might also assume that the macrocosmic linguistic context—the prevailing pattern of use of the representational medium (itself "a certain condition," quite a big one)—determines all possible expression, even though individuals appear to advance their own ideas.[4] It becomes each individual's responsibility to be sensitive to what the medium has the potential to express, as if the words were ready-made, awaiting someone with the wherewithal to think or speak them. "We [should not] suppose," Kleist states in "On the Puppet Theater," concerning the gracefulness of dancing marionettes, "simply because an operation seem[s] easy from the mechanical point of view, that it could be performed without a certain sensitivity."[5] Truth lies *in* the medium (even a mechanical one), but not everyone finds it.[6] Although discovering truth in a medium would seem to be more of a fortunate accident than an application of genius, those adept at the finding will appear to have "mastered" their source, the medium, perhaps as adversary more than collaborator. (Whether they succeed by creativity or by skill is still another matter.)

Yet, would it not be reasonable to regard these masters, immersed in their medium, as having been mastered themselves? Kleist gives several examples of situations that induce speakers to transcend self-perceived limitations. To a great extent—as Kleist and other Romantics would argue—we must refrain from attempting to plot our actions and understanding. Instead we should embody the moment, its momentum, yielding all self-conscious control, re-

gaining a quality of naive intuition that characterizes those who hardly think at all. We learn from observing puppets dance; their movement possesses the grace of naiveté, a naturalness nevertheless purely mechanical. Because puppet movement accords with efficient mechanical principles, it must unambiguously express its nature, as well as representing nature in general. There is nothing artificial about the operation of a mechanism. Or, perhaps one should say (in Kleist's view at least) there can be nothing unnatural about effective artifice; instilling dance in his puppets, the puppeteer finds himself dancing.[7]

The issues to be extracted from Kleist's essays were fundamental to notions of artistic representation during the nineteenth century and into the twentieth. Examples are abundant. Why? What advantage could there be in accepting, rather literally, the proposition that thought and its expressive representation, the core of human consciousness, might be captive to a medium? Because critical decisions must be differential, we should consider the alternatives as modern artists perceived them: when abstract structures of society and culture seem to control all thoughts and actions, base materiality—the medium, the condition—can appear as the less oppressive limitation, open to negotiation. What happens between you and the writing or drawing sheet is a personal affair, your private conversation with an acquaintance.

MECHANICAL MARKS

Exploring conditions for creative expression at the beginning of the nineteenth century, Kleist attended to the dance of puppets; he admired the grace of these mechanical dolls, which seemed to surpass that of their organic counterparts. Toward the end of the same century, the atomistic paintings of Georges Seurat were linked to the issue of mechanicity by both image and medium. Often the point was pejorative. Seurat's figures were described as rigid, inanimate, puppet-like: concerning the mural-sized *A Sunday on La Grande Jatte* (1884–86), one critic wrote (perhaps with politicized double entendre) that its Parisians appeared to be "fashioned of wood, naively turned on a [mechanical] lathe like the little [toy] soldiers that come to us from Germany."[8] A second critic, noting that others were deriding Seurat's "stiff wooden dolls [like] an array of toys from Nuremberg," suggested that the artist's motivation was caricature: he had caught the essence of the contemporary bourgeoisie, who would gracelessly affect the gestures of recreation, merely "striking poses" in the park in lieu of athletics and vigorous exercise.[9] So the first critic attributed the effect of mechanistic puppetry to the painter's own technical rudeness, while the second attributed it to behavioral

affectations Seurat was sophisticated enough to observe, assess, and mimic from a distance. Procedural stiffness in the medium differs from represented stiffness in the image.

As for Seurat's medium, viewers fixed on his application of dots or "points," the "little measured touches" of chromatic color that amounted to a regularity or uniformity of means: "Nothing artificial in this [pictorial] depth achieved without even diminishing the tones; to the farthest bits of foliage, the same tonality is maintained." [10] It was commonly noted—often with exaggeration—that Seurat's "research" incorporated advances in physics and chemistry paralleling progress in industry. [11] Initially, the harsh effect of the dots could irritate the eyes; viewers would need to become acclimated, the critics cautioned. [12] An intellectual accommodation might also be required; Seurat's technique instigated debate over the advantages and disadvantages of rigorous systems and their scientific validation. There seem to have been three fundamental considerations: Was the artist's method actually "scientific"—true to natural fact, objective, depersonalized, potentially of universal application? Would its constraints and discipline encourage or inhibit individual vision and expression? And finally, would it result in a superior product, a representation with a strong *aesthetic* effect—the raw, possibly irritating brilliance and the lack of affectation somehow converting into beauty and grace?

I will return to the case of Seurat, but for the moment, consider just one example of commentary, Thadée Natanson in 1900, nine years after the artist's untimely death. The critic's evaluation was circumspect, acknowledging this proviso: "Just as it appears certain that all theorization, intellectually conducted, ends in nihilism, so it seems evident that [material] boundaries and limits are necessary for something to result. . . . There must be a technical procedure for a work of art to come to exist in reality; this is, so to speak, its condition (*c'en est, on peut dire, la condition*)." The echo of Kleist ("condition") is unlikely to be more than fortuitous—a general affinity of thought, not a specific one, perhaps some Kantianism or residual Aristotelianism. With the "condition" in mind, Natanson concludes: "Seurat's principles . . . provide a considered means of painting that utilizes essential scientific facts without interfering with any individual talent, leaving to each his personality while mechanically obtaining the most forceful effect." [13] The critic's judgment is positive on all three counts. The mechanism is true to science (that is, nature), true to the individual, and creates a striking representation.

It did not require Seurat's kind of mechanism, his methodical approach to representation, for Natanson's constellation of three concerns to appear; in fact, it required only the aim of transcribing natural effects as naively—and, indeed, as "mechanically"—as possible. [14] In 1847, the French art critic Paul

Mantz argued that landscape painters who naively concentrated on observing what they saw would inevitably introduce their true selves into the image, even though the normative conventions of style would neither have encouraged nor accommodated this personal element. Evading any mechanistic explanation, Mantz referred to the trace of the individual as something that would simply "slip into" (*se glisser*) the picture.[15] The likely sign of the individual would be some characteristic idiosyncrasy in paint handling; and this "slippage" would be analogous to a speaker's discovering his or her deepest intentions only with their spontaneous enunciation. With landscape painting, the play of interlocutory resistance (the catalytic element Kleist invoked) would be provided by the prevailing style of representation. It would be "naively," inadvertently, resisted. Mantz's position entails that the more intensely and scrupulously, hence objectively (even mechanically), a painter observes a given site, the more subjective the picture might become, defying precisely what one would expect. Within this "condition," "objective" and "subjective" become productively confused. Mantz himself was not a particularly innovative thinker, yet a constellation of historically significant notions seems to have "slipped into" his text. He was merely being attentive to circumstances, his cultural condition.

And so with others, more or less distinguished. Reviewing the same salon of 1847, the politically oriented critic Théophile Thoré recommended that the artist limit initial action to a certain recognition: "Nature assumes the role of composing images, fully ready to be reproduced in a form of art. A landscapist stops along a forest path and finds a complete picture right on the spot, with a central effect and well-organized lines. [The landscapist] has only to paint what has been made directly by nature." [16] This was Thoré's way of asserting that painters could prosper in the absence of authoritative antecedents, without the traditions and conventions associated with an old aristocratic social order and the teachings of its schools, a set of stabilized preconditions to representational expression. Facing nature, painters would discover a "complete picture," superior to any work of academic invention. Nature's text, already written—self-composed, as it were—offered the advantage of liberating the artist from established expressive paradigms. The artist's action, like a marionette's, now became "easy from the mechanical point of view."

The value judgments of Thoré's artist, like those of a politically autonomous individual, would be guided by his or her immediate experience. Here the strict reproduction of a view given to the senses would appear as an original artistic thought, a corrective to the intellect and imagination, which would otherwise follow only ideologically sanctioned channels. In engaging a sensory present, artists would satisfy the democratic ideal of shaping their

lives as individuals in harmony with the changing social and material conditions of their historical moment. They would resist inherited authoritarian orders that worked to shape lives and responses in advance, insensitive to the truth of actuality.

Critics who championed realism and naturalism often regarded this unmediated "reproduction" of nature as a beneficial form of copying; its results were as rigorous as those of a mechanism, yet humanized and personal.[17] The antithetical approach to representation was indirect and intellectually abstract, with features and qualities of the model or scene being thematized, symbolized, or allegorized. In nineteenth-century terms, to give a modern Parisian woman an ancient Greek profile was to abstract the model, informing the image by a wealth of ideas rather than the richness of sensations.[18]

But what if one's immediate material sensations were degraded? Would this be cause to abandon materiality? The painter-theorist Maurice Denis observed that his turn-of-the-century generation of artists were being dehumanized by the leveling effects of modern urban life—mechanization, commodification, standardization, social regulation—all leading to impoverishment of intellectual and spiritual experience. The remedy, Denis argued, could be found in an "abstract ideal, the expression of interior [mental] life or a simple decoration for the pleasure of the eyes." Under the circumstances, the modern representational arts would strive to mask out dull environmental realities, "evolving toward abstraction." This kind of abstraction, however, would retain a distinct material component, located in purified form and simplified procedure, as opposed to clichéd allegorical content. The now famous Paul Cézanne (figure 15.1) and the now forgotten Charles Guérin were Denis's prime examples because both artists made repetitive sequences of marks unrelated to the size or shape of the objects they were rendering.[19] Clearly without mimetic function, these marks—as marks—were abstract, even though they were applied to represent a scene, more or less naturalistically. This was a *material* abstraction of the artist's own immediate making, an abstraction of the means.

Once manifest as a technique and articulated as a critical concept, abstraction of this sort had no clear limits. With the advent of Henri Matisse's fauvism and Pablo Picasso's cubism—styles generally regarded as derived from Cézanne's—Denis decided that abstraction had shifted from a liberated aesthetic expression to an intellectual aberration, a misguided product of bad theory. He described such work as "painting apart from any contingency, painting in itself . . . schematic compositions [with] marks (*taches*) as far removed from any concrete representation as possible."[20] To salvage Cézanne from such association, Denis claimed that this artist never "compromised" his pictorial synthesis "with any abstraction."[21] In effect, the critic reversed himself. At stake was a general observation that was being made

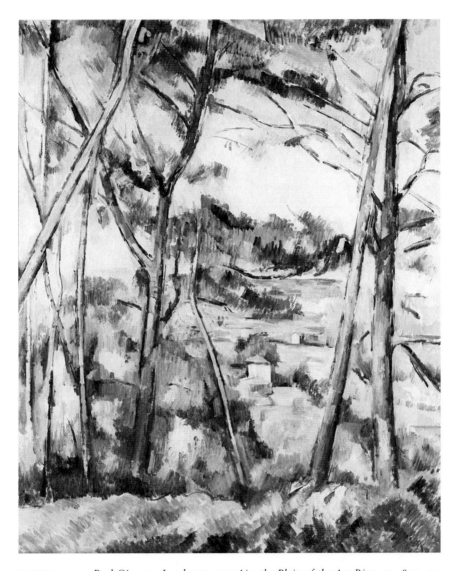

FIGURE 15.1. Paul Cézanne, *Landscape near Aix, the Plain of the Arc River*, c. 1892–95. Oil on canvas, 32¼ × 26 in. Carnegie Museum of Art, Pittsburgh, acquired through the generosity of the Sarah Mellon Scaife family, 66.44.

with increasing frequency: Material features of painting sufficiently prominent to draw attention to themselves would interfere with the representational image. Modern works, characterized by such interference as much as by anything else, were dividing their viewers along two lines of interpretation: a critic could attend to "painting in itself" (the medium, the form) or to the depiction (the image, the content).

Denis's contemporary, Emile Bernard, saw the issue exemplified in Cé-

zanne as early as 1891: "He opened to art this amazing door: painting for itself. . . . The more he works, the more his work removes itself from the external view [and] the more he abstracts the picture."[22] In Bernard as in Denis and many others, *abstraction* drifts from its older meaning of intellectualization (never entirely lost) to its newer complex of meanings alluding to absorption in material conditions, with the medium guiding the hand of the artist as much as any concept or vision of nature. Cézanne was surely not the first painter whose work provoked this line of critical observation, but he received most of the historical credit as well as the blame, perhaps because the corresponding social problems (commodification, standardization, urban *anomie*) dominated consciousness at the time his art received its greatest notice (1895–1910).

One thing was easy enough to acknowledge on the part of all participants to this long-standing art debate: The abstractions of intellectual life were ideological, cultural constructions; to concentrate on the physical, sensory aspects of nature—and, ultimately, on the materials at hand—was to resist culture. To turn inward in a physical rather than intellectual sense—to focus on paper, canvas, wood, graphite, crayon, or paint—was a way of evading the clichés of one's culture. Individual expression could be found in the most direct engagements with ordinary physical matter if only artists would yield themselves to it, abandoning the "self" formed by culture in order to reveal something else. The discovery could be something very small. Indeed, if ideology meant big ideas with pervasive implications, it would be self-deceiving to attempt to move outside the ideological; rather, an artist might find a place of refuge within, in a situation of sensory intimacy. Yet inwardness and individuality assume outward, interpretable signs. The signs of an artist's rejection of the grander culture—attention to the mundane; an awkward style; naive, rudimentary design—often came under suspicion as mere Romantic affectations, moves as calculated as any academic mannerism.[23] The stakes were too high for critics not to be wary of artistic feints.

Turn-of-the-century concerns over abstraction, as well as the issues raised by mid-nineteenth-century critics such as Mantz and Thoré, were shared by those who theorized the practice of photography. The mechanical nature of the new medium worked to its great profit: it was remarkably efficient; moreover, with an operation largely immune to human interference, it offered little opportunity for the artistic affectation that might spoil the truth of its image. (Kleist wrote that the advantage of a "puppet over living dancers [was] a negative one: namely that it would be incapable of affectation.")[24] As if agreeing to a policy of mutual non-intervention, proponents of photography noted its promise not to interfere, in turn, with the predilections of its operators. On the one hand were the mechanical virtues of ease, accuracy, ob-

jectivity, and standardization; on the other was the artistic value of sensitivity to aesthetic nuance. William Henry Fox Talbot, inventor of the calotype (paper-print) process, argued that his new medium would extend the qualities of existing modes of representation, not undermine them: "Even the accomplished artist will call in sometimes this auxiliary aid, when pressed for time in sketching a building or a landscape, or when wearied with the multiplicity of its minute details." Against the fear that photography would "substitut[e] mere mechanical labor in lieu of talent and experience," Talbot noted "ample room for the exercise of skill and judgment," remarking on the difference "produced by a longer or shorter exposure to the light." [25] With the choice of exposure, a personal element might "slip in," as Mantz would say. For Francis Wey in 1851, the soft-focus calotype print, as opposed to the crisp daguerreotype plate, was particularly effective in "animating" the camera image, affording not only "the reproduction of planes and lines," but also "the expression of feeling." [26]

Wey's term *animate* (*animer*) is crucial. It connotes organic movement and the breath, spirit, or soul that would motivate the living force. For many, the capacity for "feeling," rather than degree of visual accuracy or nuance, was the issue on which photographic representation and that of any other medium would rise or fall, at least in its artistic use. To represent feeling, a medium had to accommodate a "soul." Sentient beings possessed souls; prevailing opinion was that matter and machines, however moving, did not, other than metaphorically.[27] To the extent that commentators denied photography a soul, they alluded not only to its mechanicity but also to the character of the machine's material trace—a surface unnaturally and inorganically regular (as Seurat's would later seem to be). In 1856, Henri Delaborde, an arts administrator committed to the practice of hand copying, observed that a photographic "touch" lacked variation: "We feel that the hand, or rather the soul, is absent." [28] In 1880, a French admirer of John Ruskin, Ernest Chesneau, generalized the relevant principle: "Imperfections [irregularities] contribute to give [works of the hand] individuality—as it were, a soul. The product of the machine is lifeless and cold; the work of man is living, like man himself." [29] The distinction carried into the twentieth century. In 1930, critic Georges Duhamel described the elaborately decorated surfaces of American movie palaces as "industrial luxury, fabricated by machines lacking soul for a crowd whom the soul also appears to abandon." [30]

The last example evokes a desensitized viewer, a member of the crowd, who responds to the general effect without considering the terms of its production, industrial or otherwise. Professionals, however, knew that estimating the ratio of animation to mechanicity in the *image* (the product) yielded implications different from those produced by evaluating this factor in terms

of the particular *medium* (or process). Yet this difference would not always matter, even to experts. Concerned with artistic modes of representation applied for the sake of science, as well as with a science of art, Yves Guyot asked in 1887: "Will the mechanical process [of photography] replace the artist's hand? . . . I, as the public, do not require an account of the procedure, only that the result provokes my feeling (*émotion*). If so, it has attained its goal." Guyot compared Rubens's "artistic" images of convulsive bodies to the same physical states shown in the "scientific" images that Jean Martin Charcot and Paul Richer derived from photographs, a comparison Charcot himself made as part of his research—the image in each medium confirmed the validity of the other. Guyot believed that reliable representation in any medium depended on avoiding abstractions—in this case, preconceived formulas for depiction, whether deriving from long tradition or transient fashion.[31] Intellectualized abstraction obscured the living accuracy of observation.

Ironically, there proved to be a *mechanical* way of enhancing the liveliness of photography, and this was simply to animate it, give it movement, as was done in the photographic sequences (chronophotography) produced by Edward Muybridge and Etienne-Jules Marey, included among Guyot's examples of the art and science of observation.[32] Film projection was soon to follow, and its early name was *animated photography*—that is, either moving photography or photography-with-a-soul, depending on one's critical perspective.[33] The mechanics of cinematography were unusually complicated and only slowly perfected. One of the problems was a certain material interference known as flicker; it was caused by the eye's ghostly registration of the action of the shutter, a "rapid alternation of extreme light [open] and extreme dark [closed]," as each still frame was shifted into position before the projection lens.[34] Perhaps flicker itself was the soul of the medium, a quality of illumination belonging to the machine, not the image. The severity of flicker varied in relation to the type of shutter used, as well as the distribution of light and dark in the scene being projected. The phenomenon of flicker, which irritates and fatigues the eye, is a dramatic instance of the tension between material features of the medium and its representational function of conveying an image. When early projectionists attempted to eliminate flicker by using no shutter at all, "rain" appeared, a different manifestation of "persistence of vision," now a result of contrast in the succession of projected images rather than in the repeatedly interrupted beam of projected light.[35] The medium had not yet attained transparency or silence, a lack of "noise" with only an image remaining.

Somewhat later, broadcast radio would have its various forms of audible static, and still later, television its visible forms of interference—waves, distortion, and "snow"—that technology would work to eliminate. A pattern

FIGURE 15.2. Television test pattern, c. 1951. Source: John R. Meagher and Art Liebscher, *TV Servicing* (Harrison, N.J.: Radio Corporation of America, 1951), p. 35. Photograph courtesy David Sarnoff Collection.

of waves across a television screen indicates a conflict of electronic signals, one informational sign competing with another. Television test patterns (figure 15.2) were devised to diagnose the source of any interference according to distortions visible in differently configured areas of the fixed image. As a broadcast, the geometric test pattern itself provides no particular information—it does not move or vary—until alien "noise" interferes. The noise then becomes the information, useful to the diagnostic engineer whose concern is to restore the medium to its silence, so its projected broadcast image will once again come in line with a normative raster and appear "true."[36] In conventional North American television, the raster consists of a pattern of 525 horizontal lines that the scanner follows as it creates the picture by projecting a sequential beam of electrons, activating numerous momentary bursts of phosphorescence. The raster is conceived as a passive element in the operation, yet its structure, intended to be invisible at normal viewing distance (beyond the eye's capacity to discern it), sets material and physical limitations to the medium—for instance, its power of image resolution, of which the fixed number of lines is a factor. In order to avoid the sensation of

a discontinuous image, the individual bursts of phosphorescence, brightest at their centers and dim at the edges, require a certain amount of overlap along the raster. Imagine a painter regularizing variations in the intensity of successive strokes of the brush by touching up the edges at a late stage in the painting process. Structurally, television "touches up" as it moves along.[37]

In the case of rapidly flashing particles of "snow" (a nonfilmic flicker), interference is generated from "inside" the television apparatus. Snow can be caused by random weak signals that interfere with the dominant signal, but it becomes especially evident when the set receives only weak signals or no signal at all. In response, the amplifier seeks out a strong signal or any signal. In lieu of anything better, the receiving medium will produce a transient moving pattern of its own upon the raster—variations in illumination at or near the scale of the individual picture element (pixel), which never coalesce into an intelligible picture. Even without a broadcast signal and consequent image, the screen does not become dark. A play of void and phosphorescence animates it, an interference that interferes with nothing. In a reversal familiar to modern painters, this material assertion of the medium becomes the image (hence, the metaphor *snow*). The effect actively represents the medium as it represents itself in its sensate condition of being "on," responding to the ambient electronic environment.[38] The medium gives an electronic sign of "life," analogous to a pulse, breath, or quiver.

MATERIAL REDUNDANCY

To some extent, any mechanical or electronic medium will appear to possess or contain a life of its own, at least with respect to the part of its normal working process designed to escape outside interference. Like an extended computer algorithm, this movement or animation occurs within a sealed environment, immune to what nineteenth-century art critics regarded as the "touch" of human individuality and spontaneity, which stamps a personalized, soulful mark. "The painter's touch will always be good if it is natural, that is, if it follows his heart," wrote art educator Charles Blanc in 1867.[39]

One would think that following the heart is entirely different from following a raster. But is it? When Wey (to return to a previous example) claimed to find animation in photography, he need not have stressed the nuanced blur of the calotype print with its visual resemblance to heartfelt handwork. In fact, animation could be mechanical and yet seem entirely true to nature—so true that a separate category of *artificial* animation can have no use. The term *animation* seems to have lost all metaphorical application. By a fluid metonymy, it applies as literally to machines as to people, regardless

of one's position on the question of soul.[40] A heartbeat is not only natural, but also regular and automatic, like a mechanism.

In photographic imaging of all sorts, we consider as automatic whatever occurs during the period light is allowed to strike the photosensitive surface. We attribute objectivity to the representation that results, relative to the specifications of the apparatus. Does it matter that the device has a human operator with past experiences and expectations for the future? Perhaps not at the very moment of indexical creation. When Kleist implied that the puppet virtually animates itself around a soul-like center of gravity that guides all graceful movement, he complicated any thought of differentiating or prioritizing the roles of marionette and animator-master. He also complicated distinctions between spontaneity, willful control, and automatism.[41]

This Kleistean notion of self-contained life in a feedback loop, within terms set by a "condition," leads to speculation concerning at least three channels of experience. We conceive of the operation of a *medium* as an autonomous, self-reflexive system with its inherent determining tendencies. Accordingly, the referential meaning of a painting, a photograph, or a video image must depend on conventions of representation established by other images of the same type. We also imagine that the creative play of an *artist* isolated in a studio can be an autonomous system of a similar sort, with each work being an immediate, personal response to its predecessor. This is why art and music are such popular modern avocations; they serve as therapeutic escapes from depersonalized rituals of social life. But we then view the entire *society* as if it, too, were a hermetic environment, with ideology, technology, or the technocratic collusion of the two acting to contain and suppress human agency: "The center of authority in [a technological society] is no longer a visible personality, an all-powerful king. . . . The center now lies in the system itself, invisible but omnipresent."[42] This is to regard society itself as a representational device—one huge Kleistean puppet. The center of gravity, a principle of matter, displaces the "king," or animator. How can the operation of this silent "system" be revealed? One would need some kind of diagnostic test pattern designed to render sensible the material and mechanical noise of cultural representations. Modern art serves this redeeming social function: It tests the puppetry and probes whatever seems automatic.

In the reception of modern art, the history of technology plays a significant role. An individual's experience rarely recapitulates the general technological evolution. Typically we encounter advanced modes of representation before encountering their progenitors. Like many others of my age, I regularly experienced not only photography but also the imagery of early broadcast television before I ever attended to sophisticated techniques of drawing

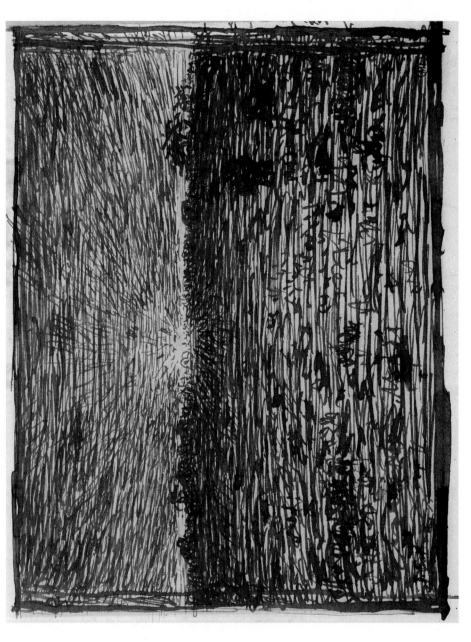

FIGURE 15.3. Jean-François Millet, *The Plain at Sunset*, 1865–70. Pen and brown ink on paper, 7¾ × 8⅛ in. Louvre, Paris. Photograph courtesy Réunion des Musées Nationaux/Art Resource, New York.

and painting, introduced to me only with higher education. Given the order of my formative experience, I tend to comprehend the older representational modes in terms of the newer mechanical and electronic ones. If I am attracted to Jean-François Millet's *The Plain at Sunset* (figure 15.3)—a sketchy, yet conceptually and procedurally complete ink drawing—this is because of its uncanny resemblance to television. Through this chance "conversation," I learn something about modern representation in general.

In his statement of 1887, set in a context that featured the new animated photography, Guyot (among other occupations, an agricultural economist) presented Millet as his prime exemplar of a nature painter who had rebelled against the intellectual abstractions of academic art; this was an artist who engaged in direct—and therefore, scientifically valid—observation of "the fields, the grasses, the forests, the sun." [43] *The Plain at Sunset* depicts fields, grasses, the sun, and even a hint of forest along the horizon; yet Guyot's evaluation cannot apply to this work without a certain irony, for Millet's effort seems to turn inward, observing the medium of drawing more than the details of nature. *The Plain at Sunset* develops counterintuitively: its opaque pen strokes represent elements of nature that should be transparent, and threaten to revert from illusion to mere literalness, to appear as nothing but lines. Let the eye scan this rather evenly distributed pattern of dark marks over its light ground—the sensation is a vague flicker. We sense the mechanism of Millet's drawing, as much as any organicism in his represented scene.

Millet's view divides into horizontal zones of earth and sky. By convention, a single horizontal line might have conveyed this information adequately: sky above, earth below. But Millet drew horizontal lines nearly everywhere across the white paper, which itself has a horizontal format. They reinforce our sense of the physical extension of the paper surface, as well as repetitively articulating the elements, units, or points that constitute it. The lines emphasize a silent material presence already there, a kind of raster.[44] In the lower zone, these horizontal lines are broken by irregular squiggles and short verticals to represent (with only the slightest mimeticism) grasses or crops and two human figures. The horizontals themselves represent the earth, a pictorial foreground, as well as the "ground" in general, precisely what the paper represents (in a very literal sense) as a support surface for drawing. The horizontals of the upper zone represent the sky, a background, but also, again, a ground in general, analogous to the paper. These lines are intersected by others in an arcing pattern of verticals and diagonals, to render sunlight. Light and air become opposing or interfering patterns of lines, both contrasting in turn with the white paper ground.

There are visual ironies in both image and medium. As an image, *The Plain at Sunset* is animated not only by the active "figures" of grasses, human be-

ings, and the event of a sunset, but also by the passive ground elements of earth and sky (or air). In fact, the relatively uninflected expanses of light, air, and earth become more palpable than the incidental figures of plants and human beings. In terms of the use of the medium, the insubstantial or dematerialized elements of light and air are rendered with nearly the same materialized graphic density as anything else, including the solid earth below. A void in nature, the sky above, becomes a dense network of interference, a materialization of the invisible. Is it analogous to an electron beam that, phosphorescing, becomes a picture of a landscape? There is a difference, of course: television lights up, appearing as flashes of illumination, whereas Millet's drawing consists of dark marks against a light reserve. Yet both mediums have a raster—a preexistent structure that guides the articulation of any possible representation, a material base for abstractions of both eye and mind.

SEURAT'S RASTER

Consider the historical sequence of mediums from painting (or murals, its more public manifestation), to photography (or illustrated magazines and billboards), to film (or cinema), to video (or television), to digital conversions of each of these types of representation. It suggests that the materiality of visual imagery has decreased to the extent that it hardly remains a factor in communication. Pictorial representations of earth and air now have neither cause nor opportunity to differ in material texture. Nor, with the newer modes of representation, do we expect to sense the expressive hand and soul of a romantic artist-creator, experiencing an individual's bodily presence "slipped into" images that imitate the look of nature.

The reception of Seurat's art reflects this shift in expectations. With ever less materiality to engage us, we detect it where it previously went unnoticed. What once appeared dehumanized and mechanical because it lacked the usual signs of manual flourish, now acquires something of an archaic or atavistic human quality due to the simple fact of its individualized hand labor.[45] With a sense of technological crisis, Meyer Schapiro in 1957 called painting and sculpture "the last hand-made, personal objects within our culture."[46] Although recent art history has emphasized Seurat's representation of Parisian social life (and debated, as ever, his application of science), he has for many years also exemplified the type of material abstraction that caused consternation in critics at the turn of the century. They hedged their assessment of the problem, regarding it as at once material and mental. For Denis, the source of Seurat's emotional "coldness" was his "abstraction and philosophical mind."[47] Charles Morice warned of the "mortal danger" of prac-

ticing a mechanistic pointillism—an "art reduced to technique [becoming] a kind of new and useless science [with] the hands in charge of the head." As for Cézanne (whom Morice nevertheless admired), he had reduced human moral values to material color values.[48] Body and soul were both affected.

One thing is evident: Seurat, like Cézanne, came to appear increasingly as a painter of the pure mark, that is, of "nothing." By nothing, I mean *images* of nothing—abstract or abstracted images—painting in which the material display of the medium becomes more involved and informative than the represented character of the scene. The analogy to interference in a test pattern, and also to flicker or snow, is obvious.[49] Seurat's "nothing" was most often viewed in his summer paintings of seacoasts, which contain expanses of sand, water, and sky rendered with an ever varied pattern of dots—a "sensation of the visual void," commented one critic in 1886.[50] "Who before Seurat ever conceived exactly the pictorial possibilities of empty space?" Roger Fry asked later; "his pictures are alive, but not with the life of nature."[51]

Yet Camille Pissarro, disillusioned with the pointillist method in general, had stated just the opposite; he compared Seurat's art to mechanized printing, its technique ending in a "sensation of leveling [and] death" (no animation, no soul).[52] It is Pissarro's opinion that seems to have died, however, or at least faded. In 1935, and then more insistently in 1958, Meyer Schapiro—for whom it was not pointillism that leveled experience, but radio and television—claimed that no one could rightfully consider "Seurat's touch mechanical"; rather, he argued, it was flexible, varied, and responsive.[53]

Schapiro might have taken a broader, Kleistean view of the mechanical, which need not be so definitively opposed to the organic. For those who have stared at video screens, it may seem that both the (active) materiality and the (passive) mechanicity of Seurat's art derived from his acknowledgment of a governing raster as much as from the sensitivity of his moving hand. Not only did he tend to lay out his dots of color in a pixeled manner, but (like Millet) he also exploited an abstract sense of the given material ground. This is evident in the way that he rubbed conté crayon into paper, utilizing the paper's minute weave with machine efficiency, animating a visible grain of flickering light (figure 15.4).[54] Seurat's drawing technique appears to re-create the substance of the paper as it creates the image.

This well-known effect has a parallel in certain of the artist's small panels, such as *Study for "The Shore at Bas-Butin, Honfleur"* (figure 15.5), painted soon after the *Grande Jatte*. It is a seascape, but also an image of nothing. Here Seurat chose to use a panel noticeably roughened with tiny grooves or striations, the equivalent of a preexisting painterly texture or "touch."[55] His dabs of paint, especially when applied horizontally to represent the sea, skip over the depressed grooves, leaving an extremely thin, but

FIGURE 15.4. Georges Seurat, *En marche*, c. 1882. Conté crayon on paper, 12 × 9 in. Private collection, England. Photograph courtesy Dickinson Roundell, Inc., New York.

visible vertical trace, which reveals the natural color of the wood.[56] These verticals cluster along the horizon line, as if to accentuate this central pictorial feature. Also appearing in the sea, they seem to represent the choppiness of waves, an effect Seurat created in larger paintings by setting vertical dabs against his horizontal, ellipsoidal dots. Granted, the textured ground works to produce the seascape image, but more than that, the vertical grooves, as a kind of cross-graining, collude with the natural horizontal grain to establish a virtual grid in the wood, the same grid one would imagine as the or-

FIGURE 15.5. Georges Seurat, *Study for "The Shore at Bas-Butin, Honfleur,"* 1886. Oil on wood, 6¾ × 10¼ in. The Baltimore Museum of Art, Bequest of Saidie A. May, 1951.357.

ganizing principle or conceptual reality of any rectangular format. Seurat's use of this grid acknowledges both the ideal form and the material substance of the wood, manifested initially by the simple presence of the grooves. It also structures his image, which (the artist seems to be suggesting) acquires properties of whatever medium facilitates its representational being. Reciprocally, a resistant panel of wood, incorporated into the image, becomes as fluid as either air or water. Here figure and ground animate each other in the medium, like forms of life emerging from a primal sea.

In Seurat's era, it was possible to believe that a handicraft medium like painting might still dominate a technological medium like photography in appeals to the cultural imagination. Critics certainly made this argument. When it appeared that Seurat had yielded his imagery to a new technology applied to an old medium (painting), he looked mechanical, as if he had sacrificed hand, soul, and humanity to gain efficiency. Most likely, he believed he sacrificed only affectation. At the present moment, when the dominant imagery is electronic and the electronic is digitized—when even television interference is being eliminated—Seurat's art offers glimpses of the medium at work, insights into persistent factors of material resistance. Seurat shows that the materiality of the medium remains in force even when the constitu-

ent mark of the image approaches the zero-degree of both reference and self-referentiality—when the mark lacks pronounced variation, direction, and character, neither describing externals nor drawing attention to itself. At whatever size, Seurat's pixel-like dot never truly recedes from view. More than merely facilitating representation, it marks representation's material limit, beyond which only marking itself is seen.

PUPPET PHYSICALITY

If the materiality of the mark always affects us (even when, or perhaps because, we inevitably encounter a condition in which the image disintegrates), is it finally the medium itself that we discern in art? Or is there still something more, beyond the representation, beyond the medium? By Kleist's account, we think most productively only when yielding thought to the encompassing condition; we dance most gracefully only when applying body mechanics without thinking. Is there some analogously naive way to face the process of visual representation, perhaps to see representation itself as our "condition"? It may be that we perceive in any representation features of ourselves, a means of achieving self-recognition and self-reflective thought—all without "thinking." [57]

Through the reciprocity that we readily sense—representations are like us, we are like representations—a drawing, painting, or photograph extends beyond its skin-like surface to present a deeper human physicality, more tactile than visual. Through material "touch," two-dimensional representation affects not only the mental concept of the body (its normative image) but also its immediate physical experience—its centering and sense of gravity. *Target*, an oil painting of 1958 by Jasper Johns (figure 15.6), will make the case. Aspects of this work demonstrate that painting represents in at least four ways: It is an image; it is a surface; it has materiality like other substantial objects; and it has physicality evoking a human body. Curiously, *Target* also resembles a test pattern. It tests human experience in terms of its four representational channels.

Materials commonly used to produce pictorial representations—especially paint, so fluid and malleable—maintain a skin-like integrity even when spread extremely thin. Think of this thinness in relation to a touch that meets resistance, as it contacts more than just a surface. Touching it, you recognize that a surface does not really conceal but simply covers; you touch the top layer and sense still others below. When you paint, you touch the skin you see (the surface of the emerging picture), forming and transforming it by adding layer upon layer. The hand that paints creates an order—part visual,

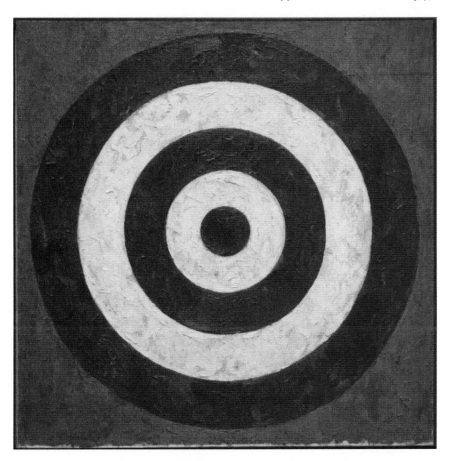

FIGURE 15.6. Jasper Johns, *Target*, 1958. Oil and collage on canvas, 36 × 36 in. Coll. Jasper Johns. Copyright Jasper Johns/Licensed by VAGA, New York.

part tactile—recording a process of material, even physical, embodiment. Wherever the means of painting are exposed to the senses, the physical link or analogy between the representation and the living being becomes obvious.

A logic of the four representational channels establishes this same connection. Consider first the *image*. It attracts and holds the eye, perhaps because its configuration is precisely what a viewer's verbal powers of description are already prepared to capture. The image is no stranger to thought and discursive concepts, which are predisposed to recognize it. It is not a condition but a product of one, of an ideology or a cultural formation. In this respect, the image is ideational and visual rather than physical and tactile. It identifies with no particular substance, but can bond with any—paper, canvas, wood—the stuff of "real" targets as well as images of targets.

Even without materialization, an image requires the support or ground-
ing of a context or environment. The most immediate element of such an en-
vironment is the *surface* of the image, the second representational channel
for experience. A surface of this type is a geometric abstraction, a plane co-
extensive with the image, whatever its configuration. It constitutes a format.
The surface of Johns's *Target* includes not only blue and yellow rings but
also a red area, a pictorial background. No more a physical object than the
image it seems to contain or delimit, surface establishes contextual support,
but makes no guarantee of material support.

Materiality is yet something else, a third channel. The specific materiality
of *Target* is evident in at least two ways. First, despite the two-dimensional
character of the configuration, the top layer of this painting is not at all flat
but textured and rather bumpy. Johns applied his oil pigment relatively
thickly and with discrete strokes.[58] Such irregularity articulates a surface as
physical matter, evoking touch quite directly. The second access to material-
ity in Johns's *Target* is more complicated. A viewer eventually notices that
this painting is not entirely symmetrical despite its centered design. Within
its format, the blue and yellow target is shifted slightly toward the top of the
surrounding red field. Outside that visual field, a thin strip of unpainted can-
vas appears at the bottom of the composition, physically beneath the layer
of red paint. Here, explicitly presented to vision, is a second surface to be
sensed lying under the first, somewhat like a body or a being, imagined be-
neath human skin. The material nature of the lower support-surface is mani-
fested not only by the distinct texture of the exposed canvas, but by a single
blue thread running through its undyed, neutral weave.[59] Such a contrasting
element resists the rule of conventional painting, under which the canvas
support should remain as uninflected and silent as a raster that no force or
energy is activating. Because the anomalous thread runs very close and par-
allel to the edge, Johns could easily have stretched his canvas so that this con-
trasting blue failed to show; and he could certainly have covered it with paint
to obliterate it, masking its interference. Instead, it seems that the artist rec-
ognized this peculiar feature of his material as a concrete fact, something to
be sensed at least as strongly as the image (recall Seurat's slivers of exposed
panel). Johns let the thread determine where his layer of red would come to
an end: his paint abuts this linear element in a casual manner, yet clearly re-
spects it as a conceptual limit or even a physical barrier.

Target is but one among a number of Johns's paintings from the late 1950s
to exhibit a blue thread along its bottom edge.[60] By this means, the material
ground asserts its identity, while also orienting the image it supports, pro-
viding that image with a definite sense of up and down. The image, like a

material object, becomes subject to gravity while yet maintaining its equilibrium. Merely a representation and yet surprisingly realistic, it resembles a puppet with a centered soul.[61] Confronting gravity, the target (its image) now seems to require the physical support of a wall or floor along with the pictorial support of a surface. Just as Millet's image of a field of crops was all the more a field of paper, we cannot but notice that Johns's image of the target has become identified with the constructed material object, *Target*. So *Target*, the painting, acquires three grounds: the planar surface that constitutes the format of the image, the material surface that supports the substance of the paint, and the horizontal that orients materials disposed in a vertical plane. In beginning to look and act like a physical thing that resists the pull of gravity, *Target* resembles a living human being.

This consideration activates the fourth channel, *physicality*. Four observations regarding the physicality of Johns's *Target* are entailed; they subsume the effects of image, surface, and materiality:

1. The physicality of image. The symmetry of the target design orients the viewer initially; it faces the viewer like an image in a mirror, calling the viewer to attention. Yet this symmetry proves inessential, for all pictorial representations mirror their makers and their viewers by fixing the line of sight and implying an exchange of looks. Any object can hold human attention in this manner; but paintings further evoke the particular stance of the painter, who faces the work while making it, with a hand that touches used as surrogate for an eye that scans.

2. The physicality of surface. More specifically, because Johns's *Target* introduces asymmetry by way of its accented bottom edge, its surface "stands" before us like another human body, head to head, toe to toe. Symmetrical from right to left and asymmetrical from top to bottom, it mimics the body like a puppet assuming the essential human posture. Although it lacks movement, we sense its virtual animation.

3. The physicality of materiality. The layering of paint on canvas, manifested by the blue thread, reveals that the image of the target and its skin of paint must have real physical support. More than a face with a look (an image), more than a figure facing us in a vertical plane (an oriented surface), *Target*—in its full materiality—becomes a body with substance, weight, and resistance.

4. Physicality proper. Because of the way the paint adheres to the canvas, gravity seems to pull against it like gravity pulling against skin supported by a physical human body. Johns's object *looks* as if it responds to physical stresses and strains just as we *feel*, in a kinesthetic and rather tactile way, that we do. The look verifies the feeling; the feeling verifies the look.

The net effect of *Target* is to counteract experiences associated with a technology of dematerialized representation. Without negating the history of technology, *Target* reverses what many would regard as an inevitable shift from substance to sign and from material body to dematerialized image. Having selected a sign or emblem as the matter of his image, perhaps Johns merely "copies" lines that are already "well organized," as Thoré might say, with the difference that Johns's figure derives from a culture of mechanical drawing rather than a nineteenth-century view of organic nature. Whatever its source, Johns's painting leads viewers from the visual effect to the materiality and touch that interfere with the target pattern itself. Both the known pattern and the viewer's self-image are put to the test, and prove to be interdependent. Although *Target* solicits an individual's gaze, its significance, like that of all materialized representations, is social, instilling consciousness of a common physicality. Representations are like us; we are like representations. Reality lies in the mutual resistance, in the patterns of interference between our pictures or thoughts and their active medium. A materialized medium takes the measure of our "condition."

Dinosaurs and Modernity

W. J. T. MITCHELL

Wallace Stevens thought there were "Thirteen Ways of Looking at a Black-bird." There are at least that many stories of the dinosaur, and, like the stories of a skyscraper or the stacked faces on a totem pole, they keep piling up.[1] The earliest stories are on the bottom, like the lowest levels of an archaeological dig or the "low man on the totem pole." But even the earliest stories, the deepest in time, no matter how fantastic or disgraced, never seem to be completely lost or forgotten. Dragons and biblical beasts, the behemoth and leviathan, underlie the modern stories of the dinosaur like the foundations of a building and they continue to be available right alongside the higher, more advanced stories. Creationist accounts of dinosaurs continue to flourish even now, and not just in tabloids. At William Jennings Bryan College in Tennessee, the battle against Darwin continues. Feasibility studies of Noah's Ark are being published, and debates are being waged on the Internet about what T-Rex could have eaten in the Garden of Eden, given the prohibition on death and violence. (Answer: Eden only lasted a few weeks, and it is a well-known fact that reptiles can go even longer without food. The fall of man came along just in time to save the great carnivores from starvation).[2]

Another foundational story of the dinosaur is offered by Carl Sagan in *The Dragons of Eden.* Sagan argues that "deep down," human beings themselves are actually dinosaurs, because the "most ancient part of the human brain" is the "reptilian or R-complex." Like every other organ in the body, the brain had to evolve from simpler, more primitive structures into its present state of complexity. The central core of the human brain is reptilian, the intermediate layer is the limbic system (which we share with other mammals but not reptiles), and the outer, upper layer is the neocortex, which we share with higher mammals such as dolphins and apes. Conclusion: "We should expect the R-complex in the human brain to be in some sense performing dinosaur functions still; and the limbic cortex to be thinking the thoughts of pumas and ground sloths."[3]

Sagan argues that much of what is irrational or savage in human behavior can be traced to the dinosaurian nature still at work in our reptilian brains. He notes that "it is striking how much of our actual behavior . . . can be de-

scribed in reptilian terms. We speak commonly of a 'cold-blooded' killer. Machiavelli's advice to his Prince was 'knowingly to adopt the Beast.'" The R-complex "plays an important role in aggressive behavior, territoriality, ritual and the establishment of social hierarchies."[4] Sagan even suggests that the triune structure of the brain may correspond to Freud's tricameral models of the psyche, id–superego–ego, or (even more precisely) the unconscious–preconscious–conscious. Language and higher order reasoning are functions of the neocortex, then, and irrational, instinctive, and compulsive or ritualistic behaviors are traceable to our deep dinosaurian nature.

How much more plausible is Sagan's story of the dinosaur than the creationist's feasibility studies of Noah's Ark? Sagan sounds more plausible because he appeals to what has become a powerful modern consensus built on Darwinian evolutionary biology. The creationists, by contrast, build their story on a "literal" reading of the Bible (I put "literal" in quotation marks because there is no evidence that the creationists actually read the Bible in its original language). So while Sagan actually engages with a modern, scientific paradigm, the creationists steadfastly oppose it, and (in their more ambitious moments) actually hope to overturn it. Their efforts to politicize the debate by arguing that evolution and creationism should be taught in public schools as rival "theories" are best seen as an admission that they cannot win the debate in any legitimate scientific forum where rival theories are actually tested. That does not mean that creationism should not be taught in public schools, only that it should be taught as a set of cultural beliefs (like the Indian legends of the monstrous reptiles or Unktehi). If it were taught with some historical depth, as culture, it would be all right.

But Sagan's story is also clearly a cultural one. And the fact that he talks the talk of modern evolutionary biology does not mean that his dinosaur story is true. For one thing, it is full of contradictions. Sagan suggests that the instinctive fear of reptiles shared by mammals and human beings is evidence of our deep reptilian brains, but one could argue as plausibly that we should experience an instinctive affinity and affection for our serpentine ancestors, and feel a warm (or cold) blooded shock of recognition. If the human brain has a reptilian core, our likeliest response to our brethren serpents would be, not automatic repulsion or attraction, but ambivalence, a combination of the two. The ritualistic behavior that Sagan attributes to our reptilian nature has been much better explained, I think most scientists would agree, by anthropology and the study of culture. The higher Sagan goes in the structure of human behavior, the less plausible his dinosaurian prototype becomes. Thus we are told on one page that the "R-complex" is at work in "a great deal of modern human bureaucratic and political behavior," and in-

formed on the next page that "there is no way . . . in which the Bill of Rights of the U.S. Constitution could have been recorded, much less conceived, by the R-complex."[5] The fact that political behavior created the Constitution, which in turn constituted a bureaucracy, seems to elude Sagan. The further one goes with his theory of our deep dinosaurian nature, the clearer it becomes that the reptilian brain is simply a metaphor for the kinds of human behavior Sagan does not like, and the neocortex is the part of the brain that gets credit for the admirable things we do. If you happen to agree with Sagan's basically liberal politics and bourgeois morality, then this seems like pretty harmless stuff. But it hardly counts as a contribution to our knowledge of either dinosaurs or human nature.

A better way of handling the knowledge that both Sagan and the creationists offer is, I think, to position it in the multistory edifice that has been constructed around the dinosaur in the last 150 years. The creationists are telling a story that was first tried out by Richard Owen in his 1841 report on "British Fossil Reptiles." But Owen told the story in a much more convincing way because he was a better reader of both the fossil record and the Bible.[6] For his part, Sagan is engaged in the kind of sociobiological moralizing that got a well-deserved bad name during the era of rampant social Darwinism, and that reared its head once again at the close of the twentieth century. The trick is relatively simple. One identifies a common human trait (aggression, ritualistic behavior, the formation of social hierarchies and bureaucracies) and traces it to its biological "cause" in our reptilian nature.[7] Human culture is reduced to a model of animal behavior, and a wide range of political attitudes (typically centered on racial or sexual stereotypes) are rationalized as natural. For Sagan, the dinosaur becomes the image of what is foundational and natural in human behavior, what lies deepest (like Freud's Id), and which must, therefore, be both acknowledged and repressed with moral fables about the reptilian brain.

We need to figure out what the relations between these stories are—both the creationist myth and the neo-Darwinist reptilian brain fable. Cultural history is, in part, just the name of the place where competing stories can be discussed *as stories*, without needing to refute one in favor of the other, without dismissing one as obsolete and elevating the other to final truth. The "two-culture split" between science and the humanities has often been deplored, but it has an important role to play in serving as a check on the claims of science to an exclusive grip on "the truth" about moral, political, and social issues. The dialectic between science and culture is what allows us to see an outside to science, to understand it as a special form of cultural activity itself, with rituals, traditions, and superstitions. Scientific reasoning,

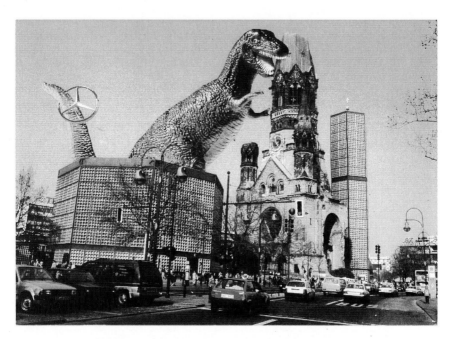

FIGURE 16.1. Claudia Katz-Palme, *Berlinosaurus*. Collage/postcard.

for its part, is what allows the study of culture to be critical and historical, to be more than merely the recitation of stories and the reinforcement of tradition. From the standpoint of cultural history, Biblical creationism and Darwinism are just two stories to be evaluated and understood at many levels other than that of truth claims. Darwinism happens to be widely believed, authoritative—and rightly so—in its proper domain (the limits of that domain being very unclear, as Daniel Dennett has shown).[8] The Bible is also widely believed to be a source of considerable wisdom in its proper domain. The problem arises when the Darwinian and Biblical "scriptures" find themselves on a collision course, as they do with a figure like the dinosaur. Hardly anyone believes the creationists' stories about dinosaurs, which is just fine. But almost every educated person regards some version of Darwinism as pretty close to the truth, and thinks of science (or scientific method or reasoning) as authoritative. That is a problem. It is exactly this widespread public faith in the institutions of science (and its impressive technological results) that lends credibility and authority to dubious neo-Darwinist and sociobiological pronouncements about human nature.

Fortunately, we have created a hybrid that gives us a glimpse of the total form of our modernity. It straddles the two-cultures split like a colossus, forcing us to think through the interchanges between science and fantasy, nature and culture. The dinosaur looms up next to the skyscraper of mod-

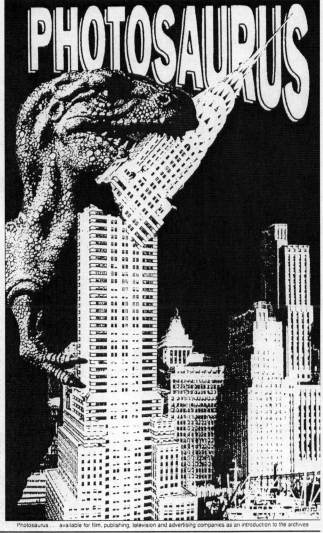

Hulton unveils digital monsters

By TRUDI McINTOSH

THIS Photosaurus is a digital dinosaur heralding the new era of digital imaging.

As part of its international multimedia marketing drive, the Hulton Deutsch Collection, one of the world's largest stills archives, has produced a fully scripted mini-monster video movie called Photosaurus using 500 of its 15 million images.

The mini-movie, which boasts a delightful, whimsical script, shows some of this century's most famous stills and photographs.

Hulton Deutsch is also building up one of the world's most sophisticated CD-ROM libraries of digital images and has just released its latest CD-ROM product, The 1930s, which contains 2500 black and white images from the high life of the "flapper" aristocracy to the Great Depression.

The Roaring Twenties disk is part of a CD-ROM Decades series.

The 1930s, 1950s and 1960s are already available for the film, advertising and publishing industries through Hulton's local distributor, The Photo Library of Australia, in North Sydney.

Hulton Deutsch's marketing director in London, Mr John Spring, told *The Australian* that Hulton planned to soon release picture packages on CD-I and Photo CD.

Users can run the Decades CD-ROMs on any Apple system that is System 6.0.7 or later using any external CD-ROM driver.

Mr Spring said Hulton Deutsch, which also digitally archives all of Reuters images and news pictures for The Reuters News Picture Service, would also be releasing a CD-ROM targeted for the international design and advertising markets.

The Photosaurus video is available in Australia for local film, publishing, television and advertising companies as an introduction to the worldwide archives.

"Our ultimate goal is to get our images on to a worldwide network so we have a truly on-line service for digital images," Mr Spring said.

He said Hulton Deutsch would be exhibiting at next year's international multimedia showcase, MILIA 95, at Cannes, France, in January.

Photosaurus . . . available for film, publishing, television and advertising companies as an introduction to the archives

FIGURE 16.2. "Photosaurus." Source: advertisement for a film promoting the Hulten-Deutsch Collection digital archive.

ern science and technology. At one moment it seems like an outgrowth of the skyscraper, at another, a rival that threatens to tear the skyscraper down (figures 16.1 and 16.2). As for the dinosaur itself, we have been building it up, tearing it down, and remodeling it for over a century now. It is just about complete, almost ready for reburial. Perhaps we should take a snapshot of the whole thing before it disappears.

STRUCTURE, ENERGY, INFORMATION

Although there may be a hundred or more stories in the dinosaurian edifice, they are articulated across a series of repetitions, like the glass wall of a Mies van der Rohe skyscraper. They appear in three distinctly articulated historical columns that correspond to distinctive remodelings of the dinosaur, and (very roughly) to three familiar periods in cultural history—the Victorian, modern, and post-modern eras.

The first two periods correspond, respectively, to the creationist dinosaur image of Richard Owen and Waterhouse Hawkins and the modernized evolutionary image of the Darwinists codified by Charles Knight and rendered as a world-picture by Rudolph Zallinger. The third phase is generally associated with the "dinosaur renaissance" pioneered by John Ostrom and promoted by Robert Bakker, which goes back to the early modern insight of Thomas Huxley, and revives the bird model of the dinosaur. This image has only recently become widely distributed to mass culture, most notably in *Jurassic Park*, which has made the lively, warm-blooded, bird-like animal the "latest thing" in dinosaurology.

As a historical science compelled to work with fragmentary and incomplete evidence, paleontology necessarily relies on a considerable amount of speculation and extrapolation. It has always relied on visual artists, not merely to popularize its reconstructions of ancient life, but to provide "theoretical pictures" that can be tested and revised as new evidence becomes available (this is why so many paleontologists are visual artists). But these theoretical pictures are themselves condensations of numerous assumptions: They are not simply windows into the past, but projections and constructions subject to all the conventions and stylistic modes that characterize image production in general. They never allow us to "see" the dinosaur, but (as Wittgenstein would put it), to see the dinosaur "as" something. The changing image of the dinosaur is not merely a function, then, of new empirical evidence, but of paradigm shifts in natural history, and, in turn, of transformations in the entire social-cultural framework in which the history of life is envisioned. This means that the dinosaur, as a figurehead of natural history, is responsive to many other determinations besides the internal professional history of paleontology. It is a weathervane for the fortunes of Darwinism as a "world picture," a totem animal of modernity as such, and thus it has a central role to play in discussion of technology, political economy, and human nature.

The overall pattern of the dinosaur's transformations becomes strikingly evident if one looks at them directly as technical, material constructions. The early dinosaur, like its cultural ancestor, Jefferson's mastodon, was princi-

TABLE 16.1
Historical Phases of the Dinosaur Image

	PERIOD		
	American Revolution to Civil War	*Gilded Age to Depression*	*World War II to End of Cold War*
Dinosaur type	Mammoth to Victorian dinosaur	Classic or Modern dinosaur	Postmodernism: Dinosaur Renaissance
Paradigm	Structure	Energy	Information
Prototype	Archetype	Engine	Program
Extinction scenario	Catastrophe	Entropy	Chaos
Historical schema	Creationism	Revolution	Evolution
Exemplar	Ark, frame, building	Train, automobile	Cyborg
Energy source	Water and wind	Fossil fuels	Nuclear energy
Stage of capitalism	Manufactory production	Mechanical production	Biocybernetic production
Exhibition site	Peale's Museum, Crystal Palace	Peabody Museum, American Museum of Natural History, Carnegie, Smithsonian	Shopping mall, Theme park
Sponsors	Thomas Jefferson, Queen Victoria	George Peabody, John Pierpont Morgan, Andrew Carnegie, Henry Sinclair	Microsoft, Ingen Corporation, Universal Studios
Image-Makers	C. W. Peale, W. Hawkins	Charles Knight, R. Zallinger, Winsor McCay, Walt Disney	Gregory Paul, John Gurche, Steven Spielberg
Narrators	Jules Verne	Arthur Conan Doyle	Italo Calvino, Michael Crichton
Narratives	*Journey to the Center of the Earth*	*Gertie the Dinosaur, The Lost World, King Kong, Fantasia*	*Flintstones, Godzilla, Jurassic Park*

pally an architectural structure. Hawkins' Iguanodon was a building of cement and brick with legs and ribs of iron, an early use of the reinforced-concrete technology that made the skyscraper possible. The early dinosaur was an archetype and an "ark," a framework that endured over time, like Jefferson's "ark of the constitution." Indeed, the first dinosaurs were designed *not* to change or evolve. Richard Owen saw them as stumbling blocks to Darwin, obstacles to the theory of evolution.[9] The modern, Darwinian dinosaur,

by contrast, was seen as a living organism, an engine or machine that moved in space and evolved over time. It was a creature of thermodynamics, a motor that consumed energy, reproduced itself, and finally died out. Its image is best represented in the setting of nineteenth-century animal landscape, and in the media of oil painting or cinematic animation. The jerky mechanical motions of early animation do not compromise the realism of the modern dinosaur. On the contrary, they fit with its role as a paradigm of what Walter Benjamin called "mechanical reproduction." The close association of the dinosaur with the steam engine and later with the automobile, with fossil fuels and the consumption of energy, reinforces this modern paradigm.

When we see the dinosaur as a product of modes of production it becomes clear that the real revolution shadowed forth in the postmodern dinosaur is not the "renaissance" of the bird model (which was, after all, never really lost, and always available in Knight's early paintings), but rather the new age of biocybernetic reproduction, an era that combines information science and biogenetic engineering.[10] The shift is from a picture of massive modern machines like the locomotive, the tank, and the steamship to creatures whose true identity is invisible, encoded in the strings of data we call genes. The essence of the animal is not in its structural constitution, or in its dynamic movements, but in its DNA, the code that, when cracked, can allow it to be cloned and reproduced indefinitely. At the same time, the cutting-edge representation of the dinosaur goes from cinematic animation of mechanical models to computer animation, video, and animatronics, or computer-driven robots. The jerky motions of live-action animation are replaced by the smooth, life-like movements of the *Jurassic Park* dinosaurs; the primitive motions of the Sinclair dinosaurs at the 1933 World's Fair give way to the smooth computer-coordinated servo-motors of contemporary robotics. And the giantism of dinosaurs like General Motors and IBM gives way to down-sized, innovative entrepreneurship.

CATASTROPHE, ENTROPY, CHAOS

> Chaos theory is not nearly as interesting as it sounds.
> —*Stephen Keller*, In the Wake of Chaos:
> Unpredictable Order in Dynamical Systems
> *(Chicago, University of Chicago Press, 1993)*

In evolutionary biology, in mathematics and increasingly these days in economics, the word "catastrophe" has acquired a somewhat technical meaning. In Catastrophe Theory the word describes not the event of common usage which could take any form, but the sequence of events

leading up to and proceeding from a critical point. Catastrophe Theory is an attempt to analyze the way in which a previously stable system can reach a point of chronic instability, a "cusp" point, which leads to a total collapse of the old order (dinosaur domination) and subsequently to the emergence of a new stability of a very different kind (mammal domination).

—*Tom Lloyd*, Dinosaur & Co.: Studies in Corporate Evolution
(Boston: Routledge and Kegan Paul, 1983), p. 5

One can see this whole progression from the Victorian to the modern to the postmodern dinosaur image with special clarity if one looks at endings, at the extinction narratives that accompany each dino-story. For the Victorians, for Owen, the dinosaur was an archetypal creature created by God. It had to be destroyed by a catastrophic transformation of the environment. The popular image of antediluvian monsters made this the Flood, a view perpetuated today by the creationists. Owen's extinction scenario (air pollution) was a compromise, making the dinosaur pre-Adamite rather than antediluvian, but maintaining the necessity of catastrophic extinction.

For the moderns, by contrast, the extinction had to be gradual, a kind of entropy, fatigue, or energy loss.[11] Like machines, living creatures wear out or run down. If thermodynamics was postulating the eventual heat-death of the universe, perhaps our waning sun had shone brighter and hotter during the age of reptiles, and they died out from slow changes in the weather. Or perhaps they simply ran out of steam on their own, worn down by the weight of their own armor and overspecialization, their sluggishness, giantism, and stupidity compared with the new, emergent mammals who were more adaptable and especially good at robbing eggs. The end of the Age of Reptiles could be signaled, as Zallinger saw, by distant volcanoes, or by a mouse and some magnolias. His mighty saurian armada could be sunk by running out of fuel, ending up like Disney's dinosaurs, as beached leviathans.

Contemporary extinction scenarios have moved away from these entropic, gradualist narratives, and re-opened the possibility of catastrophe.[12] The most widely publicized of these narratives is the Alvarez hypothesis, which proposes that a giant meteorite struck the earth about 65 million years ago, raising up a global dust-cloud, and producing something like a nuclear winter that wiped out the dinosaurs along with many other life forms. The geological evidence for a catastrophe of this sort seems irrefutable, but the jury is still out on whether this is what killed off the dinosaurs. The fossil record suggests that they had already been on the decline for millions of years, and may have disappeared before the meteorite hit the earth. If anything, the meteorite may simply have delivered the coup de grace.

From a cultural standpoint, the importance of this resurgence of catastrophe theory lies not with the scientific validity of the Alvarez hypothesis,

but with the fact that it holds center stage in the debate. Catastrophe is a remarkably flexible concept, one that slides easily from scientific to cultural, political, and social connotations. Clearly, it had a kind of automatic appeal to the popular imagination in the nuclear era, when the threat of something like the Alvarez meteorite seemed like a real possibility. Even within the scientific discourse, the meaning of the term can vary considerably. Huxley understood *catastrophism* to mean a "form of geological speculation which supposes the operation of forces different in their nature from those which we at present see in action." [13] This definition equates catastrophe with a miraculous intervention, a suspension of natural law; it is the denouement of the creationist narrative. This is clearly not what the Alvarez hypothesis proposes. Catastrophic events do happen in accordance with natural laws we see operating in the present (volcanic eruptions, plagues, mass extinctions, or removals of populations). The arrival of Europeans in North America was a catastrophe for the Indians. That effect was being felt in the form of famine and disease long before the genocidal frontier wars of the nineteenth century.

The issue, then, is not whether the Alvarez meteorite is the catastrophe that killed the dinosaurs, but what a catastrophe is. How rapidly does something have to happen to count as a catastrophe? Are there not different temporalities for cultural, political, and social change? For biological and geological "events"? Do catastrophes have to be perceived as such when and while they are happening? Or do they sometimes become evident only in retrospect? To what extent is a catastrophe a function, not of something that is happening "out there," but of the sensitivity of our instruments of detection? (The miner's canary, for instance, is an instrument to provide early warning of impending, imperceptible catastrophe.) In the debate between uniformitarians and catastrophists, which side can seize the middle ground of gradualism? Is catastrophe to be defined by the quality of its agency or causation, so that accident, chance, or Lady Luck are associated with catastrophism, while the normal, automatic, predictable causal sequence is the fundamental unit of uniformitarianism?

Under the twin influences of Sir Charles Lyell's geological uniformitarianism and Darwin's gradualism, these kinds of questions had pretty much disappeared from scientific debate for the last 150 years. They are now back on the table, spurred by information science, chaos theory, and a whole new sense of what counts as a catastrophe. It is a cliché of postmodern culture that contemporary catastrophe is likely to be unobtrusive and invisible, like the great subterranean Chicago flood of 1992, or the "industrial accident" of Don DeLillo's novel, *White Noise*. At the same time, modern information systems make actual catastrophes in our world more visible, dramatic, and commonplace than ever before. Catastrophes are the junk food (and toxic

waste) of everyday life in a mediatized culture of "action news" and disaster movies.

Stephen Jay Gould's theory of punctuated equilibrium is probably the most well-known attempt to reopen catastrophism in evolutionary theory in terms of chance and accident. Daniel Dennett dismisses Gould's revolution as an effort to erect a "*cordon sanitaire* between Darwinism and religion," and to bring back transcendental skyhooks as explanations of natural events. In *Darwin's Dangerous Idea*, Dennett contends that the slow, minute workings of algorithmic engineering (what he calls *cranes*) can still explain all evolutionary processes better than Gould's ungrounded skyhooks.

This debate (which I won't try to reproduce in detail here) seems to me still caught in a division between catastrophism and uniformitarianism that is now obsolete—a dinosaur in its way. Its dinosaurial character is best illustrated by the way our most up-to-date contemporary representation of the dinosaur (Spielberg's) completely bypasses this dilemma. Spielberg's dinosaurs are pure creations of information science, both at the level of the representation (the digitally animated image) and at the level of the represented (the fictional cloned creatures produced by biogenetic engineering).[14] Distinctions between engineering design and chance just don't operate in this world. That is why the team brought in to certify the park must include a chaos theoretician, someone who thinks about designed systems, complexity, and accident, and who is given the task of stating the "moral" of the entire film. The architectural and mechanical models of the organism give way to (and are absorbed by) informational models: The species becomes a message, an algorithm. The boundary between organism and machine, natural and artificial intelligence begins to waver. Dragons always did stand for chaos and impending disaster, but in the new era signaled by *Jurassic Park*, chaos takes on a new meaning.

THE AGE OF BIOCYBERNETIC REPRODUCTION

> Whatever the social form of the production process, it has to be
> continuous, it must periodically repeat the same phases. A society
> can no more cease to produce than it can cease to consume. When
> viewed, therefore as a connected whole, and in the constant flux of
> its incessant renewal, every social process of production is at the same
> time a process of reproduction. —*Marx*, Capital *vol. 1, chap. 23*

When Walter Benjamin wrote his classic essay "The Work of Art in the Age of Mechanical Reproduction" in 1935, the world was in the midst of deep

economic depression and on the verge of war.[15] The modern system of mass industrial production had shown its best and worst face, transforming everyday life with a host of technologies and commodities, and shattering that same everyday life with mass destruction and massive forms of social displacement and alienation. For Benjamin, mechanical reproduction (or technical reproducibility) was a kind of play on words, linking the *productive* technologies and economies of the machine age (especially the assembly line) with new *reproductive* technologies such as photography, cinema, and sound recording; and reproductive economies involving the distribution of images, words, and sounds to a mass public. The dinosaur images of this era, beginning with Charles Knight's romantic armored leviathans, and culminating in Rudolph Zallinger's world-picture of a mobilized dry-land armada, provided an image of what Theodor Adorno called the "monstrous total state" of the advanced industrial nations. In keeping with its (unacknowledged) function as the modern totem, the dinosaur image encoded radically contradictory messages. In it, gigantic energy and productivity were combined with entropy and annihilation, and scientific and economic "purity" (pure research, supported by the pure gifts of big capital) was combined with connotations of impurity and contamination (disease or racial mixing). Their status as kitsch attractions and mass spectacle belied the claim of dinosaur images to cultural purity.

It is tempting simply to adopt Benjamin's model of technological determination and apply it to explain the dominant tendencies in contemporary culture. We live, it is often said, in the period of DNA and the computer. Dramatic as the discovery of nuclear energy was, it was really only a quantitative extension of the age of energy—the development of a bigger productive and destructive force.[16] Having passed the end of the twentieth century, however, it is clear that biology has replaced physics as the frontier of science, and that computers and artificial intelligence constitute the frontier of technology. We could call this, then, the age of *biocybernetic* reproduction to reflect the double wave of scientific–technical innovations that have carried us beyond the machine and the assembly line, and beyond the mechanically reproduced images of photography and cinema. The factory in this new age might be imagined as a place where machines do the thinking, and the commodities coming down the assembly line are living creatures or organisms. As for the images, they are no longer produced by the mechanical or chemical processes of photography. They are, instead, electronic and digitally encoded strings of data that can be manipulated to produce any visual illusion that is desired. *Jurassic Park* is (among other things) a vision of this imaginary factory, where computers, biological science, robotics, and digital animation converge. It is a utopia of biocybernetic reproduction, a Disney-esque Tomorrowland where advanced imagineering shows us the frontiers of science and technology.

There are, however, several problems with a straightforward application of Benjamin's "mode of reproduction" model to describe contemporary reality. The most obvious is that the world of biocybernetic reproduction is for most people an imaginary, utopian, fictional place. It is not an immediate, everyday experiential reality in the same way that the innovations of mechanical reproduction (assembly lines, automobiles, telephones, and movies) were in the modern era. The "shock of the new" attributed to biocybernetic technologies is highly overrated, and mainly appears in very traditional modernist forms like movies, novels, and advertising. Computers are routinely marketed with all the rhetoric of revolutionary modernism, as if they were a technical innovation as profound as the invention of printing. But for most people, computers are simply speeded up extensions of the typewriter, the ledger book, the mailbox, and the filing cabinet. If Melville's Bartleby the scrivener were alive today, he would be a data-entry worker, and he would still wind up with his face to a stone wall, or maybe a blank screen. The Internet is hailed as the gateway to a new dimension of experience called cyberspace, and virtual reality beckons as the replacement for the mundane realm of modernity. But anyone who has spent very much time in these new dimensions quickly discovers just how disappointing and banal most of them still are. VR turns out to be an extension of the penny arcade or the home shopping network, and Internet pornography turns out to be about as interesting as the graffiti in a public toilet. The grand convergence of computers with biology leads, not to a new age of human possibilities, but to the high-tech fulfillment of a Victorian fantasy, a dinosaur theme park.

The age of biocybernetic reproduction, then, unlike the age of mechanistic modernism, is not a revolutionary break with the past, except at the level of advertising and fantasy. It is often associated in cultural history with postmodernism, generally defined as the period since the 1960s in advanced industrial societies. If anything is clear about the postmodern period, however, it is that it was not a time of revolution, of shocking novelty or wonder, but (as Jean-François Lyotard put it) a time of "slackening"—an age of slackers and anti-depressants, neo-vanguardism and reduced expectations.[17] It is, rather, a period of *evolutionary* transition, and as such it is almost by definition gradual and imperceptible in the present, seen only in the rear-view mirror or in utopian projections.

Is it any wonder, then, that our world is still overrun with dinosaurs? As always, they serve as the animated animal icon of the new age, their dry bones "restored to life" in a brand new form that makes earlier dinosaurs look quaint and obsolete. Spielberg's and Robert Bakker's new bird-like dinosaur makes Zallinger and Knight's modern leviathans obsolete, just as Knight's dinosaurs made the antediluvian monsters of the Crystal Palace look like Victorian fantasies. The small manufactory production of Waterhouse Hawkins

is replaced by the Fordist mass production of Sinclair dinosaurs to prime the pump of consumption, which is in turn replaced by the biocybernetic productions of *Jurassic Park*.

Perhaps of most importance, the age of biocybernetic reproduction is not primarily an age of production (or reproduction) but of *consumption* and speculative capital, epitomized by Ronald Reagan's "age of greed." In the 1950s, "progress is our most important product" was the slogan of General Electric. Now the most important product of modern industry is the illusion of progress, the fantasy of innovation, and the creation of new mass markets, new needs and desires. The "production of consumption" has of course always been central to capitalist economies. Henry Ford realized that "mass production meant mass consumption," that it wasn't enough to create an abundance of commodities, but that one also had to create a society with leisure and wealth sufficient to consume those commodities.[18] The age of biocybernetic reproduction might be seen as the period in which the Fordist dream of a society and culture almost completely oriented toward consumerism has come true. Symptoms of this development include the tendency for service and leisure industries to replace the production of basic materials and commodities (the new working class serves fast food in McDonalds instead of making steel) and the tendency for personal identity to be defined in terms of consumer and "lifestyle" choices (you are what you eat, what you wear, what you drive, what credit card you carry).

Perhaps most telling is the perfection of "planned obsolescence" as an element of design and production. The notion of producing a durable commodity that will "last forever" has become a nostalgic advertising fantasy. The reality is that the car you buy today is designed to break down the minute it is paid for, and the computer you buy tomorrow will be obsolete before you learn how to use it properly. These are not problems or defects in contemporary economic systems that ought to be corrected: They are the very basis for the proper functioning of these systems. Things have to break down and turn to junk or "our way of life" will. One can confidently predict, therefore, that the current image of the dinosaur, if not the very concept itself, will also become obsolete as this age draws to a close, only to be replaced by more terrifying monsters. As Fredric Jameson once remarked, "it has now become easier to imagine the extinction of the human species than the end of capitalism."

INTRODUCTION

1. The volume closest to this one is the excellent collection edited by Caroline A. Jones and Peter Galison, *Picturing Art, Producing Science* (New York: Routledge, 1998), in which the essays by major scholars of art and science are organized around more general themes. Representation in architecture is the subject of a similar collection edited by Galison and Emily Thompson, *The Architecture of Science* (Cambridge, Mass.: MIT Press, 1999). Two other recent scholarly anthologies that focus on art in relation to science are the exhibition catalogue *L'Ame au corps: Arts et sciences 1793–1993*, ed. Jean Clair (Paris: Réunion des Musées Nationaux/Editions Gallimard, 1993); and *Strange and Charmed: Science and the Contemporary Visual Arts*, ed. Sian Ede (London: Calouste Gulbenkian Foundation, 2000). Art historian James Elkins explores images across a broad range of fields, including art and science in such pioneering works as *The Domain of Images* (Ithaca: Cornell University Press, 1999).

Many more scholars work in the area of literature and science, as exemplified in such works as George Levine and Alan Rauch, eds., *One Culture: Essays in Science and Literature* (Madison: University of Wisconsin Press, 1987); Stuart Peterfreund, ed., *Literature and Science: Theory and Practice* (Boston: Northeastern University Press, 1990); N. Katherine Hayles, *Chaos Bound: Orderly Disorder in Contemporary Literature and Science* (Ithaca: Cornell University Press, 1990); George Levine, ed., *Realism and Representation: Essays on the Problem of Realism in Relation to Science, Literature, and Culture* (Madison: University of Wisconsin Press, 1993); Daniel Albright, *Quantum Poetics: Yeats, Pound, Eliot, and the Science of Modernism* (Cambridge: Cambridge University Press, 1997); Laura Otis, *Membranes: Metaphors of Invasion in Nineteenth-Century Literature, Science, and Politics* (Baltimore: Johns Hopkins University Press, 1999); Alan Richardson, *British Romanticism and the Science of the Mind* (New York: Cambridge University Press, 2001); Steven Meyer, *Irresistible Dictation: Gertrude Stein and the Correlations of Writing and Science* (Stanford: Stanford University Press, 2001); David L. Wilson and Zack Bowen, *Science and Literature: Bridging the Two Cultures* (Gainsville: University Press of Florida, 2001); and Ronald E. Day, *The Modern Invention of Information: Discourse, History, and Power* (Carbondale: Southern Illinois University Press, 2001). The annual bibliography on the "Relations of Science, Literature, and the Arts" in

Configurations: A Journal of Literature, Science, and Technology, the organ of the Society for Literature and Science, tracks scholarship in these fields.

2. The multidisciplinary synthesis of modernist and postmodernist cultural history in this volume is unique. For other treatments of the place of technoscience in modernism and postmodernism, see Mark Poster, *The Mode of Information: Poststructuralism and Social Context* (Chicago: University of Chicago Press, 1990); Jonathan Crary and Sanford Kwinter, *Incorporations*, Zone 6 (New York: Zone, 1992); Bruno Latour, *We Have Never Been Modern* (Cambridge: Harvard University Press, 1993); Joseph Tabbi and Michael Wutz, eds., *Reading Matters: Narrative in the New Media Ecology* (Ithaca: Cornell University Press, 1997); Tim Armstrong, *Modernism, Technology, and the Body: A Cultural Study* (New York: Cambridge University Press, 1998); N. Katherine Hayles, *How We Became Posthuman: Virtual Bodies in Cybernetics, Literature, and Informatics* (Chicago: University of Chicago Press, 1999); and Friedrich Kittler, *Gramophone, Film, Typewriter*, trans. and intro. Geoffrey Winthrop-Young and Michael Wutz (Stanford: Stanford University Press, 1999). For the impact of recent technology on the visual arts, see, for example, Timothy Druckrey, *Electronic Culture and Visual Representation* (New York: Aperture, 1996); and Margot Lovejoy, *Postmodern Currents: Art and Artists in the Age of Electronic Media*, 2nd ed. (Upper Saddle River, N.J.: Prentice Hall, 1997).

3. Charles Baudelaire, "Le Peintre de la vie moderne" (1863), in *Curiosités esthétiques: L'Art romantique et autres oeuvres critiques*, ed. Henri Lemaitre (Paris: Editions Garnier Frères, 1962), pp. 463–64.

4. Jules Romains, *La Vie unanime* (Paris, 1908); quoted in Betsy Erkkila, *Walt Whitman Among the French: Poet and Myth* (Princeton: Princeton University Press, 1980), p. 163.

5. Ezra Pound, "The Serious Artist," *The New Freewoman* 10 (November 1, 1913), 194; reprinted in *Literary Essays of Ezra Pound*, ed. T. S. Eliot (London: Faber and Faber, 1954), p. 49. See Dora Marsden's reply to Pound, "The Art of the Future," *The New Freewoman* 10 (November 1, 1913), 181–83. For more on Pound and the scientism of Imagism, see Bruce Clarke, *Dora Marsden and Early Modernism: Gender, Individualism, Science* (Ann Arbor: University of Michigan Press, 1996), pp. 109–17.

6. On this subject, see, e.g., Spencer Weart, *Nuclear Fear: A History of Images* (Cambridge: Harvard University Press, 1988).

7. F. T. Marinetti, "The Founding and Manifesto of Futurism" (1909), in *Futurist Manifestos*, ed. Umbro Apollonio (New York: Viking Press, 1970), p. 21; Umberto Boccioni, *Dynamisme plastique: peinture et sculpture futuristes* (1914; Lausanne: L'Age d'Homme, 1975), pp. 104–5.

8. Guillaume Apollinaire, *Les Peintres Cubistes* (Paris, 1913), in *Theories of Modern Art*, ed. Herschel B. Chipp (Berkeley: University of California Press, 1968), p. 225.

9. Ezra Pound, "Vortex Pound," and Henri Gaudier-Brzeska, "Vortex Gaudier-Brzeska," in Wyndham Lewis, ed., *Blast: Review of the Great English Vortex* 1 (June 20, 1914; rpt. Santa Rosa: Black Sparrow Press, 1992), pp. 153, 155–56.

10. See Michael Wutz, "The Thermodynamics of Gender: Lawrence, Science, and Sexism," *Mosaic* 28:2 (June 1995), 83–108.

11. D. H. Lawrence, *Women in Love*, ed. Charles L. Ross (New York: Penguin, 1989), p. 396. Marcel Duchamp was equally alert to the sexual implications of electricity, as is demonstrated in his notes for his masterwork of 1915–23, *The Bride Stripped Bare by Her Bachelors, Even (The Large Glass)*. See Linda D. Henderson, *Duchamp in Context: Science and Technology in the Large Glass and Related Works* (Princeton: Princeton University Press, 1998).

12. On Malevich and Klee, see the essays by Charlotte Douglas (chapter 3) and Christoph Asendorf (chapter 9) in this volume. For Duchamp's engagement with energy of various types, see Henderson, *Duchamp in Context*. For Kupka, electricity offered an effective metaphor for the creative process. He writes in his treatise of 1912–13 of an atmosphere conducive to creativity as "heavy with exciting energy, condensing of electricities, full of sparks ready to flash" (František Kupka, *La Création dans les arts plastiques* [1912–13; Paris: Editions Cercle d'Art, 1989], pp. 231–32). Max Weber embraced a concept of cosmic energy closer in spirit to Whitman, writing in his *Essays on Art* of 1916, "Art is the very fluid of energy made concrete—the rhythmic spiritual energy revealing more and more, opening infinity." However, Weber's mystical leanings, like Whitman's, were nonetheless grounded in nineteenth-century physics: "The feeling of art-form in us should correspond to the very laws of energy, of consistency, of equilibrium, of adhesion and cohesion, of gravity in nature" (Max Weber, *Essays on Art* [New York: William Rudge, 1916], pp. 67, 71). Another artist deeply engaged with the theme of energy—both scientific and occult—was Weber's fellow American painter Arthur Dove. See, e.g., Sherrye Cohn, "The Image and the Imagination of Space in the Art of Arthur Dove," Part I, "Dove's 'Force Lines, Growth Lines' as Emblems of Energy," *Arts Magazine* 58 (Dec. 1983), 90–93.

13. According to Dewey, "Inflamed inner material must find objective fuel on which to feed. Through the interaction of the fuel with material already afire the refined and formed product comes into existence." He likewise analyzes works of art in terms of their "organization of energies," and, most importantly, conceives the interaction of sensitive viewer and object in a true aesthetic experience in terms of the interaction of two energy fields. See John Dewey, *Art as Experience* (1934; New York: Capricorn Books, 1958), p. 66 and chapters 3 and 8. Dorner was the director of the Hanover Museum in the 1920s and worked closely with Bauhaus artists; he also observed the first wave of popular interest in Einstein and relativity theory in Germany in the 1920s. Recent work in quantum theory was Dorner's inspiration, as he declared, "Only now can we conceive the universe as an indivisible unity, consisting of pure energies in constant mutual transformation. The realms of spirit, sense, and nature are composed of kindred energies, and these energies are supraspatial" (Alexander Dorner, *The Way Beyond 'Art': The Work of Herbert Bayer* [New York: Wittenborn, Schultz, 1947], p. 105). As Christoph Asendorf explains in his essay "Bodies in Force Fields" (chapter 9 of this volume), in Dorner's view the work of designer Herbert Bayer best embodied this newly dynamic reality of energy. Rudolf Arnheim followed Dewey in looking to thermodynamics as a model for analyzing art, but in

the era of cybernetics it was the concept of entropy that interested him. See his *Entropy and Art: An Essay on Disorder and Order* (Berkeley: University of California Press, 1971).

14. Peter Blanc, "The Artist and the Atom," *Magazine of Art* 44 (April 1951), 152.

15. For Smithson's engagement with thermodynamics, see, e.g., Robert Smithson, *Collected Writings* (Berkeley: University of California Press, 1996), especially essays such as "Entropy and the New Monuments" (1966). According to the typed inventory of Smithson's extensive library, compiled by Valentin Tatransky, he owned not only P. W. Bridgman's classic, *The Nature of Thermodynamics*, but also Norbert Wiener's *The Human Use of Human Beings*, Von Neumann's *Theory of Self-Reproducing Automata*, and J. R. Pierce's *Symbols, Signals, and Noise: The Nature and Process of Communication*. For the complete library list, see Ann Reynolds, *Robert Smithson: Learning from New Jersey and Elsewhere* (Cambridge, Mass.: MIT Press, 2002).

16. As David Summers has commented, such "idealist representation was inextricably linked to the newly emerged realm of the *aesthetic*," precisely as the realm of the aesthetic detached representation from outer objects and promoted the immaterial play and subjective embedding of mental representations (David Summers, "Representation," in Richard S. Nelson and Richard Shiff, eds., *Critical Terms for Art History* [Chicago: University of Chicago Press, 1996], pp. 3–16, quote at p. 13). In addition to Summers's excellent survey of the history of theories of representation, other classic texts on representation in art include E. H. Gombrich, *Art and Illusion: A Study in the Psychology of Pictorial Representation* (Princeton: Princeton University Press, 1960); and Nelson Goodman, *Languages of Art: An Approach to a Theory of Symbols* (Indianapolis: Hackett, 1976). W. J. T. Mitchell's essay on "Representation" in *Critical Terms for Literary Study*, ed. Frank Lentricchia and Thomas McLaughlin (Chicago: University of Chicago Press, 1990), pp. 11–22, does for literary representation what Summers' essay does for art.

17. The technical complexities of the topic may be sampled in essays such as Charles Altieri, "Representation, Representativeness and 'Non-Representational' Art," *Journal of Comparative Literature and Aesthetics* 5:1–2 (1982), 1–23; Ruth Ronen, "Description, Narrative, and Representation," *Narrative* 5:3 (October 1997), 274–86; and August Fenk, "Representation and Iconicity," *Semiotica* 115:3–4 (1997), 215–34.

18. Antonia Phillips and Richard Wollheim, "Representation," in *The Dictionary of Art*, ed. Jane Turner (New York: Grove Press, 1996), pp. 221–26.

19. Although *abstract* or *totally abstract* has become the term most widely applied to works that do not refer in any way to the appearance of objects in the outside world—in contrast to the problematic adjectives *non-objective* (a mistranslation of *objectless*) and the questionable *non-representational*—the term *abstraction* had been used by critics in the later nineteenth century to signify an obvious departure from the goals of direct mimesis or naturalistic imitation. In his essay in this volume (chapter 15), Richard Shiff discusses the varying significations of the word in this period.

20. See, for example, Alfred H. Barr, Jr., *Cubism and Abstract Art* (New York:

Museum of Modern Art, 1936). Marxist art historian Meyer Schapiro, however, published a retort to Barr's purely formal reading of abstract art in "The Nature of Abstract Art" (1937), in *Modern Art/Nineteenth and Twentieth Centuries: Selected Papers* (New York: George Braziller, 1978), pp. 185–226. Schapiro's essay relies on scientific metaphors and the theme of energy to counter Barr's viewpoint. For example, on page 202 he writes, "To say that abstract painting is simply a reaction against the exhausted imitation of nature . . . is to overlook the positive character of the art, its underlying energies and sources of movement."

21. Michael Lynch and Steve Woolgar, ed., *Representation in Scientific Practice* (Cambridge, Mass.: MIT Press, 1990), p. 1.

22. See Bruno Latour, *Science in Action: How to Follow Scientists and Engineers through Society* (Cambridge: Harvard University Press, 1987), p. 69; see also Latour, "Drawing Things Together," in Lynch and Woolgar, eds., *Representation in Scientific Practice*, pp. 19–68.

23. See, for example, Latour's use of the term "visualization" in "Drawing Things Together." See also William C. Wimsatt, "Taming the Dimensions: Visualization in Science," in *PSA 1990* (East Lansing: Philosophy of Science Association, 1991), p. 151, on "visualization as the source of natural modes of representation for certain kinds of data." Arthur I. Miller was an early investigator of the history of visualization; see Miller, "Visualization Lost and Regained: The Genesis of the Quantum Theory in the Period 1913–27," in *On Aesthetics in Science*, ed. Judith Wechsler (Cambridge, Mass.: MIT Press, 1978), pp. 73–102. He has also written on the role of representation in art and science in works such as "Aesthetics and Representation in Art and Science," *Languages of Design* 2 (1994), 13–37.

In our broadening of the term *representation*, we differ from art historian James Elkins, who has done pioneering work in examining images across a wide variety of fields, including science. Listing a group of images closely related to those of Lynch and Woolgar, Elkins declines to use the term, stating that "there is no good name" for such "informational images" as "graphs, charts, maps, geometric configurations, notations, plans . . . scientific images of all sorts, schemata" (Elkins, *Domain*, pp. 4–5). Elkins prefers instead to reserve the term for use in its negative form in a category of things he designates as "the unrepresentable, unpicturable, inconceivable, and the unseeable"; see Elkins, *On Pictures and the Words That Fail Them* (Cambridge: Cambridge University Press, 1998), chapter 8. For Elkins, "what is unrepresentable can never be adequately put in an image because it is nonpictorial, unimaginable, forbidden, or transcendental" (Elkins, *Domain*, p. 41). Here he maintains the traditional association of representation and the visible (see also Elkins, *On Pictures*, p. 256).

24. The primary art historian to adopt a broader usage of representation is Charles Harrison in his essay "Abstraction, Figuration and Representation," in Harrison, Francis Frascina, and Gill Perry, *Primitivism, Cubism, Abstraction: The Early Twentieth Century* (New Haven: Yale University Press, 1993), pp. 200–204. According to Harrison, "Indeed, the claim for meaning in abstract art *requires* that we countenance the possibility of representation in the absence of resemblance."

25. See Ian Hacking, *Representing and Intervening: Introductory Topics in the Philosophy of Natural Science* (Cambridge: Cambridge University Press, 1983); and another milestone in the evolution of thinking on this subject, a special issue of *Science in Context* 2 (Spring 1988), edited by Timothy Lenoir and Yehuda Elkana, on "Practice, Context, and the Dialogue Between Theory and Experiment," which includes essays by a number of major historians of science. See also Levine, ed., *Realism and Representation.*

The ideas of Barthes and Foucault were highlighted for American audiences in volumes such as Brian Wallis, ed., *Art After Modernism: Rethinking Representation* (New York: New Museum of Contemporary Art, 1984), which, nonetheless, maintains a narrow conception of representation as figuration. See also Michel Foucault, *The Order of Things: An Archeology of the Human Sciences* (New York: Random House, 1973), chap. 7, "The Limits of Representation." See also, for example, Roland Barthes, *The Responsibility of Forms: Critical Essays on Music, Art, and Representation* (New York: Hill and Wang, 1985). Julian Bell presents an overview of a number of these issues in *What Is Painting? Representation and Modern Art* (London: Thames and Hudson, 1999).

26. W. J. T. Mitchell, *Picture Theory: Essays on Visual and Verbal Representation* (Chicago: University of Chicago Press, 1994), p. 420.

27. See Angus Fletcher, *Allegory: The Theory of a Symbolic Mode* (Ithaca: Cornell University Press, 1964); Bruce Clarke, *Allegories of Writing: The Subject of Metamorphosis* (Albany: State University of New York Press, 1995); and "Allegory and Science," a special cluster in *Configurations* 4:1 (Winter 1996), 33–120. See also Gordon Teskey, *Allegory and Violence* (Ithaca: Cornell University Press, 1996); and James J. Paxson, "Kepler's Allegory of Containment, the Making of Modern Astronomy, and the Semiotics of Mathematical Thought," *Intertexts* 3:2 (Fall 1999), 105–23.

28. Hayles develops these themes at length in *How We Became Posthuman.*

29. Ouspensky drew this idea from the cosmic theorizing of the British Whitmanite Edward Carpenter. On this subject, as well as Malevich's interest in the fourth dimension, see Linda D. Henderson, "Mysticism, Romanticism, and the Fourth Dimension," in Los Angeles County Museum of Art, *The Spiritual in Art: Abstract Painting 1890–1985* (New York: Abbeville, 1986), pp. 219–37. See also Henderson, *The Fourth Dimension and Non-Euclidean Geometry in Modern Art* (Princeton: Princeton University Press, 1983; new ed., Cambridge, Mass.: MIT Press, 2003), chap. 5.

30. Roy Ascott, "The Technoetic Dimension in Art," in *Art@Science*, ed. Christa Sommerer and Laurent Migonnneau (New York: Springer Verlag, 1998), p. 280. Ascott's statement continues, "construction of new realities rather than the representation, reiteration, interpretation or expression of world views which have been laid upon us." Here he is thinking less of the possibility of representation as creative construction, as we are suggesting, than of the "re-presentation" of already existing entities.

31. On Seurat's "scientific spirit," see "A Complete Reversal of Art Opinions by Marcel Duchamp, Iconoclast," *Arts and Decoration* 5 (Sept. 1915), 427. For Du-

champ's engineer-like materials, see Henderson's "Vibratory Modernism," chapter 6 in this volume.

32. Paulson notes the enormous ramifications of modern science across the academic disciplines, as well as the new disciplinary couplings created by the turn toward models of chaos, complexity, and self-organization in physical systems and biological processes. The coupling of distant discursive codes such as literature and science, Paulson argues, maximizes the increment of interdisciplinary noise, and "from the interference between disciplines can arise new forms of explanation, new articulations between levels of phenomena in a world of emergent complexity." William Paulson, "Literature, Complexity, Interdisciplinarity," in N. Katherine Hayles, ed., *Chaos and Order: Complex Dynamics in Literature and Science* (Chicago: University of Chicago Press, 1991), p. 49.

FROM THERMODYNAMICS TO VIRTUALITY

1. "The history of science is not worth an hour's trouble if it does not become as effective as the sciences themselves. In other words, it offers less interest as an object or a domain than as a set of operators, a method or a strategy working on formations different from itself" (Michel Serres, *Hermes: Literature, Science, Philosophy*, ed. Josué V. Harari and David F. Bell [Baltimore: Johns Hopkins University Press, 1982], p. 39).

2. For more on the earlier provenance of energy in the British and European cultural context, see Crosbie Smith, *The Science of Energy: A Cultural History of Energy Physics in Victorian Britain* (Chicago: University of Chicago Press, 1998); see also Stuart Peterfreund, "The Re-Emergence of Energy in the Discourse of Literature and Science," *Annals of Scholarship* 4 (1986–97), pp. 22–53, and "Organicism and the Birth of Energy," in *Approaches to Organic Form*, ed. Frederick Burwick, *Boston Studies in Philosophy of Science* 105 (Boston: Reidel, 1987), pp. 113–52.

3. "There is only one type of change surviving in dynamics, one 'process,' and that is motion" (Ilya Prigogine and Isabelle Stengers, *Order Out of Chaos: Man's New Dialogue with Nature* [New York: Bantam, 1984], p. 62).

4. But not without "a considerable confusion of nomenclature which persisted well into the nineteenth century.... The word 'force' was often used indiscriminately to refer to both the Newtonian concept F and the effect of this force acting through distance, that is $\frac{1}{2}mv^2$" (D. W. Theobald, *The Concept of Energy* [London: E. & F. N. Spon, 1966], 35).

5. Work is defined in physics as "the transference of energy that is produced by the motion of the point of application of a force and is measured by multiplying the force and the displacement of its point of application in the line of action" (*WWWebster*).

6. See Thomas S. Kuhn, "Energy Conservation as an Example of Simultaneous Discovery," in *Critical Problems in the History of Science*, ed. M. Clagett (Madison: University of Wisconsin Press, 1959), pp. 321–56.

7. *Philosophical Magazine* (October, 1852); in William Thomson (Lord Kelvin),

Mathematical and Physical Papers (Cambridge: Cambridge University Press, 1882), 1:511–14. The definitive treatment of Thomson is Crosbie Smith and M. Norton Wise, *Energy and Empire: A Biographical Study of Lord Kelvin* (New York: Cambridge University Press, 1989). See also Joe D. Burchfield, *Lord Kelvin and the Age of the Earth* (New York: Science History Publications, 1975); and Stephen G. Brush, *The Temperature of History: Phases of Science and Culture in the Nineteenth Century* (New York: Burt Franklin, 1978).

8. William Thomson, "On a Universal Tendency in Nature to the Dissipation of Mechanical Energy," in *Mathematical and Physical Papers*, vol. 1, p. 514.

9. The proper anticipations of entropy were *cultural*, a long tradition of proverbial observations on the irreversibility of time and the wasting away of the world. See Greg Myers, "Nineteenth-Century Popularizations of Thermodynamics and the Rhetoric of Social Prophecy," in *Energy and Entropy: Science and Culture in Victorian Britain*, ed. Patrick Brantlinger (Bloomington: Indiana University Press, 1989), pp. 307–38. See also Anson Rabinbach, *The Human Motor: Energy, Fatigue, and the Origins of Modernity* (New York: Basic Books, 1990). For a current rehearsal of the philosophical issues embedded in this phase of the history of science, see Isabelle Stengers, *Power and Invention: Situating Science* (Minneapolis: University of Minnesota Press, 1997), pp. 33–74; and Smith, *Science of Energy*.

10. See Lawrence Ford and Thomas A. Roman, "Negative Energy, Wormholes, and Warp Drives," *Scientific American* 282:1 (January 2000), 46–53.

11. Charles Coulston Gillispie, *The Edge of Objectivity: An Essay in the History of Scientific Ideas* (Princeton: Princeton University Press, 1960), p. 401.

12. A good overview of this development is "The Dying Universe," in Paul Davies, *The Last Three Minutes* (London: Weidenfeld and Nicholson, 1994), pp. 9–18.

13. John Tyndall, "The Luminiferous Ether," in *Heat: A Mode of Motion*, 6th ed. (1880; New York: D. Appleton, 1915), pp. 275–76. Gillian Beer places Tyndall into wider cultural context in "Helmholtz, Tyndall, Gerard Manley Hopkins: Leaps of the Prepared Imagination," *Comparative Criticism* 15 (1991), 117–45, and "Wave Theory and the Rise of Literary Modernism," in George Levine, ed., *Realism and Representation: Essays on the Problem of Realism in Relation to Science, Literature, and Culture* (Madison: University of Wisconsin Press, 1993), pp. 193–213.

14. See C. W. F. Everitt, *James Clerk Maxwell: Physicist and Natural Philosopher* (New York: Scribner, 1975); and Daniel M. Siegel, *Innovation in Maxwell's Electromagnetic Theory: Molecular Vortices, Displacement Current, and Light* (New York: Cambridge University Press, 1991).

15. "The velocity of transverse undulations in our hypothetical medium, calculated from the electro-magnetic experiments of M. M. Kohlrausch and Weber, agrees so exactly with the velocity of light calculated from the optical experiments of M. Fizeau that we can scarcely avoid the inference that *light consists of the transverse undulations of the same medium which is the cause of electric and magnetic phenomena*" (James Clerk Maxwell, "On Physical Lines of Force," in W. D. Niven, ed., *The Scientific Papers of James Clerk Maxwell*, 2 vols. [1890; New York: Dover, n.d.], 1: 500; emphasis in the original).

16. See also Bruce J. Hunt, *The Maxwellians* (Ithaca: Cornell University Press, 1991).

17. John von Neumann, "Method in the Physical Sciences," in *Collected Works*, ed. A. H. Taub, 6 vols. (New York: Macmillan, 1963), 6:492.

18. On the constitutive effects of scientific instrumentation, see Timothy Lenoir, ed., *Inscribing Science: Scientific Texts and the Materialities of Communication* (Stanford: Stanford University Press, 1998), esp. Lenoir's introductory essay "Inscription Practices and the Materialities of Communication," pp. 1–19.

19. Maxwell's Demon derived from his work on the kinetic theory of gases. His starting point was the statistical mechanics he developed in the 1860 paper "Illustrations of the Dynamical Theory of Gases," applying probability theory to create a distribution curve of velocities among gas molecules (*Scientific Papers* 1:377–409). The Demon first materialized in December 1867, in a letter Maxwell sent his frequent correspondent P. G. Tait, as a fictive sorting-agent explicitly deployed "to pick a hole" in the second law of thermodynamics: "Now conceive a finite being who knows the paths and velocities of all the molecules, by simple inspection but who can do no work, except to open and close a hole in the diaphragm by means of a slide without mass" (James Clerk Maxwell to P. G. Tait, December 11, 1867, Cambridge University Library, Add 7655/Ib 8, reprinted in P. M. Harman, ed., *The Scientific Letters and Papers of James Clerk Maxwell*, 2 vols. [Cambridge: Cambridge University Press, 1990], 2:328–33). See also Smith and Wise, *Energy and Empire*, pp. 621–22.

20. As Robert Brain details in his essay on graphic methods (chapter 7) in this volume, a scientific goal during this period was the elimination of the potential error of human agency through the perfection of automated registration devices.

21. Maxwell to John William Strutt, December 6, 1870, in Harman, ed., *Scientific Letters and Papers*, 2:582–83.

22. N. Katherine Hayles, *Chaos Bound: Orderly Disorder in Contemporary Literature and Science* (Ithaca: Cornell University Press, 1990), p. 41.

23. John von Neumann, "The General and Logical Theory of Automata," in *Collected Works*, 5:304.

24. Norbert Wiener, *The Human Use of Human Beings: Cybernetics and Society* (Boston: Houghton Mifflin, 1950), p. 7.

25. Warren Weaver, "Recent Contributions to the Mathematical Theory of Communication, 1. Introductory Note on the General Setting of the Analytical Communications Studies," in Warren Weaver and Claude Shannon, *The Mathematical Theory of Communication* (Urbana: University of Illinois Press, 1949), p. 3.

26. Weaver, "Recent Contributions," p. 9.

27. Serres, *Hermes*, p. 88.

28. William Paulson, "Writing that Matters," *SubStance* 83 (1997), 23.

29. Hayles, *Chaos Bound*, pp. 53–60.

30. Ilya Prigogine with Isabelle Stengers, *The End of Certainty: Time, Chaos, and the New Laws of Nature* (New York: Free Press, 1996), p. 70.

31. Prigogine and Stengers, *Order Out of Chaos*, p. 292.

32. The cultural repercussions of dissipative systems, deterministic chaos, and

complexity theory are usefully discussed in Serres, *Hermes*; William R. Paulson, *The Noise of Culture: Literary Texts in a World of Information* (Ithaca: Cornell University Press, 1988); Hayles, *Chaos Bound*; Philip Kuberski, *Chaosmos: Literature, Science, and Theory* (Albany: State University of New York Press, 1994); and Ira Livingston, *Arrow of Chaos: Romanticism and Postmodernity* (Minneapolis: University of Minnesota Press, 1997). In "second-order" cybernetics, the autopoietic or operational closure of natural and cultural systems connects biological to sociological models, in which the general viability of systems is contingent upon both their self-referential closure and their openness to the environment against which they define themselves. See Heinz von Foerster, *Observing Systems* (Seaside, Calif.: Intersystems Publications, 1984), and Niklas Luhmann, *Social Systems*, trans. John Bednarz, Jr. (Stanford: Stanford University Press, 1995).

33. For a sketch of the scientific development of the Demon fiction and a compendium of central documents on the topic, see Harvey S. Leff and Andrew F. Rex, *Maxwell's Demon: Entropy, Information, Computing* (Princeton: Princeton University Press, 1990). On the Demon's scene of origination, see Bruce Clarke, *Energy Forms: Allegory and Science in the Era of Classical Thermodynamics* (Ann Arbor: University of Michigan Press, 2001), pp. 103–10. Hayles analyzes a number of issues related to the Demon and provides a magisterial summation of its current informatic and computational significance in "Self-Reflexive Metaphors in Maxwell's Demon and Shannon's Choice: Finding the Passages," *Chaos Bound*, pp. 31–60. Paulson provides another excellent exposition of the Demon in *Noise of Culture*, pp. 40–44.

34. On Babbage and his calculating machines, see the essay by Tomas (chapter 10) in this volume.

35. Wiener, *Human Use of Human Beings*, p. 8.

36. For more on the initial phases of cybernetics, see the essay by Shanken (chapter 12) in this volume.

37. Weaver, "Recent Contributions," pp. 17–18.

38. Paulson, *Noise of Culture*, p. 67.

39. Philosopher of science Michel Serres's work develops at length the constructive repercussions of the noise of communication. See Michel Serres, *The Parasite*, trans. Lawrence R. Schehr (Baltimore: Johns Hopkins University Press, 1982). On the role of noise in the crossover from energy to information, see in particular Serres's "Platonic Dialogue" and "The Origin of Language: Biology, Information, Theory, and Thermodynamics," in *Hermes*, pp. 65–83. For recent overviews of Serres's career, see the special issues *An Ecology of Knowledge: Michel Serres*, ed. Sydney Lévy, *SubStance* 83 (1997), and *Michel Serres*, ed. Pierpaolo Antonello and Robert P. Harrison, *Configurations* 8:2 (Spring 2000).

40. "The advantage of working with information structures is that information has no intrinsic size": Christopher G. Langton, "Artificial Life," in *Artificial Life*, ed. Langton (Redwood City, Calif.: Addison-Wesley, 1989), p. 39.

41. Marcos Novak, "TransTerraFirma: After Territory," available at <http://www.sitesarch.org>.

42. Novak, "TransTerraFirma," 2.

43. See Pierre Lévy, *Becoming Virtual: Reality in the Digital Age*, trans. Robert Bononno (New York: Plenum, 1998).

44. Ibid., p. 28.

45. Donna J. Haraway, "A Cyborg Manifesto: Science, Technology, and Socialist-Feminism in the Late Twentieth Century," in *Simians, Cyborgs, and Women: The Reinvention of Nature* (New York: Routledge, 1991), p. 164.

46. Henry Krips, "Catachresis, Quantum Mechanics, and the Letter of Lacan," *Configurations* 7:1 (Winter 1999), 47. See also Friedrich Kittler, *Gramophone, Film, Typewriter*, trans. and intro. Geoffrey Winthrop-Young and Michael Wutz (Stanford: Stanford University Press, 1999): The real "forms the waste or residue that neither the mirror of the imaginary nor the grid of the symbolic can catch: the physiological accidents and stochastic disorder of bodies" (pp. 15–16).

47. David J. Gunkel, "Lingua ex Machina: Computer-Mediated Communication and the Tower of Babel," *Configurations* 7:1 (Winter 1999), 61–89. See also David J. Gunkel, *Hacking Cyberspace* (Boulder, Colo.: Westview Press, 2001).

48. Gunkel, "Lingua ex machina," p. 75.

49. Ibid., p. 83.

50. See the materials on the new relations between machines and bodies in Jonathan Crary and Sanford Kwinter, ed., *Incorporations*, Zone 6 (1992). For the left-ecological critique of virtual reality, see Robert M. Markley, ed., *Virtual Realities and Their Discontents* (Baltimore: Johns Hopkins University Press, 1996). See also N. Katherine Hayles, *How We Became Posthuman: Virtual Bodies in Cybernetics, Literature, and Informatics* (Chicago: University of Chicago Press, 1999), esp. "The Materiality of Informatics," pp. 192–221.

51. Lévy, *Becoming Virtual*, p. 44.

PART I INTRODUCTION

1. On ideology as representation, see David Summers, "Representation," in Richard S. Nelson and Richard Shiff, eds., *Critical Terms for Art History* (Chicago: University of Chicago Press, 1996), pp. 3–16; on the ideological implications of cultural representations, see also Robert S. Nelson, "Appropriation," in Nelson and Shiff, eds., *Critical Terms*, pp. 116–28.

2. On scientific ideology, see Georges Canguilhem, *Ideology and Rationality in the History of the Life Sciences*, trans. Arthur Goldhammer (Cambridge: MIT Press, 1988); on scientism, see Iain Cameron and David O. Edge, *Scientific Images and Their Social Uses: An Introduction to the Concept of Scientism* (Boston: Butterworth, 1979); and Casper Hakfoort, "The Historiography of Scientism: A Critical Review," *History of Science* 33 (1995), 375–95.

3. On the history and substance of thermodynamics, see Charles Coulston Gillispie, *The Edge of Objectivity: An Essay in the History of Scientific Ideas* (Princeton: Princeton University Press, 1960); P. M. Harman, *Energy, Force, and Matter: The Conceptual Development of Nineteenth-Century Physics* (New York: Cambridge

University Press, 1982); Ilya Prigogine and Isabelle Stengers, *Order Out of Chaos: Man's New Dialogue with Nature* (New York: Bantam, 1984); Greg Myers, "Nineteenth-Century Popularizations of Thermodynamics and the Rhetoric of Social Prophecy," in *Energy and Entropy: Science and Culture in Victorian Britain*, ed. Patrick Brantlinger (Bloomington: Indiana University Press, 1989), pp. 307–38; and Crosbie Smith, *The Science of Energy: A Cultural History of Energy Physics in Victorian Britain* (Chicago: University of Chicago Press, 1998).

CHAPTER 1

1. Gustave Le Bon, *The Crowd* (1895), intro. Robert K. Merton (New York: Viking Press, 1960), p. 32.

2. Ibid., pp. 35–36, 182.

3. Ibid., pp. 96, 99n, 100, quoting Hippolyte Taine, *Le régime moderne*, vol. 2 (Paris: Hachette, 1894), comparing France with England and America; p. 16.

4. Ibid., pp. 207, 32f, 29, 18.

5. I. Bernard Cohen, *Revolutions in Science* (Cambridge: Harvard University Press, 1985), chap. 13.

6. See James Secord, "Newton in the Nursery: Tom Telescope and the Philosophy of Tops and Balls, 1761–1838," *History of Science* 23 (1985), 127–51, discussing Tom Telescope, *The Newtonian System of Philosophy Adapted to the Capacities of Young Gentlemen and Ladies* (London: J. Newbery, 1761). Antoine-Laurent Lavoisier, *Elements of Chemistry, in a New Systematic Order Containing all the Modern Discoveries*, trans. Robert Kerr (1789; New York: Dover, 1965), pp. xvi, xxvi–xxvii.

7. Lorraine Daston, *Classical Probability in the Enlightenment* (Princeton: Princeton University Press, 1988), esp. ch. 4, provides a thoroughgoing study of the ideal of "reason" as a probabilistic balancing of experience based on Lockean associationist beliefs. M. Norton Wise, "Mediations: Enlightenment Balancing Acts, or the Technologies of Rationalism," in Paul Horwitch, ed., *World Changes: Thomas Kuhn and the Nature of Science* (Cambridge, Mass.: MIT Press, 1992), pp. 207–56.

8. Steven Toulmin and June Goodfield, *The Discovery of Time* (Chicago: University of Chicago Press, 1965). Classic is Arthur Lovejoy, *The Great Chain of Being: A Study of the History of an Idea* (1936; New York: Harper Torchbooks, 1960), including a chapter on "The Temporalizing of the Great Chain of Being" in the late eighteenth century, which displays the evolutionary reflections of Maupertuis, Diderot, and especially Robinet.

9. The best account of Laplace's work is Charles C. Gillispie, with the collaboration of Robert Fox and Ivor Grattan-Guinness, *Pierre-Simon Laplace, 1749–1827: A Life in Exact Science* (Princeton: Princeton University Press, 1997). John Playfair, "La Place, *Traité de mécanique céleste*," *Edinburgh Review* 22 (1808), 277.

10. William Whewell, *The Bridgewater Treatises on the Power Wisdom and Goodness of God as Manifested in the Creation. Treatise III: Astronomy and General Physics Considered with Reference to Natural Theology* (Philadelphia: Carey,

Lea & Blanchard, 1833), pp. 158–59. Laplace himself soon recognized that the friction of tidal and geological motions as well as ethereal resistance in the heavens would "considerably alter the planetary movements" (*Essai philosophique sur les probabilités*, 4th ed. [1819], reprinted as the Introduction to *Théorie analytique des probabilités*, 3rd ed. [Paris: M. V. Courcier, 1820], p. cxi).

11. J. P. Nichol, *View of the Architecture of the Heavens. In a Series of Letters to a Lady* (Edinburgh: William Tait, 1837), p. 191. See Simon Schaffer, "The Nebular Hypothesis and the Science of Progress," in J. R. Moore, ed., *History, Humanity, and Evolution* (Cambridge: Cambridge University Press, 1989), pp. 131–64; M. Norton Wise, with the collaboration of Crosbie Smith, "Work and Waste: Political Economy and Natural Philosophy in 19th Century Britain. Pt. II," *History of Science* 27 (1989), 403–9.

12. Georges Cuvier, *The Animal Kingdom, Arranged According to its Organization*, with additions (1817; London: A. Fullarton, 1859), p. 7.

13. Toby A. Appel, *The Cuvier-Geoffrey Debate: French Biology in the Decades before Darwin* (New York: Oxford University Press, 1987), chaps. 5, 6. Martin Rudwick, *Scenes from Deep Time: Early Pictorial Representations of the Prehistoric World* (Chicago: University of Chicago Press, 1992). See also the essay by W. J. T. Mitchell, "Dinosaurs and Modernity," in this volume.

14. Robert Chambers, *Vestiges of the Natural History of Creation and other Evolutionary Writings*, ed. James A. Secord (Chicago: University of Chicago Press, 1994); publication figures and quotation from Secord's excellent introduction, pp. xxvii, xlv; "Vindication of the World and Providence" (1822), pp. 199–203.

15. On the physiocratic scheme see Jean-Claude Perrot, *Une histoire intellectuelle de l'économie politique: XVIIe–XVIIIe siècle* (Paris: Ecole des Haute Etudes en Sciences Sociales, 1992), pp. 217–36. A similar point about gender pertains to the role of reason in the widespread sensationalist philosophy of Locke and Condillac. As Jan Goldstein argues in "Mutations of the Self in Old Regime and Postrevolutionary France: From *Ame* to *Moi* to *le Moi*" (in Lorraine Daston, ed., *Biographies of Scientific Objects* [Chicago: University of Chicago Press, 2000], pp. 86–116), reason and volition were built upward from sensations and memory as a natural outcome, rather than downward from an independently constituted self, or *le moi*. Thus the distinction of feminine sensibility, as passive and natural, from active masculine reason and volition did not arise in the strong form that it would take with the rise of Victor Cousin's conservative-liberal philosophy during the 1820s, with its emphasis on the priority of the unified self as the constant of personal identity and stability and its close ties to the restored order of monarchy and Catholicism. Cousin's formulation is closely related to the role of *le moi* for Cuvier, equally concerned with the maintenance of order, who made *le moi* the agent of unified self-conscious will in higher animals; *Animal Kingdom*, pp. 10–19. These distinctions are important for the notion of the female as an arrested development of the male, which became increasingly prominent from the 1830s.

16. A late defense of productive versus unproductive labor is in William Whewell, *Six Lectures on Political Economy* (Cambridge: A. M. Kelley, 1860), pp. 5–19.

17. Wise, "Work and Waste, pt. II," pp. 391–424.

18. Theodore M. Porter, *The Rise of Statistical Thinking: 1820–1900* (Princeton: Princeton University Press, 1986). Ian Hacking, *The Taming of Chance* (Cambridge: Cambridge University Press, 1990).

19. Charles Dickens, *Hard Times* (1854; New York: Norton, 1966), pp. 17, 69.

20. E. P. Thompson, "Time, Work-Discipline, and Industrial Capitalism," *Past and Present* 38 (1967), pp. 56–97.

21. Charles Dickens, *A Tale of Two Cities*, vol. 20 of *The Writings of Charles Dickens*, with engraving designs by Browne, Cruikshank, Leech, and others (Boston: Houghton, Mifflin, 1894), p. 220.

22. Dickens, *Hard Times*, pp. 120–21.

23. Theodore M. Porter, *The Rise of Statistical Thinking, 1820–1900* (Princeton: Princeton University Press, 1986), chaps. 3–5. M. A. Quetelet, *Letters Addressed to H. R. H. The Grand Duke of Saxe Coburg and Gotha, on the Theory of Probabilities, as Applied to the Moral and Political Sciences* (1846), trans. O. G. Downes (London: Charles & Edwin Layton, 1849), curve with mathematical analysis, pp. 272–75. (This was Galton's original source.) Edwin Chadwick, *Report to Her Majesty's Principal Secretary of State for the Home Department, from the Poor Law Commissioners, on an Inquiry into the Sanitary Condition of the Labouring Population of Great Britain*, intro. M. W. Flinn (1842; Edinburgh: Edinburgh University Press, 1965). Chadwick was nominal Secretary to the Poor Law Commission, 1834–47. He sent a copy of the *Report* to Dickens in 1842 (Introduction, pp. 56–57). I ignore here his serious differences with Quetelet over the general applicability of the normal curve, with thanks to Libby Schweber for pointing them out.

24. Dickens, *Hard Times*, pp. 120–21, 82.

25. M. Norton Wise, "Mediating Machines," *Science in Context* 2 (1988), 81–117; and, with the collaboration of Crosbie Smith, "Work and Waste: Political Economy and Natural Philosophy in 19th Century Britain. Pt. III," *History of Science* 28 (1990), 221–61.

26. Charles F.O. Glassford, Esq., "History and Description of the Kelp Manufacture," *Proceedings of the Philosophical Society of Glasgow* 2 (1844–48), p. 258.

27. William Thomson, "On a Universal Tendency in Nature to the Dissipation of Mechanical Energy," *Mathematical and Physical Papers*, 6 vols. (1852; Cambridge: Cambridge: Cambridge University Press, 1882–1911), 1:511–14. Chadwick, *Report on the Sanitary Condition*, p. 268; on labour and national wealth, see, e.g., p. 252.

28. Joseph Fourier, "Extrait d'un mémoire sur la théorie analytique des assurances," *Annales de chimie et de physique* [2], 10 (1819), pp. 177–89, as discussed in Porter, *Rise of Statistical Thinking*, pp. 97–100.

29. This account is from Porter, *Rise of Statistical Thinking*, pp. 111–28; also Charles C. Gillispie, "Intellectual Factors in the Background of Analysis by Probabilities," in A. C. Crombie, ed., *Scientific Change* (New York: Basic Books, 1963), pp. 431–53; and Stephen G. Brush, *The Kind of Motion We Call Heat*, 2 vols. (Amsterdam: North Holland, 1977), 1:184–87. A qualifier is perhaps necessary here. I have no evidence that any of the originators of thermodynamics and the kinetic the-

ory of gases extended their metaphor of gases as disordered crowds to specifically *effeminate* crowds, although that image was widely available. My argument is limited here to the claim that the laws of thermodynamics lent considerable weight to the image of the crowd as degraded and feminized.

30. Francis Galton, *Hereditary Genius: An Inquiry into its Laws and Consequences* (London: Macmillan, 1869); p. 2 advertises Darwin's approval of Galton's views, first published in *Macmillan's Magazine* (June and August 1865).

31. Wise, "Work and Waste. Pt. I," *History of Science*, 27 (1989), 263–301, esp. 286–89; idem, "Mediations," pp. 207–56; Porter, *Rise of Statistical Thinking*, pp. 101–4, observes also that Quetelet's moral ideal of the mean man was closely bound up with Cousin's philosophy of the self-constituting and self-centering will (see Goldstein, n. 14, above), which sought always "to return to a normal and balanced state" and thereby explained why the higher classes lived longer than the lower. (Chadwick's statistics, *Report on the Sanitary Condition*, pp. 223–27, show factors of two and three times longer.) Robert Chambers, *Explanations: A Sequel to "Vestiges of the Natural History of Creation"* (London: Churchill, 1845), p. 24.

32. Charles Darwin, *The Variation of Animals and Plants under Domestication*, 2 vols. (New York: Orange Judd, 1868), 1:195–98, 218–20.

33. Charles Darwin, *The Descent of Man and Selection in Relation to Sex* (1871), 2nd ed. (1874; New York: D. Appleton, 1913), pp. 632–33.

34. Ibid., pp. 215, 511.

35. Ibid., pp. 576, 618f. Darwin's views on arrested development in women reflect a very widely held tenet of physiologists. Chambers also included a version of the doctrine in his *Vestiges*, pp. 214–17. Later Darwinian physiologists like Michael Foster and T. H. Huxley based laboratory science and social critique upon it.

36. Herbert Spencer, *Social Statics: or, The Conditions Essential to Human Happiness Specified, and the First of Them Developed* (London: Chapman, 1851), pp. 420–22, 431.

37. Suggestive essays appear in Angela Creager, Elizabeth Lunbeck, and Londa Schiebinger, eds., *Feminism in Twentieth-Century Science, Technology, and Medicine* (Chicago: University of Chicago Press, 2001).

CHAPTER 2

I would like to thank Linda Henderson, Paul Allen Miller, and James Paxson for their helpful comments on drafts of this chapter.

1. "In the world of the symbol it would be possible for the image to coincide with the substance.... Their relationship is one of simultaneity, which, in truth, is spatial in kind, and in which the intervention of time is merely a matter of contingency, whereas, in the world of allegory, time is the originary constitutive category." Paul de Man, "The Rhetoric of Temporality," in *Interpretation: Theory and Practice*, ed. Charles S. Singleton (Baltimore: Johns Hopkins University Press, 1969), p. 190.

2. Susan Buck-Morss, *The Dialectics of Seeing: Walter Benjamin and the Arcades*

Project (Cambridge, Mass.: MIT Press, 1989), p. 164. A complete translation has now appeared: Walter Benjamin, *The Arcades Project*, trans. Howard Eiland and Kevin Mclaughlin (Cambridge: Harvard University Press, 1999).

3. "Mythic time is, clearly, not limited to a particular discourse. Science as well as theology, rationalism as well as superstition can claim that events are inexorably determined. Nor are mythic explanations limited to a particular epoch. They have their (Western) source in classical antiquity and Biblical narrative. But they reappear in the most recent cosmological speculations" (Buck-Morss, *Dialectics*, 78). See also Greg Myers, "Nineteenth-Century Popularizations of Thermodynamics and the Rhetoric of Social Prophecy," in Patrick Brantlinger, ed., *Energy and Entropy: Science and Culture in Victorian Britain* (Bloomington: Indiana University Press, 1989), pp. 307–38. On p. 307, Myers quotes Spengler: "What the myth of the Gotter-dammerung signified of old . . . the myth of entropy signifies today—*the world's end as completion of an inwardly necessary evolution,*" commenting, "The implication of this myth is that history is shaped by the laws of physics rather than the struggles of people."

4. On William Thomson's role in the theologizing of classical thermodynamics, see Crosbie Smith and M. Norton Wise, *Energy and Empire: A Biographical Study of Lord Kelvin* (New York: Cambridge University Press, 1989), esp. "The Irreversible Cosmos," pp. 497–523.

5. Ilya Prigogine and Isabelle Stengers, *Order Out of Chaos: Man's New Dialogue with Nature* (New York: Bantam, 1984), p. 116. The mythic dimension of classical calculation does not necessarily disqualify it as a functional mathematical idealization. The applicability of reversible time depends on the nature and scale of the system under consideration. Prigogine and Stengers argue that "We must accept a pluralistic world in which reversible and irreversible processes coexist" (p. 257). In current science, the mythic (repetitive, reversible) aspect of classical dynamics has now been repositioned in supplementary relation to the allegorical (irreversible) aspect of thermodynamics.

6. "It was crucial to Benjamin's theory that for the purposes of philosophical understanding there was no absolute, categorical distinction between technology and nature" (Buck-Morss, *Dialectics*, 68).

7. Buck-Morss, *Dialectics*, 170.

8. Benjamin's "dialectical image" remains a protean and contested concept, and my purpose here is simply to elicit its allegorical character. As such, it moves with equal facility in both verbal and visual registers. For a critique of visual bias in Buck-Morss's handling of the concept, see Chris Andre, "Aphrodite's Children: Hopeless Love, Historiography, and Benjamin's Dialectical Image," *SubStance* 85 (1998), 125–26.

9. Benjamin appropriated the mode of *phantasmagoria* from Marx's discussion of the commodity fetish: "Benjamin described the spectacle of Paris as a 'phantasmagoria'—a magic-lantern show of optical illusions, rapidly changing size and blending into one another. Marx had used the term 'phantasmagoria' to refer to the deceptive appearances of commodities as 'fetishes' in the marketplace" (Buck-Morss, *Dialectics*, 81).

10. Balfour Stewart, *The Conservation of Energy, being an Elementary Treatise on Energy and its Laws*, 5th ed. (London: Kegan Paul, 1881), pp. 37, 47.

11. Balfour Stewart and P. G. Tait, *The Unseen Universe or Physical Speculations on a Future State* (New York: Macmillan, 1875), 81. See P. M. Heimann, "The *Unseen Universe*: Physics and the Philosophy of Nature in Victorian Britain," *British Journal for the History of Science* 21 (1972), 73–79.

12. Karl Marx, "The Fetishism of Commodities," in David McLellan, ed., *Karl Marx: Selected Writings*, ed. David McLellan (Oxford: Oxford University Press, 1977), p. 435. See also Christoph Asendorf, "Economy and Metamorphosis," *Batteries of Life: On the History of Things and Their Perception in Modernity*, trans. Don Reneau (Berkeley: University of California Press, 1993), pp. 30–40; and Buck-Morss, *Dialectics*, p. 154.

13. Camille Flammarion, *La Fin du Monde* (Paris: Ernest Flammarion, 1894); *Omega: The Last Days of the World* (New York: Cosmopolitan, 1894; rpt. New York: Arno Press, 1975). A new reprint of the 1894 English translation is now available, with an introduction by Robert Silverberg, published in 1999 by the University of Nebraska, Lincoln.

14. Ibid., pp. 167, 177, 185.

15. Ibid., pp. 9, 194–95.

16. Ibid., p. 43.

17. Ibid., pp. 43–44. Translation altered from the *Omega* text. With regard to the financial speculator's "rolling" out of the institute's upper gallery, Asendorf notes the "rolling" of capital: Some cultures have manufactured currency in the form of little balls, their spherical form reinforcing their ability to "circulate" in all directions, or globally (*Batteries of Life*, 11–12). The racial detail also reinforces the note of the international circulation of capital in the finance of commercial trade.

18. Flammarion, *Omega*, pp. 178, 177, 181.

19. Ibid., 189, my emphasis.

20. Gregory Bateson, *Steps to an Ecology of Mind* (New York: Ballantine, 1972), p. xxi.

21. For the earlier history of comets as omens of reformations and catastrophes, see Sara Schechner Genuth, *Comets, Popular Culture, and the Birth of Modern Cosmology* (Princeton: Princeton University Press, 1997).

22. H. G. Wells, "The Star," *The Complete Short Stories of H. G. Wells* (New York: St. Martin's, 1970), pp. 644–55.

23. Ibid., pp. 646, 654–55.

24. Zamyatin noted the Wells–Flammarion connection in "H. G. Wells," in Mirra Ginsburg, ed. and trans., *A Soviet Heretic: Essays by Yevgeny Zamyatin* (Chicago: University of Chicago Press, 1970), p. 288. Flammarion's novelized work of scientific popularization was translated into a dozen languages, including the hasty 1894 English version. W. H. G. Armytage has observed that *La Fin du Monde* "must have influenced Wells though Wells never once mentioned Flammarion in his writings," in *Yesterday's Tomorrows: A Historical Survey of Future Societies* (Toronto: University of Toronto Press, 1968), p. 34. Perhaps Wells wished to keep under wraps the existence of this veritable Vulcan's workshop of science-fiction machinery.

25. Flammarion, *Omega*, pp. 11, 12.

26. Ibid., pp. 57–58.

27. Later in the debate, another version of this thermodynamic scenario is aired: "If some star, active or extinct, should emerge from space, so as to form with the sun a sort of electro-dynamic couple with our planet on its axis, acting upon it as a brake—if, in a word, for any reason, the earth should be suddenly arrested in its orbit, its mechanical energy would be changed into molecular motion, and its temperature would be suddenly raised to such a degree as to reduce it entirely to a gaseous state" (Flammarion, *Omega*, p. 113).

28. Wells, "The Star," p. 647, 655.

29. See Paul L. Sawyer, "Ruskin and Tyndall: The Poetry of Matter and the Poetry of Spirit," in James G. Paradis and Thomas Postlewait, ed., *Victorian Science and Victorian Values: Literary Perspectives* (1981; New Brunswick: Rutgers University Press, 1985), pp. 217–46; and Gillian Beer, "Helmholtz, Tyndall, Gerard Manley Hopkins: Leaps of the Prepared Imagination," *Comparative Criticism* 13 (1991), 117–45, and "Wave Theory and the Rise of Literary Modernism," in George Levine, ed., *Realism and Representation: Essays on the Problem of Realism in Relation to Science, Literature, and Culture* (Madison: University of Wisconsin Press, 1993), esp. pp. 206–9.

30. John Tyndall, "The Constitution of Nature" (1865), in *Fragments of Science: A Series of Detached Essays, Addresses, and Reviews*, 2 vols. (New York: D. Appleton, 1915), 1:6–7.

31. Flammarion, *Omega*, pp. 107–10.

32. Ibid., pp. 184, 217, 197, 202. Flammarion's spiritualism breaks loose at this point in the original text, but is largely suppressed by the English-language translator of *Omega*. In fact, Flammarion was transcribing a dialect of "ethereal vibrations" very closely tied to the late-classical description of light, heat, and electromagnetism as radiant energies transmitted by a luminiferous ether. His vision of intellectual evolution displaces into the marvelous future the physical scientisms at play in the rhetoric of fin-de-siècle spiritualism and theosophy. With the evolution of the psychic sense, "the ethereal vibrations that result from cerebral movements are transmitted by a transcendental magnetism that children themselves know how to use. Every thought excites in the brain a vibratory movement; such movement gives birth to ethereal waves; and if such waves encounter another mind in harmony with the first mind, they can convey to it the initial thought that created them, just as a vibrating wire receives the undulation from a distance sound, and as the speaker of a telephone reconstitutes the voice silently transported by an electrical movement" (Flammarion, *La Fin du Monde*, 306–8, my translation). See Linda Henderson's essay (chapter 6) later in this volume.

33. Flammarion, *Omega*, pp. 272, 275.

34. John Tyndall, *Heat: A Mode of Motion*, 6th ed. (1880; New York: D. Appleton, 1915), p. 523.

35. Ibid., pp. 519–20.

36. Stewart and Tait, *Unseen Universe*, p. 92.

37. In a popular forum, physicist Freeman J. Dyson recently discussed the thermodynamics of gravity in a way reminiscent of Tyndall's position: "The universe is dominated by the force of gravitation. Gravitational energy is quantitatively the largest reserve of energy, and qualitatively the least disordered. Because of its superior quality, gravitational energy can change easily and irreversibly into other forms of energy. Other energy sources are associated with disorder and heat, but gravitational energy is cool. . . . Gravitation is the ordering principle that holds our earth together as a stage for us to walk on, and gravitation is the ultimate reservoir of energy that can smash our world to pieces" (Freeman J. Dyson, "Gravity is Cool," *Forbes ASAP* [November 30, 1998], 180.)

38. Tyndall, "Constitution of Nature."

39. Ibid., p. 7.

40. Flammarion, *Omega*, pp. 285–87.

41. James Joyce, *Ulysses* (New York: Vintage, 1990), p. 700.

42. Yevgeny Zamyatin, "On Literature, Revolution, Entropy, and Other Matters," in Mirra Ginsburg, ed. and trans., *A Soviet Heretic: Essays by Yevgeny Zamyatin* (Chicago: University of Chicago Press, 1970), p. 107.

43. Buck-Morss, *Dialectics*, p. 95.

CHAPTER 3

The author wishes to thank John Biggart for his attentive reading of an early draft of this essay, and for his helpful suggestions.

1. For a discussion of biological thought in nineteenth and early twentieth century Russia see Charlotte Douglas, "Evolution and the Biological Metaphor in Modern Russian Art," *Art Journal* 44:2 (Summer 1984), 153–61.

2. Wilhelm Ostwald, *Elektrochemie* (1896), p. 6. Quoted in Robert J. Deltete, *The Energetics Controversy in Late Nineteenth-Century Germany: Helm, Ostwald and Their Critics*, Ph.D. thesis, Yale University, 1983, p. 598.

3. Particularly close to Ostwald's heart must have been Einstein's 1906 formulation, "the law of conservation of mass is a special case of the law of conservation of energy" (Abraham Pais, *'Subtle Is the Lord': The Science and the Life of Albert Einstein* [Oxford: Oxford University Press, 1983], pp. 148, 506).

4. Ostwald nominated Einstein in 1910, 1912, and 1913. In 1914 he was nominated by the St. Petersburg physicist Orest Khvolson, among others. The prize was actually awarded to Einstein in 1922 (for 1921), but for his discovery of the photoelectric effect, not for relativity (Pais, pp. 506–7).

5. Wilhelm Ostwald, *Monism as the Goal of Civilization* (Leipzig: Spamersche Buchdruckerei, 1913).

6. On Ostwald and Bogdanov, see Dietrich Grille, *Lenins Rivale: Bogdanov und seine Philosophie* (Köln: Verlag Wissenschaft und Politik, 1966), pp. 108–9. Although it was less well known in Russia generally, another important source for Bogdanov's notions of energetic systems was the work of the minor German philosopher

Ludwig Noiré. In the 1870s Noiré also attempted to construct a monistic system utilizing the principle of conservation of energy as one of its structural elements. On Bogdanov and Noiré see James White, "Sources and Precursors of Bogdanov's Tektology," in John Biggart, Peter Dudley, and Francis King, eds., *Alexander Bogdanov and the Origins of Systems Thinking in Russia* (Aldershot: Ashgate, 1998), pp. 25–42, and Grille, *Lenins Rivale*, pp. 79–91.

7. Bogdanov was first imprisoned in Moscow, and then from 1900 he was in exile, first in Kaluga, and then from 1901 for three years in Vologda. Alexander Vucinich, *Social Thought in Tsarist Russia* (Chicago: University of Chicago Press, 1976), p. 206; and *Neizvestnyi Bogdanov: A. A. Bogdanov (Malinovskii) Stat'i, doklady, pis'ma I vospominaniia 1901–1928 gg.* Kniga 1. Moscow: ITs <<AIRO—XX>>, 1995, pp. 5, 15, 23.

8. Vucinich, *Social Thought*, p. 207, and Zenovia A. Sochor, *Revolution and Culture: The Bogdanov-Lenin Controversy* (Ithaca: Cornell University Press, 1988), p. 7.

9. After the Revolution, Anna Alexandrovna Malinovskaia (1883–1959) was head of the children's colony at Tsarskoe Selo outside of Petrograd. In the 1920s she published several works of fiction. She and Lunacharsky were divorced in 1922, a time when Bogdanov was under severe attack by Lenin.

10. *Vseobshchaia organizatsionnaia nauka (Tektologiia)* [A General Organizational Science (Tektology)]. Part 1 (St. Petersburg: Izdanie M. I. Semenova, 1913); Part 2 (Moscow: Tovarishchestvo "Knigoizdatelstvo pisatelei v Moskve," 1917); Parts 1, 2, 3 (Berlin, Petrograd, Moscow: "Grzhebin," 1922). Further revised editions were published in 1925, 1927, and 1929. German language editions were published in Berlin in 1921, 1926, and 1928.

11. A. Bogdanov, *Essays in Tektology: The General Science of Organization*, trans. George Gorelijk (Seaside, Calif.: Intersystems, 1980), p. 56.

12. Sochor, *Revolution and Culture*, p. 19, and Iu. P. Sharapov, "Lenin i Bogdanov: ot sotrudnichestva k protivostoianiiu," *Otechestvennia istoriia* 5 (1997), 55–67. On Bogdanov's repression and recent rehabilitation, see John Biggart, "The Rehabilitation of Bogdanov," in John Biggart, Georgii Gloveli, and Avraham Yassour, ed., *Bogdanov and His Work*. (Aldershot: Ashgate, 1998), pp. 3–39.

13. On Bogdanov's connection with cybernetics, see Ilmari Susiluoto, *The Origins and Development of Systems Thinking in the Soviet Union* (Helsinki: Suomalainen Tiedeakatemia, 1982), p. 64; Kenneth Michael Stokes, *Paradigm Lost: A Cultural and Systems Theoretical Critique of Political Economy* (Armonk, N.Y.: M. E. Sharpe, 1995), p.278; and Biggart et al., *Alexander Bogdanov and the Origins of Systems Thinking in Russia*.

14. Aleksandr Bogdanov, "Printsip otnositelnosti s organizatsionnoi tochki zreniia," in *Teoriia otnositelnosti Einshteina, i ee filosofskoe istolkovaniie* (Moscow: Izd-vo "Mir," 1923), pp. 101–22, and Bogdanov, "Obektivnoe ponimanie printsipa otnositelnosti," *Vestnik: Kommunisticheskaia Akademiia* 8:332–347.

15. Even in the years before the Revolution, the Russian avant-garde had a special interest in science. Two of the major theorists of pre-Revolutionary avant-garde painting were Nikolai Kulbin and Velimir Khlebnikov. Kulbin was a physician and a psychiatrist, a well-respected professor at the Military Medical Academy in St. Pe-

tersburg. His theories of symbolism and sensation, based on Fechner, Mach, and Helmholtz, informed much of the new Russian painting before 1914. Khlebnikov, the son of a naturalist, studied mathematics and natural science at the Universities of Kazan (Lobachevsky's old university) and St. Petersburg. He was familiar with Ostwald's ideas by 1911, at the latest. Thus the post-Revolutionary avant-garde came legitimately, so to speak, to their interest in science.

16. Alexander Bogdanov, *Iskusstvo i rabochii klass* (Art and the Working Class) (Moscow: Proletarskaia kultura, 1918).

17. On Proletkult and art see also the documents published in *Gorn*, 1923, and reprinted in I. Matsa, *Sovetskoe iskusstvo za 15 let* (Moscow, Leningrad: OGIZ-IZOGIZ, 1933), pp. 276–79.

18. This was widely known at the time. Oliver Botar has pointed out that until 1923, even Hungarian artists understood that the Russian Proletkult specifically included the leftist avant-garde. In this, of course, they were not mistaken. Oliver A. I. Botar, "Hungarian Émigré Politico-Cultural Journals, 1922–1924," in Virginia Hagelstein Marquardt, ed., *Art and Journals on the Political Front 1910–1940* (Gainesville, Florida: University Press of Florida, 1997), p. 102.

19. N. N. Punin, *Pervyi tsikl lektsii chitannykh na kratkosrochnykh kursakh dlia uchitelei risovaniia* (Petrograd: Otdel izobrazit. iskusstva Narkomprosa, 1920), p. 58.

20. Ostwald's *Die Harmonie der Farben* was published in Leipzig in 1923, and appeared in Russian as *Tsvetovedenie* (Moscow, Leningrad: Promizdat, 1926). The publication of Matiushin's group was *Spravochnik po tsvetu* (Leningrad: OGIZ-IZOGIZ, 1932).

21. The author thanks Professor Zoya Ender, Rome, for this information.

22. Maria Ender, Diary. Private archives.

23. On the origin of suprematism, see Charlotte Douglas, *Swans of Other Worlds: Kazimir Malevich and the Origins of Abstraction in Russia* (Ann Arbor: UMI Research Press, 1980).

24. Malevich's use of concepts and terms drawn from thermodynamics and energetics has been recognized for some time. In a series of articles in 1978 the Czech art historians Miroslav Lamac and Jiri Padrta analyzed Malevich's confusing texts, teasing out basic principles of what they termed his "energetic aesthetics," but without referring these to particular sources. In a more recent doctoral dissertation, John Hatch points out a number of parallels between Malevich's texts and Ostwald's energetics, but works from English versions of Malevich's texts, and does not consider Bogdanov or other Russian sources for Ostwald. John George Hatch, *Nature's Laws and the Changing Image of Reality in Art and Physics: A Study of the Visual Arts, 1910–1940*, Ph.D. thesis, University of Essex, 1995.

25. *Boris Fedorovich Rybchenkov. Katalog vystavki* (Moscow: Sovetskii khudozhnik, 1989), p. 17.

26. Kazimir Malevich, "Draft for a Discussion of Suprematism" (1921?), in *Russian Avant-Garde 1910–1930: The G. Costakis Collection. Theory–Criticism*, ed. Anna Kafetsi (Athens: National Gallery and Alexandros Soutzos Museum, 1995), p. 566.

27. *Trudy VNIITE. 59. Stranitsy istorii otechestvennogo dizaina* (Moscow: Vse-

soiuznyi nauchno-issledovatelskii institut tekhnicheskoi estetiki, 1989), p. 161. A similar text is given in English in *Russian Avant-Garde*, p. 566.

28. Malevich also maintained that the Petrograd Proletkult had sponsored a course of his lectures in 1922. Eventually he moved away from his energetic philosophy to a purely transcendental idealism.

29. *Katalog desiatoi gosudarstvennoi vystavki. Bespredmetnoe tvorchestvo i suprematizm* (Moscow: Tip. T-va Kushnereva, 1919), p. 22.

30. On its stretcher, the painting is entitled merely *Construction. Painterly Construction* has come to be its standard title in English, although a better translation of the Russian title would be *Painted Construction.*

31. *Katalog desiatoi gosudarstvennoi vystavki*, p. 23.

32. *Iz istorii moskovskogo universiteta 1917–1941* (Moscow: Izdatelstvo moskovskogo universiteta, 1955), p. 118, and Anthony Mansueto, "From Dialectic to Organization: Bogdanov's Contribution to Social Theory," *Studies in East European Thought* 48:1 (March, 1996), 53. Bogdanov was a member of the Russian Academy of Artistic Sciences from the time of its incorporation on October 7, 1921. Three weeks later, on October, 29, 1921, he read a paper to the membership entitled, "The Social-Organizational Significance of Art." A typescript of the theses of this talk is held in the Getty Archives in California. This lecture was followed by another given by Arvatov on a similar topic, "Style and Stylization as Socio-Organizational Phenomena." See John E. Bowlt, ed., *Russian Art of the Avant-Garde* (New York: Viking Press, 1976), p. 197.

33. S. O. Khan-Magomedov, *INKhUK i rannii konstruktivizm* (Moscow: Architectura, 1994), p. 185.

34. *Konstruktivisty*. Katalog (Moscow: Kafe poetov, 1922), p. 1.

35. L. Popova, "K risunkam" (1921); Khan-Magomedov, S. O. *INKhUK i rannii konstruktivizm* (Moscow: Architectura, 1994), p. 188.

36. L. Popova, "Sushchnost ditsiplin" (1921); reproduced photographically in N. L. Adaskina and D. S. Sarabianov, *Popova* (New York: Harry N. Abrams, 1990), p. 370.

37. Quoted from the unpublished archives of Kudriashev in Kostin, Vladimir, *OST* (Leningrad: Khudozhnik R.S.F.S.R., 1976), p. 25. Kudriashev had been a student of Malevich at the Free Art Studios in Moscow. His father made wooden models for Konstantin Tsiolkovsky, and introduced his son to the legendary inventor. Color reproductions of work by Kudriashev and several of the other artists mentioned in this essay may be found in the exhibition catalogue, *The Great Utopia: The Russian and Soviet Avant-Garde 1915–1932* (New York: Guggenheim Museum, 1992).

38. Quoted from Redko's archive in Irina Lebedeva, "Lirika nauki—'elektro-organizm' i 'proektsionizm,'" *Velikaia utopiia: Russkii i sovetskii avangard 1915–1932* (Moscow: Galart, 1993), p. 192. Redko's statements are contained in a list of observations about painting and luminosity; the others were: "Astronomy and meteorology are the analytic means of a painting. Light in a painting is not light, but luminosity. The synthesis of color-forms in a painting is the transit of luminosity by currents of matter. The consciousness of a painting: the movement of currents

of gasses of the atmosphere—measured by luminosity" (Lebedeva, "Lirika nauki," p. 192).

39. Kazimir Malevich, "1/49; The World as Non-Objectivity," *The World as Non-Objectivity*, ed. Troels Andersen (Copenhagen: Borgen, 1976), pp. 310–11.

40. "Transcript of the Discussion of Comrade Stepanova's Paper 'On Constructivism,' December 22 1921," *Russian Avant-Garde*, p. 668.

41. V. I. Kostin, "Zhizn i tvorchestvo Klimenta Nikolaevicha Redko," Kliment Redko, *Parizhkii dnevnik* (Moscow: Sovetskii khudozhnik, 1992), p. 10.

42. Lebedeva, p. 187.

43. Lebedeva, p. 192.

44. Lebedeva, pp. 188–89.

45. The painting is in the State Tretiakov Gallery, Moscow.

46. A. Bogdanov, "Metody truda i metody poznaniia," *Voprosy sotsializma* (Moscow: Izdatelstvo politicheskoi literatury, 1990), pp. 389–90; and P. A. Pliutto, "Vremiia i liudi (iz arkhivov A. A. Bogdanov)," *Sotsiologicheskie issledovaniia* 11 (1992), 138–42.

47. N. N. Punin, *Pervyi tsikl lektsii*, p. 83.

PART 2 INTRODUCTION

1. On these discoveries and their impact, see, e.g., Linda D. Henderson, "X-Rays and the Quest for Invisible Reality in the Art of Kupka, Duchamp, and the Cubists," *Art Journal* 47 (Winter 1988), 323–40.

2. The ether "was widely taken for fact. Yet it bore even more basic marks of a fiction: it was an imaginative construct, derived in significant part by metaphor and analogy" (Donald R. Benson, "Facts and Fictions in Scientific Discourse: The Case of the Ether," *The Georgia Review* 38 [Winter 1984], 837).

3. William R. Everdell, *The First Moderns: Profiles in the Origins of Twentieth-Century Thought* (Chicago: University of Chicago Press, 1998), pp. 351–60. On the importance of distinguishing between earlier and later modernisms, see Bruce Clarke, *Dora Marsden and Early Modernism: Gender, Individualism, Science* (Ann Arbor: University of Michigan Press, 1996), pp. 4–7.

4. Einstein's theories did not gain immediate acceptance, especially in France, where science was dominated by the figure of Henri Poincaré. On this subject, see, e.g., Stanley Goldberg, *Understanding Relativity: Origin and Impact of a Scientific Revolution* (Boston: Birkhäuser, 1984), chap. 7.

CHAPTER 4

1. John Joly to Joseph Larmor, 16 March 1914, Joseph Larmor Collection, Royal Society of London.

2. On the history of ether theories, see E. T. Whittaker, *A History of the Theo-*

ries of Aether and Electricity, 2 vols. (London: Nelson, 1951–1953), and G. N. Cantor and M. J. S. Hodge, eds., *Conceptions of Ether: Studies in the History of Ether Theories, 1740–1900* (Cambridge: Cambridge University Press, 1981).

3. James Clerk Maxwell, "On Physical Lines of Force," *Philosophical Magazine* (1861–62), reprinted in Maxwell, *The Scientific Papers of James Clerk Maxwell*, ed. W. D. Niven, 2 vols. (Cambridge: Cambridge University Press, 1890), vol. 1, pp. 451–513.

4. Daniel M. Siegel, *Innovation in Maxwell's Electromagnetic Theory: Molecular Vortices, Displacement Current, and Light* (Cambridge: Cambridge University Press, 1991).

5. Bruce J. Hunt, *The Maxwellians* (Ithaca: Cornell University Press, 1991).

6. G. F. FitzGerald to Oliver J. Lodge, 3 Mar. 1894, Oliver J. Lodge Collection, University College London.

7. Oliver J. Lodge, *Modern Views of Electricity* (London: Macmillan, 1889).

8. Pierre Duhem, *The Aim and Structure of Physical Theory*, from the 2nd French edition, P. P. Wiener, trans. (1914; Princeton: Princeton University Press, 1954), pp. 70–71.

9. G. F. FitzGerald, "On the Structure of Mechanical Models illustrating some Properties of the Ether," *Philosophical Magazine* (1885), reprinted in FitzGerald, *The Scientific Writings of the Late George Francis FitzGerald*, ed. J. Larmor (Dublin: Hodges and Figgis, 1902), p. 162.

10. G. F. FitzGerald to Oliver J. Lodge, 1 Jan. 1885, Oliver J. Lodge Collection, University College London; G. F. FitzGerald to J. J. Thomson, 1 Jan. 1885, J. J. Thomson Collection, University Library, Cambridge.

11. G. F. FitzGerald to Oliver Heaviside, 25 Aug. 1893, Oliver Heaviside Collection, Institution of Electrical Engineers, London.

12. G. F. FitzGerald, "Electromagnetic Radiation," *Proceedings of the Royal Institution of Great Britain* (1890), reprinted in FitzGerald, *Scientific Writings*, p. 276.

13. Oliver J. Lodge, *The Ether of Space* (London: Harper, 1909), p. 97; cf. Lodge, *My Philosophy, Representing My Views on the Many Functions of the Ether of Space* (London: Benn, 1933), pp. 192–93. Lodge was a prominent psychical researcher and made the ether central to his theories of telepathy and communication with the dead. By the 1920s he had come to regard the ether as "the vehicle of Soul, the habitation of Spirit" and "the living garment of God"; Lodge, *Ether and Reality: A Series of Discourses on the Many Functions of the Ether of Space* (New York: Doran, 1925), p. 179.

14. Oliver Heaviside to G. F. FitzGerald, 30 Aug. 1893, G. F. FitzGerald Collection, Royal Dublin Society, Dublin.

15. Oliver Heaviside to Heinrich Hertz, 14 Aug. 1889, Heinrich Hertz Collection, Deutsches Museum, Munich.

16. Duhem, *Aim and Structure*, pp. 76–80.

17. Kelvin to G. F. FitzGerald, 9 April 1896, in S. P. Thompson, *The Life of Sir William Thomson, Baron Kelvin of Largs*, 2 vols. (London: Macmillan, 1910), 2:1065. William Thomson gave Victorian physics much of its strongly mechanical flavor, and in 1892 was made Lord Kelvin for his achievements.

18. Lord Kelvin, remarks at 1901 meeting of the British Association for the Advancement of Science, quoted in Thompson, *Kelvin*, 2:1161.

19. Lodge, *My Philosophy*. J. J. Thomson, the discoverer of the electron, also continued to believe in the ether; see his *Recollections and Reflections* (London: G. Bell, 1936), p. 432.

20. Albert Einstein, in P. A. Schilpp, ed., *Albert Einstein: Philosopher-Scientist*, 2 vols. (Evanston: Library of Living Philosophers, 1949), 1:27.

CHAPTER 5

1. Ezra Pound, "The Wisdom of Poetry," *Forum* (1912); in *Selected Prose of Ezra Pound*, ed. William Cookson (London: Faber and Faber, 1973), p. 330.

2. Ezra Pound, "The Serious Artist," *The New Freewoman* (1913); in *Literary Essays of Ezra Pound*, ed. T. S. Eliot (London: Faber and Faber, 1954), p. 49.

3. Ezra Pound, "Medievalism," *The Dial* (1928); in *Literary Essays*, p. 154.

4. Ezra Pound, *The Chinese Written Character as a Medium for Poetry* (1920; San Francisco: City Lights Books, 1969), pp. 26, 10, 12.

5. J. G. McKendrick, *H. L. F. von Helmholtz* (London: Macmillan, 1899), p. 199.

6. Preface to Leo Koenigsberger, *Hermann von Helmholtz*, trans. F. A. Welby (1902; Oxford: Oxford University Press, 1906), p. v.

7. Pound, *Chinese Written Character*, p. 22.

8. The bulk of the scholarship on this topic has been accomplished by Linda Dalrymple Henderson: see in particular *The Fourth Dimension and Non-Euclidean Geometry in Modern Art* (Princeton: Princeton University Press, 1983), and "Modern Art and the Invisible: The Unseen Waves and Dimensions of Occultism and Science," in *Okkultismus und Avantgarde 1900–1915* (Exhibition Catalogue, Schirn Kunsthalle, Frankfurt, 1995).

9. See the excerpts from Blavatsky's *Isis Unveiled*, vol.1, pp. 182–85, cited in this volume in Henderson's "Vibratory Modernism."

10. Ezra Pound, "Psychology & Troubadours," *Quest* (1912); in Pound, *The Spirit of Romance*, rev. ed. (London: Peter Owen, 1970), pp. 93–95.

11. Pound, *Chinese Written Character*, pp. 21–22.

12. For a brilliant explication of Mach and empirio-criticism on behalf of this issue, see Martin A Kayman, *The Modernism of Ezra Pound: The Science of Poetry* (London: Macmillan, 1986), pp. 85–103.

13. Ernst Mach, *Popular Scientific Lectures* (1894), trans. T. J. McCormack (London: A. and C. Black, 1898), pp. 205, 211, 206.

14. Ernst Mach, *The Analysis of Sensations*, trans. C. M. Williams (1897; New York: Dover, 1959), p. 89.

15. Mach, *Popular Scientific Lectures*, p. 250.

16. Henri Poincaré, *The Value of Science*, trans. George Bruce (1908; New York: Dover, 1958), p. 79.

17. Pound, *Chinese Written Character*, p. 21.

18. Kayman, *Modernism of Ezra Pound*, p. 92.

19. Henderson, *The Fourth Dimension*, pp. 6, 17, 339.

20. Karl Pearson, *The Grammar of Science* (1892; London: A. and C. Black, 1900), pp. viii, 103. To claim the shift from "explanation" to "description" as liberatory is not to argue for its universal acceptability. As M. Norton Wise has suggested to me in conversation, it would be difficult to imagine Einstein, to take but one example, as subscribing to such freedom. Nevertheless, the move graphed by Mach, Poincaré, Pearson, and their sympathizers does register a notable turn in late nineteenth-century thought and feeds directly into the particular trope of creativity I advance here.

21. Arthur Eddington, *The Nature of the Physical World* (Cambridge: Cambridge University Press, 1928), p. 301, xvii.

22. Pound, *Chinese Written Character*, pp. 24–25.

23. Mach, *Popular Scientific Lectures*, p. 250.

24. Respectively, in "Modern Art and the Invisible," and "Charles Howard Hinton's Fourth Dimension and the Aether of Space," forthcoming in *Modernism's Fourth Dimensions*, ed. Bruce Clarke and Linda Henderson (Penn. State UP).

25. *The Scientific Papers of James Clerk Maxwell*, ed. W. D. Niven, 2 vols. (Cambridge: Cambridge University Press, 1890), 1:156.

26. Margaret Morrison, "A Study in Theory Unification: The Case of Maxwell's Electromagnetic Theory," *Studies in the History and Philosophy of Science* 23:1 (1992), 107.

27. Pound, *Chinese Written Character*, pp. 11–12.

28. Bruce Clarke, *Energy Forms: Allegory and Science in the Era of Classical Thermodynamics* (Ann Arbor: University of Michigan Press, 2001), pp. 89–95.

29. See also Donald Benson, "Facts and Fictions in Scientific Discourse: The Case of Ether," *Georgia Review* 38 (1984), 836–37.

30. See my "Mauberley's Barrier of Style," in *Ezra Pound: The London Years: 1908–1921*, ed. Philip Grover (New York: AMS Press, 1978), pp. 155–64.

31. This is an arena shared by the extraordinary novelistic/scientific nexus of Henry and William James. For a fascinatingly suggestive pointer in this direction, see Richard Poirier, "In Praise of Vagueness," *London Review of Books* (December 14, 1995), 10–12.

CHAPTER 6

1. Einstein's general theory of relativity (1916) as well as the special theory became news items in 1919, when observations during an eclipse of the sun that year validated one of the tenets of the general theory. On the slow acceptance of Einstein's theories by scientists in France, England, and America, see Stanley Goldberg, *Understanding Relativity: Origin and Impact of a Scientific Revolution* (Boston: Birkhäuser, 1984), chaps. 7–9. The development of wireless telegraphy by the later 1890s,

grounded in Heinrich Hertz's confirmation of the existence of electromagnetic waves in 1888, was probably the single greatest stimulus to popular interest in electromagnetic waves and the ether. On the ether, in addition to Bruce Hunt's essay in this volume, see E. T. Whittaker, *A History of Theories of Aether and Electricity* (London: Longmans, Green, 1910); and G. N. Cantor and M. J. S. Hodge, *Conceptions of Ether: A Study in the History of Ether Theories 1740–1900* (Cambridge: Cambridge University Press, 1981). On the ether's fictional status, see Donald R. Benson, "Facts and Fictions in Scientific Discourse: The Case of the Ether," *The Georgia Review* 38 (Winter 1984), 825–37.

2. For these developments, see Alex Keller, *The Infancy of Atomic Physics: Hercules in His Cradle* (Oxford: Clarendon Press, 1983).

3. Boccioni, "Selected Notes for the Lecture on Futurist Painting," in Metropolitan Museum of Art, *Umberto Boccioni*, curated by Esther Coen (New York, 1988), p. 239.

4. The brief treatment of Duchamp at the conclusion of this essay is drawn from Linda D. Henderson, *Duchamp in Context* (Princeton: Princeton University Press, 1998), where much of the science and occultism discussed here is addressed more fully. Kupka's engagement with wireless telegraphy is also treated more extensively in chapter 8 of that book. Sections of the discussions of Kupka and Boccioni herein first appeared in Henderson, "Kupka, les rayons X, et le monde des ondes éléctromagnétiques," in Musée d'Art Moderne de la Ville de Paris, *František Kupka, 1871–1957, ou l'invention d'une abstraction*, ed. Krisztina Passuth (Paris, 1990), pp. 51–57; or in Henderson, "Die moderne Kunst und die Unsichtbare: Die verborgenen Wellen und Dimensionen des Okkultismus und der Wissenschaften," in Schirn Kunsthalle, Frankfurt, *Okkultismus und Avantgarde: Von Munch bis Mondrian, 1900–1915* (Frankfurt, 1995), pp. 13–31. Although unknown to me at the time of this writing, Friedrich Teja Bach discusses the importance of the theme of vibration (in both occultism and science) for the sculptor Brancusi in *Constantin Brancusi: Metamorphosen plasticher Form* (Cologne: DuMont, 1987).

5. F. T. Marinetti, "Technical Manifesto of Futurist Literature," in *Marinetti: Selected Writings*, ed. R. W. Flint (New York: Farrar, Straus and Giroux, 1972), p. 89. Apollinaire's poem was first published in *Les Soirées de Paris* (no. 25 [June 15, 1914], pp. 340–41) and appeared subsequently in his collection *Calligrammes* (Paris: Mercure de France, 1918).

6. Ezra Pound, "The Approach to Paris, I," *The New Age* 13 (September 11, 1913), 578. For Pound's "on the watch" reference, see "The Wisdom of Poetry," *The Forum* 47 (April 1912), 500; in Ezra Pound, *Selected Prose 1909–1965*, ed. William Cookson (London: Faber and Faber, 1973), p. 331. On Pound's engagement with electromagnetic waves as well as his more general interest in both geometry and science in this period (uncannily parallel to Duchamp's own), see Ian F. A. Bell, *Critic as Scientist: The Modernist Poetics of Ezra Pound* (London: Methuen, 1981), as well as his essay in this volume.

7. See *Arc Voltaic* (Barcelona), no. 1 (Feb. 1918). Apollinaire's friends Robert

and Sonia Delaunay were part of the expatriot community in Barcelona and collaborated with Barradas. For information on Barradas, I am grateful to University of Texas graduate student David Jared Morse, who recently completed a master's thesis entitled "Rafael Barradas and *Vibracionismo*: Science and Spirituality in Spanish Avant-Garde Art" (December, 2001). Roger Shattuck discusses an episode in the prehistory of this moment of such interest in invisible vibrations in his essay "Vibratory Organism: Baudelaire's First Prose Poem," in *The Inner Eye: On Modern Literature & the Arts* (New York: Farrar Straus Giroux, 1984), 135–48. Borrowing the phrase "vibratory organism" from Alfred North Whitehead's 1925 *Science and the Modern World*, Shattuck discusses Baudelaire's celebration of the "perpetual vibration" of the "great symphony of daylight" (i.e., visible light and color) in the chapter "On Color" of his *Salon of 1846*.

8. See Keller, *Infancy of Atomic Physics*, p. 20.

9. Edwin Houston, "Cerebral Radiation," *Journal of the Franklin Institute* 133 (June 1892), 489.

10. On Kelvin's vortex atoms, see Cantor and Hodge, *Conceptions of Ether*, 239–68. See also Oliver Lodge, "Electric Theory of Matter," *Harper's Monthly Magazine* 109 (August 1904), 383–89.

11. "Address by The Right Hon. A. J. Balfour," *Report of the Seventy-Fourth Meeting of the British Association for the Advancement of Science (1904)* (London: John Murray, 1905), p. 7. According to Lord Balfour, "Without the ether an electric theory of matter is impossible" (p. 6).

12. See Gustave Le Bon, *L'Évolution de la matière* (Paris: Ernest Flammarion, 1905).

13. On the popular conception of the fourth dimension as well as its ether associations, see Linda D. Henderson, *The Fourth Dimension and Non-Euclidean Geometry in Modern Art* (Princeton: Princeton University Press, 1983; new ed., Cambridge, Mass.: MIT Press, 2003).

14. See Sixten Ringbom, *The Sounding Cosmos: A Study in the Spiritualism of Kandinsky and the Genesis of Abstract Painting* (Abo: Abo Akademi, 1970), p. 37.

15. For the quoted phrases, see H. P. Blavatsky, *Isis Unveiled: A Master-Key to the Mysteries of Ancient and Modern Science and Theology* (New York: W. Q. Judge, 1877), I, pp. 129–30, 134.

16. Stewart and Tait, as quoted in Blavatsky, *Isis Unveiled*, I, p. 188.

17. Ibid., pp. 182–85. I am grateful to Bruce Clarke for directing my attention back to Blavatsky and these passages. See his *Energy Forms: Allegory and Science in the Era of Classical Thermodynamics* (Ann Arbor: University of Michigan Press, 2001), pp. 173-74.

18. B. Stewart and P. G. Tait, *The Unseen Universe, or Speculations on Future State*, 4th ed. rev. (London: Macmillan, 1876), p. 221. Gillian Beer also discusses Stewart and Tait's book, the ether, and the challenge of representing the invisible (in this case, in literature) in her essay "'Authentic Tidings of Invisible Things': Vision and the Invisible in the Later Nineteenth Century," in *Vision in Context: Historical and Contemporary Perspectives on Sight*, edited by Teresa Brennan and Martin Jay (New York: Routledge, 1996), pp. 83–98.

19. C. Howard Hinton, *A New Era of Thought* (London: Swan Sonnenschein, 1888), p. 53.

20. See, e.g., Albert de Rochas, *L'Extériorisation de la sensibilité* (1895), 6th ed. (Paris: Bibliothèque Chacornac, 1909), pp. 201–2.

21. See William Crookes, "De la relativité des connaissances humaines," *Revue Scientifique*, 4th ser., 7 (May 15, 1897), 612–13. See also Crookes, "Sir William Crookes on Psychical Research," *Annual Report of the Smithsonian Institution, 1899* (Washington, D.C.: Government Printing Office, 1901), p. 200.

22. Camille Flammarion, *The Unknown* (1900; New York and London: Harper & Brothers, 1901), p. 12.

23. "Address by Sir William Crookes, President," *Report of the Sixty-Eighth Meeting of the British Association for the Advancement of Science (1898)* (London: John Murray, 1899), p. 31. Crookes's address was published in Paris as "Les Progrès récents des sciences physiques," *Revue Scientifique*, 4th ser., 10 (Oct. 8, 1898), 449–57. Although she does not address Crookes, Lodge, or Flammarion, Laura Otis discusses the analogy between telegraphy and telepathy and its importance in literature in *Networking: Communicating with Bodies and Machines in the Nineteenth Century* (Ann Arbor: University of Michigan Press, 2001).

24. Umberto Boccioni et al, "Technical Manifesto of Futurist Painting," in *Futurist Manifestos*, ed. Umbro Apollonio (New York: Viking Press, 1973), p. 28 (with slight variation in translation: "mediumistic phenomena" versus "the medium"). The primary studies to date of futurism's engagement with the occult are Germano Celant, "Futurism and the Occult," *Artform* 19 (Jan. 1981), pp. 36–42; and Giovanni Lista, "Futurismus und Okkultismus," and Katherine Harlow Tighe, "Die Schriften von Umberto Boccioni," in *Okkultismus und Avant-Garde*, pp. 431–44; 469–76.

25. Boccioni diary, Dec. 21, 1907, in Metropolitan Museum, *Boccioni*, p. 257. For Boccioni's references to Hertzian waves, see Boccioni, *Dynamisme plastique: peinture et sculpture futuristes*, ed. Giovanni Lista (Lausanne: L'Age d'Homme, 1975), pp. 35, 105. This text is a translation of Boccioni's *Pittura scultura futuriste (dinamismo plastico)* (Milan: "Poesia," 1914).

26. Boccioni, "Futurist Painting" [Circolo Artistico lecture, 1911], in Metropolitan Museum, *Boccioni*, p. 232.

27. Ibid.; and Boccioni, *Dynamisme plastique*, p. 35.

28. Boccioni, "The Plastic Foundations of Futurist Sculpture and Painting" (1913), in *Futurist Manifestos*, ed. Apollonio, p. 89.

29. Ibid., p. 88.

30. Longhi, as quoted in Metropolitan Museum, *Boccioni*, p. 138. Boccioni's application of paint in individual stroke of pure color is rooted in Italian divisionism, a counterpart to Seurat's Neo-Impressionist style. Yet, Boccioni's brushwork is far from Seurat's methodical application of paint discussed in the essays by Shiff and Brain herein. For a detailed treatment of the painting's subject and relation to Boccioni's oeuvre as a whole, see the catalogue of the exhibition *Boccioni 1912 Materia* held at the Fondazione Antonio Mazzotta, Milan, in 1995. The backdrop behind Boccioni's mother on her balcony is the construction site of the Centrale Elettrica or central power plant of Milan.

31. In addition to the writings of Le Bon, occult sources regularly addressed such emanations; see Gaston Mery, "Le Radium et les effluves humaines," *L'Echo du Merveilleux* 8 (Jan. 1, 1904), 6–9. The writings of French occultists had a remarkable international currency in this period—both through book circulation and through the reprinting of articles in Italian journals. See, e.g., Albert de Rochas, "Registrazione fotografica degli esseri e radiazioni dello spazio," *Luce et Ombre*, no. 9 (Sept. 1908), pp. 425–36.

32. Boccioni, "Plastic Foundations," in *Futurist Manifestos*, ed. Apollonio, p. 89. See also Brian Petrie, "Boccioni and Bergson," *Burlington Magazine* 116 (March 1974), 140–47.

33. Boccioni, "Futurist Painting," in Metropolitan Museum, *Boccioni*, p. 238.

34. Boccioni, *Dynamisme plastique*, p. 102; see also "Futurist Painting and Sculpture (extracts)," in *Futurist Manifestos*, ed. Apollonio, p. 180.

35. Boccioni, *Dynamisme plastique*, p. 105.

36. On Faraday's and Maxwell's "lines of force," see Whittaker, *History*, pp. 217, 271. The futurists first introduced the concept of "force-lines," which turned the cubist grid into a dynamic system of vectors, in the catalogue of their February 1912 exhibition at the Galerie Bernheim-Jeune in Paris. See *Futurist Manifestos*, ed. Apollonio, pp. 45–50.

37. Boccioni, "Plastic Foundations," in *Futurist Manifestos*, p. 89. For the "sensible conductor" reference, see Boccioni, *Dynamisme plastique*, p. 82.

38. Boccioni, "Futurist Painting," in Metropolitan Museum, *Boccioni*, p. 238.

39. Boccioni, *Dynamisme plastique*, p. 105. Emphasis in original.

40. See again Blavatsky, *Isis Unveiled*, I, p. 185.

41. Oliver Lodge, *The Ether of Space* (London: Harper & Brothers, 1909), pp. 104–5.

42. See Henderson, *Fourth Dimension*, pp. 110–16.

43. Boccioni, *Dynamisme plastique*, p. 73.

44. C. Howard Hinton, *The Fourth Dimension* (London: Swan Sonnenschein, 1904), p. 27. For Boccioni's interest in "absolute" versus "relative" motion, see Boccioni, "Absolute Motion + Relative Motion = Dynamism," in *Futurist Manifestos*, ed. Apollonio, pp. 150–54; and *Dynamisme plastique*, pp. 69–72.

45. Boccioni, *Dynamisme plastique*, p. 104. Christine Poggi has discussed *Unique Forms of Continuity in Space* in terms of gender and the Futurist desire, articulated by Marinetti, to fuse the male body with the machine. See Christine Poggi, "Dreams of Metallized Flesh: Futurism and the Masculine Body," *Modernism/Modernity* 4 (Sept. 1997), 19–43. For an analysis of *Unique Forms of Continuity in Space* and the fourth dimension in the context of futurism's politicized aesthetics and the theories of Bergson, see Mark Antliff, "The Fourth Dimension and Futurism: A Politicized Space," *Art Bulletin* 82 (Dec. 2000), 720–33.

46. Kupka, Preliminary manuscript of "La Création dans les arts plastiques," chap. 7, p. 10 (courtesy Margit Rowell); *La Création dans les arts plastiques*, trans. Erika Adams (Paris: Cercle d'Art, 1989), p. 236. Because the 1989 publication of *La Création dans les arts plastiques* is a reconstruction of Kupka's text made using both

the original French manuscripts and the published Czech version (Prague, 1923), there are some critical changes in language. In particular, the editor's decision to replace the term *émission* by *énoncé* (see the text that follows at n.49) unfortunately distances the text from its pre-World War I origins. Kupka's original manuscripts are held today by Pierre Brullé, Paris. For Kupka's career as a whole, see Solomon R. Guggenheim Museum, *František Kupka, 1871–1957: A Retrospective*, curated by Margit Rowell (New York, 1975); Musée d'Art Moderne (Paris), *František Kupka*; and Dallas Museum of Art, *Painting the Universe: František Kupka, Pioneer of Abstraction*, curated by Jaroslav Andel and Dorothy Kosinski (Dallas, 1997).

47. See Guggenheim Museum, *Kupka*, pp. 75–77, 308. For a fuller discussion of Kupka and X-rays, see Linda D. Henderson, "X Rays and the Quest for Invisible Reality in the Art of Kupka, Duchamp, and the Cubists," *Art Journal* 47 (Winter 1988), 323–40.

48. Kupka, Unpublished notebook (1910–1911), p. 21 (courtesy Margit Rowell).

49. Kupka, Manuscript treatise, chap. 7, p. 1; *La Création*, p. 229.

50. Hippolyte Baraduc, *L'Ame humaine: ses mouvements, ses lumières et l'iconographie de l'invisible fluidique* (Paris: Georges Carré, 1896), pp. 3, 107–22.

51. Annie Besant and C[harles] W[ebster], *Thought-Forms* (1901; London: Theosophical Publishing Society, 1905), introduction.

52. For Lodge, see again Rochas, *L'Extériorisation*, pp. 201–2; for Houston's text, see ibid., "Note G" ("La Radiation cérébrale"), pp. 231–41. See again note 9 for Houston's lecture as published in the *Journal of the Franklin Institute*.

53. Houston, "Radiation cérébrale," in Rochas, *L'Extériorisation*, pp. 232, 236, 238.

54. Ibid., p. 240. See also Besant and Leadbeater, *Thought-Forms*, p. 14. Houston's original article had suggested that the generation of "ether waves" would require passing light through the photographic image; however, Rochas's translation supports the view, adopted by Kupka, that the graphic image itself could induce the appropriate molecular vibrations in the viewer's brain.

55. Henry Fotherby, "L'Éther, véhicule de la conscience subliminale," *Annales des Science Psychiques* 16 (July 1906), 406–28.

56. Crookes, "De la relativité," p. 613; Crookes, "Sir William Crookes on Psychical Research," p. 201.

57. Crookes, 1898 BAAS address, p. 21.

58. See, e.g., Kupka, Manuscript treatise (handwritten chap. 5, p. 29); *La Création*, p. 207.

59. Kupka, Manuscript treatise, chap. 7, pp. 3–4; *La Création*, pp. 231–32. For the wireless telegraphy comparison, see Henderson, *Duchamp in Context*, p. 102.

60. Kupka, Manuscript treatise, chap. 7, p. 1 bis; *La Création*, p. 230.

61. Kupka, Manuscript treatise (handwritten chap. 5, p. 1); *La Création*, p. 146. For the painted canvas as a source of waves in the ether, see *La Création*, p. 255.

62. For Kandinsky's theories, see Rose-Carol Washton Long, *Kandinsky: The Development of an Abstract Style* (Oxford: Clarendon, 1980).

63. See Ringbom, *Sounding Cosmos*, pp. 51–52, 54–55, 122–23 on Crookes,

Flammarion, Baraduc, and Rochas. Although Ringbom's text included an unprecedented overview of "Thought Transference and Thought Images," his focus on Besant and Leadbeater eclipsed his larger contextual discussion. Donald Benson provides the fullest discussion to date of Kandinsky and ether vibrations in "Kandinsky's Dramatic Reconstitution of Pictoral Space," *Annals of Scholarship* 4 (1986), 110–21.

64. "Address by Balfour," p. 7.

65. Kandinsky, *On the Spiritual in Art*, in *Kandinsky: Complete Writings on Art*, ed. Kenneth C. Lindsay and Peter Vergo (New York: Da Capo, 1994), p. 142.

66. For Kandinsky's hidden imagery and its debt to Steiner, see Long, *Kandinsky*. On the role of dissonance and anarchism in the painter's thought, see Rose-Carol Washton Long, "Occultism, Anarchism, and Abstraction: Kandinsky's Art of the Future," *Art Journal* 46 (Spring 1987), 38–45.

67. Kandinsky, Letter to Schoenberg, Jan. 18, 1911; in *Arnold Schenberg—Wassily Kandinsky: Letters, Pictures and Documents*, ed. Jelena Hahl-Koch (London: Faber and Faber, 1984), p. 21.

68. See Wassily Kandinsky, "Stage Composition," in *The "Blaue Reiter" Almanac [Edited by Wassily Kandinsky and Franz Marc]*, ed. Klaus Lankheit (New York: Viking Press, 1974), pp. 190–91.

69. See Henderson, *Duchamp in Context*, chap. 1.

70. Duchamp had adopted the model of mechanical drawing for the "non-arty" expression he was seeking in his "painting of precision." See Henderson, *Duchamp in Context*, chapter 3.

71. On the Oculist Witnesses and their parallel to Augusto Righi's creation of a spark gap, see ibid., pp. 114–15. See also Hugh Aitken, *Syntony and Spark: The Origins of Radio* (New York: John Wiley, 1976), pp. 185–86.

72. Duchamp made his "service of the mind" statement in a 1946 interview with James Johnson Sweeney, reprinted in Michel Sanouillet and Elmer Peterson, eds., *Salt Seller: The Writings of Marcel Duchamp (Marchand du sel)* (New York: Oxford University Press, 1973), p. 125, emphasis in the original. For the "sketch" quotation, see ibid., p. 71.

73. Considering the notes to be as important as the *Glass* itself, Duchamp published three boxes of facsimile notes during his lifetime: the *Box of 1914* (16 notes), the 1934 *Green Box* (94 documents [notes/reproductions]), and the 1966 *White Box* (79 notes). These notes are collected in Sanouillet and Peterson, eds., *Salt Seller*, which has been reprinted as *The Writings of Marcel Duchamp* (New York: Da Capo Press, 1989). Over a decade after his death in 1968, a final group of 289 previously unknown notes was published in 1980 by the Centre Georges Pompidou under the title *Marcel Duchamp, Notes*. See that deluxe edition or *Marcel Duchamp, Notes*, ed. and trans. Paul Matisse (Boston: G. K. Hall, 1983). For Duchamp's reference to "playful physics," see Sanouillet and Peterson, eds., *Salt Seller*, p. 49; for "painting of frequency," see ibid., p. 25.

74. See ibid., pp. 36, 38–39, 42, 44; and *Marcel Duchamp, Notes*, ed. Matisse, p. 4, notes 143, 153. The wireless telegraphy paradigm underlying the *Large Glass* is chronicled in Henderson, *Duchamp in Context*, chapter 8.

75. For Branly's experiments, see, for example, E. Monier, *La Télégraphie sans*

fil, la télémécanique, et la téléphonie san fils à la portée de tout le monde, 9th ed. (Paris: H. Dunod & E. Pinat, 1917), chapter 7.

76. On dimensional contrasts in the *Large Glass*, see Henderson, *Duchamp in Context*, pp. 80–85; and Linda D. Henderson, "Etherial Bride and Mechanical Bachelors: Science and Allegory in Marcel Duchamp's 'Large Glass,'" *Configurations* 4 (Winter 1996), 91–120.

77. Raymond Duchamp-Villon, "Manuscript Notes," in William Agee, *Raymond Duchamp-Villon* (New York: Walker, 1967), p. 112.

78. See Sanouillet and Peterson, eds., *Salt Seller*, pp. 36, 38, 42.

79. See ibid., p. 42; Baraduc, *L'Ame humaine*, p. 3.

80. See, for example, Jean Clair, *Duchamp et la photographie* (Paris: Éditions du Chêne, 1977), chapter 4; see also Henderson, *Duchamp in Context*, chapter 8, pp. 115–20.

81. Duchamp, as quoted in Pierre Cabanne, *Dialogues with Marcel Duchamp*, trans. Ron Padgett (New York: Viking Press, 1971), p. 75.

82. Edward Carpenter, *The Art of Creation: Essays on the Self and Its Powers* (London: George Allen, 1907), pp. 33–34. Although Carpenter's language echoes the general preoccupation with ether vibrations, he does not actually refer to the ether. In *Energy Forms*, Bruce Clarke analyses (pp. 196–202) Carpenter's ambiguous stance toward the ether as demonstrated in varying editions of the essay "Modern Science: A Criticism" included in his *Civilization: Its Cause and Cure* (London: Swan Sonnenschein, 1889), which was in its fourteenth edition in 1921.

PART 3 INTRODUCTION

1. See again the discussion of Latour in the section "Issues of Representation" in the Introduction. David Phillips has utilized Latour's ideas on inscriptions in his discussion of eighteenth- and nineteenth-century scientific images of patterns registered automatically (e.g., the Chladni figures discussed by Douglas Kahn), nineteenth-century spiritualists' "automatic drawings," and early abstract painting. See David Phillips, "Abstraction and Truth in Nineteenth-Century Imagery," *Bulletin of the John Rylands University Library of Manchester* 78 (Spring 1996), 123–42.

2. On Duchamp's interest in registering instruments and his self-fashioning as an artist–engineer, see Linda D. Henderson, *Duchamp in Context: Science and Technology in the Large Glass and Related Works* (Princeton: Princeton University Press, 1998), chapters 3, 5, 8.

3. Brain notes the important article on registering instruments by Peter Galison and Lorraine Daston, "The Image of Objectivity," *Representations* 40 (Fall 1992), 81–128. The essays of Brain and Kahn in this volume are complemented by Thomas L. Hankins and Robert J. Silverman's chapter entitled "Science Since Babel: Graphs, Automatic Recording Devices, and the Universal Language of Instruments," in *Instruments and the Imagination* (Princeton: Princeton University Press, 1995).

4. Friedrich Kittler also discusses this "found" inscription in Rilke's "Primal

Sound": "What the coronal suture yields upon replay is a primal sound without a name, a music without notation," in Geoffrey Winthrop-Young and Michael Wutz, trans. and intro., *Gramophone, Film, Typewriter* (Stanford: Stanford University Press, 1999), p. 46. Kahn provides another discussion of the issue of inscription, along with the issues of vibration and transmission, in his introduction to the anthology edited by Douglas Kahn and Gregory Whitehead, *Wireless Imagination: Sound, Radio, and the Avant-Garde* (Cambridge, Mass.: MIT Press, 1992), pp. 14–26.

5. Marcel Duchamp, as quoted in Georges Charbonnier, *Entretiens avec Marcel Duchamp* (Paris: Andre Dimanche, 1994), p. 59.

6. Piet Mondrian, "Natural and Abstract Reality" (1919), in Michel Seuphor, *Piet Mondrian: Life and Work* (New York: Harry N. Abrams, 1956), p. 321.

7. Arnaud Pierre has established that most of Picabia's works produced between early 1918 and late 1922 were based on illustrations in *La Science et la Vie*; see Pierre, "Sources inédites pour l'oeuvre machiniste de Francis Picabia, 1918–1922," *Bulletin de la Société de l'Histoire de l'Art français*, (1991), 255–81. For Moholy-Nagy's *Dynamic Constructive Energy System*, see Krisztina Passuth, *Moholy-Nagy* (New York: Thames and Hudson, 1985), plate 17.

8. Paul Klee, "Creative Credo" (1920), in Herschel B. Chipp, ed., *Theories of Modern Art* (Berkeley: University of California Press, 1968), p. 182. Klee's interests included Chladni figures; see Jürg Spiller, ed., Heinz Norden, trans., *Paul Klee: Notebooks*, Vol. 2, *The Nature of Nature* (New York: George Wittenborn, 1973), pp. 44–45. The scholar who has worked most extensively on Klee and science is Sarah Lynn Henry. See, e.g., her articles, "Form-Creating Energies: Paul Klee and Physics," *Arts Magazine* 52 (Sept. 1977), 118–21; and "Paul Klee's Pictorial Mechanics from Physics to the Picture Plane," *Pantheon* 48 (1989), 147–65. See also the insightful text by K. Porter Aichelle, "Paul Klee and the Energetics-Atomistics Controversy," *Leonardo* 26 (1993), 309–15.

9. See Charlotte Douglas, *Kazimir Malevich* (New York: Harry N. Abrams, 1994), pp. 27, 86.

10. See Douglas, *Malevich*, pp. 30–31; and Matthew Looper, "The Pathology of Painting: Tuberculosis as a Metaphor in the Art Theory of Kazimir Malevich," *Configurations* 3 (Winter 1995), 27–46.

11. Maria Ender, Diary. Private archives.

12. Ibid.

13. Interestingly, the surrealists also used the metaphor of the registering instrument to describe their process of automatic drawing, but here the information recorded was the highly personal, nervous line meant to express the psyche of the artist. See, for example, Jennifer Gibson, "Surrealism Before Freud: Dynamic Psychiatry's 'Simple Recording Instrument,'" *Art Journal* 46 (Spring 1987), 56–60.

CHAPTER 7

1. For some of the most important revisionist accounts, see Paul N. Edwards, *The Closed World: Computers and the Politics of Discourse in Cold War America* (Cam-

bridge, Mass.: MIT Press, 1996); Friedrich Kittler, *Discourse Networks 1800/1900*, trans. Michael Metteer, with Chris Cullens (Stanford: Stanford University Press, 1990); and Armand Mattelart, *L'invention de la Communication* (Paris: La Découverte, 1994). I take *genealogy* in the spirit of Nietzsche, in his *Zur Genealogie der Moral*, and especially Michel Foucault's important reading of his uses of this term in "Nietzsche, Genealogy, History," in Donald F. Bouchard, ed., *Language, Counter-Memory, Practice: Selected Essays and Interviews by Michel Foucault* (Ithaca: Cornell University Press, 1977), pp. 139–64. For a perceptive summary of the standard historiographies of computing and information, see Michael Mahoney, "The History of Computing in the History of Technology," *Annals of the History of Computing* 10:2 (1988), 113–25. For an interesting example of the kind of teleological history that this approach seeks to avoid, see James R. Beniger, *The Control Revolution: Technological and Economic Origins of the Information Society* (Cambridge, Mass.: Harvard University Press, 1986).

2. Alfred Jarry, "Concerning the Line," chap. 36 of *Exploits & Opinions of Dr. Faustroll, Pataphysician. A Neo-Scientific Novel*, trans. Simon Watson Taylor, intro. Roger Shattuck (Boston: Exact Change Press, 1996), pp. 98–99. Jarry dedicates his chapter to the art critic Félix Fénéon, defender of the "scientific aesthetic," who appears later in this paper.

3. Arthur Cayley (1821–1895) was a prolific British mathematician of whom James Clerk Maxwell wrote: "Whose soul too large for vulgar space, in *n* dimensions flourished." Appropriately for Jarry, Cayley was the author of the magisterial entry "Curve" in the eleventh edition of the *Encyclopedia Britannica*.

4. Jarry, "Concerning the Line," *Exploits & Opinions*, pp. 98–99.

5. Ernest Cheysson, "Les méthodes de statistique graphique à l'Exposition universelle de 1878," *Journal de la Societé de Paris* 19 (1878), 330.

6. Anon. [Granville Stanley Hall], "The Graphic Method," *The Nation* 745 (October 9, 1879), 238.

7. The felicitous phrase is from Eugene Ferguson, *Engineering and the Mind's Eye* (Cambridge, Mass.: MIT Press, 1992).

8. Etienne-Jules Marey, *La méthode graphique dans les science expérimentales* (Paris: G. Masson, 1878), p. iii.

9. The term heterotopic space was coined by Michel Foucault to designate those spaces, such as libraries, archives, and museums, where the accumulation, progress, and capitalization of knowledge was secured in an immobile space, outside of temporalities and their corruptions, and subject to rational ordering. See Foucault, "Of Other Spaces," *Diacritics* 16 (Spring 1986), 24–26.

10. Jürgen Link, *Versuch über den Normalismus. Wie Normalität Produziert Wird* (Opladen: Westdeutscher Verlag, 1997).

11. Marey, *La méthode graphique*, pp. iii, vi.

12. Ibid., pp. vii–viii.

13. On this theme see Anson Rabinbach, *The Human Motor: Energy, Fatigue, and the Origins of Modernity* (New York: Basic Books, 1990); and the "The Cultures of Thermodynamics," part 1 of this volume.

14. Marey, *La méthode graphique*, pp. iv, xiii.

15. Gabriel Tarde, *Les Lois de l'Imitation* (Paris: Felix Alcan, 1890), pp. 150–51.

16. Ernst Mach, *Die Analyse der Empfindungen*, 2nd ed. (Jena: Gustav Fischer, 1900), p. 17. On Mach's epistemological subject, see Theodore S. Porter, "The Death of the Object: *Fin de siècle* Philosophy of Physics," in Dorothy Ross, ed., *Modernist Impulses in the Human Sciences 1870–1930* (Baltimore: Johns Hopkins University Press, 1994), pp. 128–51; and Yves Kobry, "Ernst Mach et le 'moi insaisissable,'" in Jean Clair, ed., *Vienne 1880–1938: Apocalypse Joyeuse* (Paris: Centre Pompidou, 1986).

17. Hall, "The Graphic Method," 238.

18. Norbert Wiener, "Time, Communication, and the Nervous System," *Annal: New York Academy of Sciences* 50 (1948), 202; reprint Norbert Wiener, *Collected Works with Commentaries*, 4 vols. (Cambridge, Mass.: MIT Press, 1985), 4:220–43. For the context of the delivery of this paper in early 1946, see Steve Joshua Heims, *The Cybernetics Group* (Cambridge, Mass.: MIT Press, 1991), pp. 14–30.

19. Norbert Wiener, *Cybernetics: or Control and Communication in the Animal and the Machine*, second edition (1948; Cambridge, Mass.: MIT Press, 1961), p. 39.

20. Christian Licoppe, *La formation de la pratique scientifique: Le discours de l'expérience en France et en Angleterre 1630–1820* (Paris: La Découverte, 1996), p. 270; Lissa Roberts, "A Word and the World, the Significance of Naming the Calorimeter," *Isis* 82:312 (1991), 199–222.

21. On the myriad mechanical drawing and tracing devices of the late nineteenth and early twentieth century, see Martin Kemp, *The Science of Art. Optical Themes in Western Art from Brunelleschi to Seurat* (New Haven: Yale University Press, 1990), 167–203.

22. Licoppe, *La formation de la pratique scientifique*, p. 271; Simon Schaffer, "Self-Evidence," *Critical Inquiry* 18:2 (Winter 1992), 327–62.

23. Ibid., 359–62.

24. Hans Blumenberg, *Die Lesbarkeit der Welt* (Frankfurt am Main: Suhrkamp, 1981), esp. pp. 233–67.

25. Charles Babbage, *The Economy of Machinery and Manufactures*, in Martin Campbell-Kelly, ed., *The Works of Charles Babbage*, 11 vols. (1832; London: William Pickering, 1989), 8:49–78.

26. On copying from antiquity to the present, see Georges Didi-Hubermann, *L'Empreinte* (Paris: Centre Georges Pompidou, 1997).

27. On medieval and early modern impressed images, see Katharine Park, "Impressed Images: Reproducing Wonders," in Caroline A. Jones and Peter Galison, *Picturing Science, Producing Art* (London: Routledge, 1998), pp. 254–71; Hans Belting, *Bild und Kult. Eine Geschichte des Bildes vor dem Zeitalter der Kunst* (Munich: C. H. Beck, 1990); Ernst von Dobschuetz, *Christusbilder. Untersuchungen zur christlichen Legende* (Leipzig: J. C. Hinrichs, 1899); and Ewa Kuryluk, *Veronica and Her Cloth: History, Symbolism, and the Structure of a "True" Image* (Cambridge: Blackwell, 1991).

28. Andre Bazin, "The Ontology of the Photographic Image," in *What Is Cinema?*, trans. Hugh Gray I (Berkeley: University of California Press, 1967), p. 14.

29. For Herschel's extensive interests in copying techniques and its importance

for his photographic researches, see Paul Galvez, "Register and Copy: John Herschel Photographic Observations," unpublished senior honor's thesis, Harvard University, 1997. Peter Geimer has brilliantly shown how similar concerns came together in the scientific examinations of the Shroud of Turin. See Peter Geimer, "L'autorité de la photographie: Révélations d'un suaire," *Etudes Photographiques* 6 (May 1999), 67–99.

30. H. W. Dickinson, *A Short History of the Steam Engine* (London, 1938), p. 85.

31. Ken Alder, "Making Things the Same: Representation, Tolerance and the End of the *Ancien Régime* in France," *Social Studies of Science* 28:4 (August 1998), 499–545; and H. Belofsky, "Engineering Drawing—A Universal Language in Two Dialects," *Technology and Culture* 32:1 (January 1991), 23–46.

32. Charles Dupin, one of the most active proponents of new dynamical theories, summarizes Monge's views in *Essai historique sur les services et les travaux scientifiques de Gaspard Monge* (Paris: Bachelier, 1819), p. 144.

33. C. L. M. H. Navier, introduction to Forest de Bélidor, *Architecture Hydraulique* (Paris, 1819), 376.

34. On the values of the concept of work in France in this period, see François Vatin, *Le Travail: Economie et physique 1780–1830* (Paris: Presses Universitaires de France, 1993).

35. Jean-Victor Poncelet, cited in Jean-Pierre Séris, *Machine et Communication* (Paris: Vrin, 1987), p. 429.

36. Arthur Morin, *Notice sur divers appareils dynamométriques, propres à mesurer l'effort du travail développé par les moteurs animés ou inanimés, ou consommé par des machines de rotation, et sur un nouvel indicateur de la pression dans les cylindres des machines a vapeur* (Paris: Mathias, 1839).

37. Crosbie Smith, *The Science of Energy: A Cultural History of Energy Physics in Victorian Britain* (Chicago: University of Chicago Press, 1998); Robert M. Brain and M. Norton Wise, "Muscles and Engines: Indicator Diagrams and Helmholtz's Graphical Methods," in Mario Biagioli, ed., *The Science Studies Reader* (London: Routledge, 1998), 51–66.

38. Arthur Morin, *Notice sur les divers appareils dynamométriques* (Metz: Lamort, 1838), pp. 1–2.

39. Morin, *Leçons de mécanique*, p. 24.

40. Arthur Morin, *Notice sur divers appareils dynamométrique. Propres a mesurer l'effort ou le travail développé par les moteurs animés ou inanimés et par les organes de transmission du mouvement dans les machines* (Paris: S. Lamort, 1839), pp. 29–30.

41. Morin, *Notice sur divers appareils dynamométriques*, pp. 29–30.

42. Lorraine Daston and Peter Galison, "The Image of Objectivity," *Representations* 40:3 (Fall 1992), 81–126.

43. See Robert M. Brain and M. Norton Wise, "Muscles and Engines"; and Frederic L. Holmes and Kathryn M. Olesko, "Precision's Images: Helmholtz and Graphical Methods in Physiology," in M. Norton Wise, ed., *The Values of Precision* (Princeton: Princeton University Press, 1995).

44. Hermann Helmholtz, "The Application of the Law of the Conservation of Force to Organic Nature" (1861), in Russell Kahn, ed., *Selected Writings of Hermann von Helmholtz* (Middleton, Conn.: Wesleyan University Press, 1971), p. 115.

45. Emil Du Bois-Reymond, *Untersuchungen über die thierische Elektricität* (Berlin: Reimer, 1848–1849), p. xxvi.

46. On Marey, see Marta Braun, *Picturing Time: The Work of Etienne-Jules Marey* (Chicago: University of Chicago Press, 1993); and François Dagognet, *Etienne-Jules Marey: La Passion de la trace* (Paris: Hazan, 1987).

47. Thomas L. Hankins and Robert L. Silverman, *Instruments and the Imagination* (Princeton: Princeton University Press, 1995), ch. 6.

48. Marey, *La méthode graphique*, pp. v, iii.

49. Joel Snyder, "Visuality and Visualization," in Jones and Galison, *Picturing Science, Producing Art*, pp. 380–85.

50. E. J. Marey, *La méthode graphique*, p. xiii.

51. Ernst Mach, "Zur Theorie der Pulswellenzeichner," *Sitzungsberichte der Mathematisch-Naturwissenschaftliche Classe der Kaiserlichen Akademie der Wissenschaften* 46 (1862), 157–74.

52. For an extended treatment of this work see Robert M. Brain, "Standards and Semiotics," in Timothy Lenoir, ed., *Inscribing Science: Scientific Texts and the Materiality of Communication* (Stanford: Stanford University Press, 1997), pp. 249–84.

53. On the relations between Bréal and Saussure, see Hans Aarsleff, "Bréal, 'la sémantique,' and Saussure," in *From Locke to Saussure: Essays on the Study of Language and Intellectual History*, ed. Hans Aarsleff (Minneapolis: University of Minnesota Press, 1982), pp. 382–400.

54. Sylvain Auroux, "La catégorie du *parler* et la linguistique," *Romantisme* (1976), 174.

55. Ferdinand de Saussure, *Course in General Linguistics*, trans. Roy Harris (La Salle: Open Court, 1983), p. 69.

56. Ibid., p. 32.

57. Charles Henry, "Introduction à une esthétique scientifique," *La Revue contemporaine* (August, 1885), 442–469.

58. Ibid., p. 466.

59. Charles Henry, *Rapporteur esthétique. Notice sur ses applications industriel, à l'Histoire de l'Art, à l'interpretation de la Méthode Graphique* (Paris: G. Séguin, 1888). For artisans, Henry's instruments functioned in a manner similar to the use of precision instruments by workers in the Taylor system of scientific management. Taylor wrote that "by means of these slide rules, intricate mathematical problems can be solved by any good mechanic, whether he understands anything about mathematics or not." See Frederick W. Taylor, *The Principles of Scientific Management* (1911), reprinted edition (New York: Norton, 1967), 111.

60. Seurat's relationship with Henry's scientific aesthetic has been the subject of much scholarship and debate. For some of the principal works, see William Innes Homer, *Seurat and the Science of Painting* (Cambridge, Mass.: MIT Press, 1959); Robert Herbert, "Parade du Cirque de Seurat et l'ésthéthique scientifique de Charles

Henry," *Revue de l'art* 50 (1980), 9–23; Paul Smith, *Seurat and the Avant-Garde* (New Haven: Yale University Press, 1997); and Michael Zimmermann, *Les Mondes de Seurat: son oeuvre et le débat artistique de son temps* (Paris: Albin Michel, 1991). These themes are also addressed in two chapters of my forthcoming book, *Being Analog: Graphic Recording Instruments and Scientific Modernism* (Stanford: Stanford University Press, expected 2002).

61. Robert Herbert et al., *Georges Seurat, 1859–1891* (New York: Metropolitan Museum of Art, 1991), esp. Appendix L, "Charles Henry."

62. Thadée Natanson, "Expositions," *La Revue blanche* 6 (1894), 187. Thanks to Richard Shiff for this reference.

63. For Seurat's mechanicity, see also Richard Shiff's article in this volume.

64. In an anonymously authored article in a leading French anarchist periodical, Paul Signac tried to vouch for his friend's political credentials and dispel the irony and ambiguity of "The High-Kick." See Anon [Signac], "Impressionistes et Revolutionnaires," *Le Revolté* 13–19 (June 1891), 4. On the anarchist affiliations of this circle, see T. J. Clark, "We Field-Women," in *Farewell to an Idea: Episodes from a History of Modernism*, ed. T. J. Clark (New Haven: Yale University Press, 1999), pp. 55–138; Joan Ungersma Halperin, *Félix Fénéon: Aesthete and Anarchist in Fin-de-Siècle Paris* (New Haven: Yale University Press, 1988); John G. Hutton, *Neo-Impressionism and the Search for Solid Ground: Art, Science, and Anarchism in Fin-de-Siècle France* (Baton Rouge: Louisiana State University, 1994); Smith, *Seurat and the Avant-Garde*; and Alexander Varias, *Paris and the Anarchists: Aesthetes and Subversives at the Fin-de-Siècle* (New York: St. Martin's Press, 1997).

65. William Thomson and Peter Guthrie Tait, *Principles of Mechanics and Dynamics* (New York: Dover, 1962), p. 54.

66. William Thomson takes up the question of the tides as waveform in his lecture, "The Tides," reprinted in *The Harvard Classics: Scientific Papers*, ed. Charles W. Eliot (New York: P. F. Collier & Son, 1910), pp. 287–324.

67. William Thomson, "The Tide Gauge, Tidal Harmonic Analyzer, and Tide Predicter," *Proceedings of the Institution of Civil Engineers* 65 (1881), 2–31, 58–64.

68. James Thomson, "On an Integrating Machine Having a New Kinematic Principle," *Proceedings of the Royal Society of London* 24 (1876), 262–65.

69. Thomson, quoted in Herman H. Goldstine, *The Computer from Pascal to von Neumann* (Princeton: Princeton University Press, 1972), pp. 43–44.

70. On Babbage, see Simon Schaffer, "Babbage's Engines," *Critical Inquiry* 21:3 (Autumn 1994), 203–27.

71. Sir William Thomson (Lord Kelvin), "An Instrument for Calculating the Integral of the Product of Two Given Functions," *Proceedings of the Royal Society of London* 24 (1876), 266–68; "Mechanical Integration of Linear Differential Equations of the Second Order with Variable Coefficients," *Proceedings of the Royal Society of London* 24 (1876), 269–71; "Mechanical Integration of the General Linear Differential Equation of Any Order with Variable Coefficients," *Proceedings of the Royal Society of London* 24 (1876), 271–75.

72. James Clerk Maxwell, "Harmonic Analysis," in *The Scientific Papers of*

James Clerk Maxwell, ed. W. D. Niven, 2 vols. (1890; New York: Dover, n.d.), 2:797–801.

73. A. A. Michelson and S. W. Stratton, "A New Harmonic Analyzer," *American Journal of Science* 4:5 (1898), 1–13; and *Philosophical Magazine* 5:45 (1898), 85–91; U.S. Coast and Geodetic Survey, *Description of the U.S. Coast and Geodetic Survey Tide Predicting Machine* (Washington, D.C., 1915), special publication, No. 32.

74. There are few studies of this tradition of analog computing. Although it is in many respects an account by a partisan of the electronic digital computer, Hermann Goldstine's account in *The Computer* is still perhaps the most informative. On the Differential Analyzers of the 1830s, see the fine article by Larry Owens, "Vannevar Bush and the Differential Analyzer: The Text and Context of an Early Computer," *Technology and Culture* 27:1 (1986), 63–95; reprinted in James Nyce and Paul Kahn, ed., *From Memex to Hypertext. Vannevar Bush and the Mind's Machine* (Boston: Academic Press, 1991).

75. Peter Galison, "The Ontology of the Enemy: Norbert Wiener and the Cybernetic Vision," *Critical Inquiry* 21:1 (Autumn 1994), 240; and Paul N. Edwards, *The Closed World*.

76. The instrument, called the profile tracer, was used to record topographic variation for use in surveying, and described in Bush, "An Automatic Instrument for Recording Terrestrial Profiles," Tufts College, Master's Thesis, January 1913; and Bush, *Pieces of the Action* (New York: William Morrow, 1970), pp. 155–57. From Owens, "Vannevar Bush and the Differential Analyzer," 91–93.

77. V. Bush, F. D. Gage, and H. R. Stewart, "A Continuous Recording Integraph," *Journal of the Franklin Institute* 212 (1927), 63–84.

78. Vannevar Bush, "The Differential Analyzer," *Journal of the Franklin Institute* 212 (October 1931), 447–88.

79. Anon., "A Machine that Bosses Other Machines," *The Literary Digest* (September 9, 1933), 20. Instead of the mechanical Thomson integrator, Hazen made used of a light-sensitive cell, which was set up to allow light passing through a narrow slit to cause a deflection in a balanced electrical circuit through a small reversible motor.

80. See H. L. Hazen, "Theory of Servo-Mechanisms," *Journal of the Franklin Institute* 218 (1934), 279–331, put the question front and center; Leroy A MacColl, *Fundamental Theory of Servomechanisms* (New York: D. Van Nostrand, 1945), defined the state of the field at that time.

CHAPTER 8

1. An expanded version of this chapter appears in my book *Noise, Water, Meat: Sound, Voice, and Aurality in the Arts* (Cambridge, Mass.: MIT Press, 1999).

2. For a brief overview of the role of figure of vibration, which neo-Pythagoreanism presents within modernism, in relation to figures of inscription, see my introduction to Douglas Kahn and Gregory Whitehead, eds., *Wireless Imagination: Sound, Radio, and the Avant-garde* (Cambridge, Mass.: MIT Press, 1992).

3. One of the earliest recorded appeals to water for understanding was made by

the stoic philosopher Chrysippus (ca. 280–207 BC): "Hearing occurs when the air between that which sounds and that which hears is struck, thus undulating spherically and falling upon the ears, as the water in a reservoir undulates in circles from a stone thrown into it"; cited in Frederick Vinton Hunt, *Origins in Acoustics* (New Haven: Yale University Press, 1978), pp. 23–24.

4. Thomas L. Hankins and Robert J. Silverman, *Instruments and the Imagination* (Princeton: Princeton University Press, 1995), p. 135.

5. Alfred Jarry, *Exploits and Opinions of Doctor Faustroll Pataphysician*, in Roger Shattuck and Simon Watson Taylor, *Selected Works of Alfred Jarry* (New York: Grove Press, 1965), p. 244.

6. Ibid., p. 245. The fecund shift from a heavily invested single graphic line elaborated into the graphic designs of wallpaper describes catapulting from a heavily invested two-dimensions to the fourth dimension where Faustroll, "finding his soul to be abstract and naked, donned the realm of the unknown dimension." See Linda Dalrymple Henderson, *The Fourth Dimension and Non-Euclidean Geometry in Modern Art* (Princeton: Princeton University Press, 1983), pp. 48–49.

7. Sir William Thomson, *Popular Lectures and Addresses*, Vol. 1, *Constitution of Matter* (London: Macmillan, 1891).

8. Hermann Helmholtz, *On the Sensations of Tone* (1877; New York: Dover, 1954), pp. 8–9.

9. Luigi Russolo, "Physical Principles and Practical Possibilities," *The Art of Noises*, trans. Barclay Brown (1916; New York: Pendragon Press, 1986), p. 37.

10. Ibid.

11. Ibid., pp. 37–40, quotes on p. 39.

12. Ibid., p. 87.

13. Ibid., p. 30.

14. Russolo was not alone in thinking along these lines. See Henry Cowell, "The Joys of Noise," in *The New Republic* (31 July 1929), 287–88.

15. Sergei Yutkevich, "Eccentrism" (1922), *The Film Factory: Russian and Soviet Cinema in Documents, 1896–1939*, ed. Richard Taylor and Ian Christie (Cambridge, Mass.: Harvard University Press, 1988), p. 62.

16. For Varèse's use of glissandi, see Anne Florence Parks, *Freedom, Form, and Process in Varèse*, Ph.D. Dissertation in Music, Cornell University, 1974 (Ann Arbor: University Microfilms, 1974), pp. 270–72.

17. See Louise Varèse, *Varèse: A Looking Glass Diary, Volume I* (New York: Norton, 1972), p. 42. Helmholtz's *Physiology of Music* was published in English as *On the Sensations of Tone as a Physiological Basis for the Theory of Music*.

18. Étienne Marey et al, "Graphic Phonetics," *Scientific American* (November 17, 1877), 307.

19. Alfred M. Mayer, "On Edison's Talking-Machine," *Popular Science Monthly* (April 1878), 722–23.

20. Roland Gelatt, *The Fabulous Phonograph: The Story of the Gramophone from Tin Foil to High Fidelity* (London: Cassel, 1956), p. 28.

21. László Moholy-Nagy, "Production—Reproduction (1922)," in Krisztina Passuth, *Moholy-Nagy* (New York: Thames and Hudson, 1985), pp. 289–90.

22. László Moholy-Nagy, "New Film Experiments (1933)," in Passuth, *Moholy-Nagy*, p. 322.

23. Sibyl Moholy-Nagy, *Moholy-Nagy: Experiment in Totality* (New York: Harper & Brothers, 1950), pp. 68, 97.

24. Rainer Maria Rilke, "Primal Sound" (1919), in *Rodin and Other Prose Pieces* (London: Quartet Books, 1986), pp. 126–32.

25. Ibid., pp. 129–30.

26. Dayton Clarence Miller, *The Science of Musical Sounds* (1916; New York: Macmillan, 1934), pp. 22–25; quotes at pp. 22 and 25.

27. Ibid., pp. 119, 120.

28. John Cage, "The Future of Music: Credo" (1937), in *Silence* (Middletown: Wesleyan University Press, 1961), pp. 3–6, quotes at pp. 3 and 4. This was a time when Cage was particularly enamored with the musical possibilities of new technology, especially as they were expressed in Carlos Chavez's *Toward a New Music: Music and Electricity*, published in 1930. In the mid-1930s, Cage met the filmmaker Oskar Fischinger, who had already begun experimenting with synthetic music using drawn sound film and, although I have seen no indication that Fischinger employed the specific technique of line drawing, his efforts no doubt buoyed Cage's hopes or underscored his parody.

29. John Cage, "Forerunners of Modern Music" (1949), in *Silence*, p. 65.

30. For Cage's campaign against Beethoven and what he stood for, see David Wayne Patterson, *Appraising the Catchwords, C. 1942–1959: John Cage's Asian-derived Rhetoric and the Historical Reference of Black Mountain College*, Ph.D. dissertation (Columbia University, 1996), pp. 208–9.

31. Henri Michaux, *Miserable Miracle* (1956), trans. Louise Varèse (San Francisco: City Lights, 1963), chapter 5.

CHAPTER 9

Translation: Heather Mathews and Lucinda Rennison.

1. Georg Simmel, "Rodins Plastik und die Geistesrichtung der Gegenwart," in *Ästhetik und Soziologie um die Jahrhundertwende: Georg Simmel*, ed. Hannes Böhringer and Karlfried Gründer (Frankfurt: Klostermann, 1976), pp. 231ff, 232, 235; Henry van de Velde, *Geschichte meines Lebens* (München: Piper, 1896), pp. 348, 381ff; Alfred Gotthold Meyer, *Eisenbauten* (Esslingen: Neff, 1907), p. 184.

2. Henri Lefebvre, *The Production of Space* (Oxford: Blackwell, 1991), p. 125.

3. Carola Giedion-Welcker, *Paul Klee* (Reinbek: Rowohlt, 1961), p. 121.

4. Ibid., p. 56.

5. Klee first explored this theme in a smaller study of 1925, entitled *Abstraction with Reference to a Flowering Tree* (Private collection, Switzerland).

6. Robert Musil, *Der Mann ohne Eigenschaften* (Reinbek: Rohwalt Verlag, 1978), pp. 16–18.

7. *Atmosphärische Gruppe in Bewegung* is owned by Kunstammlung Nordrhein-Westfalen in Düsseldorf.

8. Giedion-Welcker, *Klee*, pp. 64, 112ff. See also Sigfried Giedion, *Die Herrschaft der Mechanisierung* (Frankfurt: EVA, 1982), pp. 133ff.

9. Martin Krampen, *Geschichte der Straßenverkehrszeichen* (Tübingen: Stauffenberg, 1982).

10. *Um den Fisch* is owned by the Museum of Modern Art in New York.

11. Paul Klee, *Das bildnerische Denken*, ed. Jürg Spiller (Basel: Schwabe, 1956), p. 79.

12. Ibid., pp. 339ff. See also Christian Geelhaar, *Paul Klee* (Cologne: DuMont, 1974), pp. 92f.

13. See Arnold Gehlen, *Zeit-Bilder* (Frankfurt: Klostermann, 1960), pp. 102ff.

14. Peter Joraschky, *Das Körperschema und das Körperselbst als Regulationsprinzipien der Körper-Umwelt-Interaktion* (München: Minerva, 1974), p. 320. See also Ann F. Neel, *Handbuch der psychologischen Theorien* (München: Kindler, 1974), pp. 358ff, chapter XXIV, "Lewins Feldtheorie."

15. A wide variety of influences mingled in the life of this largely unknown art theoretician. A dancer of the Laban School with ties to anthroposophy, Ebeling worked in the experimental department of the Junkers Company in Dessau and was a friend of Marcel Breuer, who designed the interior of Kurt Lewin's house. See Wulf Herzogenrath, ed., *Bauhaus Utopien* (Stuttgart: Editions Cantz, 1988), 272, 329; Tilmann Buddensieg, ed., *Wissenschaft in Berlin*, vol. *Objekte* (Berlin: Gebrüder Mann, 1987), pp. 68ff, vol. *Gedanken*, p. 50.

16. Siegfried Ebeling, *Der Raum als Membran* (Dessau: C. Dünnhaupt, 1926), pp. 8, 11.

17. Ibid., pp. 12, 14, 19, 37.

18. Fritz Neumeyer, *Mies van der Rohe* (Berlin: Siedler, 1986), pp. 220ff.

19. Sigfried Giedion, *Raum, Zeit, Architektur* (Ravensburg: Otto Maier 1965), p. 362.

20. From a conversation with Christian Norberg-Schulz, in Neumeyer, *Mies*, p. 405.

21. László Moholy-Nagy, *Von Material zu Architektur* (Mainz: Kupferberg, 1968), pp. 193ff, 175.

22. Ernst Jünger, "Der Arbeiter," in *Sämtliche Werke*, 18 vols. (Stuttgart: Klett, 1978), vol. 8, section 41.

23. Ernst Jünger, "Totale Mobilmachung," in *Sämtliche Werke*, vol. 7, p. 128; for Walter Benjamin's reaction to Jünger's collection *Krieg und Krieger*, see *Walter Benjamin: Gesamelte Werke*, 7 vols. (Frankfurt: Suhrkamp, 1972), 3:238ff.

24. Jünger, "Der Arbeiter," pp. 176ff.

25. Ibid., quotes at pp. 115, 126, 191; for the homogeneity discussion, see p. 262.

26. Edmund Schultz, ed., *Die veränderte Welt* (Breslau: Wilhelm Gottlieb Korn, 1933). For the history and background of this volume, see Brigitte Werneburg, "Die veränderte Welt: Der gefährliche anstelle des entscheidenden Augenblicks," in *Fotogeschichte* 14 (1994), 51.

27. Schultz, *Die veränderte Welt*, p. 160.

28. Ibid., pp. 32, 66, 126.

29. *Interstellar Exchange* was given to the Denver Art Museum by Joella Bayer.

30. Stanislaus von Moos, "Modern Art Gets Down to Business," in *Herbert Bayer: Das künstlerische Werk 1918–1938* (Berlin: Gebrüder Mann, 1982), pp. 93 ff, 100; see also Stanislaus von Moos, "Die zweite Entdeckung Amerikas," afterword in Sigfried Giedion, ed., *Die Herrschaft der Mechanisierung* (Frankfurt: Europäische Verlagsanstalt, 1982), pp. 813 ff; and Andreas Haus, "Moholy-Nagy: Sinnlichkeit und Industrie," in Stanislaus von Moos and Chris Smeenk, ed., *Avantgarde und Industrie* (Delft: Delft University Press, 1983), pp. 113 ff.

31. Alexander Dorner, *Überwindung der "Kunst"* (Hannover: Fackelträger, 1959), pp. 127, 169–71. *The Way Beyond 'Art'* was originally published by Wittenborn, Schultz (New York), in the series "Problems of Contemporary Art." See also Sokratis Georgiadis, *Sigfried Giedion* (Zürich: Ammann, 1989), pp. 135 ff, 138 ff.

32. For those excerpts from *The Way Beyond 'Art'* not included in the final chapter on Bayer in the German edition, see *Herbert Bayer: Das künstlerische Werk*, pp. 80 ff. See also Dorner, *Way Beyond 'Art'*, sec. 4, chap 3.

33. Dorner, *Überwindung der "Kunst*," p. 17; see also von Moos, "Modern Art Gets Down to Business," pp. 102 ff.

PART 4 INTRODUCTION

1. On the cultures of cybernetics, see Jeremy Campbell, *Grammatical Man: Information, Entropy, Language, Life* (New York: Simon and Schuster, 1982); Italo Calvino, "Cybernetics and Ghosts," in *The Uses of Literature*, trans. Patrick Creagh (New York: Harvest/HBJ, 1986), pp. 3–27; David Porush, *The Soft Machine: Cybernetic Fiction* (New York: Methuen, 1985), and "Cybernetic Fiction and Postmodern Science," *New Literary History* 20:2 (Winter 1989), 373–96; Lily Kay, "Cybernetics, Information, Life: The Emergence of Scriptural Representations of Heredity," in *Configurations* 5:1 (Winter 1997), 23–91; N. Katherine Hayles, *How We Became Posthuman: Virtual Bodies in Cybernetics, Literature, and Informatics* (Chicago: University of Chicago Press, 1999); and Jean-Pierre Dupuy, *The Mechanization of the Mind: On the Origins of Cognitive Science* (Princeton: Princeton University Press, 2000).

2. For more on Babbage, see Bruce Mazlish, *The Fourth Discontinuity: The Co-Evolution of Human and Machines* (New Haven: Yale University Press, 1993), pp. 130–40; and Francis Spufford and Jenny Uglow, ed., *Cultural Babbage: Technology, Time and Invention* (Boston: Faber and Faber, 1996).

3. See Espen J. Aarseth, *Cybertext: Perspectives on Ergodic Literature* (Baltimore: Johns Hopkins University Press, 1997); Marie-Laure Ryan, ed., *Cyberspace Textuality: Computer Technology and Literary Theory* (Bloomington: Indiana University Press, 1999); and Marie-Laure Ryan, *Narrative as Virtual Reality: Immersion and Interactivity in Literature and Electronic Media* (Baltimore: Johns Hopkins University Press, 2001).

CHAPTER 10

1. For discussions of the railway system as a kind of imaging system, see Michel de Certeau, "Railway Navigation and Incarceration," in Steven Rendall, trans., *The Practice of Everyday Life* (Berkeley: University of California Press, 1988), pp. 111–14; and Wolfgang Schivelbusch, *The Railway Journey: Trains and Travel in the 19th Century,* trans. Anselm Hollo (New York: Urizen Books, 1979).

2. Early commentators on photography were quick to note its ubiquitous properties. One useful early reference on photography's potential range of vision and archaeological or astronomical uses is *Historique et Description Des Procédés du Daguerréotype et du Diorama, par Daguerre* (1839), published in English as *An Historical and Descriptive Account of the Various Processes of the Daguerreotype and the Diorama by Daguerre,* illust. and intro. Beaumont Newhall (New York: Winter House, 1971). William Henry Fox Talbot's comments on photography's use in architecture and with the microscope are recorded in "Some Account of the Art of Photogenic Drawing, or the Process by which Natural Objects May Be Made to Delineate Themselves Without the Aid of the Artist's Pencil," *Athenaeum* 589 (1839), 114–117. Talbot's *The Pencil of Nature* (London: Longman, Brown, Green, and Longmans, 1844), provides a compact, but by no means exhaustive inventory of its uses. Finally, Oliver Wendell Holmes's incisive celebratory comments on the global reach of stereoscopic photography and its relationship to capital may be found in "The Stereoscope and the Stereograph," *Atlantic Monthly* 3 (1859), 738–48. For a more global catalogue of photography's visual range, see also *Excursions Daguerriennes: Vues et Monuments les plus Remarquables du Globe* (Paris: Rittner and Goupil, 1841).

3. Anthony Hyman, *Charles Babbage: Pioneer of the Computer* (Princeton: Princeton University Press, 1982), pp. 1, 145, 170; Simon Schaffer, "Babbage's Intelligence: Calculating Engines and the Factory System," *Critical Inquiry* 21 (1994), 215. For some contemporary comments to this effect, see also Bruce Collier, *The Little Engines that Could've: The Calculating Machines of Charles Babbage* (New York: Garland, 1990), pp. 220–26.

4. See Charles Babbage, *Exposition,* in *The Works of Charles Babbage,* ed. Martin Campbell-Kelly (London: William Pickering, 1989), vol. 10, p. 104.

5. Allan Bromley, *The Babbage Papers in the Science Museum Library: A Cross-Referenced List* (London: Science Museum, 1991), p. 11.

6. There is a considerable literature on uchronia and alternative history (also known as allohistory and counterfactuals), especially in relation to science fiction studies. The classic reference in all these cases in Charles Renouvier's *Uchronie* (1876). Although this literature is outside the scope of the present article, a pertinent example of a uchronic history that deals with Babbage's calculating engines is the science fiction novel by William Gibson and Bruce Sterling, *The Difference Engine* (New York: Bantam, 1991). For a discussion of *The Difference Engine* as a uchronic history, see Francis Spufford, "The Difference Engine and *The Difference Engine,*" in

Francis Spufford and Jenny Uglow, ed., *Cultural Babbage: Technology, Time and Invention* (London: Faber and Faber, 1996), pp. 266–90.

7. Dionysius Lardner, "Babbage's Calculating Engine," in Babbage, *Works*, vol. 2, pp. 170–71.

8. In addition to Collier, Hyman, and Schaffer, see John M. Dubbey, *The Mathematical Work of Charles Babbage* (Cambridge: Cambridge University Press, 1978).

9. I would like to thank Brian Liddy of the National Museum of Photography, Film, and Television, Bradford, England, for his help in tracing and identifying the various views, negative and positive, of this engineering model.

10. For other histories of the line, see the contributions by Brain and Kahn in the present volume.

11. Lardner, "Babbage's Engine," p. 162.

12. Bruno Latour, "Drawing Things Together," in Michael Lynch and Steve Woolgar, ed., *Representation in Scientific Practice* (Cambridge, Mass.: MIT Press, 1990), pp. 40, 42. Latour has suggested that "it is not the inscription by itself that should carry the burden of explaining the power of science; it is the inscription *as the fine edge* and *the final stage* of a whole process of mobilization" (p. 40, Latour's emphases). The thrust of Latour's approach is toward a radical redefinition of disciplinary activity that would account for different systems of mobilization.

13. Henry Adams, "A Law of Acceleration," in *The Education of Henry Adams* (New York: Houghton Mifflin, 1927), p. 494.

14. On the analytical engines infinite capacities, see Babbage, *Passages from the Life of a Philosopher*, in *Works*, vol. 11, pp. 93–94.

15. Although science might be organized around questions of effective mobilization and the nature and status of the immutable mobile, the disciplines that operate under its auspices are always subject to what Eugene Ferguson has described in the case of engineering as the "gap between promise and performance," a gap where, more often than not, perception reigns supreme, the Serresian parasite rules, and where misrepresentation, fiction, and even disasters claim sovereign power over immutable mobiles and individual human bodies. For the gap between promise and performance is a fertile breeding ground for other possibilities and types of histories. See Eugene S. Ferguson, *Engineering and the Mind's Eye* (Cambridge, Mass.: MIT Press, 1992), and Michel Serres, *The Parasite*, trans. Lawrence R. Schehr (Baltimore: Johns Hopkins University Press, 1982).

16. Latour, "Drawing Things Together," p. 28.

17. Ibid., p. 29.

18. For the background to this proposal for an intercultural approach to scientific and technological artifacts and, in particular, their imaging systems and representations, see David Tomas, *Transcultural Space and Transcultural Beings* (Boulder: Westview Press, 1996); "What is a New Technology: Machine Drawings, Sentience, Intercultural Contact," *Parachute* 84 (1996), 46–51; and "Echoes of Touch and the Temptations of Scientific Representations," *Public* 13 (1996), 104–17.

19. Henry Petroski, *The Pencil: A History of Design and Circumstance* (Boston: Faber and Faber, 1990), pp. 196, 197.

20. Ferguson, *Engineering*, quotes at pp. xi, 5, 3.

21. The different kinds of sketches are described in ibid., pp. 96–97.

22. Petroski, *The Pencil*, p. 94.

23. Spufford, "Difference Engine," p. 267.

24. Ibid., pp. 268–69; emphasis in the original.

25. Ibid., p. 276.

26. Randal Walser, "Elements of a Cyberspace Playhouse," in Sandra K. Helsel and Judith Roth, eds., *Virtual Reality: Theory, Practice, and Promise* (Westport: Meckler, 1991), p. 53.

27. Babbage, "Science of Number," *Works*, vol. 2, p. 16.

28. Ibid., p. 15.

29. Quoted in Bruce Collier, *The Little Engine*, p. 106.

30. Babbage, "Science of Number," p. 15.

CHAPTER 11

1. Galen Brandt, "Synthetic Sentience: An Interview with Charles Ostman," *Mondo 2000*, 16 (1998), 35. Neal Stephenson in *The Diamond Age* suggests by contrast that class structures may actually intensify amid material abundance.

2. C. B. Macpherson, *The Political Theory of Possessive Individualism: Hobbes to Locke* (New York: Oxford University Press, 1988).

3. Robert Markley, "Boundaries: Mathematics, Alienation, and the Metaphysics of Cyberspace," *Virtual Reality and Their Discontents*, ed. Robert Markley (Baltimore: Johns Hopkins University Press, 1996), pp. 55–78.

4. N. Katherine Hayles, "Virtual Bodies and Flickering Signifiers," in *How We Became Posthuman: Virtual Bodies in Cybernetics, Literature, and Informatics* (Chicago: University of Chicago Press, 1999), pp. 25–49.

5. Henry James, "In the Cage," *The Complete Tales of Henry James*, vol. 10, edited by Leon Edel (London: Rupert Hart-Davis, 1964), pp. 139–242.

6. Philip K. Dick, *The Three Stigmata of Palmer Eldritch* (1964; New York: Doubleday, 1965).

7. James Tiptree, Jr., "The Girl Who Was Plugged In," *Her Smoke Rose Up Forever: The Great Years of James Tiptree, Jr.* (New York: Arkham House, 1990), pp. 44–79.

8. James, "In the Cage, p. 153. In *Networking* (Ann Arbor: University of Michigan Press, 2000), Laura Otis traces the extensive analogies in nineteenth-century science and literature between telegraph lines and the nerves of the human body. I am grateful to her for her comments on this essay.

9. As Dale Bauer and Andrew Lakritz point out, words count as things in this economy: Dale M. Bauer and Andrew Lakritz, "Language, Class and Sexuality in Henry James's 'In the Cage,'" *New Orleans Review* 14 (1987), 60–69.

10. Stuart Hutchinson stoutly defends Mr. Mudge in "James's 'In the Cage': A New Interpretation," *Studies in Short Fiction* 19 (1982), 19–26.

11. Moreover, it could easily slide into casual prostitution or blackmail, as Ralf

Norrman and Richard Menke have shown: Ralf Norrman, *Techniques of Ambiguity in the Fiction of Henry James*, Acta Academiae Aboensis, Series A, 54: 2 (Abo: Abo Akademi, 1977), pp. 139–40; Richard Menke, "Telegraphic Realism: Henry James's *In the Cage*," *PMLA* 115 (2000), 975–90.

12. Andrew Moody in "'The Harmless Pleasure of Knowing': Privacy in the Telegraph Office and Henry James's 'In the Cage,'" *The Henry James Review* 16 (1995), 53–65, provides useful historical context for concerns about privacy in a telegraph service.

13. Ralf Norrman in "The Intercepted Telegram Plot in Henry James's 'In the Cage,'" *Notes & Queries* 24 (1977), 425–27, carefully traces out the possibility that the girl's "correction" distracted Lady Bradeen from making the correction she likely intended.

14. Jennifer Wicke, "Henry James's Second Wave," *The Henry James Review* 10 (1989), 146–51.

15. Carl Freedman discusses the cultural context for the novels of the 1960s, "Editorial Introduction: Philip K. Dick and Criticism," *Science-Fiction Studies*, 15 (1988), 121–30. See also Scott Durham in "P. K. Dick: From the Death of the Subject to a Theology of Late Capitalism," *Science-Fiction Studies* 15 (1988), 173–180.

16. The instability in the subject is often preceded by a rift in the family corporation, as in *We Can Build You*, and in a different way in *The Simulacrum*.

17. Kim Stanley Robinson, *The Novels of Philip K. Dick* (Ann Arbor: UMI Research Press, 1984), p. 61.

18. In *Networking*, Laura Otis describes Samuel Morse's belief that telegraph signals traveled at 200,000 times the speed of light. By the time of Tiptree's story, no such illusions about simultaneity were possible.

19. As Andrew Moody in "The Harmless Pleasure of Knowing" and Ric Savoy in "'In the Cage' and the Queer Effects of Gay History," *Novel* 28 (1995), 284–307, both note, upper-class patrons feared that telegraphists might learn information they could use to blackmail their wealthy clients. Tiptree's story suggests that by the late twentieth century the concern had shifted from the individual agent to the corporation.

20. I am indebted to Carol Wald for her astute reading of this story in which she closely analyzes the significance of the waldo as a potentially independent agent, unpublished manuscript.

21. Gardner Dozois comments on the importance of future time in the narrative voice in *The Fiction of James Tiptree, Jr.* (San Bernadino, Calif.: Borgo Press, 1984).

CHAPTER 12

I would like to thank Kristine Stiles for her intellectual and scholarly guidance, which has helped me transform energy to information. Final preparation of this work was supported by a Henry Luce–ACLS Dissertation Fellowship in American Art. This essay is dedicated to the memory of my loving grandparents, Pauline and Benjamin Shanken.

1. Guy Habasque, "From Space to Time," in Marcel Joray, ed., *Nicolas Schöffer*, trans. Haakon Chevalier (Neuchatel, Switzerland: Editions du Griffon, 1963), pp. 10–17. The artist had conceived of his first "spatio-dynamic" tower in 1954.

2. Jack Burnham, *Beyond Modern Sculpture: The Effects of Science and Technology on the Sculpture of this Century* (New York: George Braziller, 1968), p. 344.

3. Ibid., p. 343.

4. David Mellor, *The Sixties Art Scene in London* (London: Phaidon Press, 1993), p. 107.

5. Cohen and Kitaj taught with Ascott at Ealing, where Willats was a student.

6. Dianne Kirkpatrick, *Eduardo Paolozzi* (Greenwich, Conn.: New York Graphic Society, 1971), p. 19. See for example, Paolozzi's *Collage Mural* (1952).

7. Roy Ascott, "Letter to the Editor," *Studio International* 175:902 (July–August 1968), 8.

8. W. Ross Ashby, *Design for a Brain* (New York: John Wiley, 1952); F. H. George, *The Brain as Computer* (Oxford: Pergamon Press, 1962).

9. Warren Weaver and Claude E. Shannon, *The Mathematical Theory of Communication* (Urbana: University of Illinois Press, 1949).

10. Norbert Wiener, *The Human Use of Human Beings: Cybernetics and Society* (New York: Avon Books, 1954), pp. 23–24.

11. Roy Ascott, Interview with the author, September, 1995, Montreal.

12. Roy Ascott, "Interactive Art," unpublished manuscript, 1994, p. 3; my emphasis.

13. Roy Ascott, "Behaviourables and Futuribles," in Kristine Stiles and Peter Selz, eds., *Theories and Documents of Contemporary Art: A Sourcebook of Artists' Writings* (Berkeley: University of California Press, 1996), p. 489. Stiles's chapter "Art and Technology" offers a good overview of art and technology in the post-1945 period and a selection of theoretical writings by artists including Ascott, Schöffer, Tinguely, Takis, Piene, GRAV, and Paik.

14. Mellor, *The Sixties Art Scene*, p. 19. Mellor identified 1959 as the date of Latham's theorization of "event structure." Latham claims to have conceived of it much earlier, and certainly prior to Mathieu's performance at the ICA in 1956. John Latham, interview with the author, February 8, 1998, Los Angeles.

15. Kristine Stiles, "The Destruction in Art Symposium (DIAS): The Radical Social Project of Event-Structured Art." Ph.D. dissertation, University of California, Berkeley, 1987. On the neglected significance of George Mathieu, see Kristine Stiles, "Uncorrupted Joy: International Art Actions," in *Out of Actions: Between Performance and the Object 1949–1979* (Los Angeles: Los Angeles Museum of Contemporary Art, 1998), pp. 286–89.

16. Roy Ascott, "Is There Love in the Telematic Embrace?" *Art Journal* 49:3 (Fall 1990), 242.

17. Jack Burnham, "Duchamp's Bride Stripped Bare: The Meaning of the *Large Glass*," in Jack Burnham, *Great Western Salt Works: Essays on the Meaning of Post-Formalist Art* (New York, George Braziller, 1974), pp. 89–117.

18. Ascott, "Is There Love?"

19. See D'Arcy Wentworth Thompson, *On Growth and Form* (c. 1942; Cam-

bridge: Cambridge University Press, 1963); and Henri Bergson, *Creative Evolution* (New York: Henry Holt, 1911).

20. The Bergsonian principles of *durée* and *élan* vital gained currency in artistic practice among cubist painters in the 1900s in France, experienced a resurgence of importance for sculptors in Britain beginning in the 1930s, and became an enduring theoretical model for Ascott beginning in the 1950s. See Mark Antliff, *Inventing Bergson: Cultural Politics and the Parisian Avant-Garde* (Princeton: Princeton University Press, 1993), p. 3; Burnham, *Beyond Modern Sculpture*; and Ascott, "The Construction of Change," *Cambridge Opinion* (January 1964), pp. 37–42.

21. Kristine Stiles, "Performance and Its Objects," *Arts* 65:3 (November 1990), 41.

22. Gene Youngblood, *Expanded Cinema* (New York: Dutton, 1970), pp. 340–43.

23. Jud Yalkut, *Electronic Zen: The Alternative Video Generation* (1984), unpublished manuscript, pp. 28–30.

24. On the relationship of Schöffer's spatio-dynamic and cybernetic sculptures to constructivism, see Popper, *Kinetic Art*, pp. 134–40.

25. Ascott, *Diagram Boxes and Analogue Structures* (London: Molton Gallery, 1963).

26. Nam June Paik, "Cybernated Art," in *Manifestos*, Great Bear Pamphlets (New York: Something Else Press, 1966), p. 24. Reprinted in Stiles and Selz, *Theories*, pp. 433–34. Samsara is the cycle of life and death. Metempsychosis is the transmigration of souls.

27. Charles Harrison, *Essays on Art & Language* (London: Basil Blackwell, 1991). Subsequent quotes on Art & Language are from this text.

28. Harrison, *Essays*, p. 52. I am indebted to Harrison for bringing my attention to this and other works regarding the application of cybernetics to art.

29. Roy Ascott, "Behaviorist Art and the Cybernetic Vision," *Cybernetica: Journal of the International Association of Cybernetics* (Namur) 9:4 (1966), pp. 247–64; 10:1 (1967), pp. 25–56.

30. Harrison, *Essays*, p. 58.

31. Ibid., p. 56.

32. Ascott, "The Construction of Change," p. 37.

33. Eddie Wolfram, "The Ascott Galaxy," *Studio International* 175:897 (February 1968), 60–61.

34. Ascott, "The Construction of Change," p. 42.

35. Ibid., p. 41; emphasis in original.

36. Brian Eno, Russell Mills, and Rick Poynor, *More Dark than Shark* (London: Faber and Faber, 1986), pp. 40–41.

37. Ibid. Currently Ascott is the Director of the Centre for Advanced Inquiry in the Interactive Arts (CAiiA) at the University of Wales, Newport, which he founded in 1994.

38. Stiles, "The Destruction in Art Symposium."

39. Ibid. As Stiles has noted, Metzger organized the *Destruction in Art Symposium*, and Ascott served as a member of the honorary organizing board.

40. Ascott, Interview with the author, May 25, 1995, Bristol.

41. Ascott, "Behaviourist Art."

42. Kristine Stiles, "Process," in Stiles and Selz, *Theories*, p. 586.

43. Ascott, "Behaviourist Art," p. 25.

44. Ibid., pp. 28–29.

45. H. Ross Ashby, "Design for an Intelligence Amplifier," in Claude E. Shannon and J. McCarthy, eds., *Automata Studies* (Princeton: Princeton University Press, 1956), pp. 215–34. In regard to computers as interactive behavioral systems, Ascott noted his admiration for the work of Gustav Metzger, whom he knew in London, and Nicolas Schöffer. Interview with Ascott, May 25, 1995, Bristol.

46. Ascott, "Behaviourist Art," p. 47.

47. Roy Ascott, "The Cybernetic Stance: My Process and Purpose," *Leonardo* 1 (1968), 106.

PART 5 INTRODUCTION

1. On non-Euclidean and *n*-dimensional geometries as well as their significance for relativity theory and cyberspace, see the new introductory essay in Linda D. Henderson, *The Fourth Dimension and Non-Euclidean Geometry in Modern Art*, new edition (Cambridge, Mass.: MIT Press, 2002). See also Rudolf v.B. Rucker, *Geometry, Relativity and the Fourth Dimension* (New York: Dover, 1977); Thomas Banchoff, *Beyond the Third Dimension: Geometry, Computer Graphics, and Higher Dimensions* (New York: Scientific American Library, 1990); *Tony Robbin, Fourfield: Computers, Art, and the 4th Dimension* (Boston: Bullfinch Press, 1992); and Margaret Wertheim, *The Pearly Gates of Cyberspace: A History of Space from Dante to the Internet* (New York: Norton, 1999).

2. On the emergence and significance of cyberspace and virtual reality, see Michael Benedikt, ed., *Cyberspace: First Steps* (Cambridge, Mass.: MIT Press, 1991), with essays by contributors to the current volume Marcos Novak, "Liquid Architectures in Cyberspace," pp. 225–54, and David Tomas, "Old Rituals for New Space: *Rites de Passage* and William Gibson's Cultural Model of Cyberspace," pp. 31–47; Michael Heim, *The Metaphysics of Virtual Reality* (New York: Oxford University Press, 1993), and *Virtual Realism* (New York: Oxford University Press, 1998); Pierre Lévy, *Collective Intelligence: Mankind's Emerging World in Cyberspace* (New York: Plenum Press, 1997), and *Becoming Virtual: Reality in the Digital Age* (New York: Plenum Press, 1998).

CHAPTER 13

1. George P. Landow, *Hypertext: The Convergence of Contemporary Critical Theory and Technology* (Baltimore: Johns Hopkins University Press, 1992); George P. Landow and Paul Delaney, eds., *The Digital Word: Text-based Computing in the Humanities* (Cambridge, Mass.: MIT Press, 1993); Roger Chartier, *The Order of Books:*

Readers, Authors, and Libraries in Europe Between the Fourteenth and Eighteenth Centuries (Stanford: Stanford University Press, 1994); Roger Chartier, *Forms and Meanings: Texts, Performances, and Audiences from Codex to Computer* (Philadelphia: University of Pennsylvania Press, 1995); Sherry Turkle, *Life on the Screen* (New York: Simon & Schuster, 1995); William J. Mitchell, *City of Bits* (Cambridge, Mass.: MIT Press, 1995); Geoffrey Nunberg, ed., *The Future of the Book* (Berkeley: University of California Press, 1996); Adrian Johns, *The Nature of the Book: Print and Knowledge in the Making* (Chicago: Chicago University Press, 1998).

2. Hans Moravec, *Robot: Mere Machine to Transcendent Mind* (Oxford: Oxford University Press, 1999); Ray Kurzweil, *The Age Of Spiritual Machines* (New York: Penguin, 1999); Bill Joy, "Why the Future Doesn't Need Us," *Wired Magazine* (April 8, 2000): <http://www.wired.com/wired/archive/8.04/joy.html>.

3. Friedrich Kittler, "There Is No Software," in Friedrich A. Kittler, *Literature, Media, Information Systems: Essays*, ed. John Johnston (Amsterdam: Overseas Publishers Association, 1997), pp. 147–55, especially p. 147.

4. William Gibson, *Neuromancer* (New York: Ace Books, 1984), pp. 55ff.

5. For computer-mediated communication and notions of the self see Sherry Turkel, *Life on the Screen: Identity in the Age of the Internet* (New York: Simon & Schuster, 1995), especially pp. 177–209 and 255–270; Brian Rotman, "Going Parallel: Beside Oneself," 1996: <http://www.stanford.edu/class/history34q/readings/Rotman/Beside/top.html>.

6. I. W. Hunter, T. D. Doukoglou, et al., "A Teleoperated Microsurgical Robot and Associated Virtual Environment for Eye Surgery," *Presence: Teleoperators and Virtual Environments* 2:4 (1994), 265–80.

7. Foucault, "What Is an Author?," in Donald F. Bouchard, ed., *Michel Foucault: Language, Counter-Memory, Practice: Selected Essays and Interviews* (Ithaca: Cornell University Press, 1977), pp. 113–38; see especially pp. 123–31.

8. Michel Foucault, *Birth of the Clinic: An Archaeology of Medical Perception*, trans. A. M. Sheridan Smith (New York: Vintage Books, 1975).

9. Michel Foucault, *The Archaeology of Knowledge*, trans. A. M. Sheridan Smith (New York: Harper and Row, 1972), p. 100.

10. Ibid., p. 102.

11. Ibid., p. 103.

12. Marshall McLuhan, *Understanding Media: The Extensions of Man* (Cambridge, Mass.: MIT Press, 1994), p. 9.

13. On this point see Alan Kay, "User Interface: A Personal View," in *The Art of Human-Computer Interface Design*, ed. Brenda Laurel (Menlo Park, Calif.: Addison Wesley, 1990), pp. 191–208.

14. See Friedrich Kittler, *Discourse Networks 1800/1900* (Stanford: Stanford University Press, 1988); Jacques Derrida, *Of Grammatology*, trans. Gayatry Spivak (Baltimore: Johns Hopkins University Press, 1979). For an excellent overview of the problem, see David E. Wellbery, "Foreward," in Kittler, *Discourse Networks*.

15. Felix Guattari, *Chaosmosis: An Ethico-Aesthetic Paradigm* (Bloomington: Indiana: Indiana University Press, 1995).

16. Ibid., p. 4.

17. Madeleine Akrich and Bruno Latour, "A Summary of a Convenient Vocabulary for the Semiotics of Human and Nonhuman Assemblies," in Wiebe E. Bijker and John Law, ed., *Shaping Technology/Building Society: Studies in Sociotechnical Change* (Cambridge, Mass.: MIT Press, 1992), pp. 259–64. Admittedly, our embrace of this position is not unrestricted. See Tim Lenoir, "Was that Last Turn a Right Turn? The Semiotic Turn and A. J. Greimas," *Configurations* 2 (1994), 119–136: <http://www.stanford.edu/dept/HPS/TimLenoir/SemioticTurn.html>.

18. J. Perissat, D. Collet, R. Belliard, "Gallstones: Laparoscopic Treatment—Cholecystectomy, Sholecystostomy, and Lithotripsy: Our Own Technique," *Surgical Endoscopy* 4 (1990), 1–5. F. Dubois, P. Icard, G. Berthelot, H. Levard, "Coelioscopic Cholecystectomy: Preliminary Report of 6 Cases," *Annals of Surgery* 211 (1990), 60–62.

19. G. Herman and H. Liu, "Display of Three-Dimensional Information in Computed Tomography," *Journal of Computer Assisted Tomography* 1 (1977), 155–60.

20. M. W. Vannier, J. L. Marsh, and J. O. Warren, "Three-Dimensional Computer Graphics for Craniofacial Surgical Planning and Evaluation," *Computer Graphics* 17 (1983), 263–73.

21. M. W. Vannier, J. L. Marsh, and J. O. Warren, "Three-Dimensional CT Reconstruction Images for Craniofacial Surgical Planning and Evaluation," *Radiology* 150 (1984), 179–84; J. L. Marsh, M. W. Vannier, and W. G. Stevens, "Computerized Imaging for Soft Tissue and Osseous Reconstruction in the Head and Neck," *Plastic Surgery Clinicians of North America* 12 (1985), 279–91; R. H. Knapp, M. W. Vannier, and J. L. Marsh, "Generation of Three Dimensional Images from CT Scans: Technological Perspective," *Radiological Technology* 56:6 (1985), 391–98.

22. J. L. Marsh, M. W. Vannier, S. J. Bresina, and K. M. Hemmer, "Applications of Computer Graphics in Craniofacial Surgery," *Clinical Plastic Surgery* 13 (1986), 441–48. See also M. W. Vannier and G. C. Conroy, "Three-dimensional Surface Reconstruction Software System for IBM Personal Computers," *Folia Primatologica* (Basel) 53:1–4 (1989), 22–32; M. W. Vannier, "PCs Invade Processing of Biomedical Images," *Diagnostic Imaging* 12:2 (1990), 139–47; and M. W. Vannier and J. L. Marsh, "Craniofacial Imaging: Principles and Applications of Three-Dimensional Imaging," *Lippincott's Reviews: Radiology* 1:2 (1992), 193–209.

23. R. M. Koch, M. H. Gross, et al., "Simulating Facial Surgery Using Finite Element Models," *Siggraph 96: Computer Graphics Proceedings, Annual Conference Series* (1996), pp. 421–28.

24. R. H. Taylor, J. Funda, D. La Rose, and M. Treat, "A Telerobotic System for Augmentation of Endoscopic Surgery," *Proceedings of the Annual International Conference of the IEEE Engineering in Medicine and Biology Society* 14 (1992), 1054–56.

25. W. E. Lorensen and H. E. Cline, "Marching Cubes: A High Resolution 3D Surface Construction Algorithm," *Computer Graphics* 21:3 (1987), 163–69.

26. In a similar way, pilots of some current fighter aircraft as well as the next-generation supersonic transport SST being designed at NASA-Ames do not have a vi-

sual interface with the environment but rather fly the plane into a virtual space. It seems unlikely that space will be made to look like the environment the pilots would see if they had visual contact with their environment.

27. Lorensen and Cline, "Marching Cubes," p. 164.

28. See A. J. Greimas and J. Courtés, *Semiotics and Language: An Analytical Dictionary* (Bloomington: University of Indiana Press, 1982), especially the entries "Narrative," "Narrative Schema," and "Narrative Trajectory," pp. 203–08; and Paul Ricoeur, *Time and Narrative*, 3 vols. (Chicago: University of Chicago Press, 1985), especially vol. 2, pp. 44–60, for a discussion of the problems in spatializing narrative.

29. Foucault, "What Is an Author?"

30. See Eliot Freidson, *The Profession of Medicine* (New York: Dodd, Mead, 1970); Magali Sarfatti Larson, *The Rise of Professionalism* (Berkeley: University of California Press, 1977); Charles Rosenberg, *The Care of Strangers* (New York: Basic Books, 1987); and Paul Starr, *The Social Transformation of American Medicine: The Rise of a Sovereign Profession and the Making of a Vast Industry* (New York: Basic Books, 1982).

31. John C. Knight and Kevin G. Wika, "Software Safety in Medical Applications," *Journal of Image Guided Surgery* 1 (1995), 121–32. Donald MacKenzie, "The Automation of Proof: A Historical and Sociological Exploration," *IEEE Annals of the History of Computing* 17 (Fall 1995), 7–29. Donald MacKenzie et al., "Mathematics, Technology, and Trust: Formal Verification, Computer Security, and the U.S. Military," *Annals of the History of Computing* 19:3 (1997), 41–59.

32. T. W. Dillon and A. F. Norcio, "User performance and acceptance of a speech input interface in a health asessment task," *International Journal of Human-Computer Studies* (UK) 47:4 (1997), 591–602. G. Kahle et al., "Evaluation of digital speech processing system in clinical practice," *Current Perspectives in Healthcare Computing Conference* (1996), pp. 79–84. L. M. DeBrujin et al, "Speech interfacing for diagnosis reporting systems: an overview," *Computer Methods and Progress in Biomedecine* 48:1–2 (1995), 151–56. John Gosbee and Michael Clay, "Human factors problem analysis of a voice-recognition computer-based medical record," *Proceedings of the 6th Annual IEEE Symposium on Computer-Based Medical Systems* (1993), pp. 235–240.

33. Jerome P. Kassirer, "Managed Care and the Morality of the Marketplace," *The New England Journal of Medicine* 333:1 (July 6, 1995), 50–52. Thomas Bodenheimer, "The Oregon Health Plan—Lessons for the Nation, Part One," *The New England Journal of Medicine* 337:9 (August 28, 1997), 651–55. Idem, "The Oregon Health Plan—Lessons for the Nation, Part Two," *The New England Journal of Medicine* 337:10 (September 4, 1997), 720–23.

34. See <http://othello.mech.nwu.edu/peshkin/cobot/>. Greg Paula, "Cobots for the Assembly Line," *Mechanical Engineering*, October, 1997: <http://www.memagazine.org/contents/current/features/cobots/cobots.html>. Prasad Akella, Michael Peshkin, and Edward Colgate, "Cobots: A new generation of assembly tools

for the line worker," *SPIE Robotics and Machine Perception International Technical Working Group Newsletter* (April 1997): <http://othello.mech.nwu.edu/peshkin/cobot/spie/spie.html>.

CHAPTER 14

1. I introduce the notion of *transmorphosis* to describe an operation between-and-above *transformation* and *metamorphosis*. For more on the latter concept, see Bruce Clarke, *Allegories of Writing: The Subject of Metamorphosis* (Albany: SUNY Press, 1995). *Allomorphosis, xenomorphosis*, and *exomorphosis* belong to the same cluster of meanings I intend and are useful in describing species of the production of the alien. *Diamorphosis* and *paramorphosis* are related concepts describing other aspects of morphosis–genesis that range from the pedagogical to the monstrous. *Transmorphosis* is intended to collect these various notions of formation and to call attention to their transversal connection to the alien. That the word *transmorphosis* is a linguistic hybrid, combining the Latin prefix *trans-* with the Greek *morphe*, is only appropriate.

2. See Naomi Matsunaga, ed., *Transarchitectures in Cyberspace: Ten Architects who Simulate the World* (Tokyo: Nikkei Architecture, 1998); and Marcos Novak, "Next Babylon, Soft Babylon: (Trans)Architecture Is an Algorithm to Play In," *Architects in Cyberspace II*, ed. Neil Spiller, in *Architectural Design Profile* 136 (November–December 1998), and "Transarchitectures and Hypersurfaces: Operations of Transmodernity," *Hypersurface Architecture*, ed. Stephen Perrella, in *Architectural Design Profile* 133 (May–June 1998).

3. Peter Anders, *Envisioning Cyberspace: Designing 3D Electronic Spaces* (New York: McGraw-Hill, 1999).

4. For more on Maxwell's Demon, see the section "Statistical Mechanics and Maxwell's Demon" on p. 23 in this volume.

5. Iannis Xenakis, *Formalized Music: Thought and Mathematics in Music*, rev. ed. (Stuyvesant, N.Y.: Pendragon Press, 1992).

6. Images of various elements of Hoberman's installation appear throughout Peter Galison and Caroline Jones, ed., *Picturing Science, Producing Art* (New York: Routledge, 1998).

7. Ray Kurzweil, *The Age of Spiritual Machines: When Computers Exceed Human Intelligence* (New York: Viking Press, 1999).

8. See N. Katherine Hayles, *How We Became Posthuman: Virtual Bodies in Cybernetics, Literature, and Informatics* (Chicago: University of Chicago Press, 1999).

9. On the application of voxels in virtual imaging programs for the surgical theater, see the essay by Lenoir and Sha (chapter 13) in this section.

10. B. C. Crandall, ed., *Nanotechnology: Molecular Speculations on Global Abundance* (Cambridge, Mass.: MIT Press, 1997).

11. Brian R. Greene discusses the nanoscales at which quantum mechanics and the hypothetical behavior of "super strings" occur, in *The Elegant Universe: Super-*

strings, Hidden Dimensions, and the Quest for the Ultimate Theory (New York: Norton, 1999).

12. Edwin A. Abbott, *Flatland: A Romance of Many Dimensions* (1886; New York: Dover, 1992).

PART 6 INTRODUCTION

1. Kittler discusses Marshal McLuhan's observation that "one medium's content is always other media: film and radio constitute the content of television; records and tapes the content of radio, silent films and audiotape that of cinema" (Friedrich Kittler, *Gramophone, Film, Typewriter*, trans. and intro. Geoffrey Winthrop-Young and Michael Wutz [Stanford: Stanford University Press, 1999], p. 2). This standard of media conduct has recently been generalized as *remediation*, "the representation of one medium in another" (Richard Grusin and Jay David Bolter, *Remediation: Understanding New Media* [Cambridge, Mass.: MIT Press, 1998], p. 45).

2. W. J. T. Mitchell, *Picture Theory: Essays on Visual and Verbal Representation* (Chicago: University of Chicago Press, 1994), pp. 45–57.

3. W. J. T. Mitchell, *The Last Dinosaur Book: The Life and Times of a Cultural Icon* (Chicago: University of Chicago Press, 1998).

4. On the concept of the quasi-object, see Bruno Latour, *We Have Never Been Modern* (Cambridge, Mass.: Harvard University Press, 1993), pp. 51–55.

CHAPTER 15

1. "On the Gradual Fabrication of Thoughts While Speaking" (1805–06), in Philip B. Miller, ed. and trans. *An Abyss Deep Enough: Letters of Heinrich von Kleist with a Selection of Essays and Anecdotes* (New York: Dutton, 1982), pp. 218, 222 (translation modified), hereafter *Kleist*; Heinrich von Kleist, *Sämtliche Werke und Briefe*, ed. Helmut Sembdner, 2 vols. (Munich: Carl Hanser, 1961), vol. 2, pp. 319, 323. See also "On Thinking Things Over: A Paradox" (1810), in *Kleist*, p. 217.

2. "On the Puppet Theater," in *Kleist*.

3. *Kleist*, p. 219.

4. Kleist's final example, which can be viewed either micro- or macrocosmically, is the case of university students taking an examination; they do poorly when asked general questions out of context, but fare much better when an appropriate "condition" has been established for the examination topic (*Kleist*, p. 222).

5. "On the Puppet Theater," *Kleist*, p. 212 (translation modified).

6. My description of the effect of the medium of expression is presented as if the situation were ideologically neutral. I might instead have identified the representation of "truth" with the authoritative use of the medium by a privileged or controlling social class. My reason for featuring the material force of the medium as disinterested

(in principle, unmotivated) rather than ideological (motivated by the interests of a dominant class) will soon become evident. In sum, it is this: Modern artists have attended to the materiality of the medium for the purpose of either evading or exposing ideology, whether encoded in the form of political doctrine, normative patterns of conduct, traditional theories and practices of art, or even, in extreme cases, the seemingly individualized but socially conditioned personality of the artist. Analogous notions appear in the modern exercise of scientific investigation. In "The Image of Objectivity," *Representations* 40 (Fall 1992), Lorraine Daston and Peter Galison refer to the ideal of "exclud[ing] the scientist's will from the field of discourse" (117), while Robert Brain, in "Standards and Semiotics," in Timothy Lenoir, ed., *Inscribing Science: Scientific Texts and the Materiality of Communication* (Stanford: Stanford University Press, 1998), notes the "moral authority attached to self-registering instrumentation" (p. 257). See also Brain's essay in this volume.

7. "On the Puppet Theater," *Kleist*, p. 212. Kleist ends (pp. 215–16) with the tale of a master of dancing and fencing who fails to distract a fencing bear with his feints: "he reacted not at all . . . as though he could read my very soul (*Seele*)"; this would be a case of *ineffective*, hence unnatural, artifice on the part of the dancer (on "soul," see notes 24 and 27).

8. Anonymous [Octave Maus], "Les Vingtistes parisiens," *L'art moderne* (Brussels), 27 June 1886, reprinted in Ruth Berson, *The New Painting: Impressionism 1874–1886, Documentation*, 2 vols. (San Francisco: Fine Arts Museums of San Francisco, 1996), 1:464.

9. Henry Fèvre, "L'exposition des impressionnistes," *La revue de demain*, May–June 1886, reprinted in Berson, *The New Painting*, 1:445.

10. Jean Ajalbert, "Le Salon des impressionnistes," *La revue moderne*, 20 June 1886, reprinted in Berson, *The New Painting*, 1:433; Paul Adam, "Peintres impressionnistes," *La revue contemporaine: littérature, politique et philosophique*, April 1886, reprinted in Berson, *The New Painting*, 1:430.

11. See, for example, Félix Fénéon, *Les impressionnistes en 1886* (1886), reprinted in Joan U. Halperin, ed., *Félix Fénéon: Oeuvres plus que complètes*, 2 vols. (Geneva: Droz, 1970), 1:36, 54–55. On Seurat's "science," a concise evaluation is Robert L. Herbert, *Georges Seurat 1859–1891* (New York: The Metropolitan Museum of Art, 1991), pp. 4–6.

12. Fèvre, in Berson, *The New Painting*, 1:445; Ajalbert, in Berson, *The New Painting*, 1:433.

13. Thadée Natanson, "Un primitif d'aujourd'hui: Georges Seurat," *La revue blanche* 21 (15 April 1900), 612–13.

14. I have discussed an analogous triad of concerns in a different context, designating them as "natural," "personal," and "pictorial"; see Richard Shiff, "Natural, Personal, Pictorial: Corot and the Painter's Mark," in Andreas Burmester, Christoph Heilmann, and Michael F. Zimmermann, eds., *Barbizon: Malerei der Natur—Natur der Malerei* (Munich: Klinkhardt & Biermann, 1999), pp. 120–38.

15. "In landscape naively studied, without the preoccupation of style, a highly

poetic element, which traditional [academic methods] will not admit, can slip in—this is the personality of the artist" (Paul Mantz, *Salon de 1847* [Paris: Ferdinand Sartorius, 1847], p. 96).

16. Thoré-Bürger (Théophile Thoré), "Salon de 1847," *Les Salons*, 3 vols. (Brussels: Lamertin, 1893), 1:538.

17. Cf. Richard Shiff, "The Original, the Imitation, the Copy, and the Spontaneous Classic," *Yale French Studies* 66 (1984), 27–54; "Original Copy," *Common Knowledge* 3 (Spring 1994), 88–107.

18. Louis Emile Edmond Duranty, "La Nouvelle Peinture" (1876), reprinted in Charles S. Moffett, ed., *The New Painting: Impressionism 1874–1886* (San Francisco: The Fine Arts Museums of San Francisco, 1986), p. 479.

19. Maurice Denis, "Définition du néo-traditionnisme" (1890), "A propos de l'exposition de Charles Guérin" (1905), "La réaction nationaliste" (1905), *Théories, 1890–1910: Du symbolisme et de Gauguin vers un nouvel ordre classique* (Paris: Rouart et Watelin, 1920), pp. 9–10, 143–44, 196; Denis, statement in Charles Morice, "Enquête sur les tendances actuelles des arts plastiques," *Mercure de France* 56 (1 August 1905), 356.

20. Denis, "De Gauguin, de Whistler et de l'excès des théories" (1905), *Théories*, p. 207; Maurice Denis, "Le présent et l'avenir de la peinture française" (1916), *Nouvelles théories: sur l'art moderne, sur l'art sacré 1914–1921* (Paris: Rouart et Watelin, 1922), p. 29.

21. Denis, "Cézanne" (1907), *Théories*, p. 260.

22. Emile Bernard, "Paul Cézanne," *Les hommes d'aujourd'hui* 8, no. 387 (February–March 1891): n.p.; "Paul Cézanne," *L'Occident* 6 (July 1904), 21. On pictorialism or "painting for itself" in the earlier nineteenth century, see Shiff, in Burmester, Heilmann, and Zimmermann, *Barbizon*.

23. Champfleury (Jules Fleury), *Histoire de l'imagerie populaire* (Paris: Dentu, 1886 [1869]), p. xlvi: "One does not learn naiveté. Naiveté comes from the heart, not the brain." The educator Ludovic Vitet warned of "intentional and systematic naiveté" ("Eustache Lesueur," *Revue des deux mondes* 27 [1 July 1841], 58). Camille Corot's critics found it difficult to judge whether his apparent naiveté derived from "nature [his natural disposition] or from intention [his self-conscious strategy]"; Charles Clément, "Exposition de 1864," *Journal des débats* (12 June 1864), 2. The Romantic-modernist issue of artificial naiveté had been articulated by Immanuel Kant (*The Critique of Judgment* [1790], trans. James Creed Meredith [Oxford: Oxford University Press, 1952], pp. 166–67) and by Friedrich Schiller (*On the Naive and Sentimental in Literature* [1795–96], trans. Helen Watanabe-O'Kelley [Manchester: Carcanet New Press, 1981]), as well as, somewhat later, by Kleist.

24. "On the Puppet Theater," *Kleist*, p. 213. Furthermore, Kleist identified "affectation" with a mislocated "soul" (*Seele*) or motivating force (*vis motrix* [cf. Aristotle and La Mettrie; see note 27]), which would interfere with a proper, natural movement—a proper mechanism—in harmony with the natural force of gravity; see my remarks on "soul," to follow.

25. H. F. Talbot, "Calotype (Photogenic) Drawing," *Literary Gazette* (13 February 1841), 108.

26. Francis Wey, "De l'influence de l'héliographie sur les beaux-arts," *La lumière* 9 (February 1851), 2.

27. The modern form of this notion is Cartesian, with its radical differentiation of soul from matter and materiality; see René Descartes, "Discourse on Method" (1637), *Philosophical Writings*, ed. and trans. Norman Kemp Smith (New York: Modern Library, 1958), p. 119. For a contrary view, on the materiality of the soul, see Julien Offray de La Mettrie, "Treatise on the Soul" (1745), *Machine Man and Other Writings*, ed. and trans. Ann Thomson (Cambridge: Cambridge University Press, 1996), pp. 65–66. On ancient views of the soul, see Aristotle, *On the Soul (De anima)*, in W. S. Hett, trans., *On the Soul, Parva Naturalia, On Breath* (Cambridge: Harvard University Press, 1957). To summarize the views of his predecessors, Aristotle associates the soul with three attributes: "movement, sensation, and incorporeality" (p. 29 [405b]). On the soul as self-moving and animated, see Plato, *Phaedrus*, 245e.

28. Henri Delaborde, "La photographie et la gravure" (1856), *Mélanges sur l'art contemporain* (Paris: Renouard, 1866), pp. 371, 373.

29. Ernest Chesneau, *The Education of the Artist*, trans. Clara Bell (London: Cassell, 1886 [1880]), p. 257. See also Chesneau, "La science et l'art: la gravure et la photographie," *Revue de France* 12 (October 1874), 128.

30. Georges Duhamel, *Scènes de la vie future* (Paris: Mercure de France, 1930), p. 49.

31. Yves Guyot, "L'art et la science," *Revue scientifique* 14 (July 30, 1887), 139–40, 145.

32. Guyot's essay derived from his lecture on methodological parallels between art and science, delivered in Nantes in June 1887 and illustrated (animated?) with slide projections.

33. Cecil M. Hepworth, *Animated Photography: The ABC of the Cinematograph*, ed. Hector MacLean (London: Hazell, Watson & Viney, 1900); Frederick A. Talbot, *Moving Pictures: How They Are Made and Worked* (London: William Heinemann, 1912), p. 7 ("animated photography is not animation [actual movement] at all").

34. Hepworth, *Animated Photography*, pp. 52–58, 112–13; F. A. Talbot, *Moving Pictures*, pp. 88–95.

35. Hepworth, *Animated Photography*, pp. 54–55.

36. For examples of test patterns and types of interference, see John R. Meagher and Art Liebscher, *TV Servicing* (Harrison, N.J.: Radio Corporation of America, 1951). A functional definition of "noise" is provided by Abraham Moles, *Information Theory and Esthetic Perception*, trans. Joel E. Cohen (Urbana: University of Illinois Press, 1966), p. 79: "A noise is a signal that the sender does not want to transmit." On the concept of noise, see also the sections "Information and Entropy" and "Cybernetic Couplings" in "From Thermodynamics to Virtuality," in this volume.

37. See Vladimir K. Zworykin and George A. Morton, *Television: The Electronics of Image Transmission in Color and Monochrome* (New York: Wiley, 1954), pp. 203–04.

38. On receiver noise and snow, see Zworykin and Morton, pp. 182, 720. On a minimum signal, see M. A. Krupnick, *The Electric Image: Examining Basic TV Technology* (White Plains, N.Y.: Knowledge Industry Publications, 1990), p. 10.

39. Charles Blanc, *Grammaire des arts du dessin* (Paris: Henri Laurens, 1880 [1867]), p. 578.

40. Example: "This veritable mechanism—light on dark, dark on light—animates all great traditional landscapes": André Lhote, *Traité du paysage* (Paris: Floury, 1939), p. 31.

41. "On the Puppet Theater," *Kleist*, p. 213. Among artists, Marcel Duchamp was particularly aware of the many implications of a "center of gravity." See the discussion of Duchamp's "juggler of the center of gravity" (a figure planned for his *Large Glass*) in Linda Henderson, *Duchamp in Context: Science and Technology in the "Large Glass" and Related Works* (Princeton: Princeton University Press, 1998), pp. 163–68, 229.

42. Lewis Mumford, "Authoritarian and Democratic Technics," *Technology and Culture* 5 (Winter 1964), 5.

43. Guyot, p. 140.

44. Likewise, Millet's hand-drawn border emphasizes dimensional limits already established and evident. Bruce Laughton, "Marks and Meaning: Some Responses to the Forest by Rousseau and Millet," in Burmester, Heilmann, and Zimmermann, *Barbizon*, p. 163, interprets the drawn border as a sign that Millet had "conceptualized" the image from its initiation and is unlikely to have composed it at the site.

45. No matter what is being rendered, "the handling of the brush remains the same"; with pointillism "manual facility becomes a negligible matter": Félix Fénéon, *Les impressionnistes en 1886*, "L'Impressionnisme" (1887), reprinted in Halperin, *Félix Fénéon*, 1:36, 67.

46. Meyer Schapiro, "The Liberating Quality of Avant-garde Art," *Artnews* 56 (Summer 1957), 38.

47. Denis, "La réaction nationaliste," *Théories*, p. 196.

48. Charles Morice, "Le XXIe Salon des indépendants," *Mercure de France* 54 (15 April 1905), 550, 552–53. Morice played on the semantic ambiguity of the word *valeur* (the same in English as in French).

49. Recall the critics' references to eye irritation; Fèvre, in Berson, *The New Painting*, 1:445; Ajalbert, in ibid., 1:433.

50. Paul Adam, "Peintres impressionnistes," in ibid., p. 430. Nevertheless, the patterning of Seurat's individual marks (as opposed to their scale and distribution) alludes to conventional features of representation, especially linear contour. His is a vector system as much as a true pixel system, but approaches the latter's regularity.

51. Roger Fry, "Seurat" (1926), *Transformations* (Garden City: Doubleday, 1956), pp. 250–51. Cf. André Lhote, who wrote that Seurat's small studies were "sometimes about nothing" (*Seurat* [Paris: Braun, 1948], p. 8). Fry was aware that

an elegant organicism might well appear mechanical: "With [Matisse's] bold simplification of natural form one feels that the mechanical, the merely schematic is always lying in wait" ("Line as a Means of Expression in Modern Art," *Burlington Magazine* 33 [December 1918], 202).

52. See Georges Duthuit, *Les fauves* (Geneva: Trois collines, 1949), pp. 169–70, note 1 (Matisse reporting Pissarro's opinion); Camille Pissarro, draft of a letter to Henri Van de Velde, March 27, 1896, in Janine Bailly-Herzberg, ed., *Correspondance de Camille Pissarro*, 5 vols. (Paris: Presses Universitaires de France [vol. 1]; Valhermeil [vols. 2–5], 1980–1991), vol. 4, p. 179. For Pissarro's critique of Seurat, see also Georges Lecomte, "Camille Pissarro," *La plume* 3 (September 1, 1891), 302. Pissarro's type of complaint was particularly relevant to Seurat's larger paintings (not the seascapes), which demanded viewing from a certain distance. When such works contained areas devoid of representational incident, they acquired a "mechanical look," as even Seurat's advocate Signac stated; John Rewald, ed., "Extraits du journal inédit de Paul Signac," *Gazette des beaux-arts* 39 (April 1952), 270 (entry for December 28, 1897). Seurat's method violated the convention of making the mark "proportionate to the size of the picture"; Paul Signac, *D'Eugène Delacroix au néoimpressionnisme*, ed. Françoise Cachin (Paris: Hermann, 1978 [1899]), p. 36. See also Blanc, p. 576: "The [artist's] touch should be broad in large works and fine in small works."

53. Meyer Schapiro, "Seurat and 'La Grande Jatte'," *The Columbia Review* 17 (November 1935), 9; "New Light on Seurat," *Artnews* 57 (April 1958), 44. Schapiro expressed his attitude toward television and other electronic arts of "communication" in "The Liberating Quality of Avant-garde Art," p. 40. An exception to prevailing opinion comes from someone particularly oriented to television, not techniques of painting: Marshall McLuhan, *Understanding Media: The Extensions of Man* (New York: Signet, 1964), pp. 170–71. Among the culturally significant differences between painting and television is the temporality of their production—the one relatively slow (connoting deliberation), the other relatively fast (connoting automatism).

54. In *En marche*, Seurat's conté crayon did still more, accentuating certain irregularities or flaws in the paper so that they became features of the image—for example, the wavy horizontal line to the left of the figure's extended hand.

55. Whether as a result of sawing, planing, or some other operation, the surfaces of many, if not all, of Seurat's panels manifest a somewhat irregular pattern of tiny grooves perpendicular to the given grain of the wood. The grooves are sometimes very obvious, sometimes barely noticeable. I thank Mary Sebera, Sona Johnston, and Susan Bollendorf of the Baltimore Museum of Art and Patricia Garland, Joachim Pissarro, Anne O'Connor, and Joanna Weber of the Yale University Art Gallery, as well as Seurat scholar Robert Herbert, for puzzling through the artist's use of wooden panels.

56. As if to assert the presence of the brown panel as both the image and its interference, Seurat added a brown hue to his palette mixtures (cf. Herbert, p. 246); this creates a tension between brown as materialized figuration and brown as material support.

57. Andy Warhol's notorious desire to be a machine is relevant; see Richard Shiff, "L'expérience digitale: une problématique de la peinture moderne," *Les cahiers du Musée national d'art moderne* 66 (Winter 1998), 56–57.

58. In addition, variations in the primary hues—ochres among the more saturated yellows, for example—provide a kind of optical texturing.

59. In the industrial use of canvas, colored threads of this kind serve as visual markers (for instance, in the alignment of broad belts of fabric). They can also indicate particular weights or widths of material or even particular manufacturers.

60. In this regard, *Target* was preceded by *White Target* (1957). Most of the targets that Johns painted or drew on supports other than canvas also show a thin area of surface uncovered at the very bottom (as do many of his other works). And often when Johns did paint the very bottom edge of a work, he made the "skin" there less thick than elsewhere on the surface. Asked about the uncovered bottom edge of *Tango* (1955), Johns stated, "In painting a large canvas, it was too hard to reach down to the bottom, to bend over. So I just didn't do it. Then when I noticed what I had done, I decided I liked it, and left it" (Michael Crichton, *Jasper Johns* [New York: Abrams, 1977], 30). Clearly, this effect acquired significance for Johns and merited repetition, even in the case of small canvases where little physical difficulty was entailed.

61. Throughout his career, Johns has alluded to the physicality of gravity in diverse ways, most recently in his "Catenary" series of paintings, drawings, and prints (1997–2000), which include bridge-like suspended strings, both real and represented.

CHAPTER 16

1. Excerpted from *The Last Dinosaur Book: The Life and Times of a Cultural Icon* (Chicago: University of Chicago, 1998), this essay's central idea came out of the conference "From Energy to Information." I am grateful to Bruce Clarke and Linda Henderson for their invitation and many suggestions along the way. This occasion provided an opportunity to link the internal, professional history of the dinosaur image with changes in its popular renderings and larger shifts in scientific and technological paradigms, and to link the concepts of energy and information with a concept of structure that played a key role in pre-Darwinian formations of natural history.

2. Jack Hitt, "On Earth as It Is in Heaven: Field Trips with the Apostles of Creation Science," *Harper's Magazine* (November 1996), 51–60.

3. Carl Sagan, *The Dragons of Eden* (New York: Ballantine Books, 1977), p. 64.

4. Ibid.

5. Ibid., pp. 63, 64.

6. Richard Owen, "Report on British Fossil Reptiles," *Report of the British Association for the Advancement of Science* (1841), pp. 169–340. A cultural evolutionist would have to say that modern creationism is a degenerate version of the high flourishing of pious Victorian paleontology, and that it would be well-served by a study of its own distinguished history.

7. The best critique of this shell-game, aptly described as a modern form of to-

temism in its mapping of social onto natural difference, is Marshall Sahlins, *The Use and Abuse of Biology* (Ann Arbor: UMI Research Press, 1976).

8. See Daniel Dennett, *Darwin's Dangerous Idea* (New York: Simon and Schuster, 1995).

9. See Adrian Desmond, *The Hot-Blooded Dinosaurs: A Revolution in Paleontology* (London: Blond & Briggs, 1975) for a discussion of the anti-evolutionary character of Owen's dinosaurs.

10. See Tom Lloyd, *Dinosaur & Co.: Studies in Corporate Evolution* (Boston: Routledge and Kegan Paul, 1983), p. 5, on the "second industrial revolution" based in advances in "microelectronics and biotechnology."

11. See Anson Rabinbach, *The Human Motor: Energy, Fatigue, and the Origins of Modernity* (Berkeley: University of California Press, 1990).

12. See Derek Ager, *The New Catastrophism: The Importance of the Rare Event in Geological History* (New York: Cambridge University Press, 1993).

13. Definition in the *Oxford English Dictionary*.

14. The creators of the MacDino commercial inform me that their T-Rex is also a purely digital creation. There was no object—a skeletal model or miniature—to be photographed and then animated. The whole thing was conjured out of digital information.

15. Walter Benjamin, "The Work of Art in the Age of Mechanical Reproduction," in *Illuminations*, ed. Hannah Arendt, trans. Harry Zohn (London: Fontana/Collins, 1970), pp. 219–53.

16. Lloyd points out that "the age of nuclear weapons and nuclear energy has actually strengthened the tendency toward great size in the corporate world" (Lloyd, *Dinosaur & Co.*, p. 6).

17. Jean-François Lyotard, *The Postmodern Condition* (Minneapolis: University of Minnesota Press, 1984).

18. David Harvey, *The Condition of Postmodernity* (Cambridge, Mass.: Basil Blackwell, 1990), p. 126.

Page numbers in **bold** indicate the location of illustrations. *Passim* is used for a cluster of references in close but not consecutive sequence.

WRITING SCIENCE

Bruce Clarke and Linda Dalrymple Henderson, eds., *From Energy to Information: Representation in Science and Technology, Art, and Literature*

Ursula Klein, *Experiments, Models, Paper Tools: Cultures of Organic Chemistry in the Nineteenth Century*

Matthias Dörries, ed., *Experimenting in Tongues: Studies in Science and Language*

K. Ludwig Pfeiffer, *The Protoliterary: Steps Toward an Anthropology of Culture*

Amir Alexander, *Geometrical Landscapes: The Voyages of Discovery and the Transformation of Mathematics*

Alex Soojung-Kim Pang, *Empire and the Sun: Victorian Solar Eclipse Expeditions*

Diana E. Forsythe, *Studying Those Who Study Us: An Anthropologist in the World of Artificial Intelligence*

Steven Meyer, *Irresistible Dictation: Gertrude Stein and the Correlations of Writing and Science*

Thierry Bardini, *Bootstrapping: Douglas Engelbart, Coevolution, and the Origins of Personal Computing*

Stephen Hilgartner, *Science on Stage: Expert Advice as Public Drama*

Brian Rotman, *Mathematics as Sign: Writing, Imagining, Counting*

Lily E. Kay, *Who Wrote the Book of Life? A History of the Genetic Code*

Jean Petitot, Francisco J. Varela, Bernard Pachoud, and Jean-Michel Roy, eds., *Naturalizing Phenomenology: Issues in Contemporary Phenomenology and Cognitive Science*

Francisco J. Varela, *Ethical Know-How: Action, Wisdom, and Cognition*

Bernhard Siegert, *Relays: Literature as an Epoch of the Postal System*

Friedrich A. Kittler, *Gramophone, Film, Typewriter*

Dirk Baecker, ed., *Problems of Form*

Felicia McCarren, *Dance Pathologies: Performance, Poetics, Medicine*

Timothy Lenoir, ed., *Inscribing Science: Scientific Texts and the Materiality of Communication*

Niklas Luhmann, *Observations on Modernity*

Dianne F. Sadoff, *Sciences of the Flesh: Representing Body and Subject in Psychoanalysis*

Flora Süssekind, *Cinematograph of Words: Literature, Technique, and Modernization in Brazil*